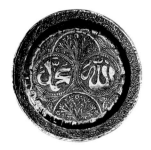

Art and Life in Bangladesh

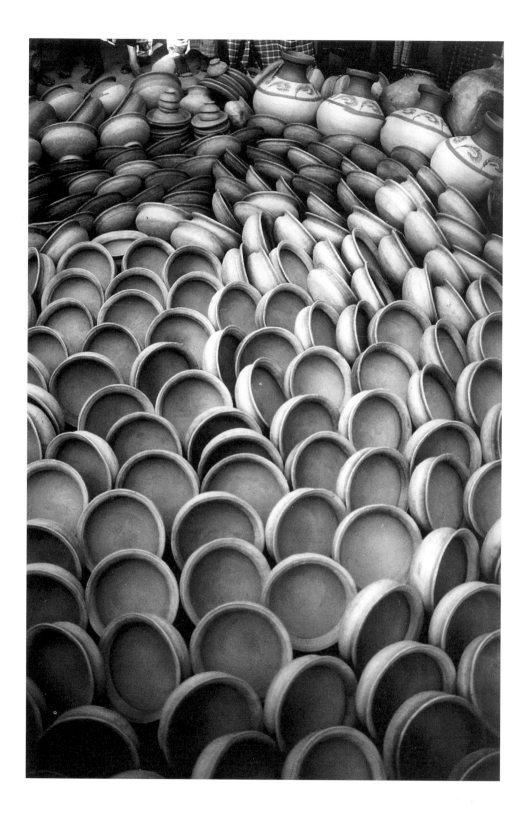

Art and Life in Bangladesh

Henry Glassie

Photography, Drawings, and Design by the Author

Bloomington and Indianapolis

Indiana University Press • 1997

The picture on the front of the dust jacket shows a *murti* of Radha and Krishna, sculpted by Babu Lal Pal in 1995; see pp. 220–21. On the back of the dust jacket, Haripada Pal poses with his image in clay of Ramakrishna. The words come from his rich statement on the meaning of his work, given in full in chapter six. The pictures below his portrait show rural Shimulia, where Haripada Pal was born, and urban Old Dhaka, where he works today. A tiny terracotta of Radha and Krishna by Haripada Pal faces the first page of the table of contents. The opening pages of the book and its section of color carry a brass plate embossed with the names of God and Muhammad; see pp. 440–41. The frontispiece shows pottery in the kiln in Charia, Chittagong.

This book is published in Bangladesh by the Bangla Academy, Dhaka.

The paper used in this publication meets the minimum requirements of the American National Standard for Information Sciences—Permanence of Paper for Printed Library Materials, ANSI Z39.48-1984.

∞™

Manufactured in the United States of America

Library of Congress Cataloging-in-Publication Data

Glassie, Henry H.
 Art and life in Bangladesh / Henry Glassie
 p. cm.
 Includes bibliographical references and index.
 ISBN 0-253-33291-5 (cl : alk. paper)
 1. Folk art—Bangladesh. 2. Bangladesh—Social life and customs.
 I. Title
 NK1050.6.B3G53 1997
 745'.096492—dc21 96-6518

1 2 3 4 5 02 01 00 99 98 97

Publication of this book is made possible in part with the assistance of a Challenge Grant from the National Endowment for the Humanities, a federal agency that supports research, education, and public programming in the humanities.

to the memory of
Kenny Goldstein

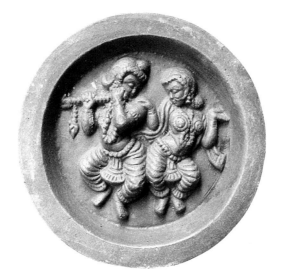

Contents

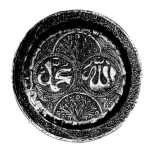

Art and Life in Bangladesh

Madhya Chandpur

Bangshai River

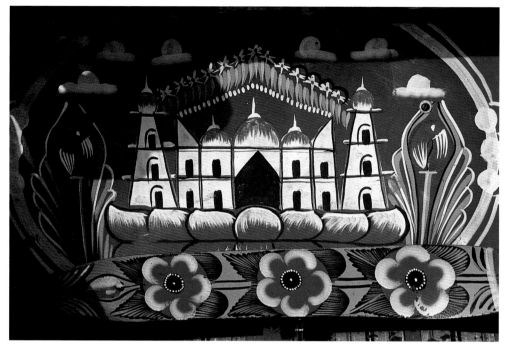

Taj Mahal. Dhaka rickshaw

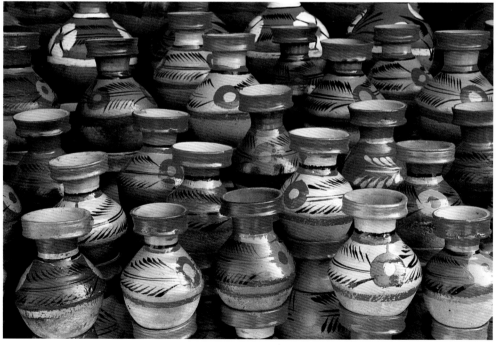

Painted *kalshis*. Mirpur Mazar

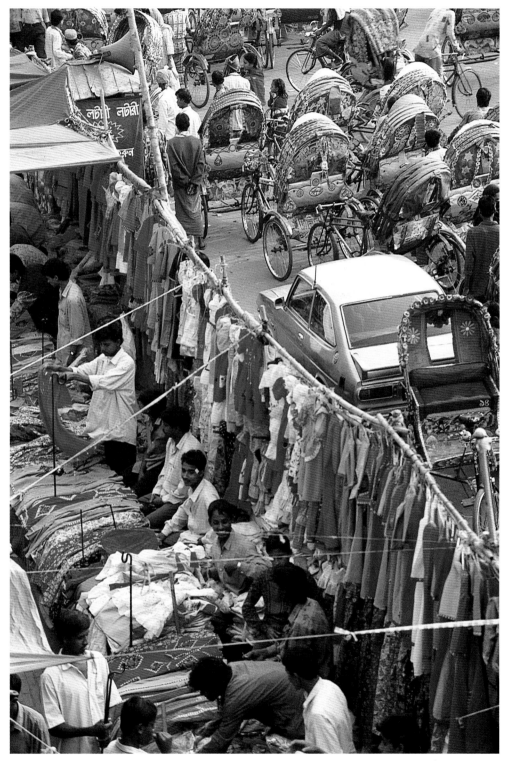

New Market

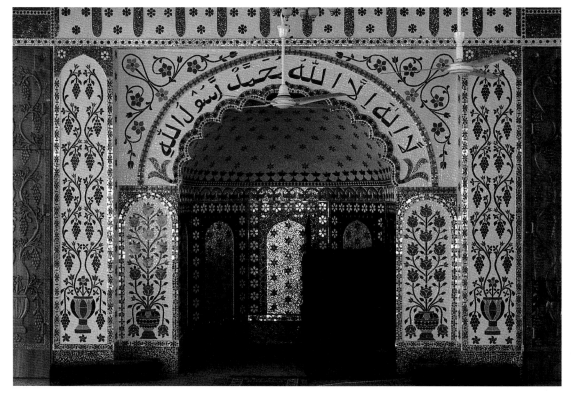

Baitur Rahim Masjid

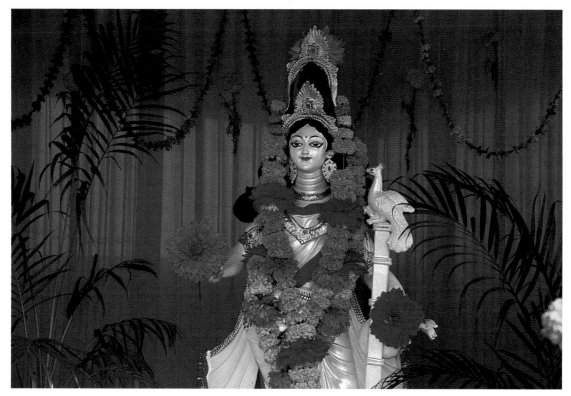

Saraswati. Dhakeswari Mandir

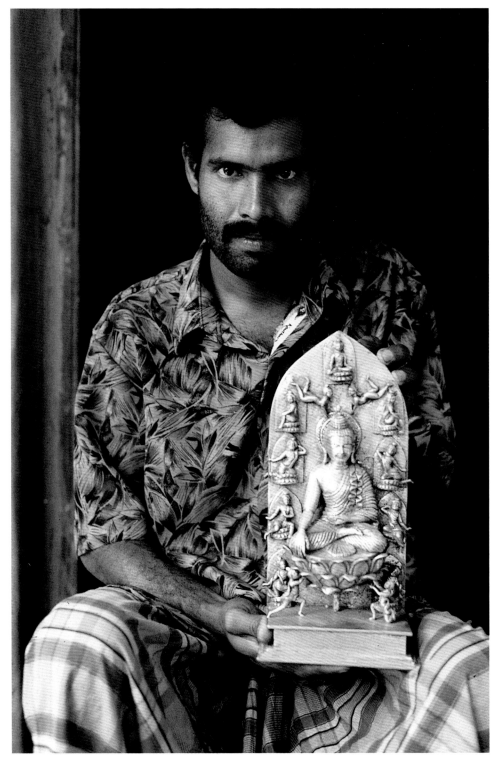

Ahmad Ali holding an image of the Buddha he cast in brass. Dhamrai, 1995

Studying Art in Bangladesh

ART IS THE most human of things. Based in the genetic, in the creative intelligence and the nimble body, art is a potential in every individual. Nurtured in social experience, taught, learned, and bent against circumstance, art is a reality in every culture. Always unifying what analysis divides, art is personal and collective, intellectual and sensual, inventive and conventional, material and spiritual, useful and beautiful, a compromise between will and conditions. Art is, given the storms and pains and limited resources, the best that can be done.

Through art, the human complexity comes into the world for consideration. It is here to see. To study art, we need not sneak about like spies or thieves or detectives, wheedling for information or bullying our companions into uncomfortable confessions. We stand with them, letting their work set the agenda for inquiry. We look together at what they have done, using it to discover what they think and intend. Learning to be fascinated by what fascinates them, overcoming our separation in a oneness of interest, we find in art a courteous entry to the life of the creator and the culture of creation.

Culture unfolds through art in accord with its own standards. Moving on the trajectory of its peculiar destiny, culture fuses for the moment in creations that offer points of contact, centers around which ethnographic study can be productively and humanely arranged. In tradition and predicament, every culture differs, and art permits us to confront cultures and compare them in line with their own profiles of value.

Since people shape their thought for presence through permanent as well as evanescent media, culture's material incarnations endure in time, allowing

comparison to be historical as well as ethnological. Deep in time, beyond the reach of memory or the written record, lie bits of burned clay and chipped flint, communications from people about whom we know nothing except that they chose to alter nature in a certain direction, forcing it toward their own idea of what was right. But that is much. Every artifact is a historical document, and the artifact's run over time compensates for the difficulties it presents to the analyst who must riddle meanings out of assemblies of silent things.

Our purpose is to encounter each created piece as the record of a human being at work in the world, learning to value it in line with the values it was designed to embody. Through study of objects in quantity, through observation and cordial conversation, we develop accounts of distinct systems of creation, much as linguists puzzle grammars out of disparate utterances. We cease evaluating all work by one standard. We understand systems of creation—artistic traditions—to be different, as languages are different, and we approach appreciation through the imaginative reconstruction of an individual's reach for quality among environmental and historical constraints.

Art welcomes our attention. It offers an entry to culture and a means for comparison. In studying art, we learn to appreciate the particular case, and we work toward a general theory of creativity that can help us position ourselves in the world, questioning the path we have chosen. Life is disappointingly short; are we doing it right?

During study, at last, we establish a relationship between our own efforts and those of the people we meet, lifting to awareness the humanity we share. We meet on the earth, with a common birthright, within a common dilemma, and there we center study in our shared capacity to do the best that can be managed in this world that thwarts more than it aids quests for excellence.

In this frame, in this mood, I have written this book. Bangladesh provides good ground for argument. If it appears at all in the Western mind, Bangladesh is a location for poverty and disaster. To see the place as a setting for excellence, to see the people as rich in art—and not as poor in money as it is convenient for people rich in money to do—is to invite a destruction of prejudice and to enable comparisons helpful in self-reflective evaluation.

I will center this book in clay, in the very earth of the vast delta that people handle diversely while rebuilding their environment to fit their vision: digging, turning, burning, disfiguring nature to configure culture. Pottery is an artistic medium far more general in the world than easel painting; it makes a sounder, more democratic base for cross-cultural comparison, and in Bangladesh

pottery provides the most common means by which the conceptual is made material.

Pottery does not miraculously encapsulate the culture. It is the focus in life for a million of the nation's citizens, but its practitioners are more men than women, and in this predominantly Muslim country, pottery is a predominantly Hindu art. Mystical song, the blend of poetry and music on sacred occasions, might offer the best way in, but no one medium, no single tradition of shaping sound or substance, is sufficient in itself, and pottery, abundant and splendid, provides a good beginning, one polite entry to life in this place.

Bangla Academy

I came to Dhaka, the capital, at the invitation of colleagues from the Bangla Academy. When the English at last left and India was partitioned in 1947, the split nation of Pakistan conjoined the western and eastern sections of the subcontinent in which Muslims formed the majority. The people of East Bengal entered warily into alliance, and their fears were realized immediately when Urdu was declared the national language. In defense of their native tongue, Bangla, the youth took to the streets. The police fired upon them in 1952, and, anointed with martyrs' blood, the Language Movement evolved into demands for political autonomy for East Pakistan. The result was massacre, resistance, and the creation of the new nation of Bangladesh in 1971. The first success in the drive for independence was the establishment of an academy for the study of Bengali language and literature. In 1955, the Bangla Academy, a center for scholarship, became a center for national aspiration.

It is January 1995, and I sit in the office of the director general of the Bangla Academy. Mohammad Harunur Rashid is a scholar, a gifted writer, and a dear friend of mine. He welcomes me to Bangladesh with a cup of tea, and I ask, now that I have come, what he wants me to do. "You have given Turkey a book," he says, "now you must give Bangladesh a book." But that bulky book took a decade to produce, I tell him, and I have only three months in Bangladesh. "Well," Harunur counters, smiling and holding his hands parallel with little space between them, "it can be a small book." I had been gratified by the Turkish response to my work, and from it I had learned how important a scholarly book can be to people who feel themselves misrepresented in the international media, dominated by the glib opinion of the West. I agree to write a book on Bangladesh.

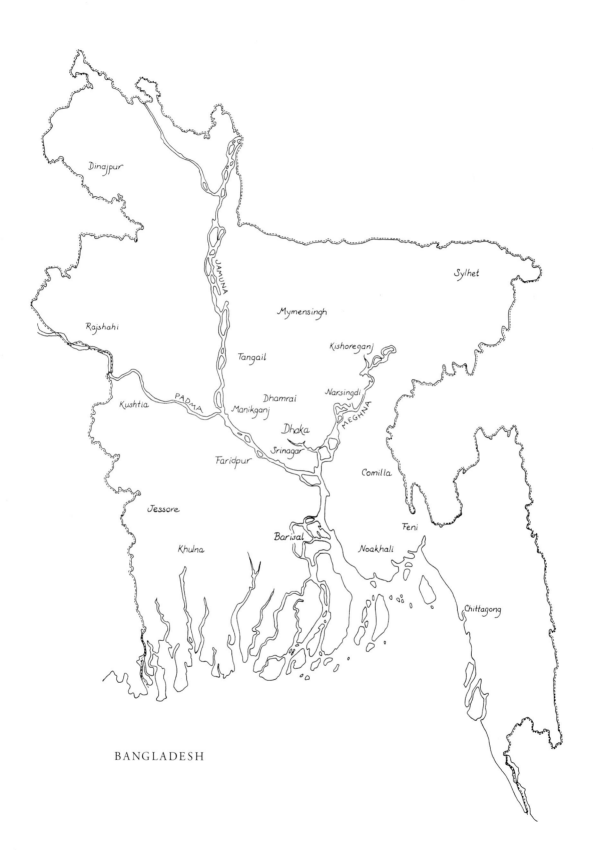

Dinajpur

JAMUNA

Sylhet

Rajshahi

Mymensingh

Tangail

Kishoreganj

Dhamrai

Narsingdi

Kushtia

PADMA

Manikganj

MEGHNA

Dhaka

Faridpur

Srinagar

Comilla

Jessore

Barisal

Noakhali

Feni

Khulna

Chittagong

BANGLADESH

"How?" asks my old friend Shamsuzzaman Khan, director of the Bangla Academy's Research, Compilation, and Folklore Division. Like me, Shamsuzzaman is a folklorist, and he knows the difficulties of fieldwork. It is not like research in the cozy confines of the library or museum. In the wide world, all is uncertain, contingent, risky. And what is hard anywhere is a touch harder in Bangladesh. The short distance on land becomes a long trip on a local bus, packed and hot, hurtling from stop to stop, waiting in the sun until it is jammed once more, lurching forward, becalmed in a sea of rickshaws and oxcarts, blessed by the chant of a beggar, lurching again, stalled, pushed, thumped, jolting without benefit of springs past wrecks through the dust. I understand why my colleagues in Bangladesh describe their place as complicated and stay home.

I answer Shamsuzzaman Khan that I begin in confidence for two reasons. I am not hunting for the furtive or arcane. During common work, people push for excellence, making art, and meeting people through art, through objects they place proudly in the world, about which they enjoy talking, I can let them lead and teach me. I do not arrogantly presume to give voice to people who have voices of their own; I listen. I do not study people. I seek to learn from them—a professor maintaining the status of a student—during collaborative interpretation of their creations.

My confidence comes from my trust in people, their kindness, their interest in their own work, their pleasure in sharing what they think is best about themselves, and it comes from practice. Just as potters get better with experience, so do fieldworkers. It is a trade that improves with age, and I have been at it for thirty-five years, refining skills and intuitive tactics in different places, among different people. It turns out I was not wrong. Fine artists were easy to find, and they were generous teachers. It was good that I was able to return when this book was half written, in March of 1996, to tie up loose ends, but I found when I wrote that most of the information I needed had been swept into the spontaneous, loquacious notebooks I kept, recounting the day's doings to myself in mad detail each night. It is the detail—the real people with real names in real places—that prevents the writing from drifting into fiction, descending into gossip, or dissolving into clouds of abstraction.

Time was my problem. Patience is the fieldworker's virtue, and patience wants time. Looking back on a decade of work in Ireland and then a decade in Turkey, I find that in both locations it took four months to discover the right way to begin—longer than I had in Bangladesh. In Ireland, it took me that

long to fight free of academical preoccupations and learn how to situate study properly in the culture of a rural community. In Turkey, I had to figure out how to adjust ethnographic techniques developed in a small country place to fit a deliciously complex urban scene, and I had to get my Turkish up to the task. In Bangladesh, I could save time by following the procedure that worked in Turkey, beginning in the open market of a big city, then moving through the merchants into friendships with the artists who supplied them. The loss entailed in importing a research apparatus might be balanced by a gain in comparative potential, and I could predict some success because I was not beginning in Bangladesh in total ignorance. It was not my first visit.

On my first day in Bangladesh, my notebook tells me, I was starting to contrive a typology of rickshaw decoration, and on my second, the first of February in 1987, I had found my way to the ateliers of potters in the Rayer Bazar section of Dhaka city. Like the artists, I enjoy doing what I know how to do. During that trip, I taught in a workshop organized at the Bangla Academy by Shamsuzzaman Khan, who gathered mature scholars to learn folklore's new theories. While 1988 became 1989, I returned for a second trip and brought those theories to the ground by leading a small team of excellent students into a fieldwork project on the pottery of Bangladesh. So when I came in 1995, I already had notebooks filled with useful data, I had interviews on tape and a thousand photographs.

I knew people, I could start immediately, and I was not confounded by an obligation to completeness. To know everything, to say the last word, is a job for the gods. The comprehensive survey is the responsibility of the local scholar, who has the time to get everywhere. Tofail Ahmad has written such a survey of Bangladeshi folk art, and Mohammad Shah Jalal has surveyed the pottery of Bangladesh. For both of their books, I supplied the laudatory forewords.

Dhaka, with its eight million people, and its flow of association through the wide delta, offered space enough. Three months were not enough, but neither would three years be enough or three lifetimes: there are one hundred and twenty million people in Bangladesh. My task was to wander Dhaka, getting into the streets every dawn and walking. There is little to be gained from more planning at the desk and much to be gained from being in action among people. My job was simply to stay in motion and learn enough to write the book Harunur Rashid requested. He suggested no topic, but I write to introduce you to the people of Bangladesh through their art, and to use their art to exemplify the study of creativity in its own contexts as part of a general

inquiry into the human condition. But it will be enough for me if I add a few names to the record. It is passing strange, a collective failing, that the names made famous by folklorists are the names of other scholars, rather than those of great storytellers or musicians, weavers or potters. Through this book, it is my hope, Amulya Chandra Pal, Maran Chand Paul, and Haripada Pal will belong to history.

Ethnographies—as W. B. Yeats said of poems—are not finished, but, at some point, abandoned to print. There is always more to learn. There is never enough time. One must be patient. Like the artist at the easel or loom, I do what I can, given real limitations. My great limitation was my bad Bangla. I had studied the language formally before coming, just as I had Turkish, but I did not have the time to let speaking get easy. Bangladeshis are more apt to know English than Turks, but fieldwork must be conducted in the native language. Pressed for time, I had to request the assistance of people who really knew Bangla.

There is nothing unusual in ethnographers hiring field assistants, speakers of the language who are revealed in embedded clauses and perfunctory acknowledgments. But that has never been my practice. It makes me uncomfortable politically and intellectually. The ethnographic record is smudged with instances of foreign scholars who have wriggled free of their own presuppositions only to become entangled in the prejudices of the native elite. I have learned by vulnerability, by arriving alone and surrendering to the direction of the local people while a way to communicate evolved slowly and friendships grew. To have the experience mediated by a third party who knows the language, and presumes to know the culture, but who does not know the individual any better than I, would disturb the intimacy of contact upon which my craft is built. But in fulfilling Harunur Rashid's charge, I needed help.

I began to solve my problem, not by hiring an assistant, a ghost researcher, but by asking colleagues, diverse in age and background, to accompany me on adventures, helping in translation and providing reactions to our shared experience. On different days, I was helped by Harunur Rashid, Shamsuzzaman Khan, Muhammad Sayeedur Rahman, Shipra Ghosh, Firoz Mahmud, Shafiqur Rahman Chowdhury, Habibur Rahman, Mohammad Anwar, Habib-ul-Alam, Sukumar Biswas, Shafi Ahmed, Akhteruzzaman Laskor, Shihab Shahriar, and Mohammad Salahuddin Ayub. All of them came to my aid through the Bangla Academy, and while I was walking in the streets, I met two men who knew English, who became interested in my project and volunteered their help:

Salah Uddin in Dhaka and Nanda Gopal Banik in Dhamrai. To all of them I am indebted, but some deserve special comment and thanks.

Muhammad Sayeedur Rahman, from Kishoreganj, north of Dhaka, is the Bangla Academy's man in the field, its folklore collector. His close knowledge of the folklore of Bangladesh is unrivaled, and our friendship was immediate. Both of us have written books eight hundred pages long on small rural communities. Our concerns differ in the way that the concerns of native and foreign scholars often do. My interest in new and common phenomena sometimes perplexed Sayeedur. His obligation is to record the old, the rare and imperiled. But bashing about the countryside with Sayeedur on my early trips was a delight, and traveling by his side in rickshaws and country boats I came to affection for him and the traditions of his land. It was an honor for me to give the speech that opened the private museum of folk art he built in his home town, and I profited by editing the English translation of the book Sayeedur wrote on the famed *jamdani* weaving of Bangladesh.

Shipra Ghosh is an anthropologist and a perceptive observer. She has conducted a fine study of the art of conch-shell carving in Dhaka. With Shipra and her husband, Biswajit, a scholar of Bengali literary history, I attended Hindu festivals, and the meals and conversation in their apartment were pleasant highpoints of my time in Bangladesh.

Firoz Mahmud is the co-author of an excellent book, both descriptive and critical, on the museums of Bangladesh. We met in the folklore workshop of the Bangla Academy. The son of a great historian, Muhammad Ishaq, and a trained historian himself, Firoz was so excited by the way in which folkloristic study can contribute to historical knowledge that, courageously, he moved his family, Daisy and boys, to the United States, and I cobbled together the funding that enabled him to receive his M.A. and Ph.D. at Indiana University. I would not say under my supervision (for Firoz is his own man), but with me as nominal director, Firoz wrote his master's thesis on the prospects for material culture study in Bangladesh (subsequently published as a book by the Bangla Academy), and his doctoral dissertation, a detailed and admirable report on contemporary metalwork in Bangladesh. I was lucky that Firoz lived in Indiana while my project progressed. We met regularly so he could teach Bangla to me and our friend John McGuigan, and we spent many nights at my kitchen table, drinking tea and wrangling into precision most of this book's translations. It was great fun, and it affirmed our collegial affection.

Muhammad Sayeedur

Shipra Ghosh

Shafique Chowdhury

Firoz Mahmud

Shafiqur Rahman Chowdhury hails from Feni, across the Meghna, southeast of Dhaka. Educated in history, Shafique works at the Bangla Academy, specializing in folksong, and in particular the songs of the modern Sufi bards. An ebullient Sufi himself, an endlessly energetic man, Shafique was my main companion, the one I could always count on, and I believe the best course I have taught in my long career was the one on field techniques I gave Shafique in the hot streets of Dhaka.

Ultimately the answer to my problem was to go alone, moving at a pace that would bore a person familiar with the country, feeling through the environment, turning from narrow streets into narrower alleys, following alleys to the end, or taking the bumpy bus to somewhere and walking the quiet countryside. I was always a wonder. In the mostly urban circles I traveled, I would see another foreigner about every four days, and it was usually someone from Japan, not a big pink European. In Turkey, I pass as a Turk; in Bangladesh, I might be a Pakistani, but I clearly do not belong. On a country lane, a farmer, characteristically old in the face and young in the body, was shocked into asking, in perfect English, "What are you, a man alone, doing here?" He was simply surprised, and, returning my greeting of peace, he kept going. But I knew what I was doing. I was putting myself in the way of events, so I could meet people, and, in particular, I was walking to the village of a potter whose works I had admired in the market. When I met people, my broken Bangla made a beginning. I could ask questions, follow the drift of chat, and explain myself well enough to gain an invitation to stay, letting time return to normal. I could begin alone, but I could not end alone. Having found the artist, having absorbed much by watching, I would return later with a friend, so the dialogue could deepen, the notebooks darken. That friend was most often Shafique Chowdhury. We laugh at the same things and share the ability to keep at it during the long days of Ramadan with neither food nor drink, sustained by delight in life.

You have, as is necessary, some notion of my purpose and practice. It is time to begin, but I must delay us with a comment on Bangla. In transliteration, I have steered between sound and scholastic convention to render words so that they will be at once recognizable to Bengalis and pronounceable by speakers of English. And that synthesis is compromised further when, as is occasionally the case, people have chosen for themselves a way to have their names appear in the Roman alphabet. Then, of course, I acquiesce to their desire. Owing to complications of pluralization in Bangla, I follow old precedent and add the

English *-s* to make plural nouns. There is a glossary in the back of the book where, too, references usually put in footnotes, or in ugly, disruptive parentheses, can be found, together with a bibliography.

Now, I will sketch the regional setting, then slow down to investigate the potter's art in Bangladesh.

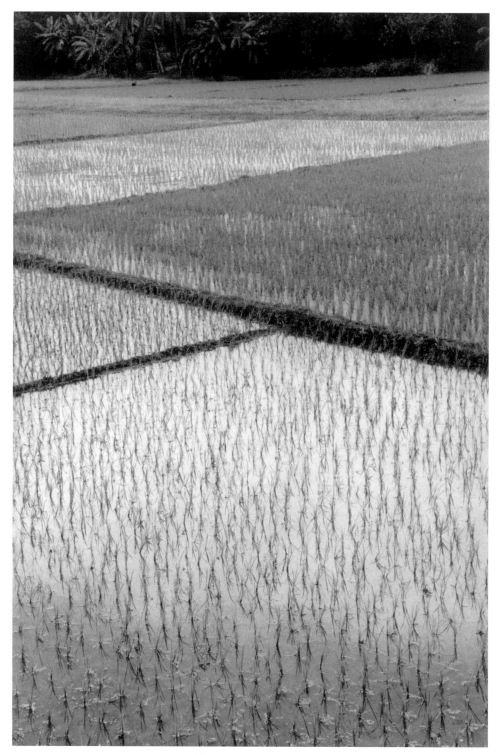

Fields of rice at the edge of Dhamrai

·1·

Dhaka

AWAY TO THE north, the world's tallest mountains rise to rip the clouds and receive the snows of Asia. With warmth, the water runs. The sacred Ganges flows southeastward, offering a corridor to the invaders who have, through time, crossed the high passes to the northwest and descended to unsettle and reshape the history of the Indian subcontinent. The Brahmaputra skirts the Himalayas and writhes westward. The rivers meet and merge, moving on to gather the Meghna and distribute streams on their run down to the Bay of Bengal. Their silt has built the widest delta in the world.

Wondrously green, the delta spreads, implacably flat. The topography is handmade, every elevation requiring an equal and opposite excavation. Dug and borne in headloads, earth has been shifted and heaped into platforms. Embanked by rivers or standing in isolation, meandering mounds of earth make islands on the land, surrounded in one season by sheets of silvery water, in another by lush fields of rice.

The earthen platform lifts habitable space out of the damp. The village has one foundation, and it has one roof. Trees stand and branch to weave a canopy of leaves against the sun. Upon the shared foundation, beneath the shared roof, individual buildings are lifted once more on earthen platforms of their own. Built of layers of clay or blocks of clay or impaled posts, they are screened and covered by bamboo and thatch or tin. Domical stacks of rice straw stand among the buildings. The clean, smooth floor of the village widens into spaces for work and contracts into paths, following walls behind which buildings cluster around familial courtyards. Life flows out of the buildings into the

courtyards, where food is prepared in fair weather, and out of the courtyards into the expanse of the village, shaded by trees and confined by its foundation of earth.

Home is not the frail building. Houses rise and fall. But the place of dwelling remains, and familial spaces join, spreading to include, within the compass of home, the one building of permanent materials that endures through the cycles of calamity: the mosque or temple.

Devotion accomplishes the minimum of architectural presence in a niche. The mihrab can stand alone, materializing the niche of the Holy Koran in which God's light gathers and glows, through which prayer is sent by the faithful, assembled beneath the sky on high holy days. The Hindu deity can shelter in a roofed niche, a stage of sticks or clay, open to veneration. But generally the holy alcove is enclosed, ideally in a masonry building, wide and shallow, offering one or three doors to the front. Inside the mosque, one or three mihrabs point toward Mecca, so the local congregation will join in orientation with all the others in the world. Inside the sanctuary of the temple, one or three clusters of images look out, drawing the gaze and the prayers of the devotee across the threshold. The long face of the mosque or temple is usually cooled by an arcaded porch. The buildings differ in that a walled courtyard, like the courtyard of the village home, encloses the front of the major temples, while the rural mosque stands free, but they are architecturally alike at the core, and they are alike in function. Both accept devotion and donation, consolidating as symbols of collective pride and settings for collective performance. Both unify the community of faith, providing through repetitive ritual a sacred argument for the interaction that is normal in the middle of the village and that is necessary at its edge where people cooperate to control the relentless waters and force the soil to yield food.

Below and beyond, green fields spread into an unfenced patchwork, expanding in vast central spaces, crossed by raised paths and worked by teams. Villages form forested hillocks on the rim of the horizon.

Settlement on the delta localizes the pattern of the agricultural openfield village, found from the Bay of Bengal to the Irish Sea. At the northwestern extremity, on the medieval landscape of England, the stone church, stepping down from tower to nave to chancel, assembled a ring of wooden homes, beyond which the farmer's holdings scattered through the broad fields. In the middle, in Anatolia, where the pattern consolidated in the Neolithic, the village occupies a slope. The minaret spires above the terraced pile of houses. The

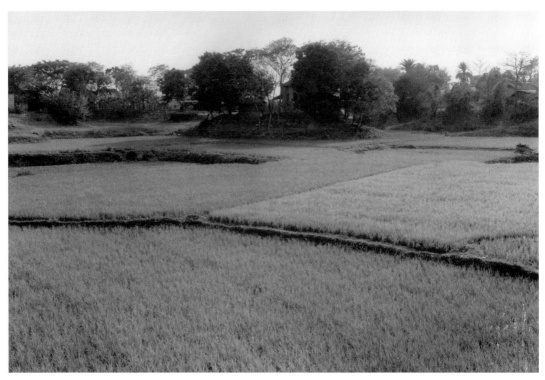

Rayerpara, Shimulia

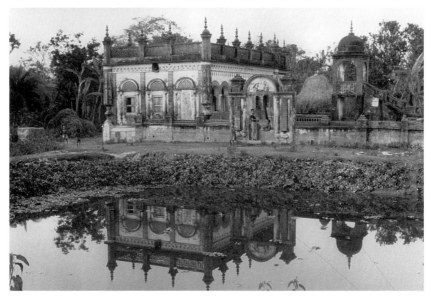

Bakhrabad Mosque. Daudkandi

Madhya Chandpur, Lemua Bazar

Kazipara, Rupshi

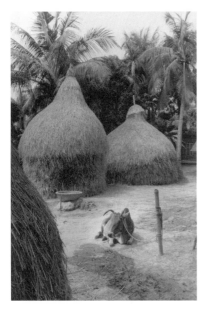

Madhya Chandpur, Lemua Bazar

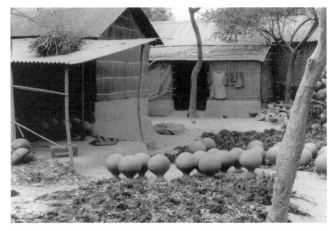

Norpara, Shimulia

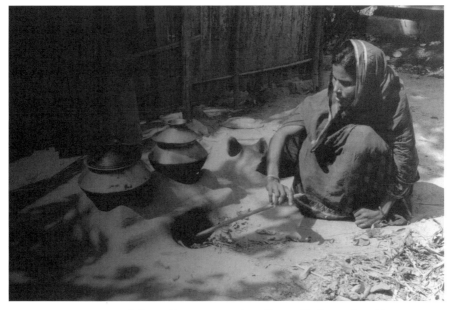

Fulbanu Begum preparing dinner. Kazipara, Rupshi

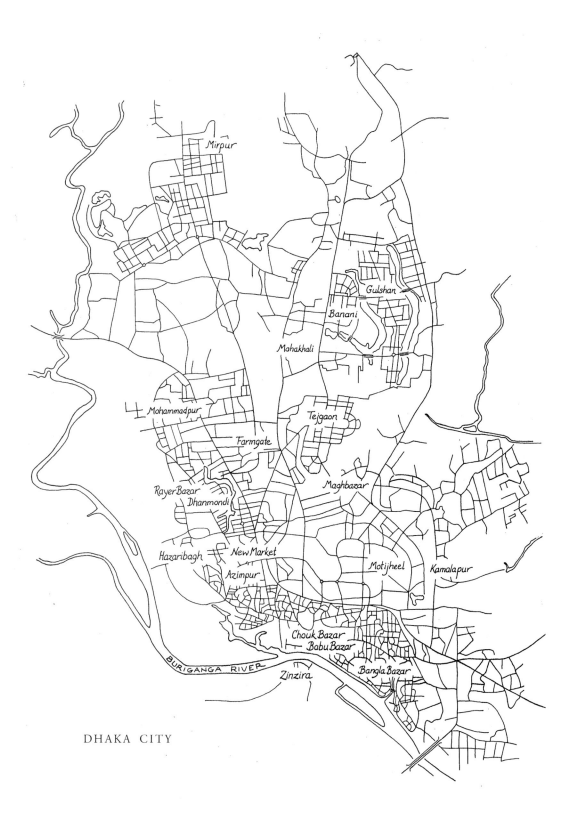

Mirpur

Gulshan

Banani

Mahakhali

Mohammadpur

Tejgaon

Farmgate

Rayer Bazar

Dhanmondi

Maghbazar

Hazaribagh

New Market

Motijheel

Kamalapur

Azimpur

Chouk Bazar

Babu Bazar

BURIGANGA RIVER

Zinzira

Bangla Bazar

DHAKA CITY

fields cluster in the valley below. The rocky pastures ascend to the ridgecrest. At the southeastern edge, in Bangladesh, there are sixty-eight thousand villages, rambling toward connection on their mounds, while the fields fan away and the storm clouds gather.

Along its northern and eastern borders, Bangladesh tilts up, but in the middle it is flat and fertile, layered with clay and free of stones. Through it rivers run, receiving lashings of rain and rising slowly into floods that drive people and snakes to higher sites. The wide quiet landscape is incomplete without people. Bangladesh is, like Ireland, predominantly rural; its space is twice that of Ireland, but its population is more than thirty times larger. No view over the land lacks people moving: plowmen following oxen in the mud, boys slinging water from field to field, women in groups, collecting the sun in saris of gold, rose, and crimson, on their walk from the bathing place at the riverside. At night, lanterns prick the dark with amber, marking bamboo stalls along the lanes. The lights flicker with the ceaseless stream of people in numbers in motion.

The great rivers, going south, inscribe a chevroned pattern on the land. The Ganges, called the Padma, intersects with the Brahmaputra, called the Jamuna, and flows on to meet the Meghna at the heart of the delta. Just upstream, the Meghna had received the Dhaleswari, and upstream again, the Dhaleswari had released then regathered the Buriganga. On the northern bank of the Buriganga stands Dhaka, city of the delta.

The City

Dhaka, sometimes still spelled Dacca by foreigners, grew rapidly during its moments of political power. From 1610 to 1717, Dhaka was the Mughal capital of Bengal. From 1906 to 1912, it was the capital of an eastern province within the British Raj. From 1947 to 1971, it was the capital of the eastern wing of Pakistan. Since 1971, Dhaka has been the capital city of the People's Republic of Bangladesh. Different periods mingle in the fabric of the modern city, but its history divides the whole into two sections: Old Dhaka, squeezed to the south, and New Dhaka, expanding northward.

The waterfront along the Buriganga makes a clear southern boundary for Old Dhaka. Nothing so conspicuous lies to the north, but a line can be traced from the tanneries at Hazaribagh on the west, past the cemetery at Azimpur, then along Fulbaria Road, the route of the old railway, and when you cross it,

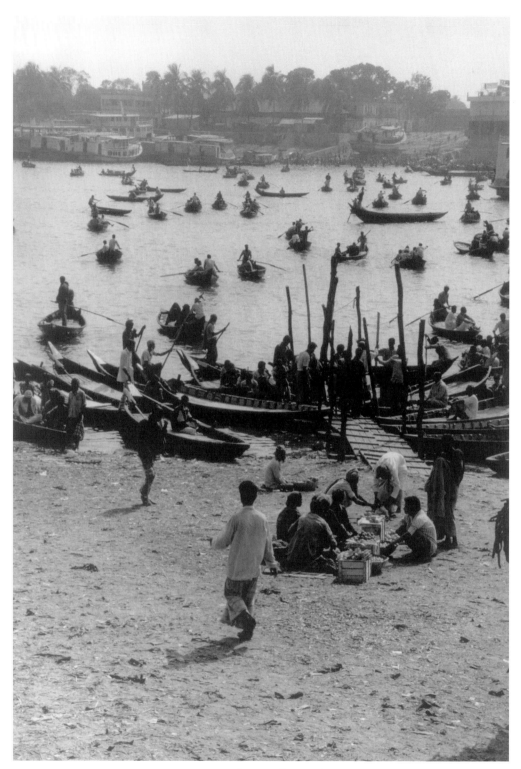

Buriganga River. The view from Sadar Ghat

Begum Bazar

Shankharibazar

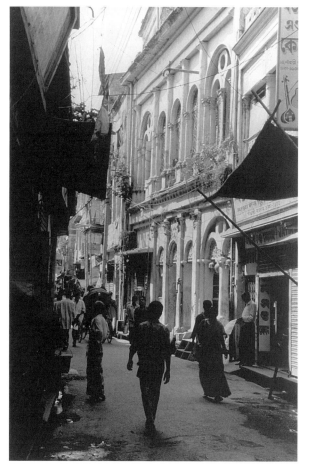

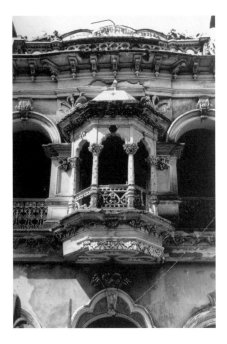

Old Dhaka

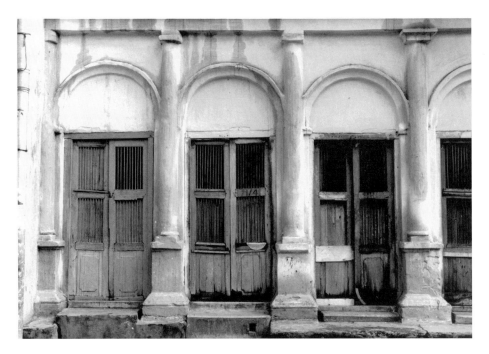

coming south, you know you are in Old Dhaka. Suddenly the pace slows, the crowd thickens, the noise dies down. The streets are too cramped for motor vehicles, too jammed with their traffic of rickshaws, handcarts, and pedestrians. Open drains run along the edges of the streets, handy for men with a need to urinate; then, abruptly, buildings rise into sheer continuous walls on each side, shaping narrow twisted canyons, deep in shadow, filled at the bottom with a perpetual roil of motion.

Old and new buildings alternate irregularly in the walls, the old displaying a characteristic style. Of stuccoed brick, tinted white or blue or pink, they conflate neoclassical and Mughal vocabularies. Engaged columns carry round or cusped and pointed arches, blooming with ornamental fancy. At ground level, shops and stalls open into an endless market. Above the stalls and behind the walls, around courtyards infilled with buildings, live the people. They comprise an intensely urban population of artisans and merchants, noted for their religiosity, whether Muslim or Hindu, distinct in their dialect and diet, distinct in Dhaka for the weakness of their connections to the countryside and for the absence among them of extremes of wealth or poverty.

Neighborhood names recall separate origins and imply functional division. Chouk Bazar and Bangla Bazar bustle with trade. Textiles are sold along Islampur Road, parts for rickshaws along Bangsal Road. Silversmiths work in Tanti Bazar, coppersmiths in Becharam Deuri. But the architectural flow is unbroken. Residential, commercial, and industrial zones merge to make one massive, impossibly complicated interlinking of small spaces.

Old Dhaka works like this. To the west, on the main street through Nawabganj, lives the master of a brass-casting enterprise. The ceilings are high. An etching of the Kaaba hangs on the wall. Salah Uddin sits on the big bedstead in his cool front room, while I drink sweet, creamy tea and he tells me that all religions are one. Muslims, Hindus, and Christians have the same God, and God sent the Prophet Muhammad with the last revelation, a perfect message of peace. But foolish people split into factions and fell into violence, so God sent Genghiz Khan as a scourge and a warning to those who stray from the path of love. When a Muslim prince in the line of Genghiz Khan entered India in triumph, Salah Uddin tells me, Hindu craftsmen presented him with a marvelous piece of engraved brass, and so great was his appreciation that, from that time to this, engraved brass has been an emblem of subcontinental artistic excellence. That is his heritage. Beginning as a repairman in his boyhood, Salah Uddin has risen to mastery of his craft. Through the back door,

a narrow courtyard runs along Salah Uddin's workshop, with its lathe and grinding machines, pointing toward the little lab where he has been mixing chemicals, he says, since the days when his hair was still black, trying to find the formula for a brass polish as lustrous and lasting as that available at high cost from the West.

Salah Uddin's production begins in a bamboo workshop at the other end of Old Dhaka, far to the east, beneath a bridge at Narinda, where the quick tempo is set by the masters Abdul Karim and Abdul Razzaque. There is a boy to crank the bellows and another to trim the sprue, while two teams keep the frames moving with rhythmic precision, packing a black blend of sand and oil around a model that is removed before the double mold is sealed and tilted to receive its radiant stream of molten brass. They are casting the parts that will be assembled into vases and ground smooth by Salah Uddin's workers in the shop at his home. Then the vases are shifted farther west into a jumble of tiny brick shops so Zakir Hossain can engrave them. With no preliminary sketch, following a plan filed only in his head, Zakir hammers a slim chisel out over the shiny surface, swiftly carving a series of flowers, then linking them with vines into a geometric interlace that his apprentice fills with detail. There is one more step. In Jamal Abedin's bamboo shed on swampy land by the river, the engraved brass vases are buffed bright.

The work is done by hand, but it is split, dispersed among many locations and many people. Space is tight. People abound. Bangladesh is small, Salah Uddin says, but its population is large. People need employment, labor is cheap, and the master divides the process efficiently, establishing an order within which each man performs, repetitively, competently, the most difficult task he can manage, and jobs remain for novices. Division in labor, requiring skills of cooperation as well as execution, is the norm, though it is accomplished differently, shop to shop. Nakshiwala Babul, Salah Uddin's young competitor in the trade, entrusts casting to another, but he has consolidated finishing and engraving in the apartment building where he lives in Pilkhana. Life and labor cohere. The master lives with his work; his skill lies in his craft, his responsibility is to organize the workforce, supply the materials, and manage sales. Once Salah Uddin sustained his operation with steady orders from Japan. Now he sells when he can to export firms, and, like Nakshiwala Babul, he supplies the stores that sell brass ornaments in Gulshan and along the New Elephant Road in New Dhaka.

Salah Uddin

Abdul Razzaque

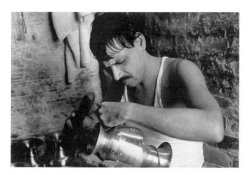

Zakir Hossain

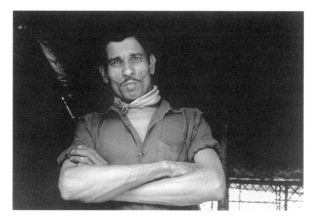

Jamal Abedin

New Dhaka, the city developed in the twentieth century, is not unified by a grid, a plan that conquers land in advance of habitation. Wide avenues cross wide spaces, open enough to bring to mind the delta beneath the pavement, open enough to lift the eye to the sky above the unruly traffic, proceeding, somehow simultaneously, at the pace of the fleet sedan, the laden truck, the cycle rickshaw, the bullock cart, the man on foot, the cow in no hurry. The main pulse is north and south (in contrast to the east-west urge along the river in Old Dhaka), but broad boulevards cut at every angle, intersecting at circles, then swinging away, sailing over the flat terrain to connect spots distinct in tone, astonishing in contrast: the business district at Motijheel, with its tall, flashy glass boxes like those of any up-to-date conurbation; the vast, fastidious parks surrounding distinguished government buildings, notably the bold Parliament, designed by Louis Kahn; the swank military cantonment, with its tennis courts and gracious homes, its jets and tanks calmed into sculpture at the gateways; the grim stretch of industrial buildings at Tejgaon; the old potters' town of Rayer Bazar, with its shadowy workshops built of earth; the busy street markets at Farmgate and Mohammadpur; the roofed bazaar and circles of shops, centered by a domed mosque, at New Market; the gridded patches of luxurious houses in Dhanmondi, Banani, and Gulshan; the *bustis* deposited at random.

"Slum" is the usual, brutal translation. Calling the *bustis* "squatter settlements" would connect them to similar communities of poor people, newly come from the country to establish themselves with desperate hope in cities expanding too fast to plan across the globe. The *busti* is a piece of rural landscape ruthlessly compressed in urban space. Occupying land to which the people own no title, bamboo houses pack tighter than they do in villages. Mosques and schools stand among them. Straight paths carry commerce to teahouses in the middle, and the outer rim runs with stalls where food and pots are sold, where vehicles are repaired. Beyond, where the fields should be, gardens are tended and cattle graze in vacant lots and swaths of park.

The rising sun throws a rosy glow around the women in colorful saris leaving for their work in distant garment factories or in the nearby white apartment buildings where they will do the cooking and cleaning of other women. Mistress and maid probably share rural origins. Memories, culture: shared notions of authority and propriety ease their joint effort at domestic order. What they do not share is luck. The daily lives of the women of the *bustis* enfold sudden, incredible contrasts of poverty and wealth. Their husbands

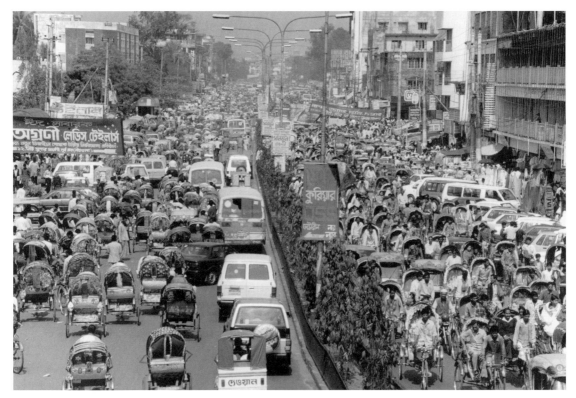

New Dhaka. Mirpur Road from New Market

work as unskilled laborers, as street vendors and rickshaw pullers. It is the job they can get. Carnivalesque rickshaws crowd the yards around the *bustis*.

In the streets of Dhaka city, there are more than eighty-eight thousand rickshaws, maybe one hundred and fifty thousand, maybe more. No one knows the number, but rickshaws are a pervasive, emblematic feature of city life, and they provoke divergent response. Men rich enough to own automobiles and influence government policy are annoyed at the way they clog the traffic. The compassionate recognize that rickshaws provide employment to nearly a quarter of the city's workforce, to hundreds of thousands of men who ply them in shifts, who build and repair them. Rickshaws carry two-thirds of Dhaka's burden of passengers. They are necessary, but the puller's labor, the compassionate say, is inhuman. It is not harder than farm work, the labor left behind. What is inhuman is less the labor than the wages that husbands and fathers gain from it. Swarms of bright rickshaws add interest to the city's slow motion, and they have frequently excited the curiosity of foreign visitors, for collectively they comprise a quantitatively astounding public exhibition of art.

Assembled in bamboo sheds, or, like brass in Old Dhaka, in a sequence of shops, each specializing in some segment of the process, rickshaws end in the hands of decorators like Ismail Mistri, at the edge of the *busti* at Agargaon, or Anis Mistri on Jafarabad Road in Rayer Bazar. The owner of the rickshaw, who will rent it to the puller, provides the decorator with no directions. "What does he know about art?" asks the artist Anis Mistri. Anis receives the forward portion of a bicycle, trailing two wheels, between which, upon stiff springs, a slipper-shaped coach is framed of wood and sheathed in aluminum. It will seat two in comfort—or a whole family or a towering heap of stuffed sacks with a man balanced on top.

Anis Mistri's shop has space for one rickshaw, and room at the side for his sewing machine. He has been at it for a decade and he finishes one every five days, adding the unnecessary ornament that, in this place of scant resources, amounts to a quarter of the cost of the whole. Working with an eye to receiving, as is customary, more than the agreed upon minimum, Anis paints birds and flowers on the iron frame, studs patterns of tacks into the aluminum, upholsters the seat with painted plastic, decorates the folding top with paint and appliqué, and adds a painted tin panel to the rear, above the flowered bumper.

Since the end of the 1930s, Dhaka has been a city for rickshaws—pedal power fits the flat surface—and since the 1950s, the rickshaws have been splashed

with color to move in schools like extravagant tropical fish. The traffic whirl has been further confused, since the middle of the 1980s, by two kinds of motorized rickshaw: the plain, light *mishuk,* developed with government support, and the more powerful, more numerous, richly ornamented vehicles called, using the English words, scooters or baby taxis or babies or taxis.

Asking among the drivers for the manufacturer they thought was best, I was led to the shop of Yunus Mistri in Maghbazar. Handling several at once, Yunus Mistri's workers produce one baby taxi every twelve-hour day. It begins with the chassis, modeled on the Vespa at the Bajaj factory in India. Rolling on three wheels, with the engine, front seat, and windshield in place, the scooter enters the first shed, where one man frames the coach of wood and sheets it with aluminum, three men seat it on the chassis, and another man bends and welds the metal tubing of the roof. To one side, in an open yard, three boys wrap the tubing with colorful tape, and two boys paint the body black and block in the program of ornament on the sides and front. In a second shed, men at sewing machines stitch the top and upholstery, a boy hatches in the detail of the minor ornament and letters the shop's signature, while Abdul Jabbar, the younger brother of the master, chalks and carefully paints the picture on the rear ordered by the owner. Another baby taxi is ready for the street.

There is one basic plan for the decoration of baby taxis, and two for rickshaws, though they merge in the process of endless repair. Most rickshaws are decorated in the Dhaka style, with the main displays on the seat and rear panel, but perhaps one in twenty is in the style the pullers associate with Comilla, east of the Meghna River, in which the main ornament is painted directly on the back of the coach. On all, the flurry of detail is distributed in bilateral symmetry on the transverse line, as it is on birds of paradise, but the major work on the rear of the baby taxi, on the back panel of the Dhaka rickshaw, or in a circle on the rear of the Comilla rickshaw, can burst out of the prevailing order with a claim for special attention.

The one image they all share is the Taj Mahal. Most of the artists and pullers I asked called it a mosque, some identifying it as a particular mosque in Dhaka. (And a concrete mosque in the form of the Taj Mahal, under construction on the city's northern edge, will make them right.) Others knew it was a tomb in India, but their deeper knowledge wound to a similar, culturally coherent conclusion when they declared the Taj Mahal to be "a symbol of our Islamic heritage." What might be taken as loosely evocative of the Indian subcontinent is unambiguously a religious emblem to the people.

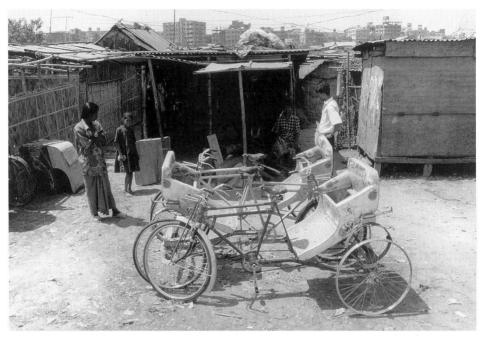

Ismail Mistri workshop.
Agargaon Busti

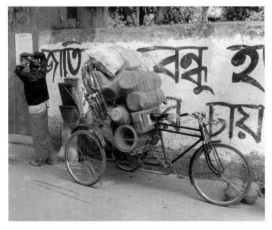

Preparing to transport pottery.
Rayer Bazar

The Cycle Rickshaw

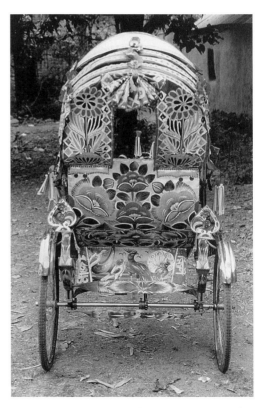

Coach in the Comilla style,
panel added below in the Dhaka style

The Baby Taxi

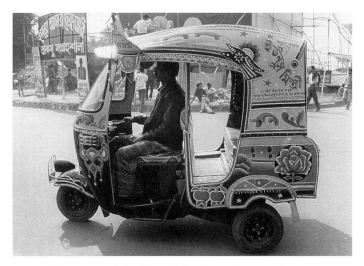

A product of the Yunus Mistri workshop on the street

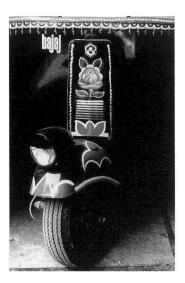

Painting on the front of a new taxi at the Yunus Mistri workshop

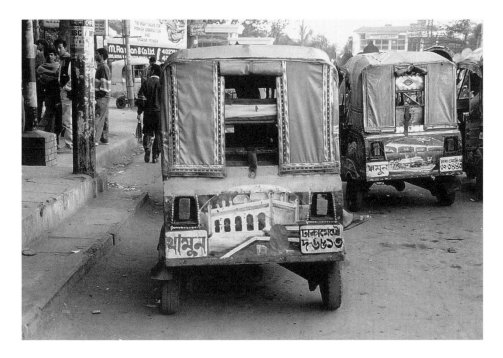

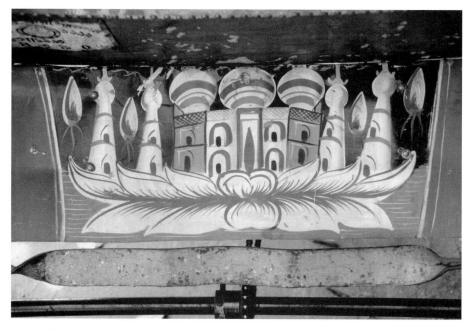

Taj Mahal.
By Anis Mistri, 1995

Anis Mistri.
Rayer Bazar

Abdul Jabbar

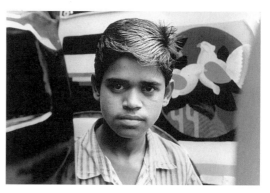

Liton.
Painter in the Yunus Mistri workshop

Taj Mahal.
By Abdul Jabbar, 1995.
Yunus Mistri workshop. Maghbazar

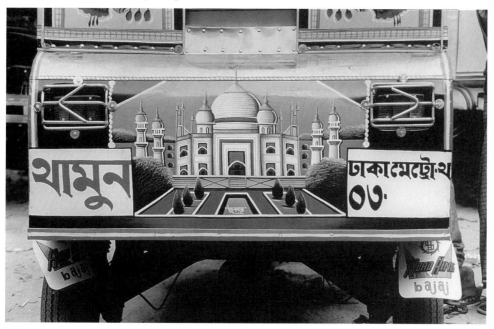

Rickshaw in the Comilla style.
By Mohammad Chowdhury.
Paleswar, Feni, 1995

Taj Mahal.
Cycle Rickshaws

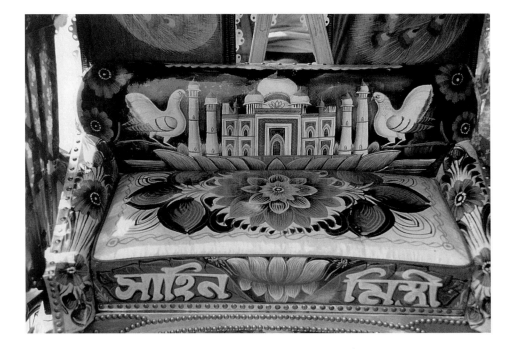

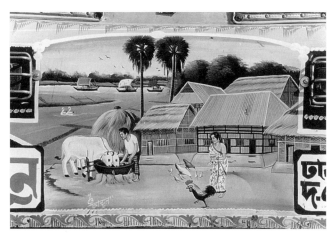

Painting signed Abdul.
The one below is signed Ujjal

Village Life.
Baby Taxis

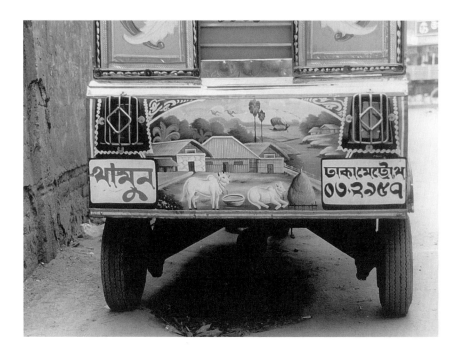

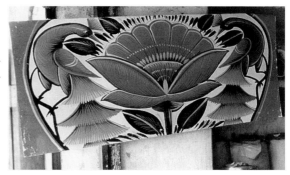

Rickshaw panel.
By Mati Mistri, 1995.
For sale, Pilkhana

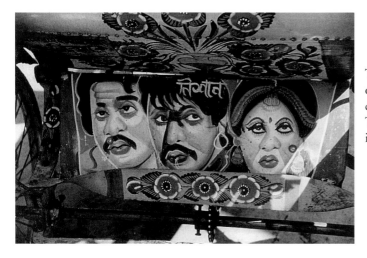

The most common image
of film stars on Dhaka's
cycle rickshaws in the 1990s.
The word *Nishan*
is the name of the film.

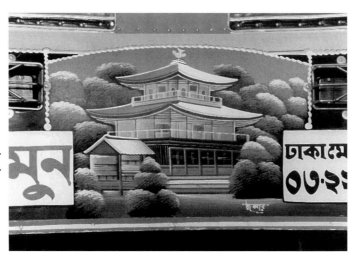

Golden Pavilion, Kyoto.
Baby taxi by Abdul Jabbar.
Maghbazar, Dhaka

The Taj Mahal is joined in the streets by other clear signs of the faith of the owners and pullers. Renderings of local mosques, most often the Star Mosque in Old Dhaka, adorn the baby taxis. The decoration of the Comilla rickshaw is generally geometric and floral in the Muslim taste, though a circle might contain a portrait in profile of the white horse that Husayn, grandson of the Prophet, rode to martyrdom at Kerbala. Above the windshield of the baby taxi, on the rear of the rickshaw, on the front of the modest green *mishuk,* in Arabic, are written the names of God and the Prophet.

Rickshaws and baby taxis share, too, flowers, birds, and animals—the lotus and rose, songbirds, parrots, and peacocks, tigers, lions, elephants, and healthy white cows—the beautiful, useful, potent wonders of nature. Then the vehicles part in depicting the human. Rickshaws exhibit gaudy group portraits of Bangladeshi movie stars in roles that generally imply a triangle of passionate violence. They call these pink and blue faces, these fleshy women with machine guns, their heroes and heroines. The cinema is the resort of underpaid laborers; prosperous people stay home and watch television. Pictures inspired by movie posters do not fit the pretentious baby taxis that illustrate Bangladesh, instead, with scenes of rural life—after mosques, next most common among his commissions says the artist Abdul Jabbar—and with modern buildings, especially those touched with national sentiment: the Parliament and the monuments to the martyrs of the Language Movement and the War of Independence. Gesturing to their own ability to conquer space with speed and ease, baby taxis carry images of modern transport—not the rich man's private car, but bridges, ships, trains, and airplanes, sometimes the Concorde, but more often jets labeled as belonging to the national fleet of Bangladesh.

Through portraits of the stars or of human creations—the village of thatched houses beside a river on which a sailboat glides; the steamer passing beneath a long iron bridge, a jet in the sky—Dhaka's public display centers upon contemporary Bangladesh. Then, through images that Abdul Jabbar collects in the category of calendar pictures, the baby taxi refers to the wider world. Global variety is not represented by people, by bodies, but in the Muslim manner by objects, signs of human accomplishment: by buildings in Europe, the Tower Bridge in London being most common, and in Asia, the Golden Pavilion in Kyoto being the favorite. Suffused with self-satisfaction, Americans fret or gloat about their nation's neocolonial expanse. While American soft drinks are ubiquitous in Bangladesh (and that is a good thing in a place of

dangerous drinking water), there is little else. The United States is a minor, marginal presence on the map implicit in the rickshaw's gallery. I saw the Statue of Liberty on a few baby taxis, Mickey Mouse dressed as Robin Hood on a few more, but the most common reference to my nation was a heroic portrait of Saddam Hussein, his hands lifted in prayer, a rocket burning an arc in the air. There are far more European images than American, more Asian than European, and most of the pictures show the native land in its own sufficient diversity.

Mosques and government buildings, sailboats and steamers, quiet villages, splendid peacocks, armed heroes, monuments to the dead: moving pictures decorate the traffic with fragments of the Bangladeshi worldview. Signs of religious and political authority, of rural peace and urban progress, of the nation's history and its connections west to England and east to Japan, sketch a context around beautiful, violent creatures. Rickshaws fill the streets, representing the people to themselves, and introducing Bangladesh to the visitor.

Dhaka is called the city of rickshaws; the rickshaw is one thing that unifies this city of division, bringing Old Dhaka and New together. The other is the mosque. Dhaka is more often called the city of mosques and minarets.

There are one thousand, six hundred and fifty mosques in Dhaka. Domed mosques in the Mughal manner are not restricted to the old city. Built to mark progress when Dhaka expanded during the seventeenth century, in its days of Mughal grandeur, they endured when the city withdrew to the Buriganga, and they stand still, interrupting the mass of twentieth-century construction with historic shells that provide modern people with places for prayer.

Contemporary development, in New Dhaka and in Old, is characterized by a new form. Agile designers have dismembered the Mughal mosque and meshed it with the modern commercial building to create a mosque fit to a compact urban setting. Walls follow the street, screening and enclosing a prayer hall built in the wide, shallow Mughal proportions. The conjunction is usually irregular, since the orientations of the screen to the street and the hall to Mecca rarely coincide. Two or three floors pile above into a high-rise house of worship. The upper walls are pierced to welcome the flow of air. Along the street, the building absorbs shops that, like those around the base of the raised Mughal mosque, contribute rents to maintain the sacred foundation. A minaret on the roof, tipped with a bulbous Mughal dome on columns, announces the mosque within. From the dome, a veil of ornament descends, defining a tower, or dropping a bright stripe to the entrance.

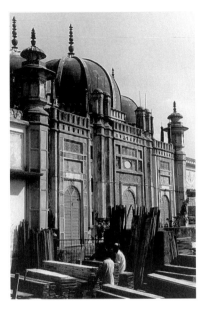

Babu Bazar Mosque

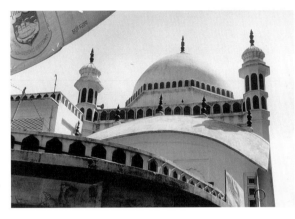

Kartalab Khan Mosque. Begum Bazar

Khan Muhammad Mirdha Mosque. Lalbagh

New mosque of the Old Idgah

Kalabagan Mosque

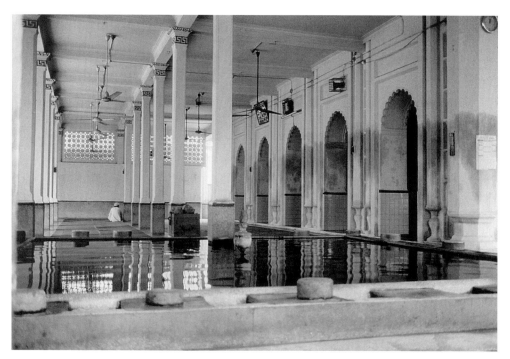

Bangsal Mosque

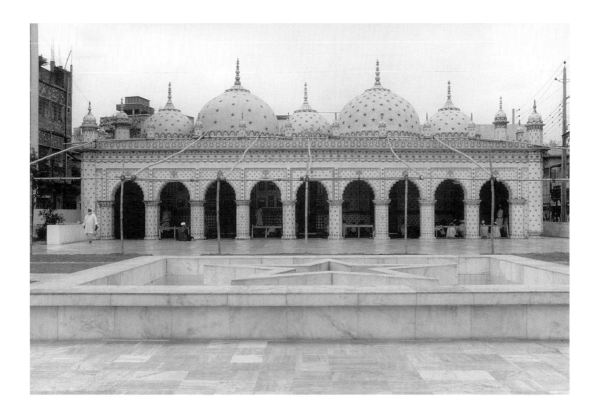

The Star Mosque

Star Mosque

Baitur Rahim Mosque

Koshaituli Mosque

It might be stucco and paint, but the ornament most typical of the twentieth century is a mosaic composed of broken bits of china and glass. This shimmering skin of recycled scraps appears in passages on mansions and Hindu temples built early in the century. On the tombs of Muslim saints, on the Koshaituli Mosque, built in 1919 and decorated in 1971, and on the Star Mosque, as pictured on baby taxis, gleaming mosaics coat the domes. When it was erected in the eighteenth century, the Star Mosque was a late realization of the basic Mughal form: a prayer hall of three bays, with three domes above, three mihrabs within. An elderly gentleman at prayer there told me that the mosque was given its revetment of English Art Nouveau tiles and its star-spangled mosaics by a wealthy tobacco merchant in the 1920s. I happened to visit first when workmen were finishing the two bays added to the northern end of the Star Mosque in the 1980s. One man was breaking bottles and crockery into neat pieces. Three young men were spreading the ceramic mosaic of the facade, and they invited me to clamber up to the scaffold and press a few shards of bright white china into the damp, gray surface, filling in between the stars, adding my bit to the fabric of Old Dhaka.

The mosaic that sheathes the old tomb or mosque is limited in the new mosque to a few key features: the domed minaret that calls the faithful to prayer; the gateway marking the transition from the racket of the street to the peace of the interior; the mihrab through which prayer is sent. In accord with Muslim aesthetic precepts, sparkles of color on the white surface form words calligraphed in Arabic—the names of God and the Prophet or the Profession of Faith—or they shape into flowers, blossoming on the vine of life or lifting from a vase. In the niches of the Koshaituli Mosque, or on the mihrab of the new Baitur Rahim Mosque in Mirpur, the flowers in the vase—cut, yet standing in full bloom, holding their symmetrical arrangement in an airless atmosphere—provide a clear symbol of life after death. This emblem of hope and promise reiterates an old Mughal motif, shared widely in Islamic art and paralleled in modern Dhaka by designs engraved on brass trays and painted on the Comilla rickshaws.

Inside, the mosque embraces a wide, impeccably clean space. Blessedly quiet and ornamented with the flora of Paradise, it offers rest to the body and hope for the soul. Outside, the street is jammed and hot, boiling with noise, clatty with dirt. Crows pick through the garbage. Smoke stains the sky.

It is different when strikes banish motor vehicles from the streets. Then there is the soft whir of the rickshaws. The pace steadies and slows. The sky turns blue.

Dhaka is the city of mosques and rickshaws. Rich with color and meaning, mosques and rickshaws embody the worker's unconquered will and bring the city together, unifying Dhaka in the counterpoint they offer to that which prevails.

The District

At some point on every road out of the city, the traffic thins, the turmoil is swallowed by the tremendous calm of the countryside. Where the vast delta reclaims dominion, it is still Dhaka. The capital city is a dense, frenzied node in the broad rural district that bears its name. The city would die without the country, the source of its food. The country needs the city less, but village people find markets for their produce in downtown Dhaka. The rural and urban combine in a reciprocal system of supply and influence, as people and goods travel the roads and rivers, into the city, into the country, continually.

South of Dhaka city, across the Buriganga, Zinzira spreads along the waterfront. Wooden ferry boats, beamy gondolas rowed from the stern, cut through the traffic of high-prowed trawlers and low vessels laden with sand, crossing from Babu Bazar Ghat in Old Dhaka to the shore at Zinzira. On the riverbank, men build ships of steel and wood. Narrow streets strike inland, lined with cramped shops full of men hammering brass and copper into globular water jars, hemispherical drums, and ornamental planters. They begin with battered scraps, scavenged from wrecks in the shipbreaking yards of Chittagong. The scraps, humpy, lumpy, corroded, and bent, seem beyond recall, but young men hammer away. They pound and pound; they snip and pound seams, solder and pound more. Intransigent fragments slowly coalesce into elegant vessels.

My time passed in one of the bamboo sheds that line the street. A bowl of coins to give beggars rests on the earthen floor in the front, where the men hammer in the light. His workers—Malek, Selim, Shamsul, Dinesh, and Liton—pound and join the forms, and then the master, Saidul Rahman, pounds them more. The metal, beaten by human will, transformed through a sequence of increasingly delicate hammerings, has become smooth, its origin in battered scraps obliterated. Next the vessels travel farther inland, through the market, and down the backstreet where Mohammad Hasnain Khan lives. In the yard by his house, Hasnain's workers fill the brass vessels with a hot mix of linseed oil, brickdust, and resin that cools and hardens to offer resistance.

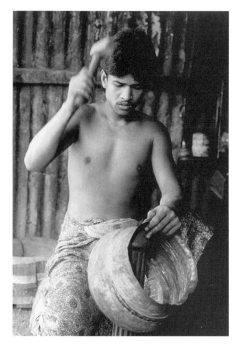

Shamsul Haque

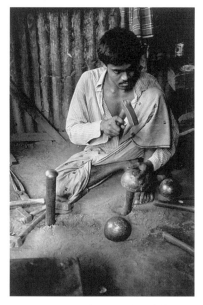

Mohammad Malek Mia

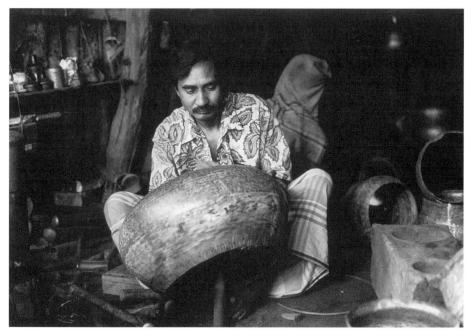

Saidul Rahman

Hasnain's Workshop.
Zinzira

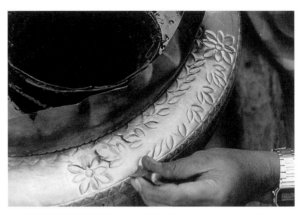

Mohammad Nazim
beginning the design

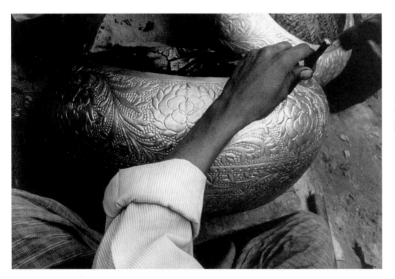

Mohammad Zakir Hossain
punching the background

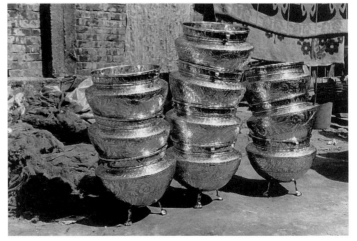

Buffed brass planters

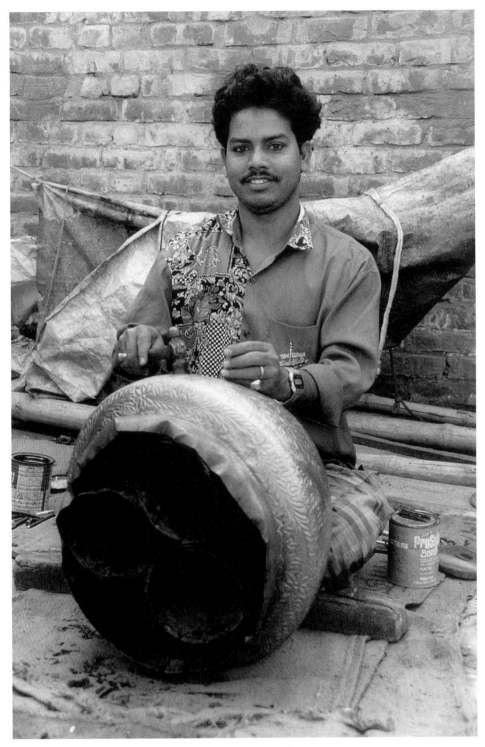

Mohammad Nazim

Moving a punch beneath his steady hammer, Mohammad Nazim divides the surface with flowers, links them into a geometric pattern with vines, then drives the background in deeply. The decoration seems to be extruded from the rear in repoussé, though it was hammered from the front in the embossing technique. The black, tar-like stuff is cracked out, and, in a shed by the yard, the vessels are buffed bright as gold, to be sold in stores in New Dhaka, to become ornamental planters in expensive homes.

Farther south, across the Dhaleswari, lies the region called Bikrampur, in Munshiganj district, where the Padma meets the Meghna at the heart of the delta. It is country again, a landscape of villages, of farmers and potters, and the potters at work around Srinagar are famed for images pressed into clay molds, fired, painted, and sold on the streets of Dhaka.

To the northwest, the main road escaping from Dhaka passes through Savar (where the city ungraciously yields to the country) and continues, crossing the Bangshai River near Dhamrai. An ancient town, the market town for the northwestern corner of Dhaka district, Dhamrai is a center for workers in metal, from blacksmiths to goldsmiths. In the town, at the Paresh shop, four buildings outline a generous courtyard. One is the master's home. In the second, two men pack clay around a brass vessel to shape the outer jacket of a mold. In the third building, a long open shed, one man models a core into the split jacket, and two men, Sunil Chandra Mandal and Subash Chandra Pal, working at the artist's contemplative pace, refine and perfect the shop's masterpiece, the trim embedded mold of clay that leaves precisely the right space for the flow of molten brass. At the far end of the shed, Prem Chand Pal tongs the egg-shaped clay crucible from the furnace, cracks it, and tips its hot liquid into the mold. In the last shed, four more men break the brass vessels out of their baked clay crusts, file and grind them smooth, then polish them on a lathe. Their product is a spouted container for water, wholesaled in Dhamrai, retailed in Dhaka, and used at the toilet.

The Great Mosque of Dhamrai, built at the very end of the last century, stands in the middle of a long market. Two porches, the second bearing four domes, darken entry to the wide, shallow prayer hall. Three domes ascend, and the central one of the three mihrabs glitters in a brilliant mosaic of rigid vines and flowers. From the mosque, roads go north and northeast, reaching into the countryside where villages stand upon mounds, where farmers work the dirt and potters fashion water jars and flowerpots for the markets in Dhaka city.

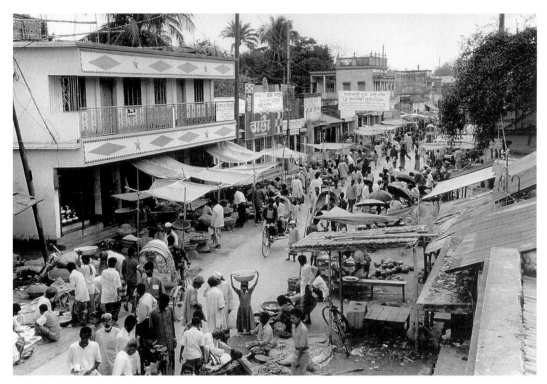

Dhamrai

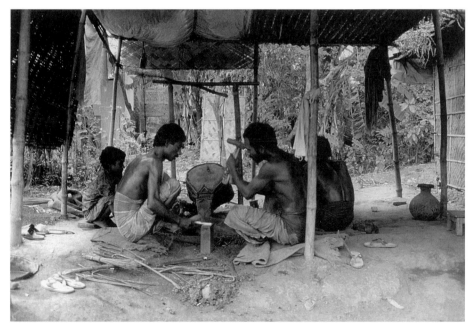

Blacksmiths. Dhamrai

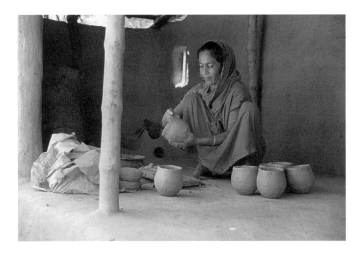

Malati Rani Dhar
making the crucibles of clay

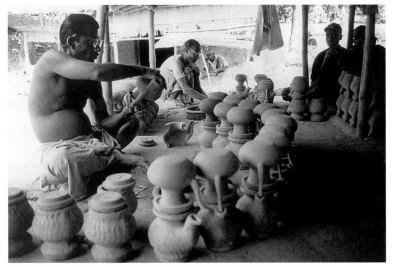

Subash Chandra Pal and
Sunil Chandra Mandal
refining the molds.
The sons of the master
watch from the right.
Work on the molds
begins in the shed beyond.

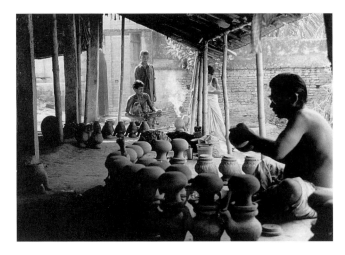

Subash Chandra Pal
making the molds,
while Prem Chand Pal
casts the brass forms

Sunil Chandra Mandal

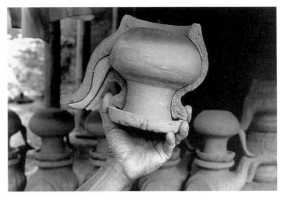

Mold for a *badna* by Sunil

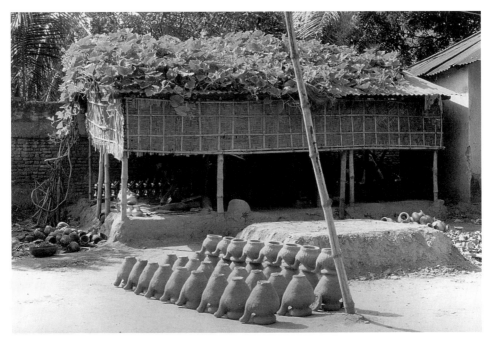

The finishing shed

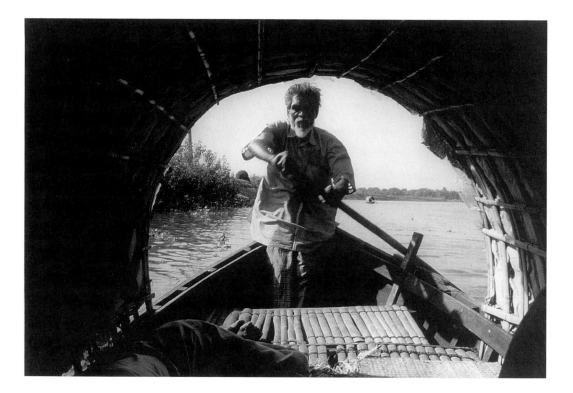

In Motion on the Shitalakshya River

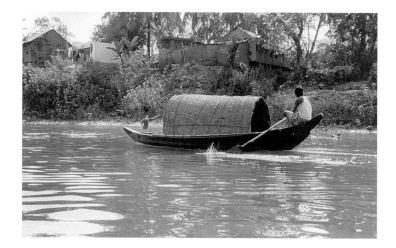

To the east, the market town of Demra marks the edge of Dhaka district. On Fridays at dawn in Demra, weavers sell and middlemen buy the *jamdani* saris that are exported to India and sold at New Market in Dhaka. One morning before sunrise, Muhammad Sayeedur and I met in downtown Dhaka with a plan to go beyond Demra and find a village of Hindu carpenters. We roused the grumpy operator of a baby taxi, and after the dreary, traditional haggling was done, he drove us the ten miles east. At Demra we found a ferryman who rowed us up the Shitalakshya River, past the long, handsome village of Rupshi where pairs of weavers at bamboo looms in bamboo shops pick patterns in the gossamer warp, running extra wefts between the shuttled shoots, brocading designs that seem to float on vapor. Called Dhaka *jamdanis,* the saris woven in these villages are the descendants of the fabled muslins of antiquity, the latest in a long line of superfine textiles that have brought traders to this region since the days when Roman women, like Dhaka's ladies today, wrapped themselves in airy fabric.

Beyond Rupshi, our boat came to ground on the eastern bank, and we walked. The sun was up and burning. Our route wandered along the raised earthen baulks that divide the wide fields of rice. There was no road, no passage for wheels, and we walked in single file, coming at last to the village of Pirulia where the brothers, Dhiren Chandra Sarkar and Sumanta Chandra Sarkar, explained their craft. When it rains, they work indoors, framing big bedsteads and carving the headboards with peacocks in pairs. In dry weather, they work in the shade of an open shed, making round-bottomed boats of the type used to ferry passengers on the Shitalakshya and the Buriganga. Their boats are smaller than the wooden ships built above the beach at Zinzira, but the technology is basically the same, and it is general in Bangladesh. They lay a hewn keel, rising high at stem and stern. Then they bend and nail planks to the keel and to each other in sequence, in tension, shaping the leaf-shaped, spoon-shaped shell into which, afterward, they build the frame.

After tea in the home of Pirulia's old master carpenter, Narayan Chandra Sarkar, we began the journey home, the long walk to the river, the boat trip down to Demra, the dusty ride to Dhaka. We walked in the heat, under the immense sky. There was no shade, no sound. On one side, damp fields, worked by gatherings of silent men, swept away to the far edge where clay and bamboo villages stood on earthen lumps in clumps of trees. On the other side, preposterously, the long green line of the horizon was broken by the surreal, glittering glass towers of downtown Dhaka.

Eid

During the month of Ramadan, trade increased gradually in the streets of Dhaka. Sweet shops packed at dusk with people buying delicacies to break the fast each night. Booths opened to sell Eid cards that commingled the sentiments of Easter and Valentine's Day. Shoppers sought new clothes, and editorials in the papers expressed the hope that Eid might boost the economy as Christmas does in the West. Though half the city's people had returned to rural homes for the holiday, crowds on the day before Eid rivaled any Christmas Eve throng. At New Market, in the press of shoppers, there was no way to stop or go quickly. In touch at all times with the bodies of two other people, women and men drifted in the thick human tide, bearing bundles of new clothing.

The night was shattered with fireworks. Ramadan ended, and it was Eid. Early in the morning, I joined eighty-five thousand men for prayer in the open field by the High Court in downtown Dhaka. We wore snowy prayer caps and loose, new *panjabis* in white, cream, ivory, fawn, buff, beige, and the most delicate shades of lemon, peach, and apricot. An amplified voice led us through *namaz* at a stately pace. It felt good to repeat the familiar postures, standing, bowing, kneeling, lowering the head in massive oneness. We sat for a long prayer of peace for the nation, the wide community of Muslims, the whole tortured world, and then, not suddenly or hastily, but without delay, the crowd dispersed, walking. The rest of the day was spent indulging in the great Bengali delights. We sped from home to home in order to sit, to feast, to be in company.

On the afternoon of the next day, I went to see the Eid parade with Shamsuzzaman Khan. As old paintings attest, Eid was marked by processions in the last century. The parade faded away during the tense Pakistan period. In 1994, the mayor invited the parade's revival.

In this, the second performance in the new series, the people of Old Dhaka march into New Dhaka. They come with banners, the first wishing peace, love, and happiness to the citizens of Bangladesh. Brass bands, uniformed in fantastic parody, provide the sound, a thumping, wailing blend, as in New Orleans, of carnival and martial regularity. The pace is set by floats, mounted on trucks or pulled by bullocks, but most often powered by a man pedaling some variant on the rickshaw. It is not the architecture of the float that demands attention, but its human tableau. Men and women perform a brief skit, over and over, or they hold theatrical postures in representational exacti-

tude. Realism is the aim. Pleasure for the audience lies first in the precision of portrayal, the costume, the makeup, the perfect gesture. Mimetic accuracy prompts the laugh of recognition, stimulating the mind into understanding, troubling the matrix of emotion where pleasure meets pain.

Filtering from two sides, joining the long line in the expedient order of chance arrival, the floats gather, clot, then move forward, presenting to the people—and to the dignitaries on the reviewing stand—glimpses of the world as it is seen from Old Dhaka. Like those on rickshaws in traffic, the pictures come in no order. Each is a colorful, engaging work on its own. But for the rickshaw artist, multitudinous images gather into a small number of significant categories—mosques, say, movie stars or village life—and, as I watched, the images flowing in the Eid parade clustered into a few categories in which they became meaningful, through which, like rickshaws in the aggregate, they connected into a view of Bangladesh. The Eid parade offers one more introduction to Dhaka.

History segments in Bangladesh by shifts of political power. Periods are not embraced arbitrarily by turns of the century, but, as in Japan, by events that separate stretches of time, unequal in length, but consistent in tone. These pieces of time do not fit easily into transnational schemes, but they hold immediate meaning for the people of the country.

The historical floats in the Eid parade concentrate at two points of transition from one period to the next. One clutch of floats evokes Mughal grandeur. Before the Mughals began the conquest of Bengal in 1575, there had been distinct periods in Muslim command, and before the Muslim conquest in the thirteenth century, the Hindu Senas, the Buddhist Palas, and the Hindu Guptas had ruled. But that is all prehistory to the creators of the Eid parade. Their tale begins in Mughal opulence.

Opulence sets the tone. In oriental splendor with a Persian accent, powdered to pale aristocratic complexions, people sit, swaddled in folds and tucks of glittery fabric. Men wear the turbans and curly silver slippers of the classy modern Muslim wedding.

Three floats carry *nawabs*. The parade's most lavish presentation, borne on a truck and accompanied by horsemen, is a painting come to life: the *nawab*, the ruler of Bengal, sits easily on his magnificent throne, attended by elegantly attired, deferentially disposed ambassadors from the Middle East and Europe. The assembly incarnates the period when the wealth of Bengal stunned the visitor and excited the greed of England. This is the last great

nawab, Ali Vardi Khan, who died in 1756, and whose grandson and heir was defeated in the next year at the battle of Plassey by Robert Clive of the East India Company. The Mughal period ended. The British period began.

The aftermath is not depicted, as it might be, by British atrocities, but by the *nawab,* transmuted into an instrument of alien power. There he sits, richly dressed and complacently smoking his *hukka.* Before him, a woman pleads with passion. Behind him, her husband is flogged with a whip. The couple represents the people of Bengal, requesting justice, beaten without mercy, while their leader puffs in luxury. The lash goes on.

No float recalls the end of the British period, in 1947, when India was partitioned and Pakistan erected; the colonial period was not over for the people of East Bengal. After 1757, when Mughal rule ended and the British period began, the next date that matters is 1971, when Bangladesh was created.

Young men in military uniforms, with powdered faces and fake moustaches, are enough to bring to mind the terror of the time when the Pakistani army cracked down and millions were massacred in 1971. But the story is made explicit in the wooden boat, borne on a float, filled with women and children while Pakistani soldiers beat them with the butts of their rifles; and by the boys, their bodies caked with clay, frozen into the postures of a statue commemorating the freedom fighters, the guerilla warriors who resisted to the death; and by the sad little girls, dressed as the grieving mothers of the heroes who fell in the liberation of their nation.

The shift from the Pakistan period to the Bangladesh period is marked by a banner reading, "Our freedom was the greatest accomplishment of the Bengali people." Behind it march men, holding above the earth a gigantic flag, the banner of the new nation, in design like Japan's, but in the colors of Bangladesh: the green field centered by a red hot sun.

The story is brought to date in a float labeled, "Our political leaders." On it women impersonate the women currently vying for power: the prime minister, Khaleda Zia, and the chief of the opposition, Sheikh Hasina. Surrounded by supporters, waving to the crowd, both speak interminably into microphones. They exemplify the dominant style of the parade, for they are neither lampooned nor lionized. It is the very accuracy of representation—the saris, the makeup, the gestures—that spreads smiles among the spectators, who stand in the street, playing the part of masses.

At the end of history's stream, lies modern life. Two floats depict the population. This is the view from Old Dhaka, so the prime distinction is not be-

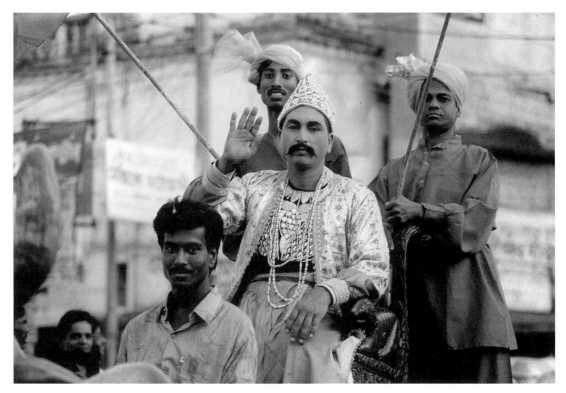

Nawab

Pakistani soldiers

tween rich and poor, but between Muslim and Hindu. On one float sits the Muslim family, the father in prayer cap and beard, the wife and children in placid decorum. Their serenity contrasts with the float portraying Hindus. A drum pounds. A boy dances in sensual abandon. He wears a wrapped and rolled *dhoti,* the emblematic dress of the Hindu male, though most Hindu men, like most Muslim men, wear the simpler sarong called a *lungi.* Even men who wear trousers at work are apt to relax at home in the loose, comfortable *lungi.*

This is a parade on a Muslim holiday in a nation that is eighty-eight percent Muslim, but the Muslim view of the world would be incomplete without the Hindu presence. Only eleven percent of the population is Hindu, but Muslims till the soil and, leaving the land, fill the apartment buildings and *bustis* of New Dhaka, while Hindus mix in large numbers among the merchants and manufacturers who are the parade's authors. (It follows that Hindus will be overrepresented in any book featuring artisans, like this one of mine.)

It is a parade on a Muslim holiday, but it does not celebrate Islamic law nor assert an Islamic politic. Only a few of the parade's pieces hold peculiar interest for Muslims. A long line of rickshaws, wrapped in cloth, wholly enclosed, recalls the bad old days of the Pakistan period when women traveled the streets in hiding. A boy and a girl snuggle openly in the last rickshaw to illustrate the enlightened present, to suggest the progress made by women within Islam. (And remember: both of this Muslim nation's principal political leaders are women, a thing apparently impossible in the liberated, Christian West.)

On one float sits a *pir* with a long beard, tangled up in chains. The *pir,* the living Muslim saint, might be a holy man, guiding his disciples on a profound mystical quest, or he might be a fraud who extracts their cash to live in luxury. The parade's *pir* is a hilarious, patent fake. Implicitly, he provides a warning to the gullible, compatible with that issued from the float on palmistry. The mad palmist searches with an enormous magnifying glass through a big book of secrets, while two men, good sports amid rough humor, hold up the handless stumps of their arms, and the sign beneath them comments that if palmistry determines what kind of luck you have, then we have no luck at all. We, the ones without luck, are the dupes who surrender our cash to false *pirs* and palmists, and we are the men without hands, and we are the people watching, standing on the ground within our own tragedies.

The parade's main topic is the troubles we share, Muslim and Hindu alike. In comedy crossed with anger, the parade raises issues for consideration by the city's people, who crowd the streets, and by its mayor, watching from the reviewing stand. One banner reads, "The Dhaka electricity supply: rubbish." Those people are annoyed by periodic disruptions in the flow of electricity, and these by the city's unhealthy water: "Boil your water or die." One man lies stupefied, crushed by a mountain of bags labeled traffic jams. Two floats show men disappearing into open manholes. Manhole covers are stolen and sold for scrap, and, were it not for conscientious citizens who flag the holes with leafy branches, and for the adroit operators of agile rickshaws, open manholes would cause endless accidents. There is one man with a blue papier-mâché mosquito on his head and plasters all over his body, and another with a sign saying, "The mosquitoes will drive us crazy." Thirty years ago, I am told, a city health inspector eliminated mosquitoes from Dhaka, but today with every sunset they return in blood-thirsty swarms. Only mosquito netting and smoking coils make sleep possible, and experience in this place teaches you why the mosquito is the lowest incarnation in the Hindu chain of rebirth.

Medicine is the subject of four floats. On one, surely clear enough, a gloomy doctor sits with his black bag shut, surrounded by sick and dying children. The sign reads, "If you have no money, you will get no cure." The label on another, in reference to a notorious local case, reads, "Not a medical center, but a love center." Above the sign, a doctor with a stethoscope over his shoulder chats up two pretty nurses, all of them uniformed in studied detail, while a man on the bed behind the doctor writhes in histrionic agony.

Five of the parade's little dramas show muggers, locally called hijackers, the highwaymen who infest the city's streets at night. One represents dacoits, the bandit bands of the countryside.

Solutions to the problems of mosquitoes and foul water, greedy doctors and street thugs, lie beyond the control of the people. These are complaints addressed to the oblivious *nawabs* of the present. But other problems lie within control, and the parade confronts them directly. One float excoriates wife beating, another prostitution, another narcotics addiction. Four raise the evils of alcohol. Boys, enjoying the role, stagger like drunks. A battered daughter turns on her drunken father and beats him, upsetting all order in the chaos wrought by drink. In truth, alcohol is not a grave problem in Dhaka. There is one bar for every two million people. But alcohol is a focus here, as tobacco is in America, because it is something that remains within the command of the

individual will, absorbing the frustrations engendered by more serious problems that lie beyond, and becoming the urgent, symbolic embodiment of wrongness itself.

In the raw, frank, funny Eid parade, the celebration of what is right—the heroic achievement of the nation—is set into tension with criticism of what is wrong: the failures of the government and the people, the trustees and heirs of the achievement. To appreciate the wit and courage of the people of Old Dhaka, imagine their parade winding through the streets of Washington, D.C., on the Fourth of July. Some of the floats would serve quite well—the profiteering, philandering men of medicine, the muggers, drunks, and dope fiends—but others would need translation. There might be a historical float of a slave auction, perhaps one of the president jogging in his shorts, another with a lobbyist for the gluttonous insurance industry showering a congressman with dollars. The point is that the people of Dhaka have their own picture of history, with its stirring, disturbing relevance for the present, and they understand their problems. They understand, complain, and endure.

Bangladesh, they say, is a country of problems. It benefits some to collude in that view. The rich, enumerating the nation's ills, repeating that these are hard times and we are a poor people, identify with the less fortunate to excuse their own lack of generosity and to preserve the flow of foreign aid. The foreign observer, in whose country so much of value has been sacrificed to the accumulation of wealth, takes comfort in seeing the poor country as a sink of misery. Foreign agencies, keeping themselves in business, fund studies that convert every facet of life into a problem in need of a solution. The worst troubles are plain to the eye, and their deep cause—as in the United States—abides in the inequitable distribution of resources. The difference between Bangladesh and the United States is not in the system, but in the quantity of wealth that, large in the United States, obscures the causes of unease, and that, small in Bangladesh, throws the problems and their causes into high relief.

I have seen the pretty young woman, her hair matted, her eyes empty, slumped beside a makeshift hovel on the street, too beaten to raise her hand to beg. I have seen the polished man in the tailored suit, sitting in glum disdain on the back seat of his air-conditioned sedan, speeding through the dust. It is not that I have not seen, but my time has passed among the people who are not the problem, the people of the poor, hard-working majority, the farmers and weavers and smiths, and this book is about them, as they are represented by those who work the land's unlimited resource of excellent clay.

·2·

Kagajipara

FLOWING WITH THE melt of the Himalayas, wide rivers search for the sea, flooding the delta, leaving silt to choke the channels and enrich the fields. Mud or dust in season, the earth laid down by the rivers is dug and heaped into foundations, shaped and burned into pots.

Clay is what there is, so clay is what they use. There are six hundred and eighty villages in Bangladesh devoted to the manufacture of pottery. One of them is Kagajipara, built on the banks of the Bangshai River, a pleasant walk from the market town of Dhamrai, northwest of the capital in Dhaka district. The largest pottery-making villages, with three hundred and more families at work, lie to the west in the districts of Rajshahi and Jessore. Kagajipara nears the national average for pottery villages with fifty-one families in the trade. As in most of these villages, most of the people in Kagajipara are Hindu. The potters carry the same surname—Pal—designating them as members of the craft-caste of the workers with clay, the creators of *mritshilpa,* clay art. In Kagajipara, on particular earth, I will shape a general introduction to the potter's art in Bangladesh.

Boys dash, vaulting, splashing in the river. Above the beach, orderly mounds of clay stand along the wooded riverbank. By each heap, steps cut into the earth lead to narrow paths through the dense green. This one, rising slightly, passes a kiln and piles of pots, turns between two buildings, loses itself in the clean courtyard the buildings define, then appears again to lead between the kitchen and a workshop, ending in a wide shady space where pots are spread to dry.

The household, a cluster of low buildings, wedges between larger homes on either side. The founder was not native to Kagajipara. His son, today's master, Amulya Chandra Pal, is an innovator in the art, a leader in the village. When the flood rises, buildings dissolve, and the women and children are sent to higher ground, he remains, living on temporary scaffolding to inspire his neighbors and preserve their claim to this place.

Like many in Bangladesh, Amulya Chandra Pal cares little about his age. In different years he has given me irreconcilably different estimates, but he believes he was born in the Bengali year of 1343, which would make him a vigorous, handsome fifty-three in 1990. Amulya's father, Jiteswar Pal, was born up the Bangshai River in the old pottery-making village of Kakran. In 1933, he moved to the village of Pathalia, east of the river, in the administrative sector of Savar, where Amulya was born. From Pathalia, the family was swept into the seethe of history, migrating to India when violence erupted between Hindus and Muslims in 1964, then returning in 1972 after the War of Independence had ended and the new nation of Bangladesh had been established. In 1979, Jiteswar settled his family in Kagajipara. Amulya learned the potter's trade from his father, who learned in Kakran from his father, Agni Mohan Pal, who had learned from his father, Iswar Chandra Pal. But Amulya's career did not truly begin, he says, until he married at the age of twenty, and received encouragement and inspiration from his wife's grandmother, Ashtrasukhi Pal.

Amulya Chandra Pal, the eldest of four brothers, is the family's patriarch and its master of the works. With his wife, Parul Rani Pal, with the next brother, Shachindra Chandra Pal, and his wife, Saraswati, he prepares the clay, designs and produces the ware. The third brother, Ramendra, manages sales, minding the family's stand in the market at Savar and arranging for orders from Dhaka city. The fourth brother, Ganesh, is gone west to India. Amulya's grandson, Sanjit Kumar Pal, mixes with the other children of the household into a mobile band. When school is out, they are sometimes earnestly at work in the family's trade, brushing ash from newly fired pots and bearing them to storage. More often they are at play, splashing in the river or constructing elaborate miniature villages out of twigs and scraps of clay, engineering for them intricate, and usually destructive, irrigation schemes. Working with their parents they learn the hierarchical orders requisite to efficiency and quality in production. Playing with their mates they learn the skills of combat and compromise, cooperation and consensus, essential to the construction of community.

Amulya Chandra Pal

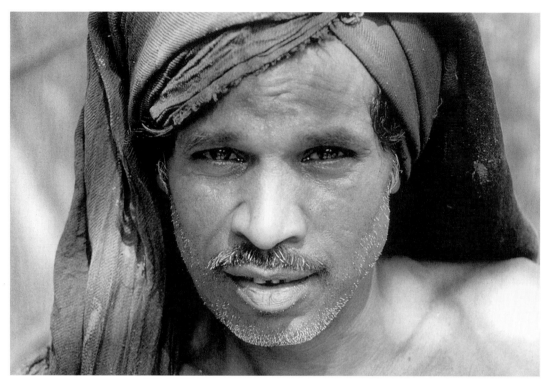

Manindra Pal

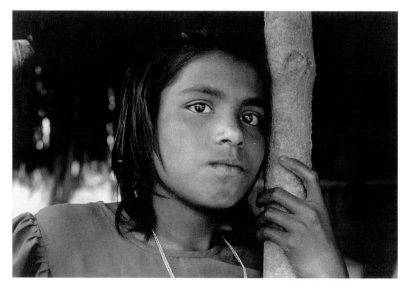

Gita Rani Pal

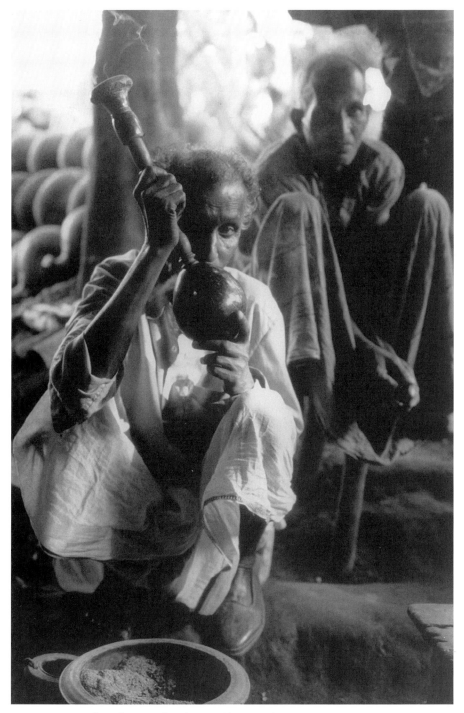

Radha Charan Pal and Ram Charan Pal

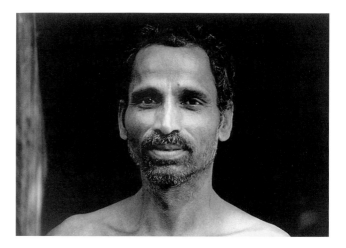

Shachindra Pal

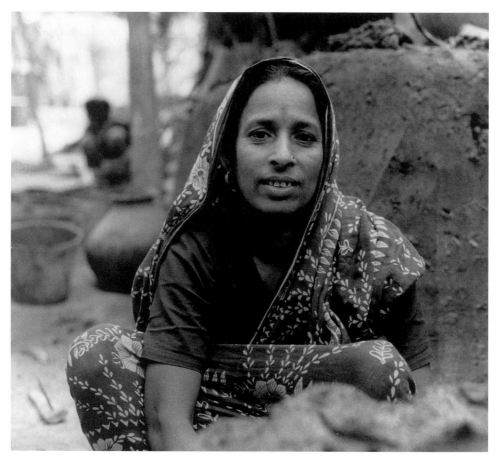

Saraswati Pal

Life depends on committed, blended energies. Shachindra's wife, named for the goddess of wisdom, Saraswati, said, "We own no land. Our hands are our land. Somehow we manage to maintain our family."

Amulya Chandra Pal's workforce exemplifies the ideal and norm in the village. The sons of one father, in their father's place, comprise a joint family, forming with their wives an economic unit. The wife of one is detailed for cooking duties. The others join their husbands in the clay. These men and women, professional potters, tend to be between twenty and fifty-five. In other households, like that of Amulya's neighbor Jatindra Pal, an older man, the last of the brothers, works on, aided by his unmarried daughters. When his daughters move to the homes of their husbands, and since he has no sons in the trade, operations will cease. That is not a rare occurrence, because the potters do not encourage their sons to follow them.

Shachindra Pal told me, "At present, our children are not learning clay art. Business is not good. Fuel for firing is costly. So we do not want our children to join this profession." Both of his sons attended high school. The elder is now studying in the technical college at Mirpur, north of Dhaka. The younger has become a jeweler, a craft like pottery conventionally practiced by Hindus but more likely to return a good wage. As a consequence, the number of families is steadily declining, but slowly declining because there are young men, like the talented brothers Santosh Chandra Pal and Govinda Chandra Pal, for whom pottery is more than a way to make a living, and for the others opportunities for alternative employment are few. In the home of Amulya's neighbor Bholanath Pal, a young man with a degree helps his mother and father, working with his hands in the heat, awaiting his chance for release. If it does not come, he may find himself reluctantly adjusting to the burden transferred from generation to generation.

When their sons are ready, the old couple slips out of labor. Elderly ladies hunker into advisory roles, sitting with the young women by the hearth or mound of clay. Elderly gentlemen drift through the village with grandbabies in their care, freeing young hands for work, sitting to watch and chat while the baby with wary large eyes clings close. Soon enough the baby will toddle after the chickens that peck through the village, then join the others for play and work, for building villages at different scales.

The Village

Physically, Amulya Chandra Pal's household consists of three dwellings for nuclear families, one kitchen, a storage shed, a kiln, and a workshop, all grouped around an open courtyard. The English word "house" does not fit. Through centuries of vernacular use, during the divisive progress of enclosure and industrialization, it has come to imply privacy and isolation; a "house" roofs and walls a couple and their offspring. We might stretch the word to think of the village home of Bangladesh as a house made of houses, or as a collection of rooms open to the sky. But it would be more graceful to adopt the Bangla term *bari.* The *baris* of Kagajipara are versions of the households usual in the villages of Bangladesh, modified to meet the needs of potters.

A courtyard opens in the center, providing work space and living room. The rear wall of the *bari,* and one or two of its sides, are formed by family houses. They are called *ghars,* literally rooms. Each *ghar* is lifted from the ground on an earthen plinth and built of smooth, cool clay or framed and fashionably sided with hot, corrugated iron. Long porches shade their fronts. In a wing on one *ghar,* or set separately and attached by a porch, there is a kitchen. The front wall of the *bari* is formed by a workshop, a *karkhana.* Often open to the courtyard, the *karkhana* is built of earth-fast posts, curtained on the perimeter with earthen walls or woven strips of bamboo, good for ventilation. There might be a small bamboo cowshed. The privy stands away by the river. Most *baris* include a kiln, a *puin,* located outside the square, convenient to the passages among the trees. Around the kilns and workshops, zones for work widen, mingling neighboring places, merging them into the collective territory of the village.

The village—the *gram*—is built of *baris.* The *bari* is a conceptual unit, consolidated by the centripetal pull of its courtyard, where women gather for work. And it is part of a continuous flow. Walls of buildings belonging to neighbors might serve to demarcate the family's central place, and small buildings, set close, string into articulated assembly, yielding an architectural whole—rhythmically punctuated by enclosed openings—that materializes the simultaneity of commitment to the unities of family and community.

Ceaseless daily interaction in the village is undergirded by membership in the craft-caste of the Rudra Pals. Though Amulya Chandra Pal commented that "in modern times, love marriages happen outside the caste," arranged marriage remains the norm, assuring that husbands and wives will belong to

Kagajipara. The northeastern neighborhood of the village is unified by a path that runs parallel to the river. Workshops and circular kilns are stippled to show their orientation to the path. Broken lines collect the buildings of particular *baris* and connect them to kilns, one of which is shared by two families.

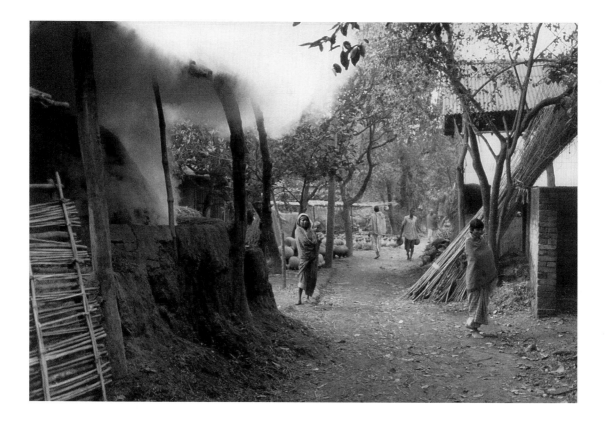

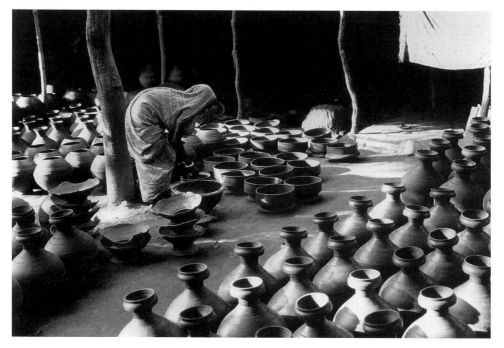

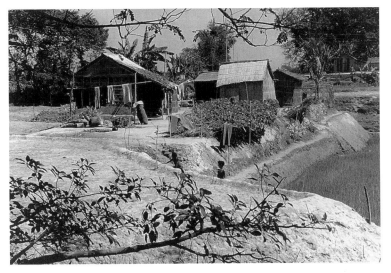

New *bari*
on a new embankment
at the village's edge

Kagajipara

Jashomadhab. The deity of the temple is a form of Vishnu. The image is said to have been made in Pala times and installed in the temple in the late seventeenth century.

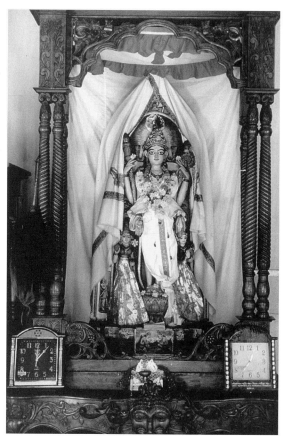

Madhab Mandir. Dhamrai

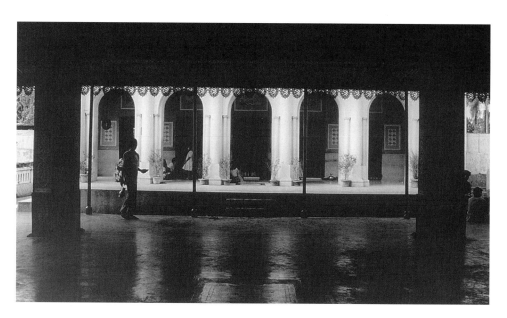

one traditional grouping. Unity among the Hindus of Kagajipara is intensified by regular worship at Madhab Mandir, the public temple in the nearby town of Dhamrai.

Trees stand through the village, casting general shade, coalescing into moments of jungle. At first look, the trees, rising in a natural scatter, disguise the regularity of the planning. Along a few major paths, the workshops strike nearly continuous walls, baffling and channeling a visitor's motion. Interior arrangements are not displayed upon a facade, no portal gestures to entry. But there are usually two ways into the *bari:* one through the workshop, suited to a man seeking the pottery's master, the other around a corner, an offbeat, oblique route to the women of the courtyard. It feels designed for privacy. But as I learned when, wishing to sketch the plans of every *bari,* I entered the homes of people I did not know, the only private spaces lie within the *ghars,* the little buildings housing the family's nuclear entities, which might be likened to the bedrooms of houses in the West. The rest of the home is casual social space. People come and go, greetings are slight or elided. The men and women of the *bari* continue on course, responding to intrusion with little by way of discomfort, courtesy, or concern.

Life is passed among others. Company is constant; it is neither sought nor avoided. Social separation is not the primary goal; familial integrity is secure, interaction is endless, and efficiency in work provides the main principle of architectural design.

All doors open into the courtyard where clay is processed, pots are shaped and stacked. On the other side of the shop—the *karkhana* that shelters wheels and molds—the major pathways provide connections among places to work. Faint trails fan from the paths into an intricate web: the villagers know a multitude of intimate routes through the porous architectural order. The main paths are more for the movement of pots than people. Most kilns stand by the main paths. Not every family has its own kiln, and when a kiln is not being fired by its owner, others are free to use it, there being no charge. Shared kilns link certain households, and the main paths link workspaces to kilns, kilns to the world.

The main paths of the village, their breadth fit to walking, make a little piece of an orderly grid, dropped upon a spread of smooth earth, soft beneath bare feet. One path bisects the village, running perpendicularly from the banks of the river to the beginning of the bricked road where a small shop stands and rickshaws wait to take villagers to Dhamrai or the highway. This path, long

and straight, clouded by swirls of smoke from the kilns, divides Kagajipara into unequal parts, the larger lying downstream. Through it, two paths follow the walls, through the trees, to meet the path that carries in one direction back into the deep expanse of tidy green fields, and runs in the other to the river, to the ferry crossing children use to get to school.

Claywork

Clay arrives and pots depart in wooden boats on the Bangshai River. The clay for Kagajipara comes from Dhalai Char, four miles to the north, beyond the village of Kakran, the birthplace of Amulya's father. Men who do that work dig the clay out in hot weather, in the first three months of the Bengali year when it is spring in the West, and sell it by the boatload to the potters on the beach. Their working clay is a blend of two kinds. They say they need a boatload of each, but the amounts in the mix are uneven. The monetary unit of Bangladesh is the *taka*. It takes sixteen *annas* to make one *taka,* and the potter makes a *"taka"* of right proportion by blending six *"annas"* of tough, sticky black clay, called *bali* or *kala mati,* with ten *"annas"* of sandy white clay, called *abal* or *sada mati.*

Dampened and champed with a spade, the clay is mixed and heaped neatly on the riverbank. Then they carry it in headloads to the *bari* and build a squat, compact cylinder called a *stup;* the word is familiar from *stupa,* the name for the commemorative mounds of Buddhism.

The great *stup* is the family's supply. Clay from it shifts through two successively smaller constructions as it gets ready for use. Working together, husband and wife shave leaves of clay from the sides of the *stup,* chopping with an arc of broken pot, a *chara,* discovering and eliminating impurities, then shaping a small *stup,* which, shaving the clay away and treading it down, they rebuild five or six times. The clay cannot be worked too much, Shachindra Pal said. With every repetition of the process, it becomes smoother, approaching the perfect consistency he likened to wax.

In the final stage, a third of the small *stup* is shaved into leaves that are heaped on a square of cloth, dusted with ash. The clay is moistened and compressed into a wide circular patty. The circle is cut in thirds. Each third is rolled into a cylinder. Shachindra or Saraswati mounts the first cylinder, turning counterclockwise to tread it down, then stretch it out with the heel. They add the second cylinder, step it down, and then the third. The circular patty

with which they began has been reachieved, so they cut it again, roll and tread it again. And that process will need at least one more repetition—they judge at their fingertips—before pieces are torn off and patted into little cylinders, in form like tiny *stups,* the right size for use.

They squat to chop, stand to tread, moving lithe bodies through old patterns in the air. Shachindra and Saraswati chop and tread, the clay gets smoother, and two girls join them. The elder, Pushpa is her name, knows her mother's work. Wielding the *chara* maturely, she peels slices of clay away from the *stup,* then wanders off, while the younger, Nupur, pats the clay into short cylinders and, smiling to herself, piles them up, seeing how tall a tower she can make. It rises and falls, rises again, precariously. Watching, I imagine a foreign observer's smug accusation of child labor.

Since Bangladesh is one of the world's poorest countries, child labor, though it is illegal, remains a problem. To earn money desperately needed at home, children are pulled out of school and sent to work, often in miserable conditions. Illiterate, they are doomed to lives of poverty. But Bangladeshi labor laws properly make exception for children working in family shops. The girls help, like any rural child with chores, and in helping they learn, like any child in a classroom.

Learning in the village derives less from instruction than from being present while the adults work. This is what is happening throughout the village, work, and watching often, helping sometimes, children absorb useful motions to imitate when they are called by time's passing into action. I remember a baby girl at the riverside, playing in the cool water, going through the motions of her mother washing clothes, repeating what she had seen, building certain routines into her chubby body. The girls appear, then disappear, work a bit, play a bit in the ambit of labor, unbidden, undirected, readying themselves for the future. Their supple parents stoop and stand and tread, steadily.

Kalshi

Amulya Chandra Pal says it takes three people five days to prepare two boatloads of clay for use. Now shaved, cut and rolled, trodden, a third of the small *stup* has been readied for the immediate shaping of form.

What they make are pots to ease necessary tasks like the deep, round-bottomed bowls for cooking—*patils,* specified as *patils* for rice and *patils* for curry. Their great work is the collared, spherical pot used to transport and

contain water. They make larger jars for storage, but the water jug that must be at once big, strong, and light is their most complex and engaging utilitarian creation. It is generally called a *kalshi,* though in Kagajipara they call it *kalash,* reserving *kalshi* for the form rendered in metal.

To this point, the work of men and women has been the same, but men and women employ different techniques to make the *kalshi.* Using their different techniques over three days, men make a hundred, women thirty-five. Women say that men's work is quicker but harder.

Men use the *chak,* the wheel. Women use *paras.* While *para* means "mold," these are less molds than dishes, set on a board on the earth and turned by hand, serving like wheels to assure symmetry. Amulya's wife, Parul Rani Pal, spreads the soft clay into the first *para,* the *natinapara.* Turning it with her left hand, she raises and smooths the round bottom of the *kalshi* with a dampened cloth held in her right. When the new pot's curve rises above the low side of the *para,* she lifts it out gently, and places it in the bottom of a broken pot for support. The old pot embraces the new while it matures. Then Parul lifts it again tenderly and places it in a second *para,* the *hatanapara,* which is much deeper in profile, and turns it while raising and shaping the walls. They grow thin as they rise above the lip of the second *para* and turn the soft shoulder toward the *kalshi's* spheroid form. Again the new pot rests, hardening in the confines of an old one. The clay is learning its shape; the pot is lifted out and pressed toward completion. Parul crimps its top to receive a thick new coil of damp clay, the beginning of its narrow neck. The third and last *para,* the *patharpara,* a dish fused in a dish, turns while the neck receives a second coil, stretching, and the sharp, overturned lip is shaped from a last coil.

Women do not use the wheel, I am told, for two reasons. One is strength. Young Bajan Chandra Pal centers an enormous, tapering cylinder of clay on the wide wheel while it lies, tipped. The big wheel, the *chak,* is used throughout the Indian subcontinent. It might seem ancient, timeless, but the *chaks* of Kagajipara display differences that record historical change. The heavy old ones are solid and socketed. The lighter new ones, of a type dating perhaps to the turn of the century, are spoked. Lifting the *chak* to horizontality, Bajan gets it going with his hands, then inserts a stick to whip it around. As the *chak* turns, he adjusts to its plane and throws off the hump, in the Asian manner, shaping form after form from the single spinning mass. His posture—and this is the second reason—would be, they say, unchaste for a woman, impossible to manage modestly for a woman wearing only a sari.

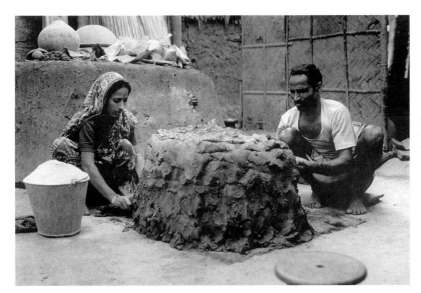

Saraswati and
Shachindra Pal
working the *stup*

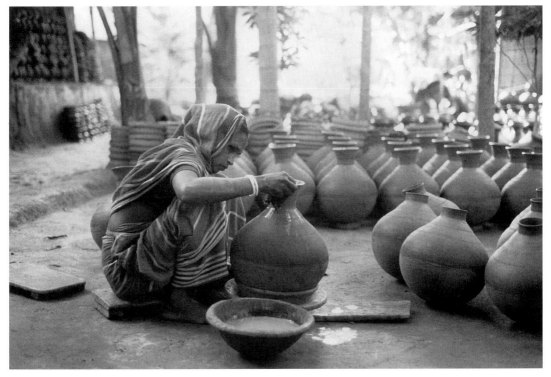

Parul Rani Pal shaping the neck of a *kalshi*

The *Kalshi.*
Kagajipara

Purna Lakshmi Pal

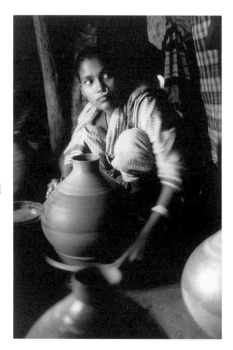

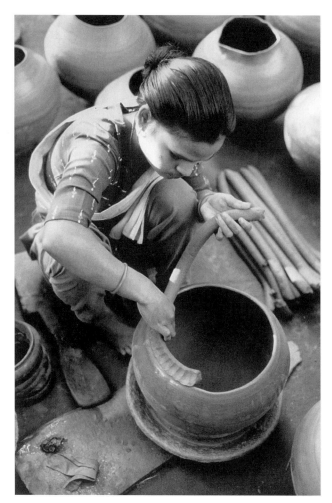

Malati Rani Pal adding the first coil to a *kalshi*

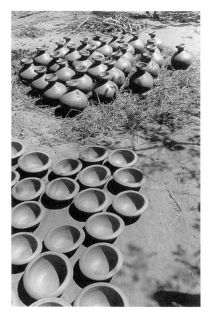

Kalshis (above) and *patils* (below),
slipped and ready for firing

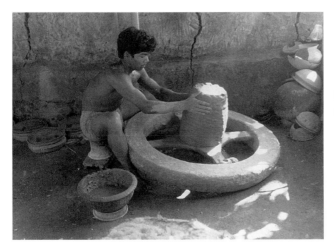

Bajan Chandra Pal
centering a *boula* on the *chak*

Bijoy Kumar Pal
paddling a thrown *kalshi*

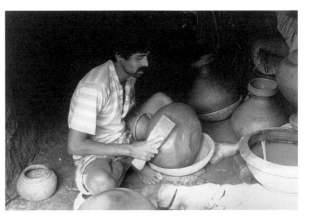

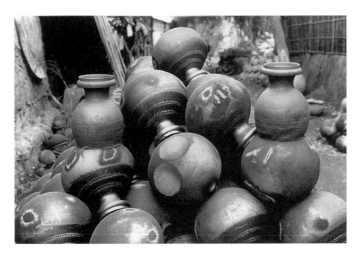

The tops of two thrown *kalshis*
dry before paddling on a pile of fired *kalshis*

Kilns.
Kagajipara

Govinda Charan Pal
stacking the kiln with *kalshis*

At the top of the whirling tower of clay, Bajan fashions the upper half of a *kalshi,* rising to its neck and lip, cuts it free, then throws the bottom half. A second man in the shop, Bijoy Kumar Pal, overlaps the parts and paddles them together along the joint, like a smith hammering the seam of a copper vessel.

While the women worked, turning the *paras,* dampening, stretching, and raising the clay, the *kalshi* achieved its final spherical form, a form that is maximally efficient, containing the greatest volume for its weight. With its sections joined, the *kalshi* of the men is more ovoid in profile. It resembles the *surai,* the water jar that is carried on the head and embodies influence from Muslim civilizations lying far to the northwest. The men's *kalshi* requires further work to make it a proper Bengali water jar that is carried in the hollow of the waist and held by an elbow crooked around its neck. A terracotta tile nearly two thousand years old shows a woman carrying a *kalshi* in the modern form, in the way it is carried today. To make it fit local usage, and incidentally—and self-consciously—to symbolize Bengali as opposed to Pakistani tradition, in quiet remembrance of the martial victory that assured cultural continuity, the men must stretch their *kalshis.* After joining its sections, Bijoy places the *kalshi* into a *para* and inserts his left hand, holding a small wooden anvil, through the neck. While pressing the anvil out and turning the pot, Bijoy paddles the exterior, rhythmically alternating light and heavy strokes, until his *kalshi* possesses the shape of the women's.

The job is done when Bijoy hammers vertical striations around the pot's upper curve. They indicate that men, with their techniques, are imitating the forms of the women, suggesting, perhaps, that the women's mode is the more ancient. On the women's *kalshi,* these striations are the residue of technical process, marking the transition from turning to coiling. On the men's pots they are applied ornament.

Nature is carefully managed. Sticky and sandy kinds of earth must be blended in proper proportion. Water brings them together, makes them pliable and capable of holding fine form. Intermittently, for lengths of time that vary greatly in accord with the weather, forms are left for the air to dry. Then they are given to fire.

In the form of its kilns, Kagajipara continues to be representative of Bengali tradition. A wide circular chamber of clay is pierced by a single deep opening for firing. Its top is dished, sloping down to a slitted monitor that breathes fire. Planted posts rise to carry the roof that shelters the pots arranged in a domical pile upon the dished surface, big ones in the middle, small around the edge.

The mound of pottery is covered with split wood that will ignite, then a layer of rice straw, and last a coating of wet earth. Wood, bamboo, and the dried stalks of river plants are fed to the flame in the chamber. Amulya Chandra Pal says they use common sense in firing and judge the heat with their eyes alone. He knows no number to name the temperature, but my friend in Dhaka, the potter Maran Chand Paul, says the village kilns achieve a heat of eight hundred degrees centigrade. Slow at first, the fire is pushed, and for two or three days, depending upon the thickness—Amulya says the heaviness—of the ware, the kiln smokes and the clay hardens.

Shilpa

Patil and *kalshi:* the main product, the base of the economy, is utilitarian ware. The pots are tools, made to become elements in systems of work, particularly the work of women who cook and carry water. The pots are commodities, designed to sell in rural and urban markets. They are also the yield of art.

Art, to the artisan of Bangladesh, is a process governed by skill. Practiced and refined, this skill unfolds for evaluation within the discipline of a particular medium. Add *kaj* to a tool, technique, or substance, and you have named the medium: *tantirkaj,* loom work, weaving; *dhalaikaj,* metal casting; *katherkaj,* woodwork; *matirkaj,* clay work, pottery. But add *shilpa* and you have *mritshilpa,* clay art, an implication of accomplishment. The distinction between *kaj* and *shilpa* parallels the Turkish artisan's distinction between *emek* and *sanat,* and it might be compared with the Western division of craft from art, though the criteria differ. Thinkers in the West tend to categorize by medium or function, conventionally calling objects in some media art and others (usually the arts of women and working men) craft, or they demean the useful while lifting art into an upper class of leisure. In Bangladesh, art emerges in every medium, and works of art can work, facilitating labor and bringing cash. Art in Bangladesh is not divided from common life and its practical needs, but art is not anything. What signals art is skilled performance, success in the aspiration to excellence.

Based upon skill, the Bengali concept of *shilpa* exemplifies an Asian idea of art. Within skilled performance, however, subtly implying Indo-European convergence, the artisans do employ the distinction of the utilitarian and the decorative—the instrumental and the aesthetic—so prevalent in Western thinking. The difference is that these abstract qualities do not sunder objects into

stratified categories. They shape distinct points of value within art, which real objects blend in different ratios and different ways, much as different dishes in a cuisine mix nutrition and flavor.

My points here are two, both simple, but the issue is so muddled by vocabularies in conflict, so clouded by ideological dust, that they will bear repetition and expansion.

The first point is that the idea of art in Bangladesh cannot be reduced to the one I learned in Turkey or to the one that I find among my Western colleagues. As in Turkey, the master—*usta* in Turkish, *ustad* in Bangla—commands a skill that eventuates both in useful form and in applied ornament. At the same time, as in the West, the masters divide objects designed for service from those designed for pleasure. The pleasure-giving are decorative, the decoration is usually pictorial, and the artisans of Bangladesh have borrowed the English word "artist" to name one who is busy with picture-making.

The second point is that, while objects can be classed by dominant function, all artifacts are multifunctional, mixed in nature. There is no art without craft, no craft lacking in the potential for art.

The object is a unity, split for understanding. By dividing an artifact into its utilitarian and decorative functions, we render it accessible to Western thought, and such a division, I believe, does less violence to the cultural reality of Bangladesh than it would in Turkey or Iran, Korea or Japan.

So we might say that the art of Bangladesh is a realm of material creation, unified by skill but divisible by utilitarian and decorative proclivities that blend in all real things. Since there are those who continue to reconstitute regressive social hierarchies in the world of creation by banishing working objects to the basement and raising the idle and ornamental into an exalted elite—regardless of quality—I am bound to emphasize that in Bangladesh, and among working people in general, both utility and decoration are high values.

Utility is valued because work must be done. Masterly skill materializes in tools that can be bought and used to meet serious needs. The poor woman trades rare *taka* for a *kalshi* that is carefully made to hold the water she must carry. It fits her body, it does not leak or tax her unnecessarily; it helps during her cycle of toil. Through the useful object, the creator and consumer, who normally do not meet directly, form a bond of mutual dependence and trust. Things that do no work, that, poorly made, do not work or break easily, things with value in commerce but not in use, symbolize societies in disarray. The well-made tool is an emblem of social order.

Decoration is valued, for it relieves monotony, bringing touches of pleasure into daily life. No one has understood this matter better than William Morris. Decoration, he wrote a century ago, provides pleasure for the creator in the midst of necessary labor and pleasure for the consumer during use.

Ornament on objects—the paint on the pot, the painting on the wall—matches in importance the spice that enlivens the rice that must be eaten again to maintain the body. (The one who would doubt the power of ornament might ponder the degree to which the searches for sugar and spice and decorative textiles have shaped world history, bringing, for instance, the British to Bengal.) Beyond immediate pleasure—the spot of color that delights the eye or the flash of savor that delights the tongue, making the moment worth it—ornament presses toward meaning. In Bangladesh, as elsewhere, social and sacred meanings whisper out of ornament, offering gifts to the mind as tools offer gifts to the body. The ornamental joins the utilitarian as an aid in the individual's quest to find an endurable place in the world.

Aesthetics

We can make a beginning in understanding the traditional art of modern Bangladesh by entering the domain of *mritshilpa,* the art of clay, and arranging works along a continuum that stretches from the utilitarian to the decorative, bearing in mind that these abstractions, forming a pair in symmetrical antinomy, do not exhaust the motives of the creators.

Let us start at the *kalshi,* made to be useful, picking up the thread of the aesthetic that, subordinate here, will become dominant in other products.

"Aesthetic" is our name for experiences that awaken the senses, bringing life to life. The aesthetic is founded upon the capacity to distinguish the pleasant from the unpleasant, shared by all sentient beings. Flowers open to the light, turn to the sun. The train of sensation is complicated by mind, by the brain in time, burdened with memory, plans, and imagination. Among human beings, the mission of the aesthetic is to pull the mind close to the body, so that, while the senses seek their own pleasures, the body can teach the mind. We become alert in the instant to feelings that forestall boredom. Experience balances ideology in the formation of consciousness.

The prime aesthetic dimension of the utilitarian pot is discovered in the midst of creation. Like the cook preparing a feast, or the scholar puzzling a recalcitrant matter into clear prose, the potter feels the pleasure of engagement

in a process moving toward completion. This is the pleasure entailed by technology: the feel of soft clay, the sensation of the muscles doing what they were built to do and the mind managing a complicated procedure through which diversity is coaxed into unity. Turning mere earth into recognizable, integral forms, translating the natural into the cultural, the potter knows power and builds confidence through the repetitive solution of a problem complex enough to task the hands and fill the mind. Creation occupies time, and, as inherent capacities are realized athletically, as plans become things, and things come to stand alone, the potter gains firm proof of existence as a capable individual.

The pleasure of creation is paralleled, with diminished intensity, in the consumer's realm of use. These are not pleasures to make one swoon away in ecstacy; they register in contrast to the discomforts felt when events thwart the will. The potter goes steadily through stages of work, unhesitant, feeling the grace in practiced action. Using the potter's product, sensing its rightness for her task, the woman knows an absence of unease while bearing water on her hip from the well to the *bari.* Nothing fights her; movement is smooth. The man who has driven nails all day with good hammers and bad knows the difference in his muscles. There is a fine, breezy sensation of fitness, an aesthetic of balance, when work is conducted with a tool well made to its purpose.

For the creator, there is a second pleasure in teamwork. No *kalshi,* from the digging of its clay, through its shaping, firing, and sale, is one person's accomplishment. At work among others, filling dull moments with talk, the potter abandons aloneness, feels union, and becomes a contributing participant in a larger entity. The capable self becomes, too, a social self, part of an intimate collective, constructed in shared work, validated by production and remuneration. Maintained by labor and gain, families consolidate, then families connect—through work at shared kilns, say—into villages, and villages reach through rural and urban markets to touch the wider society with the honorable ethic of utility. Out there, just now, someone is benefiting from our work.

The mission of the aesthetic nears completion as clay becomes pottery, and as potters become competent individuals, members of society—and beings in the world. Potters do not make the clay with which it all begins. They control things for a brief period: after the clay is dug free and before the pot, burned and used, is broken back into the soil.

When he was managing his family's estates on land now belonging to Bangladesh, Rabindranath Tagore, Bengal's great poet, wrote a letter to his

niece in which he described from afar the slow, silent motion of the village people, then asked, "Why is there always this deep note of melancholy in everything I see, in the fields and ghats, in the very sky and sunshine of our country?" His answer was nature's immensity: the skies are too wide, the sun is too hot, "the infinite aloofness of Nature" dwarfs the people of Bengal, leaving their acts feeble and transitory.

Melancholy: sadness is a feeling as integral to the sensual wisdom of the aesthetic as joy or beauty. Made by their work aware of a self and social associations, they become aware as well of their pitiable position in the world. The world wrecks their plans, limits their efforts, supplies their materials, and offers signs of transcendence. I am told in Bangladesh that God is an invisible power made manifest in the winds that sway the grasses and the light flickering on the surface of the waters. There is nothing to be done but continue while power and sorrow and wisdom accumulate.

It is more, but art is at least this: a means by which the personal, social, and environmental facets of human experience are brought into consciousness. Creating utilitarian earthenware, the potters are compelled by sensation into mature understandings they exhibit in confidence and melancholy. They make art. It is hard, dirty work, the kind of work that is left behind during what is called development. The simple jobs and easy life, to which any rational person would aspire, teach little. Art is removed from the hands of working people, leaving them with clean, plump bodies and minds vulnerable to delusion.

Physical, palpable, and tactile qualities characterize the hidden aesthetic of the useful object. The clay grows smooth beneath bare feet, the form rises amply among the fingers, the jar is lifted and judged for balance. These qualities, recognized during manipulation, differ from those discovered during contemplation of inert objects. The *kalshi*—like the Japanese teabowl, to cite the sublime instance of its class—is appreciated amid motion. It would be unjust to treat it, or the millions of works like it, as we do the rare objects that are designed to be placed beyond touch and apprehended by the gaze alone. Still, to enhance comparison, we can squash the sensorium down to the lone receptor of the retina, and consider the *kalshi* as an object, as the possessor of traits that arouse the eye to stimulate the mind.

The most conspicuous aesthetic feature of the useful artifact is applied ornament, details that might be essential to form but that are not allied to its utilitarian functions, and so—if our dichotomy is economical—belong among

its decorative functions. Around the shoulder of the normal *kalshi* runs a rhythmic ring of vertical incisions, shaped into one or two bands, demonstrating the impurity of the object's dedication to utility.

Less obvious at first but more important is color. Before the pot is fired, it is usually slipped. A special yellowish clay, called *kas mati,* is dried, pounded to powder, and thrice mixed with water, taken not from the running river but from a still tank. The sand drifts to the bottom, and the sticky clay is skimmed off. If soda is added, the color will be brighter and the sand will separate more easily. Mixed again with water, the clay becomes a slip. Pots are dipped, top down, in the solution, or the slip is wiped on quickly with a cloth. Technically, the pots are unglazed, but in process and effect, the slip is like a glaze. Where it has been slipped, the pot will shine after firing with a soft, oily glow, and it has been colored. Once fired, the slipped surface will become black or red.

If the fire is smothered, an environment of reduction is established, and the *kalshi* will emerge blackened from the kiln. Chance in firing mottles the surface from ashy gray to sooty black. Pale circular clouds, caused by the proximity of other pots, are considered desirable marks of beauty. The slip adds vitality, bringing a silvery sheen that plays against the blacker, matte, unslipped surface.

If holes are poked through the coating of earth that covers the pots piled on the kiln, oxygen in the atmosphere increases, and the *kalshi* comes out a pinkish tan. Where it has been slipped, the pot will gleam, and it will be a red, richer and deeper than the natural tone of the fired piece.

Both shiny and dull, ruddy or smoldery black with flashes of silver, the surface of the *kalshi* excites the eye. The lively look compares with the salt-glazed ware of northern Europe or the ash-glazed ware of the southern United States. The potters dress their works with color, and the colors are invigorated by accidental effects that the potters intend their process to include.

The pot is usually decorated, at considerable expense of labor, with color. But if color and ornament conjoin on a painted surface, the pot is no longer for work; it is a *sakher hari,* a pot for pleasure. Forms hold steady—the shapes remain fit for cooking or carrying water—but decoration elaborates and functions shift.

Painted decoration takes two main courses. In one, the pot is covered with a patterning of scrolls borrowed from *alpanas.* A Hindu tradition, now practiced by Muslim as well as Hindu women, the *alpana* is a geometric design painted on the floor for auspicious occasions—for weddings, to commemo-

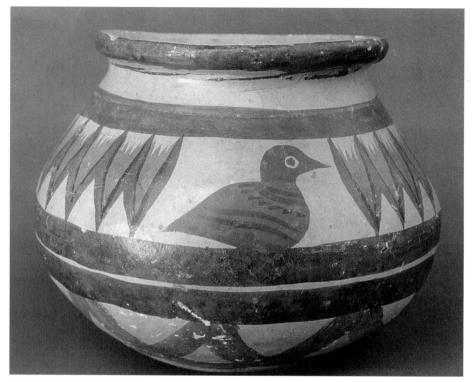

Sakher hari. Rajshahi, 1993.
Painted earthenware; 5¼ in. tall

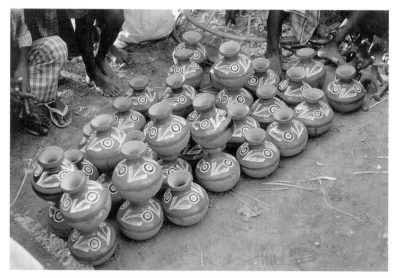

Kalshis painted with flowers.
Mela at the *urs* for Kalu Shah. Kaonnara, Manikganj

rate national events, or during devotion. The other decorative trajectory carries into the pictorial. As in the ceramic traditions of Turkey or the southwestern United States, the most usual images are birds and flowers. The practical pot becomes a pot for pleasure when it is ornamented with the bright and beautiful ornaments of nature.

By its paint a pot separates from the routines of daily life, and it appears on occasions separated from the normal run of days. Painted pots are sold at special *melas,* the fairs that accompany celebrations at the tombs of Muslim saints or the temples of Hindu deities. Purchased as mementos of spiritual experience, they might then add color to the home, refreshing the memory, or they might pass as gifts to forge or strengthen bonds of affinity. When given, they are filled with food, usually sweetmeats that are to the usual food as pots for pleasure are to pots for work. Painted earthen images of the Goddess are surrounded at times of *puja* by great painted pots, useful in form but decorated beyond utility and containing the food that is the gift of the devotee.

Mirpur

The main avenue, lined with sawmills, with shops for woodworking and rickshaw repair, turns abruptly at the gate to the Mirpur Mazar, just north of Dhaka city. The gate coils with floral arabesques, shaped symmetrically in ceramic mosaic. Beyond, above the dome, red and green pennants flutter at the ends of slim shafts.

Haji Mohammad Hossain Khan told me how the Pir of the Mazar, the saint of the tomb, Hazrat Shah Ali Baghdadi, came from Iraq and found here a fifteenth-century mosque in disrepair. For forty days he sat within, refusing entry to others, meditating until he achieved a state of blissful enlightenment. The little mosque became the saint's tomb in 1577, Haji Mohammad Hossain told me. In 1806, a devotee of the Pir repaired it and now it is a holy site of pilgrimage.

The porch of three domes, held aloft by cusped arches, bears in Arabic the Profession of Faith: There is no god but God, and Muhammad is the Messenger of God. You pass through the deep shade of the porch and enter the tomb to sit with upraised palms, praying in the narrow space left at the edges by the sarcophagus. It is enclosed by an iron grill through which pilgrims thrust bills and which they caress longingly upon departure. A wooden baldachin, its

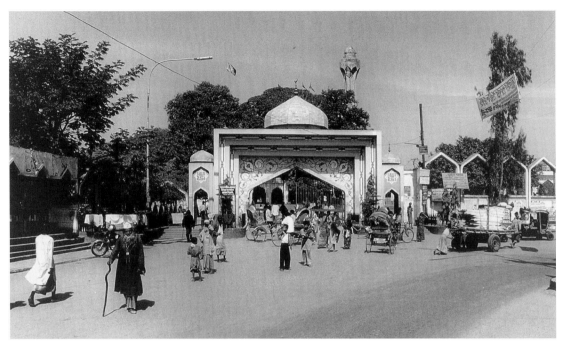

Mirpur Mazar

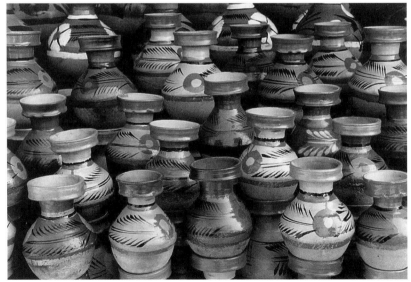

Painted *kalshis*.
Mirpur Mazar

spandrels worked with flowers, lifts a canopy of glittering calligraphy above the sarcophagus, draped in deep red cloth, beneath the expansive single dome of the tomb. The walls are pink, their details picked out in turquoise. The shutters of the windows are carved with flowers, bright with glossy paint.

Outside in the hard sun of a wide courtyard, singly or in small clumps, men and women sit or drift or lie, while the pilgrims cross to prayer. In two sections, on streets leading to the *mazar,* shops purvey special goods. There are sticks of incense, candles, and white candy to use as votive offerings to the Pir. There are tinselly, glittery strips of paper, gold and red, blue and green, repeating the names of God and the Prophet in Arabic. There are brightly painted pots to adorn the home in remembrance. The pots come from Hindu villages, and here in these stores seventeen Muslims, three of them women, embellish them with paint.

A friendly merchant named Mahmud Alam tells me he buys earthenware pots from five locations—one of them is Kagajipara—and he pays Nur Mohammad to paint them.

Nur Mohammad, born in Mirpur in 1962, sets about the job of decoration in exactly the manner of a master of useful form. He does not sketch his scheme on the pot, nor does he stop to ponder, assessing effects, imagining improvements or novel departures. Cogitation lies in the past; it is built into the plan in his head. The present is athletic, all action as he drives intently, like the potter at the wheel, through a smooth series of practiced gestures, performing in a kind of painting that might be called the artisan's style. In dynamic, it parallels the action of the engraver or embosser of brass.

Taking a *kalshi,* of precisely the sort normally put to use, Nur Mohammad paints it with red enamel down to the waist. (Decoration on painted pots is usually restricted—as is the slipped color—to the upper part of the vessel.) He also uses yellow, green, and blue as base coats, but this one is red. Allowing the paint to dry, just barely, he holds the *kalshi* across the mouth with his left hand and hits it with blue, quickly forming one petal of a flower. Next, twirling and cocking the pot into position, he paints three more petals around the belly that divide the circumference into quarters, establishing the geometric base of his design. Then Nur returns, adding three blue petals to each flower, and finishes with blue by turning the *kalshi* with his left hand, like the woman who made it, while he runs blue stripes in continuous strokes with his right, one at the bottom edge of the red and two beneath the neck.

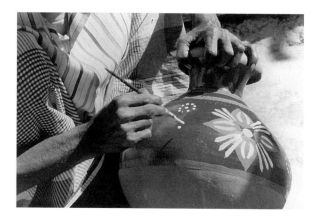

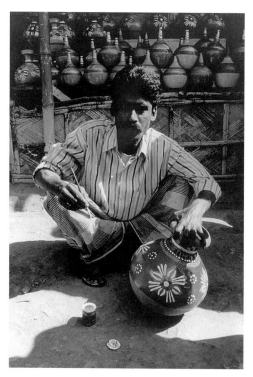

Nur Mohammad
paints a *kalshi*.
Mirpur Mazar

The third color is white. With a brush full, Nur Mohammad inserts dots in the center of each flower, two curved lines on each petal and three straight lines between them, two circles of dots between the flowers, and then a line around the collar. The last step is to paint the lip with red. It was left unpainted until the end to provide him a dry grip for revolving and clamping the pot to receive its ornament.

The result, shining and bright with color, displays a lively counterpoint between a rigidly geometrical concept and a quick, spontaneous mode of execution. This conjunction, merging the timeless and perfect with the temporal and imperfect, symbolizing the relation between God and the mortal worker, is a common trait of Islamic art, exhibited, for instance, in the carpets woven in the villages of the Middle East.

Reducing his actions efficiently, working color by color like a weaver of carpets, Nur set his design with four blue shapes that quartered the field. Then he filled it with details, decreasing in size, increasing in number, until the whole was swept into totality: a stream of flowers, abstracted geometrically at the peak of their bloom, circles endlessly to evoke the eternal garden with streams flowing by, promised in the Holy Koran. Nur Mohammad has transformed a working Hindu *kalshi* through decoration into an apt souvenir for the Muslim pilgrim to a holy shrine.

A Range of Form

Ornament and color bring to the surface aesthetic impulses that abide more subtly in form itself. No form is created by use. Forms are created out of human understandings that enmesh use in the ramifying interconnections of culture. For the maker of pots, use is an objective condition in the dialectic of creation, just as the objects of the visible world are for makers of pictures. Both potters and painters attend to precedent as much as empirical evidence, so every picture combines its subject with the norms inherent in schools of depiction, and every pot fuses use with aesthetic tradition. The pot and the flower painted on it refer to their objective correlates, a use or a blossom, and they embody an artistic style. Cross-cultural comparison will always reveal that different forms can accomplish identical ends. The handles deemed necessary to working pottery in the West are absent from the working pottery of Bangladesh.

Cultures differ, so forms differ. The thing must look right in its proportions and the swell of its curves, but in particular settings, potters tend to

Made in Bikrampur and Dhaka district, 1988.
Bought in Chittagong and Dhaka. The largest is 6 in. tall.

Earthenware Banks

For sale.
Krishna Kumar Pal's stall.
Rayer Bazar, Dhaka

Made in Bikrampur.
For sale on Sultanganj Road.
Rayer Bazar, Dhaka

judge by technical quality—by the thin and even walls of a piece, say—and to assume that form follows function. Within the objective conditions established by use, the *kalshi* is peculiar to its culture and unnecessarily handsome, but its makers value the form for its utilitarian rather than its decorative virtues.

In function, the *kalshi* associates with the *patil* and both separate from pots with which they share formal properties but which do not participate in work. The common example from Bangladesh is the bank. Named with an English word, *matir bank,* bank of clay, it is classed as a toy. Not that it is divorced from seriousness. The bank might be read symbolically as the incarnation of the relation between clay and cash that brutally defines the potter's profession. It certainly can be used to educate children about finances, and it seems successful, for I was often told that the popularity of banks is the reason for the rarity of coins in daily exchange. But the bank is mainly one in a set of inexpensive things, made of clay because clay abounds, that are bought by and for children. It has become, by convention, the pleasure pot of the young.

The usual bank is a small, rotund pot, closed into a knob at the top and slitted. Close analogs from elsewhere, from North Carolina or Sweden or Turkey, suggest the pot-shaped bank to be, in some measure, the logical outcome of the application of the working potter's skill to making something especially for children. Slipped and fired, red or black, the bank matches exactly the style of the *kalshi*. But, a thing for pleasure, it is regularly pressed toward the decorative. Ornament increases: lines are incised or run with a roulette or shaped of little bumps around the shoulder. Size increases and forms elaborate: a band is applied and pinched to strap a wavy belt around the belly, or the knob is raised into an ornate finial. And the earthenware bank might be coated with paint; colorful, floral banks are as common as *kalshis* in the shops leading to the Mirpur Mazar.

The decorated pot marks one step. In the next, form and ornament merge completely. Banks, as in Mexico, are shaped and painted to represent fruit. Surprisingly realistic, sculptural renditions of melons and pumpkins, mangoes, papaya, and jackfruit fill the stalls of the vendors of pottery. Hollow and slit, they still serve as banks, but they are found among other clay toys that complete the reach for representation. Miniature pots, exact representations of the big ones but scaled too small to use, then little parrots, ducks, and swans, cows, elephants, and tigers, statuettes of mothers with babies and brides with grooms (attired neutrally in Western costume and not in the distinctive

dress of Hindu or Muslim weddings), join the fruit banks in the class of things that adults use to ornament the home and that children accept as gifts to use in play, perhaps, but surely to hold and protect as personal possessions. From toys, children learn the joy of ownership—stressed in Bibhutibhushan Banerji's famous novel of life in Bengal, *Pather Panchali,* and realized in the clay bank rattling with coins—that is not to be underestimated in a scene of wide scarcity.

Sculpture

Debates among studio potters in the West divide the utilitarian from the sculptural. The traditional potter in Bangladesh reaches wide, embracing both.

Different techniques are used to shape figurative images. In one, soft lumps or rolls of clay are pinched and joined into shape. In Bangladesh in general, in Kagajipara in particular, two forms are most common.

Little girls model tiny statues of women, conical to the waist with stubby outstretched arms, clearly defined breasts, and faces squeezed to a hawkish nose. Sensory organs are pronounced, implying vigilance; the ears are large, bumps form wide-awake eyes. Incisions mark her hair, pulled back in a bun, and suggest jewelry—necklaces and the bracelets worn by Hindu wives—implying maturity and wealth. Called "timeless" and "ageless" in catalogs of folk art, feeling as ancient as the land, these abstract and symmetrical, minuscule but monumental, statues can be mothers in games or the Goddess in the full power of womanhood—the feminine being the active force in Hindu cosmology, the Goddess, Devi, in different forms being the prime deity of Bengal.

Mature potters, both women and men, use the same techniques to make horses, mounted on axles with rings for wheels, that are fired around the edges of the kiln and sold at the *melas.* For the boy who ties a string to his horse and pulls it along, it brings a message. Rare in Bangladesh, where bullocks and buffaloes work in traction, the horse evokes nobility and symbolizes the body that carries the soul through life as the horse carries the rider over the land. Pulled until it breaks, the earthenware horse reveals the limits of pride and the fragility of the mortal body. Bearing such connotative treasure, the horse is the most usual figurative toy made by the pinching method, though in Chittagong, in southeastern Bangladesh, the horse is joined by bulls and elephants, all slender in form and painted white and red. The more usual horse is treated like a pot. Its details are incised and then it is slipped and fired to become red or black.

96

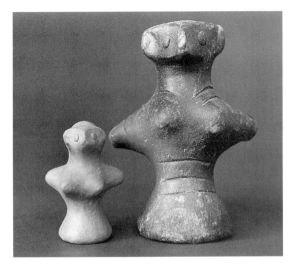

The Mother Goddess.
Made by girls in Kagajipara
and given as gifts to my
daughter Ellen Adair in 1989.
The larger one is 2½ in. tall.

Wheeled horses.
Before firing (above)
and after firing (right).
Kagajipara, 1989

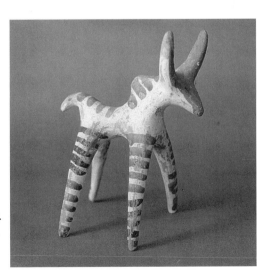

Bull from Chittagong.
Painted earthenware; 4½ in. tall

In one context, the little Goddess and the wheeled horse are playthings. In another, they are lifted in significance as votive offerings, gifts made to establish connections between people and power.

Ghora Pir

Badsha Mia is the prosperous manager of factories that produce aluminum utensils near Saturia, in Manikganj district, west of Dhamrai, and he is the great-grandson of Hazrat Sayed Kalu Shah Fakir. In meditation, gazing with the inner eye, Kalu Shah came to the Sufi truth that all is brought into oneness by the love that unites the Creator with creation. A healer, he attracted people to him, and with his sweet voice he sang to them of the love for God that lives in the heart. He died at a great age in 1906, and his domed tomb, in the village of Kaonnara, centers a celebration every winter that draws singers from afar into a convention of bards, for Kalu Shah was the author of a fabulous number of mystical songs—some say a thousand, and four hundred have been collected from oral tradition by folklorists, beginning with the great Mansooruddin.

For four days, devotees, *pirs,* and bards gather. They sing Kalu Shah's songs of the spirit. Drums beat, horns and conch shells sound. Men and women sit in contemplation, wrap in passionate possession, leap and sway, dancing in the smoke. A brass band leads a parade of dancers in circles around the tomb. Incense burns. The eldest descendants of Kalu Shah receive homage from the devotees on the long, crowded porch of the tomb. Men cook up a vast rice pudding so that all can join in a sweet communion. And there is a *mela* with rows of booths, bouquets of balloons, and a little wooden ferris wheel; flowered *kalshis* and wheeled horses are available for purchase. It is Badsha Mia's duty to maintain the *mazar* for the annual *urs* and the steady flow of pilgrims.

Badsha Mia told me that Islam was brought here, to the Dhamrai region, in the thirteenth century by seven heroic *pirs,* five of them in one mission, and he took me on a pilgrim's tour of their tombs. Two lie in one ancient *mazar* in Dhamrai, next to which a nineteenth-century tomb, sheathed in white mosaic, shelters the remains of Kalu Shah's master, Ata-ur-Rahman. Others of these first Muslim saints lie toward Kagajipara and across the Bangshai River to the east. There, on a country lane, stands the *mazar* of Ghora Pir. The keeper of the shrine, Manir Uddin, said that the proper name of the saint, who died seven hundred years ago, was Badar Pir, but he is called Ghora Pir,

Badsha Mia

Manir Uddin

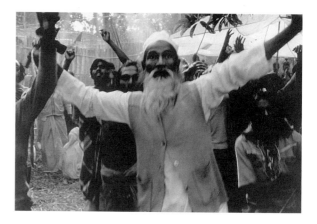

The *Urs* for Kalu Shah

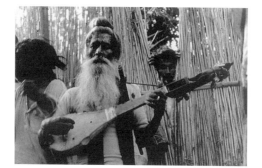

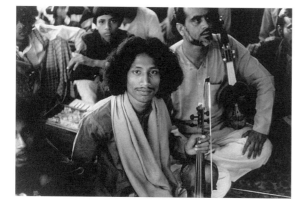

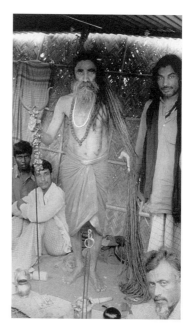

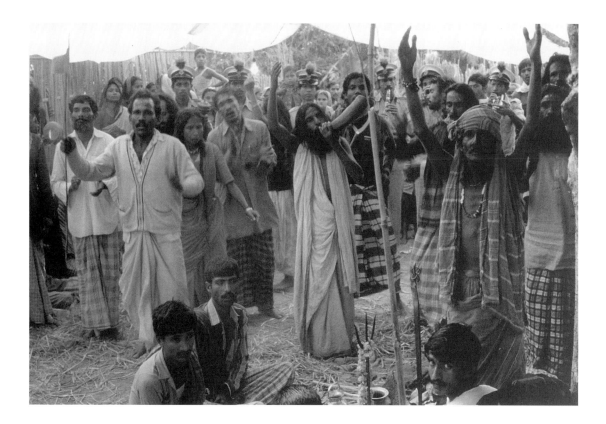

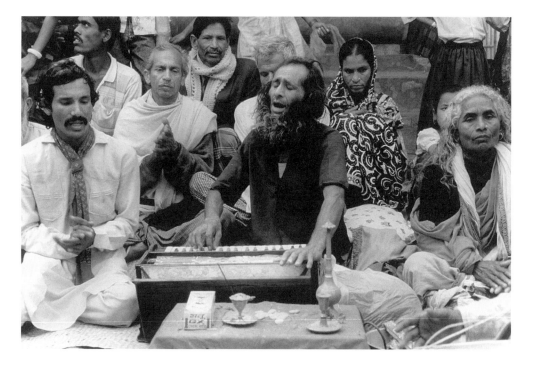

The tomb of the saints.
Dhamrai

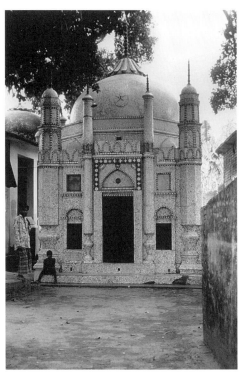

The tomb of Ata-ur-Rahman. Dhamrai

The tomb of Ghora Pir

Wheeled horse.
Made in Kakran.
Bought at the tomb of Ghora Pir, 1989.
Slipped earthenware; 5½ in. tall

the Horse Saint, because he arrived on horseback. Badsha Mia told me that people sometimes see him still, riding over the land.

The *mazar* is shaded by gigantic trees, circled by steps of smooth clay. A clay plinth lifts the tomb beneath its roof of tin. The sacred precinct is enclosed by a fence, latticed and painted green like the walls of the tomb. People arrive with requests, usually wishes concerning health. Barren women come to ask for babies. When they come, they bring a toy wheeled horse, or they buy one at the tomb that was made by Hindu potters in Kagajipara or its neighbor to the north, Kakran. Placing the earthenware horse in an open area beside the tomb, they offer their prayers, making their wishes known to the Pir. If the horse is later found broken, the prayer has been answered. Next to the tomb rises a lofty curved mound of broken horses, and the very earth around it is composed of millions of shards of shattered horses, beaten into the pale soil.

Amulya Chandra Pal

The wheeled horse is modeled in clay with the hands. More often figurative objects are shaped with molds. Some are toys, the little painted statues of animals that fill the stalls at *melas*. Others are like toys in that they are excused from work, but they are made for adults. In them, the decorative grips deep meanings.

From the plain water jug to the ornamented bank to the representational work charged with significance—the sequence will feel familiar to the Westerner. While it does not recapitulate any universal grading of form, the inner dynamic is broadly applicable. Use remains, but the aesthetic has risen to dominance. Visual experience stirs the mind, transforming the sensate through the pleasurable toward the philosophical.

Amulya Chandra Pal of Kagajipara can continue to lead us into general understanding. He is a master and innovator in figurative clay who has made things paralleled by no other; still, his techniques are shared and the semantic realms within which he creates are all general to the culture of the potters of Bangladesh.

In 1989, Firoz Mahmud and I sat with Amulya Chandra Pal on the bench in front of his workshop. A crowd gathered quietly around us, the tape-recorder ran while we talked. The language was Bangla, of course; Firoz and I have collaborated in the translation. Amulya spoke of his family:

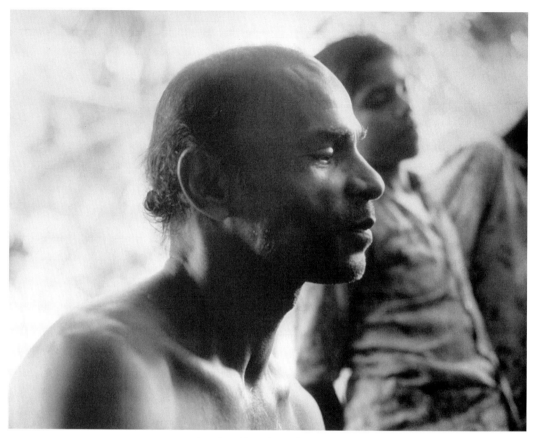

Amulya Chandra Pal

"My wife works alone, and she works with me. We have two daughters. The big one is twenty-five, twenty-five. The little one is twenty.

"One of my daughters is married. The big one is married. Both of them make pottery. Whatever can be made by hand, they can make.

"Three sons were born to me." Amulya lowers his voice, and lowers it again, in sadness:

"They died, all three.

"They were younger. The two daughters were older.

"They died of illness. One of them was bigger than my nephew." Amulya points at a tall lad standing by. "He was born after my two daughters.

"One of them died at the age of eleven. You see, there were many holes in his lungs. The first one withered and withered and died. The last one survived only two months after his birth. Two months after his birth he died."

The hard life is made tolerable for Amulya Chandra Pal through creation. When we talked, he was thrilled by change in his trade. Once he had made *hari-kalshi*, common useful vessels, but now he was experimenting with a wide range of new decorative forms, and he was buoyant. He said:

"As for our future in pottery, we think that we are, more or less, gaining new experience. I am optimistic. We are learning very much from experience.

"For example, we can make the things we see or things we do not see—things of the imagination.

"You see, previously we made common vessels for daily use. Other than the common things we used to make in the past, no other idea came into view.

"Now, for example, we have, more or less, our own ideas.

"We ourselves can think of making a thing, and then we can sell it and make a little cash out of it."

Amulya's example of a new work was the National Memorial that stands not far away at Savar. He was the first, he said, to sculpt a model of it in clay. When Firoz asked him where he got his new ideas, he answered with a specific instance, telling us how be borrowed a copy of the magazine *Desh* from a neighbor. From it he took the portrait of a great poet. With the poet, Amulya raised a new topic for himself, departing from our subject to explain:

"I am in the habit of reading books. Not only books: I am in the habit of reading books and magazines. We have the *Ramayana*, we have the *Mahabharata;* I read them and others."

With no pause, Amulya shifted again. "I have a habit, you see, on the day of Dol—you see, it is a public project, and I compose Holi songs for the day of Dol.

"I have composed a few songs. I myself can sing, though my voice is not good.

"But, you see, at least I can compose."

The day of Dol begins the spring festival of Holi, when, remembering the love play of Radha and Krishna, people joyously splash one another with red and blue dye. For the twelve days of the festival, and only then, Holi songs of two kinds are sung. One is the *bichargan,* in which two bards argue in song, advocating opposed views on a philosophical topic, opening the matter for consideration by the audience. At the tombs of Muslim saints, bards debate the virtues of orthodox and mystical Islam, of Hindu and Muslim theology, of women and men. During Holi, Amulya Chandra Pal, accompanied by a chorus, takes the bard's role to sing one side of the issue of love, celebrating Lord Krishna or his lover Radha, the spiritual body or the physical, the love of God for man or of man for God. Amulya only smiled and shook his head when I asked how many songs he had composed for such competitive performance. But during Holi, long narrative songs, ballads called *palas,* are also sung. These are rarer, demanding effort in composition, so Amulya could guess he had composed twenty-five or thirty, most of them elaborating episodes from the great epics, the *Mahabharata* and the *Ramayana.*

Amulya rummaged among the rafters of his workshop and brought out a large manuscript book of his verse. The dampness gave it a false look of great age. He put on his glasses, and from the book he chose to read us five of the poems he had composed for performance in public during the spring festival commemorating the passion of Radha and Krishna.

Two of his poems described the sweet beauty of Basanta, one of the six seasons of the Bengali year. It is late winter in the West, but in Bangladesh the weather is soft and pleasantly warm. The delicious days of Basanta are the most perfect of gentle spring days, and the green splendor of the land blesses the eye. In this queen of seasons, he says, young women fill with joy and await with restless delight the visits of their lovers. Our poet ends both of his songs in sadness, saying he cannot compass in words the deep melancholy of the one who is separated from her lover during this most glorious of times.

In a third poem, Amulya narrates an experience of his own, recounting a robbery that occurred at a wedding. He ends in dilemma: if you attend a wedding, you run the risk of being murdered by dacoits, the outlaws who roam the countryside, but if you decline the invitation, you fail to fulfill the obligations you owe to your relatives.

With his fourth poem, Amulya strikes a position on a matter of national importance. Bangladesh is about the size of Illinois. If it had a population the size of that of Illinois, it would be a paradise. But the population is ten times greater, and the carrying capacity of the land is stretched past the limit. The government has established an ideal of two children per couple, and foreign agencies are at work, spreading information about birth control. A sociological survey of Dhaka city reveals that the majority of people—rich and poor, male and female, Muslim and Hindu—support the government's goals in family planning, even if their own families are larger and although many cannot afford contraceptives. Only a few argue that children are a matter of fate and human beings should not make plans that contradict the will of God. The devout Muslim can see God's will operating through medical progress, and the opinion of Amulya Chandra Pal, a Hindu, is clear in his poem. Our translation does not distort itself to repeat his scheme of rhymed couplets (indeed, Amulya did not struggle to realize it rigorously), nor does our translation attempt to imitate his witty wordplay, but it echoes his colloquial tone and adheres strictly to his division into lines and stanzas. He titled it *Paribar Parikalpana,* "Family Planning":

Hello, brother, what has you so distracted?
Brother, tell me.
I see dismay in your face,
But I don't understand why.
Brother, what has happened to you?
Tell me everything.

Why are tears welling up in your eyes?
I don't understand at all.
Why are you so distracted?
Now, I understand everything.
I see you have many boys and girls.
About them you are worried.

You blundered in sexual obsession.
You are addicted to juicy pleasures.
What is the use of worrying in the end?
You can't repair it now.

The way population is increasing in the world,
Where will you get enough to eat?

Brother, human flesh will be eaten by human beings.
Even then there will not be food enough.
If you want to make a happy home,
After two or three children are born,
If you stop producing children then,
All your troubles will be at an end.

Amulya makes this appeal:
Practice family planning.
And then the nation will survive,
All the people will survive.
It is no longer a lying statement.

With his last line, Amulya counters conservative arguments that overpopulation is exaggerated. It is poignant that a man with no sons would sing so forcefully in favor of small families, and it is a testament to the flexibility of Hinduism that Amulya could raise such a topic, singing for sexual restraint during a religious festival celebrating passion. Amulya met the traditional scene with a traditional form, a sung monologue that he signed in the last stanza in the manner of a Bengali mystical poet. But in his poem, he stands forth as a thoroughly modern man, concerned about the future of his country.

In his last, and by far his longest poem, Amulya enters ancient tradition, recasting a sacred tale in verse. His scheme is loose; generally three lines rhyme and the fourth does not. His diction, in contrast to his jaunty song on family planning, is formal as befits a meditation upon faith. The God who intends to test the devotee in the poem's first line is Bhagaban, the ultimate power that Amulya identifies with the Allah of Islam. Seeking judgment, God, now called Hari, is Vishnu, the lord of life, come to earth in the form of an aged Brahmin. God's tremendous test parallels that of the Old Testament and the Holy Koran. In the Muslim telling, it is the story of the origin of perfect monotheism, commemorated in the annual observance called Kurbanir Eid in Bangladesh. God tells Ibrahim to sacrifice his son, and just as the knife is raised, the Angel of the Lord descends, declaring that Ibrahim's faith has been tested and found true. He is told to slay a ram in the place of his son.

The Muslim account is one of complete submission. Pure faith does not drive the action in Amulya's poem. Tradition and social transaction provide the context within which faith shapes and deepens. The event is framed by ritual obligations, founded upon acts of devotion, and centered by an explicitly articulated contract that binds its willing, responsible parties. The Brahmin says he has observed the obligatory, one-day fast of *ekadashi,* and he has come to the home of King Karna, seeking *paran,* food to break his fast. In the *Mahabharata,* Karna is called charitable and the best of the world's warriors. Providing *paran* to a Brahmin, a priest, is a sacred obligation. Karna, honored, offers to serve the Brahmin. As a noun, *seba,* and as a verb, *seba kora,* the word for "service" repeats and repeats through the text, reiterating Karna's obligation. Commands to listen, *shona,* constantly clear the channel along which words go to the brain. Told to be aware, to be certain when entering the contract, Karna agrees to meet the Brahmin's demands, saying he is doomed to hell if he fails. God asks for the flesh of Karna's only son. King Karna's response is not submission, but negotiation. He wonders what to do, he offers himself; his wife offers herself and pleads for mercy. God is adamant. The contract holds and must be fulfilled without tears, willingly.

King Karna turns to Krishna, avatar of Vishnu, setting power against power, life against death, within the dominion of God. Reassured by prayer to a statue in his home, Karna fetches his son, who places his fate in the hands of God, returns with his father, and submits. I have always been touched by the trust of the son for the father in the Biblical and Koranic narratives. He puts his hand in his father's big hand, the knife is in the other, and follows. His role is stressed in Amulya's telling. The innocent boy, who has only known the pleasures of play, accepts the death through which he will become the companion of the one he calls—as the Sufi calls God—the Friend. He washes to make himself a proper sacrifice and asks to be sacrificed properly. The god to whom he prays is Krishna. His parents invoke Krishna, and Krishna glows upon their faces, preventing tears, while they slay their son.

Murder is not aborted. The boy, Brishagata, is sincere in his wish for service, secure in his belief in reincarnation. His parents had fretted and plotted. Their son's untroubled resolve firms the faith of his parents, but Padmavati, his mother, still incomplete in submission, withholds the head of her dear son, lying to her husband that she has cooked everything. When the Brahmin calls for the head, so that the whole body will have been surrendered, so that all the parts will have been reassembled for resurrection, Padmavati realizes that the

Brahmin is one of the immortals. Faith is built upon sensate evidence. The contract is fulfilled, negotiation is over, submission is complete, and the Brahmin bids Karna to call his slain son to share in the feast prepared of his flesh. In our translation, which errs in the direction of the literal, here is Amulya's poem in its entirety:

> God intends to test the devotee.
> Just as the goldsmith judges gold on the stone,
> So Hari one day appears before Karna in the guise of a Brahmin.
> Dressed like an elderly Brahmin, carrying a staff,
> Trembling with age, he arrives at the home of Karna,
> Saying, "If there is anyone at home, come to me."
> Hearing the Brahmin's call, King Karna then says,
> "What, O Brahmin, brings you here?"
> Saying this, Karna offers a seat.
>
> Coming to Karna's home, the Brahmin says, calling Karna,
> "Listen, O Charitable Karna, listen attentively.
> Yesterday I observed *ekadashi;* I have come for *paran.*
> I have neither house nor home, I am forever wandering.
> Whoever loves me, I visit his residence.
> Whoever feeds me with love—there I receive service."
> Karna says, "Listen Brahmin, since you have so kindly come,
> I will serve you *paran.*
> Tell me, dear Brahmin, which thing would serve you."
>
> The Brahmin says, "O Karna, you must first be certain
> Whether you will give me that thing I will eat.
> If you do not give me that thing, I will leave.
> Today it is my mind's desire to break my fast with meat.
> If something else were given, I would not have been served.
> So tell me truly, King, whether you will give me that."
> Karna says, "Listen, Brahmin, the meat you want—
> I will serve that meat to fulfill your desire.
> If I cannot serve you that meat, let my abode be hell.
> Goat, deer, lamb, pig, swan, dove—whatever you want,
> With that meat, I will serve you.

If you desire some other meat, you can still tell me."

The Brahmin says, "O Karna, I desire human flesh.
If you give me some other meat, I will not have been served.
If you want to keep your promise, then fulfill my desire.
You have a beloved son named Brishagata.
Husband and wife: you two shall behead him,
In such a way that not a single tear shall drop from your eyes.
If I can see a single tear in your eyes,
Then you will lose the chance of serving me.
Dear one, if you cannot give me this, then I had better leave."

Hearing the Brahmin, Karna and Padmavati
Begin pondering what to do.
Then Karna says, "Brahmin, content yourself with my flesh."
Hearing her husband, Padma then tells the Brahmin,
"I will give my flesh today for your feast.
Have mercy, Brahmin, you have me at your feet."
The Brahmin says, "Listen, listen, I am telling you, brother,
I have no desire to eat the flesh of an aged person.
You will supply Brishagata's flesh until my belly fills with it."

They have only one son whom the Brahmin wants to eat.
If they do not give him, the guest would go unfed.
And if the guest goes unfed,
Their accumulation of pious deeds will have been in vain.
They will deviate from the truth,
If they cannot forsake their love for their son.
What to do? What shall they do? They find no answer.
At last, to uphold the truth, Karna bows at the feet of Krishna.

Outside, Brishagata is absorbed in games with his playmates.
And Karna goes out to call him.
Hearing the call of his father, Brisha tells his playmates,
"My father is calling me. Let me go home.
Think, if God spares me, I will play with you again."
Returning home with his father, Brishagata sees

The Brahmin, seated in stolid silence, a greedy guest.
He sees his pale father and mother,
Weeping, with tears falling from their eyes.
His mother and father do not say a word.
He does not understand at all.

Weeping and weeping, he beseeches the Brahmin:
"Lord, tell me what has happened."
The Brahmin sadly tells Brisha everything.
Hearing everything, Brishagata then announces,
"The Brahmin will be served with my flesh; it is my good fortune."
Brishagata then tells his own father and mother,
"Give me in the service of the Brahmin.
If my body is given to serve the guest,
I will join the merciful Friend."

Hearing Brishagata, Karna and Padmavati
Decide then to give him in the service of the guest.
Then Brishagata returns from bathing
And comes before his father and mother.
Brishagata then calls the god:
"O merciful Lord, I spend all my time in playing.
I have not called you before this day.

O Lord, accept me at your feet with mercy,
So in birth after birth, I can enjoy your fond companionship.
O Lord, this is my sincere desire:
That I sacrifice myself in service of the guest."
Brishagata then tells his own father and mother,
"Butcher me at the feet of the Brahmin in the sacred manner.
Let me yield my body to the ongoing cycles of birth."

Shouting, "Aye Krishna, Aye Krishna,"
Padmavati and Karna remove the son's head with a saw.
Both of them are smiling
As though the god were shining upon their faces.
After preparing the son's flesh, Padma goes to cook.

And she prepares a variety of meat dishes.
But, out of love, she hides the son's head.
Padmavati is done with the cooking. She tells her husband,
"I have cooked everything very well.
Now call the Brahmin to come, to sit, to be served."

Hearing Padmavati, Karna tells the Brahmin,
"The cooking is finished and done, please come.
Now, Lord, be seated and please us by partaking of your feast."
The Brahmin says, "Listen, Karna: something is yet to be cooked.
Padmavati has hidden the son's head.
Now what remains is a curry
To be cooked when the head is smashed."

Hearing the Brahmin, Karna says,
"Padma, why have you hidden the head?
Now smash that head and cook a curry for the guest."
Padmavati keeps the head secretly in the kitchen.
The Brahmin is in another room. How could he know?
Then Padma thinks: He is not a Brahmin.
He must have come in disguise with some motive.
After cooking the curry with the head, Padma tells her husband:
"I will serve the guest. Call him now."
Then Karna tells the guest what Padma has said.

The Brahmin says, "O Karna, I do not eat alone.
Now you bring me in a boy."
Then King Karna goes out straightaway to call a boy.
That King Karna has cooked the son's flesh to serve the guest,
The whole city has come to know.
Now seeing Karna, all the people flee.
Brishagata's friends are all playing games. Karna calls them.
All of them flee in terror of Karna.
Everyone says, "Escape. Karna comes.
He is one who has killed his own son, Brishagata.
The wicked king is now calling us to our death."
Karna finds that all the boys have fled.

King Karna returns, pale and sad.
Returning, he tells the Brahmin everything.
The Brahmin says, "Listen Karna, go out again,
Call immediately using the name of Brishagata.
Surely, Brishagata will return quickly when he hears his name."
Hearing the name of the dead son,
Karna's breast breaks with sorrow.
He goes out again and calls at the top of his voice:
"Now come back, Brishagata.
The time to serve the guest is running out."

Meanwhile, Brishagata is playing with his friends.
He hears his father's call: "Brishagata."
Then he says to his friends, "I will go home now."
Brishagata runs to his father.
Receiving his son, King Karna begins weeping.
What a wonder: never have I seen a dead son come to life.

This last is the poet's voice. Amulya says he has never seen a dead son come to life. But he has seen three sons die. In the linear time of mortal existence, sons die. In the reversible time of the sacred, rolling in cycles, sons are reborn. The son is playing with his friends. He is called into the house and slaughtered. Time passes. The son is playing with his friends. He is called into the house to be fed, sustained for further life.

Amulya Chandra Pal's poem exemplifies perfectly the way in which cultural and individual needs coincide in art. Retelling an ancient tale, drawn from the collective resource and containing teaching of importance for Hindus in general, Amulya speaks aloud to consider the inner pain of his own life. Brishagata is called "the son," not "his son," so that he can be both the son of the king and the son of the poet. Then Amulya can imagine a fate worse than his own, one in which a father not only loses his son but must kill him with his own hands. And he imagines a better fate: a father weeping with joy when his dead son returns to life. Lord Krishna gave King Karna the strength to meet his obligation, and for the happy festival of spring, the time of fresh life when Krishna and Radha played with color, Amulya composed a song that attests to reincarnation, at once a tenet of Hindu faith and a consolation to the grieving father.

Amulya Chandra Pal's poems present one view from Bangladesh, that of a worker in a remote village, that of a thoughtful, rarely talented artist. He describes his land as beautiful and as a setting for melancholy. He ends his narrative of the robbery at the wedding and intrudes in his narrative of King Karna and the Brahmin to describe normal life in this beautiful place as structured in dilemma. If you go to the wedding, you meet your obligations and risk death. To meet your obligations, you must forsake love and accept death, surrendering to the cycles of birth after birth.

Time runs in lines and circles. There is no escape. Life must be lived. In one poem, Amulya champions planning and asserts the need for will. In another, he champions submission and asserts the need for faith. Between will and faith, action and surrender, there is no resolution, except in the predicament of the new moment through which one must endure, doing what can be done, accepting what cannot be changed, and knowing the difference only through struggle.

While we talked, making words among us, Amulya, excited by the strange situation of an interview, found it most comfortable to illustrate his creativity through recitation of his verse. But he is a potter first.

Terracotta

Amulya Chandra Pal sculpts and fires images of two kinds. Some are three-dimensional. Others are plaques worked in relief. Both can stand as unique creations or become the models around which he forms molds. The fully round image is more common in Bangladesh, though Amulya specializes in plaques. Called in English "wall plates," molded plaques are fitted with metal loops for hanging. They are pictures in cooked clay. The plaques associate in the minds of the potters with the ancient Bengali tradition of "terracotta." Meaning burned earth, the term is used by Bengali scholars logically to divide fired from unfired images, and conventionally to separate the figurative from the utilitarian among fired pieces. The potters apply the term more narrowly to figurative tiles designed in suites.

The specialist distinguishes many periods, but terracotta in Bengal divides into six main phases. In the first, clay was pinched into form, and the little Goddess and the wheeled horse of today have antecedents over three thousand years old. During the transitional phase of the Mauryan period, faces were molded and bodies were modeled. The third phase, beginning in the second

century B.C. and lasting for five hundred years, is characterized by molded plaques comparable to those by Amulya. The signal subject was a wondrous woman, slim-waisted, full-bodied, and sometimes identifiable as the goddess of wealth, Lakshmi. That tradition did not cease, but from the time of the Guptas through the Pala period, from the fourth to the tenth centuries, Buddhist and classical Hindu images were added—plaques of the Buddha, Shiva, and Ganesh appeared in the repertory—and tiles in relief were revetted to religious monuments. Under the Hindu Sena kings, terracotta declined, but it was revived suddenly by the conquerors of the new faith. Geometric and floral tiles ornamented the mosques. Figurative tiles depicting the deities and recounting their stories, especially those of Krishna and Rama, coated the temples. This fifth phase, beginning in the thirteenth century, reaching its peak in Muslim architecture in the fifteenth century and Hindu architecture in the eighteenth, carried into the early twentieth century, inspiring modern potters, in the tradition's sixth and current phase, to create individual plaques and to sculpt ensembles of tiles on commission for buildings, now secular rather than sacred.

Images—three-dimensional or in relief, sculpted or molded upon sculpture, slipped and fired or fired and painted—fall today into three main topical classes. Within all of them, Amulya shapes particularly fine versions of the forms most common in Bangladesh and forms that are his alone.

The first class, overlapping with toys, is lifted to excellence as size and finish increase and play is left behind. It contains birds and animals. At the center there are songbirds, parrots, chickens, and ducks, swans and peacocks, horses and cows, elephants, lions, and tigers. Then there are monkeys, turtles, crocodiles, and prawn. At the edge, Amulya used a photograph to sculpt a realistic rhinoceros.

Like depictions of fruit in banks, these animals test the potter's representational skills. Often they touch wide circles of significance, absorbing meaning and rising symbolically. As symbols they stretch into connection with the two other classes of imagery. The realistically modeled and painted tiger is, in particular, "the royal Bengal tiger," a symbol of the nation. It belongs simultaneously in the class of animals and the class of national icons. Similarly, the bird might be the national bird, the *doyel,* but any bird will carry the mind toward the class of religious icons. In common conversation, conditioned by Sufi verse, the bird symbolizes the soul. The bird flies from without, giving

Amulya Chandra Pal with his rhinoceros.
Kagajipara, 1988

Parrot.
Bought at a street market in Dhaka.
Painted clay; 8½ in. tall

Monkey.
Made in Bikrampur.
Bought in Chittagong, 1988.
Painted earthenware; 7¼ in. tall

Shahid Minar.
Memorial to the martyrs
of the Language Movement.
Mural. Mohammadpur, Dhaka

Freedom fighters.
Mural. Nawabganj, Dhaka

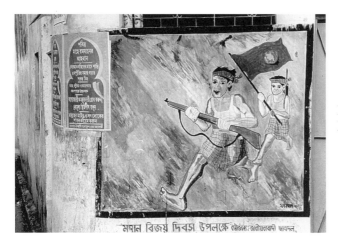

National Memorial, Savar.
Mural. Rishipara, Dhaka

form to eternal breath; it enters the narrow cage of the body to sing its song of longing for reunion with God, and then, at death, the cage collapses and the bird of the soul recaptures its freedom.

In the sequence of form, as utility declines, meaning, in compensation, ascends. Meaning enriches the statues of creatures, blurring the categories I have created to facilitate understanding, urging us on to consideration of the nationalistic and religious images fashioned of clay.

Nation

Amulya Chandra Pal is proud of the model he sculpted of the National Memorial. On earth sanctified by the blood of the martyrs of the War of Independence in 1971, the National Memorial stands near Savar, beside the highway that runs out of Dhaka to cross the Bangshai River at Nayarhat, below Kagajipara. With the monument to the martyrs of the Language Movement of 1952 in downtown Dhaka, this is one of the two main points of nationalistic pilgrimage. Meticulously landscaped gardens direct processional motion toward the monument that lifts its pieces, like the petals of a lotus, into aspiring union, sweeping toward heaven.

On the twenty-sixth of March, on the anniversary of the declaration of independence at the beginning of the war, people come in busloads to lay floral wreaths at the base of the National Memorial. Every day, people stop to walk the paths lined with flowers, recalling horrific and heroic events that live in the memory. The national past lies close.

The visitors are pilgrims, and they are tourists. Across the highway are souvenirs for them to buy: decorated pots and banks, painted earthenware figures of animals. The topic of tourism appeals to chic essayists who tend to generalize from the situation in which a wealthy foreigner buys a cheap curio made as a symbol of the locality by an impoverished native. That is surely a scene too common, and one rife with outrage, but it is not a comprehensive view. Neglected is the way that tourists can replace a failing local market and become sources of the funds that serious artists need to continue in their profession. (Sitting with friends at Native American art fairs and in Turkish bazaars, I have learned to see the horde of alien tourists not as a threatening invasion, but as a kind of migratory natural resource from which benefit can be extracted.) Neglected, too, is native tourism, certainly dominant statistically, in which people traveling their own country purchase souvenirs as mean-

ingful reminders and as gifts to compensate those who remained at home. The tourist today is a potter tomorrow. Not rich foreigners, but Bangladeshis of modest means account for the visitation at the National Memorial, and they cross the highway to buy things of the kind they would find in the country *melas* or on the streets of Dhaka.

Pottery was sold by the roadside. Then the vendors were moved to a trim open square, edged by stalls. One of them, the most distinct in its offerings, sells the wares of the Amulya Chandra Pal family of Kagajipara. As in all the stalls, the ware is special; there are no pots for daily work. The reference is to special occasions in general (of which a visit to the National Memorial is but one), and not specifically to the issue of nationalism that the location would suggest. But among Amulya's creations, there are statues of freedom fighters, the skinny peasants with rifles who resisted the army of Pakistan.

The National Memorial and the freedom fighter are icons of the nation, a political entity created by war. More usual are icons of cultural nationhood, and most common are images of poets, of Rabindranath Tagore and Kazi Nazrul Islam, who form a pair in national pride like the ceramic Staffordshire figures of Shakespeare and Milton that ornamented nineteenth-century English homes.

Rabindranath Tagore, the grandson of a man of wealth, the son of a sage, was the youngest of thirteen children in a family suffused with talent. He was a published poet at sixteen, and at his death in 1941 he was a man of such stature and saintly presence that he stuns Bengali critics, reducing them to quantities, to lists of books of verse and stories and essays, plays and novels, two thousand paintings, more than two thousand songs. Sukumar Sen concludes that Tagore was the world's most complete man. Buddhadeva Bose, in a lovely analytic memoir, locates the key to his fame when he says that Tagore was the one who introduced European romanticism to Bengal and Bengali literature to the world.

When William Butler Yeats read the poems in Tagore's *Gitanjali*, they stirred his blood, he said, as nothing had in years. The poets met. Both became public men. Similar in age—Tagore was born in 1861, Yeats in 1865—they were similar in predicament. Both matured to greatness as their nations struggled toward freedom from England. Prosperous and inspired, pulled at once by the world and the spirit, neither could become a committed ideologue of the national quest, nor could either lose himself utterly in the poet's craft or the private vision. Both received the Nobel Prize, Tagore for *Gitanjali*

Rabindranath Tagore and Nazrul Islam.
Made in Bikrampur. Nibaran Chandra Pal's stall.
Rayer Bazar, Dhaka

Rabindranath Tagore.
By Amulya Chandra Pal, 1988

Rabindranath Tagore.
Bought used at a street market in Dhaka, 1988.
Painted clay; 7¼ in. tall

Kazi Nazrul Islam.
Rooftop temple.
Shankharibazar, Dhaka

Rabindranath Tagore.
By Amulya Chandra Pal, 1996.
Earthenware; 10¼ in. tall

Kazi Nazrul Islam.
By Amulya Chandra Pal, 1995.
Slipped earthenware; 7 in. tall

in 1913. A knighthood followed that he stripped off in protest of the massacre perpetrated by the British army at Jallianwala Bagh in 1919. Four hundred died, and the same dread event fueled Mahatma Gandhi's non-cooperation movement that would carry toward Indian independence in 1947.

What amazed Yeats in Tagore's verse was its vital abundance. What he found enviable was its suggestion that the lone voice of the poet might still merge with the culture's common murmur. Like Yeats, Tagore read the ancient texts of his wounded nation, and like Yeats, he appreciated the folklore around him. He was drawn to the songs of Lalon Shah, the mystical poet of Kushtia, where Tagore managed his family's estates, and he accepted the traditional metaphor of the soul as a caged bird. The religious traditions of Tagore's land flowed into his own spiritual search. Particular poems in *Fruit-Gathering* read like parables of the Buddha, others like tales from the oceanic *Masnavi* of Mevlana Jalal al-Din Rumi, others like songs addressed by Radha to Krishna in love.

Times changed and fashions with them. Yeats and the others lost interest. Tagore's lyrical tone and his affection for the countryside did not suit the harder taste of a flashier age. But he had his work as an educator, and he had found his path as a poet. It took him to the place where the personal and cultural are one, where the momentary and eternal meet in sensual epiphanies. In fashion or out, his was the voice—sometimes profound, sometimes sentimental—of his place. His songs are still sung by the people and remain signs of refinement and identity. One of them, a hymn to golden Bengal, is the national anthem of Bangladesh, where he was not born, where he did not die, but where—if the testimony of folk imagery is taken into account—he is the greatest national hero.

In paint on wood, or shaped in clay, in images for sale in the markets of Dhaka, Rabindranath Tagore is paired with Kazi Nazrul Islam, called the Rebel Poet. Born in the last year of the last century, Nazrul followed his father as muezzin in a mosque, but he was attracted in youth to the Hindu tradition, and throughout his life he would sing of equality and unity. He translated suras from the Holy Koran. He composed songs of Hindu devotion. He married a Hindu and named their son both Krishna and Muhammad. Meshing the Muslim and the Hindu, melding the common and exalted, Nazrul embraced multitudes and embodied Bengal; imagine a mix of Walt Whitman and Robert Burns and you have some idea of the poet.

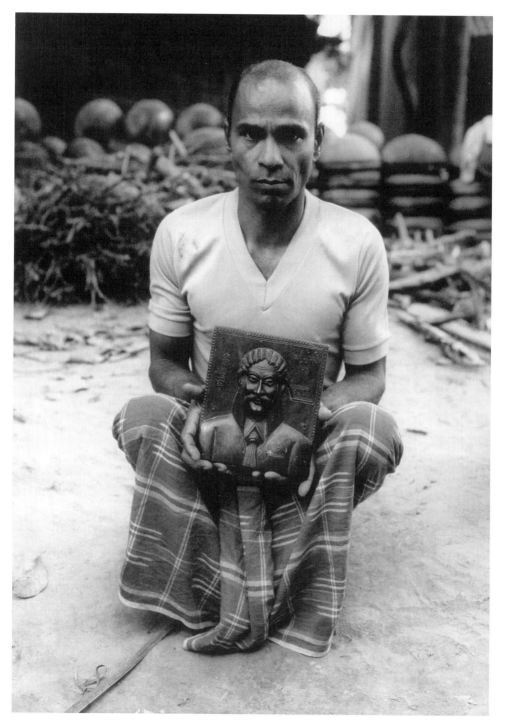

Amulya Chandra Pal with his portrait of Michael Madhusudan Dutt.
Kagajipara, 1988

Nazrul Islam said that Rabindranath Tagore wrote verse for the ages, while his own poems belonged to the violent moment. God sent him to destroy the foreigners who held his people in bondage. "I am the cyclone," he wrote, "the devastation tremendous." His eruption in 1921 shook the youth. Tagore embraced him and claimed him for the literary tradition they shared. Nazrul touched the poet's feet and became the fire and wind, the terror in rebellion, campaigning for liberation, shaping the wail of the oppressed into books for the authorities to ban. His veins ran with freedom, Mahatma Gandhi said: Nazrul wrote and spoke tempestuously; his fame widened through the new medium of film. And then he burst and fell silent. Shock treatments could not call him back. In time, the new government of the new state brought him to Dhaka to wait. They proclaimed him the national poet of Bangladesh, and he waited, the ashy memory of an explosion, until his death in 1976. If I return, he had said, it will be as a servant to the one God, the God of Muslims and of Hindus.

In making statues of Tagore, portraits in relief of Tagore and Islam, Amulya Chandra Pal is like many in Bangladesh. Then he displays his learning and originality in depictions of less popular literary figures whose art, like theirs, touched the wider culture. From an earlier generation, Amulya chose Michael Madhusudan Dutt. Born in 1824, the son of a rich Calcutta lawyer, Michael converted to Christianity and swelled with a passion for language. He mastered a deep purple English and sailed west to succeed or fail as a poet. His time in England and France was painful; his letters, rising into excitement as he learned new languages, descended more often into financial worries. He returned to his native tongue and then to his native place, declining to death in 1873.

Today Michael Madhusudan Dutt is remembered for courageous innovation in versification and for his ventures into epic. He wrote a drama based on the *Mahabharata,* and, inspired by Homer and Virgil, Dante and Milton, he reconfigured Hindu mythology into lengthy narrative poems, becoming one of those—like his Finnish contemporary Elias Lönnrot—who would form the national tradition into coherent verse before, through action, it could be shaped into political independence.

The poets led. One poem, written by Shamsur Rahman during the War of Independence, is a litany in which the abstraction "freedom" is defined, like a deity at a *puja,* through a series of worldly manifestations: the muscular arm of the worker, a student's spirited lecture beneath the trees, a stormy debate in a teahouse, the freedom fighter's nerve, an old man's prayer mat, a young girl's

swim, the mighty Meghna River. First in the list of freedom's signs is the age-
less verse of Tagore. Second is the wild creativity of Kazi Nazrul.

Rabindranath Tagore and Nazrul Islam: since the stream of events that
culminated in Bangladesh had its source in the movement to preserve Bangla,
it follows that poets who modeled the language would become national he-
roes. Like speaking the language, the veneration of these poets, one Hindu,
one Muslim, crosses communal boundaries to unify the citizens of the nation.

The unity codified in the constitution of the state, and symbolized in the
literary tradition, becomes real and insistent in daily experience. The images
labeled pictures of Bangladesh by their creators show rural life, for modern
Bangladesh remains a place of villages and agricultural labor. Scenes of *gramer
jiban,* village life, abound. They are found on easel paintings for sale at New
Market in Dhaka. Finer versions adorn the city's baby taxis. The potters make
them too, usually on plaques or panels of tile.

By far the most common image of rural life shows a man, his head down,
his strong back turned toward us, straining to aid his ox by pushing the wheel
of his cart. It is an unsentimental illustration, and it is an emblem of the
nation, portraying the heroic effort of the anonymous individual working to
free the wheels from the mud so the vehicle can progress. The image derives
from a painting by Zainul Abedin. Born in Mymensingh in 1914, he died in
the new capital of Dhaka in 1976. A teacher of art, a collector of Bengali folk
art, Zainul Abedin recorded in a modern idiom the miseries of his land, the
disasters, the bloody struggle for independence. Painted on wood, carved of
wood, cut from straw, woven into textiles, engraved in copper, molded in clay,
his image of the oxcart is constantly repeated, and Amulya Chandra Pal has
drawn inspiration from other of Zainul Abedin's works, memorializing the
famine of 1943 in the statue of a fallen man eviscerated by dogs.

Enumerating the categories of representation, we step between the cre-
ators and consumers of ceramics and begin to sketch a picture of Bangladesh
from a Bangladeshi point of view: the National Memorial, the great poets, and
now the land itself. Common life was a topic for the masters of terracotta a
thousand years ago, in the days of the Buddhist Pala kings, and today potters
lift details from experience that prove moving to all who share the land. They
make village scenes with bamboo houses and wooden sailboats. They make
scenes of work, including their own. Here is a man at the *chak,* there a woman
shaping a *kalshi* or the figure of a horse.

Among the pieces that stand for the whole, the thatched house or country
boat will serve, but human beings are more often chosen: the man at work, the

Potters at work.
By Babu Lal Pal.
Khamarpara, Shimulia.
See p. 220

Bauls.
By Santosh and Govinda Pal.
Kagajipara, Dhamrai.
See p. 187

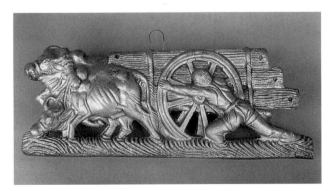

Zainul Abedin's oxcart.
By Amulya Chandra Pal, 1995.
Painted earthenware; 13½ in. long

Woman and *kalshi*.
By Amulya Chandra Pal, 1996.
Painted earthenware; 7 in. tall

woman at work, the mother with her child. She is not cozy and old, but young and beautiful with the supple, ample body of a goddess. Dressed in a clinging sari, she hugs her baby close, like a Renaissance Madonna, or she plays in the delight of their mutual youth. Amulya Chandra Pal has imaged the man with the oxcart, the mother and child, and he has pictured a Baul in clay. Rabindranath Tagore wrote of the Bauls, the mendicant bards who still travel the land, blending Muslim and Hindu mystical traditions with unchained observation into songs that comment on the course and condition of human existence.

The Baul Lalon Shah upbraids the mind for its obsession with the cage. It is flimsy and will not last. The bird will fly, going no one knows where. He asks:

> Heaven is an abode of joy, and hell of pain,
> Where are these located?
> Why this bliss on earth, why this sorrow,
> Do we get here what we earned elsewhere?
> If our fate is determined by our action,
> Why, then, does the child fall sick?
> Says Lalon, it is difficult to know
> How the child is to blame.

Religion

At the center, sublime, stands golden Durga. Below her the lion snarls, baring fangs and claws upon the body of a gray buffalo. Around her a spray of arms radiates into a nimbus ending in silvery weapons. A spear angles down, elegantly unifying the composition, pointing to a dark warrior, destined for death. In the story as I heard it in Bangladesh, the deities, threatened by the buffalo demon, pooled their strengths into a savior. She was given ten arms, this most powerful of all deities, so that she could meet multiple challenges at once. The demon transformed through a terrible sequence. He came as a buffalo, and she cut off his head. When he emerged as a muscular warrior with a sword, she killed him suavely. This is Durga, the Goddess in glory, slaying the buffalo demon, while her face preserves an expression of calm, the ultimate unconcern of complete power.

Nazrul Islam, the Rebel Poet, called Durga down to destroy the new demons loosed upon the land. Amid atrocity he cried: this is no time for pacifistic nonviolence or Koranic recitation. This is a time for blood, for the return to earth of Durga.

Ours is the last age, the fourth of the four stages of existence. In this phase of cosmic play, when disorder is the human condition, dark Kali comes like thunder to destroy pride and desire and time. She is the Goddess in wrath, voluptuous and garlanded with skulls.

Two hundred years ago, a British officer recorded in his journal that, whatever the scholars of religion might say, Kali is the most common deity in Bengal. That seems to remain true. If we approach the Hindu pantheon through the images in the temples of Bangladesh, and not from the mythology spread smoothly in the books, it is Kali, the Goddess in rage, that we will encounter most often. But Durga, the Goddess in composed power, stands at the still center. Her *puja* is the great event of the Hindu calendar in Bangladesh.

Erect and confident, Durga stands in victory, flanked by her daughters, Saraswati, the goddess of wisdom, and Lakshmi, the goddess of wealth. I was told that one could not become a devotee of both, of both wisdom and wealth, which explains crisply why the wise are so often poor, the wealthy so often stupid. That thought might console or amuse, but, in practice, all the deities are honored in their moments, worshiped as particular embodiments of infinite power.

In Bangladesh, these deities center veneration: the Goddess in full force, Durga; the Goddess in fury, Kali; and the daughters of the Goddess, rivals for devotion: Saraswati with her swan, Lakshmi with her owl. At the edges stand the sons of the Goddess: Ganesh, with his sensuous paunch and white elephant's head, and Kartikeya, the beautiful, youthful god of war.

Durga, then Saraswati and Lakshmi, then Ganesh and Kartikeya, the mother and her children, power and its issue, stand in symmetrical array within a proscenium at Dhakeswari Mandir, the principal temple in Dhaka. The great male gods of the Hindu pantheon of Bangladesh, Shiva and Vishnu, abide offstage, occupying places of their own.

Lord Shiva affiliates with the devotional center. He is the husband of the Goddess in her wifely manifestation as Parvati. But he is worshiped most often alone in the form of the phallic black Linga in small temples tipped with lofty, pointed spires.

Durga.
By Sankar Dhar.
Dhakeswari Mandir. Dhaka, 1996

Kali.
By Ananda Pal.
Kali Mandir. Dhamrai, 1995

Saraswati.
Family altar.
Dhakeswari, Dhaka, 1987

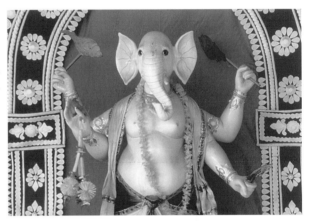

Ganesh.
By Sankar Dhar.
Dhakeswari Mandir. Dhaka, 1996

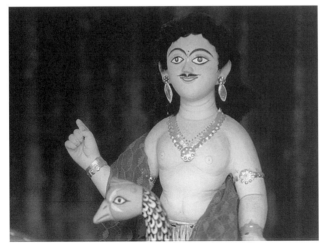

Kartikeya.
Thakur Das Pal family temple.
Norpara, Shimulia, 1996

Sitala.
By Keshab Chandra Pal.
Kagajipara, Dhamrai, 1995

Manasa.
Dhakeswari Mandir. Dhaka, 1996

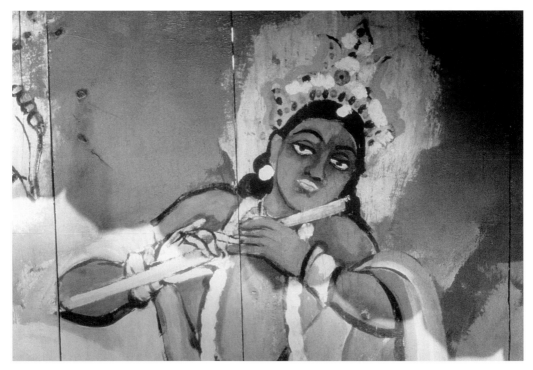

Krishna.
Painted on the temple car. Dhamrai, 1995

Linga. Shankharibazar, Dhaka

Kirtan.
Basudev Mandir.
Tanti Bazar, Dhaka

On Shiva's Night, women who have fasted during the day dress in white and come to the spiring temple, to Shiva's *bari*, bringing flowers and a green coconut. They sift the flowers onto the head of the god. The coconut is pierced, and while its milk is poured down over the Linga, they bow, praying for luck in love. The unmarried ask for good men. The married pray for the health of their husbands, the preservation of their capacity to keep them happy. At the temple, they give money and receive a *bel,* a fruit that they will mix with grapes and curds into a milky drink to break the fast on a day when nothing from the earth, neither rice nor vegetables, is to be eaten and Shiva alone is to be adored. Bathing the Linga in milk, then drinking milk themselves, communing with the god in a exchange of sweet white liquid, they participate in the perpetuation of power.

In Bangladesh, Vishnu appears most often in his incarnation as Krishna. God and man, as Christ is, Krishna eclipses Vishnu in devotion. Beautiful blue Krishna is usually shown with his flute and coupled with his lover Radha. Images of Radha and Krishna abound, and they center worship in temples of their own.

At Krishna's temple, at times of *kirtan,* men with drums and flutes and violins sing in praise, repeating the Harinama, sustaining the mantra of Vaishnavism: Hare Krishna, Hare Krishna, they chant, Krishna, Krishna, Hare, Hare, Hare Rama, Hare Rama, Rama, Rama, Hare, Hare, singing in celebration of Vishnu's dark avatars, heroes of the great epics, the *Mahabharata* and the *Ramayana.* Americans of my age will recall gaunt youths in saffron robes chanting at the edge of campus in the sixties, but the dance of devotion before Krishna's temple in Bangladesh cannot be imagined from such scenes.

The street in Dhaka is blocked. Ornate portals of white cloth filter the sun and demarcate ceremonial space. Beneath a canopy, strung with lights and hung with fluttery paper pictures of Radha and Krishna, the drums pound, the musicians cook, and the men swing with force and joy, dancing through the day, into the dark, robust, energetic, ecstatic, leaping to the ululation of the women in the audience. They come into the crowd to hug men overcome with emotion, sharing the power in manly embrace, and then return to the throbbing sound, turning, stamping, chanting. Along the street, among smiling people, the greeting for the day is Hare Krishna.

Despite the mythographer's attempt to order the pantheon and apportion duties after the pattern of Olympus, Hinduism in common practice—as shaped for presence in images in Bangladesh—seems a consortium of three religions,

untroubled by conflict or consistency. Each has a chief deity and a different means for converting unity into multiplicity.

First is Devi, the Goddess, manifest as Durga, as Kali, as Parvati. As the Great Mother, she has children: Saraswati, Lakshmi, Ganesh, and Kartikeya. Feminine power so prevails that the deities who rule danger are also goddesses: Manasa, the goddess of snakes, and Sitala, the goddess of smallpox.

In the books, Shiva is paired as destroyer with Vishnu, life's protector, but in Bangladesh, Shiva is called Mahadev, the Great God. Revealed in the Linga, the Lord is pure potency, neither destructive nor creative, but both. As Nataraja, Lord of the Dance, Shiva is poised perpetually in an endless ring of fire. His right foot tramples the dwarf of ignorance. His left leg is lifted in delicate elegance. In one of his right hands, he holds the drum that sets the tempo of existence. In one of his left hands, he holds the flame that will consume the world at the end of its current phase of misery. His hair flies; he dances the wild dance of the ascetic, away from the world, alone. Shiva lacks avatars and must join the Goddess for progeny, to be called the father of her sons. Shiva, the creator, sits with Parvati, they embrace in pleasure, they merge in the image of Haragauri, half male, half female. Shiva, the destroyer, is one with Kali but their relation is depicted in the image of Shiva prone, his eyes drooping or closed, dead to the world, while Kali stands upon him, rising in rage, her arms spread, her eyes wide, her tongue lolling. Linga, dancer, sleeper, Shiva is power, complete in potential, but She is the power active in the world.

Then beyond imagery, there is God, without form, omnipotent. In conversation, Hindus call God Bhagaban and Allah and Hari. And Hari is Vishnu. To bring order into the world, Vishnu has appeared in ten avatars, but in Bangladesh, more often, God's power is described as incarnating time through four names. In the first age, the age of truth, the name was Narayan. In the second, it was Rama. In the third, it was Krishna. In the fourth, in the dark, disordered age of the present, it is Gauranga. Golden Gauranga is the Bengali mystic Chaitanya Dev. He was born in 1486, and he died in 1533, in the period of the independent sultans of Bengal, after the Muslim conquest and before the Mughals came, when old and new, Hindu and Muslim traditions fused vibrantly. Chaitanya's contribution was to formulate Vaishnavism as a liberating faith of love, focused on Radha and Krishna, harmonized in devotional practice and logic with Sufism. He danced like one of God's mad lovers, and his followers took him for an incarnation of Krishna or of Radha and Krishna at once. In the temples, Chaitanya as Gauranga couples with his disciple Nitai to shape a protective frame around images of the lovers Radha and Krishna.

Basudev Mandir. Tanti Bazar, Dhaka. Gauranga and Nitai frame Radha and Krishna. Another Krishna appears in the niche. Shiva's trident and bull stand to the right.

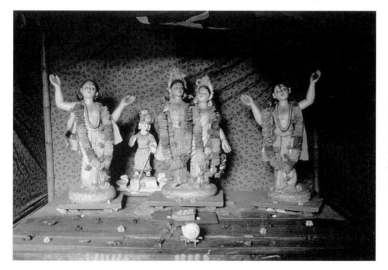

Family temple. Norpara, Shimulia. Gauranga and Nitai flank Radha and Krishna. Saraswati stands to Krishna's right.

In Bangladesh, the sharply marked minority status of the one who is a Hindu sets clear limits at the edges of a broad and richly varied terrain of concept and practice within which people discover or construct distinct, satisfying patterns of devotion for themselves. Their faith is monotheistic. It is focused during mystical reverie upon Bhagaban, power that is formless, limitless, and one. Their faith is polytheistic. It draws them through social ritual into contractual relationships with particular anthropomorphic deities. During centuries of domination by monotheistic rulers, Muslim or Christian, Hindu intellectuals have stressed the ancient monotheistic dimension of their religion, even setting it into a superior and antagonistic relation with polytheism, but in common practice, there is Bhagaban beyond and a plenitude of beautiful deities close by; monotheism and polytheism coexist comfortably. Bhagaban is Hari is Vishnu is Krishna is Chaitanya. The polytheistic traditions associate by proximity. In Durga's temple, or in Kali's or Krishna's, Shiva's altar stands to the side. In Shiva's temple, there is Hanuman, the loyal ally of Rama, avatar of Vishnu. The deities connect. Shiva pairs with the Goddess. Vishnu pairs with Lakshmi, the daughter of the Goddess, and that couple is Rama and Sita in one age, Krishna and Radha in another. The single power expands and amplifies through multiple forms, in intricate filiation, flooding in abundance.

Power, given explicit form in the Hindu deities, spreads through creation, surprising the world with significance. The deities are recognized and symbolized by the animals that accompany them. The potter shapes a lion. It suggests power, then power is confirmed, for the lion is the symbol and vehicle, the *vahana,* of Durga, the Goddess in the fullness of power.

The white swan is lovely, grace itself. I was told that the swan is also wise, fastidious in discrimination, capable of separating the milk from the water in a liquid mixture, and the swan is the *vahana* of the goddess of wisdom, Saraswati. The peacock's beauty is gaudy and aggressive by contrast with that of the swan. A kind of visual spice, the peacock was among the earliest exports to the West. Strutting in opulent gardens, it evokes the splendor of the Indian subcontinent. The Mughals ruled from the Peacock Throne. And the peacock is the *vahana* of Kartikeya. In his ambitious, troubled, and massively important autobiography, Nirad Chaudhuri recalled the image of Kartikeya from his childhood in East Bengal: the god of war "had become, as a result of successive softening touches at the hands of the potter, the very beau-ideal of a Bengali dandy." The peacock suits him.

The lion of Durga.
Dhakeswari Mandir. Dhaka, 1995

Nandi, the bull of Shiva.
By Haripada Pal. Shankharibazar, Dhaka, 1996

The little swan of painted earthenware, a pottery toy, holds the potential to evoke Saraswati. The peacock on the tile can call Kartikeya into the mind. The bull is the *vahana* of Shiva. The cow is a symbol of the Mother of all, now portrayed in a small abstract statue, now as a woman cuddling her baby, now as the Goddess in might or fury. From the deities at the center, meaning drifts through the potter's works that can be taken as toys or bits of decor or as symbols of sacred concepts.

The elephant is the *vahana* of Indra. Chief of the ancient Vedic gods, Indra is not an object of common devotion, but the elephant is also associated with Lakshmi, the goddess of wealth, who surely is. In Bengal, her *vahana* is the owl. Unlike the swan of her sister, the owl is not found frequently among the earthenware statues. The elephant is, and if connections with a particular deity remain indistinct, it is more than an astonishing beast. The elephant symbolizes water, moving ponderously over the earth in a great gray bulk like the storm clouds that roll across the skies.

In this land of rice fields and floods, water brings life and takes it. The elephant remembers Indra, the god of storms. It will work to serve human-kind, and it will break free from control to crush like a cyclone. The benevolent and violent force that is real in running water, and symbolized by the elephant, isolates the *kalshi,* the instrument capable of containing water, suggesting why it is chosen from among the practical pots to decorate into an object for sacred places. Water lifts meaning through the *kalshi* and brings it, with the elephant, into the ambit of the Goddess who, like water, gives life, and who, like water, destroys. She is the Mother, her breasts heavy with milk. She is Kali, thirsty for blood. The power of the gods overflows, filling things with significance, urging interpretation to the limit—and beyond—during efforts to understand the forces that move, seen and unseen, through the world. Water and earthen jars, cows and elephants, mothers and goddesses intersect, aligning in imperfect, evocative association.

In the potter's repertory of representation, within the class of animals, religious meanings remain ambiguous, abide as potentialities. The Hindu potter like Amulya Chandra Pal is fully aware that he is creating a symbol of Saraswati when he makes a swan. His customer, a Muslim most likely, might buy a toy swan for his child, an ornament for his home, or a sign of the abounding grace of God. About other works there is no question. The potters depict the deities. It might be expected that earthenware products would recapitulate the patterns of devotion, that Durga and Kali would be most frequently represented,

but now a distinction made by the scholars of terracotta is crucial. The potters employ two distinct techniques to fashion the *murti,* the image of the deity. When they mold *murtis* and fire them for sale in the market along with banks and statues of elephants and poets, the common images are few, usually one of two: Ganesh or Radha and Krishna.

Ganesh and Radha-Krishna

Ganesh was formed of sacred earth, scrapings from the body of Parvati. She set him to guard her while she bathed. When he blocked Shiva's entry, the Lord cut off his head. Like Brishagata, the child in Amulya Chandra Pal's poem of King Karna and the Brahmin, Ganesh was beheaded, but Brishagata's own head was reunited with his body so that he could be returned to life. Ganesh was restored to wholeness with the head of an elephant. The embodiment of rebirth, Ganesh is venerated as the guardian of portals, the lord of beginnings, the remover of obstacles. Prayers to Ganesh function in Hindu life as the opening formula of the Holy Koran—In the name of God, the Merciful, the Compassionate—functions in Muslim life to move frail human beings into the unknown with courage.

Ganesh wears the tapering crown of a god. In one of his four hands he holds the sweetmeats he loves. His belly is plump. One tusk is missing; he lost it in combat when he was protecting a doorway beyond which his parents, Shiva and Parvati, lay in the delights of love. His *vahana* is the rat, as small as the elephant is large, and capable, like his lord, of finding tricky ways past every barrier. A child of the Goddess, Ganesh lives on the wing of power. Though he is marginal in the pantheon, his is, it seems, the most common image in the Hindu world. Certainly I found Ganesh pictured more than any other deity in prints and statues in the shops of Hindu workers in Dhaka. I mean no disrespect, rather I acknowledge feelings of affection, when I opine that his popularity is owed to more than his sacred attributes. Reconciling the power of the elephant with the self-indulgence of the child, his image is warm and appealing. In contrast to the great deities, with their perfect physiques, pudgy Ganesh is a lovable presence, consorting comfortably among the toys in the markets.

It is not that the great deities are missing. Amulya Chandra Pal has sculpted for firing two handsome plaques of Saraswati. But, in my experience, Ganesh is the one found most often among the molded, fired, and painted religious

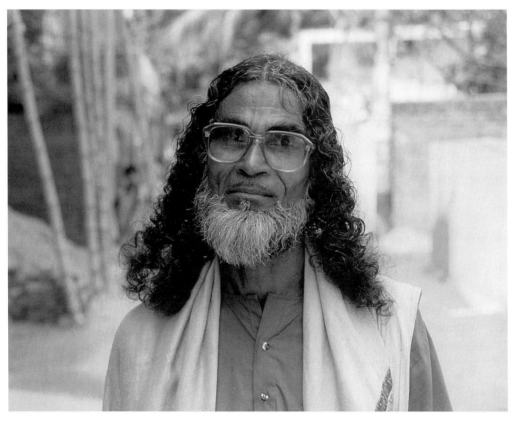

Saidur Rahman Bayati

images in the markets of Bangladesh. Radha and Krishna are next. People speak of them as a unit: Radha-Krishna. They swing together in clay to the sound of Krishna's flute. Hearing that sound, Radha overcame indifference and surrendered in love. The earliest images spark debate among scholars who wonder whether the amorous couple in ancient terracotta is this couple, but by the thirteenth century the love of Radha and Krishna, erotic and transcendent, had become a theme in Bengali art. By the end of the fifteenth century, in the days of Chaitanya called Gauranga, they focused a devotional cult, and their love became the dominant topic of Bengali literature. If the theme reached its peak in the sixteenth century, and began to decline among the Hindu and Muslim literati in the seventeenth, it was popular in song, drama, and terracotta revetment during the eighteenth century, and it remains vigorous. Their love attracted Rabindranath Tagore to fresh formulations early in our century, and it persists as a subject for singers in modern Bangladesh.

In one of the songs Amulya Chandra Pal composed for performance at the Hindu festival of spring, the beautiful season deepens the melancholy of a woman separated from her lover. Life is hollow without Krishna, and Radha suffers in love.

In the earthen and bamboo village of Hashli, Manikganj, Saidur Rahman Bayati sings for Muslim farmers the songs of Radha and Krishna. During his beautiful youth, he played the female parts in folk theater. Now in his sixties, a healer and Sufi bard, Saidur Rahman sings of the earthly ardor of men and women through which a third power, simultaneously Radha and Krishna, is created as a realization of the ultimate unity that is God.

On a pleasant evening, I joined a party of prosperous Muslims, men in dark business suits, women in elegant saris, on the breezy porch of a fine house in Dhaka, to listen as Sultana Nahar, a lawyer by profession, a poet by fame, accompanied herself on the harmonium and sang with throaty emotion the songs of Radha's rapture.

Coming at once from the renowned poets of the past and the itinerant Bauls of the present, the songs of Radha and Krishna cross the boundaries of class. More remarkably, they cross the communal divisions of religion.

Krishna is a Hindu god, the eighth among the ten avatars of Vishnu, the third incarnation of time. From his life the episode of the flute has been selected for artistic remembrance and symbolic investment. The song is a love song. It expresses a woman's love for a man, her pining, her passion, and, in line with Sufi thought, it has become, simultaneously, a song of the soul on

143

earth longing for God. Out of love, God created the world. In love, the devotee yearns for reunion, for the reachievement of oneness, almost imaginable through the ecstatic instant of bodily fusion. With faith, the man or woman of the earth becomes to God as Radha is to Krishna, complete in surrender, utter in devotion. The image in clay shows Radha and Krishna, swaying as one; it recalls a story, echoes a song, and pictures the reciprocal love that unites the visible and invisible worlds.

These come into public to mix in the market, the most accessible of Hindu deities: lovable, imperfect Ganesh and Radha-Krishna, the beautiful couple in love. Each is a popular image from a different strain in the Hindu tradition. What links them is charm—they attract devotion through affection, not fear or awe—and the potential for identification. A conjunction of god and animal, Ganesh is the symbolic analog of the human being whose beastly body contains the divine spark of soul. Ganesh is a deity of the second generation, a perpetual child. He invites identification by standing to his parents, Parvati and Shiva, as the devotee stands to God. He is one deserving of love. Krishna incarnates Vishnu in human form. He is handsome, playful, and lusty. He can be loved by Radha, a human being, who invites identification by standing to her lover as the devotee stands to God. She is one filled with love.

These images, one lovable, the other loving, together make visible the Hindu version of the original contract celebrated in Sufi verse. The world is held together by love, by the love the Creator holds for creation, the love returned to the Creator by the creature.

It is a relaxing duty of the student of material culture to prowl antique shops, gathering hints about past practice. In the shops of Dhaka, the old metal images are most often of Radha and Krishna. Krishna as a mischievous baby is common as well. Ganesh follows. There is continuity between the images cast into permanence in the recent past and those burned into permanence in the present.

Meaning runs beyond Hinduism. Radha and Krishna can make a Muslim symbol, and Hindu potters feel comfortable reaching into the other religious traditions of Bangladesh. There are Bangladeshi Christians. While their numbers are small—Dhaka city has one church for every three hundred and thirty mosques—I have attended Christmas parties with men in suits and women in saris when I was the only foreigner present. For the small Christian minority, the Hindu potter will shape with conviction an image of Christ on the cross.

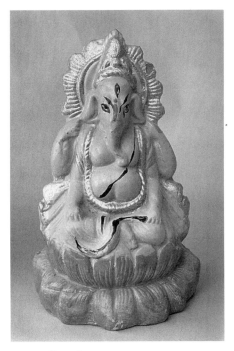

Made in Bikrampur.
Bought in Rayer Bazar, Dhaka, 1989

Ganesh.
Painted earthenware; 7¼ in. tall

Radha-Krishna.
Painted earthenware; 10¼ in. tall

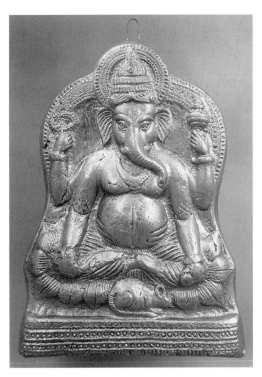

Radha-Krishna.
By Amulya Chandra Pal, 1988

Ganesh.
By Amulya Chandra Pal, 1995.
Painted earthenware; 10½ in. tall

Taj Mahal

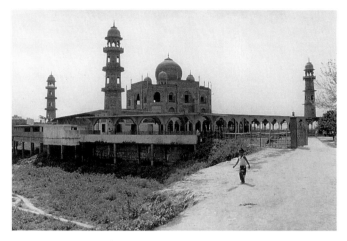

New mosque.
Under construction north of Dhaka

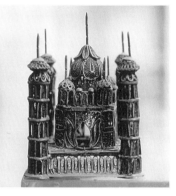

Silver filigree.
Jeweler's shop. Islampur Road, Dhaka

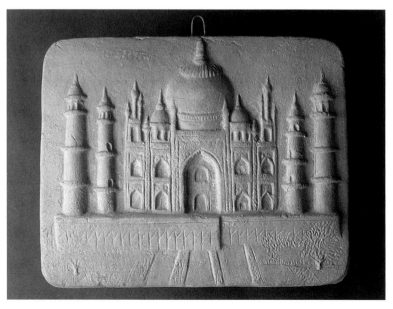

By Amulya Chandra Pal, 1995. Earthenware; 8 in. long

Islam and Hinduism, the major religions of Bangladesh, seem complete in their difference, the one aniconic and rigorously monotheistic, the other polymorphous and iconic in the extreme. Yet Amulya Chandra Pal acknowledges their unity in the timeless creative energy that is given form in his religion in the multitudes of deities and that is given form, in his mind, in the Muslim house of worship. Of slabs he has constructed a model of a Bangladeshi mosque. On a plaque he has sculpted a version of his country's most pervasive iconic emblem of Islam, the Taj Mahal. The tomb ordered by the Mughal emperor Shah Jahan for his wife, and built in Agra between 1632 and 1643, is ubiquitous in Bangladesh—cast in concrete vents, worked in silver filigree, engraved on brass plates, painted on rickshaws—and though it is a tomb, it is generally identified, as Amulya Chandra Pal identifies it, as a mosque and as a symbol of Islam.

The Hindu potter's reach beyond Hinduism is more than an effort to meet the demands of a diverse market. It is incorporative, a recognition of ultimate unity. While telling his vast tale of the decline of Rome, Edward Gibbon contrasted the open, inclusive, syncretistic quality of polytheism with the closed and strict nature of monotheism. At the top of a winding stair, in a temple on a roof in Shankharibazar, Old Dhaka, I find, along with the Hindu deities, calligraphed Koranic texts and prints of Christ of the Sacred Heart. At Hindu festivals, I find posters of Durga and Kali, Lakshmi and Saraswati, of Krishna, Christ, and Putai, the merry, fat bodhisattva of Buddhism.

In his bold, abstract style, Amulya Chandra Pal has sculpted a plaque in relief of the Buddha. Bengal was once a Buddhist stronghold. With the Muslim conquest, beginning in 1204 and taking a century to complete, Buddhists escaped, died, or converted. The monasteries fell to ruin, and today only a small number of Buddhists remain, in Chittagong especially. At Kamalapur in Dhaka, there is a Buddhist monastery, founded in 1960. Named Dhammarajika, it is as pure a force for good as this sorry world allows. There orphan boys of all religions are educated and given hope. Alokendu Barua led me to the hall of worship, where old Bengali statues of the Buddha mingle with new images from abroad, and then I followed him around the tank to an enormous Bo tree. It was grown from a cutting of a tree in Sri Lanka that was grown from a cutting of the tree beneath which the Buddha attained enlightenment. There a small earthenware statue of the Buddha concentrates devotion.

The Buddhists of Bangladesh are too few to make a market for the potters. Images of the Buddha, however, are not rare. Gautama is revered by Hindus,

The Buddha.
Dhammarajika Monastery.
Kamalapur, Dhaka

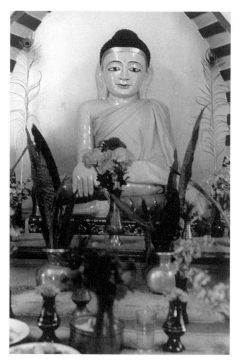

The Buddha.
Buddhist monastery. Chittagong

The Buddha.
By Amulya Chandra Pal.
His original model and the mold he made from it

as Jesus is by Muslims, as an embodiment of the sacred in its gentle mood—so revered that the Buddha has been welcomed as a Hindu deity. He is, like Krishna, an incarnation of Vishnu. There are passages spoken by Krishna in the *Bhagavad Gita* and passages spoken by the Buddha in the *Lotus Sutra* that seem to teach one doctrine. This world is a place of sorrow and illusion. The reality lies beyond, demanding perseverance and the mastery of feeling. Modern commentators differ on whether the Buddha walked the land that is Bangladesh now, and it is a problem for historians or mystics to unravel how Buddhism, Hinduism, and the Sufi strain of Islam converged. But when the Buddha characterizes life as a transit of suffering, he seems, like Rabindranath Tagore or Amulya Chandra Pal, to be giving voice to the melancholy of Bengal, making words out of the place where optimism was defeated by heat and jungle and flood, where the soul is wrapped in sadness. When the Buddha describes the world as transitory and reality as a unity experienced in fitful snippets, when he counsels patience, balance, and love, there is no conflict between Buddhism and Islam. And there is no conflict between Buddhism and Hinduism when the Buddha speaks of the multitudes of metaphor through which the final unity is approached, and when he praises those who offer flowers, incense, and music, and those who fashion images of metal or clay.

Pressing clay into molds, firing forms and then painting them, the potters make banks shaped like fruit, they make statues of tigers and cows, of women with babies, of men who were poets, and they make *murtis,* images of Ganesh and Radha-Krishna, as well the crucifix, the mosque, and the Buddha. Distinct from these are *murtis* that are not fired before painting, that are made for seasonal worship. For *pujas,* the potters sculpt representations of the great deities, of Durga and Kali, of Lakshmi and Saraswati.

Saraswati

The potters tell me that Pals—workers in clay—divide into two kinds. One makes *kalshis,* the other *murtis.* Their distinction eliminates many kinds of product in order to establish an efficient contrast between the objects I have set at the opposite ends of the continuum of creation, the *kalshi* for carrying water and the *murti* for worship in the *puja.* The distinction entails technique, separating the fired from the unfired, and it manifests a contrast in value. In our terms, it seems, the utilitarian is divided from the aesthetic, but in terms to fit Bangladesh, the contrast is between two kinds of usefulness, two varieties

149

of instrumentality. Things for work divide from things for worship. The mundane is set into contrast with the spiritual. Potters create devices to aid worldly labor and devices to bridge the gulf between visible and invisible realities.

Made in relation to potters, not pots, the potters' distinction is overly clear because, while, indeed, only some potters—all mature males in my experience—shape images of deities, that work is seasonal. It could have been different in the past, but today the specialists who make *murtis* fill the intervals between *pujas* with the manufacture of less exalted objects. They might make the things everyone makes, but the modeling and molding skills required for *murtis* lead them, more often than the others, to shape representational works and tiles for roofs.

The first time I visited Kagajipara happened to be the eve of Saraswati Puja. The children returned from school, rowed by a boatman across the river. Boats going upstream were towed by men trudging the bank. The sky melted from blue to pink, work ceased among the makers of *kalshis,* night fell. Attracted by a light still burning in a bamboo workshop, I entered and found Ananda Pal at work. Large pale statues of the goddess stood back in the shadows, sparkling in reflected light. Ananda was bent over a hosting of small white figures that he was detailing with red and blue, black and yellow paint. Since I am a teacher, he sold me one of the small images of the goddess of wisdom, and I returned to Dhaka, holding her gingerly while she dried.

Ananda Pal's small image of Saraswati was made by pressing clay into a deep open mold, exactly as one would make the plaque of a poet. Released from the mold, the piece might be treated as nearly complete or as a kind of sketch to be refined. When Amulya Chandra Pal makes plaques, some are left as they are, while others are smoothed, sharpened, and chased with tiny wooden chisels, then, logically, assigned higher prices. Ananda Pal's small Saraswati was elaborated with an addition to her crown, spattered with silvery glitter, but she was painted as she came from the mold. When Manindra Pal of Kagajipara shapes a *murti* of Saraswati, he uses, like all the masters, a mold he has created from his own model, and then he perfects the image, taking time to sharpen the details of her face, her ornaments, and the folds of her sari. Thus refined and incised, Manindra's image costs four times Ananda's.

People need *murtis* for domestic worship, and the potters accommodate clients of different means with images requiring different amounts of time to complete. They shape small statues in open or double molds, refining them or

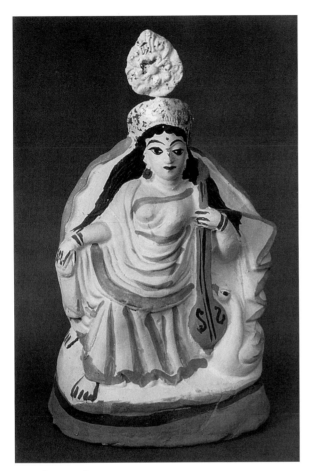

Saraswati.
Kagajipara

Saraswati.
By Ananda Pal, 1987.
Painted clay; 10¾ in. tall

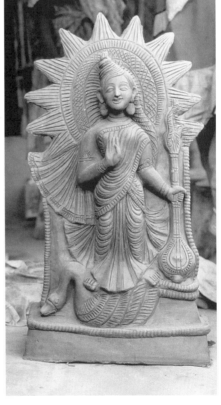

Saraswati.
By Manindra Chandra Pal, 1995.
The molded image has been incised;
it awaits smoothing and painting.

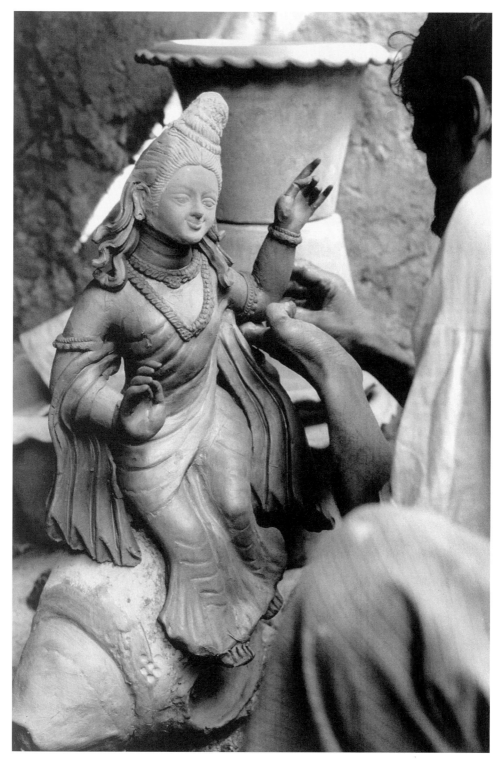

Sumanta Pal working on a *murti* of Saraswati. Kagajipara, 1995

not, exactly as they would make any molded image. The difference is that they are not fired before painting; they remain *kacha,* earthen like the potters' homes. For large *kacha* images, they use different techniques.

Work on a *murti* begins with a prayer, its words a secret of the potters. They split a stick to make a stable base of two parts, joined by two lighter sticks, one rising to form the armature around which rice straw is bound tightly into an approximation of the form of the deity. Clay is packed over the straw, and then working by hand, *hate hate,* the master models the image, adding clay and removing it, pushing and pulling until the form is blocked out. During its last stage, its detailing to completion, the master employs a battery of small molds.

Years after that first visit to Kagajipara, I watched Sumanta Pal finish a statue of Saraswati on the eve of her *puja.* On other days I had seen him at work in the shop of his elder brother Basanta Kumar Pal, shaping vessels, carrying wood to the kiln. Now he kneels before the goddess, eye to eye, nearly embracing her as his hands move. Sumanta says he needs ten different molds. One is for her face, the others for her ornaments. To one side he has a small plate, a flat piece of fired clay impressed with a neat row of pits. Rolling a ribbon of clay across it, he peels off a band with a series of domical bumps that he circles onto her wrist for a bracelet.

His molds insure exactness of repetition and they speed the task, but Sumanta alternates between techniques, doing much of the detailing freehand, *tipi tipi,* with the fingers. He works the drape of her sari with care, gouging sweeps with his thumb, then softening them with dampened hands. There is no wish for the deep shadows cast by undercutting. The cloth looks more natural early in the process, and were he a sculptor of the European Baroque he would exaggerate the effects he created at the beginning. Instead, he smooths deep incisions and sharp ridges, rounding every edge and line so that the sari clings to the body beneath it, and its patterned folds roll smoothly over the form, blending the parts into a steadily flowing, gently modulated unity. Eventually this unity will be confirmed by a smooth coat of paint.

The emotional quality of the image of Saraswati is set in the relation between her face and her hands. The face is perfectly composed. It bears no hint of the subtle imbalance of the human form. The mold secures exact symmetry: a straight nose is positioned precisely between the wide almond eyes, above a small smile. Smooth as plaster, unwrinkled, undimpled, the face realizes geometric order and points forward, projecting a calm and distant abstraction. The lovely hands seem, by contrast, human, alive, and near.

While I watched Sumanta form Saraswati's fingers, one by one, from rolls of clay, gently bent at the joints, I was reminded of the classical canons of beauty established for Hindu icons in the Gupta and Pala periods. The parts of the body are to be urged toward perfection by analogy with other forms from nature. Beauty emerges as different forms are compared, their essences are merged and given material presence. The human eye borrows the shape of the deer's eye or the petal of a lotus. The eyebrow curves like a bow. The thigh tapers like a young elephant's trunk, the calf swells elegantly, repeating the lines of a spawning fish. The fingers are perfected through comparison with beans in a pod, and that is exactly what they look like before Sumanta Pal attaches them to the hand, raised in a gesture to dispel fear and welcome approach.

To make the tresses of the goddess, Sumanta rolls a rope of clay. With his thumb and first finger he runs two incisions for the length of the rope, then two more, until it is cruciform in section. He bends it into a sinuous sweep and attaches it with others to the head. The tresses lift like hair in a breeze, offering counterpoint to the motionless composure of the face. Yet each is the same in size, all are units of four equal parts. Like the folds of the sari, they gesture to nature, but reveal a rhythmic order more exact than that found on the surface of things. The mind improves the patterns the eye pulls from the world, making them more regular, more cadenced, as the hand blends the real and the abstract.

What struck me while I watched was Sumanta's technical command, how he managed to bring the clay to the point where it was soft and pliable, yet held the shape he gave it. I would have thought more armatures to be necessary. But the hand stood, the fingers held, delicately and naturally relaxed. Her tresses swam into the air, above her shoulders, without drooping.

What strikes me in retrospect is how consistently Sumanta Pal shifted the form of the goddess away from the worldly. In worship his statue will stand between the seen and unseen. In form it incorporates both, exhibiting, like the art of medieval Europe, a simultaneity of attraction. Drawn to the world, it depicts a handsome woman. Drawn to the spirit, it abstracts form to perfection, fusing the sacred with the aesthetic.

One feature of this aesthetic is smoothness. The sari flows over the body, the body flows from part to part to unity. Wholeness is the outcome of smoothness. Form does not disassemble into segments; it consolidates with consistency, realizing compositional integrity.

Another feature of the aesthetic is idealization. The figure is located beyond the bonds of time and space. There is no gravity, no tug of the earth, no sign of aging, no distraction of momentary anecdote. The arms display no musculature, no strain. The skin is smooth, the body full and ripe, poised perpetually at a perfect instant of youthful health. At once light and taut, the graceful form seems suspended in the air and inflated by an inner force. In smoothness, in liquid continuity, in youthfulness, the modern image reiterates classical Hindu precepts, and it compares with the sculpture of West Africa in which, similarly, power is displayed in swelling form, fecund in stillness, ripe in youth.

Idealization is accomplished by abstraction. Seizing upon the timeless essences in worldly forms, drawing concepts from the geometric imagination, and acceding to the habits of hands trained by a daily routine of shaping symmetrical forms in repetitive sequence, the master creates an abstract figure. Through one process, abstraction yields rhythmic regularity. The rolls of flesh on the neck and the folds of the sari seek pattern, exhibiting a repetitiveness that joins smoothness in effecting wholeness. Then wholeness is challenged by hyperbole, as forms abstracted from nature are exaggerated during the quest for the ideal. The eyes are large for the head, the head and hands are large for the body. A hierarchy of importance is implied through proportional distortion and emphasis. Then exaggeration is calmed and confined by analogy with the forms discovered in nature or extracted from geometry. The head takes the impeccable shape of the egg, the face submits to pure symmetry, the breasts are regular hemispheres. Smooth, repetitive, idealized parts build through abstraction into compositional unity.

This is a goddess. Mere realism is not the goal. By idealization and abstraction, she is removed from the world to sit in perfect beauty, an incarnation of the aesthetic. Incarnating the aesthetic, the image can represent a deity. The sacred and the aesthetic, I repeat, come to oneness in the *murti*.

Influenced by the steady repetitions of common bodily experience, shaped to suit the sacred, the aesthetic of the *murti* diffuses through the range of creation to inform all the potter's works. The mother and child, the famed poet, the lion or swan or horse—all seem suspended between the real and ideal, the temporal and the timeless, the optical and the essential. All are smoother and more abstract than their earthly counterparts. Even the useful pot, the *kalshi* or *patil,* seems drawn toward aesthetic unity with the deity by hands and minds that favor the smoothly composed and geometrically idealized form.

In one-tenth of Kagajipara's pottery households there are men who specialize in making *murtis*. On most days, the *karkhana*, the workshop of Basanta Kumar Pal is busy with men throwing and paddling *kalshis*. On the eve of the *puja*, the *karkhana* is filled with large images, their eyes staring, their paint drying. One wall of the shop is open. There Sumanta Pal kneels in the sun, his hands moving quickly, patiently over the body of the goddess. A path runs behind him into a courtyard. Across it stands the kiln that marks the entrance to the village.

Next to Basanta's *karkhana*, close and parallel in position, a bamboo workshop offers one low door to the path slicing through the village toward the river. Inside, in the dark, Manindra Chandra Pal sits in a semicircle of *murtis*, ten large ones of Saraswati, four small ones of Saraswati, one of Kali. The images of Saraswati have been painted white, their crowns and jewels sprinkled with silvery glitter, and he is painting the last details. He outlines the eye in black, centers it with a black dot, then carefully adds red inside the outlining, filling the corners. With red he will run lines along the borders of her sari and coat her palms and the soles of her feet. A door in the back of the shop leads toward the house with its porch and courtyard where his wife and daughter work in the bright air.

Manindra Pal uses a *chanch*, a mold, to make the tapering, towering crown of the goddess. He uses another for her face, others for her necklace, her earrings, her bracelets, and the ornament at her waist. Unlike his neighbors, he does not shape her locks out of clay, but adds false hair, dyed black, that he buys in the market at Dhamrai. Entirely by hand, Manindra forms the swan, the *vahana* of the goddess, and the long-necked lute, the *vina* she plays in some renditions and more often holds as one of her signal attributes. Music—an aural mathematics, the beautification of the eternal sound of the beginning—belongs to the realm of learning, so Saraswati is pictured with a musical instrument, just as she will be surrounded by books during worship.

A small molded image of Saraswati costs fifty *taka*, about a dollar and a quarter. The smallest *murti* built on a wooden frame and finished with a combination of sprigging and hand modeling costs a thousand *taka*. Manindra guesses it takes him three or four days, but estimates are loose because he works on several at once, turning to a second while the first dries. Prices rise with time and size, and Manindra grades images into ten-, twelve-, fifteen-, and twenty-thousand-*taka* classes. The largest one takes him a month and a

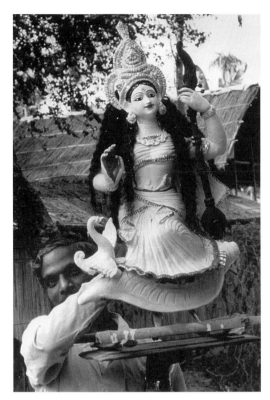

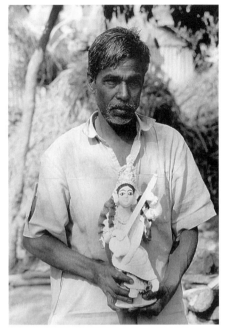

Saraswati by Manindra Pal.
Commissioned by Sribash Sarkar
for his family's altar in Dhamrai

Manindra Chandra Pal
holding a *murti* of Sawaswati he made
in the smallest hand-modeled size

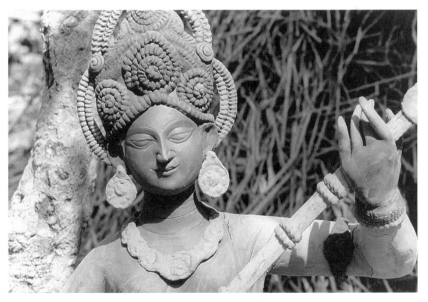

Saraswati by Manindra Pal, drying in the sun before painting. Kagajipara, 1995

half, and he has occasionally spent as many as four months to create an image of Durga, commissioned by a rich man for a temple, and received as much as sixty thousand *taka* for his effort.

He generously taught me the technology and answered economic questions, but Manindra Pal stressed the religious importance of his work, the prayer with which it began, and his sacred obligation to remain within the received confines of form and color. He concluded with the aesthetic. "The image," he said, "makes my livelihood, but it is not for my livelihood I make them. I make these images out of pleasure, out of pleasure. It is a satisfaction."

Manindra Pal works on commission, mostly making images in the smaller sizes for domestic worship. During the evening before the *puja,* men came, paid, and carried statues away, returning by rickshaw to Dhamrai. Manindra also makes large statues for temples. He has received orders from all over Bangladesh, from Sylhet, Chittagong, and Kushtia, and he often makes the *murtis* worshiped in the great temples of Dhaka city, at the Ramakrishna Mission, at Sutrapur and Dhakeswari.

Dhakeswari

In phase with the moon, at a certain time on a certain day in the Bengali month of Magh, Saraswati Puja begins at Dhakeswari Mandir. Downtown in a market district crowded with shops for rickshaw repair, a narrow street leads to the gate. Beyond the gate, a wide plaza spreads, paved and scored into squares. At the rear, four identical temples to Shiva form a line, each sheltering a Linga. To the left there is a tank, a manmade pond; to the right stands the main temple. The Brahmin, Pradip Kumar Chakrabarti, told me the temple was built about 1800, but this was a place of worship long before Dhaka, then the Mughal capital of Bengal, expanded in this direction during the seventeenth century. By a great tree, in front of Shiva's houses, between the tank and the temple, a tented pavilion has been erected for the *puja.* The masonry buildings are painted a tawny yellow with red trim. The pavilion splashes the plaza with color, pink and blue and scarlet.

At the end of the long, canopied tunnel, the statue of Saraswati is raised upon a stage. The goddess has descended, enticed into the clay by prayers and the beauty of the image prepared to receive her. She has been garlanded as a revered guest should be. Flowers and green plants surround her. Baskets and

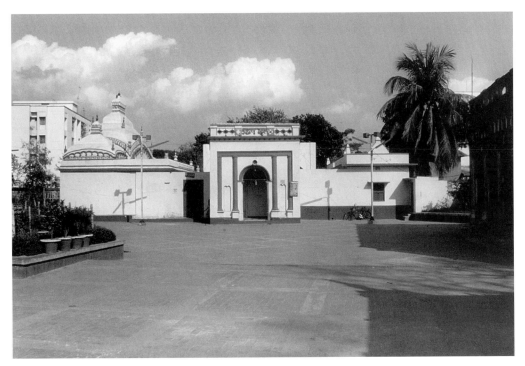

Dhakeswari Mandir. Dhaka

The pavilion for Saraswati Puja. Dhakeswari Mandir

bowls of food are spread before her. Water, the source of life, must be present, and it is—in the tank beyond and in the painted *kalshis* set below the stage.

One rail isolates an area at the front where the Brahmin and his assistants, young men in crisp white shirts and dark pressed slacks, control the flow of events. Another rail separates the women and men who press forward in a warm crush to see, to take *darshan,* connecting, eye to eye, with the deity. Saraswati sits, smiling, her whiteness sharp against the deep red backdrop, pulling people toward her. The boys crumble blossoms into a basket and pass it among us. We return the flowers to a brass tray that moves from hand to hand, returning to the front where the flowers are floated over the image. The flowers are our gift of welcome to her. Then the boys pass us green leaves, stitched with sticks into small containers, filled with fruit and sweet cakes, and we accept this gift from the goddess.

People enter in a pure state. Those defiled—by the deaths of relatives, say—do not participate. All have fasted, so the day's first sustenance is this *prasad,* food that is both sacred and delicious. Trading flowers for sweets, dining with the deity, we work to the front of the crowd. There people offer silent prayers of praise and bring worldly concerns to the attention of the goddess of wisdom and learning. Parents for their children, students for themselves, make requests for educational success. Reaching the front, each of us receives from the Brahmin a black dot on the forehead. There is an ornate dot on the forehead of the goddess, the third eye that sees within, that looks beyond, and for a moment there is a oneness among us, based on exchange and symbolized by the mark left by the pressure of the priest's finger.

At irregular intervals, the Brahmin or one of the boys with a microphone initiates a responsorial litany. In quick exchange, words of praise to the goddess are spoken and repeated. Responding as one, we consolidate; repeating his words, we follow our leader, joining him in the congregation of devotion. The sound rises, sustains itself rhythmically, then fades away.

People edge forward to pray, to give and receive, to know unity through the silent, motionless image, and then they leave, shouldering back through the crowd, for others are arriving behind them. In the front, beyond the rail, a mother stands with her child until the Brahmin breaks the pattern to sit, gently hugging the child beneath Saraswati. He writes the first letters of the Bengali alphabet on a slate. He speaks softly, explaining, and the child's first lesson has passed. The mother bows gracefully before him, sweeping the air from his feet into her face. The process of the child's formal education has begun at the feet of the goddess of wisdom.

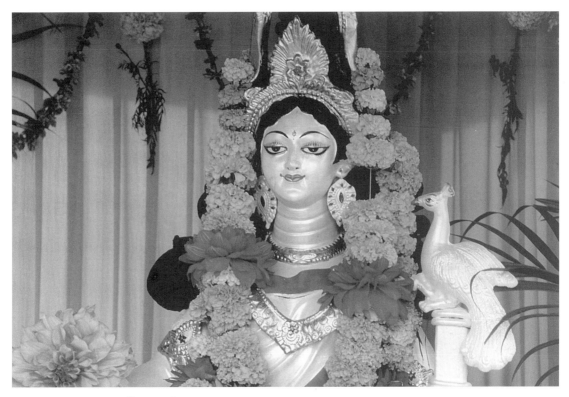

Saraswati.
Puja at Dhakeswari Mandir, 1995

Having seen the beautiful image and worshiped the goddess it contains, men and women drift into the plaza, eating the sweets they have received. A booth offers colorful posters of the deities for sale: Durga, Saraswati, Krishna, Ganesh.

Before they leave, the people drawn to the *puja* will visit the great temple. Its gateway gives into a square courtyard, enclosed by walls. In many temples the courtyard is left open to the sky. In others, and this is one, it is roofed. In shadow, young men with big cylindrical drums fill the space with pounding sound, pulsing every motion, drawing all toward a single dance. We turn left, leave the roofed courtyard, step through a flash of sun, and mount the porch that runs along the sanctuary. Three doors offer the dark interior to view. Within the central door there is an image of Durga. Both flanking doors disclose the Linga of Lord Shiva.

Men and women do not approach the image of Saraswati in the pavilion. She is removed, raised on a stage within a draped frame. Communication must cross the territory commanded by the Brahmin. People do not enter the inner rooms of the temple. They see the image beyond, but stop at the threshold. The space dividing the image from the viewer brings into experience the separation of worlds, this and the other, suffusing the visual with special power. Distance intensifies the act of seeing as the devotee strains through the eyes for contact, and it charges the icon with a demanding task: it must body forth with such presence that it can provoke an emotional response that obliterates distance. Though absent, the artist plays a central role in Hindu ritual. The artist, like the priest, mediates between the deity and the devotee. He creates an abstract and integrated form that can be apprehended from afar. The swan and musical instrument specify the deity. The large eyes in the large head, black on white, nimbed with glitter, hold the gaze. Exaggerated into clarity, bold in color, the *murti* signals over space, effecting engagement along the visual channel, closing the gap between subject and object, between the seen and unseen worlds.

People stop at the threshold, peering into the darkness. They place money into the room, bow in prayer, and caress the building upon rising. Drums throb and crack against hard surfaces. Smoke flows from the candles and incense burning at the edge of the courtyard. There we pause to pray again, planting tapers and lighting sticks of *dhup*. Making requests for the health of their families, parents stroke the smoke into the hair of their children. Trading cash for smoke, we move to the drum, we smell like incense. Spicy aromas

mingle with the sugar in the mouth, the drumming, the clang of the bell rung when people leave the temple.

It is a sunny day in a dry and pleasant season. People go and come. The drums do not stop. The sky darkens. Festoons of light swag dots of color through the night. The rails are down, space has unified. No barriers are necessary to direct the thinning crowd. Boys pass paper bags of *prasad* among us. The Brahmin loads another earthenware censer and swings it to get it burning, filling the atmosphere with scent and smoke. To the beat of the drum, his arm alone dances incense or flaming lamps before the image, delighting the goddess, preserving her interest, keeping her in place so that the people milling in the smoke and the dark can continue to offer their prayers and receive her grace.

The time is not made sacred by denial of the world or inversion of the norm, but by intensification of earthly experience. The senses are heightened; the aesthetic and sacred converge in the body as they do in the image of the goddess. The full sensorium is activated. There is sweetness for the tongue, drumming and chanting and bells for the ear. The nostrils fill with incense. The fingers know the coolness of the temple wall and the heat of the candle's flame. Smoke clouds the vision, forms blur and sharpen; the eye is pleased with saturated color, dazzled by dancing lights and flashes of glitter.

With all the senses aroused, the body awake, the mind alert, the devotee enters into a transaction, making a memorable compact between the worlds. A beautiful form, flowers, and food are offered to Saraswati. Sweets are received. The devotee shares a meal with the goddess, having made requests for health and success in intellectual pursuits. The sweets consumed are palpable signs of wishes to be granted. As in Amulya Chandra Pal's song of King Karna and the Brahmin, obligatory ritual brings people into contractual relation with divinity, momentarily visible in human form. The willing and aware host serves food to the guest, confirming faith, affirming the sacrificial cycles, entering into an alliance with power through exchange.

Central to this exchange between the people of the world and the powers that rule the world is an image that represents an exchange between the worldly and otherworldly, manifesting a synthesis of natural beauty and unnatural perfection.

The image is not the goddess. It is a materialized prayer, saying: Behold, this is how perfect thou art in our eyes. It is a graceful container, made extraordinarily beautiful so the goddess, pleased, will descend into the clay. She will

Saraswati.
Family altar. Dhakeswari

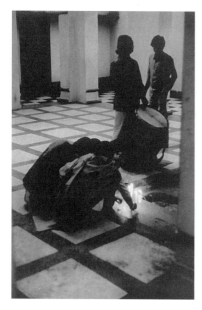

Saraswati Puja.
Dhakeswari Mandir

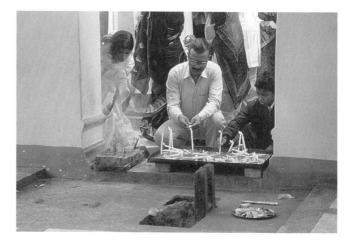

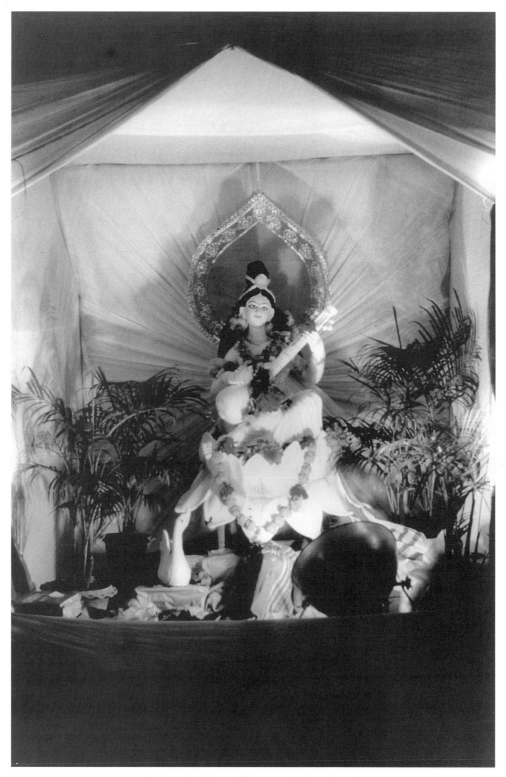

Saraswati. *Puja* at Dhakeswari Mandir, 1987

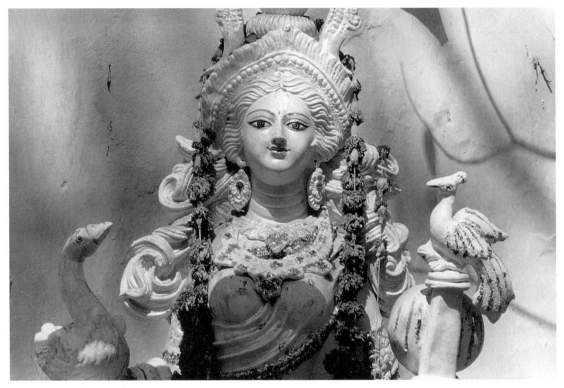

Saraswati.

The *puja* is over, and this *murti* awaits sacrifice on Shankharibazar in Old Dhaka. Like the statues of unfired clay pictured on pages 130, 131, 132, 139, 152, 157, 161, 164, 165, 186, 189, 191, 192, 194, 219, 304, and 318, this *murti* no longer exists. She has gone into the flow of the water.

remain so long as she receives praise and flowers and food and water and music and incense and dancing flames.

At home it might be a small altar, a print of Saraswati on the wall, flowers, candles, incense, and a plate of fruit on the table before her. Or the domestic display might be grand, with a tall *murti* accompanied by painted vessels and heaps of books, and the proud family will welcome others to their private shrine. From Dhakeswari Mandir, I was led at night along black paths into homes in the neighborhood to see the goddess, flooded by light, and receive the sweetmeats transferred by her human agents.

In the home or temple, one full day is customary, but the period can be extended to two days, or three, or more. So long as the goddess is entertained in the manner of a guest, provided with fresh flowers and food, she will stay. But when the entertainment ceases, she leaves. The statue remains, but it is empty, a painted shell, a pretty husk.

The goddess enters the clay as the bird enters the cage. When the cage fails and the soul has flown, the body is but a thing to bury or burn.

Knowing traditions, like that of Hispanic Catholics in New Mexico, in which the icon is sacramental, an embodiment of the holy, capable of working wonders and deserving veneration on its own, I was surprised at first by the casual treatment of old statues of Saraswati. Drawn down, held a while by the attention of her devotees, the goddess departed, leaving no tincture of power in her image. On the day after her *puja,* I found beautiful statues on the thronged, narrow streets of Old Dhaka, abandoned with stains from candles around them. I saw three on one corner, another standing forlornly in a vacant lot. In time, I saw others accumulating dust and losing luster in open sheds.

At Dhakeswari Mandir, the old *murti* of Saraswati is propped in a dark corner, out of sight, in one of the temples to Shiva. There it will wait, a thing of clay and paint and glitter, for one full year. Then before the next *puja,* when a bright new image is installed, the old one will be sacrificed, carried to the water and, to the ululation of the women, drowned. Unfired clay will decay, sifting back into the dampness and silt, melting into the running water from which it came. The circle closes, the cycle is complete, the rivers go on flowing.

Amulya Chandra Pal.
Kagajipara, 1996

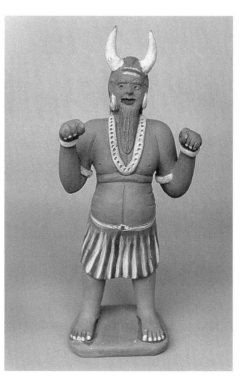

Jinn.
By Amulya Chandra Pal, 1996.
Painted earthenware; 9½ in. tall

·3·

Return to Kagajipara

ART CONNECTS TO mortal life. That was Amulya Chandra Pal's summary statement at the end of a long conversation at his workshop in 1995. He was offering a general principle of Bangladeshi art. The process of skilled creation is not divided from the quotidian flow. It belongs to the daily round of work, and even its most glorious products are meshed in commerce and destined for participatory roles in human affairs. Amulya was, as well, explaining his own life and how it had unfolded among events beyond his control, how his career has echoed history.

To introduce the art of Bangladesh through pottery, and pottery through the real village of Kagajipara, I have employed a trick conventional to anthropology, collapsing history into the synchronic. No one of my visits produced enough data; compensating for my own temporal limitations, I have combined findings gathered between 1987 and 1996 to sketch a comprehensive picture of the potter's repertory as I imagine it to have existed about 1990. Time was not avoided, but in order to describe kinds of time that history accommodates poorly, I pushed conspicuous developments to the side and concentrated on times too small or too large to fit conventional history. Conditioned by the generic constraints of narrative to emphasize change and progress, history neglects the sorts of time brought to attention by the strategy of the synchronic.

One is the intimate, human time of creation, the sequences repeated again and again as the mind and body fuse and clay is shaped into objects. Another,

providing context for the first, is the geographer's time, named the time of the long duration by Fernand Braudel. People endure, living and working in a particular environment, here one of heat and damp and clay, perpetuating practices that remain adaptive. They make jars to carry water and statues for worship in a manner thousands of years old, doing again what has been tested redundantly and proved workable, cutting long continuous tracks through time. Yet another is the helical time of the sacred. People assemble to reaffirm continuity in rituals that celebrate timelessness in cyclical performance. Now to recapture history we return to Kagajipara.

Biography is a little history, a series of happenings linked not by mere theories of functional interdependence or cause and effect, but by the steadily evolving experience of an individual. Born to be a potter like any other, maturing in his trade, Amulya Chandra Pal entered in midlife a decade of delicious creativity. When we talked during that period in 1989, he was optimistic and excited. He was making the things that others made, but making them especially well, and he was stretching for new ideas, welcoming influences from disparate sources. From an elementary school reader, he took a Hindu myth and recast it into a poem of his own. From paintings by Zainul Abedin, he lifted pictures to sculpt in clay. The capstone of that period was a strange creation.

Strange—*ajob* and *adbhut*—was Amulya's word for his work. He had fashioned a clay statue of a mermaid, its idea taken from the cover of a matchbox he saw in the Pakistan period. One day in 1994, he got a glimpse of a photograph in the newspaper. He read the article quickly. It seems a monster had been found dead on a beach, somewhere in Europe, or maybe America. It was the usual mermaid's opposite: the top of a fish coupled with the lower part of a woman. He shaped the idea into statues, one swimming, one standing, then slipped and fired them. In one long curve, the head of the fish articulates with the belly of a woman, then the hips swell and descend to shapely legs. The statue is abstract, smooth, and patterned in its detail; it is fastidiously finished, sexy, and strange.

The *matsyakanya,* the fish-woman, stands at the end of Amulya's great period of creativity, not because it marked the limit of his aspiration, but because its invention coincided with the death of his beloved wife, Parul Rani Pal, in the first month of the Bengali year, during 1994. A heavy sadness settled upon him. Order evaporated. He became edgy, ill at ease, unable to concentrate, and, since mortal life connects to art, although he continued to work, he

had lost the will to create artfully. I was visiting him with my friend Shafique Chowdhury, and Amulya told us he had begun the negotiations that would bring him a new bride. Married, settled again, he said he thought the old spark would flame anew, and he would be creating as he had in the past. That series of negotiations concluded unsuccessfully, but at the end of my trip, when I brought my wife and daughter to visit his family in Kagajipara, he bade us wait. Shachindra and Saraswati continued to work. My daughter's playmates opened their presents from America. At last the new bride emerged in a burst of color. She was young, pretty, and splendidly dressed. Floating in a scarlet sari and gleaming with gold, she bowed in respect before us. Amulya beamed.

A year later, Amulya's new wife, Bedana Rani Pal, was at work in the clay with her sister-in-law Saraswati, and Amulya had regained his old spirit. In the past, he had carved tiles in relief with depictions of the peacock boat that heroes in Bengali folktales use like magical stallions to conquer distance with ease. But now he sculpted the wondrous boat in big, three-dimensional versions. His main new inspiration had come from a series of the Arabian Nights on Indian television. Others had also responded. In Rayer Bazar, Dhaka, Chittaranjan Pal shaped a magic lantern of clay, and scenes from the show appeared on the panels of the city's rickshaws. Amulya had tried different things, including a lamp with a jinn erupting from its spout, but his signal piece, repeated in variety, was a statue of a jovial, robust jinn, horned and erect. Miraculous transport and the healthy male body: Amulya's life was back on track.

It might be convenient for the biographer if life were a stream of personal events, but life happens in a broad environment of force and counterforce. It was not only his wife's death that brought sadness to Amulya Chandra Pal in 1995, snuffing his creative urge. He was also deeply depressed, he said, by the increase in communal tension, the hostility between Hindus and Muslims exacerbated by the disaster of Babri Mosque.

In October 1990, thousands of Hindus marched on the Babri Masjid at Ayodhya in India. The mosque was built in 1528, in the days of Babur, the first Mughal emperor. Hindus claimed it occupied the spot where Rama, hero of the *Ramayana*, was born. Long in dispute between Hindus and Muslims, the mosque was closed and out of use; it was to be protected as a symbol of Indian religious tolerance. But now, rallied by the leaders of the conservative Bharatiya Janata Party and inspired by a televised serial of the *Ramayana*, people came to

tear it down. They were stopped, but in December 1992 they succeeded. In less than two days, they had leveled the mosque and erected a temple. In it stood a statue of Lord Rama, Vishnu incarnate, who endured exile in the wilderness, who killed the demon king Ravana and ruled Ayodhya in peace for eleven thousand years. Riots flashed. Other Muslim monuments, including the Taj Mahal, were threatened. Muslims in Bombay were attacked. Three thousand died in the worst sectarian violence since the partition of India in 1947.

Muslims reacted in Bangladesh. They paraded noisily through Hindu neighborhoods, and Hindus fled, seeking shelter with Muslim friends or crossing the border to India. Temples were sacked. The beautiful *murtis* of Durga and her children, created by Ramesh Chandra Pal at Dhakeswari, were smashed; the golden image of Durga was stolen from the temple. By 1995, the cycles of creation and sacrifice were rolling once more, and fine new statues of Durga, Saraswati and Lakshmi, Ganesh and Kartikeya, stood in the outdoor proscenium, awaiting immersion. Inside the temple, a print of Durga hung in the place of her statue. Outside a sign solicited donations for a new *murti*. In that year, sitting with Amulya Chandra Pal and his friends at his workshop, I listened as they said they were Bangladeshis. It made no sense for the wrongs committed by their co-religionists in another country to be visited upon them. They felt no personal danger, they said, because their relations with the Muslim farmers in adjacent villages were good, and they were sure their neighbors would defend them if trouble boiled out of the city and approached. Still, the destruction of Babri Mosque, and the harrowing events that followed, lived in their minds, causing them unease, disturbing their will to work.

I understood by analogy. When I lived in Philadelphia, I saw on one fine day a cloud of smoke billow in the west. The city's police had bombed a house. Children died, the neighborhood burned, and the city was wounded. The civic spirit, once lifted by the success of the city's athletic teams, never seemed to rise again from the ashes. The neighborhood was rebuilt, but the scar remained in the mind.

I understood by contrast. Artists in Turkey—potters, weavers, and calligraphers—told me that the military coup of 1980 brought peace and order, establishing a climate within which they could concentrate again, and from that time to this, their arts have improved in quality; their market has expanded, and they have been happily, successfully soaring to unimagined new heights.

The rare artist might benefit from turmoil, but the unmonied artists whose creations lift from common work need stability. "The world is disturbed," said Amulya, "so my art is disturbed." Though feeling personally secure, the potters of Kagajipara live in an uneasy atmosphere which they breathe into the mind where it tangles their thoughts, preoccupies and saddens them.

The source of their sadness is not to be found at contested ground in Ayodhya. Babri Mosque marked a new phase in an old story. Seeking deeper understanding, we step into the reality the Buddha described, one so complex in its fluid intermixtures of cause, so bewildering in its overlappings of temporal pattern, that connections ramify to infinity and only the predicament of the moment as understood by a flawed mortal can determine which parts of the past are pertinent. The past is too vast. Obliged to ignore most people and events, historians will select different facts and string them into different arrangements to develop different interpretations useful in the moment. Narrative order suggests we begin at the beginning and march forward, but do we begin with the first people who penetrated the lush delta, or with the Aryans driving down the Ganges, or with God's revelation to the Prophet Muhammad? As Jean-Paul Sartre taught, we must begin in the middle, in the midst of flux, at some point from which time at once retreats and proceeds.

A Little History

Unfortunately, Clive's first attempt at suicide was unsuccessful, unfortunately the *nawab* of Bengal was young, impetuous, and new to his job, and the English won at Plassey in 1757. The Mughal emperors had differed in their relations to their Hindu subjects. The English had followed the Arabs and Armenians and joined the Dutch in establishing factories for trade at Dhaka in the seventeenth century. But international commerce was an ancient feature of Bengali life, and, to begin, we can posit a delicate balance between Muslims and Hindus— established during half a millennium of Muslim dominion and two centuries of Mughal rule—that was upset by the completion of the English intrusion.

For a century, at first by force and then by Mughal indulgence, Bengal would be ruled by the East India Company. Then administration was ceded to the crown. A *nawab* remained, suffered to govern in the grip of English power. He came of a Muslim line, and it might be thought that their mutual monotheism would have inspired the British to favor their Muslim subjects. But greed and ambition called men out of England. The Hindu assumption of

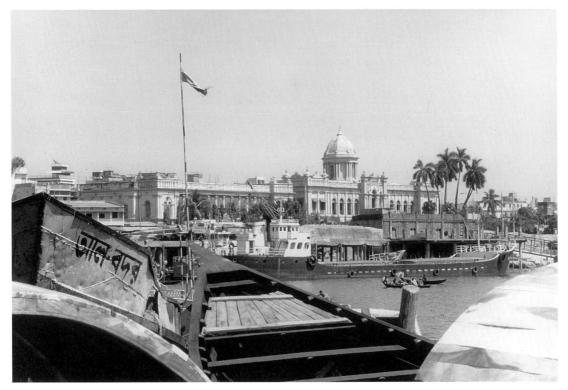

Ahsan Manzil, the palace of the *nawab,* built in 1872, rebuilt in 1888.
Wiseghat, Dhaka

caste difference proved more congenial, more useful than religion during the construction of colonial order. The aim was to sharpen division, to consolidate hierarchy, and the inbuilt democracy of Islam would have hindered the effort. After Lord Cornwallis, defeated in Virginia, attempted redemption by reordering the law of the land so that its wealth could be more efficiently extracted, the native beneficiaries were largely Hindu. Millions of Hindus remained in penury, sharing the suffering of the Muslims while the new rulers set about the destruction of the local economy, but in eastern Bengal the landlord was typically Hindu, the peasant typically Muslim. I was told how the *zamindar* called his Muslim laborers beasts and forced them to crawl in his presence. Anger rose, and, as in Ireland, clarified itself by religious labels, generating the hostile sentiments that I would call sectarian but that Bangladeshis call— the slant of the word being wholly negative in their vocabulary—communal.

In lucid moments, communal differences were overarched in rage directed against the invader. The Sepoy Mutiny of 1857, sparked by affronts to both Muslim and Hindu religiosity, erupted too early in the course of events to become a successful war of liberation. But the rebellion did provoke proclamations calling upon Hindus and Muslims to stand against English tyranny. Out of defeat, a nationalist ideology that could frame a future revolution began to rise and spread. The English response was to destabilize resistance through divisive policies. Bengal was partitioned in 1905, creating an eastern territory in which Muslims would dominate statistically. Muslims imagined options for power and wealth, but Bengali Hindus, advocates of a broad nationalism, were undermined and alienated. Then partition was lifted in 1912, alienating the Muslims. The divided were not conquered, but the Muslim League, founded with the *nawab* present in Dhaka in 1906, persisted in opposition to the nationalist movement led by Hindus, and ultimately secured the partition of India. In 1947, India was freed and the double nation of Pakistan was erected. Bengal was split again. Ten million moved, Hindus to India, Muslims to Pakistan.

Rabindranath Tagore had predicted long before that when Hindus and Muslims lost their common enemy, they would turn on each other. The British left, communal rage flamed, and a million died.

Divided by a thousand miles of India, Pakistan was vexed from the beginning. The joy of living in a new country with a Muslim majority was immediately disrupted when Mohammad Ali Jinnah, the creator of Pakistan, visited Dhaka in 1948 and told the people of East Pakistan that Urdu would be the one and only state language. Bangla was characterized as a Hindu tongue,

sullied by Sanskrit. It would yield to Urdu, a language deemed more properly Muslim. Opposition shaped quickly into the Language Movement. On February 21, 1952, the police fired upon students rallying for Bangla in the streets of Dhaka, and their martyrdom is commemorated in the annual observance of Ekushey.

As it became clear that the colonial era had not ended, that West Pakistan was draining the wealth of Bengal as England once had, the language argument of the 1950s transformed into the economic argument of the 1960s. Sheikh Mujibur Rahman, though often imprisoned, became the leader of a new and growing movement. His party, the Awami League, welcomed Hindus and rose as the force of national aspiration. In 1966, Sheikh Mujib announced a militant six-point program that would secure autonomy for East Pakistan.

Martial law followed, but repression only stiffened resistance. The Awami League won a decisive victory at the polls in 1970, gaining a mandate for autonomy. Parliamentary assembly, scheduled for the beginning of March in 1971, was postponed. The streets filled with protest. The army opened fire. Sheikh Mujibur Rahman addressed the people, describing the criminal neglect of the government and witnessing to the economic woes of East Bengal. His movement, he argued, did not run counter to Islamic precepts: there can be no conflict between Islam and a just cause. Sheikh Mujib spoke of Muslims and Hindus as brothers, he promised a generous, tolerant new state, and he called his people to resistance, to a struggle to the death for freedom.

On the night of March 25, 1971, the Pakistani army cracked down. Sheikh Mujib was taken to prison. Independence was declared. The massacre began. I was told how Pakistani soldiers made Bengali men expose their private parts so the uncircumcised could be slaughtered. But the slaughter was not fine in discrimination. Three million were murdered. Ten million fled. Freedom fighters scattered through the delta to wage guerilla war, and the Awami League formed a government in exile in India. The United States held aloof, ignoring reports of atrocity and sending arms to the agents of genocide. But India intervened, and the Pakistani army surrendered on December 16, 1971. Indira Gandhi welcomed a new nation into the world. At the beginning of the war, she had grieved for the destruction of the beautiful land; at its end, she praised the freedom fighters for their valor and dedication. They had been trained on her soil and finally supported in the field by her professional troops. Most of the citizens of Bangladesh were Muslims, but they had fought for liberation from

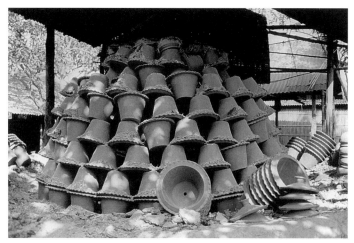

Basanta Kumar Pal's kiln

Kagajipara in the Days of the Flowerpot

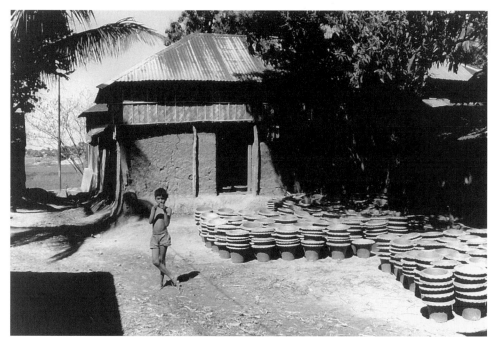

Shotesh Pal's workshop

During the final stage, Saraswati puts the pot in a dished *para,* formerly used to make *kalshis,* and drops the *bola* in to give it weight. Dampening the top, she adds a thick, wet coil, and, while turning the *para* with her left hand, she holds a damp cloth in her right to form the rim, flattening it outward, then crimping it as it turns. Here is a little instance of aesthetic convergence. Sumanta Pal gouged the folds of the sari of the goddess, then blended and softened them with wet hands. Saraswati Pal completes the flowerpot by gentling the deep dips she shaped in the rim, softening them into a sinuous series of shallow waves. The *murti* and the *fuler tab* share smoothness and regularity.

Flowerpots are made on order for Dhaka and Chittagong in five sizes ranging in price from three hundred to twenty-five hundred *taka.* The potters sell as many as they make, and if you calculate a ratio of cash return to time spent, the *fuler tab* equals the *kalshi.* The economic problem is that change has brought no improvement. The larger problem is that the potter's trade is more than a matter of economics. The flowerpot is too easy to make. Unlike the *kalshi,* it offers no test of skill, it brings no pride with completion, it leaves little room for art.

The flowerpot is not void of ornament. Its crimped rim is decorative, but forming the rim from one coil of clay is less of a challenge than using three coils to finish the neck of the *kalshi.* Making simple objects that fill minor, decorative roles in urban homes is not the same as making difficult objects that people need in their everyday work. Through one creation, potters labor as servants in a system that brings them little more than the ability to maintain their families. Through another, making things for others that they use themselves, they join in a system of interdependence, contributing to the process through which water is managed, food is prepared, life is made possible. The new work is less important, less interesting. Time did not pass joyously in the days of the *kalshi,* but time passes less pleasantly now. There is less to engage the hand, less to fill the mind. The mood is different in the village when the flowerpot is the product. The energy is low. The women seem resigned, the men distracted.

The shift from the *kalshi* to the flowerpot is more than a change. It marks a distinct stage in a historical process through which Kagajipara connects to Bangladesh and Bangladesh to the world. This process is the material dimension of a larger process named modernization, and it is called development. Marked by the transition from handwork to industry, development is characterized as progress by its beneficiaries who do not include the workers themselves.

Potteries close. It is a function of communalism to stimulate emigration. To escape the tension, Hindus remove to India, freeing new land for the Muslim majority. Four-fifths of the people of Bangladesh live by agriculture. The land is rich but burdened by overpopulation. Farm size is decreasing, and two acres under cultivation is the national average for holdings. Potteries close, and industrious Muslims, hungry for land, have bought house sites in Kagajipara. Ownership is announced by a sign. A house follows, surrounded by walls that set it apart from the architectural flow of the village.

Kagajipara remains a village of Hindu potters. But the population is declining. The product has shifted. In 1995, only two families continued to make *patils* and *kalshis*. In Bangladesh, as in places throughout the world, factories supply cheap, unbreakable vessels of plastic and aluminum in traditional forms. Industrial capitalism is too strong a competitor. Though it remains enormous and will not have ended in our lifetime in Bangladesh, the market for handmade utilitarian pottery is clearly diminishing.

Change closes some options and opens others. The expansion of nurseries in Dhaka, the increase in the number of vendors of flowers and plants, has produced a new demand. Since about 1992, most of the families in Kagajipara have gained their living by making large flowerpots. Amulya's neighbor Bholanath Pal said, "We can no longer earn rice by making *patils*. So now we make flowerpots. Selling them we somehow manage to make a living. Now in Dhaka city what they want is flowerpots."

In making a *fuler tab*—a flower's tub—the potter modifies old techniques. The same clay is processed in the same way. Pots are fired in the same manner in the same kilns. Differences appear in shaping. The bottom of a flowerpot is formed as one would begin to make the bottom of a *patil*. A short cylinder of clay is flattened into a pancake with a wooden *bola*. The sides of the flowerpot are formed in two sections in a mold. Saraswati Pal lets a large lump of clay drop onto a board, forcing it into the shallow, tapered and arched, depression excavated from the surface. She cuts through the lump with a wire, peels it back, smooths the clay with her hands, and removes the shaped slab from the mold. Sprinkling it with ash, she lays the slab atop the pile growing beside her. After dusting the interior of a mold in the form of a flowerpot, she puts the pancake in the bottom, two slabs around the sides, and with dampened hands she seals the joints, unifying the parts within the mold. She need not wait for shrinkage. The ash has prevented the clay from sticking. She turns the mold over, the pot slides out and stands to dry.

Hindus and Muslims mingle in constant, easy, cordial exchanges, founded upon shared earthly experience. Even in religion, despite theological divergence, they reach toward accord. The Hindu potter shapes an attractive image of a mosque. The Muslim poet invokes Saraswati and uses Radha's love for Krishna as a symbol of the human being's love for the one God. At the tombs of Muslim saints and the temples of Hindu gods, bards argue, drums pound, incense and candles smoke, surfaces gleam and glitter, and the devotees partake in a sweet communion. Through the Sufi tradition and the open, syncretistic nature of Hinduism, Muslims and Hindus locate a middle ground, discovering unity in the single power that brought the world of difference into being.

Experienced on the land and in mystical ecstasy, oneness is more real, more common than difference. Yet honest differences remain. The senses will not reconcile the silence and serenity of the mosque at times of *namaz* with the color and racket of the temple at times of *puja*. It is no business of mine—or of any other outsider—to say how those charged with the difficult task of governing Bangladesh should do their work. But my experience as an American leads me to believe that efforts to unify the state by establishing one language or religion are counterproductive. Law and custom govern different spheres of life. As an ethnographer, I see the unity of custom as more powerful than the disjunction of law, but as a human being, I can share in the sadness of the Hindus of Bangladesh.

For Amulya Chandra Pal, the sadness is specific and general, brought on by the death of his wife, by the destruction of Babri Mosque, and, he said, by the decline of his trade. He was optimistic in 1989, but not in 1995.

Change in the Trade

Time's track through Kagajipara runs downward now. Kagajipara was not originally a village of potters. There were six or seven families of potters in the old mix, but after a potter named Ganga Charan Pal married and settled in Kagajipara, about 1900, pottery became the specialty. Others moved in and the number of families in the trade reached its peak around 1930. In the early 1980s, there were sixty families of Pals in the village. In 1990, the number was fifty-one. In 1995, it was forty-five. As Amulya's brother Shachindra said, the young are not encouraged to follow their parents and practice a craft that is steadily proving less lucrative.

separate Bangladesh from India, and manipulating the faith of the people to enhance their own power. But Islam with its clear rules for moral conduct is a force for order. In times of confusion, deprivation, and discord, the mosque provides an oasis of calm in the storm. It is experienced as the emblem of an order that might be usefully affirmed and extended by sincere leaders.

Through constitutional reform, Islam was established as the state religion of Bangladesh. Hindus felt pressed to the edge, while politicians set a tone that divided the people, as the English once had, accelerating the return of communalism. The women contending for power—one the widow of Ziaur Rahman, the other the daughter of Sheikh Mujib, both of whom rose in opposition to General Ershad—were criticized in graffiti painted on the walls of Dhaka in 1995 for ignoring the plight of the poor and betraying the spirit of secular tolerance in which the nation was forged. Hindus say that things have been growing steadily worse for them since the assassination of Sheikh Mujib in 1975.

Into that stream of bad feeling fell the news from Babri Mosque. The sadness comes from fears for a future in which conditions might worsen, and it comes from realizing that the immediate cause for travail was a communal act perpetrated by Hindus. The politicians who led the attack on Babri Mosque exploited the faith of their followers in India as politicians have exploited the faith of the people of Bangladesh when promoting Islamization for their own ends. The secular constitution of India did not protect the rights of the minority. There seems no exit from the dead end of communalism, no release from tension.

My tale is too quickly told. Facile and lacking in nuance, it fails to meet my own standards for historical discourse. I dislike the topic and dislike generalizing at so glib a level, but it would not do for me to send you off through subtle footnotes to a scatter of publications, and you must understand the sadness. To know the art, we must know the artist's conditions, for, as Amulya Chandra Pal correctly asserted, they connect. Before I abandon the level of generalization my historical story required, let me continue, balancing the narrative of political division with sweeping, but no less valid, comments on ordinary life.

Through millennia of adaptation, during daily work, the people of Bangladesh have developed one culture of the quotidian. Hindu and Muslim villages look alike, built of clay and bamboo, lofted on manmade islands above the rice fields and flood. More unified by the land than divided by religion,

a Muslim state, and they had received crucial aid from a nation with a secular constitution that was largely populated by Hindus.

The Muslims and Hindus of Bangladesh had claimed their place on earth. They now formed the eighth most populous among the world's nations. Their leader was Bangabandhu Sheikh Mujibur Rahman, who returned to Bangladesh, through India, and established a government that offered hope to the poor through socialism and tolerance to the minorities through secularism. My Hindu friends in Dhaka call the Pakistan period bad for the nation but good for them because progressive Muslims identified with the Hindu minority in a unified cause, symbolized by the language they shared. They tell me Sheikh Mujib's period was one of great hope. The slaughter had ceased. They returned to their homes and work.

Then Sheikh Mujib was murdered with his wife and sons at his home in modish Dhanmondi, Dhaka. The house is a museum now, a monument to the slain leader whose reputation continues to grow as his image is purified toward the heroic in the popular consciousness. More than that of any other politician, before or since, his portrait appears in public. His grave has become a site of pilgrimage. The nation's first prime minister, Sheikh Mujib might have been its Washington or Atatürk. He emerged as a student leader, a champion of the language. He courageously spoke the national will. But he spent the war in prison, he could not serve in the army of liberation, nor share in its glory, and he was killed before the transition from military order to civil could be completed, as it had been in the United States or Turkey.

The period of Sheikh Mujibur Rahman, who is called Bangabandhu, friend of Bengal, as Mustafa Kemal was called Atatürk, father of the Turks, promised hope for religious toleration. A celebratory document, published in the new nation's first year, described the victory of Bangladesh as a victory for the whole Indian subcontinent: "communalism, as we have known it, is now a thing of the past." Religion has been saved from exploitation for political ends. "The Bangladesh experience has shown conclusively that the intermingling of religion and political power corrupts both religion and politics."

For a brief, bright moment communalism seemed dead, but Sheikh Mujib's time was short, cut off by military assassins, and the powerful men among the leaders who followed, General Ziaur Rahman and General H. M. Ershad, guided the law of the land through a process of increasing Islamization. Hindus say that the leaders acted out of political expediency, not piety, striving to

Development as it has unfolded, say, in English history is not inevitable, and any effort to extend the process to evolutionary law is blocked by counterexamples. In Japan, where the double economy supports small business as well as large, where prosperity is accompanied by affection for tradition, handwork is thriving. Japan alone falsifies the argument that shoddy goods and unhappy workers are the price that must be paid for material comfort. In Scandinavia, the effects of industrialization have been softened by socially responsible government and by the revival of handcraft. Through hobbies like weaving and gardening, people explore inherent creativity and accomplish a modicum of personal satisfaction.

Modern Bangladesh provides a different example. The nation cannot yet be subsumed in the process of development, naturalized as growth and pushed by Western governments to benefit big business. (Outsiders call Bangladesh underdeveloped, despite the intense development of the agricultural landscape. By Bangladeshi standards, the land of the United States is severely underdeveloped.) Colonialism dies hard, and many Bangladeshis—influenced by foreign agencies that trade cash for compliance with alien values—accept Western measures to describe their nation as lagging behind. If standards are imported from countries steadily advancing on their own trajectories, and not generated from within in accord with environmental and historical realities, then Bangladesh will never catch up; frustration will harden into depression.

Signs of change abound, but the shape of the future is known to no mortal. Today handwork remains common in Bangladesh. Much of it is attributable to limited capital and copious cheap labor. When Claude Lévi-Strauss, the greatest anthropologist of our era, visited East Bengal, he envisioned the workshops around him as parts of a vast factory without walls. Along the narrow streets of Old Dhaka, in thousands of cramped shops, young men work with their hands at simple, repetitive tasks, making components to assemble into things that would be manufactured by machines in big buildings in other places. Change in this environment would lead—inevitably, it seems—to industrialization, unemployment, and wealth for the capitalist. But that is not the whole story. Millions work in teams in small *karkhanas,* making by hand the things people need. They continue because industry is, as they say, underdeveloped, because in many realms handwork remains competitive in pricing, and because there are things machines cannot make.

No object is reducible to pure utility. There is something more in the *kalshi* than use, but the impoverished customer will rationally accept aesthetic

loss when utility is the dominant function and cash is scarce. The creator must adapt. *Kalshis* are still made, still made in their millions, but in Kagajipara the potters changed their product and entered a particular stage of development. Old people have described it to me in the United States. In Turkey I observed it in full force. In Bangladesh it has begun. As a consequence of industrial competition, the market for utilitarian objects shrinks. A distinctly middle-class market emerges. The handmade object simplifies and shifts function from the utilitarian to the ornamental.

The solution for the worker is to seize upon the new market for ornament by making things that machines cannot make. Then the effort is to create things that are complicated enough to satisfy personal needs and things in which one kind of use replaces another: the loss of utility is balanced by an expansion of meaning. With industrialization in the West, artists claimed through the quality and significance of their commodities the right to continue the anachronistic, integrated lifestyle of the artisan. In Turkey, while I watched, the descent of the utilitarian was countered by the ascent of the evocative. Artists expanded technical command, and they intensified significance through national and religious reference, making excellent objects from which they gained a reasonable living. Turkey differs from the West and resembles Japan in that works of art are developed out of a wide range of craft disciplines, and they remain accessible, both aesthetically and economically, to a large constituency. This, too, I see in Bangladesh. The handworker meets the diminishing demand for the utilitarian by making simple things like flowerpots—and by creating decorative objects that are technically accomplished and redolent with significance.

For the unusual artist like Amulya Chandra Pal the change is not great. His tradition included options for difficult, significant, decorative creations. And in the days of the *kalshi,* he had chosen to specialize in making images for which demand remains sufficient. This sadness is not his; he feels it through empathy. The problem of the shift from the utilitarian to the evocative, from the *kalshi* to the statue of a poet, is that it requires fewer workers. Most people must make simple things or forsake their trade, seeking employment in the industrial or service sectors where wages are supposed to compensate for lower intrinsic interest.

Like most of the others in Kagajipara, the family of Amulya Chandra Pal has abandoned *kalshis* and *patils* for flowerpots. Like only a few of the others, they have a metal, foot-powered wheel in the workshop. Using English words,

they call it a "wheel" or a "machine" to distinguish it from the big, hand-powered *chak*. All four of the brothers have mastered the wheel. On it they throw banks and other forms that are like flowerpots in being useful but inessential, and not part of their own lives, such as ashtrays and flower vases. With the molds Amulya created during his decade of excitement, they also make decorative objects through which representation raises national and religious meanings.

Pioneering the route to adjustment, Amulya Chandra Pal has served as a model for the brothers Santosh Chandra Pal and Govinda Chandra Pal. They mold and fire "wall plates," and they make terracotta panels on commission. One day in 1995, they led me through the shop and courtyard, into the house, and up the stairs to the attic to see a work of which they were justly proud. Ordered by a government official for a new building in the posh neighborhood of Gulshan in Dhaka, it covered the floor of the loft. Once fired, it would bring them twenty thousand *taka*.

In assembled segments, meticulously sculpted in relief, their work pictures Bangladesh. The scene does not diminish in the optical perspective of a single subjective viewer. Distance is indicated by elements at one scale piled vertically in the manner, say, of a Persian miniature. A river flows at the bottom and bends up to the right to pass a village, its houses accurately capturing the variety of contemporary Bangladesh, the usual jumble of clay, bamboo, and corrugated iron. The boats on the river reveal careful observation of traditional types of watercraft. A road angles up through a landscape spattered with episodes from common rural life: a mosque, a gathering of Bauls, fishermen, gypsies, a mother teaching her child, potters at work.

Santosh and Govinda classify themselves as Pals of the kind who make *murtis*. Santosh showed me the beautiful image that he had shaped of clay and painted white for Saraswati Puja. Their terracotta suite is a successful performance in the new context, a victory in the age of the flowerpot. It will decorate a prosperous urban home. Yet it tested their skills to the limit in its composition and execution. And it is richly evocative. As a modern instance of the ancient and peculiarly Bengali tradition of terracotta, it carries historical reference. More important is the topic. Through painstakingly sculpted and incised detail, it elaborates the idea often pictured on the baby taxis of the city. Pieces of rural life combine into a certain vision of Bangladesh. The work of village men, the panel by Santosh and Govinda avoids the urban, but it is neither sentimentalized nor sensationalized. It depicts from within the com-

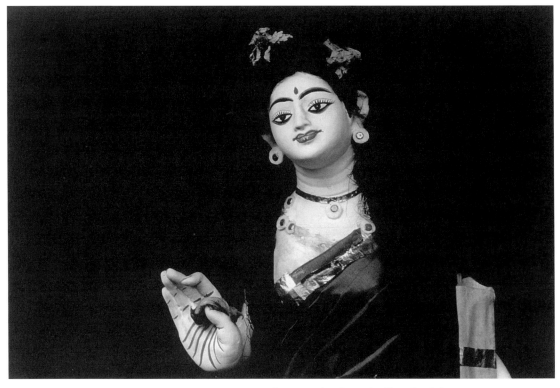

Saraswati by Santosh Chandra Pal, 1995

Santosh Chandra Pal

Details of the terracotta of rural life in Bangladesh.
By Santosh Chandra Pal and Govinda Chandra Pal.
Kagajipara, 1995. See also p. 127

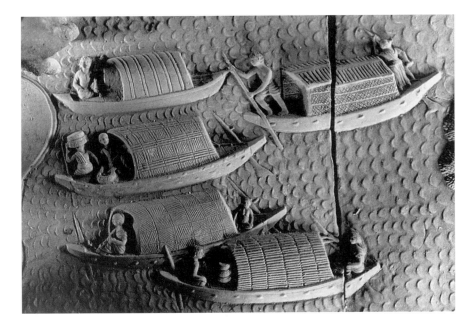

mon experience of the rural majority. Portraying the land to symbolize the nation, it exposes difference—adults and children, men and women, Hindus and Muslims, settled and itinerant life—while containing diversity within the unified setting of the riverine, agricultural landscape.

History, this chapter's theme, is the outcome of traditions in collision. Tradition is culture's inbuilt mode of construction, a process of constant adjustment during which people adapt their resources to their conditions in order to shape the future to their own vision. Rational adaptation can yield repetition, the replication of old forms that continue to work. We know from ancient terracottas that the *kalshi* of today resembles that of two thousand years ago in form and use. That is because some needs remain the same. But tradition's natural state is change. It lives only in the minds of individuals, all of them different, all of them in motion through the mutable, driving toward each other in space, perhaps, with irreconcilably different ideas of the good and the true, and with unequal access to the weaponry of conflict. History is made of continuity, and of change. New people inspire, new conditions require the process of rational adaptation, of logical ecological adjustment, to respond with new forms.

While *kalshis* are still made in Kagajipara, and continue to form the base of production in other villages, the current range of creation differs from the old. Formerly the *kalshi* stood at one end, the *murti* at the other. Now at one end, instead of tools, the potters concentrate on things that are like the clay coin banks of the past, things that can be used but exist primarily to fill decorative roles: flowerpots and vases. At the other end, the *murti* remains. The market for the *murti* has not failed, but here, too, change registers in form as potters create in accord with their understanding of circumstances.

On the eve of Saraswati Puja in 1995, Manindra Pal's workshop is filled with *murtis,* and he is filled with an argument. The image should be made, he says, as he learned to make them and then painted pure white. White is the color for Saraswati, as yellow is for Durga and Radha. Change in form and color is wrong. Plenty of his customers agree and he is busy.

The *karkhana* of Manindra's neighbor, Basanta Kumar Pal, is no less busy. Large statues of Saraswati stand through the shop. Sumanta is painting one against the bamboo wall. There is no change in the deep aesthetic. The images are smooth, patterned, idealized, and abstract, but in two ways they differ from those of the recent past and those made next door by Manindra. The body of the goddess is plumper, more like that of the star of a Bangladeshi film

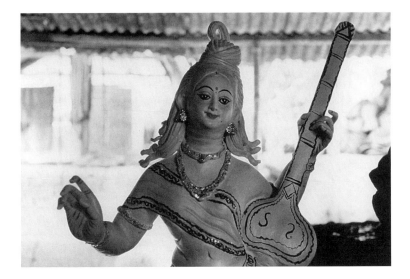

Murtis of Saraswati.
Workshop of Basanta Kumar Pal. Kagajipara, 1995

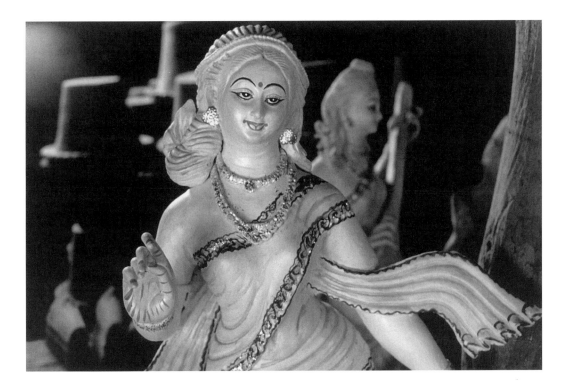

than like that of a classical goddess. More noticeable is color. Instead of blank white, the flesh is shaded and modeled to an opalescent glow in baby blue, pale yellow, or rose.

Saraswati Puja

At Dhakeswari Mandir, Saraswati is white, and she is white at the Ramakrishna Mission. Beneath Shiva, Lord of the Dance, the temple at the Ramakrishna Mission opens like a stage, deep and brightly lit. People climb the steps, remove their shoes, and pack tightly, sitting on the floor. Most are women, many with their children beside them. Boys in the front beat drums. Little cymbals glitter in the sound, as the low, steady song rolls on. All are turned toward the *murti* set at the left. A drape falls behind her. A weightless musical instrument rests in her lovely hands. She is colored in the old style: white with black hair and large black eyes above a small red smile.

The new style rules at Jagannath Hall. Veneration of the goddess of wisdom is, logically, especially intense among students. When I attended Saraswati Puja at Jagannath Hall, the dormitory for Hindu students at Dhaka University, in 1987, I found one temporary pavilion erected to shelter the image. Another *murti* stood on the large outdoor stage where men pounded at drums and people crowded to worship.

In 1995, I was amazed by the expanse of the *puja.* I counted thirteen large stages, made of colored cloth, stretched and pleated over elaborate frames. In youthful competition, as American students might decorate floats for a parade, different departments had built stages along the walkways of the campus. In each one stood a statue of Saraswati, shaped of clay and painted to meet the festive mood. Some were white, others gaudy in hue. The *murti* of the Soil Sciences Department was white like the one at the Ramakrishna Mission, but the white goddess of the Marketing Department was resplendent in a golden sari. At Economics and at English, she was vivid pink with a blue sari.

A young woman welcomes the goddess, ululating into a microphone while she drapes a floral garland over the statue at the altar of the Mathematics Department. Students assemble in chanted prayer before the image at the Sanskrit Department. At Geography, a golden Saraswati sits on a globe, instead of the more usual lotus or conch shell. Young women pass papayas and white candy as *prasad* to the visitors.

190

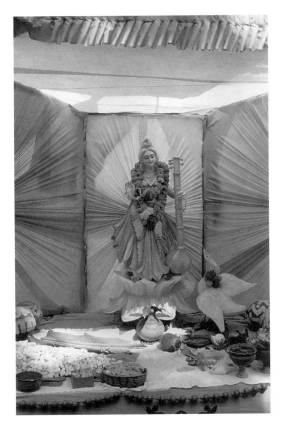

Saraswati Puja.
Jagannath Hall

Saraswati.
Economics Department

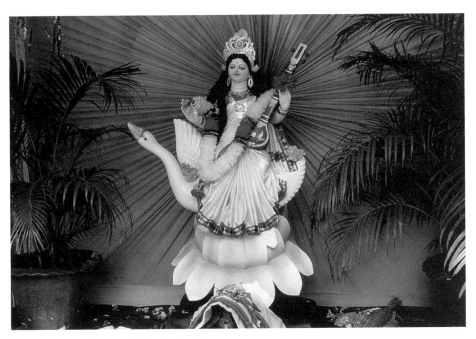

Saraswati. Marketing Department

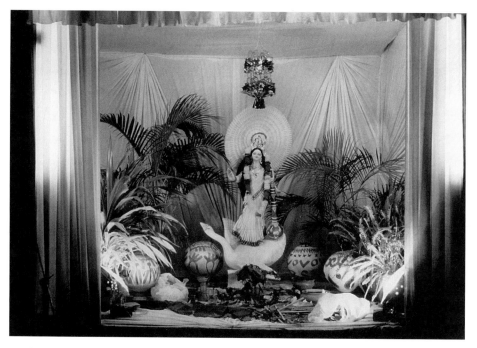

Saraswati. Management Department

Saraswati Puja at Jagannath Hall.
Dhaka University, 1995

Prayer at the Sanskrit Department

At night, the campus is a carnival. The stages are lit, the goddesses glow. Strings of lights swoop and loop, dropping necklaces of color through the dark. Strobe lights blink and flash. From a battery of speakers, loud music thumps to a rock beat and crackles into cacophony. The sparse crowd of the afternoon has become a thick throng. Neatly dressed young men and women crowd so close, pack so tight, that you have to force your way through to see the goddess, rising through the smoke and smiling with the delight of it all.

I went to Jagannath Hall with my friend Sukumar Biswas. He was as surprised as I was. There was not one demure *puja* for the University as usual, but many for the departments, and they were brilliant and noisy. He agreed when I told him I thought the sudden expansion of the *puja* signaled a surge of spirit among the youth, an assertion of pride in the midst of communal tension.

People act: change meets change; the tradition, renewed, drives forward. Through light and sound, through the proliferation of images, fear was defeated and Hindu identity was aggressively affirmed, downtown in the capital city, at Jagannath Hall. The context is significant. The campus is a center of political activity from which students have often emerged to assume roles of leadership in the larger society. Dhaka University was the first target when the Pakistani army cracked down on March 25, 1971. On a campus once red with the blood of martyred intellectuals, in a time still disturbed by the memory of Babri Mosque, the worship of the goddess of wisdom, the goddess of the students, was a victory over conditions. Extended in space and time, loud and crowded, the *puja* incarnated religious resurgence, proclaimed Hindu presence, and announced a new generation's claim to leadership. A symbol of the joyous, brave new spirit was a new image of Saraswati, superstar, colored brightly to sit among the strobe lights and smile through the racket of pop music. A Muslim friend told me he envied the fluidity of the Hindu tradition that allowed young people to adjust their ancient ritual to fit the new style of a new age.

On the next day, I chanced to visit the Akhra Mandir in the Rayer Bazar section of Dhaka city. In 1971, Rayer Bazar was a scene of slaughter. The Brahmin of the temple, Bhudhyanath Ja, said the Pakistani army did not molest him during the massacre. Now he lives in a small room beside the arcaded courtyard within the temple. He is seventy, his wife is dead, and all he has, he said, is his love for God.

For thirty years, Bhudhyanath Ja has conducted the *puja* for Saraswati at Akhra Mandir. The statue is tilted against the wall. Next year it will be carried

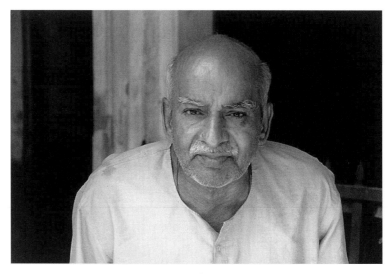

Bhudhyanath Ja

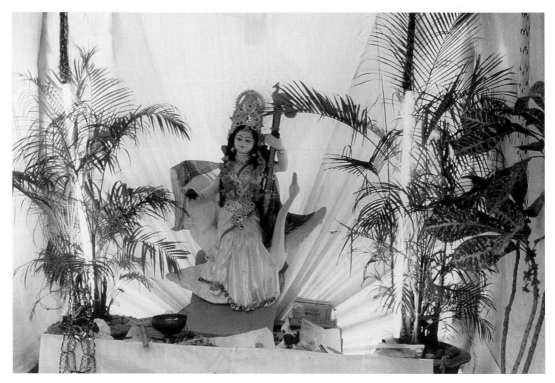

Saraswati.
Akhra Mandir. Rayer Bazar, Dhaka, 1995

to the Buriganga River and immersed. Bhudhyanath Ja was disappointed, he told me, that this year, for the first time, the young people wanted their own separate *puja.* Outside the gate of the temple, in a small pavilion of cloth and bamboo, a boy sits by the image, holding the goddess in place for one more day. Bowls of food are spread before her. His boombox fills the air with an American rap song, its lyrics in an incomprehensible foreign tongue complaining of sexual frustration.

Up the street, across from the imposing Pulpar Mosque, young men are also insistently prolonging the *puja* in the Pulpar Kali Mandir. The statue glows at the end of a tunnel of cloth. The building pulses to a disco beat.

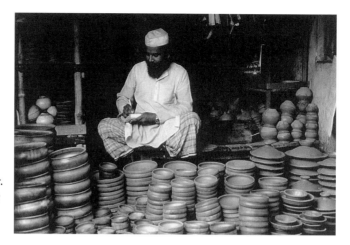

Abdul Gaffar.
Thatharibazar

Pottery for Sale.
Dhaka City

Agargaon Busti

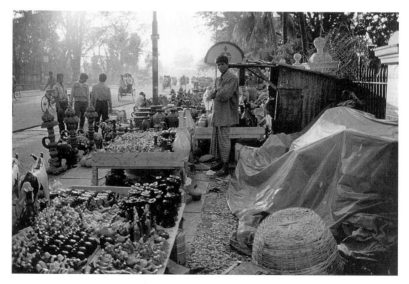

Market near the old High Court

·4·

Dhaka, Kakran, and Shimulia

WHEN BENGAL WAS partitioned in 1905, and Dhaka was briefly elevated to the status of a provincial capital within the British Raj, a new center was established, just north of the dense old city. There a palace was built for the governor. In time, it would house a college and then the high court. Called now the old High Court, the building lifts its lofty dome and spreads its symmetrical bulk in the Renaissance style that is an international sign of imperial presence. The gateway, a triumphal arch, crowds with beggars seeking alms from pilgrims visiting the High Court Mazar, the tomb of the seventeenth-century saint Khawaja Sharfuddin, where bards gather for mystical song on Thursday nights. Across the street stands Curzon Hall, its geometrical mass tricked out with Mughal detail. Designed to be the town hall and named for Lord George Curzon, the brilliant and arrogant architect of partition, it is now part of Dhaka University. The avenue separating these colonial monuments is named for colonialism's foe, Kazi Nazrul Islam, the Rebel Poet. Cars and rickshaws pull to the curb of the broad, straight street so that nicely dressed women and men can purchase pottery.

Pottery made in the villages is sold throughout Dhaka city. Utilitarian ware is sold along with food in many markets, though the main center for commerce in the useful remains the old potters' town of Rayer Bazar. Along Mirpur Road, north of New Market, where flowers and plants are sold, open stalls pile with flowerpots and ceramic ornaments. But the main market for decorative pottery is here, downtown, near the old High Court.

A dozen stalls present a single massive exhibition of pottery along the iron railing of the Shishu Academy. The market was established on the wide sidewalk, at a bus stop on the wide avenue, across from Curzon Hall, at the beginning of the 1990s. The vendors are both Hindus and Muslims. Their stalls flow together like households in a village. The center is held by Mohammad Hanif and his elder brother Jainuddin. Mohammad Hanif was born in Rajshahi; he is a successful entrepreneur and a generous, upbeat man. His English is better than my Bangla, and in answer to my question, he listed eight places from which he bought pottery. One is Rayer Bazar in Dhaka, two are specific villages like Kakran, three are country towns like Shimulia, surrounded by pottery-making villages, and two are markets like the one near Savar, where the works of Amulya Chandra Pal's family are sold. The stalls near the High Court offer a good sample of the pottery made in perhaps twenty-five villages in districts less than forty miles from the city. The bulk of production remains useful pots for sale to the rural majority. Terracottas and sacred images continue to be made on commission. But this is the ware the sellers consider appropriate for the urban middle-class customer.

When I compare the works for sale near the High Court in 1995 with the pottery I saw in Dhaka's markets before 1990, I find a first difference among the toys. There are banks shaped like fruit and painted statues galore: birds, especially the parrots that were so numerous on eighteenth-century terracottas, swans and peacocks, cows and horses, tigers and elephants, mothers with babies, brides and grooms. But—and this is a pattern I find in smaller markets in Dhaka as well—the most clearly meaningful images are nearly gone. Common only a few years before, the national poets and the Hindu deities have become rare. In the whole spread along the street, I find only one small statue of Ganesh and two images of poets, one the face of Rabindranath Tagore, the other a plaque of Nazrul Islam by Amulya Chandra Pal. The offerings in the city—though not in the country—have retreated from reference toward ornament. It is not that significance has vanished. Mohammad Hanif identified the tiger as a symbol of the nation and described the earthenware cow so as to evoke the Holy Koran in which the cow, providing milk and meat to humankind, is miracle enough to prove the existence of God. But in response to public tension and to meet middle-class materialism, meaning has left clarity for subtlety, and the painted statues stand as primarily and directly decorative.

As significance contracts, decoration expands in four ways: through color, form, scale, and style.

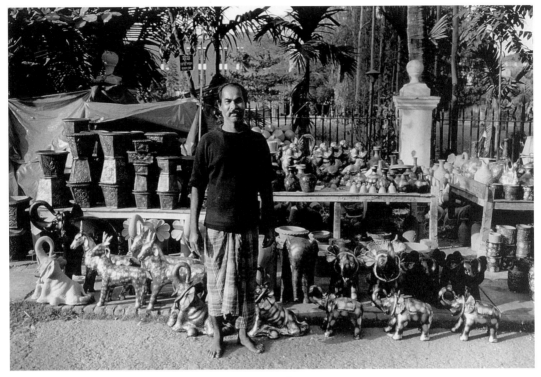

Mohammad Hanif

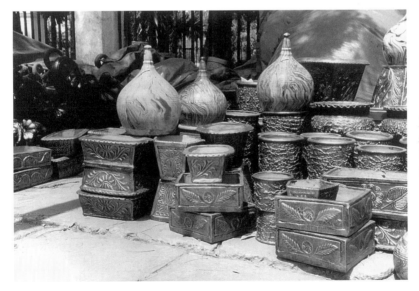

Marbled banks and
slab-built planters.
Pottery stall near
the old High Court

Parrots from Kaliakoir, tigers from Savar, brides and grooms from Rayer Bazar arrive at the market gaily painted. Other pots come buff from the kiln, but they are not sold before the young men in Mohammad Hanif's employ give them coats of shiny, bright enamel.

At the Mirpur Mazar, *kalshis* and banks are painted with geometric floral designs. Here the object is a bank or an earthenware flower vase, thrown on the wheel in an ultimately Chinese form. Working in the shade of a small shed, Mohammad Hanif's nephew Shah Jahan, named for the patron of the Taj Mahal, covers the surface of the vase in a swirling, liquid flow of mingled color resembling marbled paper. An Asian tradition refined by Ottoman masters, marbled paper was called Turkish paper when it was introduced to Europe early in the seventeenth century. Providing backgrounds and borders for the calligraphed word of God, marbled paper is sacred by association, and it is sacred implicitly. The marbling process involves a quick mode of execution in which control is relaxed and accidental effects are welcomed. The finished piece records an exchange between the mortal artist and the powers of the universe, representing handsomely the essential Muslim tenet of submission. Marbling fits Islam so well that it is applied in other media. In Turkey and in European countries influenced by the Ottoman style, in Romania and Bulgaria, pottery is decorated in a spontaneous marbling technique. The customer who buys Shah Jahan's vase may not recognize the Chinese origin of the form or the Islamic connotations of its ornament, but there is no dissonance between the object and the deep structure of belief. The ornament is abstract and nonfigurative, a play of color like a sunset or a gemstone, a wonder out of God's creation. In the vase—as in the statue of a cow that is capable of evoking the Koran or the Goddess—meaning is latent, ornament is obvious.

The form of the vase is simple and elegant. Other forms, made in quiet Hindu villages and painted by Muslim youths on the noisy street in Dhaka, are elaborated by encrusted decoration. There are fantastic, rococo "light stands," tall lamps made in Baliadi that would suit the decor of an Italian restaurant in the United States, and there are flowerpots in abundance. Called *fuler tabs* like the flowerpots made in Kagajipara, these are also planters, but they are not in the usual rimmed and tapering cylindrical form. Instead, they are shaped like tall East Asian jars, spattered with ornamental bosses, or they are rectangular and slab-built with molded detail, applied as it is to *murtis*. Made especially in the village of Kakran, north of Kagajipara, these elaborate planters are painted, like the banks, black and gold and red, or, like the light

stands, with blackened ruddy gold to simulate bronze. Ornamented and complicated, they part from work and gain an aura of luxury. Exotic in form, they seem modern. Aping finer material, they harmonize with middle-class aspirations for higher social status.

The ornamental quality of the things for sale near the old High Court becomes conspicuous in paint, formal elaboration, and size. While most of the painted images are small, in the scale fit to child's play, some of the statues, in a new departure, stand three to four feet high. They are made to grace fine homes. All are animals: elephants, deer, cows, and especially horses. Of horses there are two kinds. A few are stately and abstract like the famed votive horses of West Bengal. Most of the horses, and all of the largest ones, are agitated with dilated nostrils and tossing manes, like spirited mounts from a carousel. The smaller elephants come from Kakran and Shimulia; the largest animals are all from Shimulia. They are painted here, some like bronze, more of them naturalistically, white being the preferred color for horses.

Scale is not the end of the story. As size increases, so does realism. Earthenware horses are larger than cows, cows are larger than tigers, but the largest rendition of every animal is pressed through shape and paint toward naturalism. The smaller images display some variety in style. Carefully painted little parrots perch in leafy trees, cocks with every feather expressed stride like any rooster in a village, but most small animals are calmed and simplified by abstraction. They stand rigidly on four feet, looking straight ahead, so that they are as symmetrical as possible in profile and exactly symmetrical when viewed from the front or rear. But the big animals step and twist, shifting their heads out of the geometrical planes into lively attitudes. The vital effect of their postures is nurtured in sharp detail. They do not manifest the idea of the animal, abstracted toward the geometric in the mind, so much as the appearance of the animal moving in the world.

Country potters use heightened realism in representation, as they use ornamental elaboration, to capture the interest of their new urban customers. In the contemporary United States, as a dispersed market for decorative objects has replaced the local market for utilitarian vessels, traditional potters—that is their own name for themselves, traditional—have come to stress formerly rare figurative strains in their practice. Responding to customers who do not understand the art in the useful and who think of art as necessarily pictorial, Native American women in New Mexico have taken to making storytellers, little statues of seated adults entertaining children, and men in rural Georgia and North Carolina have come to specialize in jugs with human faces mod-

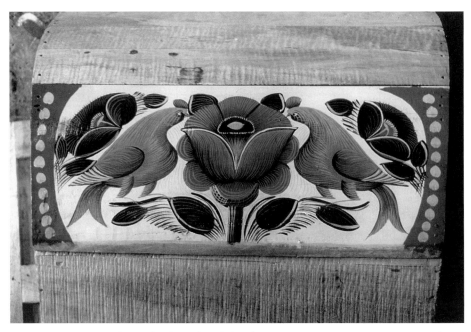

Painting on the coach of a cycle rickshaw by Anis Mistri. Rayer Bazar, 1995. On the finest rickshaws in the Dhaka style, like this one in progress, a strip of painting is added below the aluminum sheathing to appear above the tin panel.

Painting on a baby taxi. Exceptional in beauty and significance, this dove, rising before the memorial to the martyrs of the Language Movement, exemplifies the naturalism of animals depicted on the backs of Dhaka's baby taxis.

eled upon them that, once rare, now dominate their output. During the last thirty years, while the storytellers of the southwest have expanded amazingly in number and complexity, the face jugs of the southeast have left haunting, abstract form for greater and greater realism. In Bangladesh, figurative sculpture, created in the ambit of the *murti,* has always been a major part of the potter's craft, but during the 1990s, animals while increasing in size have also increased in naturalism. With their colleagues in the United States, Bangladeshi potters push the realistic in response to the middle-class market.

Rickshaw decoration offers a parallel case. To go short distances on land, you have two choices: the cycle rickshaw or the motorized baby taxi. The cycle rickshaw, pulled by a hardworking, poor man, is the people's transport. The baby taxi, speedier, more enclosed and costly, is distinctly middle class in association. Both vehicles are fabulously decorated, but their painting differs in style. When a bird or cow or lion is pictured on the seat or back panel of a cycle rickshaw, it is rendered in a quick, conventional style, echoing that of the small earthenware animal, and it is reduced to an element in a symmetrical composition, like the flower engraved on the brass vessel, or it is one in a group, part of a scene that implies a narrative, as jungle beasts battle or birds flock at the edge of a river. But the parrot, tiger, or horse on the rear of the baby taxi is positioned in a carefully finished portrait that approaches photographic realism. The rickshaw's animal is stylized and potentially symbolic. The baby taxi's animal is specific, shaded into three-dimensionality, and drawn from the world.

Worldly realism—in the image painted on the vehicle or molded in clay— is one feature of middle-class taste. When artists worked for newly rich patrons during European industrialization, their creations (those we might call Victorian now) were marked by exoticism, ornamental extravagance, and extremes of realism. Today, potters in Bangladesh please their middle-class customers with things that are decorative in function, strong in color, weak in significance, foreign in form, pretentious in substance, elaborate in ornament, large in scale, and worldly in their reference. Middle-class values, as symbolically represented by country potters, are solidly materialistic.

Prosperous customers, purchasing decorative objects to signal their estate, favor the imposing, the elaborate, and the mundane. Working potters, who need cash to live, favor the useful, the excellent, and the spiritual. Conflict and compromise necessarily follow. Study commenced in the concatenation of artifacts must continue in quest of the creators.

This is the pattern of my work. I began in the markets of Dhaka, seeing things in large numbers, gaining an impression of the variety of common modern production, and making inquiries about origins. Then I went in search of the creators. From Mohammad Hanif's stall, downtown, near the old High Court, I reversed trails of trade into the countryside, to Kakran and Shimulia.

Kakran

Eighty percent of the villages of Bangladesh are not connected to the world by roads. That is the kind of statistic used to define the undeveloped. In Bangladesh, for every thousand people there are two motor vehicles (in contrast to the seven hundred and fifty per thousand in the United States). But in Bangladesh, a tenth of the households own boats, and half of the commercial traffic moves on the inland waterways. In this land of rivers, efficient transport goes by water, not land.

You begin at Nayarhat, a low spread of dust-colored, tin-roofed buildings. At the *ghat,* you will find a long, slender wooden boat, its benches shaded by an awning, that serves as a bus on the Bangshai River. The sputtering putter of the motor is the only sound. Trees rise and retreat along the banks. Kagajipara slides by on the left. Wooden boats, low in the water, slip past, so laden with *kalshis* or *patils* that they seem floating mounds of pottery to which men cling, gliding downstream. At one *ghat, kalshis* are heaped, boats are moored, and women bathe in the brown water. At another, a herd of earthenware elephants waits by the riverside. Kakran is the third and last stop. The bank is steep, its face carved into steps. A kiln stands at the top, beneath the umbrella of trees.

Kakran, like Kagajipara, is a composition in clay and bamboo, a village of Hindu potters, all named Pal. The potters of Kakran divide the workshops of the village neatly into two kinds: those called modern have metal pedal wheels; those called old have big, hand-powered *chaks.* The type of wheel connects to a type of product. The modern *karkhana* produces flowerpots and vases; the old ones produce *patils* and *kalshis.* The master Tarani Pal says there are twenty-six workshops, six of them modern. Gaura Chandra Pal says Tarani's information is out of date, and my visit in 1995 proved him right when he said there were twelve modern and ten old-style workshops in the village. The difference in their numbers tells a simple story of decline in the number of shops and of increase in the number making flowerpots.

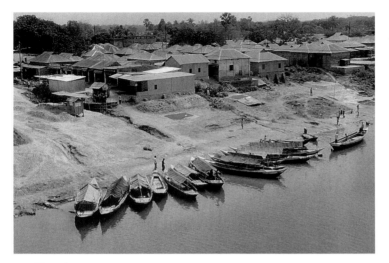

Nayarhat

Buriganga River

Shitalakshya River

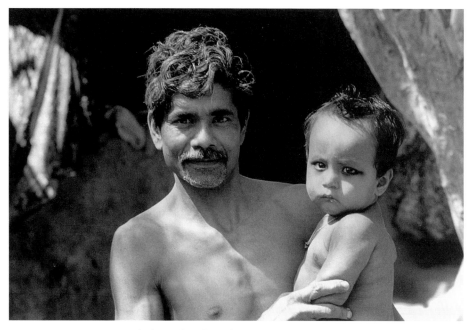

Khokan Chandra Pal with his grandson Krishna

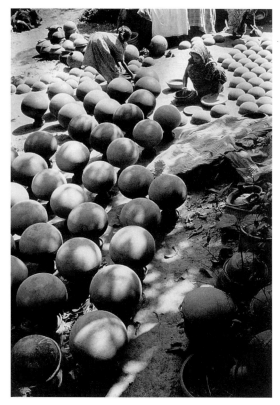

Jamuna Rani Pal
making *kalshis*

Khokan Chandra Pal, master of an old-style *karkhana,* tells me that the demand for *kalshis* remains strong and he believes it will never end. He works in Kagajipara's manner of a decade ago, mixing black and white clay into a *stup,* shaving and treading the clay to make a range of utilitarian forms: pots for washing fish, draining rice, cooking curry, and *jalkandas* on which pots of milk or curds are set to protect them from ants. Khokan throws *kalshis* in two sections on the *chak* and paddles them together. His wife, Jamuna Rani Pal, raises the *kalshi* in a series of *paras.*

The leader of the modern potters, serving in Kakran as Amulya Chandra Pal does in Kagajipara, is Nepal Chandra Pal. Often collaborating with Subash Chandra Pal in Rayer Bazar, Dhaka, he is a renowned designer of terracotta. He showed me the souvenir brochure from the inaugural ceremony of a center for family planning, funded by the German government, for which he produced the terracotta revetments. Using his modeling skills, Nepal Chandra Pal makes the molds for the ornaments of slab-built planters. He manages a large operation. Clay is processed and pots are fired in the old way, but he has five pedal wheels on which young men make ornate flowerpots and elegant vases.

Nepal Chandra Pal told me that, early in the nation's history, he heard Bangabandhu Sheikh Mujibur Rahman say that, since Bangladesh has so much clay and so many potters, options for export should be explored. Nepal has led his neighbors in Kakran into associations with export firms in Mirpur and Dhaka.

In the *karkhana* of Nitai Chandra Pal and his brother Ram Prasad Pal, there are four metal pedal wheels, three in a row and one alone in the middle of the shop. A big *stup* of blended clay stands in the corner. Pots are drying on racks in the back: thrown and slab-built planters, vases, candlesticks, sugar bowls, lamp stands, pen holders, and ashtrays, some cylindrical with sprigged floral decoration, others molded in the shape of an open hand. Down at the *ghat,* at the end of the path that runs by their door, Nitai and Ram have filled a wooden boat with ornamental earthenware bird feeders, bedded in rice straw and headed for Canada. For fragile pottery, the smooth journey by water is far better than a jolting trip in a truck on rutted roads.

The workshop of Gaura Chandra Pal stands beneath the trees near the center of the village. Like Nepal and Nitai, Gaura is expanding with demand, and he has augmented the familial workforce with hired employees. He owns four pedal wheels. Work on the foot-powered wheel is performed in his shop much as it is in Japan at one end of Asia and in Turkey at the other. Forms are

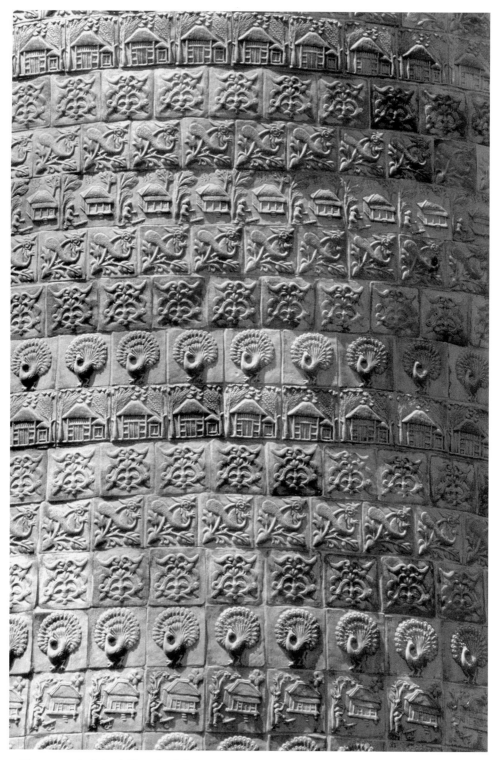

Terracottas by Nepal Chandra Pal, 1988.
National Institute of Population Research and Training Extension Building. Azimpur, Dhaka

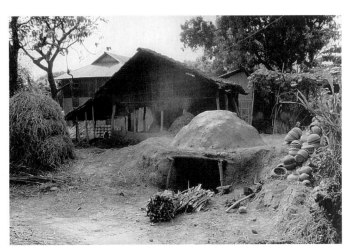

Nepal Chandra Pal's kilns

Kakran

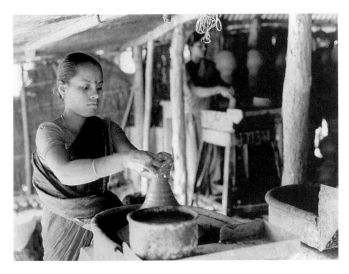

Shefali Rani Pal
and Nayan Tara Pal
at the wheel

Loading pottery for shipment
on the Bangshai River

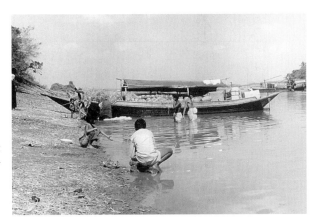

thrown off the hump, shaped at the top of a spinning mass of clay, cut free with a wire, placed in the sun to dry, and then, leatherhard, returned to the wheel for refining. For the first phase, the throwing, they use the verb *ghura;* like potters in Turkey and the rural United States, they do not "throw" pots, they "turn" them. For the second phase, when the form is shaved to exactness with chisel-like tools in the manner of a turner at the lathe, their verb is *chancha,* derived from the word for the molds used to make *murtis.*

Two of Gaura Chandra Pal's workers are young men, Ratan Chandra Pal and Shapan Chandra Pal, and two are young women. Since the *chak* was a man's tool, men work on the new pedal wheel. But arguments about bodily strength and unchaste positions do not hold for the pedal wheel, so, in a bold move late in the 1980s, Nayan Tara Pal took up throwing and became the first woman in the village, and maybe, they say, in all of Bangladesh, to work at the wheel. A year after her success, she was joined by Shefali Rani Pal. Nayan is four years older than Shefali. They are not sisters; now both in their twenties, they are colleagues and masters. Standing before the wheel, throwing form after form in high confidence, they preserve the dignified, erect posture that girls learn as babies, that is required for wearing the draped sari, that characterizes the graceful carriage of the women of Bangladesh.

Near the workshop, across the ground where pots are spread to dry, there is a large bamboo warehouse where we sit so I can learn from Gaura Chandra Pal and his neighbor Dinesh Chandra Pal. My question was about pottery, but Dinesh, not often given a chance to speak to the wide world, chose to make a formal declaration:

"We want to live in peace. We have no quarrel with anyone. But sometimes communal violence breaks out in our country, and we no longer feel safe.

"This is our country, but sometimes we feel like we have no choice but to leave it and go to India."

Then Dinesh Chandra Pal and Gaura Chandra Pal turned to my subject. They have arrangements with export firms that supply them with color photographs of objects required by their customers in Europe and America. The orders are mostly for strange flowerpots and vases. They showed me pictures of tall and squat vases in Chinese forms and said that the things they are asked to produce are neither beautiful nor interesting to create. They are simple and boring, but the potters make them to make money, and while they are filling orders, they borrow ideas that they use in making other pots that are beautiful

and that are interesting to make, which they send then to local markets, like the one near the old High Court.

Contrasting the photographs of the pots ordered with the pots in the warehouse, Gaura and Dinesh showed me that beauty and interest, for them, lie primarily in the amount of ornament and in its degree of relief. From one order, based probably on Mexican precedent, they lifted the idea of a sun, radiating wavy rays and centered upon a jovial face, but their version is more precisely modeled, and it is accompanied on the pot's surface by an orderly web of floral bosses. From another order, they got the idea of a rope modeled around the shoulder of a tall Chinese jar, but their version is rendered more complex and realistic by deep incising.

In Kakran, excellence registers in ornament. To supply the new middle-class market in the city, the potters do not emphasize reference. They exaggerate ornament, complicating technical procedures to make necessary labor more interesting. While filling orders from abroad, they gather hints that they mesh with ideas drawn from years in the trade to create commodities for the urban market that meet their needs for engaging work and adhere to their own standards for beauty. The result is some satisfaction in the process and some success in business.

Shimulia

Past the Great Mosque, the main street of Dhamrai cuts through the market, going north to Madhabbari Ghat. Across the river by a new mosque, the track begins that leads on to Shimulia. It is too rough and narrow for motor vehicles, though rickshaws bump along it unsteadily, and it is good for walking, soft beneath the feet. Built above the fields, the path carries through characteristic landscape. The green is the green of Ireland, saturated and intense, damp with fertility. The yield in rice does not match Japan's, but the look of care is the same. Every corner has been cajoled into productivity. Trim and neat, the fields expand in a lush patchwork, spreading wide to the horizon. At the edge of vision, on every side, stand the villages of the people who work this central space in teams. Their homes, hidden in clumps of trees, occupy manmade islands near the rivers that serve as their highways.

There is no shade on the track, no place to rest, but I stand to breathe in the freshness. The sun touches the green with gold. The sky is high and blue, the silence splendid. You are never alone in Bangladesh. I stop to look at the

land. A young man stops to look at me. So many young men like him have told me their country is poor and lagging behind, that, weary of negativity, I cannot resist forming emotional sentences out of my primitive Bangla. *Dekhen,* I command politely: Look at this place. It is rich and beautiful. Bangladesh is very beautiful. *Khub sundar,* I repeat. It was a little moment of madness. He did not seem to mind, and he continued to stand as I wished him God's protection and walked on. Village homes gathered near, I turned from one track to another and reached Shimulia, a market town of low, dark shops, known for its work in metal. Men there make beautiful *kalshis* in brass. Next to the town stands a tall *mandir,* its spire coated in white mosaic. In proportion, the spire recalls the middle period of Gothic ecclesiastical architecture, and from a distance Shimulia presents the odd effect of an English village set in the wrong environment, one as green as Devon but relentlessly flat and fringed with palm trees.

Three villages near Shimulia make pottery, but I wanted to find the place where they make the big horses sold near the old High Court, and I was lucky, in the way the fieldworker is always lucky, to fall in with Tamiz Uddin Ahmed, who in his work as tax collector has learned the area intimately. He leads me along another raised track through luscious, verdant fields. At the junction with the path leading to his village, Bhattacharjapara, stands the empty, improbable pile of the old high school, the consequence of a collision between reason and fancy, built by the *zamindar* Samaprasad Roy Chowdhury. A short walk further, past an ancient banyan tree, and we have come to a village of Hindu potters named Khamarpara.

It is all familiar: iron and clay buildings embracing courtyards, smoking kilns, *kalshis* stacked like cannonballs, men muscling *chaks,* women lifting useful forms out of *paras* at their feet, children running in packs, busy with play. At the far end of the village, through the trees in a separate cluster, two *baris,* one small and one large, crowd with big horses, cows, elephants, lions, tigers, and deer.

That is how it goes. In the city, earthenware horses are attributed to the national tradition, located in space no more precisely than Bangladesh. Ask the seller, and you are told the big horses come from towns, from Savar or Dhamrai. The knowledgeable man says Shimulia, beyond Savar, north of Dhamrai. Ask at Shimulia, and it turns out they come from a particular village, Khamarpara. Get there, and you find the big horses are not the product of a district, a town, or even a village, but of two shops where they are created

Khamarpara

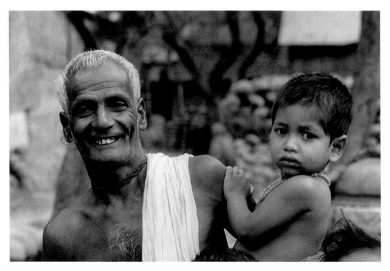

Dhirindra Pal

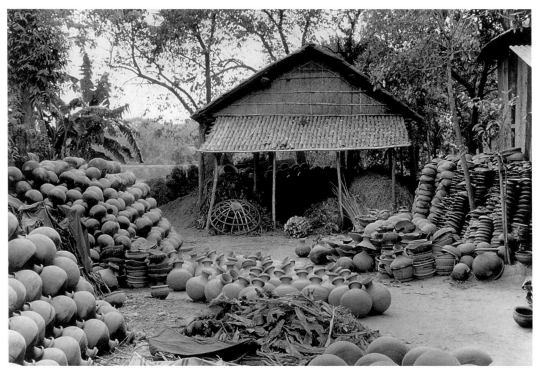

Kiln

Khamarpara

Courtyard

Maran Chandra, Babu Lal, and Narayan Chandra Pal

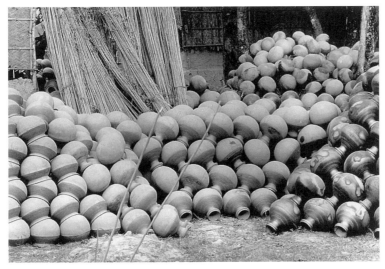

Kalshis

by individuals with names and biographies. Falan Chandra Pal and Joy Pal, brothers, work in the smaller *karkhana*. In the larger, the masters, the brothers Maran Chandra Pal, Babu Lal Pal, and Narayan Chandra Pal, are assisted by a squad of young men and women.

They make their animals with molds. For small ones, they use two clay molds, each impressed with half of the image, split transversely. The large horse takes four molds, two for the head, two for the rest of the body. Additional molds are needed for ancillary forms like the antlers of the deer. Falan spreads clay into each half of the horse's body, then into each half of the horse's head, thickening the clay at the joints. He binds the parts of the mold tightly together with twine. Drying, the form shrinks free of the mold. Unbound, released, the new animal is stable, simple, and rough. Most of the work remains. The lines of the joints must be erased, pinches of clay pressed into hollows, the form smoothed and smoothed, details added by sprigging and sharpened by engraving. Once dry, the animal will be fired and shipped to market.

The men in these workshops are Pals of the kind who make *murtis.* Narayan Chandra Pal broke from his work, incising the detail of a deer, to show me a photograph of a gigantic statue of Durga he made with his brother Babu Lal Pal. The *murti* of Durga is sacrificed, immersed in running water at the end of her *puja,* but images of Saraswati are kept for a year, so they remain to exemplify the potter's highest achievement. Babu Lal Pal led me to his family's private temple to see his most recent, and truly splendid, image of Saraswati.

Babu Lal Pal is the great artist of his village. In addition to *murtis,* he sculpts terracottas in relief with episodes from the *Mahabharata* and scenes from the common life of Bangladesh. Babu Lal was born in Khamarpara in the Bengali year of 1342—1935—and he learned from his father, Chand Mohan Pal. "We made," he said, "all the *murtis*—Durga, Kali, Lakshmi, Saraswati— all the *murtis* needed for *pujas.*" Today he receives orders from throughout northern Bangladesh, from Sylhet, Netrokona, Narsingdi, Pabna, and Manikganj, and he continues to concentrate on large images for worship. Babu Lal has three daughters and two sons, none of them following him in his trade. One of his sons, Shapan Kumar Pal, knows the craft, but he is moving on the historical arc of the artist through study at the Art College in Dhaka.

The *murti* is his work, and when we met, Babu Lal Pal was shaping the straw form for an image of Radha and Krishna. A year later, he fetched the completed piece from the house and set it in the sun so I could record it on film.

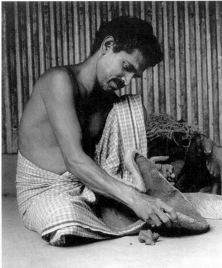

Falan Chandra Pal
pressing clay into half of the mold
for a horse's head

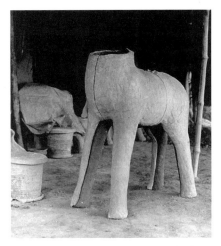

Falan's mold for the horse's body

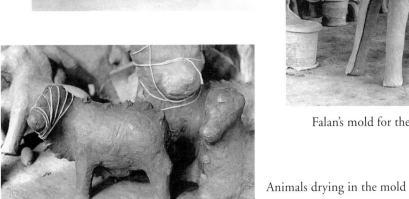

Animals drying in the mold

Cow before firing.
By Falan and Joy Pal.
Khamarpara, 1995

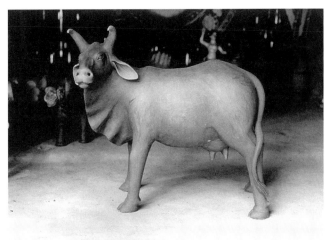

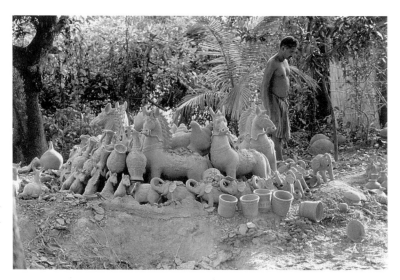

Falan Chandra Pal
opening the kiln

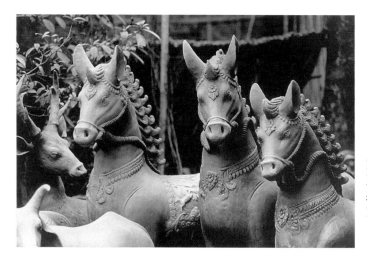

Horses in the workshop of
Maran Chandra, Babu Lal,
and Narayan Chandra Pal.
Khamarpara, 1995

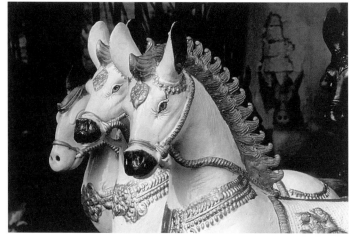

Horses painted and for sale.
Mohammad Hanif's stall
near the old High Court.
Dhaka, 1995

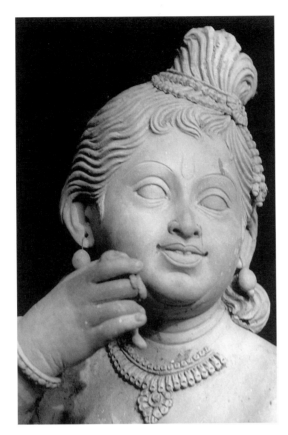

Gopal.
By Babu Lal Pal, 1996

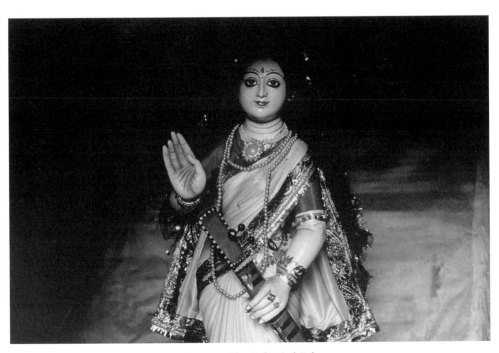

Saraswati by Babu Lal Pal, 1995

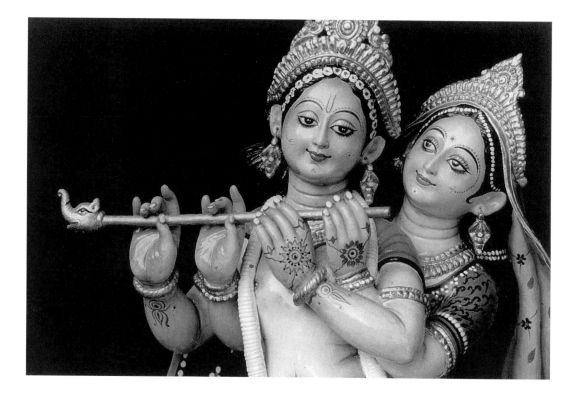

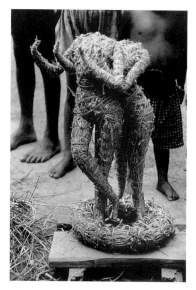

The straw form for
Radha and Krishna, 1995

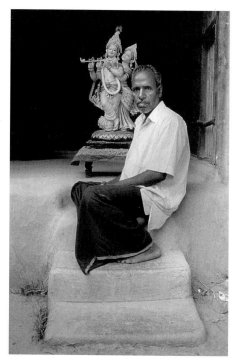

Babu Lal Pal
with his *murti* of Radha and Krishna, 1996

Radha and Krishna burst in color from their scene of gray clay and gray tin. They smile, intertwined, their hands alternating on the flute. A peacock feather tips Krishna's crown. Babu Lal modeled and painted them with extraordinary care, Krishna blue, Radha gold. While the shutter snapped, the master stood back in shy pride, smiling too. This image, created by Babu Lal Pal for his own devotion, is a modern masterpiece. Looking upon it, I thought that it alone was worth my trip halfway round the world and over the dusty roads from Dhaka. He was pleased by the appreciation I shaped into words and displayed, no doubt, more articulately in my eyes, and he brought me his work in progress, so I could see and photograph it too: a statue of Gopal, the baby Krishna, delighted in the theft of butter.

When he was a boy, Babu Lal Pal said, they made only *murtis.* But in the early 1980s, they began receiving orders from Dhaka to sculpt animals, and recently, he said, they had striven to improve them by making them larger and finer in design.

To make the rare horse of great size, topping six feet and too large for the kiln, they use exactly the techniques of the *murti,* building an underbody of rice straw upon a frame, then coating it with clay. But the big animals that go to market now are like the small ones of the past, molded and fired before painting.

The difference between the big horse and the small one, or the big horse and the big *murti,* is the shift to mimesis, signaled most clearly by a turn of the head away from the body's midline. Clay is smoothed in harmony with old ideals, but in its basic form and detail the animal has become distinctly more realistic. It is as though the momentary action normal on the terracotta relief had achieved fully round presence.

It varies with observational opportunity: the potters see cows more often, know them better, so their cows incorporate a greater naturalism than the other animals, whose forms are derived more from artistic precedent than from direct experience of nature. But not even the cow reaches the extreme that would be accomplished if exact imitation of the world were the lone goal. Exaggeration and idealization, features of the aesthetic of the *murti,* remain, and the animals look like the figures that accompany the deities in major compositions. Durga is abstract, oblivious, symmetrical in stance, but her lion and the beheaded buffalo writhe with their mouths agape, their eyes wide with fury or terror. The big horses of Khamarpara are neither real in the extreme nor abstracted to the degree of the Goddess. They match the style of the beasts

Sarada Devi.
Temple to Kali.
Dhamrai

Ramakrishna and Sarada Devi. Kali Mandir of Tallabagh. Dhaka

around her, the style that evokes the subdivine in the greatest works of the modern creators of *murtis*. In older works, this worldlier style was used to portray the mortal devotees who flanked the Goddess. The tradition of the *murti* can be inflected realistically for the earthly figure or abstractly for the deity, proving, among other things, that the abstract image of the god is not the result of an inability to master the difficult effect of realism, as might be inferred from the history of art in the West. The new statues of horses and cows are not without antecedent: they isolate the tradition's capacity for worldly reference, presenting it in works that stand free.

All the animals travel along the route to realism and arrive at commercial success. The money returning along that materialistic track enables the potters to continue their most important work, sculpting spiritual images that are useful in worship and that embody the taste and skills of the artists most richly.

Khamarpara near Shimulia is one place—merchants in the markets name Palara, Manikganj, and Baliadi, Kaliakoir, as others—in which the skills employed at times of *puja* to make *murtis* are used between times to fashion images of animals for the open market.

During the 1990s, as the middle-class market expanded in the city, rural potters adapted their tradition to shape new commodities. The potters of Kagajipara, using skills developed to make utilitarian vessels like *kalshis,* turned to the manufacture of plain flowerpots. The potters of Kakran, using those same skills but learning from foreign orders, made ever more ornate planters. The potters of Khamarpara, using skills developed to make *murtis,* increased the size of their molded animals. Muting religious significance, making their animals larger and more realistic, the potters created for themselves work worth doing and for their customers ornaments worth owning.

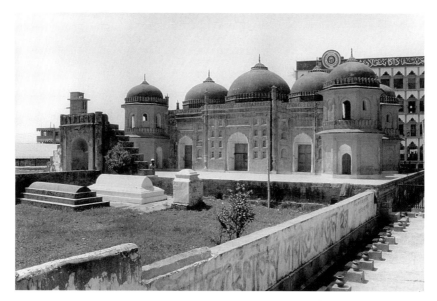

Sat Gumbaz Masjid

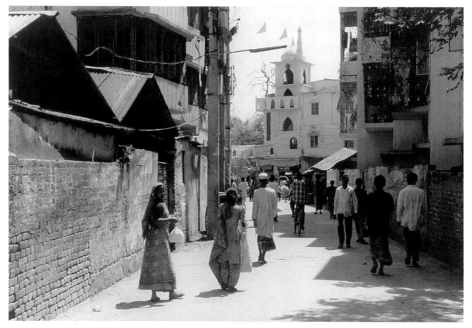

The Pulpar Mosque on Jafarabad Road at the northern end of Rayer Bazar

·5·

Rayer Bazar

MOVING SOUTHEASTWARD across the broad land, the Buriganga River bends, turning south, then east, before continuing on course for the mighty Meghna. Where the river bends, Dhaka city shifts its axis. The ancient city gripped a short stretch of the northern bank. Then when Dhaka became the Mughal capital of Bengal in 1610, and the city pressed west, it also shoved northward, following the Buriganga upstream but holding away from the swampy sinks on the floodplain. Expansion ceased when the regional capital was shifted west to Murshidabad in the early eighteenth century. Forty years later, the British won at Plassey, and soon James Rennell, a Devon man, would come to survey the rivers of Bengal. On Rennell's map, the city is today's Old Dhaka, and the low land lying along the river is empty except for the landmark of the Sat Gumbaz Masjid.

At its core, the Sat Gumbaz Masjid exemplifies the Mughal mosque: three doors pierce the clean paneled facade, three mihrabs within point to Mecca, three domes rise above. Coherence is accomplished amid this tripling by bilateral symmetry—the middle door is larger, the middle dome is taller—then it is all driven into unity by the towers that stand at each corner, bearing domes to give the *masjid* its distinctiveness and its name: the Mosque of the Seven Domes. Built late in the seventeenth century, the mosque centered the community of Jafarabad, a Mughal post on the road leading northwest, out of the city toward Dhamrai; Major Rennell calls it Dumroy.

Engulfed now by Dhaka, the Sat Gumbaz Masjid occupies a green patch in the crowded residential district of Mohammadpur. From the mosque, the main road runs south through country that was open on Rennell's map, carry-

ing a continuous stream of busy buildings down to the tanneries at Hazaribagh. Forming the western limit of Dhaka city, the road is called Jafarabad on its passage through Rayer Bazar.

"You should have seen it," Shambhunath Pal told me. Rayer Bazar stretched all the way from the Sat Gumbaz Mosque to the tanneries. It had seven hundred and fifty Hindu households. In every one, in every *ghar,* said Nibaran Chandra Pal, there was a potter, often two, sometimes as many as four. Haribhakta Pal put the population of working potters at sixteen hundred. Since then, in the last fifty years, decline has been swift.

The pattern in the recent past of Rayer Bazar resembles that of the village today, but—driven by competition for urban living room—it is even more dramatic. Losing economic viability, potteries close, plots are sold, and high-rise apartment buildings stalk among the earthen *karkhanas.* Muslims now outnumber Hindus. Potters are in the minority. When the kilns are fired and the smoke rises, irritable folks in the flats above shower stones down upon the workshops. The pots piled in the courtyards are riddled with holes. One old man, the son and grandson of potters, told me that God would avenge the evils inflicted upon Hindus during the War of Independence and the disturbances following Babri Mosque when crowds of youths stormed through Rayer Bazar. He did not imagine the clouds parting and a gigantic hand smiting the land; he saw God's will working through physical law to lift the water and drown Dhaka for its sins.

The elders of Rayer Bazar—Shambhunath Pal, Nibaran Chandra Pal, Gauranga Chandra Pal—are consistent about the number of pottery-making households in the days of their youth, at the end of the British period. Seven hundred and fifty. They are as regularly uncertain about the present, putting the number around thirty or forty when I ask, and contrasting the impoverished present with the robust past. Their eyes shine when they recall the old days, the big wheels spinning in the *karkhanas,* the kilns heaped and smoking, the thick crowds at the *pujas.* My Muslim friends fault their Hindu compatriots for living in the past, for dwelling upon decline. Surely things were better for Hindus during the British period, just as they were better for Muslims during the Mughal period; now it is time to get on with the life that lies ahead. But the Hindus of Bangladesh have seen too much. Like the Irish, they have been so abraded by the experiences of colonialism and war that their historical consciousness is vivid, oppressive, and volatile. Their present floods with the past. They inhabit a historical document.

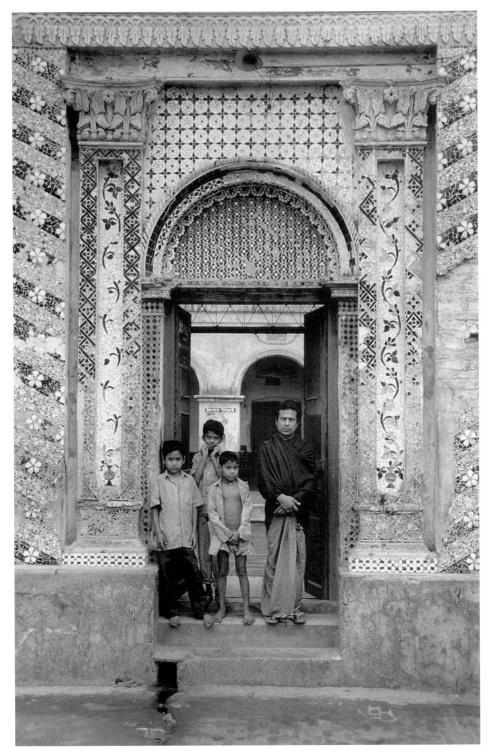

Akhra Mandir. Rayer Bazar

Mahapravur Akhra Mandir.
Rayer Bazar

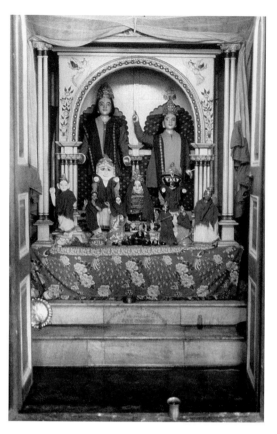

The images of the sanctuary, according to the Brahmin, Bhudhyanath Ja, are: a large Gauranga and a small Krishna on the right, a large Nitai and a small Balarama on the left, the Jagannath icons (Krishna, Subadhra, and Balarama) in the middle, and two pairs of Radha and Krishna below.

Mantu Chandra Shil in the courtyard of the temple

All around them rise monuments to defeat. At the market and along Jafarabad Road, stand temples in decay. New mosques and towers of flats lean in upon them. Their place shrinks beneath their feet. Contracting like a puddle in the sun, Rayer Bazar withdraws, retreating toward the Akhra Mandir.

This is the stronghold, the midmost point: the arcaded courtyard of the Mahapravur Akhra Mandir. Freshly dressed *murtis* cluster in the temple's womb. Eternal, placid, inviolable eyes stare out of the darkness. Krishna smiles, and a faint aroma of incense mingles with the tinkle of tiny cymbals. At the center, time obliterates history in circles and stillness. At every edge, time drifts into history bearing signs of decline.

At the western edge, north of the vast market for produce, on a narrow lane, stands the workshop of Haribhakta Pal. Built in 1942, the trim earthen house faces into the courtyard with a kiln to one side, a bamboo warehouse to the other. Haribhakta lit his last kiln in 1990. He lives now by selling pots made in the villages.

At the eastern limit, Shambhunath Pal tells me that his is one of the last old-time *karkhanas.* His house forms one side of the courtyard; his workshop forms another, sheltering a kiln like those in the country. He says he will fire it again. Dust coats the sloped surface of the kiln. Thick dust covers the leaning piles of old pots. Shambhunath asks me to take his picture with his cow. He strokes her lovingly and poses. Like Haribhakta's, Shambhunath's clay workshop, its kiln cold, huddles in a maze of back alleys. When you come from the east, on the bumpy road twisting out of Dhanmondi, your first sign of Rayer Bazar is not a *karkhana* but a store piled with earthenware for sale.

To the north, a gateway opens from Jafarabad Road into a wide space established for commerce in pottery by Bachchu Mahajan in 1962. Next in the line of Muslim entrepreneurs, his son Badruddin manages the largest wholesale operation in Rayer Bazar, buying pots locally and bringing them in from the countryside, from Savar, Faridpur, Munshiganj, and Barisal. His sheds are heaped with pots in astonishing quantity and variety: banks, flowerpots, potlids, mammoth storage jars, *kalshis,* and *patils.* Men hustle through the yard, bearing pots in headloads and packing them tight without bedding into handcarts. They smash the chipped ones while they work, for as the Holy Koran directs, the imperfect cannot be sold. The earth is paved with shards. I went there once with my old friend Muhammad Sayeedur. He had heard me give a lecture at the Bangla Academy during which I paused at a slide of a plain wooden farmhouse to say that it contained the spirit of my place. "That house is your

Rayer Bazar

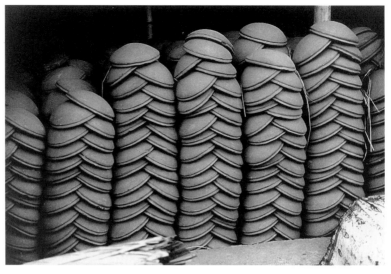

Patils for curds.
Badruddin Mahajan's warehouse

Kalshis.
Nibaran Chandra Pal's stall

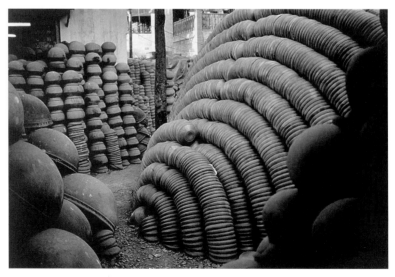

The warehouse of Krishna Ballab Pal

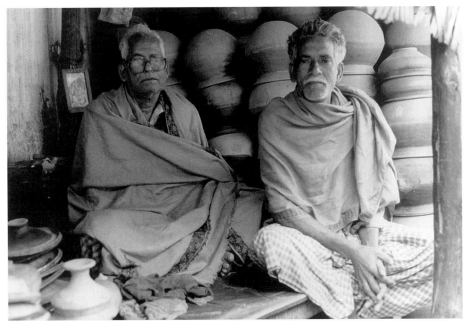

Nibaran Chandra Pal and Dhiren Chandra Pal

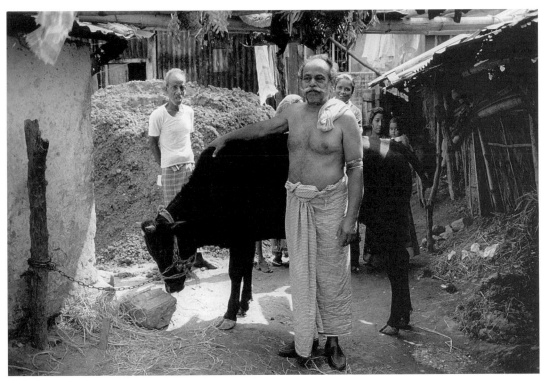

Shambhunath Pal

country; this is mine," he said, handing me a *basan,* an earthenware dish, slipped red, from which poor people eat rice.

To the south, down the road toward the tanyards, one earthen room embraces a small altar. On an early visit, I found the red curtain pulled back to reveal prints of Kali and statues of devotees in the worldlier style of the *murti.* Candles burned. The flowers were fresh. Outside, in the shade of the porch, the potter Nimai Chandra Pal had his workspace. Earthen walls and smoke, a temple and a pottery, this—the Kali Mandir of Tallabagh—was once the southern outpost of Rayer Bazar, but in 1995 the building was closed, there were no signs of life, and I walked north past carpenters and smiths, past shops in which harmoniums were made and rickshaws repaired, until I came to the stall of Nibaran Chandra Pal and his eldest son, Dhiren Chandra Pal. Nibaran was a potter in the Pakistan period, but with the creation of Bangladesh he became a merchant, selling what he once had made. He listed fifteen places in the countryside from which he buys, including Kagajipara, Kakran, and Shimulia. In 1988, Nibaran's stand featured molded statues of Rabindranath Tagore and Kazi Nazrul Islam, of Ganesh and Radha-Krishna, all made in Srinagar, Bikrampur. The stock in 1995 was entirely utilitarian. His market is made of the urban poor, immigrants from the country who comprise the city's majority and need traditional pots to prepare traditional dishes. Though the yard in the back was piled with working ware, Nibaran said his trade was dwindling. Pottery breaks easily, unlike plastic, and making pottery, he said, is exactly like my research. It takes time and care, and there is no way for the potter to speed his work in competition with the factory.

If this city within a city, the old potters' town of Rayer Bazar, once stretched all the way from the Sat Gumbaz Masjid to the Hazaribagh tanneries, it is contained now between the Pulpar Mosque and the cinema hall on Jafarabad Road. While the energies of the place were formerly given to manufacture, they are bent now to business. North, south, and east, at every point where Rayer Bazar touches the larger city, contact is made through merchants, not potters. Rayer Bazar is rimmed by commerce, and in its interior sales dominate. By my count in 1995, there are seventeen stores selling pots and fifteen shops making them, but those numbers are deceiving: only five of the workshops are substantial and active.

Like the shift from *kalshis* to flowerpots in the village, the shift in the city from manufacture to sales deposits a landmark on the road to development. In the past, creation and commerce mixed. Village potters made the pots they

used themselves; they made what they wanted, and their customers were those who wanted what they made. Creator and consumer, form and use merged. The urban population is diverse, the market complex, but direct interaction was possible when the potter was also the seller. As sales and production separate, the relationship between the customers with their needs and the artisans with their skills attenuates. It becomes harder for the artisan to adapt adroitly to changes in the market. He loses one of the things that enabled him to compete with the factory, his intimate knowledge of his clients. And that is but one dimension of the change that hastens the decline of handwork. As the artisan becomes a merchant, like Haribhakta Pal or Nibaran Chandra Pal, he reaches wide to find cheap merchandise. Bringing goods in from the countryside, he falls into competition with the local producer. The city potter must buy clay from the country and pay his employees urban wages. Competing with the rural potter, through the local merchant, he must step ahead, making things country potters cannot make, or fall back, struggling with *kalshis* and *patils* that can be produced less expensively in the familial shops of the villages. Then he gives up and becomes a merchant whose reasonable effort to adjust to shifting economic conditions serves to undermine the effort of his neighbors, driving them out of creation into commerce, accelerating the downward spiral.

The process is general; I find it in Turkey too. In the great city of Istanbul, downtown in Beyazit, the coppersmiths' market once combined creation and commerce. Sited efficiently for trade, the old ateliers became new stores. The masters became merchants, bringing handmade copper vessels from suburban workshops into the city and buying them from distant markets in Ordu and Trabzon, striving to keep prices down while big factories stamped out useful forms in aluminum. The next step, of course, was to sell aluminum, contributing to the destruction of the old craft. Fine copper has become marginal in the coppersmiths' market in Istanbul. In Old Dhaka, in the coppersmiths' market of Becharam Deuri, the sound of hammering has not died away, but the shops have filled with shiny aluminum.

They are not selling plastic yet in Rayer Bazar, but seeing how the blushing gold of hammered copper can be replaced by heartless aluminum, it is not hard to imagine stalls stacked with *kalshis* and flowerpots in the bland machined shapes and horrid colors of plastic.

Though the elderly potters of Rayer Bazar know the number of shops in the past, none can state exactly how many there are now. Change in the present

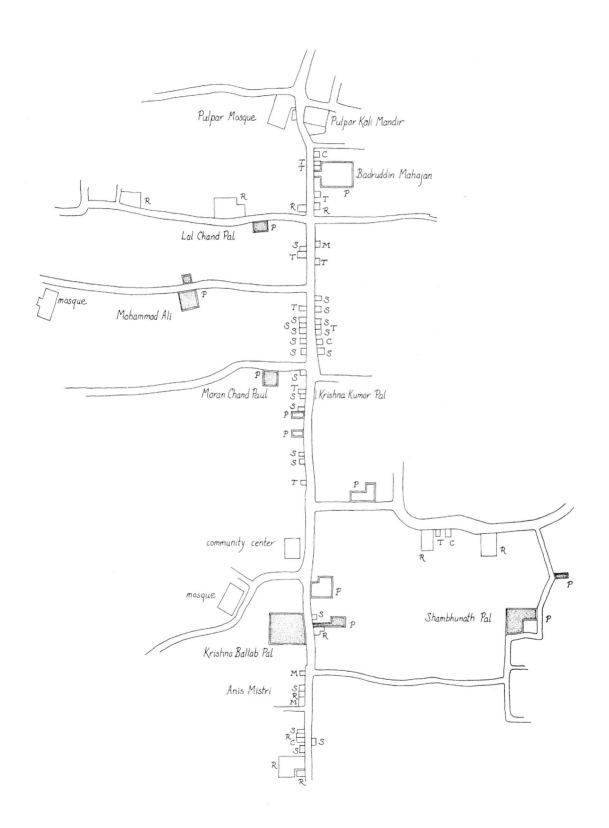

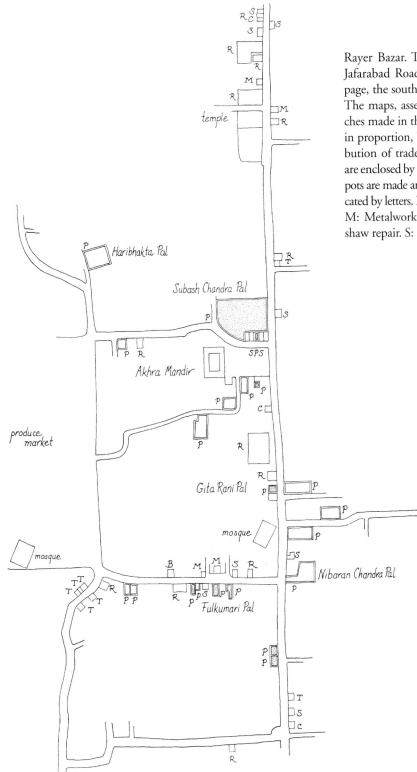

Rayer Bazar. The northern section of Jafarabad Road appears on the facing page, the southern section on this page. The maps, assembled from many sketches made in the streets, are not reliable in proportion, but they show the distribution of trades in 1995. Pottery shops are enclosed by double lines; shops where pots are made are stippled. Trades are indicated by letters. B: Baskets. C: Carpenters. M: Metalworkers. P: Pottery. R: Rickshaw repair. S: Silversmiths. T: Tailors.

temple

Haribhakta Pal

Subash Chandra Pal

SPS

Akhra Mandir

produce market

Gita Rani Pal

mosque

mosque

Nibaran Chandra Pal

Fulkumari Pal

is too quick. The shift from making to selling can happen subtly, and the making remains diverse.

Fulkumari Pal and Gita Rani Pal

At the northern entry to Rayer Bazar, the Pulpar Mosque stands to one side, the Pulpar Kali Mandir stands to the other, and Jafarabad Road cuts between, heading south on a tolerably straight line, running past Badruddin Mahajan's warehouse, past the low shops of silversmiths and the modern town hall, past the workshop and warehouse of Krishna Ballab Pal, past the shop of Subash Chandra Pal and the Akhra Mandir, past the stall of Nibaran Chandra Pal, down to the cinema hall and on toward the tanneries.

From the first intersection north of the cinema hall, Sultanganj Road strikes west to the big produce market, offering a sample of Rayer Bazar's variety. Interspersed in the string of buildings, there are three blacksmiths and two of the many silversmiths who work in Rayer Bazar, fashioning the delicate, elegant jewelry sold downtown in Dhaka. To the west of the market with its bounty of fruit and vegetables, the Buriganga River flows south. The eastern side of the market is lined with shops for tailors, and five more bunch at the entrance to the market on Sultanganj Road, where firewood is stacked and rickshaws are repaired in two sheds. Back along Sultanganj, stand two more shops for rickshaw repair, one for selling baskets, and three crammed with earthenware for sale. And there are three small shops in which potters make the big clay ovens called *tanduris.*

One of them is the narrow *karkhana* of Nanda Kumar Pal and his wife, Fulkumari. Red clay, *lal mati,* is dug out near Mirpur or Savar and brought to them in handcarts. They pay eighty or ninety *taka* for a load of clay from which eight *tanduris* can be made and sold, depending upon size, for ninety to one hundred and fifty *taka* apiece. Nanda prepares the clay, cutting and treading it smooth. Fulkumari makes the ovens.

Fulkumari Pal is the mother of four daughters and one son, and she is a strong, spirited, thoroughly delightful person. She was born in the village of Katlapur, Savar, and both of her parents were potters. Her father, Minonath Pal, worked at the *chak;* her mother, Raj Lakhi Pal, made *patils* by hand. Fulkumari learned to make *tanduris* from her husband and his father.

Working in the back of her deep, cramped space, Fulkumari Pal rolls coils and circles them into a tall, tapering cylinder. She reaches in with a *bola,* smooth-

Nanda Kumar Pal

Fulkumari Pal

Gita Rani Pal

Tanduri drying.
Jafarabad Road

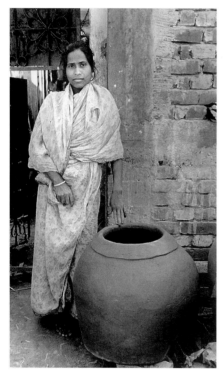

Sabita Rani Pal

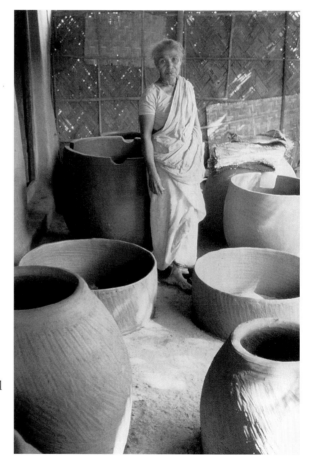

Durga Rani Pal

ing the interior and pushing it out to create the bowed, swollen form of a dome. Her work is like that of the man stretching his thrown and joined *kalshi* toward its final globular shape. She paddles over the exterior with a wooden *pitna* to strengthen it, and then smooths the surface with a stone before leaving the *tanduri* in the sun to dry. It will receive its only firing when it is used.

Around the corner, in one room of a small earthen building on Jafarabad Road, Gita Rani Pal does the same work, coiling and paddling *tanduris* of red clay. Her narrow space crowds with big ovens drying. Children's drawings of the Hindu gods hang on the walls.

Gita Rani Pal's husband was killed by the Pakistani army during the War of Independence, and the mother of two sons and two daughters, she struggles on alone. Gita Rani makes *tanduris* as her father did, and she squats in the back door of her shop, making the simplest of potters' products. She uses a *bola* to pound cylinders of black clay into flat circles. Dusting them with ash, she piles them up, slices around a square metal template, then spreads the squares on the tin roof of a shed behind her to cook in the sun. To these black clay squares, people will paste vibrant prints of the deities to hang in their homes.

Here is one reason why the men cannot place a number on Rayer Bazar's workshops. In most of them—in eight out of fifteen—the masters are women. Their work requires strength and dexterity but only the minimum of capital and technology. They need no permanent building to provide wide scope for complicated procedures. Their clay must be processed, but it is unmixed, either red or black. All their tools—a *bola*, a *pitna*, a *pathar*—can be held in one hand. Like Native American women, they coil pots then polish them with stones. They use no molds or wheels, and most important, their works are not fired. They need no kiln. Some women, like Fulkumari Pal and Gita Rani Pal, are professionals with little *karkhanas,* but others work intermittently, collecting the few tools necessary and working on the porches of their homes to supplement their husbands' wages. Their number is forever in flux, but during the 1990s many were drawn to the ancient craft and held at work because *tanduri* cooking became popular in gracious homes, in restaurants and hotels. Throughout Rayer Bazar, in doorways, in the courtyards beside dwellings and empty old workshops, domical ovens stand, baking in hot patches of sun.

Krishna Ballab Pal

The old masters, Shambhunath Pal, Haribhakta Pal, and Nibaran Chandra Pal, may be unsure about numbers, hazy around the edges, but they are certain at the center. They classify workshops into old and new on the basis of technology. The old have hand-powered *chaks* and wood-fired kilns. The new have metal, foot-powered wheels and gas-fired kilns. All name Subash Chandra Pal, Maran Chand Paul, and Mohammad Ali as the modern masters, and all agree that there is only one real old-time *karkhana* still in operation, that of Krishna Ballab Pal.

Directly off Jafarabad Road, the front door opens into a passage leading through the shop to a narrow courtyard in the rear, with Krishna Ballab Pal's house to the right, an open shed to the left, and a big building for greenware in the back. The earthen walls are not stout enough to bear the timbers that span the shop. An aisled frame, its outer posts buried in the walls, its main posts reinforced with stalks of bamboo, carries the roof across the wide kiln. The kiln, the *puin,* is like those in Kagajipara. Its wide firing chamber of clay fills the shop to the left of the passage. To the right of the door, a low shuttered window can be opened to bring a little light to the *chak* in the front. The big *stup,* constructed of clay excavated near Savar, stands in shadow near the back wall. From the *stup* to the *chak,* the space is Gauranga's.

Gauranga Chandra Pal began in the potteries when he was fifteen or sixteen. He has been at it for forty-five years. Gauranga's work goes as it does in Kagajipara, though there are small differences. The *stup* is a blend of black and red clay, rather than black and white. Gauranga uses an iron *lek,* a tool in the drawshave family smithed to the purpose, instead of a disposable scrap of broken pot, to shave leaves from the *stup.* Patting the shavings into a wide circular mass, he bisects and rolls it, treading the clay down, then driving it out with his heel through three repetitions. At last the clay is soft. Gauranga cuts his circle into thirds and rolls three compact cylinders. He breaks one of them into four pieces. Lifting one piece, he turns it in his hands, tearing off bits and slapping them back, adding the second, then the third, turning, tearing, and slapping until he has built a neat, cylindrical loaf called a *boula.*

Gauranga presses a pat of clay, the fourth bit ripped from the cylinder, onto the center of his wide *chak,* laying the adhesive foundation for the towering *boula* he slams on now. Raising the wheel, he gets it moving, counterclockwise. Like the newer *chaks* in Kagajipara, Gauranga's is spoked, and it is wob-

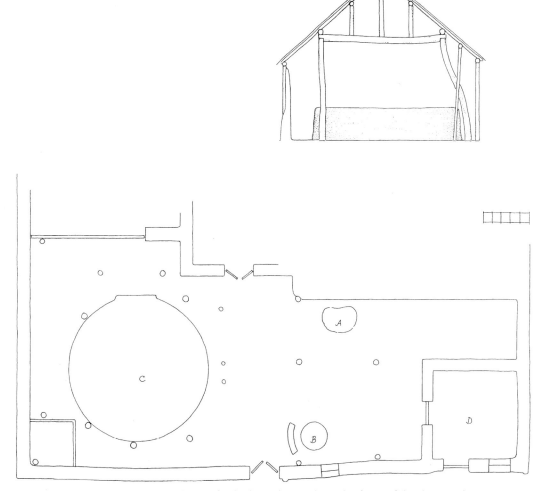

Krishna Ballab Pal's workshop. Jafarabad Road runs along the front of the shop, at the bottom of the plan. A shed and a dwelling extend from the rear. Above is a section through the shop, revealing one bent in the aisled frame; the view is from the middle of the shop, looking toward the kiln. A: *Stup*. B: *Chak*. C: Kiln. D: Separate shop, unoccupied when the plan was drawn in 1995, but later used by a silversmith. The scale is in feet.

Krishna Ballab Pal's.
Rayer Bazar

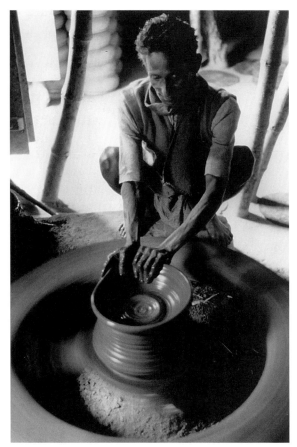

Gauranga Chandra Pal
throwing rims for *patils*

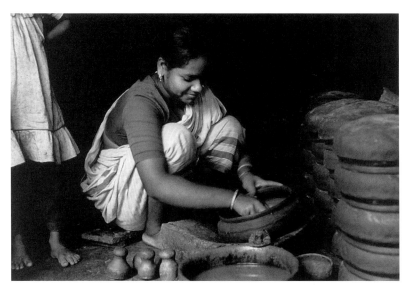

Raswesari Pal bottoming a *patil*

bling slowly around. He inserts a stick, a bamboo *lathi,* and drives it hard, whipping the wheel around and around into a whirring blur. He leans far over, spreading the *boula* and shaping its top into a *kanda,* the rim for a *patil.* From every *boula,* he will get thirty-five to forty rims.

Sun runs in the door behind him, fluttering and flashing with the traffic in the street. The window is closed against the dust and heat. The *boula* spins. In it Gauranga arranges his hands through a graceful series of habitual positions. With choreographic precision, he blends shaping with the fingers and shaving with tools into a single smooth procedure.

Gauranga Chandra Pal pulls the clay up and presses it out, hollowing the top of the *boula.* Motion is ceaseless: he sweeps a sliver of bamboo, the *bansher agli,* into action, using it to turn the lip and slick the side. A second bamboo tool, the pointed *bansher chota,* emerges in the spin to smooth the inside of the rim and cut it free. Now quick, Gauranga springs from his low clay bench; without straightening his back, he runs to place the new *kanda* in the walkway along the kiln, pausing to nudge the ring gently into circularity, then he scuttles back to the *chak.* It has slowed. He gives it a push, leans out, presses in, pulls up, shapes and cuts another, then runs again. About every fourth rim, and more often the lower he goes, he needs to insert the stick and get that wheel whirling.

In a couple of days, the rims will have dried enough to move. At work in the shed by the courtyard, women using *bolas* have squashed little cylinders into pancakes. They had been spread to dry across the shop's floor before the rims, then gathered and stacked. It is now the women's job to join the parts into *patils.* Raswesari Pal lifts a flattened circle of clay and presses it down, pounding it into a dished *para* to create the rounded bottom, the *tala.* Then she dampens the edge and fuses it with the *kanda* thrown by Gauranga. Slowly *patils* fill every corner of the shop, waiting to be piled on the big kiln and burned.

Circles intersect in the form; the ring of the rim rides on the hemisphere of the bottom. The *patil* is the conjunct issue of men's work on the *chak* and women's work with *bolas* and *paras.*

The potter in the uplands of the southern United States centers a lump of mud on the wheelhead and raises the form in one act. At work with refined clay, the Japanese or Turkish potter throws the form, lets it dry, then returns it to the wheel for shaving to precision. In Bangladesh, the work is comparably conducted in two stages in the modern shops, but the old practice, exempli-

Gauranga Chandra Pal. Rayer Bazar, Dhaka

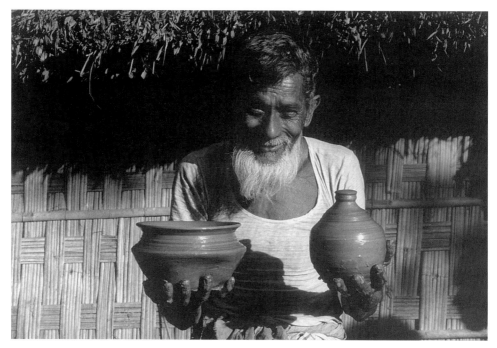

Mohammad Nur Hossain. Charia, Chittagong

fied in the *patil,* divides the process differently. Using dissimilar techniques simultaneously, potters shape components that will be consolidated in the final form. I recall my surprise on an early visit to Bangladesh, when I visited a village in the Chittagong district. Charia resembled other villages, though it was unusual in that its potters were Muslims rather than Hindus. I watched a nimble old gentleman, Mohammad Nur Hossain, spin the big *chak.* It did not surprise me when he cut forms from the tip of a tower of glistening clay. What surprised me was that, unlike potters in Japan or Turkey, he did not cut them below the foot, but straight through the lower body. They came from the wheel without bottoms. Then the bottoms were added by another worker, a woman who paddled the pots into completion.

The *patil* is special. In one form, it combines the main techniques of Bangladesh, throwing and molding. In one form, it weds the male and female. And the *patil* is commonplace, so familiar that it can stand in metonymy for all ceramic vessels. Hawkers bearing headloads in the streets of Rayer Bazar cry out, *Hari-patil,* linking nouns to create an abstract category, saying "bowl-pot" to mean all utilitarian ware, as others in Bangladesh say *dal-bhat,* lentils-rice, to name normal food or *ghar-bari,* room-house, to mean domestic architecture. Always round on the bottom, like the *kalshis* thrown by men or raised by women from *paras, patils* differ delicately in form by use. There are *patils* for rice and curry. *Patils* are so conventionally the containers for sweet, delicious curds that they have a secure place in the daily lives of people of all classes. Through the countryside, *patils* vary formally in accord with the size of the local fish. *Patils* are useful, and Krishna Ballab Pal's workshop is full of them. So is his big warehouse across Jafarabad Road where his own products commingle with the pots he buys from the country. Krishna Ballab is between a merchant and the manager of a pottery. He is his own competitor. Business, he says, is bad.

On some days, Krishna Ballab Pal's *karkhana* bustles. On other days, nothing happens. His workers are not young, and like all workers in Bangladesh they are always a touch ill, sometimes too ill to come to work. People die, and ritual requires a suspension of labor. The body is naturally weak, but this is more than a matter of occasional disruption: his workshop, the last of hundreds like it in Rayer Bazar, feels like it is sliding, slowly, unsteadily, but ineluctably toward a quiet end. Krishna Ballab is one of those Hindus described as having one foot in India. The master has four sons and two daughters, all of them educated, none with any interest in pottery. Once when I was there,

Subash Chandra Pal

when Harinath Pal, rather than Gauranga Chandra Pal, was bent over the *chak* and the shop was rattling with action, one of Krishna Ballab's sons, heading to the house in the rear, stopped and turned to me. I was fascinated as usual, a bag of expensive photographic machinery on my shoulder. Locking my eyes in his, he said, in Bangla: To hell with this work.

Subash Chandra Pal

At the center, the Akhra Mandir stands back from Jafarabad Road. A shed to the south houses the rolling *ratha,* the temple's chariot, spiring and crocketed with arched niches for *murtis.* To the north, across a narrow lane, spreads the big workshop of Subash Chandra Pal. When I visited first, the work was done as it is in Krishna Ballab Pal's *karkhana.*

Behind the earthen curtain that runs along Jafarabad Road, Gopal Chandra Pal spun rims from the *chak* in the light from the front door. In the big shop to the rear, women washed slip onto finished *patils.* Each swirled the bottom with a design like a knot or a flower that served as her signature. It would be read after firing to pay her by the piece. They piled *patils* in columns on the wide, concave surface of the kiln. After twenty-five hundred or three thousand *patils* had assembled, they were covered with rice straw, plastered with mud, and the chamber below was stoked with wood to burn for six days.

Patils dominated the space, but in 1988 Subash Chandra Pal's workshop exhibited the technological gamut. Next to the *chak,* the middle of the floor was spread with gleaming, dark rims, but all around the edges stood big *tanduris,* built by coiling and dried in the air. On a shady porch, flower vases and tea sets were thrown and shaved on a metal wheel, then glazed and fired in a gas-burning kiln.

Subash Chandra Pal is more than the manager of a successful pottery. Born in Rayer Bazar in 1946, Subash learned the craft from his father, Nihar Ranjan Pal, before going to the Art College for formal training. His own art is terracotta, and examples of his work can be seen in the Parliament Building, in the luxurious Sonargaon Hotel, and at the Bangla Academy, where his tiles encircle the base of the old banyan tree around which outdoor assemblies are convened. Subash married in 1970. Both of his sons work with him and intend to continue as potters. While others work in his shop, Subash works with an agency dedicated to development, and the government has sent him to Madras to exchange ideas with other South Asian artists.

Subash Chandra Pal's home and workshop. Jafarabad Road runs along the front, at the bottom of the plan. A: Workshop. B: Old wood-fired kiln. C: Gas-fired kiln. D: Wood-fired kiln used by Chittaranjan Pal. E: Porch with wheel. F: Chittaranjan Pal's dwelling. G: Porch where Chittaranjan Pal works. H: Yard behind the house where ware dries in the sun. I: Dwelling of the children. J: *Stup*. K: Subash Chandra Pal's dwelling. L: Porch with wheel. M: Former position of the *chak* in the workshop that is now used for drying and storage. N: Amar Chand Pal's dwelling. The scale is in feet.

Chittaranjan Pal's daughters, Shonita and Monika,
in the courtyard in front of Amar Chand Pal's house

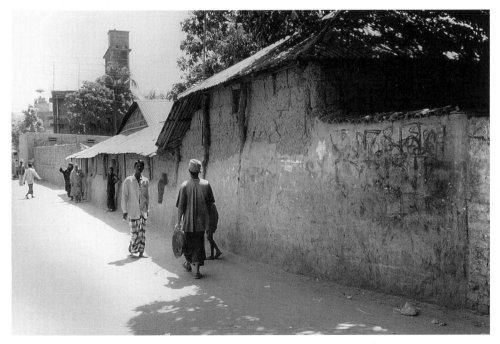

Subash Chandra Pal's workshop on Jafarabad Road

Subash Chandra Pal is a proponent of modernization in his trade. He drives progress, and when I came in 1995, there were no more *patils* or *tanduris*. Work flowed much as it did in the modern *karkhanas* of Kakran.

His building has turned inward, away from the street. The front door is sealed. Where the *chak* used to circle, ware spreads in the dark. The shop to the front makes one wall of a courtyard, with Subash Chandra Pal's house to one side, a metal wheel on its porch, and the house of his brother Amar Chand Pal to the other. Behind the fourth wall, a roofed corridor shelters a gigantic *stup* of clay and offers a subtle entry from the side into a second courtyard, flanked by houses and closed by a big shop. Inside, the old wood-fired kiln stands idle. Outside, in a shed, Babu Pal bends over a metal wheel rigged with a bicycle chain to a crank. A boy powers the wheel while Babu throws forms, then shaves them with a metal "turning tool." His product is mixed. He makes banks in two traditional Bangladeshi types, and he makes a variety of small pots and bowls and vases ordered by European customers through export firms in Dhaka. All will be fired with gas.

One side of the sunny yard is formed by the new house where the children of Subash and Amar live. Subash rents the house on the other side to Chittaranjan Pal who brings another technique into the mix.

Chittaranjan makes swarms of small statues. He molds images of Rabindranath Tagore, standing and bent by a sad thought; like other potters, Chittaranjan calls him Rabithakur. But mostly Chittaranjan Pal makes animals—parrots and swans, elephants, lions, and cows, crocodiles and prawn—and nameless people: mothers with babies and brides with grooms.

Chittaranjan and his wife, Mongoli Rani Pal, the parents of four daughters and one son, work together to mold the statues. They press clay into each half of a mold, wait, then join the parts with soft, damp clay. Their pieces dry in the sun before Chittaranjan smooths them quickly and fires them on a small wood-burning kiln. It stands back in the earthen building that shelters the other kilns, the enormous cool one where *patils* were fired, the small hot one where vases are cooked by gas.

Working silently, steadily on the porch of his house, where his chatty wife prepares the family's meals, Chittaranjan paints his statues. He coats the abstract and stolid cow white, shades in gray for a pinch of verisimilitude, then adds sharp details in black and red.

Chittaranjan Pal was born in Srinagar, Bikrampur. He does not know the date, but in 1996 he guessed he was fifty-two. His father and grandfather made

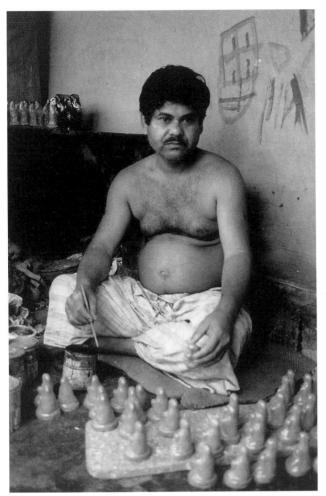

Chittaranjan Pal

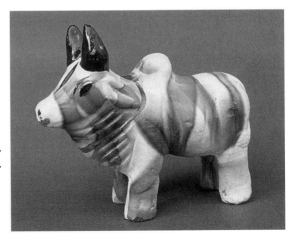

Cow.
By Chittaranjan Pal, 1995.
Painted earthenware; 4¾ in. tall

Maran Chand Paul with Nishi Hossain, the daughter of a friend

murtis—Durga, Kali, Lakshmi, Saraswati, and Sitala—and they made toys. Srinagar, south of the city of Dhaka, is a major source for the small painted earthenware statues sold in Dhaka and Chittagong. About 1980, Chittaranjan moved to Dhaka and the toys he learned to make in his youth are widely distributed. They are sold, along with fruit banks from Bandura, by Krishna Kumar Pal who sits all day in the sun on the verge of Jafarabad Road. They fill Mohammad Hanif's stalls near the old High Court in downtown Dhaka.

Subash Chandra Pal is one of Rayer Bazar's three modernizing potters. They collaborate, sharing workers and information. All are successful in business, but the acknowledged star of Rayer Bazar, the teacher and leader in matters of art, is Maran Chand Paul.

The Realm of the King of Clay

Maran Chand Paul calls himself Mritraj, the King of Clay. He rules a distinct domain within the pottery tradition of Bangladesh.

To locate Maran Chand Paul's realm, I will sketch a simplified map of the whole territory. At one end of the creative continuum, potters make *kalshis*. At the other, they make *murtis*. Both are ancient forms, still made to fill serious needs, the one material, the other spiritual. In between, they make toys—banks and small statues—weaker in utility than *kalshis,* weaker in significance than *murtis.* Seeking new markets, some potters turn from the poles of power toward the middle. Makers of *kalshis* step toward the bank, make flowerpots, and confirm their move to the decorative in extravagant planters. Makers of *murtis* step toward the figurative toy, make large images of beasts, and confirm their move from the sacred to the secular in a style of heightened realism. Utility, on the one hand, and significance, on the other, diminish. Production yields attractive, inessential commodities, saleable less because people have needs than because they have extra income.

Shifts toward the decorative, the secular, and the inessential comprise one part of the pattern of current development in Bangladesh. A shift of emphasis from creation to commerce logically follows. Another dimension of development, the one clearest in the minds of the potters, lies in technology, in the change from the *chak* and the wood-fired kiln to the pedal wheel and the gas-fired kiln. This change is not so great as ones we can imagine in the past by arranging contemporary techniques in evolutionary sequence, from coiling to

paras, from the *para* to the *chak.* But as it continues to unfold through stages toward mechanical command, the technical tradition brings particular consequences for its practitioners.

One is ease. The *chak* takes more bodily effort than the pedal wheel. Stoking the wood-burning kiln is tedious and laborious. The pedal wheel and gas-fired kiln are easier on the body, and easier on the mind. They take less practice to master, welcoming workers not born to the trade. With more power in the tool and less in the body, the new technology demands fewer hands and less cooperation. The master of the *chak* collaborates with others to make *kalshis* or *patils.* The turner at the pedal wheel fashions forms alone. To keep the big kiln burning, people work in teams and shifts. The gas-fired kiln operates at the direction of one man.

As physical and mental effort decrease, so does collaboration. The new technology permits workers to achieve their goals with little assistance, loosening the social bonds the old technology requires, replacing collective effort with individual and bodily effort with mechanical, as energy shifts from the muscles to the tool.

While restructuring work and the workforce, the new technology reshapes relations with the environment. The old kiln is part of its place, in material, color, texture, and action. A ring of earth, burning the earth's growth, clouds the air around it with smoke. The new kiln is a box, confected of processed sheets, fueled by a refined substance, and neatly containing its labor. The old kiln feels autochthonous. The new kiln seems an alien presence, a shiny cube dropped out of some other world into a scene of sinuous clay and twisted wood, symbolizing a radical disjuncture between nature and artifice.

With mechanization, the individual's power expands; social connections weaken on one side, environmental connections weaken on the other, and life becomes increasingly dependent on international systems of commerce. The *chak* and wood-fired kiln are constructed of native materials at low cost by local artisans; money circulates in the vicinity. But the metal for the wheel and the gas for the kiln entangle the potter in ramifying nets of capital exchange.

Corrugated iron offers the conspicuous instance of the historical process into which the potters have stepped. In Bangladesh, as in Africa and South America, indigenous materials for walls and roofs are giving way to milled "tin." I understood it first in Ireland where farmers class houses into old and new by roofing. The old are thatched, the new are covered by sheets of metal. Thatch makes good insulation, and it costs only time and energy. The mate-

rial grows from the land. It is processed and applied by hand. It demands no money. The problem is that thatch requires regular maintenance and frequent renewal. The metal roof obviates the need for constant intervention; it is effectively permanent. The householder is not obliged to be a craftsman or to have neighbors who are. He manages alone without effort or skill or social connection. But metal does not suit the climate, it is environmentally inept, and it requires ready cash. To pay for a foreign product, people must accumulate examples of their national currency. They are drawn into paying jobs, becoming little wheels in the big machine that gathers wealth for distant capitalists. The change from thatch to metal signals the surrender of local autonomy. At the *ghats* of Bangladesh, men are carrying sheets of shiny corrugated iron, made God knows where, to wooden boats for distribution through the green countryside. People have chosen. They want tin, not thatch, overhead. They have chosen ease, permanence, reliance upon distant producers, and participation in the cash economy.

Their new technology brings the potters into the international economic system through which they find new routes to profit. While most potters depend upon middlemen, wholesalers, and retailers who supply Bangladeshis with what they need and want, others make arrangements with export firms that send their products abroad and bring them exotic models to copy and modify.

Despite decline and grim prognostication, most potters make utilitarian ware, using old techniques to supply local needs. Others employ new devices to make decorative commodities for the international market.

In form, function, technology, and economy, the pottery of Bangladesh divides. Provisionally, I will say that the contemporary tradition includes two dynamics: the maintaining and the modernizing. If the distinction is efficient, Maran Chand Paul is, like his friend and relative Subash Chandra Pal, a modernizing potter. He concentrates on the decorative, making neither *kalshis* nor *murtis*. He uses a metal wheel, locally made to an English model, and he fires with gas. He sells to export firms that distribute his works throughout the world. They go to Japan and Europe especially, to fifty-two different countries, he says, nearly every country except the Muslim nations and India, because India has her own handcrafts. Maran Chand Paul has developed a multitude of new forms for vases, and he has experimented with sgraffitoed and slip-trailed decoration in the English manner and with thick, drippy glazes in the Japanese manner.

But the bulk of Maran Chand Paul's product is not made of foreign forms, like those of Kakran. Nor does he push realism like the potters of Khamarpara, or stretch for novelty like Amulya Chandra Pal of Kagajipara. Instead, he returns to native forms and adheres to the native style, while working toward his own vision.

"I get my ideas from rural Bengal," he says, "from the *melas,* from the markets and the *melas.* But the things in the *melas* are roughly made, and I do not like rough things. I want to make them beautiful."

For Maran Chand Paul, beauty is a matter of clean designs in which forms integrate symmetrically. Even more, it is a matter of finish, of impeccably smooth surfaces. At the Rathermela in Karatia, Tangail, he saw an example of a *chaka ghora,* the ubiquitous toy wheeled horse. It had the lumpy look that hasty hand-modeling leaves, but the basic form pleased him, and he preserved it in his own wheeled horses while enhancing their regularity and increasing their polish, exactly as singers of the urban folksong revival in the United States reworked the rough wonders collected from country performers.

Made in Assam and West Bengal as well as Bangladesh, the *cycle chalak,* the cycle rider, is a witty updating of the wheeled horse. In Maran Chand's version the finish is smooth and black. The wheels circle together, rising into a figure whose arms merge with the handlebars, closing a protective ring around a child. The form is geometric and efficient, the detailing clever, for he has modeled the faces in the abstract style of the tiny Mother Goddess of the village with her pinched nose and large applied eyes. The circles of the eyes repeat the circles of the arms and the wheels and the wheels beneath the wheels. A circular headlight points forward, and the whole composition, like a *patil,* becomes one in its interlinking of rings. The riders cohere into an image of security amid motion, of stability within change. Both wear the tapering crowns of deities. Zipping along in unconcern, gazing ahead, their postures erect, the gods of the whimsical toy mix the sacred and playful as it can be mixed in Hindu myth and ritual.

Maran Chand Paul's *cycle chalak* offers a fine illustration to the concept of right action within which Ajit Mookerjee unifies art and ritual at the beginning of one of his handsome volumes on Indian religious art. Wisdom in action, Mookerjee writes, is a matter of "retaining equilibrium in a condition of change." He refers, then, to the *Bhagavad Gita,* to Krishna's instructions to the hero Arjuna before the great battle of the *Mahabharata.* Out of affection for his enemies, Arjuna faltered. He was taught to persevere despite context, to

Vase.
By Maran Chand Paul.
Rayer Bazar, 1988.
Slip-trailed and glazed; 6½ in. tall

Cycle rider.
By Maran Chand Paul.
Rayer Bazar, 1995.
Slipped earthenware; 5½ in. tall

hold to the course of his responsibility, balancing and aligning himself during his reach through action toward perfection.

The *cycle chalak,* preserving equilibrium in motion, exemplifies the direction of Maran Chand Paul's personal quest for perfection. This is how he summarizes his course: "I sell traditional things. But I use good design and smooth finish. I am not leaving the tradition. Out of the old tradition, I am creating beautiful new things."

Reaching back into the tradition of the wider Bengal, then driving forward with improvements, Maran Chand Paul shapes a recursive pattern in time. His work cannot be reduced to the maintaining or the modernizing.

Maran Chand Paul forces us to return to our dichotomy for review and complication. The contrast between the maintaining and the modernizing sets up a long train of antinomous pairs: old, new; utilitarian, decorative; sacred, secular; abstract, realistic; necessary, inessential; creative, commercial; collective, individual; hard, easy; bodily, mechanical; natural, artificial; transitory, permanent; native, foreign; local, international.

The pairs of words are only words, names for tendencies. They label directions, not categories, clarifying abstract, dialectical relations within the contemporary field of action. All real situations are, of course, mixed. The modernizing potters of Kakran throw on pedal wheels then fire with wood. But Maran Chand Paul does more than mix tendencies in real actions. He sets them at tension and inverts them. One way to say it is that he uses modernizing means to maintaining ends. A better way to say it is that, through recursion, he brings a third force into the whole system.

The maintaining dynamic provides stability, while the modernizing dynamic forces change. We tend to be satisfied with a view of the world as a theater of conflict between stability and change. Collecting a congeries of phenomena under the rubric of modernization, we project a future that will be purified in a certain direction. With only the craven desire for stability to overcome, the victory of modernization seems assured, and the world must progress toward the mechanized, the artificial, the commercial, the secular, the individual, and the international. There is, however, an oppositional force of self-conscious resistance on behalf of the bodily, the natural, the creative, the sacred, the collective, and the local. This countervailing force is underestimated because we have not yet learned, as we have with modernization, to gather its disparate signs under one label.

Oppositional actions do not connect directly; they align independently in negative response to modernization, the force also called, depending upon

258

context, progress, development, secularization, industrialization, westernization, or colonialism. The goal is not maintenance; the orientation is progressive, but the dynamic is recursive. The mind scans the past to imagine the future. Consider the popularity of hobbies involving handcraft, the concern for environmental conservation and historic preservation, the profusion of civic festivals, the resurgence of ethnic identity, the escalation of nativism and nationalism, the institution of reactionary values in politics and education, the convergence of alternative ideology and spiritual yearning in religious revival, in new age cults, in Christianity and Judaism, in Buddhism, Hinduism, and Islam. In detail it is too much to encompass: the *Mahabharata* in ninety-three installments on Indian television, mosques destroyed in Bosnia and built in Afghanistan, powwows in Oklahoma, martial arts in Japan, new music in Colombia, glass painting in Poland and Romania, rosemaling in Norway and Wisconsin, political order in Iran, rebellion in Chechnya, separatism in Quebec, fundamentalism in Christianity, the Mao cult in China, Kwanzaa in Philadelphia, the Eid parade in Dhaka city, Saraswati Puja at Jagannath Hall. But take it all together, name it revitalization, and it is a power to balance modernization.

Let us bring these thoughts to earth. Pottery, a quiet part of common life, displays the force and counterforce of normal existence.

Wrought in direct engagement with nature, meeting serious local needs through arduous, cooperative work, pottery embodies the maintaining dynamic. As an industrial product, incorporating new techniques and forms, complicit in the global economy, pottery manifests the process of modernization.

And pottery fits revitalization. When in a new frame, more aesthetic than utilitarian, the artist creates to counter modernization, the local ceramic tradition provides a rich resource. It holds examples of artistic excellence that elude the grip of the internationalizing art establishment—the wide, shallow association of artists, dealers, and connoisseurs linked along the trails pioneered by colonial conquest and economic enterprise. You do not find pottery given a central place in books or museums or university courses that purport to survey world art. Despite the expansive efforts of European artists early in our century—their appreciation of alternative traditions, their ratification of the spiritual in abstraction—representational pictures still dominate the academic idea of art, and along with pictures come evaluative assumptions, pretending to universality but derived from the individualistic, materialistic, and cosmopolitan values of the capitalist elite.

Pottery resists. Marginal on the international scene, it is logically central to local revival. Pottery owes some of its virtue to what it is not. It is not art— not art of a kind that can be accommodated comfortably within the process of modernization. Pottery's greater virtue lies in what it is. Composed of common, cheap, accessible, native materials, a thing of earth and water, wind and fire, demanding athletic bodily involvement, strength and patience more than genius, constrained by craft discipline and entailing collaborative procedures, evoking collective identity and remembering a history that belongs to its own place, referring frankly to use, to the humble routines of workaday existence, gathering its deepest significance from the numinous—an art far more common in the world than easel painting—not rare, not strange, pottery has become one small, clear sign of the global counterforce of revitalization.

Revitalization in Clay

Spain or Italy, Sweden or Germany, Mexico or Peru, Morocco, Uzbekistan, China, or Korea would offer us rich examples, but, knowing only what I know, I will begin in the United States.

At Acoma in New Mexico, Wanda Aragon does not stress the figurines popular with tourists, nor does she employ the technical shortcuts to which some of her neighbors resort. As she was taught by her mother, the master Frances Torivio, she grinds her clay, coils her pots, and colors them in earthy tones. Wanda shapes her family's forms and paints them with her family's geometrical designs, but she has also searched through the storerooms of museums, looked through books, and determined that the most perfect works of her tradition were made in the 1880s. From them she takes ideas that she recombines into thin-walled, meticulously painted water jars. They are made of the earth of her place, they incarnate her idea of the sacred, and they are Wanda Aragon's signature written upon the world.

In the hills of north Georgia, C. J. Meaders digs the clay, turns and burns it in the old-time way. He and his wife, Billie, made special commemorative pieces to celebrate the centennial of the family's trade in 1992. After his retirement, C. J. came home to take up where his cousin Lanier left off. He worked successfully to recreate the lively ash glazes that sheathed his family's working ware. His son Clete uses those glazes on the jugs he models with comical human faces. Lanier's nephew David prefers the plain utilitarian forms made by his grandfather Cheever, and he works with his wife, Anita, in Cheever's

260

old shop. The family's signal piece is the big churn by C. J. Meaders, standing tall, swelling up beneath its skin streaked with rivulets of natural glaze. It does not bother C. J. that people do not buy his churns to use but because they want to own "a piece of history," and he strives to make each one better than the last. The potters of the Meaders family are restoring their tradition to new life, making objects that fit the restrained rural aesthetic of utility and that offer themselves as symbols of regional identity.

Japan is the world's center for ceramic revival. In 1926, Soetsu Yanagi, Kanjiro Kawai, and Shoji Hamada—the last two of them potters—founded the Mingei Movement. Built upon the negative reaction to westernization of the late nineteenth century, influenced by English and Swedish resistance to modernization, and incorporating Buddhist concepts of selfhood, Mingei has pushed creation along certain lines, establishing a cultural climate within which potters in great numbers find worthwhile employment, and the process of revitalization is fostered. Many of those designated living national treasures in Japan are potters who have experimented in our days to recover the excellence of past practice.

At Arita, a small city of potters on Kyushu, Sadao Tatebayashi was one in the team that reachieved the milk-white ground and gem-like colors of the Kakiemon porcelain of the seventeenth century. He established his own kiln in 1978 where his son Hirohisa is the master today. Hirohisa Tatebayashi disdains the name artist, for it implies individualism of effort and arrogance of status. He manages a workshop in which men and women divide the tasks and collaborate to create refined and radiant works of art that meet the challenge of the seventeenth century.

As Arita is to Japan, Kütahya is to Turkey. Ware with a composite white body, painted beneath a transparent glaze, has been made in the city since the end of the fifteenth century. To counter general decline—late in the nineteenth century and twice in the twentieth—artists have renewed their tradition by returning to the masterworks of the second half of the sixteenth century. The taste maker in the current generation, Mehmet Gürsoy, calls the sixteenth-century masters his teachers. They instruct him through their example, communicating to him a blessing they received from God. Mehmet suffers criticism for his adherence to old models, but his goal is excellence, not originality. He willingly submits to tradition, closing a tight ring of influence around him to force progress in a certain direction, hoping someday to surpass his teachers. One result is commercial success. Another is the brilliant

261

plate that recalls a time when the Turks moved close to God, that argues in a rhetoric of harmony for a world governed by love, that embodies Mehmet Gürsoy's faith, place, nation, and pride.

This is the company of Maran Chand Paul: Wanda Aragon, C. J. Meaders, Hirohisa Tatebayashi, and Mehmet Gürsoy. I brought them to his side because the path he has chosen is rare in Bangladesh. The realm of the King of Clay is distinct, but small, and if the view were restricted to his locale, he might seem only anomalous, when, in international company, he points one route to the future.

Looking ahead, we see makers of *patils* enduring, but their market shrinking and workers seeking alternatives. One option for adjustment is to slip into alignment with modernization through mechanization. Environmental and social relations fray while technology and commerce elaborate toward the end William Morris called one of the modern world's most astonishing accomplishments: ugly pottery. Bound to need, grounded in manual labor, pottery is always handsome. When the young Le Corbusier went in search of taut, true forms for a new architecture, he was led to the remote workshops of rural potters who were doing again what had been done before, conventionally, beautifully.

Another option for adjustment is to take command, confirming the direct relationship between design and handcraft, and claiming to be an artist. Once a master of the principles of maintenance, the artist succeeds now through innovation, like Amulya Chandra Pal, or through revitalization, like Maran Chand Paul. In his own view, adamantly, Maran Chand Paul is an artist.

Maran Chand Paul

It is time for his story. On consecutive afternoons, at the end of December in 1988, Habibur Rahman, Firoz Mahmud, and I sat with Maran Chand Paul while my tape-recorder ran in the room best called his studio. It is also a warehouse. Shelves in the narrow space crowd with his works. At one end stands the table where he sits to give molded forms the fine finish he loves. Beyond the door, a metal wheel occupies the porch through which you pass into the walled yard in front of his house.

In telling his story, I will hold to his sequence of topics, omitting things that should not be preserved in print and eliminating the wordy flurries that accompanied his struggles to make sense of our confusing requests for clarifi-

Maran Chand Paul's home and workshop. This plan represents Maran Chand's place in 1988. The workshop on the road in the front has been renovated since. A: Clay supply, sheltered by a palm tree. B: Vats for clay processing. C: Dwelling. D: Studio. E: Porch with wheel. F: Kiln. G: Workshop. The scale is in feet.

cation and that followed the coming and going of visitors. This was but one of the many times we talked, so I will interrupt him to expand and explain. When he is quoted, the words come from the translation Firoz and I developed from a transcript of the tapes.

Maran Chand Paul, like all the potters in Rayer Bazar, does not speak English, but the transcript is spattered with English words—pottery, workshop, wheel, kiln, family, migration, system, and the numbers that name years. They are signs of his urbanity, as is the spelling of his surname—Paul rather than Pal—which he prefers for its familiarity to speakers of English.

I asked him to tell of his life. He did not reply, as an American might, with an autobiography, a string of personal events, beginning with his birth and stitched together by the first person singular. Amulya Chandra Pal responded to the same request by exemplifying his creativity with his verse and reciting an ancient tale that enfolded his deepest feelings. Maran Chand Paul, as befits a master of revitalization, told his story so that it was also the story of his place. Simultaneously, the identity he creates widens culturally and intensifies personally as he locates himself in an intricate web of association. He began with his lineage.

Maran Chand Paul's father, Gopal Hari Pal, his grandfather, Ganga Charan Pal, and his great-grandfather, Jagannath Pal, all were potters. Though he "cannot go farther back" with the names of ancestors, his surname suggests a line of potters running far back in time.

Maran Chand's father did not live in Rayer Bazar. He owned land in Motijheel, now a commercial center of Dhaka city. Yet Maran Chand was born in Rayer Bazar because, he explains, it was his mother's place, and it is the Hindu custom for mothers to return to the homes of their fathers to give birth. His mother's father was deceased, but still she came home for the birth of her third son. "My birthplace is Rayer Bazar," he says, "because the home of my maternal uncles is Rayer Bazar."

Maran Chand Paul was born in 1946, the year before the partition of India and the creation of Pakistan. It was a time of intense unrest. Maran Chand was born in October, shortly before a communal riot drove his father out of Dhaka. Fearing for the safety of his family, Gopal Hari Pal sold his considerable holdings in Motijheel—twenty-seven *bighas*, nine acres of land—and moved to West Bengal:

"After that riot, we left for India. Immediately after that riot. After six or seven months, we came back. Two months after the birth of Pakistan, we came

back. After coming back to Pakistan, we settled in Rayer Bazar. About six or seven months after the riot: after the birth of Pakistan."

Hoping that the creation of Pakistan would restore order, Gopal Hari Pal brought his family back to East Bengal in October 1947. Muslims formed the majority in the new state, but this was his native place. His land was sold, but land was available in Rayer Bazar, vacated by potters who moved permanently to India, so he settled near his wife's family, purchasing the homestead where Maran Chand Paul lives and works today. Maran Chand's first year passed in a time of violent, historic change.

"This is our original home. The land in Motijheel was sold out, and land was bought here.

"Rayer Bazar was then a village. In nineteen forty-six, some Pal families went to India, and they did not come back. The Pals had been here for a long time.

"Rayer Bazar spread from Mohammadpur as far as the end of the tannery. And it went from west of Dhanmondi to the bank of this river. All potters. About—more than eight hundred families.

"From north to south, it was one and a half miles. From east to west, it was half a mile. On the west: the Buriganga.

"My elders used to say that the weavers were here before. After the weavers came the Pals.

"Here was a *zamindar,* named Ray Babu. He brought the Pals here from Murshidabad in India to make pottery.

"This place was named after him, Rayer Bazar.

"That is what my father said."

The suffix makes the possessive, so Rayer Bazar is Ray's Market. Ray is a family name, and Babu is an honorific, like Mister. To honor a man, as you shall hear, Maran Chand follows the name of a Hindu with Babu (which is, confusingly enough, also a given name among Hindus), and the name of a Muslim with Shahib. Maran Chand had said that this Mister Ray brought people from Murshidabad in West Bengal to make pottery on his land in Dhaka, presumably after the British had destroyed the local textile industry in the nineteenth century, but then Maran Chand stopped to correct himself, saying that, in fact, they were brought from Bihar: "from Rajmahal, beyond Murshidabad. Yes, that is what I heard from my father."

Though the potters from Rajmahal were of the caste of the Pals, they belonged to a different *gotra,* a different endogamous unit, from that of the

Pals of East Bengal, the Bengali or Rudra Pals. Among the Rudra Pals, there is one *gotra,* the Aliman Gotra, while the Rajmahali Pals belong to the Aladeshi Gotra, so, though the rules have relaxed recently, in the past intermarriage between the native Rudra Pals and the immigrant Rajmahali Pals was forbidden.

"Rajmahali Pals are found at Rayer Bazar, Mirpur, and Savar. And they are also found in Dinajpur and Rangpur—but few.

"But at Rayer Bazar they were more numerous. In comparison, Rudra Pals, or Bengali Pals, are darker. Even though fair Pals are found in both groups, I would say that Bengali Pals are darker.

"It is the Bengali Pals who are Rudra Pals.

"I am a Rudra Pal.

"Among the Rudra Pals, there is one *gotra,* and that is the Aliman Gotra.

"Ray Babu brought here only a few households of Rajmahali Pals. Their number grew bit by bit.

"There is a difference between the Rudra Pals and the Rajmahali Pals in their work."

Maran Chand is establishing his identity, asserting a special cultural claim. He was, by virtue of Hindu custom, born in this place and raised here, but, unlike the other potters in Rayer Bazar, he belongs, like the potters of Kagajipara, to the Rudra Pals, the native Bengali *gotra.*

When Maran Chand says the work of native and immigrant potters differs, he does not mean techniques. They use the same technology, but they create different forms. He lists the products of the Rudra Pals: *kalshi* (water jars), *matka* (large storage jars for water), *chari* (hemispherical bowls used to hold water and mix feed for cattle, so large they can be used, like Welsh coracles, as vessels to paddle across streams), *tawa* (baking pans), *ayla* (pots to contain coals for heating), *dhakna* (potlids), *jalkanda* (rings to protect pots of milk or curds from ants), *jaldhakna* (lids for water jars), *shanki* (plates), *khancha* (food trays), *chati* (earthenware oil lamps), *gachha* (earthenware receptacles for oil lamps), *badna* (spouted containers for water used in washing at the toilet), *lota* (unspouted containers for washing water), and *ghat* (small pots for water used in *pujas*). Rajmahali Pals, he says, make *bhater hari* (rice bowls) and *takarir patil* (curry pots). "And they do not make any other thing." Maran Chand extends his claim by crediting his group with a more diverse product. The general distinction is that Rudra Pals make containers for water and Rajmahali Pals make vessels for cooking. The distinction is clear, but in practice Rudra

Pals make everything, and Maran Chand, in line with general usage, links the forms he attributes to the Rajmahali Pals—*hari* and *patil*—in order to label the utilitarian ware made by all potters.

The stricter distinction lies between Pals who make *hari-patil* and those who sculpt *murtis,* grand images for worship:

"We did not make *murtis.* The artisans who made *murtis* made *murtis* only. They never made *hari-patil.* And this is still the case.

"At the time of Durga Puja, we bring artisans from the other side of the river to make *murtis* for us.

"They use molds to make the heads of the *murtis.* Durga *murti,* Lakshmi *murti,* Kali *murti*—we need statues of these goddesses.

"The artisans use molds to make the heads of these *murtis,* but the other parts are made by hand—except for the decorative things, the ornaments, the jewelry; that is made by molds.

"In earlier times, there were artisans for making *murtis* among the Pals of Rayer Bazar. But they made only *murtis.* Now these artisans are no more. That is why we bring artisans now from across the river to make *murtis* of Durga for us."

From the history of the founding of Rayer Bazar, Maran Chand Paul turns now to speak of his father. While he made the usual useful ware, his specialty was the *fuler tab.* Maran Chand's claim for himself intensifies: within the native group, he belongs to a distinct and particularly innovative line:

"My father. He used to make *hari-patil.* Before, in Motijheel, he used to make flowerpots. Our thing was flowerpots. At that time, no one else made flowerpots. No one else.

"Now, seeing our family, many people make flowerpots. Now this thing has spread all over Bangladesh.

"Before, only our family made flowerpots.

"I learned the basics from my father. Later, I went to the Art College. There I learned from Mostafa Shahib. I went in nineteen sixty-two. I was a student there. I got my diploma there."

His diploma was in ceramics. It marked the end of a phase in his life which began with an event that he labeled with excitement as a story when he told it later in our long interview.

The key figure in Maran Chand's story is Zainul Abedin, the most renowned artist of modern Bangladesh. He was the author of the image of the man straining to push his oxcart from the mud, which has been repeated and

repeated into a national symbol. Since 1949, Zainul Abedin had served as the principal of the Art College, renamed the Institute of Fine Art, and now part of Dhaka University. In search of subjects, he led a group of students—a party that included two teachers of ceramics, Mir Mostafa Ali and a Japanese master Maran Chand names Ita Kita—on a sketching ramble through Rayer Bazar. They were like the Swedish artists who summered in Dalarna, painting the people and the landscape, and whose fears for the death of picturesque traditions led to efforts at preservation, eventuating in Skansen at Stockholm, and through it to the worldwide movement for open-air folk museums. Seeking genre scenes to paint, Zainul Abedin and his students became interested in the people and their own art. Zainul Abedin assembled a rich private collection of Bengali folk art, which his widow generously showed me, and before his death in 1976, he worked to build a Bangladeshi folk museum on the Skansen model at Sonargaon, the ancient capital, sixteen miles from Dhaka.

Zainul Abedin—Maran Chand calls him Abedin Shahib—believed Rayer Bazar's tradition could survive only if it opened to incorporate, as it has, Japanese techniques of shaping and English techniques of glazing. He asked Gopal Hari Pal for one of his four sons to train:

"In nineteen sixty-two, Abedin Shahib came to Rayer Bazar, along with students and Mostafa Shahib, to draw pictures. At that time, he met my father and said to him, 'The Pal families are slowly disappearing.

"'I want a son from you.

"'We will teach him.'

"That group included a Japanese man who was a master at the Institute. All of them came and all of them insisted that someone from our family should come to the College to learn.

"And then, Abedin Shahib said, 'We will teach him glazed pottery. The things that you are making—if you glaze those things, they will have a good market.'

"Then my father said, 'All right.'

"And then he gave me.

"I had just passed from class five to class six.

"Listen. This is a story.

"I had just passed from class five to six.

"And they took me away. I was wearing short pants—a mere schoolboy.

"In the College, I stood first in the first class consecutively for three years. Then I got a job there. Abedin Shahib himself gave me the job.

"I have remained in the same post—where I began. And I have not been promoted. And the only reason is my basic education. I am a sixth grader, while all the others have master's degrees in their fields.

"Now it is part of Dhaka University, and I am on the faculty. But how can I be promoted without a master's degree? I have not even graduated from high school.

"That is why I have remained where I was.

"Now I am a teacher, a ceramics teacher. My title is ceramics teacher. And I have been in the same post for the last twenty-four years.

"In our department, I work more than anyone else. Because the students need me more than anyone else.

"Now I have students everywhere. Subash is my student. Wherever you go, you will find my students."

The maintaining dynamic depends upon intimate, disciplined training in ateliers where the children or apprentices of the master learn forms and procedures while performing repetitive, menial tasks, developing skills that are delicately poised to prove adaptive in the local environment. With modernization, students diverse in background are gathered in institutions and trained in synthetic systems with a pretense to universal validity. Pedagogical methods differ more than results. In both locations, students shape personal styles within the constraints of precedent. But precedents differ. In the workshop, they are local. In the college, they are international. Raised in his father's atelier, then trained in a college, Maran Chand Paul became a conduit for the exchange of information between these distinct, but simultaneous traditions of education.

Maran Chand Paul says that, though he is a ceramics teacher and not a professor, he is the one his students need the most. Using the education he received from his father, he teaches his students about clay and shaping and firing. Without the practical knowledge he brought from the workshop to the university, his students' artful experiments would fail. As a student, then as a teacher, he continued to work at home, becoming a local resource for information about new techniques, teaching his colleagues in Rayer Bazar.

Continuing to work at home, Maran Chand first made statues for sale, then he added a kiln to fire glazed pottery. Using the English words, he calls it a "wood kiln":

"I went to the College in January of sixty-two. And while I was working there as a teacher, I used to make small statues at home.

"Then gradually I began making glazed pottery here.

"In the beginning, I did not have a gas kiln. At that time, it was a wood kiln, and I myself made it to make glazed pottery. And it was round in shape. At that time, I used to burn sticks, and sticks were cheap in those days, only four *taka* a *maund*. And I called that kiln a wood kiln.

"I did everything to build that kiln. I collected the clay, and I plastered it. But I got the idea for making that kiln from the Japanese teacher at our College.

"I got the gas kiln in nineteen seventy-eight."

It was the first gas-fired kiln in Rayer Bazar. Visiting artists had selected his father's shop from the many. They saw the flowerpots, they recognized the distinct style and the potential for innovation that Maran Chand realized with his gas-burning kiln. An instructor in the university, a potter in Rayer Bazar, Maran Chand melds in himself the complexities of contemporary existence. The identity he creates as his story unfolds is utterly distinct. Master in two domains, he is the King of Clay.

Having described his education as a potter, filling out his self-portrait, Maran Chand returns to his place, locating it in history:

"In Rayer Bazar, change has happened. Now the situation seems to be one of decline."

That decline has been steady, the result of the expansion of Mohammadpur to the south and Dhanmondi to the west, bringing Muslims in, squeezing Hindus out, but it has been punctuated by violence. East Pakistan absorbed an influx of Muslims from India. The new residential area of Mohammadpur in northwestern Dhaka was readied to receive them, and it remains distinct in feel. The Muslims of Bengal are Sunnis, but Mohammadpur contains a colorful, domed Shia mosque, built in 1964. In 1964, Muslims, driven from their homes in Bihar by Hindus, rioted, storming through Rayer Bazar and burning Hindu homes in revenge. Hindus escaped to India, as they had in 1946 and 1947 at the time of partition, and as they would again during the War of Independence in 1971, but Maran Chand Paul believes that 1964 was the year in which the decline in Rayer Bazar's Hindu population was sharpest. Of the riot, he said:

"It broke my heart.

"I thought, I love this country so much. I did. So much.

"A riot took place in sixty-four. Yet I did not go.

"A great upheaval took place in nineteen seventy-one. But I was still in

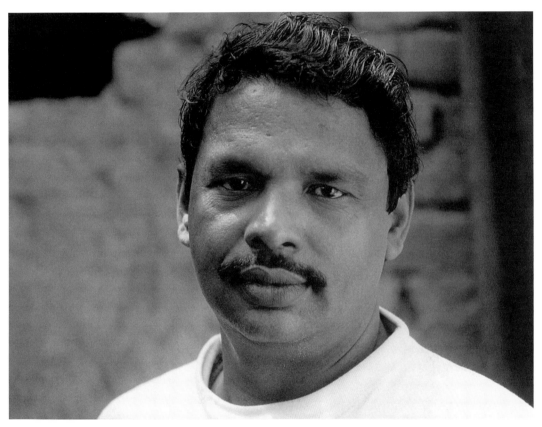

Maran Chand Paul

Rayer Bazar. Here the military lined people up and shot them. I escaped to the market. Still, I did not go out of Rayer Bazar.

"Now the troubles continue. But I remain.

"But my heart is broken.

"Now do you understand why people have left this place?

"As I said, from Mohammadpur, from the Sat Gumbaz Masjid to the end of the tannery, all were Pals. They were ninety percent of the population.

"Here was a system. It was such a beautiful village that here lived Brahmins, lived barbers, lived washermen, lived wealthy merchants. For the survival of a family, whatever was needed, we had here. We had milkmen.

"Most of them were Pals. They made *hari-patil;* they made *kalshis, patils,* rice *haris,* curry *patils,* and a variety of other things of clay like pans for baking bread. All these things were made in Rayer Bazar.

"And those things were sold over the river by boat. They went by boat all over Bangladesh, and even as far as Assam. *Kalshis* and flowerpots were mostly sold in the towns. *Hari-patil,* things for cooking, were mostly sold in the villages.

"There were seven hundred and fifty to eight hundred families here. But every family had three or four artisans."

Maran Chand's word for artisan is the usual one, *karigar.* Later he would suggest multiplying seven hundred and fifty or eight hundred by three or four to get the population of professional potters. His final figure would be higher than that of the older men, who number the families at seven hundred and fifty then multiply by a bit more than two, but their logic is the same, and their results are so consonant that they imply much talk in the present about states of affairs in the past.

Their numbers are consistent enough and probably no exaggeration. A survey of the industries of East Bengal published in 1908, reporting conditions forty years before the high point in the population, notes, "In Dacca town there are about 400 families of potters, nearly all Hindus." G. N. Gupta, the author, goes on to say, "They complain that their earnings have fallen off lately." Talk of decline, like certain numbers, seems to be part of traditional discourse in Rayer Bazar.

Rayer Bazar's "system"—Maran Chand used the English word—was based on more than people, diverse in skill and wealth, interacting to create a self-sufficient entity within a city. Order was insured by the Pal Society, the potters' guild:

"In the past, the price of one basket of ware was five *taka*. And for each basket of ware, we potters had to pay a tax of one *paisa* to the Pal Society. Without payment of the tax, the boat would not be allowed to take off. The tax collected was used for the maintenance of one large temple, two mosques, and three schools.

"Let me explain it. We are all Hindus. You are probably thinking, what do we have to do with mosques? All our boatmen were Muslims.

"Since they are Muslims, they have to say their prayers five times a day. So we built two mosques for them on our land. And we thought it was the right thing to maintain those two mosques, so they could say their prayers.

"In those days, Durga Puja was celebrated at four places in Rayer Bazar. For each area, one hundred and fifty *taka* were provided by the Pal Society. And then at the time of each Eid, for each mosque, the Pal Society would provide one hundred and fifty *taka*."

It takes four *paisas* to make an *anna*, and sixteen *annas* to make one *taka*. The money was collected by the Pal Society from Hindu potters, one *paisa* per headload, when the ware was taken by Muslim boatmen for shipment on the Buriganga River. It was used to maintain the Akhra Mandir, which was built in 1909, two mosques, and three schools. Then it was equitably disbursed at times of religious festivity. Annually there are two Eid holidays: Id al-Fitr, the day for prayer and eating, generally called Eid, that ends the austere month of Ramadan, and Id al-Adha, the feast of sacrifice, generally called Kurbanir Eid, that commemorates the origin of monotheism, the day on which Ibrahim, absolute in faith and obedience, led his son up the mountain, then slaughtered a ram at the command of the Angel of the Lord. Since there were two days and two mosques, Muslims received the same amount of money as the Hindus who celebrated Durga Puja in four neighborhoods.

This busy, beautiful village of Hindu potters in a Muslim city—the Rayer Bazar conjured up by Maran Chand Paul—was not only self-sufficient, industrious and prosperous, it was munificent and just in its governance. Rayer Bazar was a tiny ideal state in which the majority acted in more than tolerance toward the minority. Hindus cared for the Muslims, building and maintaining mosques for the boatmen who served them, respecting their need to break work for prayer.

Maran Chand Paul has created this fine system so that we will feel his pain when it is destroyed. From the memory of harmony, he turns abruptly to what he as seen:

"In nineteen sixty-four—I am saying now what I saw—after that riot happened in sixty-four, busloads of potters left for India. It was a migration.

"They burned all their homes. Our house, this house of ours, was also burned to ashes.

"We took shelter at the camp located in the temple.

"From here, all of them went away. Only a few of them returned. And only eight or ten families did not go."

His was among the few families that stayed. Gopal Hari Pal took the family to the Akhra Mandir, waited through the holocaust, and then returned to rebuild. But most of his neighbors were gone. "After the Hindus left, the new owners began building their houses."

The battle for living room was on. Muslims began encroaching upon the land of their Hindu neighbors and buying sites for low prices. At the time of the riot in 1964, Pakistani law prevented Hindus from selling their land. While seeming to hold them in place and secure their tenure, the law, in fact, dispossessed them. Fearing for their lives, unable to sell their real estate legally, they took whatever they could get from men who contrived mock documents, and fled. From that time to this, the number of Hindus in Rayer Bazar has been steadily decreasing, and the number of potters, owing to economic competition, has been decreasing even more steeply. Maran Chand illustrates with his own family:

"We are four brothers. We have two sisters. One sister was married in Mirzapur. The other sister now lives at Faridpur with her husband.

"But we four brothers live in Dhaka. My younger brother is doing business, and my two elder brothers are tailors.

"I alone am making pottery.

"My father is dead. He died in nineteen seventy-one."

Because so many Hindus were murdered by the Pakistani army in 1971, Maran Chand quickly adds, "He died of illness." His father's death left Maran Chand alone in the family trade. Maran Chand and his wife, Gita Rani, have two daughters and one son. The son was given a fashionable, poetic name, Aniket, meaning rootless, and he has abandoned pottery. Their eldest daughter, Anita, however, manages, together with her husband, a large *karkhana* in Patuakhali, Barisal, and a small one in Mirpur, from which they fill orders for export.

The cultural and the individual blend in the identity Maran Chand Paul builds for himself. He was born and raised in this place, where he is unusual

for his membership in the native Bengali Pals. His was one of the few families that stayed in 1964 and 1971. He comes of an innovative line, he has received academic training, and he alone remains to practice the tradition of his family and community in his nation's capital.

Maran Chand Paul has established himself in his story and sketched a general history of Rayer Bazar, its lovely past, its violent past, its current decline, and now he turns to the trade that he and his place share. While utilitarian ware is still made, he says, there are three shops—his and those of Subash Chandra Pal and Mohammad Ali—in which the needs and taste of the modern age are met:

"In the past, each house had a workshop. Now some Pals still make *hari-patil*. But only we three or four families—by family I mean Subash Babu, myself, and Mohammad Ali Shahib—only we are making things in line with present needs. These things are being made in these three workshops."

Subash is a Rajmahali Pal, Mohammad Ali is a Muslim. Maran Chand Paul calls them both his students, assuming the leader's role within the small group of modernizing potters. He also calls them his friends, then continues:

"Mohammad Ali Shahib is not a potter himself. He employs artisans. Mohammad Ali is not originally a local man. He comes from Munshiganj.

"Two or three of his artisans are potters themselves. They are Pals. There is also one Muslim boy who works at the wheel. And there are two or three other Hindus, but they are not Pals."

Like many Muslims, Mohammad Ali came from beyond and purchased land from a Pal. But only he adapted to the system of the locality, learning the trade from Maran Chand Paul, establishing a workshop, and offering employment to Hindus.

Maran Chand Paul and Mohammad Ali continue to work together. Their cooperation, the friendship of these men, a Hindu and a Muslim, realizes intimately the hope in which their new nation was founded.

Having divided current production into old and new types, placing makers of *hari-patil*, like Krishna Ballab Pal, on one side, and placing himself, with his friends Subash and Mohammad Ali, on the other, Maran Chand Paul launches on a contrastive catalog. He moves away from himself, refining his progressive role, while compiling a history of change in his trade that can be set within the history of his place.

"My father used to make flowerpots, and he was an expert at that. I am making statues, flower vases, and ashtrays—I am just the opposite.

"These days, the *hari-patil* made in Rayer Bazar have their market in Dhaka. Today we no longer send our ware to the villages over the river route.

"But a little ware goes out of Dhaka by truck. Middlemen carry it by truck to other districts."

Next Maran Chand lingers on the topic of *mati,* of clay:

"In my boyhood, *kala mati* of a high quality—or *rag mati*—was brought from a place called Gaidyar Tek in Mirpur. That was very good clay.

"Babupura *mati* was brought from Babupura, which was near the present-day New Market. At that time, Babupura was a jungle."

It is startling to think of Babupura as a jungle. Southeast of Rayer Bazar and north of Old Dhaka, at New Market, fine stores run rings around a domed mosque, offering books, luggage, household goods, electronic devices, and elegant saris. Past New Market, Mirpur Road strikes north, wide and straight, through miles of modern buildings. Across Mirpur Road, at Babupura, there is a low, cramped, crowded market. On my first visit to Dhaka, I found its stalls packed with used books and heaped with inexpensive textiles. Under improvised roofing, pathways, maybe muddy, maybe dusty, led into a labyrinth. A little restaurant puffed smoke, contributing savory aromas to the dense olfactory mix. Printing presses clanked. Men bound books by hand. I liked it back in there, went often to admire the embroidery of Muslim men, to get my books sturdily bound by Mohammad Yusuf Ali. Now it is a tidy assembly of small stalls selling textbooks, and it amuses me to think of this busy place as a jungle where potters once quarried their clay.

New Market was built upon clay in 1954. As remarkably, *lal mati,* the red clay for coiling *tanduris,* was dug in Dhanmondi, now a fashionable neighborhood of straight, shady streets and white mansions in the international style, located east of Rayer Bazar. Today's red clay comes from north of Dhaka, from a spot in Mirpur near the zoo.

The potter's story contributes to Dhaka's tale of development. Only half a century ago, Maran Chand's father made pottery where towers of steel and glass glitter today in Motijheel.

Mati, clay, the earth on which it all depends, naturally fascinates Maran Chand Paul. He spoke first of the black, sticky clay that is necessary in the potter's blend, calling it *kala mati,* as they do in Kagajipara, and *rag mati.* For the other clay necessary in the basic blend, the white clay, he also uses one of the names employed in Kagajipara:

"Another clay that we use is called *abal mati.* The farmers call it *doash mati.* We call it *abal mati.*

"*Abal mati* is found in rice fields. *Rag mati* is found underneath the *abal mati*. And if you go farther down, you will find *sail mati.* We use *sail mati* to plaster the kiln, but not for pottery.

"The clay from Babupura was very good for making *hari-patil.*

"The clay from Mirpur was very good for making storage jars. Now we get our clay from farther north in Mirpur.

"Before, we would collect clay only in the month of Baishakh for the whole year, and in that month we would not do any work."

Not that digging and transporting the clay was no work, but shaping and firing operations were suspended in the *karkhanas* during Baishakh, the first month in the Bengali year, when it is spring in the West and profoundly hot in Bangladesh.

"In the past, the Pals themselves collected the clay. Now Pals do not collect clay. Nor is it the custom to collect clay only in the month of Baishakh. Now clay is collected throughout the year. But we still follow the custom of not working in the month of Baishakh.

"Now the sources of our clay are Salmasi, Nayarhat, and then a place farther north of the zoo in Mirpur, called Bailampur. We get *rag mati* from Bailampur. Salmasi is west of the Buriganga; it is a village west of the Buriganga. There used to be a community of Pals at Salmasi. At present there are only two households.

"We also get clay from the Savar area.

"In the forties, we collected the clay ourselves. Now it comes right to us. We get it at home.

"Now, since we do not collect the clay ourselves, we have to buy all kinds of clay.

"Even now, clay is brought by boat over the river route as before, and clay is sold to us by the oxcart load.

"In the forties, each oxcart load of clay contained fifteen *maunds* of clay, and the price for a cart was eight *annas.*

"Now it is three hundred and fifty *taka,* and if the clay is very good, four hundred.

"In nineteen forty-seven, the price of eighty *patils* was two and a half to three *taka.* And today it is between one hundred and sixty and one hundred and eighty *taka.*"

Prices have risen steeply. In fifty years, clay has become eight hundred times more costly, and pots sixty times more costly. The potter's profits have not kept pace with his expenses. It is hard.

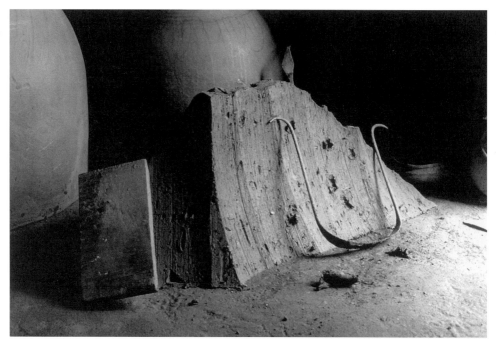

Lek and *stup*. Nimai Chandra Pal's workshop. Rayer Bazar

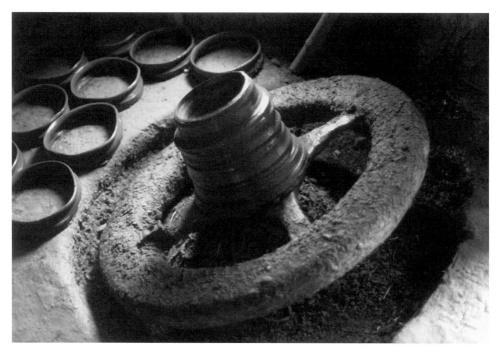

Chak. Subash Chandra Pal's workshop. Rayer Bazar

Maran Chand says clay was processed in the past in the way it is today, and I had watched while he used a *lek* to shave the *stup* located at the far end of his house, while he cut, rolled, and trod it to smoothness as Gauranga Chandra Pal does in Krishna Ballab Pal's shop or Saraswati Pal does at home, beneath the trees, in Kagajipara.

"We need two kinds of clay. Then we mix it in the right proportion. For glazed pottery, the mix is three parts of *rag mati* and one part of *abal mati*. For *hari-patil,* the mix is one part of *rag mati* and one part of *abal mati*. But for heavy things, the mix is different: three parts of *abal mati* and one part of *rag mati*. By heavy things, I mean terracottas. And I make terracottas."

We had talked on other days about the changes from the *chak* to the wheel and from the *puin* to the gas-fired kiln, so he passes these topics swiftly, commenting that, though he uses the metal wheel, the *chak*—he says *chaka*—is still used to make *hari-patil,* but the *chak* alone is not enough:

"We use the *chaka,* but not for the bottom. The bottom is made separately by hand.

"This is done by women. Men never do it. Men alone make rims on the *chaka*. The bottom is fixed to the rim by a woman. That men cannot do.

"So there is this change. I use the wheel and not the old *chaka*.

"The kiln is not changed. The kind of kiln we used in the forties is still used today. But the only difference is the gas kiln has come—in addition to the old one. And I use the gas kiln."

That kiln is enclosed by a frame building beyond his studio's porch. It took much experimentation, he says, to learn how to fire different objects in the gas kiln:

"The amount of firing depends on the thickness and size of the thing. If it is a terracotta, it needs five or six days of slow firing. But you can do it in four if the terracottas are dry. But if they are wet, it might take even seven or eight days. Then the final, full firing takes ten or twelve hours.

"Other things, little things, need two or three days of slow firing, then a full firing of ten or twelve hours.

"Glazed pottery needs little slow firing, only five or six hours, and then a full firing for twelve hours. But glazed things need a biscuit firing and then a second firing."

For small statues, the heat reaches eight hundred degrees centigrade. The heat at the end of terracotta-firing reaches eleven hundred and fifty, and while,

he says, it might be better to push it another hundred degrees, that would be risky since the kiln is so near his house.

The kiln forms one side of the yard in front of his home. Between the kiln and the street, at tables in a narrow room, men and boys finish small statues of animals, working to his exacting standards. Maran Chand sculpts the model by hand. Then:

"For production on a large scale, I make a mold.

"Our ancestors made molds, but only for making small statues. And those molds were made by the Pals in clay. They never made molds in plaster of paris. Today I make molds in plaster of paris."

The form he takes from the mold is simple and rough, a transfer from his concept that awaits completion like the pounced design of a fresco painter. He sits at the table, nurturing the rough animal to life and art with applied detail, with incising and polishing. It is slow work, demanding patience and concentration. Subash stops by to chat. Dhananjoy Pal comes from the clay to pack a box for shipment. The men in the shop to the front sit quietly, finishing small statues, while Maran Chand works gently over a big one in his studio. All are making horses and elephants.

Horses and Elephants

The earthenware horse is one pervasive feature of the artistic culture of the Indian subcontinent. The votive horses of Gujarat, in the far west, have received excellent study from the artist and scholar Haku Shah. In the north, at Gorakhpur in Uttar Pradesh, the lustrous horse is lavish with applied ornament. To the far south, in Tamil Nadu, gigantic terracotta horses, dedicated to the god Aiyanar, guard the villages and fields. Coming northeast toward Bangladesh, we find earthenware votive horses at Puri, Orissa, and in Darbhanga, Bihar, where the horse bears a rider and a coat of bright paint, as it does in Rajasthan, away to the west. In the villages of the Bankura district of West Bengal, the small horse is pinched and wiry, like the horses of Chittagong, and the large one, with its neck erect and its ears pricked, is assembled of wheel-thrown components.

One of them, probably made in Panchmura, Bankura, West Bengal, provided a crucial element in Maran Chand's formation of his art. It was his second year at the Art College; he says:

"In nineteen sixty-three, C. M. Murshid visited our College. He was then

the ambassador of Pakistan in China. He came to our College, and he gave me a horse. That original horse is still in our College.

"Murshid Shahib asked me, 'Maran Chand, can you make six horses like that for me?' And he told me that he brought the horse from Bankura. It is called the Bankura horse.

"Then I made the horse. I got an idea from that horse how to make something like it."

Maran Chand's brief narrative of an instance of diffusion contains an exchange vulnerable to misinterpretation. Seizing history's power for people like themselves, thinkers in consumer societies credit princes with palaces built by masons, stress patronage and criticism in studies of creativity, evaluation in historical accounts, response in aesthetic theories, and call handmade souvenirs "tourist art" as though the tourist had made them and not the native artisan. It is not the patron, nor the buyer, nor some quasi-divine force called the market: creators create, producing for consumers who are, during the performative act, constructs of their imaginations. But they can be coopted and coerced. When the potter in Kakran reproduces a flowerpot from a photograph, making an object he does not like, he remains the producer, but he has become a subordinate component in an economic system from which he derives little more than not enough money. But when he reconfigures the model to make an object he does like and sends it through the market to a customer who likes it too, an identity has been achieved between something in the creator and something in the consumer; their values align sufficiently to allow for a communication between them, effected through a material medium. There is some match of taste in the middle-class customer and the potter who makes an extravagant planter or a naturalistic cow, just as there is between the farm wife and the woman who makes her *kalshi*. Those potters in Kakran are not driving change to no end; they are working toward a middle-class life.

When C. M. Murshid placed his order and Maran Chand Paul filled it, they connected in the horse as a symbol of their tradition. It is not that they viewed the horse in the same way, but their independent opinions were like enough to enable meaningful interaction. The customer wanted earthenware horses to give as gifts that would evoke his place. He was a Muslim, a man with a strong interest in regional history, and he was a government official at a time of tension between West Pakistan and East Pakistan, when separatist feelings were growing in his native East Bengal, and he selected a distinctly

Maran Chand Paul at work

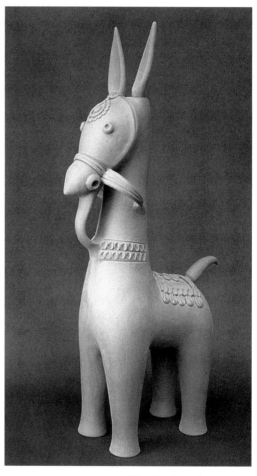

The Bankura horse.
By Maran Chand Paul, 1987.
Earthenware; 17½ in. tall

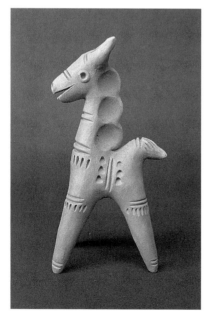

Horse.
By Maran Chand Paul, 1987.
Earthenware; 5½ in. tall

Bengali form to use as an ambassadorial gift—a symbol of the political nation. The creator, had profit been the only motive, might have filled the order and stopped. Instead, he made the horse into his signal piece and the basis of the line of production he was developing as an artist with academic training. For Maran Chand Paul, the horse from West Bengal eradicated the political boundary sundering East Pakistan from India. It unified him with his co-religionists on the other side of the border and offered an emblem of regional identity. The horse was like the image of Rabindranath Tagore, who was born in West Bengal and who died there, but who, as the great poet of the Bengali tongue, can stand in the land that is Bangladesh now as a symbol of the cultural nation.

Ideas fly by constantly, but the idea that becomes an influence is the one that is actively grasped and actively assimilated. From that horse, Maran Chand took the notion of basing his new art upon the old tradition of Bengal. Revitalization, it is often the case, consolidates when the historical interests of the customer—native or foreign—meet the historical interests of the creator, and they become mutually reinforcing.

While filling C. M. Murshid's order, Maran Chand Paul taught himself to make a fine version of the Bankura horse. At first, he made each one individually, throwing the legs on the wheel and shaping the head by hand. Then he carved a mold out of wood, which broke, and finally he built a plaster mold around one of his thrown and modeled horses so that the basic form could be reproduced with ease.

"Many began telling me, 'I am going abroad. Can you make a horse for me, but not as big as the one you made for Murshid Shahib?'

"And that encouraged me to make the little horse."

Maran Chand made small horses on the model of the big one, a good size to pack in a suitcase, and, in line with the masters of Khamarpara, he made gigantic versions to decorate local homes. His customers understood the horse, as he did, to be a cultural symbol, and his horses became popular. Then he lifted the Bangladeshi horse from its wheels and fashioned a distinct, smaller statue, which, in time, he made in an even smaller size. Horses of the Bankura type, with separate ears and tails inserted in sockets, stand forth in rosy, buff terracotta, while those of the Bangladeshi type—their models formed by pinching rather than throwing—are usually slipped and fired, red or black, in the local style. All share a perky, alert verticality and a fastidious finish.

In the menagerie of subcontinental art, the horse and elephant are most common. They are noble animals. In ancient times, according to Strabo's

Geography, owning a horse or elephant was a royal prerogative. More than a millennium later, during the Muslim conquest, the new rulers made it illegal for Hindus to ride horses and they gave elephants as gifts to loyal retainers. They are sacred animals. When Vishnu appears in his incarnation as Kalki, arriving at last to destroy the oppressors of the Hindu people, he will come on horseback. Indra rides the elephant. Maran Chand Paul had mastered the horse. He added an elephant.

Maran Chand takes a terracotta statue from the shelf to tell us, "I made this elephant on the basis of the idea I formed from that horse." It was his own idea. He threw the legs, modeled the head, and made the mold. From the mold he lifts the rough form to which he applies ears and eyes and tusks and ornaments. Having designed one at the scale of the original horse, he then, as with the horses, added smaller elephants. One of the small elephants, modeled on the large one, he glazes in a manner reminiscent of the celebrated pottery of Hagi in Japan. Smaller and smaller ones are slipped and fired, red or black.

The masters of Khamarpara push realism in their horses and elephants. Maran Chand does the opposite. He confines his horses and elephants in symmetrical abstraction. Four columnar legs, lacking knees or sinews, hold a cylindrical body off the ground. The head is set firmly on center, the horse's neck swooping up, the elephant's trunk swooping down. The parts flow through continuous lines into unity, like the segments of a *murti,* and, as with the image of the deity, there is no motion or strain, no muscles or bones. The skin stretches over the form, integrating the whole into a stable, timeless presence. And then, precisely as it is with the *murti,* the smooth, taut surface is relieved by meticulously defined ornaments. The horse wears a necklace, the elephant wears bracelets; both have jeweled pendants on their foreheads and tasseled saddles on their backs, each centered by a radially symmetrical blossom, a unit assembled of repeated units. Free from particular historical precedent, Maran Chand's elephant is more ornate. Incised, geometric borders mark the shoulders, and applied flowers decorate the ears. Both animals, in their counterpoint of smooth surfaces and sharp detail, in their postures of abstract composure, in their integrated design, incarnate the ancient style of the gods. Sacred by implication, Maran Chand's animals recast the tradition of his place for a new life.

Maran Chand's act of revitalization led to artistic and commercial success. He set up a booth one year, late in the 1970s, in the Baishakhi *mela* at the Shishu Academy. Mritraj, the King of Clay, his banner proclaimed, and his

Elephant mold

Fresh from the mold

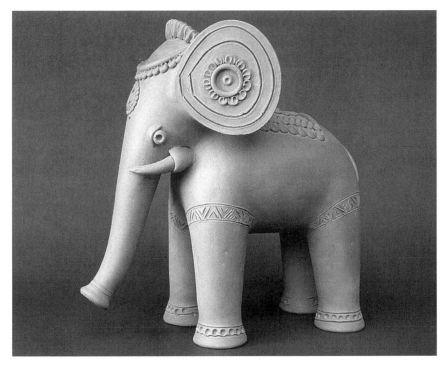

Elephant by Maran Chand Paul, 1987. Earthenware; 11½ in. tall

works took the first prize. He had no reason to enter again, but he smiles when he tells us that his protégé Mohammad Ali won the same prize at a later *mela.*

Maran Chand's originality, his distinct and refined expressions of the native tradition, attracted attention, and in the late 1970s he formed a cooperative arrangement for education and manufacture with Karika, a firm that exports handcrafts and sells them in bright boutiques in Dhaka. Today poor women gain employment in garment factories, but in those days Maran Chand's workshop was one of the few places in which women could find work:

"I ran a school here at Rayer Bazar, and both men and women were my students.

"But most of the students were women. Many of them were widows or divorced. At that time, there were no garment factories in Dhaka. In these days, poor women work in garment factories. So I was doing a good service to these women by teaching them pottery.

"I used to give each student seventy-five *taka* a month, and they made things for me. They were trained by me for six months, and they would receive that pay. After I had trained them, they would leave and make things in their own homes.

"And those things Karika was sending abroad and selling locally.

"I produced sixty or seventy students in this way, not more than six or ten at a time. Each of them set up a workshop. And then they employed some women and taught them. In this way, four hundred female potters appeared.

"I taught them my models, but their things are not so good as mine because they are mass-produced for the market."

In 1978, Maran Chand got his gas kiln. At about that time (he is not sure about all the dates), he won first prize at the *mela* and he established connections with export agencies. His arrangement with Karika was not exclusive, though Karika had advanced him a useful loan, and he began selling to eight or ten different firms, including Aarong, Champak, Chandan, Saju Art, Jiraj Art, Bangla Craft, and the Bangladesh Agency, as well as Karika. Those were good times, he says: "They did not place orders. Whatever I made, they bought."

When we met in 1987, Maran Chand's success was near its peak. At the center, he was making glazed vases but concentrating on his big earthenware statues of horses and elephants. On one side, women working at home were imitating his models. His personal taste had escaped to become general—not in the country *melas* or the urban market, but among producers for export and for sale in the upscale craft shops of Dhaka where wealthy Bangladeshis

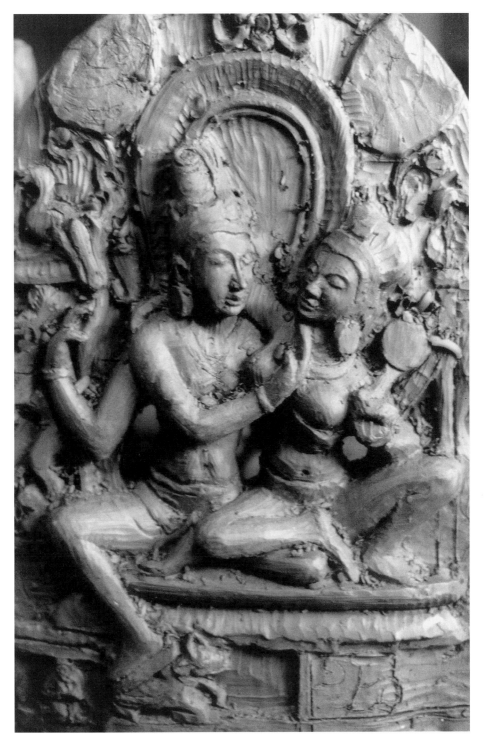

Shiva and Parvati, based on a tenth-century stone sculpture from Dhaka district.
In progress by Shapan Kumar in the workshop of Maran Chand Paul. Rayer Bazar, 1988

outnumber foreigners in the clientele. On the other side, especially talented students, one Hindu and one Muslim, were using illustrations from art books to reproduce in clay the stone and bronze masterworks of the classical Bengali tradition, sculpting under his supervision exquisite images of Ganesh and Shiva. For Maran Chand's Hindu student, Shapan Kumar, the sacred, the aesthetic, and the historical meshed in his work. For his Muslim student, Jahid Latif, the aesthetic and historical predominated, just as they did for his prosperous customers. Revitalization can entail such complexity because art's manifold nature permits divergent readings to coexist without conflict. What is primarily sacred for the creator can become primarily aesthetic or historical for the consumer because the aesthetic and historical dimensions were present, if subordinate, in the creator's act.

Maran Chand's zenith coincided with that of Amulya Chandra Pal at the end of the 1980s. In 1995, I found a sadness, an empty feeling, in his urban atelier, as I did in the village of Kagajipara. The causes seem different. After Babri Mosque was demolished, Maran Chand said, boys ran through the streets and tossed a few stones, but their riot was not the major source of his sadness. He has seen worse.

In filling orders from export firms, Maran Chand says, he has become the manager of a factory. He must endure abuse from the firms he supplies. They treat him like a mere merchant, not an artist, grousing about deadlines and wrangling over prices, bargaining hard and paying him the bare minimum while their own profits soar.

He is doing well financially, he says, and though he had just returned from a trip to India, he declares he will never abandon Bangladesh. He loves his country. But he is weary of the mistreatment he receives from the export firms, and he pines for the days of his creativity. He must change, he tells me in 1995, recovering the excitement of his original work:

"I want to make new things. Always. But now I am busy making little toys for export. So I cannot make new things.

"I get money. But I am not satisfied. I get no mental peace or satisfaction from business. I want to create, to make new things, new designs. But now my creation has stopped.

"Sometimes I wonder whether I should stop the export business.

"I love to create."

At last, the cause is the same: the deep source of the unease in Maran Chand's shop is like that in Kagajipara. In both places, commerce has come to

dominate creation, and the work people must do, molding flowerpots or managing sales, leaves them unfulfilled. With history, during what some call progress, the working artist descends, becoming a laborer or a supplier within an economic system that yields its prime benefit to a wealthy few.

Today, Maran Chand Paul designs, and he oversees quality. But it was far better, he says, when he was less prosperous and he did the work himself, feeling the fullness of creation and the sweetness of clay in objects he brought into the world and controlled from the beginning to the end.

His commercial success has swallowed his artistic success, and there is sadness in the brown eyes of my gentle, gifted friend Maran Chand Paul.

Mohammad Ali

"Maran Chand Paul is a great artist," Mohammad Ali said. "Bangladesh cannot afford to lose such an artist." Maran Chand is determined to stay. He has raised masonry walls along the street and hung an iron door in the entry. While Shafique Chowdhury and I were talking with Mohammad Ali, Maran Chand was off in Dhaka's military cantonment, planning a major terracotta program for an expensive new house. Commissions come, success continues for Maran Chand Paul, but Mohammad Ali is worried. He fears that the troubles squeezing and nettling Maran Chand might drive him to India. Mohammad Ali sympathizes with the Hindus he works among. Though he is a member of the majority, his life is disrupted by armed thugs who demand money for "protection." He feels insecure, like his Hindu neighbors, and he can understand why they might wish to seek a place to work in peace. Settled conditions, he argues, echoing the sentiments of Amulya Chandra Pal of Kagajipara, are necessary for creative work.

Rayer Bazar's elders call Mohammad Ali and Subash Chandra Pal the students of Maran Chand Paul, and Mohammad Ali calls Maran Chand his teacher and his profession's leader. In teaching a Muslim, Maran Chand transferred a Hindu craft into the hands of the nation's majority. The art persists while the population changes. In Mohammad Ali's *karkhana*, there are seventeen workers. The six Hindus among them fill the senior positions, teaching their Muslim mates, continuing the process of transfer.

It is so unusual for a Muslim to be a master in Rayer Bazar that, despite his name, Mohammad Ali has been mistaken for a Hindu; he wished to have it recorded in this book, and I am happy to oblige, that he is a Muslim, secure

289

and deep in his faith. Mohammad Ali was not born in Rayer Bazar, nor was he raised a potter. He was born in Fulbaria, in Dhaka city, in 1958, and he became interested in pottery by chance. Seeing the work done, intrigued and wanting to know more, he visited a ceramic factory and the Art College, then sought training in the Ceramic Institute, Tejgaon, Dhaka, and at BSCIC—the Bangladesh Small and Cottage Industries Corporation. But he learned the most from Maran Chand Paul and continues to repay him through service. On one visit, I found Maran Chand using Mohammad Ali's workshop to create a large terracotta panel for the American embassy. On another, I found Mohammad Ali firing small, glazed elephants for Maran Chand Paul.

Mohammad Ali's work began in 1978, the year he married. At the time, he made flowerpots and fired them with wood on an old-time kiln. Five years later, he secured a loan from BSCIC, added a gas-fired kiln, and began "imitating things from foreign countries." In 1987, when we met, his workshop was given primarily to flowerpots, made of shaped slabs joined inside tapering molds, then rimmed, exactly as they are in Kagajipara. Lead-glazed vases, ashtrays, and figures of birds comprised a small part of his production. But by 1995, he had abandoned flowerpots and turned exclusively to new forms. From Maran Chand's father to Mohammad Ali, the flowerpot passed through Rayer Bazar on its way to the villages.

Mohammad Ali is Rayer Bazar's only master who was not born in the place, who did not mature in his father's atelier, learning pottery at the same time he learned everything else, building bodily habits and intimate knowledge into his growth. Tradition is not merely a mental construct. Through the aesthetic it melds the mind and muscles; sensual and visceral as well as intellectual, tradition checks, channels, and eases action. Mohammad Ali's connection to the tradition is weakest. It follows that he has pressed modernization farthest. Little in him naturally resists change.

His techniques are modern. He uses a white china clay from Mymensingh. Forms are thrown, then shaved on foot-powered metal wheels, or they are molded. His workers press pale clay into each half of a plaster mold, buttering it thick at the joints, and using a third molding component to flatten the base. Then they work the leatherhard piece, erasing its seams and enhancing its details with carving. The ware is fired, glazed in the biscuit state, then fired a second time in a gas-burning kiln in which the heat reaches nine hundred and fifty or a thousand degrees centigrade. Pots on the old *puin* are fired once at about eight hundred degrees.

Mohammad Ali

Flowerpots drying in Mohammad Ali's workshop. Rayer Bazar, 1987

Mohammad Ali Workshop

Vase shaped like a fish, 1996.
Glazed; 11¾ in. tall

Pitcher

Venus de Milo.
For sale.
Pottery stall near the old High Court

His products are new. Some are designed for export: soup bowls, sugar bowls, and pitchers, English in form. More are made for the native market. Of these, some are figurines: horses, elephants, swans, and especially images, in five different sizes, of the Venus de Milo. She provides a fine instance of secularization in the decorative objects intended for the Bangladeshi middle class. A beautiful nude, she possesses the opulent body of a goddess, and, though a goddess in fact, she stands in the local context as decorative. At once familiar and exotic, the statue presents the vision of a goddess, stripped of sacred association, like Durga's lion brought to the earth by the naturalistic modeling of the masters of Khamarpara.

Within Mohammad Ali's output for domestic consumption, most plentiful are ashtrays and vases. The vase molded in the form of a conch shell carries evocative potential for Hindus. The conch is the trumpet of the gods; it sounds to dispel evil and it contains holy water at times of *puja*. The vase molded in the form of a fish, rising and opening its mouth for flowers, materializes a Bangladeshi symbol of life. A man of his place, Mohammad Ali has reached into the common stock of imagery, finding horses, elephants, shells, and fish that might signify to their buyers, but his motive, he says frankly, is commercial:

"Rich men buy flower vases from India, Japan, and China. But our vases are used by the common people. The price is cheap.

"People used to buy foreign flower vases, but now they are buying our things. So we are helping with foreign exchange, and our prices are cheap."

Mohammad Ali sees his economic enterprise as service to the nation. He offers employment at a time when people moving from the village to the city need work. He manufactures things for export, bringing foreign currency into Bangladesh. Even more, he competes in the local market, filling needs once filled by foreign commodities, keeping cash home, while supplying his fellow citizens with things they want at low prices.

His forms and technology are modern, but, associating himself with Maran Chand Paul's revitalizing vision, Mohammad Ali declares his products to be traditional. His argument for traditionality is not formal, like that of Maran Chand Paul who provides old things with new elegance. Nor is it technological, like that of American potters who stress continuities in shaping and firing. It is functional. The things he makes fill a traditional role; they occupy the conventional slot in life of *melar mal,* the toys people buy at festive markets. Once they bought wheeled horses and painted *kalshis*. Today the same people buy vases shaped like fish:

"There is great demand for the things we make. In the old days, in rural Bengal, traditional toys and dolls were made, *patils* were made.

"I am only improving the tradition. I am giving a new form to our tradition. People want change. They want change, they want new designs. For the taste of the modern age, I am making new designs. People do not like the old toys, so I am making new toys for the *melas.*

"These things are sold at the *melas,* in the country, in the city. They are sold in shops for handcraft and crockery in New Market."

Dividing tendencies in the present into old and new categories, then relocating much of the present into the past—a time when people wanted traditional toys, which many still do, and will continue to do for years—Mohammad Ali acts like any historian. He reduces complexity to a linear narrative, simplifying the present in a way that might make for bad history, but which promotes modernization while aiding in economic planning.

No one surpasses Mohammad Ali's entrepreneurial energy. Buildings jam the yard I remember as open. There is a big bamboo shed for molding in one corner, and next to it another shed with a metal wheel where molded pieces are finished. Warehouses fill the front of the space, leaving his pretty girls little room to play. Across the street, gas-fired kilns occupy the ground floor of the new apartment building where he lives with his wife, Shefali Begum, and their three daughters.

He is planning to move his operation. The road running past his workshop ends at the old bank along the floodplain where a small mosque stands. A new levee now holds the Buriganga on course to the west, and the low land, formerly cultivated, is filling with bamboo apartment buildings, rising on bamboo stilts above the sodden earth. The land reclaimed from the wild river has become valuable. Today bamboo buildings provide temporary housing for the poor, but apartments of brick and concrete and glass will rise here in time. A mound has been heaped on the swampy plain to lift a memorial to the martyrs massacred in Rayer Bazar by the Pakistani army in 1971. From the bank, a long, wobbly bamboo footbridge runs out, parallel to the old cremation ground, to reach another mound on which Mohammad Ali has erected a brick building for his new factory. It is surrounded by a bamboo tenement with single clean rooms he rents to poor men.

His move has begun. At one end of a large, brightly lit room, with trim masonry walls, a young man bends over a metal wheel. He works at the limit

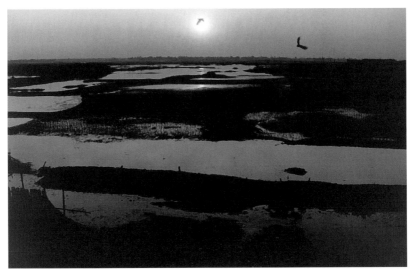

The floodplain. Rayer Bazar, 1989

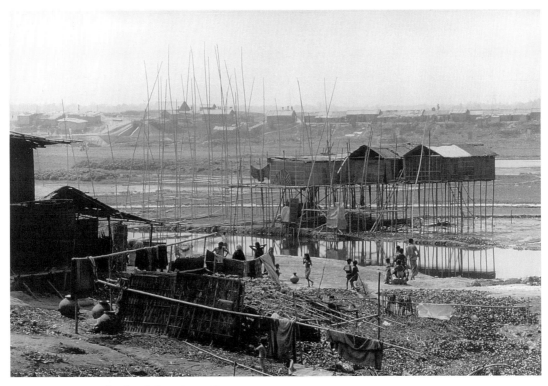

The floodplain. Rayer Bazar, 1995

Mohammad Ali's new workshop

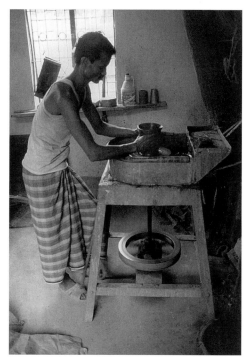

Nurul Haque
throwing on the pedal wheel
in Mohammad Ali's new workshop

of the modern in Bangladesh, but his body still supplies the power—his wheel is not run by a motor as it is so often in the contemporary world—and momentary control remains in the hands that shape the clay spun by his feet. At the room's other end, a slim woman in a sari treads the clay like any woman in a village. Clay preparation in the old style—no machines, only bending and treading—is one constant, founded on limited capital and abundant labor, that links old and new workshops.

Mohammad Ali calls his plan for the future commercial. It is to make glazed terracottas; the term is not contradictory among potters for whom "terracotta" means tiles sculpted in suites. On the tiles he will mold images from rural Bangladesh, keeping piles in stock so that prosperous people—rich, but not so rich as to be able to afford special commissions—can purchase terracotta revetments for their houses, adding an earthy local touch to buildings designed in the artificial and mechanical, international modern style.

"In Dhaka city," Mohammad Ali says, "new housing is going up. If I make terracottas, the new rich men will get things readymade from my factory." The building boom in Dhaka provides the setting for his scheme. The new middle class provides his market. His workforce and technology provide him the means. And he will create tiles that portray Bangladesh affectionately, popularizing for a new generation an ancient Bengali tradition.

Lal Chand Pal

When Maran Chand Paul classified the potters of Rayer Bazar by their work, he distinguished between the Bengali Pals who made vessels for water and the Rajmahali Pals who made vessels for food. With time, their work overlapped, but they remained distinct from the Pals who made *murtis* for worship. Maran Chand said that makers of *murtis* had vanished from Rayer Bazar, and yet two blocks north of his workshop, in the same position on the south side of a road going west to the river, Lal Chand Pal makes *murtis*. It is a clear indication of the separateness of his endeavor that no one mentioned him to me. We met by chance when I was mapping Rayer Bazar, one purpose of the map being precisely to insure completeness.

Everyone directed me to Krishna Ballab Pal's shop, calling it the last old-time *karkhana*, but Lal Chand Pal contends that his workshop is the oldest in Rayer Bazar. During one visit, he said it was built in the British period, when one *maund* of rice cost one *taka*. A year later, shoving history around to meet

Lal Chand Pal's home and workshop. A: Clay supply. B: *Stup*.
C: Kiln. D: *Chak*. E: Kitchen. F: Dwelling. The scale is in feet.

the interest I demonstrated by measuring his shop, he said it was built in the days of the Mughal emperor Jahangir, when sixteen *maunds* of rice cost one *taka*. Those were Lal Chand's ways to stress antiquity, and though Jahangir's reign in the early seventeenth century is about two and a half centuries too early, I believe him right when he says his small *karkhana* is Rayer Bazar's oldest. In a wealthy country, it would be designated a historic property.

Like the workshops of the village, and like the others in Rayer Bazar, Lal Chand Pal's shop is one building in a compound that includes the home. The earthen front wall follows the edge of the street. Inside, to the left of the door, his *chak* is lit by a low window. To the right stands his circular, wood-burning kiln. Clay is heaped at the far end by the toilet. A *stup* rises in front of the rooms that file along the rear to end in the kitchen by the courtyard. Across the narrow courtyard stands the house, its four spotless rooms embracing an intruded porch with an ornate column supporting the roof. Three of the rooms are for sleeping. Lal Chand and his wife, Haridasi Pal, have six daughters and two sons. The fourth room is the study of their daughter Saraswati, a brilliant student who alternates work at the clay with classes in college. Saraswati asked to have her picture taken there, and she changed into her school uniform and posed at her desk among her books.

On a green door in the rear of the shop, Lal Chand Pal chalks the orders for *murtis,* with the downpayments received and the dates of delivery. The orders come from Dhaka city and from Narayanganj and Munshiganj, just to the south.

I thought I knew the answer, but it is the ethnographer's duty to preserve the innocence of the student, so I asked Lal Chand to name the *murtis* he makes. For the Akhra Mandir, he has shaped the family of the Goddess: Durga, Saraswati, Lakshmi, Ganesh, and Kartikeya. Most often he sculpts single statues, and he listed them: Durga, Saraswati, Lakshmi, Manasa, and Haragauri, the fused image of Shiva and Parvati. I had also seen a Krishna by his hand, but Kali was absent. Assuming he had simply forgotten, but knowing nothing should be assumed, I asked. Lal Chand replied that he used to make *murtis* of Kali, but there are many Kalis, pressing in upon us, perpetually probing for weakness. Once while he was sculpting her image, Kali found a fissure in his mind, entered and drove him mad. His mind flew apart. He was rattled, confused, unable to recognize his wife and children. In a rare clear moment, he approached a holy man who interviewed him, discovered Kali to be the source of his insanity, and ordered him to cease sculpting her image. In a year, a year now long past, he was fully recovered.

While Lal Chand told his terrifying story, my friend Mohammad Salahuddin Ayub, a scholar of Bengali literature, was sitting on the bed where Lal Chand breaks from work for a comforting smoke. Salahuddin said that his madness had been like that of Kazi Nazrul Islam, and Lal Chand agreed. The Rebel Poet wrote wonderful hymns to Kali, and Kali broke into his mind and lured him away into darkness and silence.

Lal Chand Pal believes he was twelve years old during the famine of 1350—1943 by the Western calendar—so he was probably sixty-four when we met in 1995. His father, Amar Chand Sardar, was a man of importance, and he was a potter who specialized in ritual objects, modeling images of the snake goddess, Manasa, and constructing ornate crowns for weddings out of pith. Lal Chand was poor in his youth. For eight years he worked in a sweet shop, and he still confects delicate sweetmeats at times of *puja.* Then he returned to his father's house, to the shop where he works now, and continued to practice the potter's trade he had learned in his boyhood, making earthenware jugs, tumblers, and banks.

Today, Lal Chand Pal throws banks on the old hand-powered *chak,* but he spends most of his time molding tiles for roofs. Tiles, he says, make the best roofing, more permanent than thatch, cooler than tin, and handsome in appearance. The tiles he molds and fires are sent out through Dhaka as far as Khulna to the southwest and Sylhet to the northeast.

Tiles provide the steady drone of his life, filling the floor of his shop and the time between *murtis,* but they are not his true work. With his wife, with his daughter Saraswati and his son Panchananda, Lal Chand creates religious objects. He is busiest during the season of rain and harvest and *puja* that extends from July through October. A large image of Durga, requiring a month of modeling, molding, and painting, will bring him fifteen thousand *taka.* More of his trade is in small molded and painted *murtis* for domestic worship that fetch, depending upon size and complexity, from one hundred to three hundred *taka.*

Murtis are not his only product. From Old Dhaka especially, people come to Lal Chand Pal to buy all the things they need for rituals, such as the earthenware plates in which sweets are served at weddings, and the earthenware *dhupdanis* in which incense is set alight and brushed upon the air before the deity. Still vulnerable, Lal Chand will not come into direct contact with Kali, but he makes the objects with which others serve her at times of *puja:* the earthenware bell that calls her attention, the jar that holds her water and mango leaves, the small *patils* in two sizes in which she is given sweets, the painted

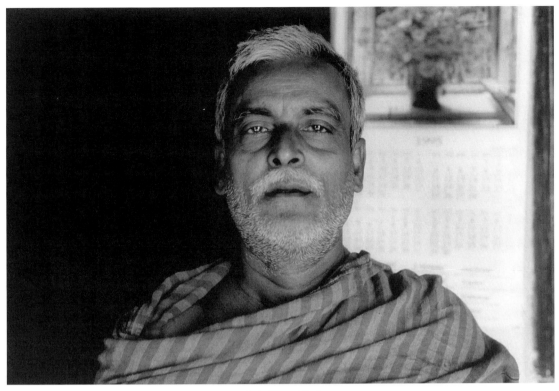

Lal Chand Pal

Saraswati Pal

Saraswati.
By Lal Chand Pal, 1995.
Painted clay; 15½ in. tall.
This is the larger of the two
molded *murtis* of Saraswati
that Lal Chand Pal makes in
Rayer Bazar for the *puja*
of the goddess of wisdom.

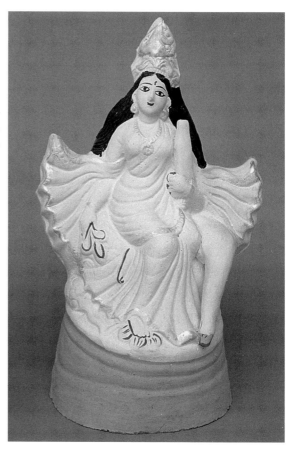

Nouka.
Dish for Kali Puja.
By Lal Chand Pal, 1995.
Painted earthenware; 8½ in. long

dish called a *nouka,* a boat, in which she is offered puffed rice of the kind that Muslims eat to break the fasts of Ramadan. Of sugar, Lal Chand shapes images of the noble beasts, horses and elephants, for insatiable Kali to consume. His creations are not for Hindus alone. Lal Chand makes the earthenware tumblers in which water is distributed among Muslims during Muharram when the martyrdom of the Prophet's grandson at Kerbala is recalled in grief.

In 1972, Lal Chand Pal sculpted an image of Durga standing upon a country boat, and presented it to Bangabandhu Sheikh Mujibur Rahman. Power upon power. Durga is the Goddess in triumph, killer of the demon who menaced the home of the gods. The boat is one symbol of the country—like the oxcart or village, a sign of the presence of the common people—and it is the emblem of the Awami League, Sheikh Mujib's party. In creating out of his ancient craft an image of victory for the new nation, Lal Chand combined force with force and set them in order. Replacing the lion with a boat, he made a political party into the *vahana* of the Goddess, and argued in clay for the superiority of a power that is not human. Bangabandhu gave him a woolen shawl that remains a treasured possession.

Lal Chand Pal complicates and completes the story. In our days in Bangladesh, the modernizing, revitalizing, and maintaining dynamics all have their artists, their skilled practitioners. The artist succeeds today by innovation. Some like Mohammad Ali advance by novelty. Others like Maran Chand Paul progress recursively. And the artist succeeds today by maintaining equilibrium amid change. Within the oldest tradition, a role had always existed for gifted individuals who put their talents in service to the sacred, as Babu Lal Pal does in Khamarpara, as Lal Chand Pal does in Rayer Bazar. There is no decline in the demand for the beautiful objects they make, the tools modern people use to cross the divide between the little realm of the senses and the vast realm of power.

Another Year

During the spring of 1995, I frequently visited the workshop of Krishna Ballab Pal. I was drawn by affection for Gauranga Chandra Pal, a lovely man, and I was drawn by a documentary obligation. Change is the constant state of affairs, always has been, but that is an urgent reason to record, and not an excuse to relax. The last of Rayer Bazar's big clay *karkhanas* in which *patils* were made, Krishna Ballab Pal's shop deserved careful documentation. It was a piece of the present that cast light on the past, and its future seemed bleak. I was not

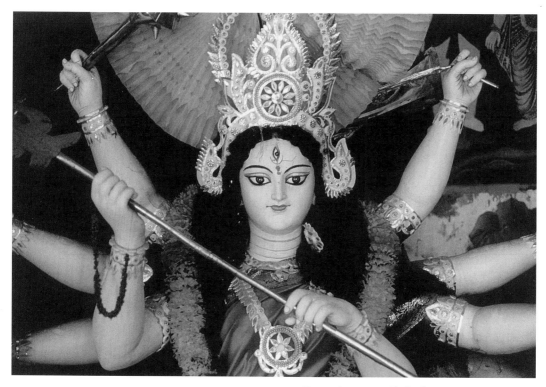

Durga by Biren Chakrabarti.
Akhra Mandir. Rayer Bazar, 1996

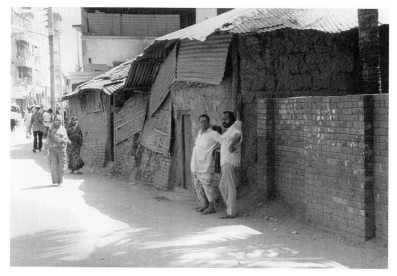

Krishna Ballab Pal's workshop, 1996

surprised when I came a year later and found its roof collapsed, its interior dark and silent. Gauranga met me there, in the scene of his life's work, in the dusty beginning of an archaeological site. He told me that pottery was labor too hard for the current generation. The shop was done. I gave him the photographs I had taken of him, and we embraced. He had now, he said, only one reason to live, and that was to see this book. The one who writes about the living has extra reasons to keep going, late at night, when the body complains.

Not all change was decline. Mohammad Ali had torn away the sheds in the front of his yard and built a raised earthen road out to his new shop on the old floodplain. His move to modernization continues. We sat with cold drinks in the refurbished front room of Maran Chand Paul's shop. Sheer, solid masonry walls enclosed us. The shelves were laden with ware, with slip-trailed vases, with small horses and elephants. Mohammad Ali and Maran Chand said that things were no worse.

I wandered about, distributing photographs and catching up. Shambhunath Pal had leveled the kiln in his old shop and turned exclusively to making *tanduris*. Fulkumari Pal and Gita Rani Pal were in place at work, and one more shop for *tanduris* had opened. On Jafarabad Road, a silversmith had added a display of Chittaranjan Pal's earthenware animals for sale. But I noted in Rayer Bazar, and in the stalls by the old High Court, an absence of banks shaped like fruit. They seem to be following the deities and poets out of the urban market, leaving a void to be filled with vases shaped like fish. In the middle of Rayer Bazar, young Ramrup Pal, the son of a goldsmith, the grandson of a potter, had established, just three months before, a new store selling utilitarian pottery. The deep yard behind his shop was stacked with *kalshis* and *patils* from Faridpur, Bikrampur, Barisal, and Dhamrai.

The most notable change in Rayer Bazar affirmed the spirit asserted a year before at Saraswati Puja. In a visible demonstration of Hindu presence, the open space in front of the Akhra Mandir had been enclosed by a stout masonry wall. A fortress has risen at the heart of Rayer Bazar. At its eastern end, a new concrete temple, still lacking its roof, had been dedicated to Durga, the Goddess in victory, during her *puja* in October 1995. In an extravagant gesture, a famed artist, Biren Chakrabarti, had been brought from Calcutta to create the *murtis* for the dedication ceremony. Residue from his creative flurry littered the courtyard of the Akhra Mandir, and on the porch, awaiting immersion, stood Saraswati, Lakshmi, Ganesh, Kartikeya, and Durga, no worry on her golden face, her hands filled with silver weapons.

305

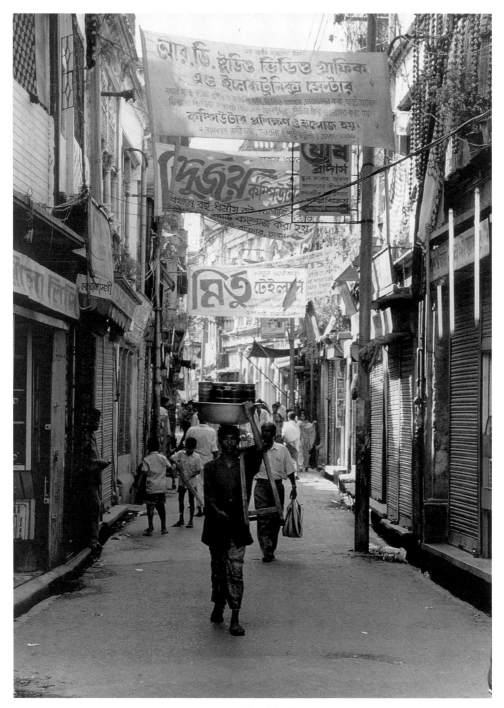

Shankharibazar

·6·

Shankharibazar

ACTION ALONG THE waterfront of Old Dhaka concentrates in the city's most ancient section, between Babu Bazar Ghat and Sadar Ghat on the Buriganga. Just inland, Islampur Road, named for Islam Khan, Dhaka's first Mughal governor, parallels the river between these points, carrying commerce in textiles for its length. Toward the east, textiles mingle with the overflow from Tanti Bazar. Once the weavers' market—*tanti* means weaver—it is now a place for silversmiths and goldsmiths, some of them Muslim, more of them Hindu. A temple stands to the south, and another, the Basudev Mandir, anchors the center where the line of jewelers' shops slips east, mixes with general trade, and then continues north along Tanti Bazar to the English Road. At the complex intersection where textiles meet silver, a third street strikes eastward. This is Shankharibazar, a neighborhood said to be four hundred years old.

The narrow street, walled on each side by a continuous run of tall buildings, is an architectural treasure, deserving recording and preservation. Shankharibazar is a coherent piece of old urban fabric, brought to life in craft and commerce and worship. A temple blends into the wall at each end of the street, a third stands back in the middle, on an alley going into a courtyard.

Slim, deep buildings, pressed flank to flank, offer shops to the front: an open arcaded porch where men work, or a store jammed with goods for sale. A corridor, just wide enough for walking, jogs around the shop, leading from the busy bright street to the dark silent interior. I was told the corridors were made narrow to protect the inhabitants from the pirates who once plundered the waterfront. There is no reason to doubt the explanation (though saving space

307

would suffice), but the need for an explanation shows that I am not alone in feeling the corridors to be strangely narrow. On the ground floor, behind the shop, small gloomy rooms enclose men bent over their work. From the corridor, a stair ascends to the floors above, where the people live. You leave your shoes in a vestibule and enter. Each crisp room is dominated by an enormous bedstead. The walls, plastered smoothly over brick, are tinted to cool hues of blue or green, touched for contrast with pink or red. Niches inlet in the walls contain the television and gleaming, unornamented vessels of brass. The ceilings are high. A high niche holds a *murti,* and above the stuccoed cornice, heavy joists, set close, make the ceiling of this room, the floor of the room above, and help explain the ponderous stasis of the building. Internal spaces lack windows, and the passageways are so tight, the walls so massive, that the rooms feel as though they were cubical voids hewn out of a solid block of masonry.

Life is drawn upward to the breezy roof. There women relax from their work in the apartments below and a small temple stands. The building is like a village, compressed and upended, its industry and commerce on the bottom, accessible through the street to the world, its *baris* piled above, its temple dropped on top.

Shankharibazar is the market for *shankhashilpa,* conch-shell art. Near the middle of the street, the Shankhashilpa Karigar Samiti—The Conch-Shell Art Artisans' Society—has its headquarters, managed by Gopal Chandra Roy. In the back room, heavy with the odor of the ocean, conch shells brought from Sri Lanka have their ends and flanges knocked off with a hammer. Until about 1990, in work I have seen, the shells were then sliced by a man swinging a heavy half-moon saw, rocking it back and forth through the white case of the shell. Now two men with electric saws cut the tapered end on a bias, and five men, hunched over electric motors rigged with circular saws, use shims while shoving the bulk through the blade to cut pairs of shell circles. They will be cleaned out and then decorated to become the bracelets worn, one on each wrist, by married Hindu women.

The pairs of rings, sawed in the Society's shop, are distributed to *karkhanas* scattered for the length of the street. In each one, in porches to the front and rooms to the rear, men, usually sitting in pairs for company, straddle wooden anvils and stroke sharp files into the surface of the shell. They say they know fifty or sixty designs, all held in the head, and they work like engravers of brass, marking points to set symmetry, and then filling the pattern with detail.

Shankharibazar

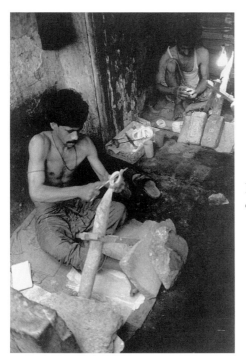

Khokan Nandi
decorating conch-shell bracelets

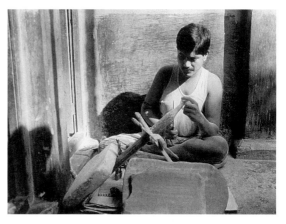

Shiva Narayan

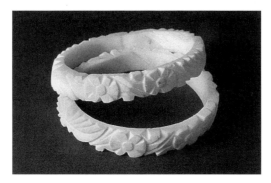

Bracelets.
By Shiva Narayan, 1995
Conch shell; 2½ in. diameter

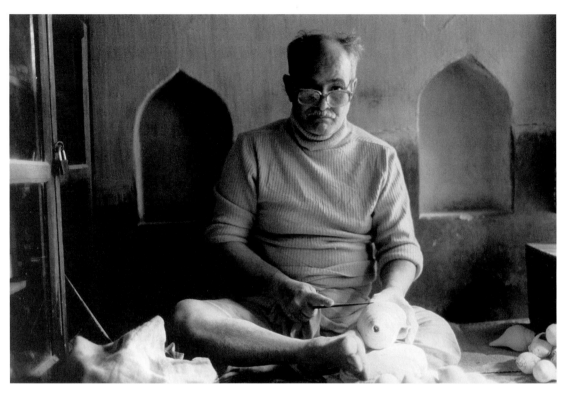

Tarakeswar Datta

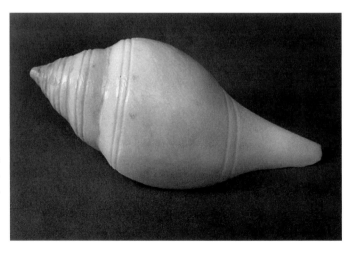

Vessel for holy water.
Sukanta Nag workshop.
Shankharibazar, 1995.
Carved conch shell; 5¼ in. long

Quickly flipping the ring over the horn of the anvil, first one way, then the other, they drive hard with the file, cutting matching designs in each member of the pair. The job is finished by one man who dabs filler into minuscule pits to make the surface smooth, and another who whitens and brightens it with a chemical solution.

I had been to Shankharibazar several times before, attracted by its crowds and high energy, but I learned the most about conch-shell art when I visited with Shipra and Biswajit Ghosh. The conch-shell bracelet provides—like pottery in Rayer Bazar—a clear instance of the complications in current history. Many women, acting in a spirit of maintenance, continue to wear them because it has always been done, since the mythic moment when Shiva gave Parvati the first bracelets of conch shell. Because the custom is old-fashioned, and because conch-shell bracelets mark a woman as Hindu, as well as married, some women, moving with the tide of modernization, have ceased wearing them, while others, intellectuals like Shipra, acting in a spirit of revitalization, wear them proudly. In the context of communal tension, some retreat into hiding and others stand forth boldly.

In Hinduism, it seems, the conch shell is generally associated with Vishnu, but on Shankharibazar, I find it tied most closely to Shiva. The sound of the conch shell, blown like a trumpet, is the sound of Shiva, the sound of pure goodness. On Shankharibazar, conch shells are not only sliced and filed into bracelets, they are smoothed and carved, by masters like Tarakeswar Datta, into horns blown at times of *puja* and danger, during earthquakes and storms, to clear the air of evil. And conch shells are smoothed and carved into receptacles in which water is held during worship. Conch shells lie among the bowls of water and flowers at the feet of the deities in the temples.

A product of the water, like the seafoam on the beach, the conch shell is the symbolic analog of the lotus, the flower that blooms on the surface of the water. A seat, a place to sit and rest, is the first gift of hospitality in Bangladesh. Acting properly, respectfully, people give the deity a seat for her *puja*. The clay *murti* is that seat, and in it the deity is portrayed upon a seat. It might be the deity's *vahana*—the lion of Durga, the donkey of Sitala—but it is often a lotus. In the ancient tradition, the lotus is associated with bountiful Lakshmi, as the conch shell is associated with her mate Vishnu, suggesting that the lotus and conch shell are the female and male embodiments of one idea. But for centuries the lotus base has been conventional for images of the deities, and today in Bangladesh, Saraswati and Ganesh, as well as Lakshmi, sit lightly

upon the lotus, rising from it as it rises from the water. As in Lal Chand Pal's image of Durga borne in a boat above the water, power rests upon power. The lotus manifests in beautiful form the power of water. The deity manifests in beautiful form the power of all creation. Beneath the deity—in, for example, the *murti* made for Saraswati Puja—the conch shell may be substituted for the lotus. They are semantically alike. On Shankharibazar, the shell that holds water, the palpable sign of power, is often carved with a lotus in relief. The shell, like the lotus, is the beautiful yield of water, and water is—for the Muslim as well as the Hindu—the source of life. This evocative richness—the associations with Shiva, with goodness, with water—makes the conch shell a sacred substance to be fashioned into artifacts that carry power through daily life. I was told that conch-shell bracelets protect and enhance the health of the women who wear them.

The front of Sukanta Nag's shop is open to the street. Past it a corridor leads to the back rooms where his workers file and polish bracelets. A door from the corridor opens into the side of his shop, where his customers can sit, where he has drawers full of bracelets, tied by thread into pairs, and a few shells to blow and hold water. Sukanta knows English, and he laments the decline in the quality of his ware. None of the shells, carved for him by women who work in their homes, attempts the complexity of the old examples on display in the National Museum. The best artists, he says, have all gone to India. A handsome woman, his customer, sitting beside me and listening to us, remarks sadly, "Everyone is going to India. Slowly."

The story they tell on Shankharibazar in Old Dhaka is like the one they tell in Rayer Bazar. At the end of the British period, they say, there were four or five hundred families in the conch-shell trade. Now estimates vary from twenty to twenty-five *karkhanas*. One craft goes, another comes. Potters are replaced by silversmiths and tailors in Rayer Bazar, weavers by jewelers on Tanti Bazar. On Shankharibazar, other artisans have filled in. They make musical instruments: drums, harmoniums, and *vinas*. They shape crowns of pith for weddings, like those worn by the gods. They chisel stone. Young men peck the grinding stones that are useful in food preparation and symbolic in Hindu weddings. Muslims carve marble with business names in Bangla and the names of God and the Prophet in Arabic.

As in Rayer Bazar, the old trade declines, new trades arise, and action drifts toward commerce. Not long ago, metal vessels were made in quantity along the back alleys off Shankharibazar, but Guru Chandra Mandal, a smith

reduced from creation to repair by the expense of his material, says that the artisans have crossed the Buriganga to Zinzira, seeking cheaper sites for labor, and the need among Hindus for brass vessels is filled now by craftsmen working outside of Dhaka city, in Zinzira, Tangail, and Faridpur.

Filing shell and pecking rock, artisans work along Shankharibazar. Handcraft gives the place its vibrant feel, and the Hindu tone is maintained by shops selling images of the deities: cast-brass figures, largely of Krishna and imported from India, and colorful prints, framed here by boys sawing through miter boxes. Stores fill with glittery hangings and strings of lights for *pujas*. One rents costumes for traditional theater. Jewelers' shops cluster toward the west, little restaurants filter through the string of buildings, and the crowd moves and mills in the street.

Haripada Pal

On my first visit to Shankharibazar, I caught a glimpse of a deep blue interior. My knowledgeable guide refused to stop, saying the shop was of no importance, and we hurried on through the crowd to sit with tea in the home of one of his friends. But the instincts nurtured in me through years of fieldwork had been aroused, and once my companion found a rickshaw and left, I returned. No matter how slowly I moved, I could not find the place again. I did not forget, and on subsequent visits, as soon as I passed the Shankharibazar Kali Mandir, I would slow down and peer into every dark doorway. I found men making drums of wood and crowns of pith and bracelets of shell, but I could not find the shop in which I thought I saw men making *murtis* of clay.

When spring vacation broke the semester, my wife and youngest daughter came to Dhaka. They had been to Bangladesh with me before, but I was anxious to share my new knowledge with them. I let them rest only one day before taking them to Shankharibazar because it was Holi, the first day of spring, an exciting time to see the place. Our long rickshaw ride ended at Tanti Bazar and we walked. Passing the shops of jewelers, we were stopped at the little Basudev Mandir to receive *prasad*. Our foreheads were spotted with red. It was hot, and the red ran with the sweat, pulling us into the play of the boys with purple faces who ran through the streets, collapsing in giggles, drenching one another and splashing passersby with red and blue dye.

This time the door was open, and I did not miss my chance. Inside, a man was gently modeling an image of Sitala, the goddess of smallpox. He took in

stride the bizarre appearance of an authentic American family, emerging out of the glare of the street, tall, pale, and dripping with color.

There were no windows, no breath of motion in the air. The shop is maintained in intense humidity to keep the clay moist for working. My excitement increased the flow of sweat that ran color from my face into my sodden shirt. Jatish Chandra Pal offered us a seat, but I was in motion, perplexing him with an inept account of my appreciation. Along the back wall of the small blue room, a glass-fronted case contained a dusty jumble of images, including two of Rabindranath Tagore, one of Christ, and a lovely, shopworn statue of Radha and Krishna, all unusually realistic and highly professional. Soon I had bought, for one hundred and one *taka,* an image of Saraswati, left over from her *puja,* and Jatish had gone to fetch the master, the *ustad,* so he could deal with us.

When Haripada Pal arrived he was calm and cordial. Bengalis say that they do not smile, a generalization confirmed by my photographs, but smiles burst easily and frequently on the lively face of Haripada Pal. He sent a boy for cold drinks, got me to sit, and explained his work. He makes small molded and painted images for domestic worship, like the Saraswati I had bought. He makes larger, hand-modeled images for public *pujas,* like the Sitala that Jatish was patiently smoothing. And he makes on commission permanent images for temples. Divine power, he said, remains in the *murti* so long as it is offered water and flowers. During *pujas,* veneration lasts for a day in the case of Saraswati or a week in the case of Durga, and then, immediately in the case of Durga, after a year in the case of Saraswati, the *murti* is borne to the water in a jubilant procession and sacrificed through immersion. But an image of unfired clay can be preserved indefinitely in a temple, so long as fresh offerings continue, so long as water is brought to the *murti.*

Haripada Pal's cramped, damp shop, a step off the dusty street, is as close as one can come today to experiencing the atelier of a Renaissance master. Assisted by his worker, his uncle Jatish, Haripada makes quantities of small conventional icons between the major commissions that incarnate his signature. He peeled the cover away from his work in progress, a large "wall plate" in relief that he was creating for the neighboring temple to Kali. Flowing and folding, smooth, undulant surfaces shaped into the beautiful face of Krishna. My wife, Kathleen A. Foster, is a real art historian, the author of many books on nineteenth-century academic art. Sometimes she must indulge my enthusiasm for the brave efforts of impecunious artisans. Not this time. Standing in perspiration before Haripada's marvelous Krishna, she said she believed him

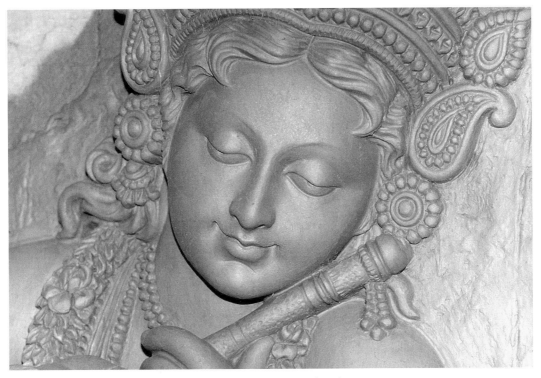

Krishna by Haripada Pal.
Shankharibazar, 1995

to be one of the finest sculptors at work in the modern world. Jetlag had overtaken our daughter Ellen Adair. Carrying Haripada's Saraswati, a fragile, commonplace embodiment of Haripada's spirit, we packed into a rickshaw and returned home. The first of many visits was over.

Haripada Pal was born in Norpara. His village stands on a long mound of jungle, off the road to the right when you pass out of Shimulia on the way to Khamarpara, where the big horses are made. Today there are seventy-four households of Pals in Norpara. Most of the people make *kalshis* and *patils* in astonishing numbers, but in a tenth of the *baris* there are sculptors of *murtis*— about the same proportion that obtains in Kagajipara. Haripada says he is a Pal of the kind who makes *murtis*.

In a prominent place, near the entry to the village, Haripada has built a tall temple for his family's *pujas*. In the adjacent *bari*, Haripada was born to receive his family's tradition. His father, Thakur Das Pal, is called Jhar Chandra Pal because he was born in the year of a great storm. *Jhar* means storm, and the year was 1326, so Jhar Chandra Pal was seventy-seven when I went to Norpara, in 1996, to meet him and learn more about Haripada. Jhar learned from his father, Niroda Prasad Pal, who was, he said, the region's great artist. He, in turn, learned from his father, Judhistir Pal, who had learned from his father, Chandranath Pal, and then the line runs out of memory. "Our grandfathers' grandfathers did *murti* work," Jhar said, and he listed the images: Durga, Kali, Narayan, Saraswati, Lakshmi, and Bashanti. Narayan is Vishnu, and Bashanti is an image in the form of Durga, made to invite the Goddess to her *puja*.

Jhar Chandra Pal had three brothers. One is deceased and two are living. One of them is Jatish Chandra Pal, Haripada's assistant. Jatish was trained by Niroda Prasad Pal, and so was Haripada. Shared instruction eases their cooperation. In making *murtis*, Jatish usually models the bodies, while Haripada shapes the faces and hands, and the parts blend to perfection. Haripada had two brothers. One disappeared into India about 1980. His younger brother, Paltan, has a shop in Bangla Bazar, Old Dhaka, where he makes *murtis*. When I asked Jhar if Haripada showed signs of his talent in his childhood, he smiled, nodded his head in amazed remembrance, and said Haripada always loved art.

Often when we talked in his shop in Dhaka, men would stop by to greet him, then stay to listen for a while. Haripada is an engaging teacher. One of those visitors, Gopal Datta, told me that Haripada is the best sculptor in all of Bangladesh, and if he had been born in a rich country, instead of a poor one, he would be a rich and famous man. Haripada attributes his lack of wealth to

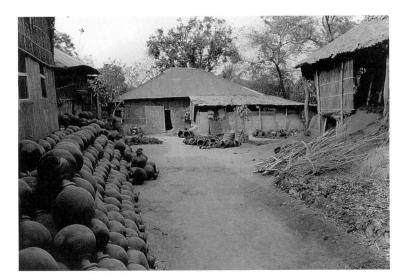

Norpara, Shimulia

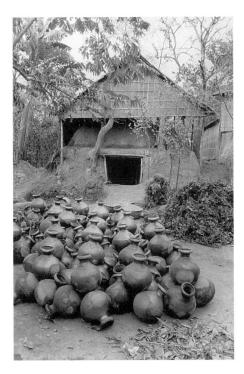

Kiln and *kalshis*

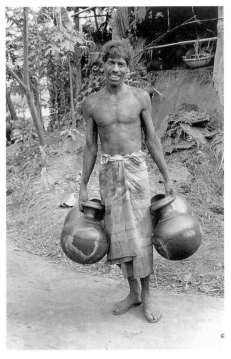

Chaitanya Pal

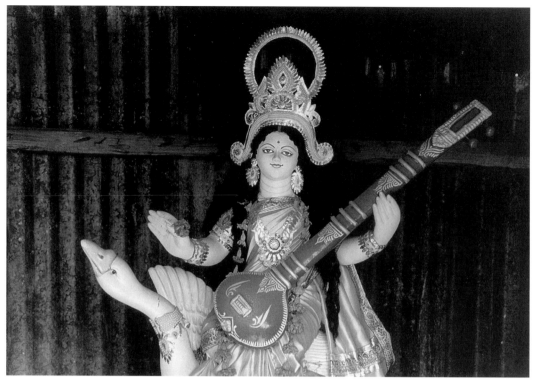

Saraswati by Haripada Pal

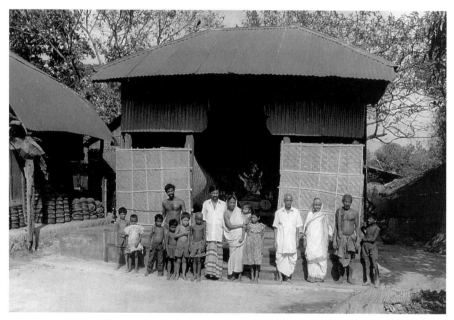

Haripada Pal's family temple, Norpara.
His relatives gather in front; his mother and father stand together toward the right.

his birth in a poor village, but he is not resentful; he is proud of what he has accomplished, given his beginnings. Although he has worked most of his life in the city, Haripada emphasizes his rural origins. On his business card, he calls his tiny shop The Art Abode of the Sculptor from Shimulia. He named his son Shimul. Of the next in the line, Haripada said:

"I have only one son. He reads in class nine. He has no interest in this line. And I also do not encourage him to do this work. If he does not enjoy the work mentally, I should not insist.

"I have my wife. She deserves to have more children. It would be good to have another child. But I told her that everything is one. The main purpose will be served by one child.

"To come into this world is to become involved in different activities. Now, if I say to do good work, and you do bad work, it will be harmful."

Being alive, stuck in this world, we must work at something, but if Haripada's son does not enjoy his father's trade, then forcing him against his will would not only make him unhappy, it might bring, through his unhappiness, bad work into the world that would disrupt the harmonious order the artist strives to enhance. It would be harmful in particular and harmful in general. His son must pursue a profession through which he will be able to contribute to goodness:

"So I want to make my son a perfect man. Now, I do not know whether God will make him a man. If he does not become a good man, then there will be no good in the world."

The future depends upon good people. Through his profession, Haripada has pushed toward becoming a perfect man, one who brings good into the world. He works in a crowded city, using clay he brings from his village, using the skills he learned from his beloved grandfather, to make images that people use to make connections with the sacred power that provides them with blessings and urges them toward virtue.

Haripada uses his native clay and talent to fill orders from urban temples. Sometimes a rich man endows a *murti,* but more often, Haripada stresses, he works for the whole community. Accumulating small donations from many people, the executive committee of the temple commissions a *murti* that will stand in public to benefit everyone. Haripada gathers ideas from the past, then during performance he presses them through the narrow, particular aperture of the self, shaping them anew for presence within society where they will help to make the future endurable.

His work is ordered by a patron, and, Haripada says, the patron is always pleased. Satisfaction might be guaranteed by detailed directions; the patron might employ the craftsman as a device by which he realizes his own desires. Such is the case in scenes of disorder. But when—and it is a good thing for art and artists alike that this is more usual—the patron and artist share culture, when they have matured through experience into compatible understandings of form, meaning, and value, then there is little need for instructions or plans. Satisfaction unfolds from cultural congruence. Haripada says he receives no instruction from his patrons. They name a deity. They have a sum of money. More information is unnecessary, and they are always pleased, Haripada says, because he has received from God the blessing of talent, the ability to make things people like, and because he has received, also as a blessing from God, the ability to know what the patron wants. There is no need for elaborate words between them.

Unfolding from God's blessings through the mind and hands of Haripada Pal, the *murti* stands in the world to bring people into contact with power. In contact, they receive blessings, gifts like Haripada's talents, and they are drawn toward duty, encouraged to perform acts for other people that, like Haripada's images, sustain harmony and marble existence with goodness.

The Artist's Life

At the beginning of March in 1996, Shamsuzzaman Khan sent me a fax, saying it would be better for me not to come to Bangladesh. A general strike had been called. Designed to bring the government down (which it eventually did), the strike would close offices and banish motor vehicles from the streets. Travel would be difficult, there would be demonstrations, perhaps violence. But it was time for me to come. My writing had generated a list of questions, and, above all, I wanted to record an interview with Haripada Pal. He is a man skilled with words as well as clay. Our many conversations had convinced me that a statement from him should be preserved in print, and I had been building this book as a stage for his performance.

The dangerous time turned out to be pleasant and productive. The absence of engines and exhaust rendered the streets quiet, the traffic calm, the long rickshaw rides delightful. On one soft night, returning from dinner at a friend's home in Old Dhaka, I could hear the cheers across the hushed city as people watching television greeted each run in Sri Lanka's defeat of Australia

in the cricket finals. The disruption in commerce and work meant the artists were home and free to talk, and my colleagues found helping me a way to pass the time. My old friend John McGuigan had come with me to see Bangladesh. It is worth seeing.

We gathered Shafique Chowdhury and Mohammad Salahuddin Ayub and went to see Haripada Pal. He had received my letter. The photographs pleased him, and he was anxious to make his statement to the world. Haripada covered the *murti* in progress with plastic to keep it moist, flicked on a fan to stir the air, and we sat down together. John ran the recorder. Shafique and Salahuddin, as I had asked, did not interrupt with questions, but held themselves in attitudes of interest. Given the animation of Haripada's delivery, the energy with which his gestures shaped the air around his words, their job was not hard. As is usual with me, the machine stood in plain view (reminding him that he was speaking generally, and not in confidence to a few friends), and I was interviewing someone I knew well. I had no questions, but rather a few requests, invitations to create verbally.

Haripada needed no prompting, no cues along the way. With each topic, which I raised and Shafique recast into reasonable Bangla, he was off, talking rapidly but so clearly I found him easy to follow. He sat with his back straight, his eyes bright, speaking directly to me, often taking my hand in his while his words flowed and the tape rolled. In response to our requests, Haripada shaped a fourfold statement that met my highest hopes.

Haripada was done. Our task was set. Shafique skipped sleep to hammer out a transcript, and then we gathered on consecutive dawns at a table in my room and drove through the day, pausing for sustenance, and then getting back to it, experiencing the giddy euphoria of close, concerted effort. Shamsuzzaman Khan stopped by, Salahuddin joined in, and Shafique was always there. Listening to the tape and reading Shafique's transcription, we struggled for precision, word by word, creating a collective translation. Haripada has a rich vocabulary; he often selected a lofty word to express himself in Bangla, and I tried to preserve his tone in English. Then we returned to Haripada to ask for clarification, point by point, drawing him into the collaboration our translation represents.

First, I asked Haripada to tell the story of his life. He began with his birth and proceeded with an autobiography, the story of a village boy's quest to master his art. His life runs like an eighteenth-century biographical novel, accumulating incident as the hero careers from place to place on the picaresque

321

journey of his passion. In telling his tale, Haripada employs a tactic that I have encountered often when recording personal narratives, in Turkey and Ireland as well as the United States. He asserts the main point, so the outline of his narrative will be sharp, so the story will be told even if he is interrupted. Then seeing interest sustained in our eyes, receiving no requests to hurry on to other topics, he backtracks to fill in the detail that explains his point, and then goes on. The tale spirals forward.

This is what he said on March 11, 1996, without omission, shuffling, or emendation. Though he digresses occasionally to explain words he thinks I might not know, much remains inchoate, so I intervene in the flow of his quoted words to amplify with understandings derived from other conversations, and in particular the one that followed our translation. Haripada Pal begins:

"My birthdate I do not know exactly. My father, maybe, knows it.

"It is the custom in the village that some can remember and some cannot remember. It is a custom within the Hindu community to write genealogies. But in village locations, many people do not write genealogies, and they forget the date of birth. It is not written. Under the circumstances, I cannot exactly say in which year I was born."

It is testimony to what matters that a man so self-conscious as to begin his story with the date of his birth would never have bothered to ask his father what that date was. Haripada said his father might know. I asked Jhar Chandra Pal, and he said he did not know but that his wife, Mata Rani Pal, might know. So I asked her and she did. Haripada was born four years after the terrible famine of 1350. Haripada was forty-nine when he spoke, beginning his story by emphasizing his origins in a poor, remote village, where genealogical records are not kept, and where he learned his art in boyhood:

"My work is hereditary, and by birth. My grandfather used to do it, and after my grandfather, my father.

"The name of my grandfather is Niroda Prasad Pal. The true name of my father is Thakur Das Pal, but he is called Jhar Chandra Pal. He always used to make *murtis,* and this and that.

"We had a business of *hari-patil.* My dad used to do it. My father did it. Then always in season, he used to make *murtis* to maintain his family. When I was there—my grandfather was very interested in all these matters, in the making of art.

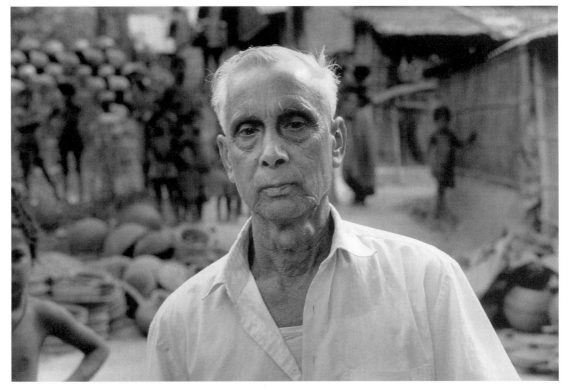

Jhar Chandra Pal

"Then I always stayed with him. My grandfather would hug me and help me get to sleep. He had a fascination for different varieties of work, and he wanted to know which kind of work I most loved.

"My grandfather wanted to help me. And I used to sleep with him. I want to say that my mother did not nurture me or care about me very much in my childhood. But my grandfather did everything for me. What a mother should do, was done by my grandfather. And my grandfather taught me this art by hand.

"Then I used to make the *murtis* of Durga, Saraswati, Lakshmi, Ganesh. These ceremonial *murtis* for *pujas,* which were made in season for every festival—these I used to make. And my grandfather taught me to make these *murtis* by hand. And I liked it. I also liked it."

Twice Haripada says that his grandfather taught him *hate dore,* by hand. When I asked later precisely what that meant, he said his grandfather taught him by direct demonstration. Saying few words, he held his grandson on his lap and moved his big hand above the small one, teaching by touch, so that instruction registered through sensation in the fingertips and muscles. During the educational process, Niroda Prasad Pal was experimenting, discovering which kind of work his grandson enjoyed. Haripada learned from his grandfather; he does not force his son against his wishes. The teacher must find the natural inclination in the pupil, then guide it gently toward perfection. When he says, "I also liked it," Haripada means that he liked the work his grandfather liked, the making of *murtis.* But following his own desire on his grandfather's path, exemplifying the common pattern in which arts skip generations, Haripada ran counter to his father's wishes for him. Jhar wanted him to go to school, where he was unhappy, and from which, at examination time, he escaped:

"When I became interested in this, my father became anxious about my education. But, in the end, I did not enjoy school. Sometimes I became upset, and my education ended when I was in class nine.

"I developed an inclination to leave the village. I wanted to come out. During that time, there was no general tendency to leave the village and go to Dhaka city.

"But I had a strong desire to go to town, and to see what happens there. And then I developed an interest in doing something much better, to make art of a higher quality than I had been doing before.

"And I developed a desire to show what I could do and to learn more.

After developing this feeling, I came to Dhaka with the help of a man I knew. With his help, I came to Dhaka, I suppose in sixty-two or sixty-three."

Haripada's quest had begun. At a time when it was unusual for village boys to go to the city, when he was only fifteen or sixteen, he came to Dhaka to demonstrate his talent and improve his art. He had learned what he could in the village. Haripada moved into a Hindu neighborhood in Old Dhaka and began practicing his rural craft in the city:

"After coming to Dhaka, I came to number sixteen, Tanti Bazar, and stayed in the house of Sudhir Dey, or Sudhir Babu; he was a goldsmith. After coming to Dhaka, I began working during the season, making *murtis*. And then slowly I moved to number twenty-eight, Shankharibazar.

"There is a *sadhu* (that means a holy man); the name of the *sadhu* is Surendra Chandra Sarkar. He lived in number twenty-eight, Shankharibazar. The *sadhu* used to make *dalpuri;* it was very tasty. This *sadhu* used to treat smallpox. He attended his patients through *sadhana*. He was a good healer of smallpox. That *sadhu* used to worship the goddess Sitala."

The beautiful Sitala, the goddess of smallpox, rides a donkey because donkeys eradicate smallpox bacteria. The *sadhu*, whom Haripada later likened to a Muslim *pir*, pleased his young friend with breakfasts of *dalpuri*, spicy flatbread with lentils, and he cured smallpox through *sadhana,* ascetic exercises that bring the blessing of health to the sufferer. In the company of the *sadhu*, Haripada developed his rich interpretation of the *murti,* our next topic. The *sadhu* was drawn to Haripada through his art, and he commissioned from him a *murti* of Sitala, which remains one of Haripada's specialties:

"When I came to Tanti Bazar, he was pleased to see my *murtis*. He was attracted. Then he became attracted to my work. I was young. Then he says, 'You come to my house and make a *murti* for me.' Then I came here, to Shankharibazar.

"I used to work at different places—away from here. And then again I would return here, and I lived in his house. I used to call the *sadhu* my big brother. And he used to love me like a little brother. When the friendship between me and the *sadhu* became deep, I began to live in his house.

"And I used to make ceremonial *murtis* for *pujas*. During my offtime, I used to go out and make other kinds of statues.

"During sixty-three and sixty-four, I got myself admitted to the Bulbul Academy. There was a department of sculpture in the Academy. I decided to go there to learn.

"I was not getting satisfaction in my mind from the things I was making, so I became interested in receiving more training.

"The *sadhu* knew a man, and that man introduced me to the Academy. And I was admitted. I am not an educated man, but, with the help of that man, I gained admittance there.

"I studied there for some time—for two or three years. I learned drawing and sculpture. I learned both of them. After learning there for some time, I got bored. Then suddenly I went to Calcutta. I went without informing my big brother. Nobody knows at home. In the dead of night, I went without telling anybody."

Haripada does not mention the communal unrest of the period. His tale is his own. It tells how, unhappy in school, he left his village to learn more, how he enrolled in an art academy in Old Dhaka not far from his new home, became bored, and then, like many, left for Calcutta. Haripada was about eighteen. He was not pushed by trouble, but pulled by desire, and in Calcutta his training advanced with two men, both of them, like him, from East Bengal. First he apprenticed to the master of an atelier who came from Bikrampur, south of Dhaka. Then he studied with a professor of art who came from a village neighboring his own, near Shimulia, north of Dhamrai. Haripada is unconcerned with the differences in educational style between the traditional atelier and the state college. He learned wherever he could:

"I began to work at Kumartuli in Calcutta, a famous center for clay art. I took some money with me, and while I worked there I received no salary. I used to make *murtis*. There I worked under the guidance and supervision of Rakhal Pal, an artist from Bikrampur.

"I learned different methods of making *murtis*. I did not receive a *paisa* for the *murtis* I made. I had my meals there but my pocket money was my own. I learned there for some time. From there, I went to attend extramural classes in the Dharmatala Government Art College. At that college, there was a professor from my village in the modeling department. His name is Subal Shaha. His village was a neighbor to our village in Shimulia. He was a very rich man and very sophisticated. He graduated from the Art College and became a professor in the College.

"They are two brothers: Subal and Sridam. One was teaching in a village art college, and the other was teaching as a professor in the modeling department at Dharmatala Government Art College. They were good friends of my father's. When they would come to the village, they would discuss many things

with my father. Because of this link, I met him one day in Calcutta, and I began to learn modeling during the extramural classes.

"After learning there, I became distracted, and I wished to return to my own country. My big sister lived in Calcutta. I lived in her house. I told her, 'I am not feeling well here. I must return to my own country.'

"Then I came back to my own country. After coming to my country, the events of seventy began. Although many people left, I did not go to India. I lived here, in isolation. Then I lived in my village during those events. Again, I came to Dhaka. After coming here, I went to the Agartala side to see if I could learn something there."

Like his contemporary Maran Chand Paul, with whom he used to chat at the Art College in Dhaka, Haripada remained in 1971, lying low during the War of Independence when the Pakistani army slaughtered Hindus. Then he returned to India, not west to Calcutta, but east to Agartala, Tripura, and then he went north to Assam:

"My goal was clear. I was seeking to learn new things about art. Then at last one day I went to Assam with one of my friends. I worked there for one and a half months.

"Again I came to Dhaka. After coming to Dhaka, I began to live in the house of that *sadhu.* There I became acquainted with a man; he loved my work. He said, 'I will establish a shop for you.' His name is Biswas Sen. Nabin Sen and Brindaban Nag also helped me in getting the shop.

"After Independence, in seventy-one and seventy-two, I moved to this shop at fifty-two, Shankharibazar.

"From then on, I have been living here permanently. I am working here. I sometimes also go out of this place and work in different locations. When I receive orders, I also go outside of Dhaka city. While working outside, I buy clay through the men who placed the orders. They collect the clay and bring it to me, whenever it is available. I have worked in Narsingdi. I have worked in Faridpur. I have worked in Kushtia. I cannot go to other places because I have no time.

"Everything is ready and set for me in Dhaka. My work is done here in Dhaka. Everything is ready and set for me in Dhaka."

During an earlier conversation, Haripada mentioned that he had filled orders from Chandpur, Noakhali, and Chittagong to the southeast, as well as Narsingdi to the northeast, and Faridpur and Kushtia toward the west. But most of his orders come from temples in Dhaka. Haripada is so successful as

an artist that he fills the time between major commissions—the time his father filled with *hari-patil* and Lal Chand Pal fills with roofing tiles—with sculpture. He molds small images of the deities, and, differentiating carefully in the verbs and nouns he chooses, he models secular statues. Once he made a statue of Bangabandhu Sheikh Mujibur Rahman for a political parade. Babu Lal Pal, the master of Khamarpara, uses the skills developed for making *murtis* to model statues for the army base at Savar, and Haripada, born in Norpara, near Khamarpara, makes statues for the army in Dhaka:

"I also work for the army. I do all the modeling for the army museum. You know every officer has a rank—a rank with special insignia. I make the mannequins they dress up in uniforms. I do all this modeling. I did it before for the East Bengal Regiment. Then Khaleda Zia presented a tiger to the Chittagong East Bengal Regiment. That was also done by me. I made it with my own hands.

"The pay is not bad. But it is not too much. They have a limit, and they do not give beyond the limit. Because they have a problem. They have a budget. The modeling is not in the budget, and they arrange this out of miscellaneous funds. They pay me from other sources. They give me five to ten thousand *taka*. It is less than it should be. But I do not mind.

"There are different kinds of modeling. I do modeling for the sari shops on Bailey Road. I do modeling for jewelry stores. Advertising.

"In most of my work, I make *murtis* for temples. I make *murtis* out of cement and also of clay. Sometimes the *murti* will be cast in metal. I also make wall plates and architectural ornaments for the temples. When I receive orders from rich men, I make all of these things.

"I make different kinds of *murtis*: Durga, Kali, Saraswati, Lakshmi, Bishwakarma, Bashanti, Mahadev."

Like his father, like all the artists, Haripada starts his list with Durga, then, like most of them, he includes Kali, Saraswati, and Lakshmi. Other names begin the long series that includes deities less commonly represented. Mahadev is Shiva, Bashanti is a form of Durga, Bishwakarma is the divine artisan, worshiped by craftsmen like the carpenters of Pirulia. Haripada shapes permanent statues of concrete on iron frames, and he makes models to be cast in brass, but most of his *murtis* are made of unfired clay for worship in *pujas*:

"There are some main *pujas*—Durga Puja, Saraswati Puja, Kali Puja—and I make *murtis* for these *pujas* whenever it becomes necessary.

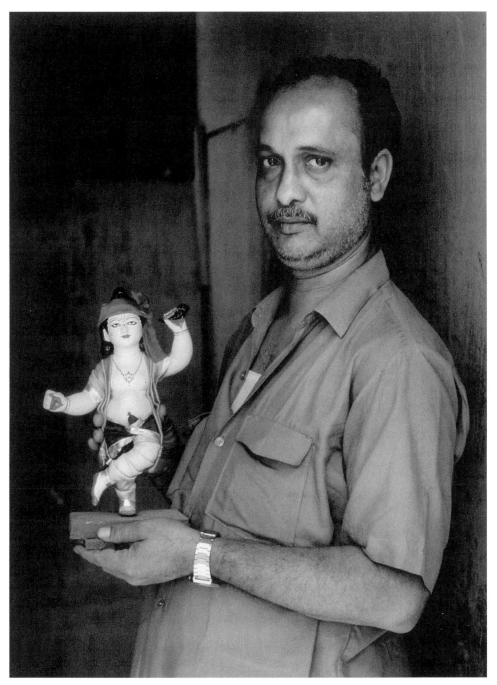

Haripada Pal with his image of Ramakrishna

"The price depends on the quality and size of the *murti.* If it is two to three feet tall, I take two and a half thousand *taka,* or three thousand *taka.* It is also sometimes less than that and more than that. If the *murti* is richly ornamented, I take ten to fifteen thousand *taka,* because it takes me one and a half months to make such a *murti,* and it takes much time to make a model of three feet, or three feet and a half."

For the first time, Haripada pauses. He focused the story of his life tightly upon his personal career, his drive for excellence in art, and he ended it in the mundane realm of finances. It is with him as it was with his father: one purpose of art is to bring the money with which the artist maintains his family.

The Idea of the Murti

Haripada Pal had paused, his eyes in mine. His mind was shining, his tongue was limber. I asked for an essay on the meaning of his work.

In Haripada's answer, metaphor is layered upon metaphor into a text that is, at different points, two, three, or more levels in depth. As a magnet when moved on a surface will draw a piece of metal, hidden beneath the surface, along its course, so Haripada explores the ramifications of a metaphor on one plane, while creating parallel motion silently on the other planes. He comes to conclusions, at once surprising and logical, by shifting suddenly from the plane of his speaking to another on which unspoken, identical moves had been accomplished. In his text, the spoken plane is usually the simplest to grasp, the most worldly, but all the levels are valid. Simultaneous constructions preserve their own integrity, while holding their relation, resonantly, one to the other.

Having often heard such metaphorical, allegorical discourse among Sufis in Turkey, I found Haripada clear and easy to follow. Having studied his text and discussed it with him, I will risk your annoyance and interrupt to be sure you are following the implicit development on the planes he is not overtly addressing. The quality of his mind is amply displayed by the way he holds the parts together, tracking the unspoken concept while speaking. The historian of Hindu art struggles valiantly in interpretation to reconcile the silent icon and the ancient text, but it is easier, and more fruitful, to ask the man who makes the *murtis.* Haripada begins his account of meaning in the clay:

"During my childhood, I used to think that this clay, the things made out of this clay are transitory. But now I realize that the clay, our clay—in it is hidden the seed of all creation.

"If you put a seed in the clay, whether there is water or not, it will sprout. The saints and sages thought that the seed is like a mantra. We call God by placing mantra-like seeds in the earth, and God comes quickly and fulfills our wishes quickly. So, for this reason, if you can plant these mantra-like seeds, at the auspicious time and day, and in accord with the rules and regulations, and if it can be acted upon, then God will appear. Because God is everywhere. He is at work, intermixed through nature.

"If we can unite our minds with nature, and place our mind's wishes before God, then God will fulfill our wishes, then and there. Immediately.

"If we attain this state of oneness of the mind with nature, then God hears immediately, and our wishes are easily fulfilled.

"That is why the saints and sages of our religion instructed us to make the bodies of *murtis* with sacred words."

Clay contains the eternal seed of creation. The clay is the soil from which plants grow, and it is the plastic substance out of which the artist creates, and it is the flesh of the body of the artist. All are part of the unity of nature through which God—power without form—is mixed. God abides in the clay, in the earth and in the body, and immanent power is roused by prayer. When the seed is planted, when the prayer is spoken, the mind becomes one with nature, it contains God, and wishes are fulfilled immediately: sprouts spring from the soil; God appears in the *murti;* a vision forms in the mind's eye:

"While you are calling God, the mind's eye acts immediately.

"If you do not see a body, it will take a long time to get the feeling. For example: you are seeing me. If I had not come here, you would continue, talking to other people, without talking to me.

"If I were not here, you would not get the detailed interpretations of the things I am making now.

"You could not have the feeling, if I were not here. You could listen to something from my worker about myself. He could say something good or bad about me. But he could not describe what I do perfectly. He could not make you understand. So you send a man to call me, and after I come into contact with you, I can describe things perfectly to you. This is so."

In explaining how the artist obtains the image that he shapes out of clay, Haripada casts me in the role of the artist and himself in the role of God. To make my *murti,* I need to have a feeling that is hard to achieve when God is absent. If I wish to know God and ask his helper, his priest, I will get a partial, perhaps erroneous, understanding of the Creator. Direct contact is necessary.

So I send a man—a prayer—and God appears immediately. In God's presence, I understand easily and completely. A feeling fills my body. An image forms precisely in my mind. My vision is not mediated by tradition; it is a direct revelation. My work is to materialize the inner vision that has come to me. To do so, I manipulate the stuff of which my body is composed, in which the seed of creation abides:

"I am made of clay. Your body is also made of clay. Because everything will be absorbed into clay.

"When that thing, like a seed, is in your body in a subtle manner, you can speak.

"Though I do not know everything, and I cannot know everything—the power of motion, inhaling, exhaling, and speaking—everything is done because of that."

The seed that is planted to lift life from the soil, that is uttered to bring God to the mind, is the seed that is the life force in the body that enables all motion, both automatic like breathing and voluntary like speaking. The seed is the timeless power that unites the body with the mind, the human being with nature, and the world with God. That seed effects an identity between the artist's body and the body of the *murti* he creates. The frame of bamboo, the form of rice straw wrapped with twine, and the coatings of clay have their analogs in the human body, and just as the seed is planted in the soil to bring life, so God's seed, planted in the clay of the artist's body to render it animate, is transplanted, through action, into the *murti* where it fuses with the force already present in the clay, cycling creation into unity through God's power:

"The body is constructed of clay, and within it, the bamboo, the twine, and the straw are set systematically. And these can be compared with the human body. As, for example, the bamboo is bone, the twine is sinew, the straw is veins. If you pinch your flesh, you will find veins that feel like the straws in the *murti*. And the whole is built up, part by part. One part comes from this direction, another part comes from another direction, and then the whole is interconnected with the straw. Then we cover the structure with clay to stabilize it.

"When we put the cover on the form with clay, then it cannot move. Then we put another coat of clay on it. And in the human body, there is also another cover beneath the skin.

"Then we do the work of finishing. Then we do the work of coloring. And then I do whatever people find attractive. Now it has become a complete body."

The one who will create this new body of sticks and straw, string and clay, calls God, and God appears in the mind, just as the *murti* appears in the temple—the mind is a temple—and just as Haripada, when I called him, appeared in his shop. I am a student seeking information; I am also still the artist with my duty to perform, and I am now, too, the devotee with my wishes. Haripada, the creator, is still God with the power to appear in my mind and to grant my wishes:

"You have invited me because of my qualities. And you have come because of your qualities. I have a fixed place to sit. If you come here, you can meet me, you can have a discussion with me. You can do anything you like. Similarly, we have made a fixed temple. In the temple, we have installed the body of a *murti*. And there we call God through mantras, through names. Because of those mantras, God appears. He becomes manifest in the body of the *murti*."

That is, through prayer, God appears in the mind and will become visible in the *murti* the artist creates, and, through prayer, God appears in the statue of clay the devotee sees in the temple. Now Haripada returns to his role as artist:

"When God appears in the body, my mind fills with affection. My mind becomes concentrated. When my mind becomes concentrated, my eyes fixed, then I do not see anything. Then I see only God. I see only the Supreme Being."

Prayer has brought to his mind an image as clear as the one the devotee sees in the temple. In the temple, the devotee sees a representation of a vision that came to the artist through prayer. The artist strives like the artist of realism, but instead of precisely depicting objects in the world, he precisely depicts a vision in his mind. Through prayer, the feeling has come; the feeling necessary to creation is love. In love, the artist sees God in the body. God—Bhagaban, Allah—is formless, so the body in which God appears is that of a particular deity, a visible embodiment of the infinite. God gives the artist a blessing, a particular version of the blessing of life, which is the ability to create correctly, to hold the formless as form in the mind while the hands materialize the form in an object. The object, the *murti,* makes visible the power that is mixed through nature. The *murti* contributes to the orderly functioning of the world:

"In this state of mind, when I submit my wish to God, He gives me a blessing. By that blessing, we are able to move in the world, and the world is running beautifully.

"The mantra is written in the Shastra books. I read the mantra whenever it is necessary, while making the *murti*. I read the holy words, and then I give the words new life by working with my hands."

Creation is based on the long struggle to prepare the mind and hands. But the particular instance is no struggle for the mature artist. The mantra brings an image to the mind. The *murti* materializes the mantra. Art will incarnate a prayer, and it begins with a prayer. Haripada says his prayer is like that of the Muslim who begins a journey by repeating the mantra-like formula, In the name of God, the Merciful, the Compassionate:

"As you have come out of your house by praying to God, similarly by reading the mantra repeatedly, I begin my work. And that was written in the Shastra. On that basis things are functioning.

"Our religious rituals and environments are described in our scripture. It instructs us what to do and in which settings the ritual will work.

"If we maintain things in a more beautiful manner, God will be more satisfied, and He will receive more pleasure. And out of these circumstances, our wishes will be brought to life."

The purpose of beauty in the *murti,* in the temple and in the ritual, is to please God. The patron for whom the artist works is God. It is God's satisfaction he seeks, a divine aesthetic toward which he strives. The artist must do the best he can to secure God's blessings. In explaining his point, Haripada reverses our roles. Now I am God, he is the artist, and his task is to prepare a comfortable, attractive seat for me:

"There are different environments. For example: I have given you a chair to sit on. You can also sit on the ground. But out of a sense of decency, I have given you a chair. And I could put a cushion on the chair to make it more comfortable. So there are various ways to make things beautiful and attractive. And it also depends on the financial capacity in life.

"If you want to do it in a royal style, there is also an appropriate system. But if you are not a rich man, you can still call God in a pious way. That is also a system.

"That also has a different kind of interpretation. And if you have nothing, if you have only water and flowers—with these two it will be sufficient. And note: if you unite your mind with water and flowers, nothing more is necessary. And if you have only the mind, it will be excellent. There is nothing above the mind."

The beautiful *murti* is one, the pious gift of water and flowers is another, the mind is the loftiest offering to God. The *murti* and the flowers are manifest

versions of the mind. Art is not necessary, but it is decent; it is right to do the best you can, given your resources of skill and wealth. Since the mind is the highest gift, then art aspires to materialize the moment of the mind in prayer, when God appears and attention is concentrated exclusively upon God's presence. The feeling of prayer, of art, is love. So the aesthetic mobilized during the patient creation of the beautiful body of the deity is shaped out of love. And so the acts of affection between people in the world, between friends in conversation, between husband and wife in passion, align with the signs of love that are *murtis* and flowers and prayers. The mind's desire for beauty and unity is built upon the emotion of love. Haripada illustrates with our relationship. Now, in his words, I am me and he is Haripada, and I am again God and he is the devotee. I respond to his love. I come from afar so that we can reunite in reciprocal affection:

"If I can love you with my mind, you will accept me. It cannot be denied. And then the water and flowers are not needed anymore.

"I love you. And you love me. As you have come out of America, you love me. A connection has been established—through the mind. So the connection is established.

"Through spiritual meditation, you have come here. I have remembered you. You have also remembered me. So the contact is established. Otherwise, where is your address? Where is my address? Where was it? Where was my address? Where was your address?

"It was in the *atma* that the mind's connection was established.

"That is why, searching for that address, you have beautifully come to my house.

"With you, with me, communication has been established.

"With you, with me, that *atma* has a relationship.

"Not with the body. The human body takes form on the basis of *karma*— on the merit of *karma. Karma* is related to *atma,* and it makes the communication.

"It is not only a fact of this age.

"It has been the practice for ages and ages."

Our relationship is not disrupted by the different places in which we chance to reside, because our relationship is not bodily. It exists in *atma.* That word is familiar in the West as the second element in the compound name by which Mohandas Gandhi is known: Mahatma, meaning Great Soul. I have not yet translated *atma* into "soul" because I want to preserve the connotations the word has for Haripada, which he shares with Bengali Sufis. *Atma* is the seed,

the life force, the presence of God within the human being that brings people together with one another and with nature and with God.

Atma has no form. It exists in the world, in clay, in human bodies, enabling actions like breathing, creation, and communication. To live, people work, and in working, doing things well or poorly, they accumulate *karma*. Human actions are enabled by *atma,* which is otherworldly and perfect, but they unfold through *karma,* which is shaped by earthly patterns of success and failure. *Karma* requires *atma,* and it determines the sensate form in which *atma* momentarily resides. *Atma* endures, despite *karma,* through the cycles of birth after birth. Lodged in *atma,* and not in the body, our relationship abides outside of time. And remember: the ones united in *atma* by love, despite differences of address, are me and Haripada—and God and the devotee. The eternal soul in the devotee, located in a mortal body that has been shaped by *karma* for this brief life, calls to God, located in a clay *murti* that has been shaped by the artist for this brief *puja*. As it is with Radha and Krishna, the desire is for reunion. The love in one (God or the devotee) calls the other (God or the devotee) into communication.

"This communication has been continuing since long before.

"With you, with me.

"I had not seen with my eyes, but when I feel a great attraction, then we meet each other.

"But the contact between you and me was established long ago.

"Then I did not see, because I had no mind's eye. Now the mind's eye has matured, so we have seen each other."

The relationship has existed for ages, but it takes time, maturity, and knowledge for the mind's eye to gain an image of God in the body. When God appears, the soul is pleased, and the devices through which contact was established—the prayer, the ritual, the beautiful *murti*—become unimportant. The soul and God are one in love. On the worldly plane, friends of the soul meet, and in their friendship, God is present. There is no need for ceremony. Love is enough:

"Now, I am enjoying your company. This pleasure of mind, and this discussion with you—through these the *atma* gains pleasure, peace, and happiness. There is no need for money or glamor. I love you. You love me. And God lives in it. And everything else is trivial.

"Just a call from my mind, from the emotions in my mind—that is what we are discussing—and we are satisfied with this. Now God exists here.

"We are not bound by anything else. The connection is between two minds. There is nothing but bliss. There is nothing but love. So where there is love, there is God. That is why my connection with you is for a long time.

"Out of a former existence, the connection is established, the connection is established. The connection may not be established in this life, but it might happen in the next life if the *karma* permits. If I can abandon material goods and greed, and if *karma* can be performed with righteousness, then and then only will contact be established with you."

The spiritual plane, on which the connection is between the soul and God, rises into view. There is always a relation to God through *atma.* But *karma* might prevent or permit contact with God in different lives. If *karma* allows the suppression of materialism, then contact with God will be possible. The soul will meet God. The eternal will reunite with the eternal through the worldly. Through art, God will communicate with God. Consciousness will fuse in oneness. Art will cease to be necessary; only love, formless and silent, will exist. Now Haripada returns to our plane, where the contact is between men. In this particular life, our *karmas* coincided, so we could meet, calling each other through affection. That act is paralleled by the love in the devotee who uses the prayer or *murti* to call to mind the God that the soul has always known:

"Not once or one time: this contact will be established so long as we live in this world. So long as we continue to move, coming and going, we will meet. Through *karma,* we will meet.

"When love increases in me, attraction will be created, then I will see, then I will remember."

The soul remembers and pines for reunion. Desire increases. The mind wishes for a vision:

"I wish I could see you. When you say, 'I also want to see you,' then connection will be established. Through *narod—narod* means the power that makes the contact—*narod* makes the connection, whether good or evil. Since you have come, *narod* makes the connection.

"An individual lives in that place there, so let us go there. I live in this place, I will show you; I will take you to that place. When he reaches that place: 'Yes, yes, this is the man I am looking for. I have seen him before. This body I shaped beyond my vision, it is now manifest.

"'That is right.

"'Yes. I desire him. I saw him before.'"

The *narod,* the mediator, leads the devotee into an encounter with God. The soul had seen God before. Now the mind sees God. Contact is made. Communication is possible. The *narod* is dismissed:

"But you have not seen. But I saw you. I could recognize you when I saw you: 'Yes. I met him before. I saw him before. So now I can recognize him. Now I will talk with him. Now you can go and do your business. My business is with him.'

"Murti worship is for this."

There is Haripada's conclusion. The *murti* is the *narod.* Its purpose is to bring the human being into immediate contact with God. Direct exchange is possible. The wishes of the devotee will be fulfilled. At that point, the *murti* has accomplished its mission. It is returned to water. Haripada summarizes, then cites his sources:

"It is a system. Everything is done instantly through *murti* worship. Everything depends upon the clay. The clay acts immediately. When you sow the seed in the clay, you will get immediate results.

"You have water in your mind. You have flowers in your mind. You have everything in your mind. You have everything in your body. If you can concentrate—an instantaneous illumination—then you can see everything. And you will see the whole creation instantly. So it acts instantly.

"They wanted to do good for the world. The saints and sages had no family life. They had no difficulty in finding food. They have no wants. For the welfare of the world, they gave their ideas and concepts. People who move through this world with greed—they show them the right road: to call God, to know God.

"This world is transitory. God is all powerful. You know Him with emotion. You develop yourself, stage by stage. You cannot develop yourself all of a sudden. The mind is not concentrated all of a sudden. Bit by bit, you reach power. Bit by bit. You cannot get there quickly and easily. Because this world is full of beauty, full of distractions. You cannot surrender this world easily.

"Why cannot He be seen? Why cannot He be known?

"I have seen with my eyes that this is beautiful. Living in this world, I cannot go to Him. Impossible. Because I have not seen Him, what He looks like. He might be uglier than this world, because—my beautiful things, I love all these things. If I did not love God, it would be hard for me to surrender this world. So, step by step, slowly, slowly, gradually—if you come by bus, you can

come by taxi, or you can come by rickshaw—if you cannot come by rickshaw, you can walk. You can come in this way. You must come. You must go to that place. So the saints and sages have mortified their bodies for the welfare of the world."

Through ascetic self-denial, the saints and sages—the *muni-rishi*—have shown the path along which one must travel, by whatever means, to come, through love, to God. As philosophers, historians, and critics—the priests of the temple to the muses—have built the contexts within which certain works of art become meaningful and valuable in the West, so the saints and sages have built a context around the *murti*. Like his Western academic contemporary, Haripada is the recipient of a tradition of making and a tradition of interpretation, both of which he reconfigures for himself. From the saints and sages, Haripada has learned to interpret his creations as vehicles people use to reach the mature state in which the world ceases to matter and the soul is reunified with God.

"This is our system. Through this system, we can know God easily. And if you want to have your wishes fulfilled, that is necessary. It comes instantly."

Through the *murti,* contact with God is instantaneous. Through contact, wishes are granted immediately. The beautiful *murti* is designed to inspire and deepen the love in which God is approached. Through visible imagery, in its portrayal of a Hindu deity, the *murti* assists in the communication between the worlds that is the goal of all religion:

"You think it over. And you will find that if you see a thing, and if you do not see a thing, the attraction is different. That is what it is. Nothing other than that.

"There is no difference in it; whatever country you belong to, everything is the same.

"In your daily life, you need ink to write with a pen. For keeping the ink, you need a container. If you put ink into a container, it flows instantly. With this system, a thing is to be made. This is so."

What matters is the ink. The ink is God in the *murti* and *atma* in the body. The *murti* and the body are vessels for power, as the pen is for the ink. The shape of the container and its fluid content suggest the point Haripada made explicit when we discussed the matter later. The seed which, when planted in the soil, sprouts into blossoms, and which, when planted in the artist's body, enables creation, is the same as the seed which, when planted in the

womb, produces children. This is one of the many times when Haripada's argument harmonizes with Sufi belief. In Bangladesh, there are Sufis who hold that *atma* is the light of God in every body. God is discovered within the self. There is no need to travel to Mecca. The mind is a mosque as well as a temple. When the life force in separate individuals joins in love, then eternal power flows between them and merges in the third individual who is created out of love. Reincarnation is alien to the Muslim, but the Sufi sees that bodies die, while *atma* endures from generation to generation. For the Muslim and the Hindu, the body is but the pen that holds the ink.

While describing the meaning of the *murti,* Haripada Pal does not stress its appearance. To do so would be to emphasize the differences among people, among religions. Instead, he concentrates at points where oneness is possible. All people, he told me, are one, and all religions are one. In speaking to men who are not of his religion, Haripada describes his *murti* as an aid useful to making a connection that is desired by all people—whether Hindu or Muslim—between God and the immortal soul. People differ and communal sentiments exaggerate difference, but in this they are alike: they inhabit a world controlled by God. And in this too: if they love God, God will love them.

"Every man is different because of his own interests. If you take things communally, then it becomes different. But God is controlling everything. If you observe that system, you cannot deny the policy making of God.

"The rules of Shastra are systematic and scientific. The pen is made so beautifully to contain the ink. The pen means the body. But I do not need the body, but I need it for the ink. Through the body, ink will flow. Then it will be possible for me to write.

"When God comes, there is a time, a special, auspicious time. He will stay so long as He wishes. After that, He will not stay. He has to depart because it is very difficult to keep Him always in the physical world. So He has to be thrown in the water, because water is harmless."

With effort God is held in the *murti,* as with effort *atma* is held in the body. Then the *murti* must be sacrificed because it is particular. It does not represent God, but a certain deity who commands a certain moment in the calendar. It is not shaped out of pure *atma,* but through the *karma* of a living artist. The *murti,* neither complete nor perfect, is like the body. When it becomes empty, like the pen, it is thrown away, but the *murti*—the seat the artist has prepared for God—is treated with respect after it has been abandoned by God. It is painlessly, gently absorbed back into innocent water:

340

"The *murti* represents a special *karma* and also a special form. They are given special importance. In your office, you cannot sit on the chair of your boss. This chair is made of wood, and that chair is made of wood. Why will you not sit on the chair of your boss? Because your boss does more exalted tasks than you. So you will not sit on that chair. You will leave that chair in a place of respect, so that others cannot say you are acting foolishly. So for this reason, when this will become useless, then perhaps we can throw it in any place, but we do not throw it in a bad place. For this reason, we sacrifice it in the water. Because it is harmless. If you throw anything in the water, it is harmless. So we sacrifice it in the water.

"People say, 'Why do you waste so much money in sacrificing the *murti?*' For sacrificing in the water, there are reasons. What is money? Your body has no value. If your body has no value, then this also has no value."

The sacrifice of the *murti* proves that it is not the statue that is worshiped, but the deity that momentarily occupies the statue. The *murti* is like the body, made of clay and attractive to the eye. But the body is only the container, shaped by *karma* to hold *atma* during life, and the *murti* is only the container, shaped by *karma* to hold God during the *puja*. As *atma* exists in body after body, so God appears in *murti* after *murti*. To complete its resemblance to the body, the *murti* must be sacrificed. Its beauty makes sacrifice difficult, but its sacrifice prevents you from becoming distracted by beauty and keeps the mind fixed upon God. The *murti* decays. It is God that holds value, not the *murti,* just as it is *atma* that holds value, and not the body. Repeated sacrifices of statues insure that the mind will not confuse the beauty of the world with that which it seeks. What matters is God:

"Only the qualities of God have value. For this reason, we come into this world. So long as there is ink, there is value. When the ink is gone, the pen has no value. You throw it away. This is what it is.

"We do not need it. But we need it."

Haripada has reached another conclusion. The body has no value, but we need it to contain *atma*. In itself, the *murti* has no value, but we need it to assist in our quest for God that makes life in the body valuable. The body, like the *murti,* is a device we use to know God. It is to know God that we come into the world. The *murti,* like the body, is a thing in the world, a means by which the artist keeps body and soul together during his search:

"In the case of God, it is for knowing God. The money is for me. The money is for God. But God is not for the money. I have invented money for

341

my own necessity. Money has not invented me. For this reason, for my own convenience, I will use money as I see fit.

"Man is above money. But if, for my own good and welfare, the exchange of money is necessary, then that money is for me.

"I am a man of God. God has sent me. I will do good for the world. But money will not do any good; I will do the good. But it is a temporary social system to follow, a system of exchange, of exchange of one thing for another.

"In those days, there was no money. There was a barter system. Now, in this modern world, it is a neat system. People have analyzed and classified. You will get this thing for that thing at an established rate of exchange. If the government decertifies the currency, the money has no value. It is only paper and paper."

For the second time, Haripada pauses, descending to the quotidian, stopping again in the realm of finance, but holding his metaphoric tone. Without the government, money is only paper. Without God, the body is only flesh, the *murti* is only clay.

Making the Murti

Jatish Chandra Pal, listening, keeps working, his hands moving patiently, steadily. The rest of us are bent toward Haripada Pal, beaming with his success. The energy remains high. I make my third request, asking him to put on tape a description of making a *murti*. Haripada's answer is a less coherent creation. It depends on knowledge he knows I have gathered while watching him work, so I am less reluctant to intrude while I construct my text out of his words and mine.

As he did in his essay on meaning, Haripada begins his technological description in the clay. Like other potters, he uses two kinds, one black, one white. The black clay that Amulya Chandra Pal calls *bali* or *kala mati,* that Maran Chand Paul calls *rag mati,* Haripada calls *etel mati.* The white clay that Amulya calls *sada mati,* that Maran Chand calls *abal mati,* Haripada calls *bele mati:*

"First we dampen the clay, slowly, slowly, with water. As wax softens, so the clay softens. The name of the clay is *etel mati*. It is available in our village areas. There are different layers of clay. There are different clays in different places. We can recognize the clay after checking. By touching with the hand, we can distinguish between the clays. I bring clay from my village, Shimulia. Our birthplace is there.

"We collect the clay from the land. The clay is underneath; it is not found on the surface. But sometimes it is found on the surface also. But in most places, it is found underneath. *Bele mati* is above the *etel mati*. After cutting the *bele mati*, *etel mati* appears. It is dug while seeing and testing. Then we bring the clay from Shimulia by water to Wiseghat. From Wiseghat, we bring the clay to my workshop by *thelagari*."

Haripada finds his clay in the place of his birth. Brought by boat to Wiseghat, near Sadar Ghat on the waterfront, the clay is transported from the Buriganga to Shankharibazar by *thelagari*. A long bamboo frame, balanced on a pair of wheels and pulled by a man walking, the *thelagari* works, as the rickshaw works, because of the flat terrain. Haripada's blue workshop, his *karkhana*, is entered through an open vestibule. In the front room, where the *murtis* are made, where we sit to talk, there is a large glass cabinet in the back, a small one in front, and a loft to one side, where molds are stacked and finished *murtis* stand, wrapped with paper against the dust. To the rear is a narrow room, embedded in the building, where the clay is worked. At one end rises a tall *stup*, which is shaved, as it is in Kagajipara, with a scrap of broken pot. Next to the *stup* is a pile of processed, "fresh," clay that Haripada dampens to three grades of liquidity, one like mud, one like pudding, one like soup. He continues:

"In the *karkhana*, we dampen it with water, and we make it suitable for making things. But if the clay dries, we have to break it into pieces, and then dampen it. The clay is sticky.

"We have to dampen it for some time. Then it becomes liquid. After it becomes liquid, then I pick out the stones. Then it becomes fresh clay.

"After it becomes fresh, we use it as the cover on the structure."

Beginning his technical account with clay, Haripada preserves his hierarchy of value, but if his story were governed by chronology, rather than significance, he would have begun with the frame. Made of wood and bamboo, and sometimes of iron, the sturdy frame is covered with rice straw, bound into form with twine. Then the form—he calls it the structure—is covered with clay, a blend, half and half, of *etel mati* and *bele mati*, mixed with chopped scraps of straw. Parts of the statue are joined and cracks are filled with the same mixture. The matted mass of straw weaves a fibrous web through the hardening clay. Then pure *etel mati*, sticky and tough, is used for modeling, to shape the head and hands and feet, and to cover the whole with a smooth, carefully shaped surface. Then the *murti* is given a coat of *bele mati* mixed with filaments of jute. Haripada calls *bele mati* "weak." It is thin in solution, not sticky,

and it follows the contours shaped of *etel mati* upon the thick base of blended clay. If cracks appear, he spackles with *bele mati*. Here is how Haripada said it:

"Rice straw is used for making the structure. This straw is cut into small pieces and mixed with the clay. If cracks appear, and it becomes weak, we join it to make it tight. It becomes absolutely tight after it is dried. After it becomes tight, I make a cover of *etel mati*. After it is covered, the mix of clay and straw becomes solid.

"The outer layer becomes strong. Now in order to make it beautiful, I use a cover of *bele mati*. I use *bele mati* because *bele mati* is weak. In order to avoid cracking, we use jute fibers with the *bele mati*. Then it is covered.

"If again cracks appear, we use *bele mati* as pudding to fill the cracks. After covering, we use sandpaper for finishing wherever we use designs, and also for making it better quality. By using sandpaper, it is smoothed to make it consistent and smooth."

The first task is to make the *murti* strong and solid. Now to make it beautiful, he coats the *etel mati* with *bele mati* and sands it smooth. As it is for Maran Chand Paul, smoothness is a key to beauty for Haripada Pal. His creation will not be rough with the textures of nature, but perfectly, transcendently smooth.

"Then we again use *etel mati* for a cover because coloring cannot be done on the *bele mati* cover. If we use color on the *bele mati,* the color will fade and blacken. So we use an *etel mati* cover, so that coloring can be done perfectly.

"After giving it a thin cover, we use a white color. The white color is used for this reason: if we paint directly on the *etel mati,* the color will not be bright. So we use a white color. On the white color, if we paint in different colors, it will be bright and beautiful."

Smoothness is the first feature of beauty. Brightness is the second. Haripada uses a powdered, water-based paint. If he paints on *bele mati,* the color will be absorbed; it will darken in time. *Etel mati* retards absorption, but it is dark, so over the *etel mati* he carefully layers a coat of white paint thickened with a paste of boiled tamarind seeds. It is like the gesso applied to the wooden carving of a saint by a Latin American artist. Haripada's paint fills tiny holes, seals the surface, enhances smoothness, and creates the pure white undercoat that will make the applied colors luminous. The smooth surface will seem to glow from within.

Rough and dull are the materials with which the worker contends. At work, pressing toward excellence, he drives substances toward artificiality.

Demonstrating mastery in his craft, he asserts command over materials and manual procedures by smoothing the rough and brightening the dull. I am talking about Haripada, but the words would fit the maker of utilitarian pottery, who smooths with a dampened cloth and brightens with slip, and they would fit the worker with brass or wood or conch shell whose last step is to polish and buff. Excellent craft negates the natural and embodies the perfect which can, then, represent the eternal. The *murti* departs from the world and stands forth in smooth and bright perfection.

The surface is unnaturally smooth and luminous. The interior is natural clay. The surface is for beauty. The interior is for power. In India, there are potters who believe that firing purifies the clay. Haripada believes that firing kills it.

Haripada explained it first to me while I watched him make a *murti* of Vishnu for a temple in Chandpur. The *murti* used in the *puja* is not fired; the clay will be absorbed easily into running water. Fired clay, he said, will eventually melt, but it takes time. The cycles of birth and rebirth are delayed. The *murti* made for permanent presence in the temple is also unfired, because the clay contains moisture. Haripada identified the moisture—the moisture that would be eradicated by firing—with sacred power. During prayer, the water in the body of the devotee connects with the water in the *murti,* as the *atma* in the body connects with the deity in the *murti.* They are alike in substance; action is instantaneous. Just as a seed planted in damp clay sprouts quickly, so a prayer planted in the damp clay of the *murti,* while water is offered to the deity in a conch shell, brings blessings immediately. One can pray to a *murti* of fired clay, but it demands great effort, and the blessings come very slowly. Unfired clay contains power in abundance. Dead, burned clay is used during earthly labor. Live, unburned clay is used to make contact with God. This is what Haripada said about firing on the day of our interview:

"The *murti* is dried. Without drying, there will be no color. I dry it in the sun. If I cannot dry it in the sun, I use a blowtorch for drying.

"I do not burn it. If I burn the *murti,* it would not be effective, and if I burn it, there will be no *puja.*

"As I say, one reason is because there will be no power. It will take much time to make it powerful. Burned clay takes much time to be melted. It will melt. Then I will sow a seed in it. It will be sprouted. So it is a long process. For this reason, there is among us no *puja* to burned *murtis.* You can preserve

such a burned *murti* in your showcase, but you cannot use it for *puja.* It is against the rules. Because there will be no immediate action. I need immediate action. I can satisfy my body with burned clay *murtis,* but not your mind. It does not work, and it has no quality."

To build potent clay into a form that will carry a smooth lustrous surface, Haripada uses different techniques. For small *murtis,* he shapes a plaster mold around a model sculpted of clay. Then he, or more often Jatish, presses clay into the deep mold, removes the image, smooths it, coats it white, and then paints it brightly. They work on many at a time. For large *murtis,* created one by one, Haripada might work, like Sumanta Pal of Kagajipara, in the manner conventional to makers of *murtis,* combining modeling by hand with molding. The molds speed the job. He can make a face with a mold in one hour that would take him a day of work by hand. Speed is necessary when pay is slight, but he has patrons who will pay more for a *murti* modeled entirely by hand.

Haripada prefers to work by hand. Molds, he says, break his concentration, but working with his hands, *hate hate,* his concentration increases as time passes, and he enters the altered state of creation:

"Many times I become so devoted to my work that I feel no other one around me, and I unite with God.

"Sometimes I become part of God. Sometimes God becomes part of me.

"I feel God in myself when I concentrate. Then God goes out of me, and I become a man again. When I concentrate, God goes out of me and into the *murti.*

"I must give everything out of myself in concentration, or it will not be a creation."

To explain himself, Haripada asked me if I ever wondered how it is that children born of the same parents can be so different. His answer was that the quality of the child depends upon the concentration of the mind during sex. The better the concentration during the creative act, the better the result, whether child or work of art. A casual, perfunctory act yields a misshapen thing. So there is Haripada's definition of art—and it corresponds exactly with what I was taught by artists in Turkey: art is the object into which one has put oneself lovingly and completely. Haripada's reasoning is that the more the mind is concentrated, the more completely will God be transferred out of the mind, through the body, and into the creation. Haripada's art is the growth of his seed, planted in complete devotion.

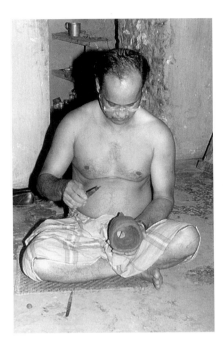

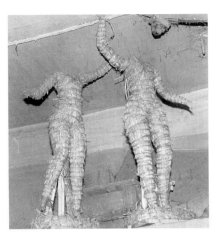

Straw forms by Haripada

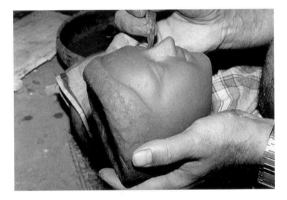

Haripada Pal sculpts the head of Vishnu, which is then attached to the body modeled by Jatish Chandra Pal. Images in progress of Sitala and Kali stand beyond Jatish.

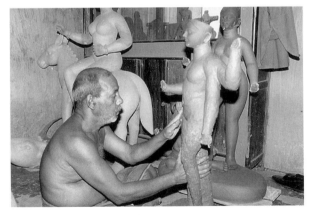

Jatish Chandra Pal

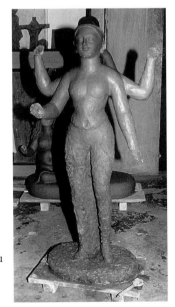

Vishnu

In concentration, Haripada works the form slowly, patiently, over and over. He uses a wooden, pen-like tool called a *cheari* that is flat on the bottom, round on the top, pointed at one end and rounded on the other. He draws in the clay with the point, then softens every line with the rounded end, caressing the form continually, massaging with the fingers, pressing himself into substance. Working and reworking, he refines symmetries to perfection, and he melds the parts into flowing coalescence. As time passes, he drains out of himself and into his work, transplanting the seed of creation into the receptive clay. Power increases as beauty increases. The subtly modulated, integrated form of the *murti* is the outcome of the time passed in concentration when there is no difference between the sacred and the aesthetic.

The surface is for beauty. The clay is for power. The form fuses beauty and power. Those things I learned by watching Haripada Pal and talking with him later. This is what he said about molds on the day of the interview:

"I use molds when I have to make large quantities. When people give me low remuneration, I also use molds.

"Making by hand needs more time. They do not pay me much, considering the time I spend. To shorten the time, I use molds. Good quality as well as bad quality things can be done in molds. On the basis of wages, on the basis of time, different practices are used. I use molds for masks, main parts, attractive details, parts of fingers, toes, faces—part by part—those things are hard to make. It takes time to make if I work with my hands. I make those parts using molds."

Having discussed molds, Haripada leaves the topic of technology—it is better to demonstrate than to describe—and returns to his own life. He begins with an assertion of mastery. In fact, he is assisted by Jatish, who makes the small *murtis* using Haripada's molds, who saws the boards Haripada frames for the base of the *murti*, who mixes the clay Haripada models, who slowly smooths the bodies while Haripada cradles and shapes and smooths the heads. They work as a unit, but Haripada is the master. Their integration is hierarchical; it is Haripada who knows and can do it all:

"I make the structure with my own hands. I make it myself. There are others who cannot make it. They purchase it from some other places. But I make it myself. I do all the modeling myself. I make the molds myself. I make the whole thing myself.

"Once I had a dream to establish a ceramic factory, but I could not, because I do not have enough money. I own no house, so I could not do it.

Despite my knowledge of art, I have failed in my life to do anything, because I have no money. I make things in my *karkhana* sometimes. I also go out sometimes.

"My mood is now changing. By making the deities—I mean, by making God every day—I have developed a different attitude toward God. And now I think that I could not use my talent, what I have learned—I could not supply things in large quantities, because of the paucity of finances.

"Whatever I earn, I somehow manage my family. I cannot do anything else. Under the circumstances, gradually, my greed is decreasing. And my love and devotion to God are increasing.

"I have now begun to realize the inner secret knowledge. My greed is decreasing day by day. To know Him—now I do this work because I consider it to be the work of God.

"Doing this work is praising God. It has a spiritual connection, so I adhere to it.

"I hope I can continue this work until I die. I wish I could adhere to this work until my body decays into nothing at all.

"And I hope I can contribute something to God. That is my attitude now."

It seemed as though Haripada would bring the third segment of his statement to an end, as he had the first two, by returning to the daily life where money matters. Instead he made the point that he summarized later when he said:

"Money is necessary, but what I do is also necessary.

"My work is a prayer. It is a part of my devotion to God, and it is a benefit to the people. It is a goodness."

Haripada has ended the story of his life. His biography contrasts with that of Maran Chand Paul. Both are successful artists in modern Bangladesh. They are contemporaries. Maran Chand was born in 1946, Haripada in 1947. Both were raised in their fathers' workshops, then both sought academic training. Maran Chand graduated. He became part of the international system of education and then part of the international system of commerce. He manages a workshop in which his employees make decorative objects in quantity for export. Haripada received no degree. He gained knowledge, but remained outside of the academy, maintaining his commitment to a local idea of art, a local economy, and a universal vision of the sacred. Haripada was unable to establish a ceramic factory like Maran Chand's, so he works with his uncle in his tiny shop, making the sacred images his community needs.

Both are gifted artists. Maran Chand Paul preserves his art by means of subtle revitalization within the context of modernization. He is prosperous and unhappy. Haripada preserves his art by driving for personal excellence within a sacred tradition of maintenance. He is not prosperous. He is happy.

Haripada knows the rapture of oneness with God in his daily work. He is smiling now, satisfied with a job well done. It is my last request. Since his words will be saved in a book, I ask if he wants to say anything more. Haripada Pal completes his statement:

"I have nothing to say. I do not know for whom I came into this world, and I do not know whether I have succeeded. I wanted to contribute something. I mean, I wanted to create some works of art. But the flow of money is slight, and my place is small.

"If I had a big place, then I could use my formulas, and then I could maintain my family, and at the same time I could provide for my workers. Those were my wishes. But, for various reasons, I could not manage it. Otherwise, I had plans. I know many things. I learned something from the deities, and something from God, but I am unable to use it. There are surely social reasons, but I could not do as I wished. I had no chance to use my knowledge.

"I could not do anything in my life. I had wishes to do something, but I could not. But what I am doing is nothing other than the blessing of God.

"Whatever it is, it is enough.

"I have nothing to ask from God. I have only one prayer: that I continue my work until my death. I also pray that I might continue to live with mental satisfaction by adjusting myself with the environment.

"I had many things to do, but my opportunities are limited. And I think that is the wish of God. Because I have done exactly what God wished me to do. I cannot expect more than that.

"So I think I have achieved more than I could expect. Because I was born in a certain community, in a certain family, and in a certain society. Considering this, whatever I have achieved, it is much.

"I want to die in this state of satisfaction. I see that it is tolerable. And after that I do not want to return here to this lower environment, because then I could lose my mind. So I pray to God that whatever You have made for me, it was enough for me. I am grateful to You. And I want to die in this environment. And I feel no need to rise above this state, or to know more than that.

"I am very happy. This is enough: that I would receive such appreciation from you. This is very much. I have nothing more to ask from God."

"Whatever I have said, there may be mistakes. I am not an educated man. Sometimes I cannot correct my errors, and I cannot speak in a sophisticated way. I have limitations, so I could not make you understand everything. I have passions, desires, and a curiosity for knowledge. But since I have no formal education, I failed to express everything perfectly.

"But my heart is full of passions, which I could not express. I lack a language for expressing it fully. But I thank you. I feel very good. Bless me."

Haripada smiles, glowing. Our hands join, and our eyes. The shop is quiet. The tape turns. He continues:

"But one thing more, and that is this: I am blessed by something, by God. If I make anything with full concentration, by my hand, by the grace of God, everyone is pleased.

"If I touch it with my hands, and work with my own eyes, the form of the *murti* appears in perfection. It is beautiful. This is my blessing from God.

"If I use clay, and touch it, and work on it, whatever I attempt will be accomplished. And this is the thing God has given me.

"If you tell me something, I will do it. I can understand your signals. When you tell me the *murti* will be like this, I understand it correctly.

"After a full understanding, I will apply my system and methods. After my work is done, you will not be dissatisfied.

"So I have nothing to ask. I am happy. I have received what I have been looking for. And even what I am doing now is a kind of blessing.

"Your appreciation of my art is only because of God's blessing."

Haripada Pal's Art

In his village, where clay becomes many things, potters divide into makers of *kalshis* and makers of *murtis*. Set apart, the *kalshi* and *murti*—the water jar and statue—seem to repeat the Western distinction between the utilitarian and the aesthetic, but they are, both of them, useful and beautiful. Both are vessels, the one to hold water, the other to hold power, symbolized by water. Primarily useful, both are discarded when their work is done, just as the dry pen and the lifeless corpse are discarded. Yet both possess beauty, exhibiting an aesthetic of balance, formal integration, and smooth, bright surfaces. Both are composed of common, abundant materials, a blend of sticky and sandy clay, though the clay is treated differently: it is burned for earthly work, unburned for sacred work.

As Haripada tells it, the *murti's* task is as specific as the *kalshi's*. It is a tool people use to make contact with God in order to receive earthly benefit. There is no reason why a crudely shaped image of unfired clay would not do its job effectively. Haripada described to me a saint who rose every dawn and shaped a *murti* through the day that he worshiped at sundown, then sacrificed in running water. A rough image would do, but Haripada's autobiography records a man's arduous quest to perfect his craft. The simplest formulation of his motives would have him striving to create objects that others find appealing. Liking his work, his customers return him cash and praise. In that formulation, there is no difference between the *murti* and the *kalshi*. Artisans master their trade so that their products will be communications, signs of their competence, and comprehensible, acceptable, usable, even admirable commodities in the eyes of their consumers.

Haripada Pal is a competent performer. Like the maker of a *kalshi* or the narrator of an old tale, he fulfills his creative urge through graceful completion, reconfiguring shared concepts into objects to set before others who reward him. That view is not false, but it is incomplete, and it is no easy thing to arrange the words that reduce Haripada's work to a social exchange transacted on the mundane plane where there is a fitness, a cultural coherence, between self-satisfaction and the satisfaction of the observer.

Description of Haripada's work becomes easy and complete when we accept his account of his motives and admit the sacred into the system of creation. Then Haripada makes beautiful *murtis* not only to please his customers, but also to spark within them the emotion of love in which they can approach God and make their requests, properly and successfully. Then Haripada makes beautiful *murtis* not only to please his patron, but also to please God.

To please his patron is not difficult; he shapes the tradition they share with care, so that things will be useful and beautiful. But in the effort to please God, there is no limit. Haripada must drive his powers as far as possible. To please God, he must please himself, pushing past the point at which his customer knows satisfaction, past the point at which social explanations suffice. From other artists, simple products would do, but not from him. Haripada has been trained by great masters, beginning with his grandfather. He has been blessed with talent by God. So he works to improve his skills, to deepen his concentration, and, receiving help from the deities and from God, he does, as he must, the best he can. His best is a prayer, and he prays that, in return for the constancy of his commitment, he will die in a state of contentment, and that

he will not be reincarnated into this lower environment where it is hard to keep the mind on the path of love.

Haripada Pal gives himself completely, he creates works of art, not only to gain the approval of others or ease their journey through life, not only to obtain cash or display his skill or bless the world with beauty, but so that, repaying the gift of talent with the gift of devotion, he will be released from the cycles of birth and rebirth into an eternal state of bliss.

To do the best he can, Haripada must do all that can be done. He makes his own molds, shapes his own forms, models and paints the images. As an artist, he must be a master of technology. In operating at the highest technical level, he is like few others. Where he is like no other is in his shaping of form. Haripada has actively sought to be influenced, testing himself in different work-shops and academies. Enfolding influences into his practice, Haripada commands a wide range of creation.

In each work, the master creates a relation between the conceptual and the retinal, the abstract and the realistic, between a transcendent geometric order and the messy look of the world. It is easiest to understand when the image is viewed within a symmetrical grid.

When he models small *murtis* for molding, Haripada Pal nudges his work toward realism to emphasize the counterpoint his images contain. In the usual molded image of Ganesh, the belly and head pile on the midline that divides the *murti* into equal halves. Haripada's Ganesh tilts his head to one side of the vertical axis established by the pointed nimbus behind him. Motion begins: the head shifts to commence the curve that undulates from the tip of his crown to the bottom of his one planted foot. Amid that sweep, the god's paunch accedes to gravity, nestling into his lap and centering the design sensually.

Haripada says that Ganesh normally holds one object in each of his four hands: the mace and discus, the conch shell and lotus. His image of Ganesh, he says, differs from all others. One of the god's hands lies upon the book of sacred wisdom. Another opens in the gesture with which the deities bestow blessings. It recedes to rest upon his lifted leg, above his *vahana,* the rat. His left side, the more mobile half to which his head inclines, is the source of personal blessings. The more stable right side, to which his trunk points, aiming down his straight arm to the book, is the locus of collective, sacred benefit. Ganesh's lower, inner, asymmetrically disposed hands, those near the plump stomach, offer gifts. His upper, outer hands hold weapons, the mace and discus, displaying power and confirming the symmetrical form that, anchored at

353

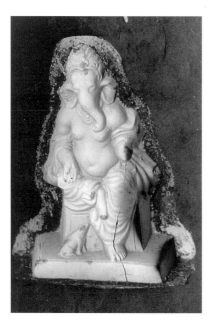

Plaster mold

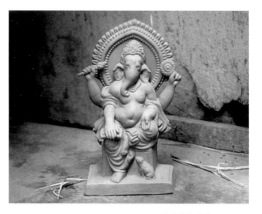

Molded image

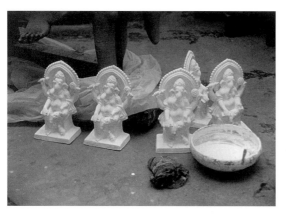

The white coat

Painting begins

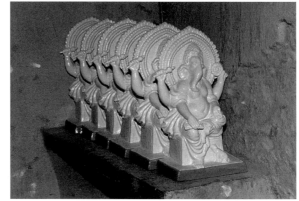

Ganesh.
Haripada Pal

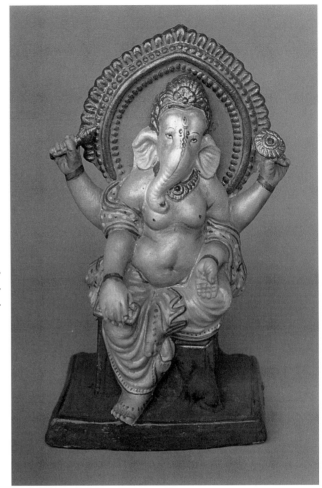

Ganesh.
By Haripada Pal.
Shankharibazar, 1996.
Painted clay; 8¾ in. tall

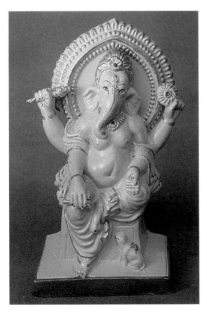

Ganesh.
By Haripada Pal, 1996.
These *murtis* suggest the variety that painting can bring into images taken from the same mold. The one to the left is a creamy, pinkish beige with details in black, red, and gold. The one above has a pearly white head, a deep pink body, a green shawl, a yellow *dhoti,* and details in black, red, and gold.

the base of the belly, carries through the halo behind his head to create the dominant order within which boons are presented to humankind. Stability contains motion. Power contains blessings.

Haripada Pal's molded images of Lakshmi and Saraswati resemble, in style and form, his rendition of Ganesh. Saraswati sits forward, while Ganesh sits back, but her face tilts to capture your gaze, and her soft body curves as his does. Like his, her right hand rests on the book. Her left hand supports the *vina* upon her left leg, lifted above her *vahana,* the swan. The lotus seat swings an arc at the base. Her sari rises to balance the *vina,* and it flows over her body, wrapping it into union with the lotus below and the pointed nimbus above.

Although he has not yet made a mold from it for reproduction, Haripada has sculpted a new image of Saraswati in which she turns away from us, into herself, and plays the *vina.* The twist of her supple body is exaggerated, and the flaming halo shifts with her head. Haripada has bravely abandoned the symmetrical frame that stabilized his earlier fluid figures, relying on the opposed axes of the nimbus and instrument to accomplish order through balance.

Symmetry aids the designer. Amulya Chandra Pal of Kagajipara was not born into a family that specialized in making *murtis.* Nor was he taught drafts-manship and modeling in workshops and academies. He has trained himself, refining his gift through practice. In Amulya's plaque of the Buddha, a line splits the torso, rising from the navel to the neck, upon which the face is set rigidly within a circular nimbus. Beneath the navel, the hands rest upon the feet. The knees, elbows, and shoulders step up the pyramid to the head, main-taining the rigorous bilateral symmetry of the whole. Amulya's plaque of Ganesh is similarly designed. It, too, has a stream of repetitive, geometric motifs along the bottom and a border outlining the symmetrical back panel. Seated upon a lotus, Ganesh looks forward, two arms down, two arms up. Deviations from symmetry are limited to the swing of the trunk, the items he holds, and the rat drawn in profile. Reducing worldly reference to geometric order, symmetry evokes eternity and assures stability in the composition.

When the inherently symmetrical body steps into worldly space, order disassembles and options for postures are infinite. The contortions trapped in snapshots testify to endless variety, and amateur realists can rationalize a host of positions as plausible. The artist's problem is to imply a purpose for depar-tures from the stark frontality in which the body is imaged without temporal distraction. One purpose is aesthetic. If, as in Haripada Pal's new Saraswati,

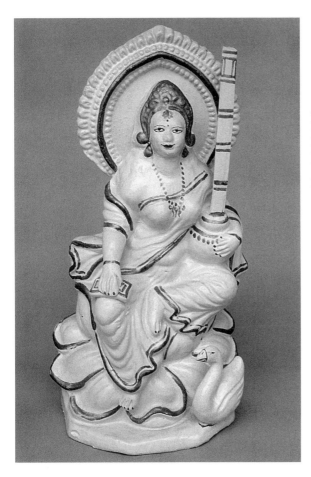

Saraswati.
By Haripada Pal, 1995.
Painted clay; 11¼ in. tall.
For comparison: Amulya Chandra Pal's
images of Ganesh and the Buddha can
be found on pp. 145, 148.

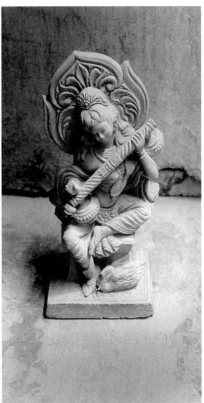

Haripada Pal's new image of Saraswati.
The model sculpted of clay.
Shankharibazar, Dhaka, 1995

Saraswati

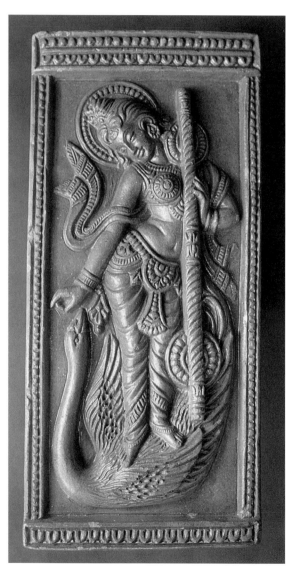

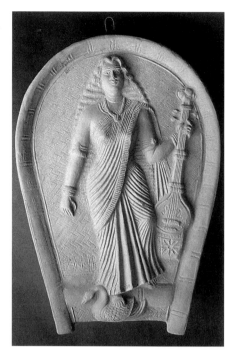

Saraswati.
By Amulya Chandra Pal, 1996.
Earthenware; 13 in. tall.
The plaque is in the form of
a winnowing tray.

Saraswati.
By Haripada Pal, 1981.
Glazed earthenware; 8¼ in. tall

symmetry is replaced by a more subtle and complex kind of balance, the composition is enlivened, increased in formal interest with no loss of beauty. Another purpose is semantic. Geometric order might be softened in behalf of meaning, as in Haripada's Ganesh, or jettisoned to suggest a narrative, as when figures scattered in space are gathered by the story they tell. Or, of course, the figure might be intentionally ungainly and void of reference to signal the absurd.

Absurdity, the style of a world lacking in transcendent order, is far from the mind of the creator of a sacred image in Bangladesh. Beauty and meaning are the goals. Holding to symmetry, evoking eternity, the designer is safe, but shifts toward realism, toward scenes of fleeting change, test the master.

In one of Amulya Chandra Pal's plaques of Saraswati, her face is set on the median. Her right foot steps on the swan. Her left knee is bent to balance her rightward sway. The right arm dangles, paralleling the *vina*. The flattened left arm attaches her musical emblem to the composition; it can be rationalized as plausible.

Haripada Pal has also sculpted a plaque of Saraswati in which the goddess stands on the swan with the *vina* upright in her left hand. Haripada's Saraswati twists farther from frontality than Amulya's, but his image retains coherence in design and meaning. The *vina,* drawn within the compass of her body, strikes a vertical line in contrast with the swing of her hip. Her right arm is not merely set out in the air. She reaches down to her swan, while the swan reaches up to her, so that, behind the stabilizing pole of the *vina,* a long curve sweeps from the breeze-borne cloth above her shoulder, across her waist, around the body of her *vahana,* along its neck and up her arm to her face, bent down and smiling to reverse the curve along the opposite course. Motion is at once endless and confined within the design. The parts cohere through studied manipulation, and the beautiful goddess and her beautiful swan intertwine in affection to become a symbol of the love that unites the universe. In comparison with Amulya's Saraswati, Haripada's possesses more vitality, more stability, and more significance.

Haripada Pal's plaque of Saraswati was glazed and fired. Though unfired *murtis* focus his effort, Haripada, a complete master, also sculpts terracotta reliefs, especially exquisite miniatures of Bengali rural life. In one square, less than two inches on a side, he carved a man in profile, trudging with his plow over his shoulder. In another, a woman husks rice. One tiny ring throbs with

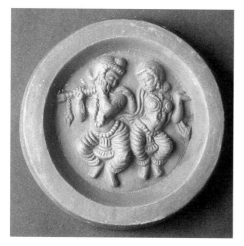

Radha and Krishna.
By Haripada Pal, 1976.
Earthenware; 2½ in. diameter

Radha and Krishna.
By Haripada Pal, 1994.
Painted clay; 9 in. tall.
For Babu Lal Pal's version,
see p. 220.

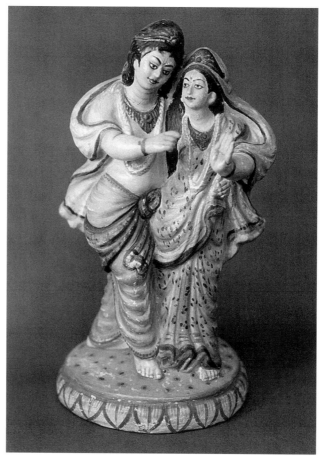

energy: Radha and Krishna, their faces turned together, make visible in their bodies the joyous sound of Krishna's flute.

The bodies of Radha and Krishna mirror away from the midline to fill the circular form of Haripada's terracotta. Bilateral symmetry is similarly submerged in his molded *murti* of Radha and Krishna. The vertical axis, as in his Ganesh, bends, forming a sinuous curve where the bodies of the lovers meet. A pink shawl rolls around them, connecting their outer arms, Krishna's right and Radha's left. Their heads follow the motion of their hands toward the midline, and the two faces, the two exposed hands, the two shot hips, and the two exposed feet, Krishna's right and Radha's left, pattern the whole with pairs, gapped evenly and alternating from side to side, to hold motion subservient to stability.

Haripada's statue of Radha and Krishna compares with the beautiful *murti* made by Babu Lal Pal in Khamarpara. In Babu Lal's image, Krishna poses characteristically, his feet crossed, his flute raised. Radha embraces him from behind. Their hands, equal in size, identical in position, alternate on the tube of the flute. They play one melody. Krishna smiles ahead, while Radha smiles at him, drawing the eyes of devotion to the face of the god. In Haripada's version, Radha and Krishna also stand together on a lotus base, but both of their faces turn away from us. Haripada eliminates the flute and reduces their crowns. Their proportions come closer to human norms. They might be any pair of lovers, except that Krishna is blue and Radha is gold, as they are in Babu Lal Pal's *murti,* and Radha raises her hand to invite devotion. And in Haripada's *murti,* as in Babu Lal's, as in *murtis* in general, there is unfired clay within, smoothness and bright color at the surface, idealization in the features, rhythm in the ornamental detail, and overall coherence in the composition.

When he makes small, molded *murtis,* Haripada Pal steps closer to realism than his contemporaries in Bangladesh. But, especially through his arrangement of flowing textiles and his balanced structuring of abstract volumes, Haripada preserves, subtly but surely, the formal integrity that most designers effect through rigid symmetry. Smooth, bright, and securely gripped in contrived designs, his images stand away from the flux of accident.

When Haripada Pal makes larger images for *pujas,* however, he locates himself at the very center of his tradition. Male and female faces are alike in softness, certain in symmetry, and set squarely upon smoothly modeled, youthful bodies. The body holds the head. The head holds the eyes that engage the

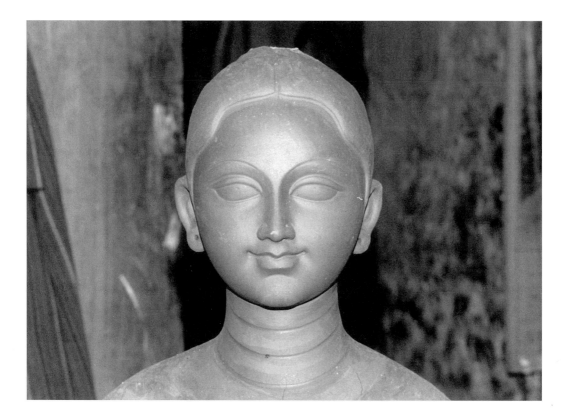

Sitala.
To the right is the body of the *murti* of the goddess of smallpox, prepared by Jatish Chandra Pal to receive the face, seen above, which Haripada Pal sculpted upon it, using no molds.

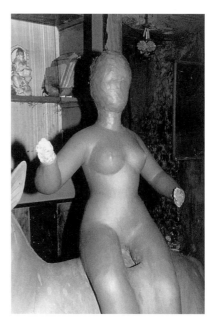

gaze of the devotee, so that his image, like the repeated prayer, can mediate immediately between the seen and unseen worlds. In his images for *pujas,* Haripada's excellence is the excellence of the artist or priest who reiterates convention with perfection.

Haripada's reach is widest in his creations for temples. One day, after work, I asked him to lead me on a tour of his works for places of worship. Three of his large wall plates are installed in the Shankharibazar Kali Mandir. Near the entry, across the hall from each other, sculpted in relief and finished in black, Durga slays the buffalo demon and Shiva carries the body of Sati through the world. Farther in, on one side, painted in vivid color, his sculpted picture shows Arjuna, the heroic archer of the *Mahabharata,* kneeling before Shiva with Krishna behind him. The blank spot across the hall will be filled with Haripada's beautiful Krishna, the one that stunned us on the first day. Sculpted in low relief, glossy with paint, and sheeted by glass in the dark room, his large wall plates defy photography. Haripada signed them, as the painter signs the canvas, and he fashioned them in a realism, inspired by prints, that exceeds that of any of his three-dimensional images. Their coherence depends less on the clever interrelation of abstract forms than it does on the narrative that each one illustrates, the stories Haripada trusts his viewers to bear in their minds.

At the end of the tiled hall, an altar to Shiva stands in an alcove to the left. The wider space to the right is dominated by Haripada's gigantic image of Kali. Richly ornamented by the goldsmiths of Tanti Bazar, wrapped in a shimmering sari, Kali stands erect. Composed in strict frontal symmetry, Kali lowers two hands and raises two hands to frame her blue face. Enormous eyes stare ahead. At her feet, pairs of warriors flank a dozing Shiva balanced by a vigilant lion. The Goddess has absorbed Durga and appeared in the form of Kali, the form Haripada Pal calls power.

Haripada Pal's Kali explores the end of the spectrum of design opposite to that materialized in his plates on the walls of the same temple. Kali is simpler in form, more geometric and abstract, less sensuous than the *murtis* he sculpts for *pujas.* The critic would be unlikely to attribute all of his works to the same hand. What connects them is not style—they range widely between the abstract and the realistic—but the patient excellence of their craft and the deep seriousness of their art: each one manifests, precisely, distinctly, an image that prayer brought to his mind.

I followed Haripada through an alley near the middle of Shankharibazar to see the *murtis* of Radha and Krishna he made for the new Harisabha Mandir.

Details of a Wall Plate by Haripada Pal.
Shankharibazar Kali Mandir

Krishna

Shiva

Arjuna

Kali by Haripada Pal. Shankharibazar Kali Mandir

The smell of the ocean came to us from the shop where they slice shells into rings. We stood in the fading light, and Haripada spoke at length, earnestly, telling me that, though his images portray the Hindu deities, the purpose of his work is to bring humankind to God, making the world better for us all. All of us, Hindus, Muslims, Christians, Buddhists, he said, are here in this vexed place, struggling to endure for a brief span. The world is one, and we are one, all of us alike in the drop of God we contain. United by conditions and nature, we should, he said, work for peace and join in love. I understood, but I had no words to match his, so I opened my arms, and we held a long embrace, Haripada and I, in the reek of the sea, in the heat of the street.

·7·

Art in Bangladesh

WHILE I WALKED AND watched and talked, seeking art in Bangladesh, my view was not limited to pottery, and while I wrote, describing pottery, I hoped to discover a pattern that would accurately represent the particular case of creation in clay and that could be formulated abstractly for application to other media. My aim was to derive from pottery the beginning of a general theory of art in Bangladesh. In this concluding chapter, I will shape the pattern into a model and suggest its use. In application, the model should order diverse artifacts and align them for comparison. During comparison, the model might be modified, extended, and refined into a full account of the current state of traditional art in Bangladesh. Then this idea of art could stand to challenge and productively complicate any universalizing concept of creation.

I broke into the multiplex unity of *mritshilpa*, the potter's art, with the dichotomy of use and beauty. That contrast is conventionally employed during efforts to rank artifacts in the West, and it is not altogether alien to Bangladesh, but it is logically imperfect. Use is not opposed by beauty, but by the useless. Beauty is not opposed by use, but by the ugly. It would be neater to contrast the useful with the decorative. Decorative objects are removed from touch for visual apprehension. But, in English, the idea of the decorative carries connotations of insignificance, and when the intention is to arrange hierarchies of value among artifacts and to erect a supreme class of things called art, considerations of meaning as well as beauty are entailed. It would feel wrong to identify art with the decorative.

Now, it is not my wish to bewilder us in a thicket of words, but to find words that will confound comparison as little as possible, and I am following a functional line of argument because it contains cross-cultural potential. Even if art were defined as meaningful decoration, the desired contrast with handsome tools—the useful and beautiful objects collected in the strangely named category of decorative arts—would remain incomplete, so art gathers the idea of representation, the notion that an artifact, in its gesture to significance, should seem to be other than what it is, manifestly and materially: the hewn chunk of stone is taken for a pretty youth; the canvas laden with paint is read as a mind in turbulence. All this means that when I began investigation of the potter's art, intending to make it comprehensible in Western terms, I had to stress the coexistence of use and beauty in real things, and I needed to add the ideas of meaning, decoration, and representation to get the job done. Trim antinomies ceased to hold, and relations complicated into a sixfold scheme.

We began in the village of Kagajipara with these categories of creation, each poised, like literary genres, for exploitation and reconstruction during historical action: First, the dominantly utilitarian, subordinately aesthetic tool manipulated within systems of labor (the *kalshi* and *patil).* Second, the object of decorative use, crafted in the plain style of the tool (the bank, flowerpot, and vase). Third, the object of decorative use, elaborated by applied ornament (the painted *kalshi,* bank, or vase; the planter with sprigged and incised detail). Fourth, the image, decorative in purpose (the plaque or statue). Fifth, the decorative image, significant in intent (the plaque or statue that insistently evokes the cultural or sacred during contemplation). Sixth, the image in which beauty and sacred significance combine with utility (the *murti* for worship).

Here at the end, I feel that the categories, the subclasses within the art of the potter, remain useful, but that their structuring together has been distorted by the intrusion of foreign values that occlude utility. When industrialization expands, the personal creativity involved in making tools becomes diminished and obscured. When work is done by machines and servants, and social stratification is symbolically rebuilt in the realm of the artifact, then objects ascend in status by eschewing labor, and art becomes associated with leisure. When religion is purified philosophically and stripped of magic, images become things to contemplate but not to manipulate. Utility declines in value as wealth, not to be confused with creativity, increases. In the unluxurious world of the Bangladeshi artisan, where handcraft remains common, where hard work must be done, where religion is an aid in the daily struggle, as

intimately a part of the process of work as the tool, utility remains a high value. It is at great cost that the worker acquiesces to a structure of value that demeans work.

In Bangladesh, usefulness centers the system of creation. The objects separated into the first and sixth categories by linear ordering—the tools for earthly work and spiritual work, the *kalshi* and *murti*—should stand together in the dominant position. Then to each side, utility will descend to decoration. Away from the *kalshi,* as utility decreases, elaboration increases to signal technical virtuosity and consolidate ornamental purpose. Away from the *murti,* in the sequence of images, the sacred diminishes as utility is lost, then meaning is lost, and then only beauty remains. The fifth category, in which beauty and meaning coalesce, approximates the usual Western idea of art, but the beautiful and significant image that is posed for view and ranked highest in the West, is, in Bangladesh, clearly stationed below the object in which beauty and meaning serve useful purpose. As Haripada Pal taught, the *murti* in the showcase is a thing of less importance than the *murti* amid *puja.* Importance declines as meaning wanes in the fourth category, but because its artifacts are clearly representational and shaped aesthetically, they would probably also be considered art in the West. Were they old and bereft of association, they would be assembled for presentation in a museum of art. They connect with the nonrepresentational objects elaborated with representational ornament that would be called decorative arts in the West. The system of Bangladeshi art should associate the decorative image and the object of decorative use (the big horse of Khamarpara and the elaborate planter of Kakran, both devised for the new middle-class market), just as it associates the secular and sacred tools (the *kalshi* and the *murti,* the numerically and conceptually dominant ancient forms). So when I structure the categories anew, attempting to picture the system of creation in local terms, free of alien distortion, when I derive the overall order as well as the categories from experience in Bangladesh, I come up with a circle, split by representation, but connected below in decoration and above in utility.

My claim for the circular diagram is only that it presents graphically the relations among the potter's creations. But if it holds through tests against other media, it could represent, abstractly and in outline, the idea of art in Bangladesh. Beyond that, I am certain that it cannot be taken for a universally apt functional model of art, though it would make a better first step in that direction than the Western ideas that have been deeply molded by Christian

First Formulation

utilitarian | 1 | 2 | 3 | 4 | 5 | 6 | aesthetic

Second Formulation

useful

secular — sacred

1 6

2 5

3 4

nonrepresentational — representational

decorative

Categories of Creation

1. The tool: the object plain in style and used in work.
 Examples: vessels for carrying water *(kalshi)* and preparing food *(patil)*, the cane mat for drying rice, the boat.
2. The tool used decoratively: the object plain in style and used in ornamentation.
 Examples: the flowerpot, vase, and bank.
3. The decorated tool: the useful object coated with ornament.
 Examples: the painted *kalshi,* the sprigged planter, the engraved vase, the brocaded sari, the rickshaw.
4. The decorative image: the representational object, ornamental in purpose.
 Examples: the earthenware or brass statue of an animal, the rickshaw panel of birds and flowers.
5. The evocative image: the representational object, ornamental in purpose and clearly referential.
 Examples: the plaque of a poet, the picture of a village on a terracotta or baby taxi, the rickshaw panel showing a mosque, the brass statue of a deity.
6. The useful image: the representational object used in sacred ritual.
 Examples: the *murti* for worship, the prayer mat depicting a mosque.

The System of Creation in Bangladesh

theology, and that have been, in later days, so contaminated by the class and gender prejudices endemic in industrial capitalism that, despite baby steps toward redress and revision, art has nearly become identified with objects made by educated males for consumption by the rich. The view from the markets of downtown Dhaka would be better than the view from the uptown galleries of Manhattan for the one who would wish to understand art in general, for most of it is created today, as it always has been, by the world's working majority. (For perspective: let me guard against provincialism by reminding you that there are more peasants in the Indian subcontinent—not to mention China— than there are people of all classes in the United States and Europe combined.)

The circular diagram will picture the whole, holding the parts in relation to each other, and in relation to the art of the potter we have examined in detail, as I turn to application, employing the model while working ahead toward a comprehensive view of art in Bangladesh. Scholars differ: some use theory to understand reality; others use reality to refine theory. I am of the former kind, and my purpose is less to illustrate the model than it is to use the model to advance investigation, opening things up more than closing them down. I will begin at the center, where things are useful, where utility divides by sacred and secular purpose, and I will not only shift from one medium to another, I will shift from work performed by Hindu men to work performed by Muslim women.

Cane Mats

In the markets of Chittagong city, I found mats woven of strips of split cane. Most were plain, unornamented, but their vendors divided them scrupulously by the quality of the weave. Those woven of slender splints, so fine in texture they could be folded into tiny bundles, were made, I was told, in Sylhet, while the rougher pieces came from rural Chittagong. The shops offered as well a few smaller mats through which dyed strips in one or two colors, red or green, had been woven into symmetrical designs. The finer in weave and more complex in design were made in Sylhet, the rougher and simpler in Chittagong, and whatever pattern they bore, they were made to be used in prayer. The right size to shape a clean space around one person for the ritual sequence of *namaz,* the mat is called a *jainamaz.*

In Dhaka city, at New Market, in Chouk Bazar, at Sadar Ghat and Kaptan Bazar, I found large mats rolled up for sale. The finest came from Sylhet, in the

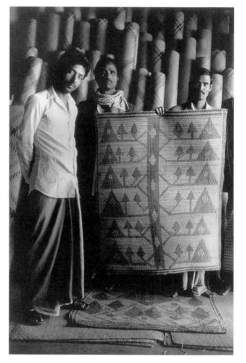

Cane prayer mat for sale.
Chittagong

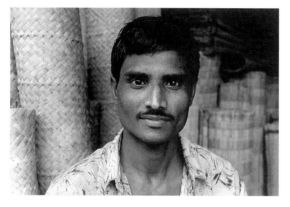

Zakir Ahmed. Kaptan Bazar

Cane mats, baskets, and *kalshis* for sale. New Market, Dhaka

northeastern corner of Bangladesh, and others came from Chittagong, but the majority were made southeast of Dhaka, on the road to Chittagong. They were usually said to come from Noakhali, meaning a region embracing the districts of Noakhali and Feni.

Using, like many, his rural connections to make it in the city, Zakir Ahmed, from Senua in Feni, sells cane mats in Kaptan Bazar. His stock is composed of large, plain mats, but now and again he has for sale a fine *jainamaz,* woven in his home district. So I got on the bus with Shafique Chowdhury, a Feni man himself, and went to find the artists.

During his trip home for Eid, Shafique had learned the name of a weaving village, and on our second day in Feni town we persuaded the operator of a baby taxi to drive us into the countryside. The roads were not planned for motor vehicles. At the end of our first attempt, we landed in a ditch. Young men walking to the rice fields made no comment and waited for no thanks when they lifted the taxi back on the track. All in a day's work. The second try was a success. Our driver slept through the day in his vehicle at the village of Madhya Chandpur, while we learned about the craft from the brothers Abdul Kalam Azad and Zakir Ahmed (a farmer and no relation to the seller of mats at Kaptan Bazar), and from Zakir's wife, Parul Begum, and her neighbors Afia Begum and Roshna Begum.

Green cane, called *patipata,* grows in *patipatar bagans,* cultivated sally gardens. The cane is split for weaving with a *da,* the mainstay of the blacksmith's trade: a stable, upturned knife of the kind used to sliver vegetables for cooking. Afia Begum shoves the cane through the knife's curved edge, splitting it, then splitting it again into quarters. She snaps the end, peels off the green bark, and shaves flat splints, separating the pulpier interior from the woodier exterior. The softer strips will be used in rough work, the harder in finer. All the strips are dried in the sun, and then moistened to make them supple for weaving.

There is no loom; the process is like a basketmaker's. Afia arranges twenty strips neatly one above the other on the ground, holds them down with her foot, and then weaving begins when she crosses new strips through the first ones into a twill pattern. One woman can weave a large mat alone, adding strips vertically and horizontally as she shifts atop the mat, but a team of three is ideal, and Afia works with her neighbors Laila Begum and Parul Begum.

From soft cane splints, they weave rough mats that are agricultural implements, beds on which rice is dried. From harder splints, they weave tighter

Patipata for sale. Lemua Bazar

Afia Begum
splitting cane

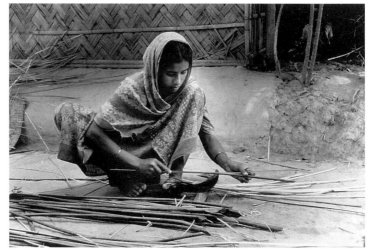

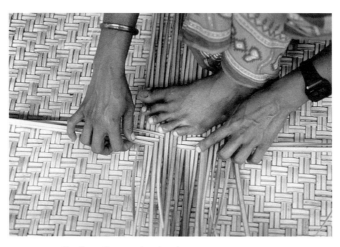

Roshna Begum beginning a new cane mat

mats that provide smooth, cool covers for the clay floors of village homes, beds on which people sleep comfortably in the heat. Both are sold in the market at nearby Lemua Bazar, along with cattle, vegetables, dried fish, and raw cane to be split and woven. Some of them will go then to urban markets as far away as Dhaka.

Fine hard splints are also used to weave prayer mats, here called *botnis*. The pattern is shaped against the natural tones of the ground with splints in one or two colors. They tint the splints by boiling them with synthetic dyes bought in Lemua Bazar. The dyed splints lie in the warp. The weft is undyed, and the weaver's problem is to hold the whole design in her mind, and to maintain the strength of the web, while bringing color to the surface at the right junctures.

If you ask a man in the market who made them, he will say he did. Ask again, and he will say his wife weaves them, that all women can. But when you get to the village, the women say that weaving prayer mats is very difficult and only a few can do it. In Madhya Chandpur, those few are two: Parul Begum and Roshna Begum. All the women in a weaving village can make plain cane mats. The rare master makes *botnis,* and she works alone on commission. Between commissions, she does the work everyone does, but Parul and Roshna agree that commissions are frequent. Their fame has spread far beyond their village, so usually they are doing interesting work for good pay, making mats for prayer.

Roshna Begum, in honest confidence, told me that she so commands her métier that she can weave any design, and she sent her son, Mohammad Anwar Hossain, to fetch the *jainamaz* she made for him. The center is dominated by the word *ma,* mother. He will remember her when he prays. She will continue to enwrap him in love during his devotion.

Words in Bangla are not rare on prayer mats, but they are usually minor parts of the design. Some designs cover the surface with a geometrical pattern, like a checkerboard. Parul Begum showed us a beautiful mat of embedded purple squares she had woven. More often the design is bilaterally symmetrical and directional: the sides mirror from the midline, but the top and bottom halves differ to imply an orientation. The mat will point, as the one at prayer points, through the mihrab, toward Mecca. The forms that build to symmetry on the surface are representational: flowers, flowers on trees and vines and in vases, flowers scattered among birds or beasts or artifacts—farm tools, *kalshis,* even airplanes—but the most common image is a mosque.

Roshna Begum. Madhya Chandpur, Lemua Bazar, Feni

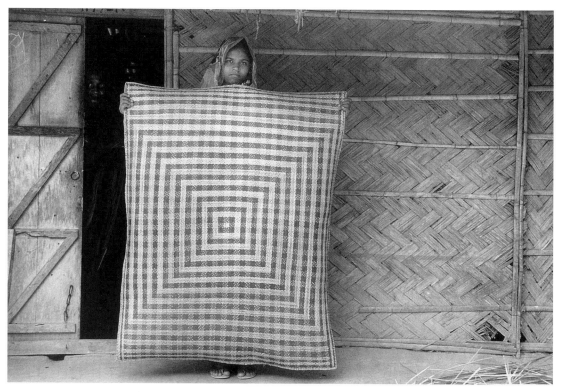

Parul Begum holding a *botni* she wove. Madhya Chandpur, 1995

Cane prayer mat, woven in Sylhet, bought in Chittagong, 1988. In red and green, it exhibits the overall design of Islamic order: boxes containing quartered diamonds repeat vertically, horizontally, and diagonally into an image of totality. The mat in purple by Parul Begum on the facing page represents the centered design of Islamic order: boxes expand radially from the midpoint into an image of unity. The mat from Sylhet measures 3 ft. by 3 ft. 8 in., that by Parul measures 3 ft. 3 in. by 4 ft. These mats suggest the norm; the others pictured on this and the next page are like them in size.

Cane mats woven in Senua, Feni, bought in Dhaka, 1995. One shows a mihrab, the other a vase of flowers. On the vase is the name of the favorite wife of the Prophet, Aysha, an evocation of the feminine and sacred in Islam.

Woven in Chittagong.
Bought in Chittagong, 1988

Woven in Senua, Feni.
Bought in Dhaka, 1995

Cane Prayer Mats

Woven in Noakhali.
Bought in Dhaka, 1987.
It is green. The one above to
the left is purple; the one
above to the right is red. The
text reads, Raj Gate, meaning
the mihrab is the main portal
to immortality. Crockery, a
table, and a chair make a com-
fortable, hospitable home
within the mihrab.

The prayer rug of the Middle East, like the *jainamaz* of Bangladesh, needs only to be the right size for the performance of *namaz*. Its imagery does not necessarily recall the act of prayer, but characteristically the surface carries a pointed arch, a depiction of the mihrab. Prayer rugs woven in the Middle East surely inspired the mats of Bangladesh, but in Bangladesh, more often than in the Middle East, the mihrab is part of a design that abstracts the whole mosque, with columns to the side and domes and minarets above. One cause for the design is its specific source. Prayer rugs woven in Turkish factories and sold at mosques in Bangladesh tend to be detailed in their architecture. Repeating courtly formats from the past, in which columns flank the mihrab, they are more conspicuously representational than the prayer rugs woven in Turkish villages. Other causes lie in the local culture. Even among Muslims, ornament in Bangladesh drifts toward the pictorial. Whether painted on *kalshis*, engraved in brass, or woven in cane, the inherently geometric design avoids the human figure, but it pushes past the abstract relations of shape and color that would satisfy the Turkish artist and moves on to the portrayal of flowers or animals or human creations, like the mosque. And the mosque has gained such significance as a religious emblem, balancing for the Muslim the *murti* of the Hindu, that it is, in the guise of the Taj Mahal, the signal ornament for rickshaws. The rickshaw painted in Feni, even more often than the one decorated in Dhaka, displays the Taj Mahal, and the women of the countryside weave their mats with deftly abstracted mosques.

The prayer mat is a picture. It is often fitted with a loop at the top, like the loop on the potter's wall plate, so that when it is not in use it can be hung on the wall for decoration. But it exists primarily to use, to create a space around the one who stands upon it and lowers the head to the cool, smooth surface, while the blood flows, the soul soars, and the prayer seeks God.

The parallel is clear. The pair of the large, plain mat and the decorated prayer mat is like that of the *kalshi* and *murti*. Cane and clay are common, local substances, shaped into objects for use. One object is part of workaday life. The other is an element in a sacred ritual through which people communicate with God. The object for daily use is plain in style; it is crafted handsomely, and it is what it is: a sleeping mat, a water jar. The ritual object is representational. The *botni* is a picture, the *murti* is a statue, but in both of them representation is enhanced by selectively applied color, and the forms are at once abstract and referential.

The parallels that are clear in function and style persist in the social and economic spheres. Materials are processed by everyone; men and women split the cane and tread the clay. Everyone in the trade can make the object for daily use, and they work cooperatively for the open market. But ritual objects are made by talented individuals of one gender. Women make *botnis,* men make *murtis,* and they work alone on commission, filling slack time with the work everyone does, but concentrating on the specialties that bring them cash and status.

Unified by utility, divided by secular and sacred purpose, the central creations of workers in cane and clay echo the contrast in village architecture. In Madhya Chandpur, the daily routine circles the *bari,* composed of buildings walled with bamboo and roofed with thatch. Their colors are nature's. Their style is plain; there is no applied ornament. The new and elegant house fills the gap with its cladding of tin and touches of paint, but the contrast remains between the house and the mosque. The building used in prayer sparkles in white, smooth and bright, to divide from its surround of mottled greens and browns. It is ornamented internally with painted floral vines that climb the columns and rise beside the deep mihrab, complementing the symmetry of the *qibla* wall facing west to Mecca.

As I have come to understand it, the system of Bangladeshi art is centered in need, by the useful things, some secular, some sacred, with which a hard life is made possible. Having located the center, set in clay, confirmed by cane, I will begin an examination of the full circle of creation with another look at the realm of the *kalshi* and the plain cane mat, the category of artful action within which people make tools.

A Wooden Ship

The authors of the Eid parade had their complaints about life in Dhaka, and I had mine, but the city also offered me a tonic to purge anger. I felt tensions evaporate when the streets narrowed and I joined the crowds of Old Dhaka, and I felt the spirit lift when I crossed the Buriganga for my regular visit to the builders of boats. Their steady industry, calm confidence, and ready cheer— the sure signs of people who have mastered difficult trades—overbalanced all frustration.

East of the new *ghat* at Zinzira, fifteen shipbuilding yards pack tight along the riverbank. One of them was my destination. Ashrarul Hasan Asu, the

Zinzira

Motahar Mistri

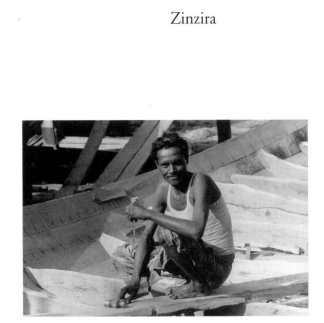

Abdur Mannan

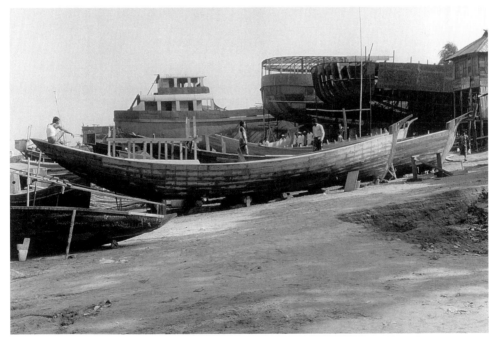

Boatbuilding on the beach

Zinzira

Laying the keel

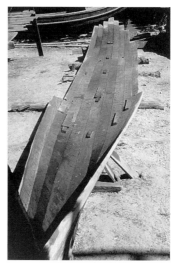

Planking the shell

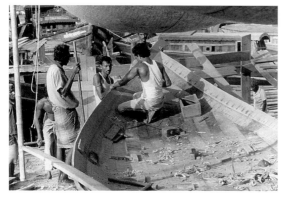

Finishing the bottom

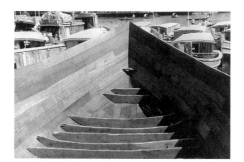

Bakas emplaced

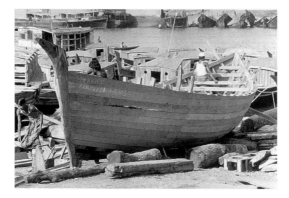

Nearly complete

manager, welcomed me cordially with cold drinks in the shade of his bamboo office, and he gave me the run of his hot yard. He deals in timber and specializes in the construction of wooden watercraft. During my time in Dhaka, he was building, through multiple contracts, a fleet of "trawlers." Once finished, they would travel from the Buriganga to the Meghna, and then down the great river to the Bay of Bengal, there to ply the coastal waters. Ten teams worked on the beach, making the boats from which the nets would be cast. The mother ship, in which the catch would be iced, rose in his yard.

Each of the boats on the beach is the product of a different team of carpenters. The master Kalam Mistri tells me his work and workforce are typical. Assisted by three men, Muslims like himself, Kalam lays the *dara,* the keel that lifts proudly at the stem into a painted *goloi.* The prow calls to mind the dragon's head of a Viking longship, and the rest of the boat, though not clinker built, loosely sustains the analogy. It is a smooth, round-bottomed double-ender with swinging, graceful sheer.

Kalam Mistri and his men spike planks to the side of the keel. Nailed to one another, planks rise on both sides, bending into an elegant shell. Then Kalam builds the frame into the hull in unattached segments. In series, rounded *bakas* cross the bottom and bowed *gosas* rise up the sides. The construction, characteristic of Bangladesh, differs from the old European practice in which, as in a house, a rigid frame is built, then sided, but it is a technique found across the globe, in Europe and North America as well as Asia, in places where larger craft have evolved from dugout canoes. The builders rely on the skin to shape the whole, and then they reinforce it with frames that do not articulate into a stable skeleton. A cabin, framed aft, completes the craft.

To build the ship in his yard, Ashrarul Hasan Asu hires three crews, the first to frame and deck it, the second to caulk and paint it, the third to install its Japanese four-cylinder engine. The small boats on the beach take four men a month to build. The ship in the yard takes, I am told, six men three months before it is ready for caulking. It will cost one hundred and fifty thousand *taka* to build, and it will be worth a million *taka* when it is done, the value lying more in materials than labor.

The master of the carpentry crew is Bimal Chandra Mandal, who travels from site to site with his team. During the difficult framing phase, four men help him: Ganesh Mandal, Niranjan Mandal, Nepal Sarkar, and Mohammad Sadek, three Hindus and one Muslim. For the final planking phase, he lays on two or more men.

Like the builders on the beach, Bimal and his men have no plan on paper. The agreement with the patron was brief, oral, and largely about pay. They use no model, no prepared templates, and they make no reference to a system of measurement that lies in abstract perfection beyond the immediacy of their work. All measurements are organic, a matter of relating new work to old, while overall order abides in the mind to be checked with the eye. Their process of creation relates to systems dependent upon detailed plans and intricate devices of mensuration as oral performance relates to literary endeavor. Holding the narrative line in mind, the storyteller works along it, episode by episode, choosing words that link the past, gone and beyond revision, to the future, yet to come, as sounds accumulate toward their inevitable end in totality. Bimal Chandra Mandal has the ship in his head, and he guides his men through act after act, as elements cohere into segments and segments build into a new unit that can be moved down the ways and into the water.

Successful creation requires authority, but authority is not displaced into a realm of numbers and letters; there is no text beyond performance. Authority exists in social interaction. The patron commissions a fleet and surrenders authority for creation to the masters. No absent designer supplies instructions that must be respected. The master is both architect and builder. He has developed a plan in his mind by moving his body experimentally among the things of the world, collecting experiences and refining concepts. The members of his team, though they know the work well, and though they are accustomed to cooperation, cede all power to the master, doing what he says, quickly when he says it. The patron yields, the workers yield, and the authority of tradition exists for the moment of creation in the master who operates at the top of an interactive, hierarchical order to keep the ship, like a story, moving toward its conclusion.

Bimal and his men begin, like the builder of any country boat, by laying the keel. It differs from the keels on the beach in size and in that it rises at the stern into a transom. The transom and high *goloi* are held aloft by temporary scaffolds. The keel is bound down to the shipway with wire. The planks await placement. Above and below, along the edge, acute channels are chiseled into the first plank. Common nails, hammered into an arc, are driven into the channels, then seated with a punch, to unite the plank with the keel. The master hammers above, a helper below. Toward the stem and stern, the plank must be bent, violently twisted and bent, and it takes all the team's strength to lever the plank into position and hold it while the master saws into the joint to tighten the fit, and then drives the nails home.

Bimal Chandra Mandal

To assure symmetry, they work from side to side, nailing one plank, then its opposite mate, and to assure symmetry, they string a line from the prow to the center of the transom, and drop a plumb bob from it, so Bimal can step back and sight along the midline to be certain that the sides are rising along identical curves. Numbers do not matter, but balance does, and Bimal checks as he goes by picking a stick off the ground and running it from the center out to the edge, marking the midpoint with his thumbnail, then swinging the stick across the floor to compare the halves.

Right and left, planks are nailed, levered ferociously and nailed, until the round bottom is complete and it is time to turn the bilge. They consolidate the bottom by cutting and nailing *bakas* across the dished floor.

To this point, their process is the same as it is for a smaller boat. Soft wood is nailed in tension, then stiffened by added frames. Now, though they use the same wood, *garjan,* their process shifts to approximate the other woodworking system, the one usual among furniture makers in Bangladesh, in which hard wood is fitted and joined. Bimal's tool is an iron rod. He hammers it until its lower curve repeats the rising bottom and its top outlines the swelling side of the ship's hull. Bimal has sketched the ship in iron against the sky, and his rod holds the curve of one rib in the ship's frame.

When I asked Ashrarul Hasan Asu how the components in the ship's frame were fashioned, he gestured over his shoulder at a power bandsaw in an open shed, and said they were sawed. The words spoken in interviews do not always quite capture the state of affairs. He also said the ship would contain—he used the English words—a freezer system. What that meant is that the fish will be packed in ice in the hold. This is how the ribs are sawed. Bimal ties a string near the top, at the deck level, of his bent iron rod and gives it to the sawyers, Niranjan Mandal and Nepal Sarkar. Resting the rod on a thick plank, locating it carefully to use the wood as efficiently as possible, they draw a pencil line along the curve, move the rod into a new position parallel to the first, trusting the eye to gauge distance, and then draw a second line. They repeat the procedure on a second plank, then, rolling a log under one end of each plank, the men get up, bend forward, and rip along the lines with small handsaws. While they stand on their tilted planks, cutting the matching ribs that will stand across the ship from each other, they keep a third man busy, filing saws. Each saw is sharpened fifteen times during its long, curving cut. Niranjan and Nepal bring the finished ribs to Bimal who checks them in place by touch and eye.

386

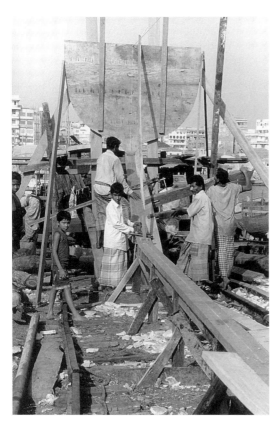

Levering the first plank at the stern

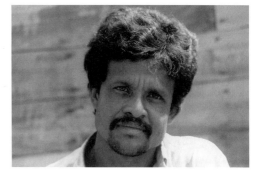

Ganesh Mandal

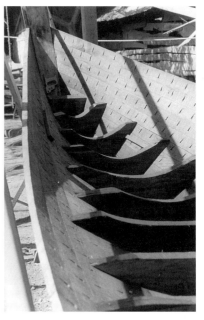

Bakas in place in the bow

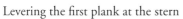

The first planks at the bow

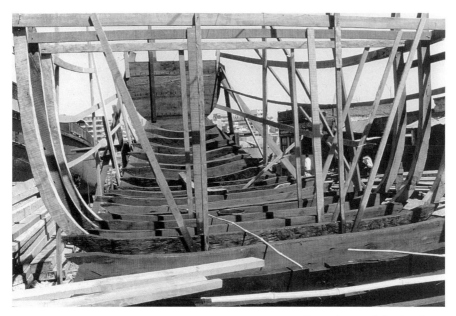

Central sets of ribs in place

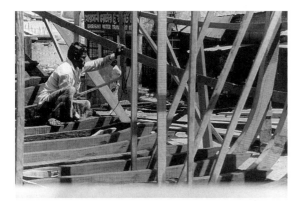

Bimal Chandra Mandal
bending the rod to the rib's contour

The frame complete,
the planking nearly done

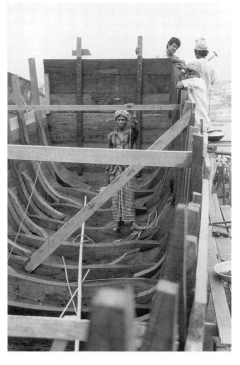

Decking in the bow

Bimal Chandra Mandal's Ship.
Zinzira

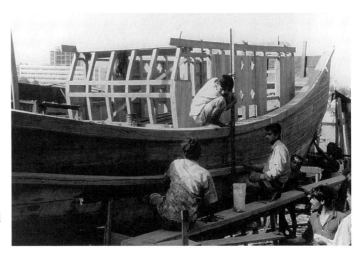

Finishing the hull

Planking the hull

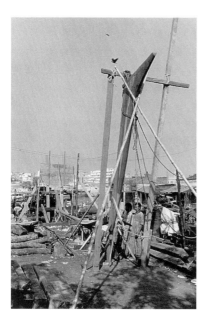

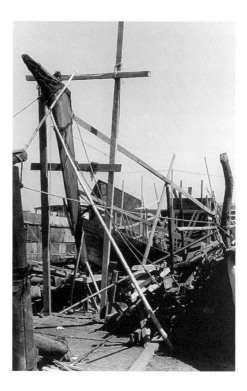

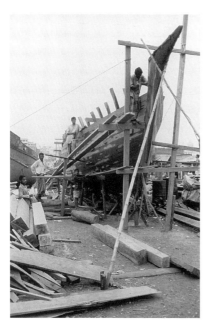

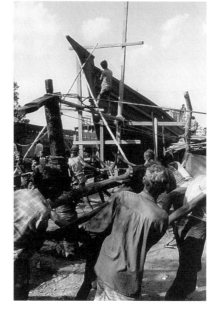

Bimal's Ship

Once the three middle pairs of ribs have been nailed in, the men tack three long laths to each side that run from the bow, over the ribs, and on to the transom, outlining the ship of the future. Now Bimal Chandra Mandal hammers the iron rod to the curve that runs from the bottom and up the laths. The ribs are sawed in pairs, checked by eye, and heaped beneath the hull for emplacement in a single campaign. They will depend for stability on the planks nailed across them, for, as in the smaller boats, the supports of the sides are separate from the supports of the bottom, and the whole depends on its skin for coherence.

The ribs are in place, the pace picks up. Bimal adds workers who drift around the shipyards and who can handle the relatively easy task of nailing the planks to the ribs. Bimal's men frame a cabin at the stern and plank the sweeping deck, and before they are gone, the next crew has come, and the engine has arrived in its shipping crate.

Snipping tufts from the backs of the sheep who poke for grass around the yard, the men of the new crew roll the wool on their thighs into ropes to pound into the gaps between the planks. Bimal Chandra Mandal has gone. The sleek surface is painted against the weather. The engine goes in. The ship is ready for launching.

From the particular case of Bimal's ship, I wish to lift two general principles, the first about the structure of work, the second about aesthetics.

The System of Work

The objects that center the art of Bangladesh are similar in utility, but different in their spheres of operation and in their norms of creation. Tools, like *kalshis,* are made by teams for the open market. Ritual objects, like *murtis,* are made by individuals working on commission. By noting that the ship is a tool made by a team on commission, I begin to explore one of the issues I intended Bimal's ship to raise. Facts lead to complications that disrupt neatness and expand understanding.

The creator works within a system of production and in relation to a consumer. Useful things have users: devotees at prayer, fishermen on the sea. Between the user and the creator, there might be a patron who places the order: the executive committee of a temple, the manager of a shipyard. What is crucial within patronage is the preservation of the artist's right to create. The owner of a rickshaw provides no instructions. The artist does as he wishes. The owner of a baby taxi specifies the picture it will carry. The artist is constrained

by topic, but free to paint the picture in his own style, and to arrange around it the decorative program he deems best. He proceeds like the sculptor of a *murti* or the builder of a boat, and the result is satisfactory because the patron and artist share culture; their expectations align. Out of similar experience, they have drawn similar notions about the appearance of a baby taxi or of Saraswati or of a trawler.

When culture is not shared, when the patron distrusts the artist, instructions elaborate and creation is cramped. That is what happens when an exporter relays the desires of a foreign client through photographs to the potters of Kakran. Then the basic form and ornament are set beyond performance, and, like a concert pianist, the artist surrenders design and situates creativity in the constricted realm of technology. It might be that, needing money, artists make things they do not admire, that might please the patron but cannot stand as fully achieved signs of creative competence. Artists require scope, space in which habit and will can conspire in objects that incarnate the worker's own standards. The potters of Kakran have beaten the system by using new ideas in the production of improved commodities for the native market. But Kakran suggests how patrons can squeeze the creator and undermine art.

Writings about Bangladesh are conventionally framed by a rhetoric of aid, shaped to offer solutions to problems in order to ease the life of the people. At this point my book is like the others. In describing the customary relations between the patron and the artist, I mean to confirm a cultural norm, in which the artist remains free in matters of design and production, and to argue that greater intrusion is destructive. When agencies, wishing to do good, force people to make certain things in certain ways, when they act out of pity, not fellowship, and proceed on the pompous assumption that their people know more about art than the artists, they assault artist and art alike. Across the globe, efforts to invigorate the arts while controlling them compulsively have generally served to kill them off. Agencies should learn to stand to the creator in the traditional role of the patron, placing orders, perhaps offering alternatives for consideration, then getting out of the way. Those who want to help should learn to sit placidly in the office, like Ashrarul Hasan Asu, while the masters get on with their work.

Patrons personify market forces. From them, as from the middlemen who buy for the open market, the artists learn what people want. The patron and the open market function similarly. They are, through the money they offer, sources of information, and they are, during creation, no different. Both are,

like the writer's publisher, occasionally remembered but usually forgotten, while the artist bears down, doing the best that can be done, upholding standards that surpass the requirements of the buyer to meet, and normally exceed, the needs of the user.

The consumer sets one limit for creative expanse. Co-workers set another. The artist who works alone is not truly independent. Painters in the West rely on others to manufacture their canvas and paint. The weaver of the *botni* who splits her own cane and the sculptor of the *murti* who treads his own clay come closer to independence than the modern Western painter, but the artist in Bangladesh normally enjoys, at least, assistance in securing materials. Men harvest the cane and mine the clay. They bring raw materials to the artist who refines them, usually in collaboration with others, and then sets about the task of creation. What is crucial, within production, is that the artist be, at some point, alone, absorbed in a communication with the self through materials.

Alone in concentration, forgetting those around him, the artist sculpts the *murti.* The woman who makes a *kalshi* knows a comparable moment. She was one in the team that prepared the clay; she will be one in the team that fires the kiln. In the middle, she alone brought clay into form, fusing design and production in performance.

Haripada Pal can do it all, but he is helped by Jatish Chandra Pal. Haripada controls the design of the whole *murti,* and he produces the prime features— the face and hands—while Jatish models the bodies. Division clarifies when the master steps out of production and becomes a manager and a designer. In his familial workshop, Amulya Chandra Pal oversees the entire procedure, while others use his molds to make objects for sale. The works are attributed to him. Though Amulya did not make them, he is the master. It is all hand-work, but for the usual wall plate Amulya is like an industrial designer; he conceived and created the prototype. So it is in Maran Chand Paul's shop in Rayer Bazar. Like Haripada and Amulya, Maran Chand makes the major works, the biggest horses and elephants, and he creates the original designs his workers replicate under his supervision.

The organizational extreme is reached with the making of a *patil* in Krishna Ballab Pal's *karkhana* in Rayer Bazar. The master's work is not to design but to set a protocol of production within which others create. Men mix the clay and throw the rims. Women shape the bottoms and join the forms. Men fire the kiln. The *patil* is the joint creation of the workers. The master has become a manager. It is much like that in Salah Uddin's brass-casting operation in Old

Dhaka. From casting to buffing, Salah Uddin arranges the work of others. Abdur Rab manages the shop in which Abdul Karim and Abdul Razzaque do the casting. Each is attended by a boy who packs the mold with sand and both are assisted by boys who maintain the heat in the crucible and trim the cast pieces. The master works in a hierarchy of labor. There are helpers below to perform simple tasks, and there might be managers above. The key to success is that the managers are artisans, men like Krishna Ballab Pal and Salah Uddin, who have risen through the trade. They understand the work, they know what the masters can do, and they let them do it.

The manager acts like a patron, leaving the masters in command of their segment of the process and in charge of the laborers who serve them. Krishna Ballab Pal need not be present while the work proceeds. He can concentrate on commerce. When Yunus Mistri was killed in a motorcycle accident, his brother Abdul Jabbar, the shop's artist, stepped gracefully into his role, and work continued smoothly in his factory for baby taxis in Maghbazar. When the manager of the Paresh casting shop in Dhamrai died, his widow and two young sons were able to manage the enterprise, because the masters knew their parts and required no direction. Each controlled production within his own sphere.

In a book of high importance, John James argues that Chartres cathedral, one of the masterpieces of Western art, was not the creation of a single unknown architect, but of a series of master masons, each of whom did his part in the creation of the magnificent whole. The building did not spring from lone genius. It unfolded, like a grand *patil,* from the culture, from the distinct, but coherent understandings of the workers. During cooperative production in Bangladesh, it is normally the case, one person manages the business and knows the whole procedure, but creation depends on individuals who perform their parts in sequence, like actors in a drama.

Options for self-directed creation exist, of course. Babu Lal Pal prayed and shaped an image of Radha and Krishna for his own devotion. But usually the creator at work is surrounded by others. A user stands to one side, co-workers to the other. It is different in industrial settings where expensive machines facilitate the fragmentation and simplification of the worker's responsibility, but in Bangladesh, in scenes of handwork, the user's agent, the patron, and the manager of the workforce both, trusting the masters, provide them space in which complex actions continue to be governed by will.

The worker's will might control both design and production, or only design, or only a piece of production, but, however complicated the procedure, the potential for art remains so long as creators can move in their own spheres to satisfy their own ideas of quality. I belabor the point because critics of art, who live in old industrial scenes, tend to dismiss tools from serious consideration. But where handwork reigns, the maker of the tool is like the artist of the West, exploring and exposing talents and skills during creation. Systems of production differ. What is important in a system is the tolerance it provides to the creator. Creators differ in capacity. The product might be a useful pot or a useful statue, but what matters in creators is the will to do the best that can be done.

As the will expands to enfold more of the creative process, the master rises in power until one person is credited with the product. Roshna Begum made this *botni*. Haripada Pal made that *murti*. Making is the center but not the end of the creative process. Haripada Pal considered it a failure that he was unable to establish a factory through which he could, like Maran Chand Paul, bring benefit to his workers. Haripada is a great artist, but in Bangladesh, as in Turkey, the loftiest role is not that of the creator, the lone artist, but that of the great master who can create, and who, at the same time, manages a team in production. Bimal Chandra Mandal, shipbuilder, ranks higher than the artist. A designer in command of the skills of his discipline, he is an artist, but as one who must teach and guide young workers, as one who is socially responsible as well as individually gifted, he is granted the higher title of master, *ustad*.

The Aesthetics of Utility and Command

Utility is a general principle of art in Bangladesh. Things are made to use, to help people in their struggle to assert the will. Will is a general principle of art. The more that the will commands—design, production, commerce, and the education and direction of the workforce—the greater is the master. The locus of art is work. Bending to their tasks, potters and shipwrights work at once to express mastery and to make things needed by others during their effort to master conditions. Utility and will blend in the aesthetic.

The master shapes parts so that they will cohere into a unit, a *kalshi* or a trawler. Coherence is required by use. If the parts do not fit together, the *kalshi* and trawler will leak and fail in their mission of service. In both the *kalshi* and

trawler, curves coalesce in symmetrical form. Curves allow for the maximum of internal volume, given size and materials, and symmetry effects balance in use, easing the task when the *kalshi* is filled with water, lifted, and carried, and when the ship, laden with her catch, holds a steady course in the wash of the waves.

The features of the *kalshi* and trawler that enhance utility simultaneously demonstrate the master's command. Parts build to unity. When the parts are curved, the process complicates, the master is tested, and when the unity is symmetrical, mastery is affirmed. Symmetry emphasizes coherence by establishing its own measure for judgment. Each half is like the other; they mirror into wholeness. Then wholeness is stressed beyond need in smoothness. The parts do not seek independence and threaten disunion; they blend smoothly. Smoothness exhibits command over materials that are rough in nature. Striving for excellence, potters and shipbuilders reach success in artificiality. They improve upon nature in smooth surfaces and symmetrical wholes, in abstract geometric orders that express their control over materials and techniques. Out of hard work, up against nature, they develop ideals, a style, an aesthetic of command that transcends conditions, ratifies the will, and stands ready for application to images of transcendence, to symmetrical prayer mats and smooth, coherent statues of the gods.

Left space for creation, the artist aspires. The smooth, balanced vessel is a victory for the one who works amid roughness and disorder. It represents, as surely as an abstract canvas represents, its creator: Parul Rani Pal, potter in Kagajipara, Bimal Chandra Mandal, shipbuilder in Zinzira.

The traits in objects that demonstrate mastery, and that characterize the tools used in daily labor, are traits found generally in the art of Bangladesh. At the base there is need. The creator who makes the tool and the consumer who puts the tool to use—*kalshi* or trawler—are alike in their struggle to overcome conditions during work. Workers meet in an aesthetic of command and utility that informs the whole system of art. Whether objects are utilitarian or decorative, secular or sacred, they tend to smooth surfaces, curved shapes, a coherent integration of parts, and the perfection of wholeness in symmetrical design.

Engraved Brass

The tool used in work is smooth and balanced, shaped aesthetically. It resembles decorative objects, and decorative objects resemble tools. Within the potter's repertory, the style of the *kalshi* is repeated in banks, flowerpots, and vases.

The question is one of appreciation. In Turkey, I found that objects plain in style—useful in form, frank in materials, lacking in applied ornament—were appreciated as works of art, as outward signs of inner virtue, as exhibits of technical virtuosity and of the honest and direct, austere and responsible, personality of the great master. The plain style also characterizes old masterpieces in Japan and in the Protestant West, among Puritans, say, or Shakers, in which the ego is submerged and beauty coincides with utility. But, in Bangladesh, when a pot is lifted out of labor, it is normally ornamented. To make it decorative, the *kalshi* or bank is painted with flowers. The plain vase or flowerpot is empty, incomplete without its flowers, and, enhanced for appeal, the vase swirls with floral color and flowerpots elaborate into planters, exotic in form and encrusted with flowers. The decorative object gathers the useless, lovely blossoms with which nature is decorated.

Pottery does not tell the whole story. Cane mats divide—as *kalshis* divide from *murtis*—into plain and representational. But the plain mats also divide. Though lacking in ornament, the mats of Sylhet are not only priced higher in the markets, they are appreciated as works of art because of their stunning technical qualities: the fine and even weave, the pale fabric so supple that, like Dhaka muslins of the past, they seem miraculous to those who handle them.

Useful forms in metal, especially brass and bell metal, are appreciated for more than the help they provide during labor. When not in use, the bright brass *kalshi* is displayed in the Hindu home, just as the prayer mat, when not in use, is displayed in the Muslim home.

The brass vessels of the Hindu and the copper vessels of the Muslim are both now challenged by traditional forms manufactured of aluminum in factories. Since handmade artifacts must compete in the market with industrial products, the end of handwork seems inevitable. But inevitable does not mean tomorrow. In 1968, a team of American scientists confidently predicted that there would be no rickshaws in Dhaka by 1990, at which time there were something like one hundred and fifty thousand plying the streets. In the middle of the 1980s, foreign observers offered grim predictions concerning the future of handmade wooden boats, but the builders figured out how to replace sails with engines, and their craft is flourishing. Mohammad Shah Jalal concludes his study of pottery in Bangladesh by declaring the trade to be "on the verge of extinction." Decline is clear, but none of us will be around when pottery finally expires in Bangladesh, and occupying the real world—rather than the dream world of the progressive planners with their nostalgia for the future—

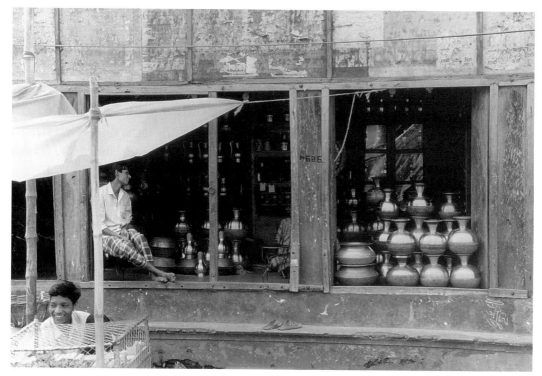

Brass *kalshis* for sale. Dhamrai

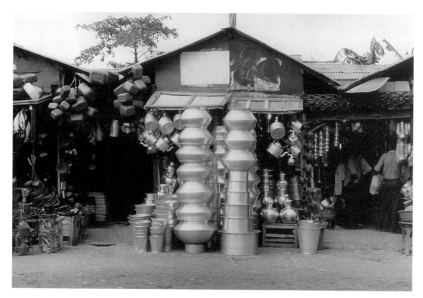

Aluminum. Kaptan Bazar, Dhaka

country potters continue to make *kalshis* and *patils,* filling an immense need, and rural and urban potters have adapted by shifting to decoration, making terracottas and lavish planters for the people Mohammad Ali calls the new rich men.

Makers of metal vessels, like makers of working pots, describe decline in their trade, but they, too, have adjusted. As potters make banks, flowerpots, and vases, brass workers in Old Dhaka and Zinzira make jewelry boxes (containers for wealth) and planters and vases (containers for flowers) that are, like painted *kalshis,* decorated with geometric, floral patterns. The change is toward the decorative, and it is a change in decorative taste. The brass *kalshi,* smooth and bright on the surface, curvaceous and symmetrical in form, embodies the plain taste. Appreciation among Hindus today for plain vessels in brass keeps workers at work, and the breadth of that appreciation in the past has bequeathed to the nation a bounty of beautiful old *kalshis* and bowls, vases and trays, in golden brass and silvery bell metal. A new craft has emerged. Artists are engraving plain old pieces, much as carvers embellished plain antique furniture in Victorian England. I know of a Hindu engraver, a jeweler named Rabindranath in Old Dhaka, but engraving is an art for Muslims.

Such a one is Sirajul Islam. He is a great master; Firoz Mahmud, who has studied the craft closely, considers him the greatest engraver in modern Bangladesh. Siraj works with three or four apprentices in a narrow open shop behind the market at Mahakhali, New Dhaka. He was born to be a farmer in 1947, in Comilla, east of the Meghna. Life was hard. At the age of ten, he went to Chittagong, seeking work, and he found his profession in a metalworking shop established by a Muslim who had immigrated from Moradabad, Uttar Pradesh, after the partition of India. Sirajul Islam was trained in the shop, all too briefly he says, by Sharafat Hossain, a master from Moradabad, which remains the major center of brass working in India. After Independence in 1971, the shop's owner left for Pakistan, and soon Siraj came to Dhaka, the new capital, to set up a *karkhana* in which he has trained many, notably his cousin Mohammad Manik Sarkar, and where he continues, determined to carry on the Moradabad style.

Sirajul Islam divides the surface of the plain antique piece into segments, engraving the main forms, then filling them with fine detail. Like the Iranian or Turkish artisan, he calls his chisel a *kalam,* a pen; in his work, he shadows the calligrapher who writes the word of God beautifully. Siraj hammers the *kalam* across the shining surface, with a minimum of planning and a maxi-

Vase.
Probably made in Dhamrai, c. 1920.
Engraved by Sirajul Islam.
Dhaka, 1993.
Brass; 10¼ in. tall.
The name of a former Hindu owner,
Chandra Dev, interrupts the endless
arcade of newly engraved mihrabs
containing flowers.

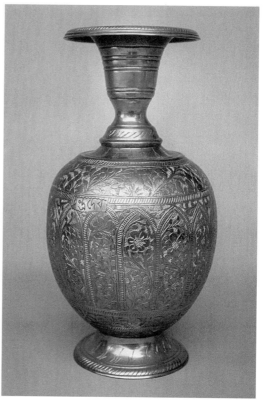

Bowl in the plain style, probably made in Dhamrai, c. 1920.
Bell metal; 10¼ in. diameter

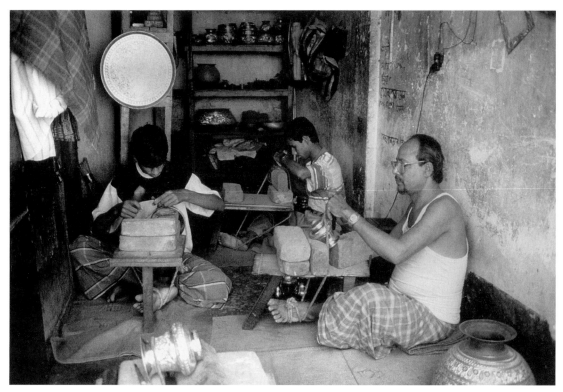

Sirajul Islam at work in his shop. Mahakhali, Dhaka.
For engraving, the brass object is held to a bed of bricks by a rope, kept taut with one foot.

mum of practiced certitude, creating intricate patterns in which flowers rise from a vase into an orderly spray, or spring from a vine to fill a pointed niche, or repeat into a grid that pulses toward infinity, or radiate from the midpoint into a circle of unity. Flowers, bits of earthly beauty, cohere in transcendent symmetry, pointing to Paradise and describing abstractly the inner balance of the world ordered by the will of God. Then the surface is buffed to catch and toss the light.

The old piece of brass or bell metal, newly engraved by Sirajul Islam, is sold in classy stores in New Dhaka to prosperous Muslims. In metalwork, the shift is not only to the decorative, but to designs that are new in the markets of Dhaka, but old in Islam. The bright, plain surface appreciated by Hindus in the past is carved, cut up, faceted to glitter with the geometric and floral designs favored by Muslims in the present. Sirajul Islam's customers are the same people who buy marbled vases, ornate planters, and big earthenware horses.

The use of a *kalshi* of brass instead of a *kalshi* of clay bespeaks the wealth of the owner. When I asked Hindus why they used brass vessels, they answered that it is because golden brass seems aristocratic. The brass *kalshi,* freshly engraved and set beyond use, idle in ornament, makes an even clearer sign of wealth. On the old brass tray, the engraving is limited to the name of the Hindu owner on the back. Now the face floods with ornament in curling, symmetrical array, and a loop is soldered to the back so that it can be hung on the wall, like a painting in France or a ceramic plate in Turkey, for visual appreciation.

On the wall, removed from work, the object works to signal wealth. The engraved tray might evoke Islam, but it surely implies care and contains time, the time of the engraver, and the one who owns it now owns that time, that effort, that skill. More is more: the more elaborate the better, for the time spent in its making becomes the object's inherent wealth. The ornate work of art is an index to wealth, a marker of class, and in Bangladesh artists have learned to fill the need prosperous people have for signs of their separation from the poverty around them that characterizes their nation in world opinion. The use of the decorative object is to embody the taste that refines social relations, drawing people together or pushing them apart.

Symbols of wealth intensify as they approach the body, the clearest sign of prosperity being flesh itself. The artists who supply decor for fine private houses—the Hindus who carve terracotta revetments for the exterior, the Muslims who engrave brass for the interior—succeed in the new environment. They scramble, working long hours, and their traditions endure. But

even more stable are the traditions through which ornament is created for the body. The workers are not rich, but there is no rhetoric of decline among the silversmiths and goldsmiths who make the ornaments that are worn by all but the most impoverished of women and that are stockpiled in private hoards of wealth, or among the weavers of the exquisite *jamdani* saris, worn by wealthy women on important occasions.

Jamdani

To the market of Demra, east of Dhaka city, merchants came in Mughal times from as far away as Turkey and Arabia, seeking fine textiles. The muslins named for Dhaka were a technical marvel; women in Erzurum in the mountains of eastern Anatolia continue to weave an imitation of the brocaded muslins, the *jamdanis* woven at the damp heart of the delta. During the early nineteenth century, British colonial policy succeeded in destroying the textile industry of Bengal and reducing the people to poverty. Bengalis became suppliers of raw cotton and consumers of cloth woven in England, but, according to James Taylor, whose topographical sketch of Dhaka was published in 1840, the English mills could not produce fabric as fine as the muslins of Dhaka. As it is today in other trades, industrial production challenged handcraft. The weaving of cloth in normal grades declined abruptly, but the weaving of muslins, beyond the reach of machines in fineness, continued. Taylor noted a difference in style paralleled in brass today. Hindus wove fine plain muslins, while Muslims flowered them with embroidery or brocade. Since Taylor's time, the center of production has shifted northward in Narayanganj district, from Sonargaon to Rupganj, but his description of the brocaded "jamdanee" holds true.

Across the river from Demra, Tarabo is a busy market for timber. From Tarabo, a road follows the east bank of the Shitalakshya River, northward through Noapara and the sections, the *paras,* of the village called Rupshi. Each section has its mosque, but otherwise they look like the potters' village of Kagajipara. Smooth paths are lined with trim buildings, usually workshops, latticed to admit the light and air. Slots between the buildings lead to clean shady courtyards, loosely walled by the houses of brothers, their wives and children. Women work in the courtyards, preparing meals and reeling yarn for weaving. The weavers, all of them Muslims, say there are two to three thousand *jamdani* looms in the region, nearly half of them in the villages that run together, north of Tarabo, along the bank of the river.

The road through Rupshi,
along the Shitalakshya River

Mosque.
Kazipara, Rupshi

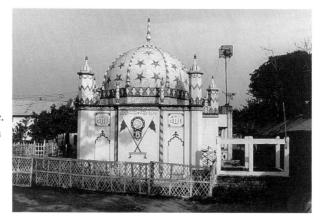

Mosque.
Noapara

Ali Azghar.
Yarn merchant. Noapara

Courtyard. Kazipara, Rupshi

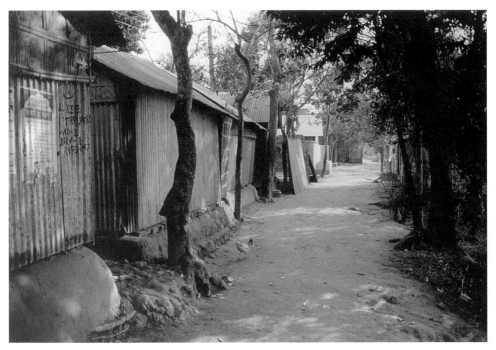

Dakhin Rupshi

Mother and daughter,
makers of *sanas*.
Chochonpara

Earan Nesa

Sufia Khatun

Alauddin

Father and son,
jamdani masters.
Kazipara, Rupshi

Golam Mowla

Rokea Akhter

Kabir Hossain

Rupshi

Rahima Khatun

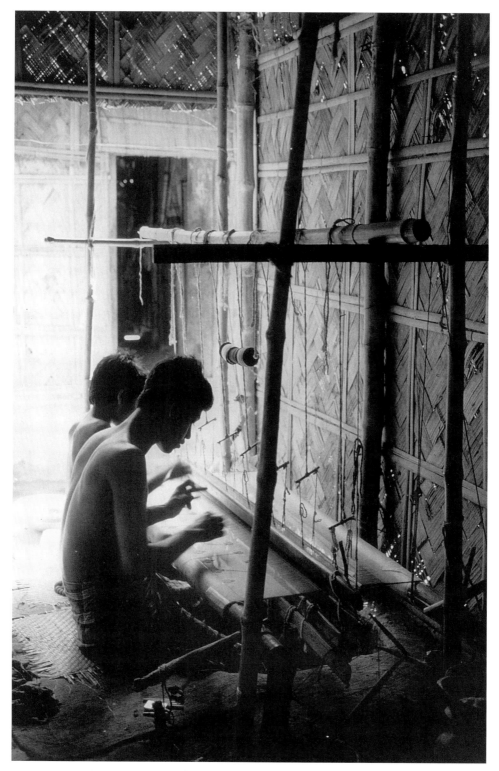

Weaving in the workshop of Askar Ali. Kazipara, Rupshi

The weaving shop, called, as the loom is called, a *tant,* is built on a raised platform of earth. Posts impaled on the perimeter carry the walls of woven bamboo and the roof of tin. Inside, pits are dug for each loom. The weavers sit on the clay floor, their feet in the pit, while the loom rises before them.

The loom, a pit loom like those common in the Indian subcontinent, has two harnesses and a swinging beater, something like the *takahata* of Japan or the old European box loom. Four planted posts of bamboo outline the frame. The beam from which the warp is unrolled hangs from the back posts. The beam on which the cloth is rolled rides on a pair of stout posts in the front. Both beams are levered and pegged in tension. Sticks lashed as girts between the posts at the sides carry a pole that crosses above, end to end, parallel to the cloth and warp beams. From it the loom's machinery dangles. Strings fall to hold sticks at both ends of which strings drop to suspend the heddles through each of which, in alternation, half the warp is threaded. Strings from each heddle are tied to pedals in the pit, so the shed can be shifted by tramping down on one, then the other. From the beam above, a reed beater hangs.

The one complex component in the loom, the reed, the *sana,* is made by women in the village of Chochonpara, near Demra, who splinter bamboo into slivers, shave them smooth, then bind them with cotton thread into a tight series. The *sana* usually consists of fourteen hundred or eighteen hundred slices of bamboo, though reeds with counts above two thousand are known. Beside each slick sliver of bamboo runs one thread in the fine warp.

Weavers work at the loom in pairs, the master to the right, the apprentice or helper to the left. The master controls the sheds with his feet, sets the pattern, and he is obliged to teach. In the past, I was told, all the weavers were men, but now some women have risen to mastery, and one, Firoza Begum, has become the manager of a large *karkhana.* Girls are entering the trade in slowly increasing numbers. Apprentices begin at the age of ten or twelve. They receive no pay while they learn. Adjudged competent, occasionally in as few as two months, but usually in a year—it depends on the native skills of the individual—the apprentice becomes a helper, and helpers receive pay from the shop's owner. Masters, mostly men in their twenties, receive food and sometimes lodging. They work on salary or for a percentage that might rise as high as half the selling price of the *jamdani.* Out of the other half of the profit, the owner must buy dyed thread, usually cotton, maintain the looms and building, and pay the helpers who get about eighteen percent of the selling price.

Teaching and weaving
in the workshop of Firoza Begum

Moksud Alam and Nargis Begum

Nurul Amin and Churush Mia

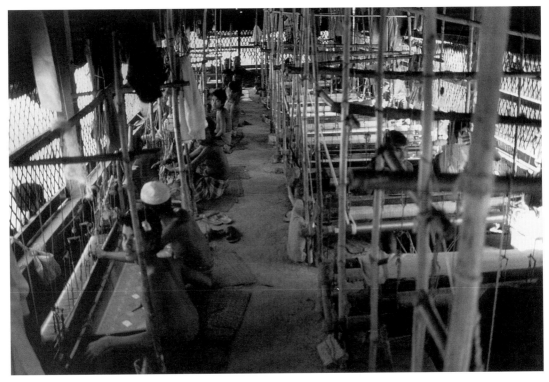

The workshop of Golam Mowla

Jamdani workshop. Kazipara, Rupshi

The owner's wealth depends on volume. A man like Askar Ali with four looms is comfortable, but masters like Firoza Begum and Golam Mowla with large shops containing as many as forty looms do quite well in the world where money matters. Shukur Ali's operation is typical. He learned weaving from his father and uncle in a year, the year 1337, and then in 1345—1938—he established his *karkhana* in which seven looms stand today. Like the other owners, Shukur Ali has risen through the trade. He manages the business and directs production knowledgeably, while the masters, some of them his wives, weave and teach.

I learned the most when I sat at the loom next to the great master Showkat Ali. Before us the threads of the warp course through the *sana* in lines so fine that they spread in a clean white expanse. Showkat measures up with his fingers, then using a notched wooden stick, he measures across the warp, pricking it at even intervals to mark the beginnings of motifs. The warp is massed so fine that you cannot seek a particular thread, in the manner, say, of the woman who weaves an extra-weft rug in Turkey. Instead, you draw upon it as you would with a pen on clean paper. The weaver's pen is the carved wooden *kandur* that swells into a grip at one end and narrows to a point at the other.

Showkat Ali pierces the warp with the *kandur,* runs it under to the left and lifts it to loop the colored thread and bring it back to the right. He repeats the process, motif by motif, across the warp, taking separate extra wefts through identical steps. Next he beats the new wefts toward him, down into the cloth, shifts his feet, changing the shed, then flicks the shuttle that glides to carry the weft that binds the fabric, and beats the weft back. Now the extra weft lies to the right of his motif. He loops it in the *kandur,* carries it over to the left, beats, shifts the shed, then his helper, me in this case, and clumsily, returns the shuttle through the warp to Showkat who beats the weft back into the cloth, and begins again to move the extra wefts to the right.

One passage is done. Two shoots of weft, shuttled through opposed sheds, make the web of the fabric. Two repeated motions with the supplementary weft, one to the right, one to the left, set the design within the web. There is no going back, all motion is progressive.

The *jamdani* will be a sari, one and a half yards wide, six yards long. Quality and cost depend on the fineness of the warp, the count of threads that pass through the *sana,* and the weight of the design. The weavers divide designs into light and heavy. The light have small motifs sprinkled neatly into an overall pattern. The heavy have larger, interconnected motifs. All leave plenty

Showkat Ali with his son Selim

Shukur Ali

Jamdani. Golam Mowla workshop. Kazipara, Rupshi.
Diagonal motifs in progress. The *kandur* lies upon the transparent warp.

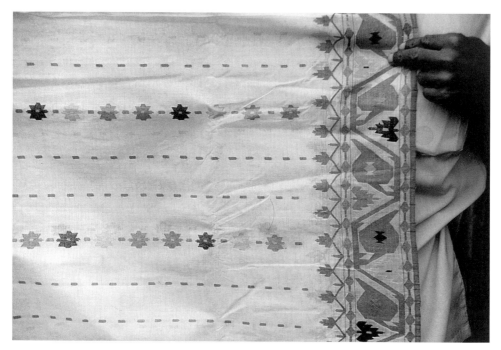

Jamdani. Shukur Ali workshop. Dakhin Rupshi

of space to display the surprising transparency of the ground, the woven air on which brocaded motifs float, and all have rich, running borders like those of Middle Eastern carpets.

Showkat Ali told me that the weavers know one hundred and sixty designs. New designs have been supplied to them by agencies for development in Dhaka, but they do not use them, unless they are pressed by special commissions. Their own designs, they say, are quite sufficient. They do not prefer them out of unthinking conservatism, but out of deep understanding of their process. Having learned them while they learned to weave, and as they grew, their old designs are built into their being. They hold them easily in their minds, and it breaks the rhythm of creation, it disrupts the aesthetics of production, to have to shift the eye in reference to a cartoon. Carpet weavers in Turkey told me the same thing. They resist cartoons, patterns drawn on graph paper, because they slow them down and disturb the intense concentration that lets the work flow; they prefer to weave *kafadan*, from the head, and they believe the best carpet, at once lively and integrated, is always so created. Plans introduce a mechanical quality that makes weavers uncomfortable and weavings bland. Similarly, Haripada Pal dislikes molds because they interrupt the creative passion into which he loses himself, while the head and hands move in accord. The best *murti* and the best *jamdani* are the yield of concentration, the moment in which planning melts into performance, and attention focuses precisely upon the little act in which the past and future merge.

I have read that *jamdani* weavers place cartoons to copy beneath the warp to guide them, and perhaps they do in West Bengal where emigrants from Bangladesh weave *jamdanis*. But during many visits to Rupshi, in different years, I have never seen cartoons in use. Teaching is based on instruction by direct demonstration. Young weavers learn as Haripada Pal learned from his grandfather, during cooperative work. And weaving proceeds as sculpting does for Haripada. People pull images out of experiences stored in the mind and muscles, and move suavely toward completion.

Light or heavy, sprinkled or continuous, simple or complex, the designs are angular, repetitive, and geometric. They are named for things out of the world to which the geometric forms bear, often fanciful, resemblance. The usual objects of reference are alive with brightness, rich with color, and graceful in shape: jewels and stars or birds and flowers, the peacock and swan, the lotus or lily. Names are chosen to evoke natural beauty, which is identified

with brilliance, color, and grace, and these qualities intensify in motifs titled in combination, such as the star-flower or the swan-flower.

Usually two weavers work two weeks to make a sari that brings two thousand *taka* at market, but the range is wide. Showkat Ali once spent four months weaving a *jamdani,* brocaded with pure gold thread he had manufactured at Tanti Bazar in Old Dhaka, and received forty thousand *taka,* roughly a thousand dollars, from a lady from Sylhet who had prospered in the hotel business.

Special commissions are rare. Some shops fill orders from firms in Bangladesh and India. But most *jamdanis* go to market at Demra. At six on Friday mornings, the buyers set up in the plaza to be engulfed by the sellers, men who circulate continually, holding neatly folded *jamdanis* above their shoulders, until they are stopped with the command, *Kata:* How much? Two thousand, five hundred is the usual answer. The buyer takes the *jamdani,* opening its fold to inspect the quality, and drops it into his pile, saying, Two thousand. If the weaver protests insistently, he might receive a bit more from the roll of bills in the buyer's pocket. By nine in the morning, the market is done.

As many as seven hundred *jamdanis* come to market, and most are sold, some for as much as six thousand *taka.* With new money in hand, the weavers pause for tea in the town to discuss the day's prices. They shop for their needs—parts for looms are sold around the edges of the mercantile turmoil—and then head for home. The middlemen take their bundles to buyers in the city, especially to the fine stores at New Market, where the *jamdanis* will be sold for about double the price the weaver received.

Showkat Ali called the *jamdani* sari a luxury item. "The women of Rupshi make them," he said, "but they do not wear them."

When a traditional art is made by poor workers for poor consumers, tradition becomes associated with an impoverished past, and the art seems imperiled by the hope that progress will lead to prosperity. Understanding their conditions, learning from sales, artists shift from *kalshis* to flowerpots, from plain brass to engraved, from religious icons to portraits, and their traditions alter for a new future. Simultaneously, during times of change, there is steady continuity in arts, no less ancient, no less traditional, in which workers create for the rich things they do not use themselves. At the end of his book on the *jamdani,* Muhammad Sayeedur breaks the tradition of writing about the art of Bangladesh by saying that the future of the *jamdani* seems bright.

Jamdani Market.
Demra

Bangladeshi Style

Before us now there are things of clay and cane, cotton and wood and brass, hammered and hewn, molded and woven by women and men, by Muslims and Hindus in the country and the city, for sale to the rich and poor, for use in labor, to ornament the home and body. Different in medium, form, function, and value, they join in style, in the aesthetic they materialize. The base of the aesthetic is the balance of the tool: the symmetry of form, the unity of parts. The surface is smooth and bright.

Perfecting the forms in nature by clarifying their implicit symmetry and coherence, objects exhibit mastery and stand ready for use. Smoothness extends coherence, and brightness runs beyond need into a celebration of beauty. The colors selected do not match the dull tones of the environment, the gray of dust, the brown of mud. Artists pick out the vivid greens of the fields and the brilliant hues of jewels, blossoms, and plumage—pink, magenta, and ruby, turquoise and royal blue—and give them sheen. The color is bright. The paint is glossy. Things shine. The pot is slipped to a metallic glow. Metal is buffed and buffed. Surfaces gleam. Then brass is chiseled and gold is hammered to facets that splinter light and sparkle. Things flash and glitter. The object's desire to dance with light is clear in its transparency. Silver is pierced and fabric is stretched to allow the passage of light. Pulled across bamboo frames, draped and pleated to make portals for weddings and *pujas,* to make festive frames for *melas* and stages for deities, sheer cloth collects and diffuses the sun, surrounding events with a luminous haze. The fine *jamdani* sari does not reveal the body beneath. It is layered and stiff. But around the woman in motion, the edges of diaphanous fabric assemble a halo of light. Young women wear long, gauzy scarves that cross the bosom modestly and float behind to trail them with a flow of colored light. This world holds no vision more beautiful than the slim women of Bengal, moving gracefully in groups through the low sun that their saris and scarves gather, transform, and transmit.

In the Muslim view, God is beautiful, and God's beauty collects beauty. The likeness of God is light. As close to an image of God as the Muslim comes is to erect or depict the mihrab—on a cane mat, say, or a shimmering surface of mosaic—in which light is framed. The bright artifact that attracts and reflects light is a symbol of proper behavior. As the person should, the object accepts God's light and casts it back, unifying with nature's beauty—the color and sheen and glitter of flowers and birds and stars that are signs of God's beautiful presence.

418

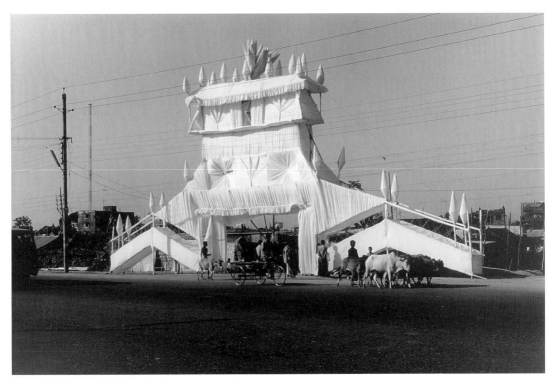

Wedding portal. Mirpur Road, Dhaka

Use and beauty fuse in the tool. Balance and coherence continue, but as coherence moves through the smooth to the bright, and brightness intensifies in color and gloss, utility diminishes, while decoration expands and seeks the spirit. In balance and brightness, the tool, the slipped or buffed *kalshi,* gestures toward an otherworldly perfection that is nearly caught in the decorative object, the engraved tray or diaphanous sari.

When the object is coated with ornament, when the clay *kalshi* is painted, the brass *kalshi* is engraved, or the muslin is brocaded, the decoration repeats the qualities that lie in the forms of tools. Surface ornament is symmetrical and coherent. The order of detail on the decorative surface is perfected geometrically, as the form of the object is perfected geometrically—they cohere— and then the ornament reaches toward the pictorial. In the recent West and for centuries in Islam, artists have been satisfied by arrangements of shapes and colors, but in Bangladesh, in a context conditioned by the pictorial drift of Hinduism, artists, both Muslims and Hindus, do not stop at nonobjective ornament. They press toward reference, imaging, if abstractly and geometrically, things out of this world.

To the aesthetic—balanced, coherent, smooth, and bright—we must add the will to depiction.

Moving Pictures

Distinct approaches to depiction in sculpture are exemplified by the horses made by Maran Chand Paul and the masters of Khamarpara. Maran Chand's horse is stable, symmetrical and smooth, frank in its display of burned clay. It presents the idea of a horse in the style of the tool. The horse of Khamarpara is mobile, detailed and twisted toward naturalism, then painted. It presents the vision of a horse in the style traditional to the *vahanas* of the deities. Neither reaches the extremity of its impulse: more abstract horses than Maran Chand's and more naturalistic horses than Khamarpara's are easily imaginable, but the contrast is clear.

Sacred sculpture in clay stretches wider, absorbing the styles of the horses in a spectrum of possibility that extends from the abstract to the realistic, from the conceptual to the optical: from the geometric composition of the little Mother Goddess, even more abstract than Maran Chand Paul's horse; to the symmetrically designed, unpainted plaque of the Buddha by Amulya Chandra

Pal; to the classic *murti,* Manindra Pal's Saraswati, gazing forward in balanced integrity, then painted; to the small molded *murti* by Haripada Pal, shifting toward motion in a manner comparable to the horses of Khamarpara; to the wall plate by Haripada that, like the finest terracotta panels of rural life, positions people in space in relation to each other rather than to the viewer. The most realistic retains abstraction, the most abstract retains worldly reference, and between them, with the classic *murti* at the very center, a wide territory for synthetic action opens for the creator.

Styles of two-dimensional depiction range comparably, and rickshaws offer diverse examples in abundance. Within the continuum of rickshaw decoration, I find three distinct modes of composition: the artisan's style, the style of the relief, the style of the photograph.

The artisan's style is the way of the engraver of brass and the weaver of *jamdanis.* It is the style in which Nur Mohammad paints *kalshis* at the Mirpur Mazar. If it seems Islamic in essence, it is also the style of the Hindu carvers of conch-shell bracelets, and in the past it was employed in the terracotta tiles of both temples and mosques.

On the rickshaw, ancillary ornament is created in the artisan's style. Tacks are studded, appliqué is snipped, and the armrests are painted in shapes that assemble geometrically, most often toward the floral. The style peaks on the Comilla rickshaw when the coach spreads symmetrically with birds and flowers, and on the Dhaka rickshaw when back panels carry a bilaterally symmetrical, tripartite composition achieved by two mirrored forms flanking a central form, itself symmetrical. Two birds flank a flower or the Taj Mahal. Two peacocks flank the head of a lion. In the artisan's style, a pattern is laid out geometrically on a single plane, and then detailed toward representation.

Repeating identical forms in series, or integrating parts into symmetrical unity, the style manifests technical command. Relying upon the quick and practiced skills of artisans who approach decoration as they approach the creation of form, this is the style used to decorate tools, rudimentarily in the striations that circle the shoulder of a *kalshi* of clay, richly in the carving of ornament for furniture, for boats and trucks.

On heavy trucks, an extension for loads, framed above the cab, is carved in low relief and then painted by masters such as Nitai Sarkar at Gabtoli, north of Dhaka. A floral vine, like those engraved in brass or woven in the borders of

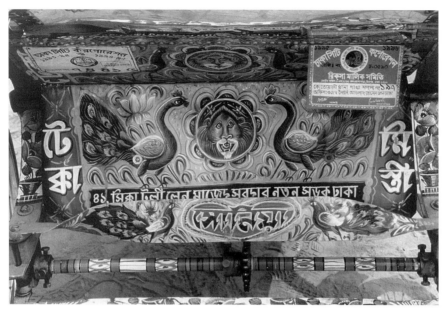

Rickshaw painting by Tekka Mistri. Dhaka

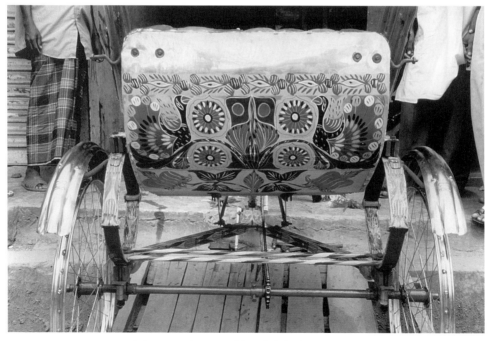

Rickshaw coach painted by Abdul Khair. Feni, 1995

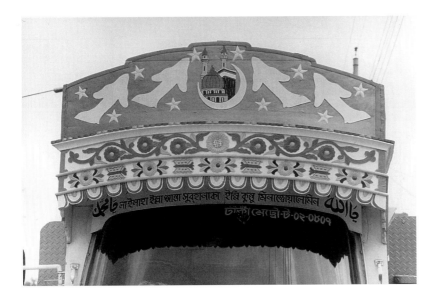

Trucks.
Gaptoli, Dhaka

Fresh carving
by Nitai Sarkar

saris or fashioned of mosaic in the mosques, courses along the boards. Or airplanes fly from each side toward Mecca, aligning the truck's motion with the hajj, and displaying the goal of the trucker's enterprise. There are spiritual as well as mundane reasons to toil for cash.

The main ornament on Dhaka's cycle rickshaws is most often created in a different style that I will call the style of the relief. Meditating upon the paintings in the Ajanta caves, Stella Kramrisch, a great historian of Indian art, struggled to get at their essence, arguing that the images, instead of retreating into space, protruded forward from the pictorial plane. Modern rickshaw pictures, the birds and movie stars painted on plastic and tin, need not be validated by association with those ancient wonders, but it is clear that they work in the same way. I take it to be the result of painters creating on flat surfaces in an artistic tradition dominated by sculpture. The paintings are like terracotta plaques. Their subjects are not modeled to stand within space, interacting among transitory effects in a scene of raking light and cast shadow. Rather, they are modeled to body forth sculpturally, to emerge from their generally perfunctory backgrounds, to stand out in relief.

Come with me to the workshop of a great master. I met Ranjit Kumar Dey on Bangsal Road in Dhaka. I was going through the stores that sell parts for rickshaws, looking through the paintings, and I was fortunate to find my way to Nasir Uddin's. He is a warm man, a natty dresser, and while we were talking, R. K. Dey arrived with a delivery of rolled up paintings for the backs of seats. They were outstanding, especially strong and sure instances of the usual rickshaw art. He said he made them. Then seeing that I was serious, he said I had better come home with him to meet the artist, his wife, Tapati Rani Dey. We piled into a rickshaw for the first of many visits. Ranjit and Tapati are lively intellectuals. Talk and meals in their home are fine.

Theirs is the characteristic Old Dhaka neighborhood. The street gives out, becomes an alley. The alley seems to end, but you squeeze around the corner of a building, cross a piece of courtyard, pass through the corridor of a tall house, cross another courtyard, and ascend the steep stair, at the top of which a wide, bright room is perched aloft to receive the air. The walls are deep blue. A huge bed fills one corner. A rack in the opposite corner offers a rich exhibition of neatly folded saris. On a cabinet, a color television flickers beneath a portrait of Rabindranath Tagore. Shelves are packed with books. The floor spreads with pots of paint. Clothes lines swing from side to side, carrying paintings draped to dry.

Tapati Rani Dey

Ranjit Kumar Dey and Nasir Uddin

Three young women sit on pads, working around the spread of paint in the light from the windows. Two are Tapati's sisters, Doly Ghosh and Ani Karmakar, the third is her daughter Songita Rani Dey, a college student. At Ranjit's request, their younger daughter, Bulu Rani Dey, lifts her harmonium onto the bed and sings the haunting songs of Tagore, while the others work and I watch.

The piece is painted, like the *murti,* white for brightness. Then Tapati Rani Dey, using her imagination and working entirely freehand, draws into the paint a sketch of the design with a pencil. Her strokes are bold and few; her act is like an engraver's. The pencil does not trail gray lines on the white primer but cuts through the paint, furrowing the surface with sgraffitoed incisions that can be followed through layers of paint. Tapati's compositions typify rickshaw art. The three faces of the movie stars or the flock of birds could be organized geometrically on a flat plane in the artisan's manner, but she always syncopates them in asymmetrical balance.

I have watched Tapati paint, holding the brush far from its tip, moving it in easy sweeps, but usually Tapati designs and the others paint, completing the picture in three stages. Songita mixes the color directly on the surface, spreading it quickly over the background, between the figures, leaving passages of emerald, purple, and blue, a circle of pink, and streaking white through the blue for clouds. Then she returns, blending colors together, blurring edges, diminishing contrast to create smoothly modulated tones, just as the sculptor of the *murti* gouges sharp lines, then rolls and softens them with dampened hands. Once the background is done, she puts the picture aside to dry and turns to another.

When Songita returns to her picture to take it through the second stage, the figures remain white. She did not cut neatly around them, but let the background smear and overlap. Songita patches the color in, then shades the hues, modeling the figure so it lifts, rising away from the background. The centers of forms are clear in their paler values, but the edges remain rough and indistinct. She begins the picture's third stage. As the shipwright reverses the Western norm by building the form and then inserting the frame, Songita puts last what another artist might put first: the outline that contains the color. Using a fine brush, she deepens the shading by hatching and she draws contour lines upon the robustly modeled, smoothly flowing shapes of bright color. She uses color, not clay, but she works like the sculptor of a terracotta relief who models the form and then incises the detail.

Tapati's sketch on the primer

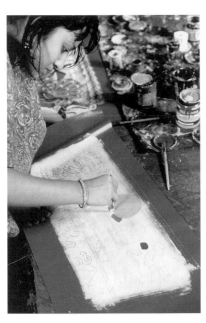

Songita
begins the painting

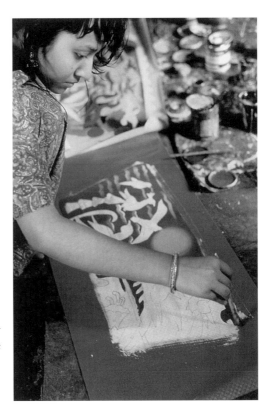

Songita Rani Dey
finishing the painting's first stage

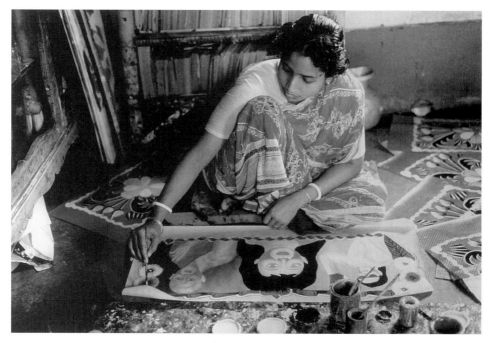

Doly Ghosh

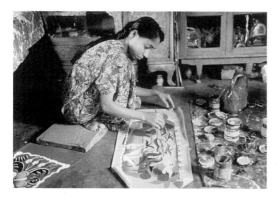

Tapati Rani Dey's Workshop

Ani Karmakar

Ani Karmakar
beginning the picture's third stage

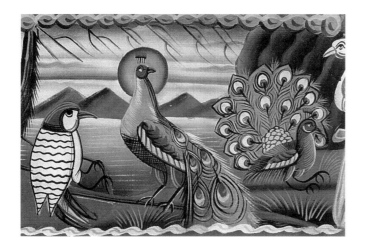

Seatback Details.
Tapati's Workshop.
Dhaka, 1995

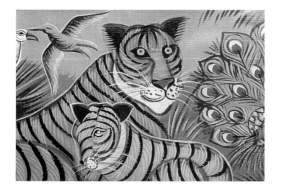

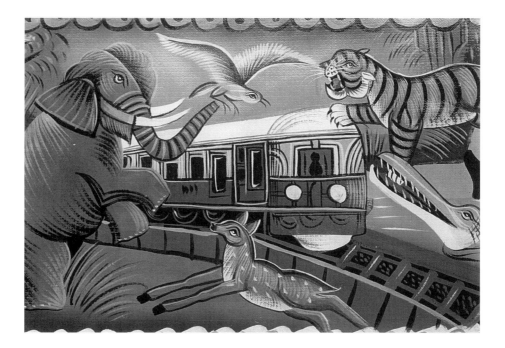

Bangladesh is full of surprise. Pictures by Tapati Rani Dey, her sisters and daughters, make an unexpected contribution by refined Hindu women to the male and Muslim world of rickshaw work. They receive sheets of tin and pieces of plastic cloth from Nasir Uddin and return them painted. Ranjit Kumar Dey says each artist paints five pictures a day; their shop, its works signed with the name of the youngest worker, Bulu, produces something like six thousand annually. Nasir Uddin sells them for eighty to one hundred *taka* apiece to men who use them for panels and seatbacks on the rickshaws that carry the city's people.

Let me remind you that I am describing points on a continuum. Individual forms are more and less naturalistic, all built of color then outlined, but compositions differ. The shift from the artisan's style to the style of the relief brings a relaxation of geometric order, and a change from arrangement on a single plane to a sculptural effect in which forms bulk forward from their backgrounds. It is a step toward realism, and in the third style another step is taken. Now the photograph is the inspiration. Objects occupy deep space. While this style suits the baby taxi, with its middle-class associations, exchange in design is common. The styles blend, especially in portrayals of village life, found commonly on baby taxis, occasionally on cycle rickshaws, but the contrast remains. On the cycle rickshaw, the Taj Mahal stands out from a unified field of color and rises from a pink lotus in an image that captures the syncretistic qualities of culture in Bangladesh. A mosque, a symbol of Islam, replaces the Hindu deity upon the lotus seat. On the baby taxi, the Taj Mahal is set in perspective, within a park, among green tress, in optical space through which light flits.

When Abdul Jabbar, the artist in Yunus Mistri's baby taxi factory, paints the Taj Mahal, he draws the image, he says, from his brain. He gathered it from a picture in about 1980. Most of his paintings come from his imagination, but when he receives orders for unusual pictures, they are accompanied by photographs, taken from calendars.

Abdul Jabbar learned painting from the master Azmal Khan in 1979, when he was nineteen. Since then, he says, he has decorated one baby taxi every single day. I watched him paint a portrait of the Bhairab Bazar Masjid, the neighborhood mosque of his patron, the taxi's owner. Looking at the photograph, he chalks a sketch on the rear of the baby taxi. Then he puts the picture away so he can concentrate. He blocks in the form with color, colors far brighter than the photograph's, then he shades them together, modeling the form, and finishes it by hatching the shadows and drawing the outline. Basically like the

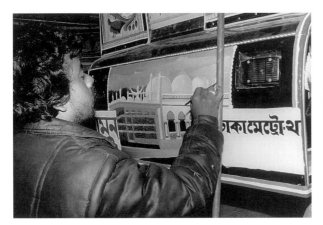

Abdul Jabbar
painting the Bhairab Bazar Masjid.
Maghbazar, Dhaka

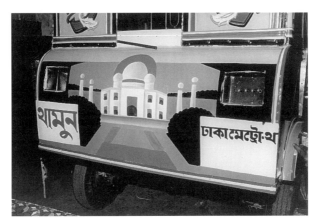

Taj Mahal.
Blocked out by
Abdul Jabbar

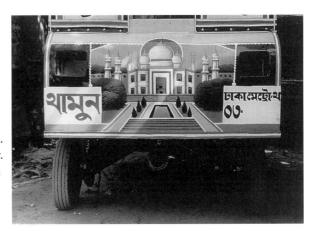

Taj Mahal.
Nearly finished by Addul Jabbar.
See p. 33

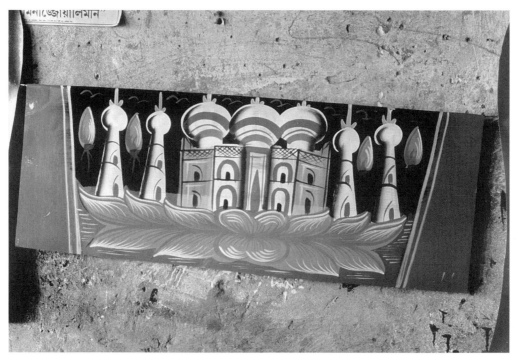

Taj Mahal by Anis Mistri. Rayer Bazar, 1995. See p. 32

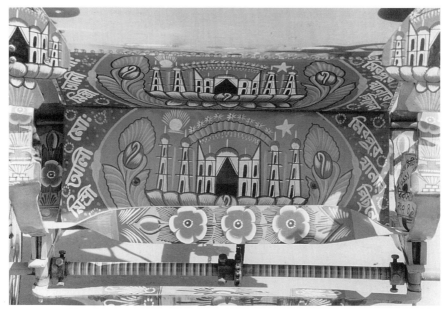

Taj Mahal by Mohammad Ali Mistri. Mirpur, 1995

cycle rickshaw's, his process differs in that he begins with a photo, and while he goes, he snaps chalk lines to guarantee straightness, and in the final, detailing phase, he stops to think, working back and forth across the picture, sharpening the detail and adding touches of color. Work in the style of the photograph is slower, more contemplative than it is in the other styles. In them the plan is set in the conventional image held in the mind, the hand moves swiftly, but Abdul Jabbar alters and improves his plan as he ventures into new territory. Though his picture is only about twice the size of the rickshaw's, it takes five times longer to finish. His time goes into the background and details, his purpose being to enhance realism.

Like images sculpted of clay, images painted on rickshaws diversely synthesize the abstract and realistic. They are representational, and, through representation, they raise meanings. Clay images fall into three broad topical categories: the natural (flowers, birds, and animals), the cultural (political icons, literary figures, and rural life), and the spiritual (the mosque and the deities). If we come to rickshaw paintings from works in clay, attempting to merge the two in a single pictorial system, we will find reinforcement in similarity and complementarity in difference.

The Pictorial System

In the realm of nature, among birds and animals, the images are centered comparably. In clay and on rickshaws, there are songbirds, parrots, peacocks, and swans, deer, tigers, lions, and elephants, horses and cows. Different spheres of depiction overlap in mutual reinforcement at the bright, beautiful, powerful, noble, useful beasts that are wonders in themselves and that might stand as symbolic embodiments of human qualities. The flower most often chosen is the lotus. Blooming on the water, and symbolic, like the elephant and the conch shell, of the power of water, the lotus can be read as an emblem of Bangladesh, the damp, radiant place shared by Hindus and Muslims. Then there is difference: flowers are more abundant in rickshaw decoration than they are in clay. Rickshaws are owned and pulled by Muslims, and in Islamic art the flower is the object most frequently depicted. It incarnates the promise of a garden where the flowers that wilt in the world will stand in perpetual bloom.

In the cultural sphere, differences increase. Amulya Chandra Pal sculpted the National Memorial, but icons of political nationhood—the National Memorial, the monument to the martyrs of the Language Movement, the Parlia-

Village life.
Rickshaw panels.
By Tutul Mistri.
For sale. Pilkhana, Dhaka, 1995

Village life.
Baby taxi. Dhaka

Movie stars. Rickshaw seatback by Sushil Mistri. Dhaka, 1996

ment, the flag, the portrait of Sheikh Mujib—are far more common on rickshaws than they are in clay, suggesting that Muslims feel closer to the political nation than Hindus do. The suggestion seems affirmed when we recall that, as an alternative to political icons, Hindus create icons of artistic nationhood in portraits of the great poets. It is certainly not true that veneration of Rabindranath Tagore and Nazrul Islam is limited to Hindus. Hindus make their images for Muslims as well as Hindus to buy. But it is true that the poets do not appear on rickshaws, and that their portraits in clay have faded from the markets that serve prosperous Muslims.

When creating symbols of the nation, it seems, Muslims favor the political, Hindus the literary. Asked in a sociological survey to say what made them proud of their country, the respondents spoke less of political order and artistic success than they did of their land's beauty and agricultural bounty. In art, images of the land outnumber nationalistic icons, and when artists picture their place, the central image is the same. On terracottas and on baby taxis, as in reality, Bangladesh is a landscape of villages built of clay and bamboo and tin, of golden stacks of rice straw, of rivers alive with wooden watercraft, of men and women at work. The picture of the village, flowing through urban traffic, is not exactly nostalgic, a dreamy view backward, for urban workers maintain connections to the country, returning home for the holidays, and the painted village resembles the villages they know—clean, quiet places of hard work. It is one picture of the contemporary reality. The mood of calm it captures is as much a part of modern experience as the city's frenzy. For the rural potter, it is the only view of the land fit for art, but for the urban painter, it is one alternative. To the village view, rickshaw artists add progressive urban images, cities with towering buildings, and visions of swift, mechanical transport: steamers, trains, and airplanes.

Now the key distinction is not between religions, but between rural and urban contexts. Cycle rickshaws feature urban entertainment, not music or sports, but film, the pleasure peculiar to men of the class who pull rickshaws. They have different heroes. The artist offers an homage to the artist: the rural potter to the poet, the urban painter to the movie star. While images in clay fasten to the rural, and cycle rickshaws accommodate the urban, baby taxis stretch into the international with photographic renderings of monuments from Asia and Europe. As exhibited on rickshaws, the urban worldview encompasses the rural, with its peace and labor, the urban, with its chaos and progress, and then it expands through the modern world.

Detail of a rickshaw seatback.
Tapati Rani Dey workshop.
Dhaka, 1995

Rickshaw seatback.
"The Wedding of Uncle Lion"

Rickshaw panel.
Dhaka, 1995

I asked Ranjit Kumar Dey about meanings in rickshaw paintings. He laughed and said they have no meaning. They are merely decorative. Then he leafed through a stack, pausing to comment that the tiger was the Bengal tiger, the *doyel* was the national bird, the fantastic city was Dhaka, the village was only a picture of normal life in Bangladesh. The picture at hand, showing people in a bullock cart on a road with a thatched village in the background, told him a story about a family going to visit relatives in another village. He said the pictures had no meaning, then glossed each into an evocation of Bangladesh. In the cultural sphere, pictures, modeled of clay or painted on tin, portray the complexity of the people's place in the world.

Complexity appears between the rickshaw's pictures, in their sharp contrasts, and it appears within them. That rural and urban views are contemporaneous becomes clear when an airplane crosses the sky above a placid, thatched village. Culture intrudes on nature when a train thunders through the jungle, scattering the lions and tigers in terror. If the animals stand for people, which they surely do in pictures that show animals performing civilized acts, such as marching in a traditional wedding procession, then the train could stand for modern technology in its malign aspect, ripping into the environment and upsetting the social order. But any interpretation that would identify progress with evil is counterbalanced by favorable portrayals of the modern and by displays of violence in nature—the graceful, innocent deer, bloodied and brought to earth by the lion. People have enemies enough in themselves. They are raised from the idyllic and monstrous state of nature by faith.

Works in clay ascend to the *murti*. No Hindu deities appear on rickshaws. The single most common image is the Taj Mahal, a symbol of Islam. The religions are different, but their orientations are so consonant that the potential for sacred interpretation diffuses through the whole pictorial system.

In the middle of the 1990s, the cycle rickshaw's most usual image of animals showed a pair of peacocks facing a white cow with her calf before her. Peacocks and cows could represent the beautiful and useful dimensions of nature, distinct facets of God's gift to humankind. In the Hindu view, the cow associates with Krishna and symbolizes the Goddess. The peacock is the *vahana* of Kartikeya. In bringing the god of war to the Mother, as though to receive orders, the peaceful picture gathers a threatening undertone. In the Muslim view, the cow exemplifies God's provision of an inherently useful environment to working people; it proves God's existence and demonstrates the benevolence of God's order. The pair of peacocks, in Sufi verse, stands for God and

the Prophet Muhammad, whom God created out of pure light to bring the truth to the people of the earth. The picture might portray creation, revelation, the world of forms bestowed by formless power. Interpretive options proliferate. I asked Anis Mistri, who paints such pictures, and he said there is no meaning in them, only beauty. His answer displaces the question. We wonder why a particular composition is so popular, and answer that it arranges conventional images in a way that does not narrow meaning toward the literal, but spins it away into a generous realm of possibility, and we accept his answer. Anis is right. Beauty is quite enough for the one who creates in a world where beauty is an unambiguous sign of God's grace.

Sacred Brass

Upon the balanced, coherent base, the smooth bright surface shapes into pictures of the beauty and power of nature, and of rural peace, urban progress, political success, and artistic achievement, and of the beauty and power of the sacred. During comparison with other media, the pictorial system, established in clay, amplified on rickshaws, will simultaneously consolidate and expand.

Workers in brass cast statues in sand of handsome animals: songbirds, peacocks, and eagles, dolphins, deer, tigers, lions, and elephants, cows and horses. Sleek and realistic, the horse in brass parallels the earthenware steeds of Khamarpara.

The first time I went to Dhamrai, I was taken by Shamsuzzaman Khan and Muhammad Sayeedur to visit the workshop of Manaranjan Pal, called Bhambul. His family specialized in blackening copper, then engraving floral designs that brought a glitter of rosy gold to the surface. Bhambul has died, his sons have taken up other trades, but their technique continues in Dhamrai. Young men engrave brass and copper plates, cutting through the matte black to picture rural life in the manner of the baby taxi. A river passes a thatched village. A woman bears a *kalshi* on her hip. A man plows the wet fields. When they are sold on the New Elephant Road in Dhaka, these plates, engraved for hanging on the wall, are sometimes carried closer to realism with paint daubed above the black surface.

The workshops in Dhaka that cast brass statues of animals also produce religious icons. Side by side at markets in the city, I find flat brass reliefs of Ganesh, Radha and Krishna, and the Kaaba at Mecca with the name of God written in Arabic, configured in the style of the carved panels above the cabs of

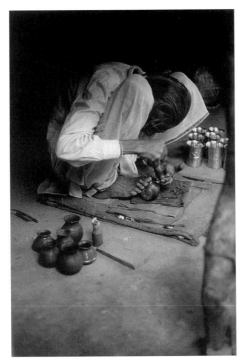

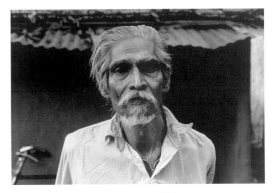

Manaranjan Pal

Manaranjan Pal at work

Kalshi.
Engraved in Manaranjan Pal's atelier.
Dhamrai, 1987.
Copper; 9½ in. tall

Allah and Kaaba.
Abdul Latif Mia workshop. Lalbagh, Dhaka, 1995.
Cast brass; 8¼ in. tall

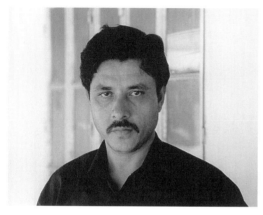

Mohammad Hasnain

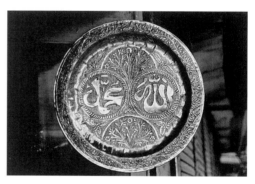

For sale on the New Elephant Road. Dhaka

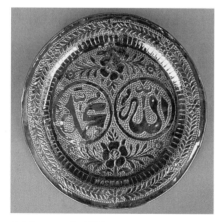

Muhammad, Allah.
By Mohammad Nazim.
Hasnain's workshop. Zinzira, 1995.
Embossed brass; 11½ in. diameter

Embossing at Hasnain's. See pp. 44–48

trucks. The sacred images in clay are largely Hindu, those on rickshaws are Muslim. Both religions are amply represented in brass.

Amulya Chandra Pal sculpts a relief in clay of the Taj Mahal. Anis Mistri paints the Taj Mahal on the back panel of a rickshaw. Abdul Jabbar paints the Taj Mahal on the rear of a baby taxi. And, as you would expect, the engraver draws the Taj Mahal on brass plates. Floral designs are more common. Sirajul Islam, Dhaka's great engraver, arranges flowers into the two classical geometric formulations of Islamic art. In one, the elements repeat in sequence, and then spread the surface with an overall design that moves simultaneously in every direction toward totality, capturing a fragment of infinity. In the other, parts expand from a single point into a radially symmetrical image of unity. Together they do not picture God, but God's power, at once infinite and single.

If the Taj Mahal and the geometric arrangements of flowers leave room for ambiguity, other works in brass do not. At Mohammad Hasnain's workshop in Zinzira, Mohammad Nazim sets brass plates in a thick black puddle and hammers their faces, embossing them with flowers, or, more often, with the names of God and Muhammad in Arabic. Hasnain says the calligraphic designs come from Pakistan. Though he was born in Dhaka, his father came from Bihar, and Hasnain began his apprenticeship in 1975, when he was fourteen, learning from a master who came from Moradabad in India. Sirajul Islam was born in Comilla, but his style came from Moradabad. Salah Uddin, the master of cast brass in Old Dhaka, says his ancestors came from Afghanistan. Islamic art in brass is associated with regions to the west, regions from which Islam came into the delta, and—revitalized, purified by new influences— fine brass is increasingly popular among prosperous Muslims in Dhaka. In ritzy Gulshan, stores gleam and glow with old brass, newly engraved in floral, geometric designs. Along the New Elephant Road, bright plates and trays embossed in shops like Hasnain's bear inscriptions in Arabic: the Profession of Faith, the opening formula from the Holy Koran, and, abundantly, the names of God and the Prophet. Such pieces of brass, representing holy words, depicting prayers, are hung on the wall at home to orient prayer, and they flank the mihrabs in the mosques.

For more than a millennium, cast metal images of the Hindu deities have numbered among the masterworks of world art. If we can extrapolate backward from modern Bangladesh, it seems as though the historians of art have been reduced to the study of shadows. The greatest works are shaped of unfired clay, then sacrificed through immersion. They leave behind for study, for as-

similation in academic schemes, mere memories in metal, modeled by artists whose prime task is to sculpt the *murti* that stands between people and power, amid song and smoke and dancing flames.

In the village of Kagajipara, Amulya Chandra Pal's nephew Ananda Pal sculpts *murtis* for *pujas.* He was born in 1956 and learned the potter's art from his father, Moghlal Chandra Pal. Other potters fill the time between *pujas* with work in the clay, but Ananda and his brother Gauranga make images of wax. While modern sculptors in Tamil Nadu replicate historical statues as part of a revival of their craft, Ananda shapes the wax model as he does the clay image: out of his experience, through prayer, without direct reference to disconcerting pictures or elder examples. Ananda's wax model is covered with clay and then cast in the lost-wax process in one of two shops in the nearby town of Dhamrai. With heat, the wax melts and runs out, leaving a delicate void to be filled with molten brass. Then the clay is cracked away, the mold is destroyed. Every image is unique.

Ananda Pal has his own style, set to the realistic side of the center marked by the classic *murti*. His images exhibit less composure and restraint than Haripada Pal's. There is frequently a merry look on the wide-eyed face, a dancing quality in the postures, a sexy curvaceousness in feminine forms. The deities Ananda models most often are the ones that were most often cast in brass in the recent past, the ones most often molded of clay and then fired in the present. Ananda's Ganesh sits frontally on the lotus. Two arms lift weapons, the axe and the goad, signs of strength. One hand holds his delicious sweetmeats; the last gestures in gentle reassurance, welcoming approach and devotion. Ananda sculpts lovely pairs of Radha and Krishna, Krishna's hands raised to shape the air into a flute. And then he images Durga, slayer of the buffalo demon, and Shiva, the cosmic dancer. Ananda and Gauranga both depict Saraswati on her swan, Lakshmi on her owl, and the Buddha seated elegantly upon the lotus.

Both of Dhamrai's shops for casting images are run by Muslims. When Rashida Musharraf's husband died, she stepped boldly into his position, and the work went on. She tells me that no one in the Muslim community objects to her manufacturing idols. Though they are modeled by her Hindu colleagues, the works, she insists, are her own. Rashida suggests the images, she manages the complex process through which these gods of other people are cast into permanence, and she conducts the commerce, selling them to upscale stores in New Dhaka. She gets from two to twenty thousand *taka,* depending on

Ananda Pal

Gauranga Pal

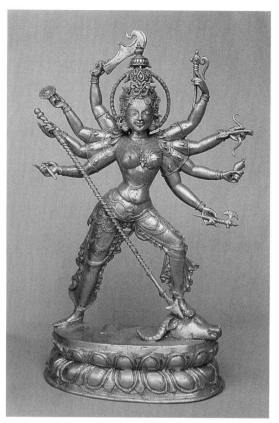

Durga.
Modeled by Ananda Pal.
Cast by Rashida Musharraf.
Dhamrai, 1996.
Brass; 19½ in. tall

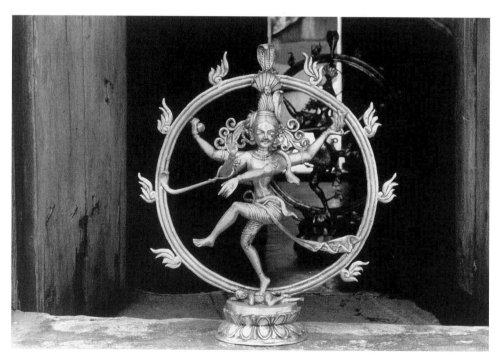

Shiva, Lord of the Dance.
Modeled by Ananda Pal. Cast by Rashida Musharraf, 1995

Krishna and Radha.
Modeled by Ananda Pal.
Cast by Ahmad Ali, 1995.
Blackened copper; 7 in. tall

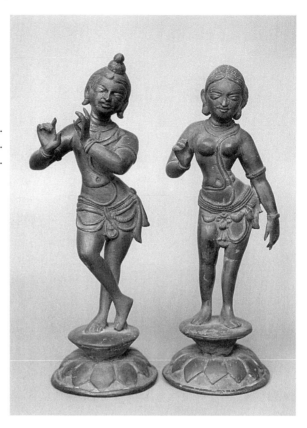

Mold for an image of Durga.
Clay packed around wax.
Ahmad Ali workshop

Ahmad Ali
with images of Krishna, Radha, and the Buddha,
cast in brass from models by Ananda Pal.
Dhamrai, 1995

Rashida Musharraf with an image of the Buddha that she cast in brass.
It was modeled in wax by Gauranga Pal. Dhamrai, 1995

size, her cost lying largely in materials. Some of those who buy her products are Hindus, and one occasionally sees new images of brass in the temples, but most of her customers, she says, come from foreign embassies. They seek fine images that, unlike the antiques stolen from the nation by unscrupulous collectors, can be exported legally.

Rashida's success has inspired a former worker of her husband's, Ahmad Ali, to establish a workshop near hers in a trim compound with clay and bamboo buildings set in the four corners. Like Rashida Musharraf, Ahmad Ali receives wax models from Ananda and Gauranga Pal to be cast, laboriously refined with files and chisels, and then, generally, darkened to give them the look of age. Some, I know, are sold for old by antique dealers.

For Ananda Pal, the buyer cannot matter. His work might come to rest in a temple. More likely it will ornament a foreign home. He cannot know, so he prays and shapes the image properly, making it as perfect as his considerable skills permit, knowing it must embody a sacred concept correctly, knowing it cannot be as important as the grand image he shapes of moist clay that will open a channel between the worlds and then melt away in running water.

Bangladesh provides good ground for the investigation of art. Art is always conditioned by cosmology, by first principles that relate human power to the powers beyond. Whether it is formulated in theological or magical or scientific terms, there is a tradition, a religion, a cosmological mandate that gives creators the right to create, to break into nature and make things. The question raised regularly and richly by Bangladesh is how artistic traditions as different as Hinduism and Islam coexist. One answer is provided by this image: the Buddha, modeled by a Hindu man, cast in brass by a Muslim woman.

Talk in the Shade

Art is centered, profoundly, in making. In the act of making, the artist occupies the world.

Through art, creators connect to the environment. Nature supplies their materials. Because God created nature, because nature is suffused with God's power, because all resources are limited and precious, materials are handled reverently. Nothing is frivolously wasted. I was touched when Gauranga Chandra Pal, at work in Krishna Ballab Pal's *karkhana* in Rayer Bazar, finished his treading and kneading by scraping wee bits from his feet, picking tiny crumbs from his hands, and patting them gently into the tower of clay before

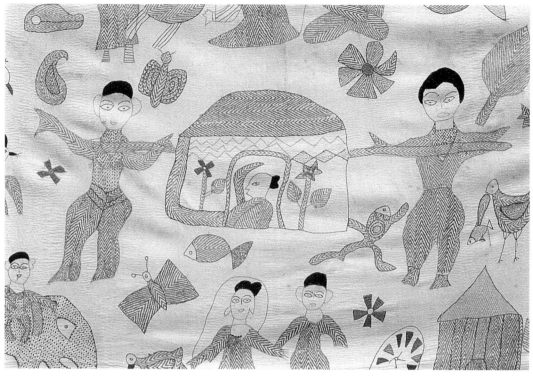

Detail of a *nakshi kantha* by Shamsun Nahar. Kishoreganj, 1983

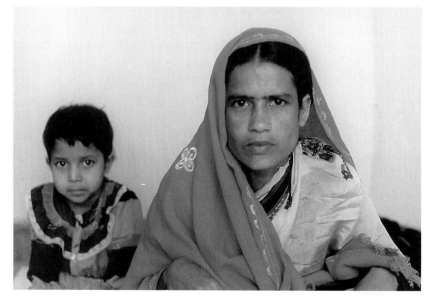

Shamsun Nahar

plopping it on the *chak.* The delta widens with layers of clay in vast quantity, but there is none to be wasted.

The fastidious handling of natural substances extends logically, in a scene of scarcity, into the economical recycling of manufactured materials. One lovely poem, written by Jasimuddin, has made the embroidered quilt, the *nakshi kantha,* the most famous of traditional arts in Bangladesh. Quilts of patchworked scraps are made throughout the delta, and north, west, and south of Dhaka, distinct regional styles of *nakshi kantha* developed in the past. Form and decoration are diverse. Prayer mats are stitched with domed mosques. Bags for the Koran are covered with geometric designs. The signal piece, brought to its peak in Jessore, is a large cloth, composed of worn, white saris, and embroidered with colored thread raveled from the borders of old saris. A lotus, the seat of the gods, expands at the center. Trees of life point from the corners. The border runs with mihrabs confining stiff flowers.

The art of the *nakshi kantha,* once meticulously contrived of scraps, was revived during the 1980s. Now there are *kantha* pillow covers and bedspreads and pictorial wall hangings that recycle used imagery, reassembling old motifs: the artifacts of rural life, the chariot of the Hindu temple, and especially the wedding procession that brings into conjunction the male and the female, urging diversity toward unity, just as the *kantha* did when its artist made a beautiful new thing out of old rags.

Continued commercial success for the agencies that effected the revival, training women to the needle and selling their products for profit, will insure continuity, and perhaps the *kantha* will also endure as an art, attracting talented women to free performance. Though the *nakshi kantha* is no longer composed of tattered scraps, instances of recycling abound. The rickshaw artist reuses industrial tin for his paintings. Metalworkers freshen old brass with engraving. They gather scrap to cast new images of the deities. They bang bruised chunks from wrecked ships into gleaming new vessels. And most splendidly, men assemble busted bits of bottles and china into glittering mosaics that, like the *kantha,* trail color over white fields into meaningful forms.

Taken carefully from the world, materials are transformed and consolidated during the courageous act of making, and then set back into the world. There they extend human control, making it possible to carry water or travel on water, to grow food and cook it, to rest and work. There, in balance and brilliance, they harmonize with flowers and birds and stars, as the artificial blends with the brightest in nature, sharing in, contributing to, the world's

need for beauty. And there, in the world of work, they join the rolling cycles of birth and death and rebirth.

People receive materials as gifts from God. In making, they align their creations with God's creation of the useful and the beautiful. Then they surrender their creations to the world, watching them fade and break. Art positions people in their environments, and it positions people among people. The work from which art grows is collaborative. In collaboration, three main social connections are forged.

One joins the master and the worker. Sirajul Islam said the worker's relation to the master is like that of a disciple to a saint, a *murid* to a *pir*. The master teaches and guides. The worker humbly accepts direction, carrying forth the learning that came most often from a parent, investing tradition with affection and the act of making with a sense of filial duty.

A second connection binds co-workers, often members of a joint family, in cooperative production. Each worker performs ably one part of the process, submitting to the desire for unity and quality, working in a team because no one can do everything excellently. Working among others, enjoying the chat when the task is dull, enjoying the work when it is engaging, people develop a sense of interlinked destiny and fellowship. They see in the final product how they fit together.

I am told that the one who works in isolation drifts into meditation when the job fails to fill the mind. During meditation, sadness rises naturally, for life is hard, and it converts, as it lingers, into anger falsely attached to missing people. It is hard to maintain balance, to preserve peace of mind, when the work is unchallenging and no one is there, but it is easy, I am told, to keep the self in proper hierarchical relation to the master, and in proper collegial relation to co-workers, when others are in sight, when work flows amid the give and take of talk and cooperative action.

A third connection brings the creator and the consumer together. Present in the person of the patron or only imagined, projected from the self, the consumer is served, the return of cash is validated, when artists make things as useful and beautiful as they would wish them for themselves.

Trapped in the world of clay and decay, surrounded by others, the artist is, then, at last alone in concentration. Past and future fuse, the mind and body run into unity; there is soft, sweet clay in the hands, and the only goal is excellence. This is the moment of making, the instant of individual command, the inevitable, inviolable bedrock of art.

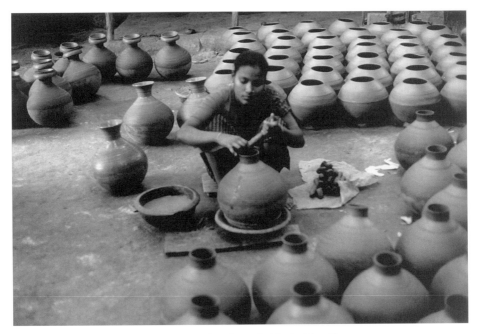

Purna Lakshmi Pal making *kalshis* in Kagajipara

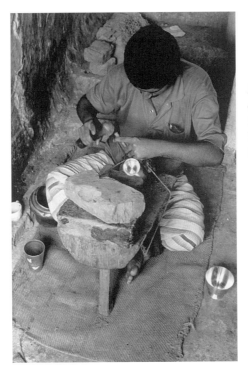

Mohammad Nur Hossain
engraving brass
in the workshop of
Nakshiwala Babul.
Dhaka city

Art records these realities: all people inhabit the world, all are members of societies, and all are individuals, alone on their quest. Absorbed in making, in this place, the individual does not collapse through aloneness into the self, for the self is built upon the soul. The soul is the breath of God, caged in the body, and art is its song. It is the inner force that unifies the human being with nature and with God, and art is its prayer of love.

Here art is not reducible to material conditions or economic functions, to a social exchange between competence and expectations, to tradition or taste or rare genius. It is rooted in God's gift of power, and it flowers in the existential act of making, when men and women draw substances from the environment to perform in concert with others, in service to others, and, above all, to repay the gift of power with the gift of devotion by bearing down and making well while positioning themselves correctly in relation to God.

Late in the day, I sat on the bench in front of Amulya Chandra Pal's workshop, in the shade beneath the lofty trees in Kagajipara. Our talk drew a few of his neighbors. Art, Amulya repeated, is part of life, and life is a search for God. That is so, he said, for all of us. We are one people, one species. We inhabit one little neighborhood—he said *busti,* one slum—and we have one God.

Our traditions give us different names for things. So it is with water. Some call it *jal,* others *pani,* but it is one substance. Bhagaban and Allah are but different names for God, and God is one and formless. Muslims, Amulya said, fault Hindus for worshiping *murtis,* but Muslims have mosques, and mosques have mihrabs, and Muslims pray through mihrabs to God, exactly as Hindus pray through *murtis.* We do not see God in the *murti,* Amulya said, but through the *murti.* Hindus have Durga and Saraswati, Muslims have the Kaaba, and they go to great expense to travel to Mecca to see it. Both Muslims and Hindus have buildings, the mosque and the temple, that provide forms within which the formless is approached. But, Amulya continued, travel is not necessary, nor is the building necessary. If you serve your parents and family, if you serve others, then you serve God. To make a plain, useful vessel of clay is to serve God. All that matters is belief, and if you believe, you will know peace, you will serve others, and you will receive blessings from God, whatever your tradition of devotion.

God's power abides in the soul, Amulya Chandra Pal said. Muslims call it *ruh,* Hindus call it *atma,* but it is one, and it is one with God. When the bird of the soul enters the cage of flesh, Amulya said, there is life in the body, and when it flies, the body is only a thing that some bury and others burn.

Life is a sign to the believer. God is made visible in motion, in the light dancing in the leaves, in the scarlet bird on the wing, in the body bending about its tasks, and God is felt as the power within that enables the mind to plan, the hand to grasp and relax. One hand moves to chisel flowers in brass. Another shapes clay into supple bodies. Both do the best they can, implying the formless through form, while the soul seeks reunion with God, and the fingers busy themselves with art.

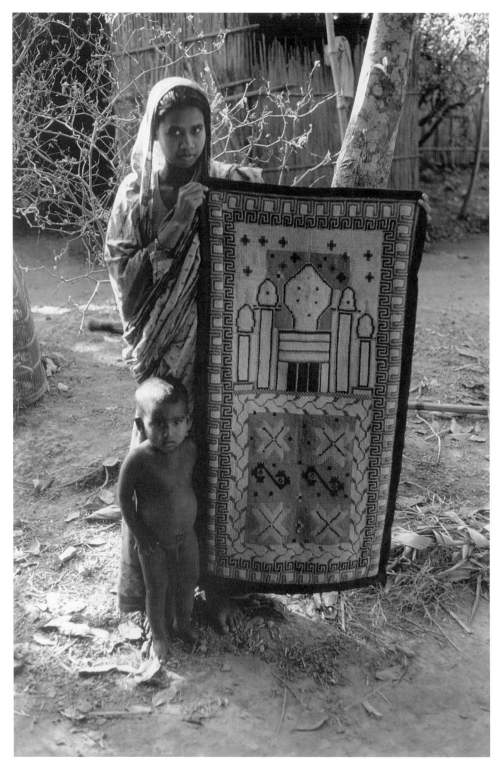

Nasima Begum displaying a prayer mat she wove. Gillande, Manikganj

Acknowledgments

Among the generous artists of Bangladesh, I thank these once more: Ahmad Ali, Askar Ali, Mohammad Ali, Showkat Ali, Shukur Ali, Nakshiwala Babul, Parul Begum, Roshna Begum, Ranjit Kumar and Tapati Rani Dey, Mohammad Hanif, Sirajul Islam, Abdul Jabbar, Mohammad Hasnain Khan, Bimal Chandra Mandal, Anis Mistri, Rashida Musharraf, Sukanta Nag, Mohammad Nazim, Amulya Chandra Pal, Ananda Pal, Babu Lal Pal, Chittaranjan Pal, Gita Rani Pal, Govinda Chandra Pal, Haripada Pal, Jatish Chandra Pal, Lal Chand Pal, Manindra Chandra Pal, Nanda Kumar and Fulkumari Pal, Santosh Chandra Pal, Shachindra and Saraswati Pal, Subash Chandra Pal, Sumanta Pal, Maran Chand Paul, and Salah Uddin.

For help in the field, I am particularly indebted to Muhammad Sayeedur Rahman, Shafiqur Rahman Chowdhury, Firoz Mahmud, Shipra and Biswajit Ghosh, Sukumar Biswas, Mohammad Salahuddin Ayub, Tofail Ahmad, Salah Uddin, Nanda Gopal Banik, and Badsha Mia.

This book was written at the request of Harunur Rashid when he was director general of the Bangla Academy. The piece of research it reports was unusual in that it was conducted at the invitation, and with the support, of an institution in the host country. I am indebted to the Bangla Academy for securing the funds that enabled me to do the fieldwork. My dear friend Shamsuzzaman Khan arranged for my trips to Bangladesh. The directors general of the Bangla Academy—Abu Hena Mostafa Kamal, Mohammad Harunur Rashid, and Monsur Musa—provided quick and steady assistance while I worked. Sultana Nahar gave me a comfortable home in Dhaka, welcoming me into the life of her family and serving me a steady stream of spicy Bengali delights.

During the year of this book's preparation for the press, there were many changes in Bangladesh. Dr. Syed Anwar Husain, a noted historian, became the director general of the Bangla Academy. Shamsuzzaman Khan became the director general of the Shilpakala Academy. Shafiqur Rahman Chowdhury ascended to command of the Folklore Department of the Bangla Academy. To all of them I am deeply grateful for their help toward the goal of this book's publication in Bangladesh. Books like this one must be made available in the places they describe and to the people upon whom they depend. My books on Ireland were published in Ireland as well as in the United States, my book on Turkey was published in Turkey as well as in the United States, and I am honored that this book will be published by my university's press and by the Bangla Academy in Dhaka.

My friends in Dhaka have continued to help in this book's late stages. I faxed Mohammad Salahuddin Ayub, asking that he visit Haripada Pal to translate a letter and to place an order so that Haripada could be represented by a major work in the permanent collection of the Indiana University Art Museum. Salahuddin's reply in March 1997 provides a coda to chapter six:

"I asked him how he was doing, how he had been 'passing the time in Shankharibazar,' what about his Pandit father and Shimulia, etc. I gave him the pictures. Then I opened your letter and explained what you have written about him and his works in your book. He looked very happy and said, 'I don't deserve it, do I?' He said, 'I could have made many more wonderful *murtis* if I had enough time. I have duties. I am confined in the world. I have a family to look after. I have to make money.' Then I stopped, and he started his philosophical talking. The evening was marvellous. I got energized, and then I went to my house, thinking, How can a man say those things anyway? How?

"Haripada Pal is a wonderful, unique, brilliant, spirited man. I am grateful to you that you brought me with you to Shankharibazar and introduced me to such an artist, such a beautiful personality."

455

My debts continue: Shamsuzzaman Khan, Firoz Mahmud, Kathleen Foster, John McGuigan, and Karen Duffy read the manuscript and offered helpful suggestions for improvement, not all of which I followed.

It is customary today for writers to express gratitude for the costly technology of our age. I am grateful primarily for paper that comes ruled with lines and for cheap pens already filled with ink, but I also used computerized techniques, for, while they are slow, they are flexible, allowing me to fulfill my main desire in the design: bringing the text and pictures into informative relation. Kathy Sitarski did a marvelous job of typing the manuscript. Then I drew a version of each page which John McGuigan and Bruce Carpenter translated for the computer, and it proved a great pleasure to work in close collaboration with John and Bruce while crafting this book. Michael Cavanagh and Kevin Montague printed my photographs with great care. John Gallman and his staff at the Indiana University Press once again supplied solid, professional support.

As I practiced my trade in the street and at the desk, I was constantly mindful of the community of thinkers within which I am privileged to work, and I must state my gratitude, first to my old friend Jim Deetz, my companion on the long road, and next to these colleagues who enrich my life: Roger Abrahams, Ron Baker, İlhan Başgöz, Dick Bauman, Alison Bell, Dan Ben-Amos, Charles Bergengren, Hande Birkalan, Jean-Paul Bourdier, Bruce Buckley, John Burrison, Özkul Çobanoğlu, Bob Cochran, Cece Conway, Marsh Davis, Linda Dégh, Walter Denny, Karen Duffy, Alan Dundes, Hasan El-Shamy, Marshall Fishwick, James Marston Fitch, Alan Gailey, Bill Hansen, Lee Haring, Bernie Herman, Mark Hewitt, Lauri Honko, Marjorie Hunt, Dell Hymes, Joe Illick, Susan Isaacs, Sandy Ives, Alan Jabbour, Kersti Jobs-Byörklöf, John Johnson, Mike Jones, Suzi Jones, Sung-Kyun Kim, Barbara Kirshenblatt-Gimblett, Barbro Klein, Peirce Lewis, Billy Lightfoot, Orvar Löfgren, Jiang Lu, Firoz Mahmud, Rusty Marshall, John McDowell, Patrick McNaughton, Don McTernan, John Moe, Baqi'e Badawi Muhammad, Peter Nabokov, Marion Nelson, Elliott Oring, Arzu Öztürkmen, Barry Lee Pearson, Phil Peek, Jerry Pocius, Jules Prown, Irwin Richman, Warren Roberts, Greg Schrempp, Muhittin Serin, Nazif Shahrani, Nancy Sweezy, Takashi Takahara, Bob Thompson, George Thompson, Barre Toelken, Sue Tuohy, Dell Upton, Serena Van Buskirk, John Vlach, Mats Widbom, Bill Wiggins, Bert Wilson, Wilbur Zelinsky, and Terry Zug. I miss old friends and masters, and I wish I could give a copy of this book to Fred Kniffen, Estyn Evans, Kenny Goldstein, Ralph Rinzler, and Erving Goffman, as I gave them books in the past, small tokens of thanks and affection.

A close ring of friendship sustains me, and I thank İlhan Başgöz, Inta and Bruce Carpenter, Trish Scott and Jim Deetz, Karen Duffy, Ayşe and İbrahim Erdeyer, Polly and Allen Grimshaw, Tülay and Mehmet Gürsoy, Mary Beth and Bill Hansen, George Jevremović, Neslihan Jevremović, Bethany Mendenhall and Charles Lave, Dale Hodges and David Logan, Daisy and Firoz Mahmud, Pat Glushko, Mike, and John McDowell, Deb Bowman, Niamh, Eoin, Rory, and John McGuigan, Barbara and Warren Roberts, Mona, Jacob, and John Pearson, Nurten and Ahmet Şahin, Greg Schrempp, Maha and Nazif Shahrani.

My family is my joy. I miss my father, and it still seems strange and sad that I cannot give this book to him. But I can thank my mother, my sister and Bill, and Isabella and Wally and the extended family in Oregon. I can say that my children—Polly, Harry, Lydia, and Ellen Adair—are my blessing and that Harry and Lori have brightened my life immeasurably by bringing Katie Rose and Carly into the world. And I can say again that it is to my love, Kathleen, that I owe the most.

Glossary

anna: monetary unit in the British period; there are sixteen *annas* in a *taka.*

atma: soul.

ayla: pot to contain coals for heating.

badna: spouted container for water.

baka: framing member for the bottom of a boat.

Bangla: the language of the Bengalis.

bansh: bamboo; *bansher agli,* bamboo tool used in throwing pots; *bansher chota,* bamboo tool used to cut forms from the *boula.*

bari: home.

basan: dish.

Basudev (Vasudeva): Krishna.

bayati: bard.

bazar: market.

Bhagaban (Bhagavan): God, Allah.

bichargan: song of argument.

bola: wooden tool, shaped like a pawn in chess, used to flatten cylinders of clay.

botni: prayer mat woven of split cane.

boula: cylinder of clay centered on the wheel from which forms are thrown.

chak (chaka): hand-powered wheel for throwing pottery.

chanch: mold for sprigging; *chancha,* to refine leatherhard pots.

chandra: moon.

chara: arc of broken pot used to chop clay.

chari: large hemispherical bowl.

chati: earthenware oil lamp.

cheari: pointed tool used in modeling clay.

cycle chalak: cycle rider.

da : stable knife used to dice vegetables.

dal: lentils; *dalpuri,* flat bread with lentils; *dal-bhat,* lentils-rice, common food.

dara: keel.

darshan: to connect visually with an object of veneration.

Devi: the Goddess.

dhakna: potlid.

dhalaikaj: metal casting.

dhoti: wrapped dress of the Hindu male.

dhup: incense; *dhupdani,* incenser burner.

doyel: the national bird of Bangladesh, a kind of magpie.

Eid: holiday at the end of Ramadan.

ekadashi: one-day fast practiced by Hindus.

ful: flower; *fuler tab,* flowerpot.

gachha: receptacle for an oil lamp.

garjan: a soft wood, used in building boats.

Gauranga: Chaitanya Dev.

ghar: room, house; *ghar-bari,* domestic architecture.

ghat: landing, the place where land transport and river transport meet; small pot for water used in *pujas.*

ghora: horse; *chaka ghora,* wheeled horse.

ghura: to turn, to throw pots.

goloi: boat's prow.

Gopal: Krishna.

gosa: framing member for the side of a boat.

gotra: endogamous subcaste.

gram: village; *gramer jiban,* village life.

Hari: God, Vishnu, Krishna.

hari: round-bottomed pot with an everted lip; *hari-kalshi* and *hari-patil* are collective names for utilitarian pottery.

hat: market.

hate: hand; *hate dore,* by hand; *hate hate,* with the hands.

Holi: the Hindu festival of spring.

hukka: water pipe.

jainamaz: prayer mat.

jal: water.

jaldhakna: lid for a water jar.

jalkanda: pot to protect milk or curds from ants.

jamdani: brocaded muslin.

jhar: storm.

kacha: earthen, made of unfired clay.

kaj: work.

kala mati: black clay, the same as *bali mati, rag mati,* and *etel mati.*

kalam: pen, chisel.

kalshi (kalash): globular water jar.

kanda: rim.

kandur: tool used to insert the extra weft in a *jamdani.*

kantha: quilt; *nakshi kantha,* decorated (embroidered) quilt.

karigar: artisan.

karkhana: workshop.

karma: accumulation of worldly merit.

kas mati: special clay from which slip is made.

kata: how much?

katherkaj: woodwork.

kirtan: song or musical performance in celebration of Krishna.

Kurbanir Eid: the Muslim feast of sacrifice.

lal: red; *lal mati,* red clay.

lek: iron tool used to shave clay from the *stup.*

lota: unspouted container for water.

lungi: sarong, skirt worn by Muslim and Hindu men in Bangladesh.

Mahadev: Great God, Shiva.

mandir: temple.

masjid: mosque.

mati: clay; *matirkaj,* clay work, pottery; *matir bank,* coin bank of clay.

matka: large storage jar for water.

matsyakanya: mermaid.

maund (man): a measure of weight, about eighty pounds.

mazar: tomb.

mela: festive market; *melar mal,* merchandise sold at *melas.*

mrit: clay; *mritshilpa,* clay art, pottery; Mritraj, the King of Clay, Maran Chand Paul.

muni-rishi: saints and sages.

murti: image of a Hindu deity.

namaz: the ritual sequence of Muslim prayer.

narod: mediator.

Nataraja: Lord of the Dance, Shiva.

nawab: governor in the Mughal period; honorific title in the British period.

nouka: boat; boat-shaped dish in which puffed rice is served.

paisa: monetary unit; there were four *paisas* in an *anna* in the British period; currently there are one hundred *paisas* in a *taka.*

pala: ballad.

pani: water.

para: dished mold for shaping round-bottomed pots, with specialized forms called the *natinapara,* the *hatanapara,* and the *patharpara;* neighborhood of a village.

paran: food to break the ritually obligatory fast of *ekadashi.*

pathar: stone used to smooth clay forms.

patil: round-bottomed pot for cooking.

patipata: green cane; *patipatar bagan,* garden in which cane grows.

pir: Muslim saint.

pitna: wooden paddle used to beat clay forms.

prasad: sacred food received at *pujas.*

puin: kiln.

puja: Hindu worship.

rani: queen.

ruh: soul.

sada mati: white clay, the same as *abal mati, doash mati,* and *bele mati.*

sadhana: ascetic exercise.

sadhu: holy man.

sail mati: clay used in constructing kilns.

sakher hari: decorated pot for pleasure.

sana: the reed of the beater of a *jamdani* loom.

seba: service.

shankhashilpa: conch-shell art.

shanki: plate.

shilpa: art.

stup: mound, pile of processed clay.

sundar: beautiful.

surai: long-necked water jar.

taka: monetary unit; in the period of this study, there were about forty *taka* to the U.S. dollar.

tala: bottom.

tanduri: oven.

tant: loom, weaving shed; *tanti,* weaver; *tantirkaj,* loom work, weaving.

tawa: baking pan.

thelagari: wheeled hand cart.

tipi: finger; *tipi tipi,* with the fingers.

urs: commemorative celebration at the tomb of a Muslim saint.

ustad: master.

vahana: animal vehicle and symbol of a Hindu deity.

vina: a stringed musical instrument.

zamindar: landlord.

Notes

This book is a report from the field. It tells how I found things to be in Bangladesh between 1987 and 1996. In these notes I acknowledge debts to works that helped me shape my interpretation, and I cite works through which comparative study might be expanded. The bibliography that follows permits abbreviated reference in the notes, and it widens past the specifically pertinent to incorporate books I have found generally inspirational as well as works of my own in which issues treated summarily here are handled more fully.

Introduction: Studying Art in Bangladesh

Pp. 1–3 At the beginning, I argue that the problems of art and ethnography would be solved by their integration. Students of art, in response to the multicultural reality, must do more than revise the conventions of late Western art, accommodating the alien to confirm its inferiority. The goal is to begin ethnographically, meeting works within their own systems of creation and use, devising the concept of art anew for each culture, and then to attend to both difference and similarity while working through comparison toward general principles. Ethnographers do not study culture, for it is abstract, conceptual, invisible; they come to culture through phenomena, and while it seems easy to displace phenomena with academic preoccupations, or with private reactions, it is more rigorous and decent to recognize the reality of phenomena, the particular creations of other people, their acts, and to discover culture within and among them. To the question of which phenomena, I answer those that are art, tautologically defining art for ethnographers as the phenomena richest to consider. For both the student of art and the ethnographer, art is that into which people build themselves most completely. Works of art are those phenomena that incarnate and exhibit simultaneously the personal, environmental, and social, the material and spiritual dimensions of human existence. Since it combines an interest in art and a concern for the individual with the techniques of the ethnographer, merging the topics of the humanities with the methods and theories of the social sciences, folklore is the name of my discipline. My own fullest treatment of the idea of art is *The Spirit of Folk Art,* in which I come to the position that art is a universal reality, that works of art are the richest expressions of the manifold human experience, and that works are called "folk" as part of an academic effort to designate for consideration creations that would be ignored if the presuppositions of study remained unexamined. Art is real. Folk art is a compensatory category, unfortunately necessary. I state my position on ethnography briefly at the end of *Turkish Traditional Art,* pp. 917–18, and exemplify it in *Passing the Time in Ballymenone.* In *Passing the Time,* through storytelling, agricultural work, and the landscape, in *Folk Housing in Middle Virginia,* through historical architecture, in *All Silver and No Brass,* through drama, in *Turkish Traditional Art,* through calligraphy and woodwork, ceramics and weaving, and again in this book, through pottery in particular, I illustrate how ethnography and art history interrelate to answer the problems that bedevil them when they are kept separate.

P. 3 The Academy: Harunur Rashid, *Introducing Bangla Academy,* pp. 3–6; Kabir Chowdhury, "The Language Movement and the Bangla Academy," in S. M. Islam, *Ekushey,* pp. 26–30.

P. 6 Tofail Ahmad's *Loka Shilper Bhubane (In the World of Folk Art),* with my foreword, is in Bangla, but an idea of his work for the reader of English can be gained from a paper he co-authored with Hameeda Hossain and Muhammad Sayeedur Rahman in S. Khan, *Folklore of Bangladesh,* vol. 2, pp. 64–117. Mohammad Shah Jalal's *Traditional Pottery in Bangladesh,* with my introduction, was

published in 1987; the text is reprinted in S. Khan, *Folklore of Bangladesh,* vol. 2, pp. 118–88, a book that includes, pp. 189–98, my preliminary sketch for a study of pottery in Bangladesh.

P. 8 *The Museums in Bangladesh,* by Firoz Mahmud and Habibur Rahman, is a comprehensive survey and model study of the problems and potentials of the museum in national life. Anticipated by his "Methodologies for the Study of Folk Art in Bangladesh," in S. Khan, *Folklore of Bangladesh,* vol. 1, pp. 446–87, Firoz Mahmud's thesis was published as *Prospects of Material Folk Culture Studies and Folklife Museums in Bangladesh.*

Chapter 1: Dhaka

Pp. 13–19 The look of the landscape was captured in 1840 by James Taylor in his *Topography of Dacca,* p. 7. He is describing Bikrampur, south of Dhaka city: "The course of the rivers at a distance is indicated by belts of trees along their banks, while the interior of the plain is studded with villages, built upon artificial mounds of earth raised above the height of the inundation. These little islands vary in extent, some of them only affording room for the huts of two or three families of ryotts with their cattle, while others are of a considerable size, and are covered with villages and gardens." Villages drift together on the mounds and break into neighborhoods. The difficulty of defining a village, with respect to a particular place in Manikganj, is described well in the report *Who Gets What* by the Bangladesh Rural Advancement Committee, p. 19. In his excellent study of the spread of Islam through Bengal, *The Rise of Islam,* pp. 231–34, R. Eaton argues that the village of Bangladesh is not nucleated in the European sense, that the physical unit is not necessarily coterminous with the social unit, and he is right, but neither is the landscape one of consolidated farmsteads like the United States. The openfield village has been adapted to the delta, but its key features remain: clustered housing is surrounded by fields through which the family's holdings scatter. Brief characterizations of the village and its architecture are common in the literature: Day, *Bengal Peasant Life,* pp. 9, 22–25, 110, 126, 174, 176–77, 200, 235–38; Banerji, *Pather Panchali,* pp.

28, 47; Chaudhuri, *Autobiography,* pp. 1, 13–15, 23–31, 68; A. Islam, *Bangladesh Village,* pp. 44–48, 55–58, 61, 67–68, 75; K. I. Ahmed, *Up to the Waist in Mud,* pp. 6–11, 25–31, 43–44, 47–48, 94–95, 105, 107, 112; Greenhill, *Boats and Boatmen,* pp. 55–60; Novak, *Bangladesh,* pp. 24–25, 44–45. The general pattern of the mound that holds the *gram* (the village) that is made of *paras* (neighborhoods) that are made of *baris* (households) that are made of *ghars* (homes of the nuclear units within the joint family) is exemplified in Kagajipara at the beginning of the second chapter in this book.

P. 19 The pattern in Dhaka's history is clear; the dates are not. Dates are not as confusing as spelling. (Authoritative texts spell names differently; authors even spell their own names differently, from book to book. The four modern maps I used to create my own map of Dhaka had different spellings for many of the neighborhoods.) But dates, a fascination for historians, are hard to reconcile. The end of Dhaka's Mughal period is set at different years between 1702 and 1717; I have been persuaded to the latest date. The period of the partition of Bengal is usually dated 1905 to 1911, but Dhaka's time as capital is, I believe, more accurately stated as 1906 to 1912.

Pp. 22–23 Koch characterizes the late style in *Mughal Architecture,* pp. 132, 136, in a way that fits Old Dhaka.

P. 23 I am helped in generalizing about the population of Old Dhaka by the sociological survey reported in *Social Formation in Dhaka City* by Siddiqui, Qadir, Alamgir, and Huq, pp. 45, 56, 125, 144, 195, 375–76. The people of Old Dhaka mostly fit in their class of small entrepreneurs, a third of whom have their shops and homes together; they are described on pp. 357–63.

Pp. 23–25 In this chapter, I use metalwork as one entry to Dhaka, the urban space encircled by villages of farmers and potters. It is a testament to the richness of art in Bangladesh that none of the metalworking shops I emphasize—Salah Uddin's in Old Dhaka, Hasnain's in Zinzira, those of Paresh, Ahmad Ali, and Rashida Musharraf in Dhamrai—are treated in Firoz Mahmud's comprehensive doctoral dissertation, "Metalwork in Bangladesh."

In chapter 13 on Dhaka city, Mahmud does discuss Salah Uddin's competitor Nakshiwala Babul. Sirajuddin in E. Haque, *Anthology on Crafts in Bangladesh,* pp. 69–72, offers a brief, but solid, account of metalworking techniques in Bangladesh.

P. 26 Speaking of Calcutta in *Portrait of India,* p. 363, Mehta comments that *busti* is "imperfectly translated" as slum. A. Q. M. Mahbub and Nazrul Islam treat the *bustis* among the dense settlements of the poor in "The Growth of Slums in Dhaka City," in S. U. Ahmed, *Dhaka,* pp. 508–21.

Pp. 28–38 Rob Gallagher has written an excellent book on *The Rickshaws of Bangladesh,* from which I have lifted statistical and historical facts: pp. 1–2, 6–9, 51, 87, 92, 381–95, 430–520, 639; see too Huq in S. U. Ahmed, *Dhaka,* pp. 438–39. I agree when Gallagher argues, pp. 349, 590, that social conditions and economic needs, not the work itself, make rickshaw-pulling inhuman. On pp. 93, 144–46, 360–62, Gallagher shows that the baby taxi was introduced in 1955, and the *mishuk* in 1986, about when the baby taxis began to be elaborately decorated. Gallagher adds a brief postscript on rickshaw art (it is not his focus), but there is an excellent paper on the art, "The Painted Ricksha" by Joanna Kirkpatrick. She seems right to me when she speaks of the difficulties in interpretation and then interprets the art as representing varieties of desire, pp. 80–82. Images of animals replaced images of people; the animals stand for people, pp. 76–77, and help to embody a male view, often erotic and violent. The differences between her account and mine are matters of history. Rickshaw art changes quickly—I noted a distinct decline in the percentage of painted rickshaws between 1995 and 1996—and the fieldwork for her paper was conducted between 1975 and 1982, while I intend to describe the situation in 1995. In a more recent paper that Kirkpatrick co-authored, "Transports of Delight," p. 35, she comments that pictures of movie stars, now the most common category of depiction on the cycle rickshaws, began to appear about 1986. Changes of fact, of course, temper interpretation. Even in my own time, I have noted a change in the jungle scenes; in the late 1980s they were often violent, though in the middle of the 1990s they were usually placid.

Kirkpatrick notes, p. 76, that the owner sometimes suggests the images. The artists I met said they made the decisions themselves. Surely both things happen.

P. 38 Writing on "Rickshaw Paintings" at about the same time as Kirkpatrick (she refers to another paper of his in "Painted Ricksha"), Asad Chowdhury comes to conclusions congruent with hers, p. 74, and on p. 72 he says of Dhaka, "It would be appropriate to call this 'the rickshaw city' rather than 'the city of mosques' which was its old name." I took the number of mosques from the valuable sociological survey by Siddiqui, Qadir, Alamgir, and Huq, *Social Formation in Dhaka City,* pp. 11, 47. To characterize the city, pp. 12–15, they list its main traits: first is the mosque, second is the rickshaw (on which they provide information like Gallagher's, pp. 229–30, 251, 266–78). In order, their other traits are: traffic jams, rusticity (the rural origins of the population; see pp. 73–74, 78), poverty, mosquitoes, markets, noise, a youthful population, an interest in fashion, the low public profile of women, and the fact that people know each other and so enjoy gossip. In *Tarnished Gold,* Marshall Fishwick provides a characteristically energetic essay, introducing Bangladesh through his reaction. Amid the racket and poverty and dirt, he finds vitality in rickshaw art, pp. 12–13, and a sweet calm with a Buddhist in Chittagong, pp. 17–19. Art and spirit—rickshaws and mosques—balance the view drawn too quickly to the conspicuous problems.

Pp. 38–41 The basic three-bay, triple-domed type of the Mughal mosque is described by Bari, "Mughal Mosques of Dhaka," pp. 321–22, and by Qadir, "Conservation and Restoration," pp. 140–41. The mosques of Khan Muhammad Mirdha at Lalbagh (1706) and Kartalab Khan at Begum Bazar (1704) are described in: N. Ahmed, *Islamic Heritage,* p. 54, and *Discover the Monuments,* pp. 178–79; E. Haque, *Islamic Art Heritage,* pp. 81, 84, 97, and *Glimpses of the Mosques,* pp. 8–9; S. M. Hasan, "Muslim Monuments," p. 302. The Koshaituli Mosque is not only spelled diversely in the literature, the building is said to have been erected in both the eighteenth and the twentieth centuries; I follow S. M. Hasan, "Muslim Monuments," pp. 306–7. He treats the Star Mosque, pp. 305–6. The authorities differ, some attributing it to the earlier, more to the later

eighteenth century, but they agree that the Star Mosque was of the usual Mughal type, with three domes and a paneled exterior, before it was sheathed with mosaic in the twentieth century. N. Ahmed, *Discover the Monuments,* pp. 181–82, says the Star Mosque is architecturally unimportant, but its mosaics, added about 1930, make it popular. Qadir, "Conservation and Restoration," p. 159, considers the change from three to five bays in the 1980s to have been a "ruthless interference" in the nation's patrimony, though the historical importance of the Star Mosque has not been destroyed. For more on this pair of decorated mosques: Taifoor, *Glimpses of Old Dhaka,* p. 267; E. Haque, *Islamic Art Heritage,* pp. 94–95, and *Glimpses of the Mosques,* pp. 26–28. The research energies of architectural historians press backward in time, and the vital twentieth-century tradition of mosaic awaits a major historical and ethnographic study.

Pp. 42–43 Koch, *Mughal Architecture,* pp. 70, 89, comments on the frequency in architectural ornament of niches containing flowers during the period of Jahangir in the earlier seventeenth century. The objects from an exhibition, catalogued in Skelton's *Indian Heritage,* pp. 71, 76, 83–86, 90, 146–47, 150, display instances of similar designs in Mughal prayer mats and tent hangings. Classically, the flowers stand within a niche, an image of the mihrab, so that the flowers, representing souls, rise to hope within the frame of Islam. I discuss the image as it appears in ceramics and textiles in *Turkish Traditional Art,* especially pp. 549–52, 557–62, 580–81, 841–42. In *Spirit of Folk Art,* pp. 148–66, I include examples from Bangladesh while describing the meaning and spread of the image. In my account here I de-emphasize the frame of the mihrab, for, though it is usual in the mosques, unframed flowers appear in other arts to which I wish to make connections.

P. 53 The topics raised here, *jamdanis* and shipbuilding, are handled in this book's last chapter. My point—that rural and urban Bangladesh are radically different in feel but complexly intertwined—is stressed by A. Islam, *Victorious Victims,* pp. 2, 59.

Pp. 54–60 Enamul Haque shows pictures of an early nineteenth-century Eid parade in *Islamic Art in Bangladesh,* pp. 22, 26, and *Islamic Art Heritage,* pp. 212, 221, 238. Taifoor mentions them in *Glimpses of Old Dhaka,* p. 236. Nita Kumar produced an excellent ethnographic study of the craftsmen of one Indian city in her *Artisans of Banaras.* Following the usage of British historians—see E. P. Thompson, *Customs in Common,* and P. Burke, *Popular Culture in Early Modern Europe*—Kumar calls popular culture what the folklorist calls folk culture, and she emphasizes recreation. I believe that she and those who inspired her would have found the task easier if they had concentrated in detail upon the work people do, as well as their entertainment, for it is no less a part of popular culture and more central to life, but that is not to take anything from her achievement upon which she reflects in her fine book on fieldwork, *Friends, Brothers, and Informants.* In *Artisans of Banaras,* pp. 180–99, especially pp. 190–91, and in her paper "Class and Gender Politics in the *Ramlila,*" in Sax, *Gods at Play,* pp. 165–70, Kumar describes the *Ramlila* processions of the 1930s as incorporating themes like those of the Eid parade in Dhaka today. Kumar characterizes today's parades in Banaras to be—like the objects made for Dhaka's middle class (see chapter 4)—less significant and more decorative. My treatment of the Eid parade provides a simple instance of a method for meaning. Whether it is old houses in America, Irish stories, Turkish carpets, or Dhaka's rickshaws (see notes to pp. 1–3), I do not find meaning within isolated objects, but—dialectically, systematically, structurally—in the object (the float) as part of a set (the parade); see Lévi-Strauss, *Way of the Masks,* pp. 56–57.

Chapter 2: Kagajipara

P. 61 General statistics on pottery production are available in Mohammad Shah Jalal's *Traditional Pottery in Bangladesh,* pp. 15–16, and in the appended tables following p. 55.

P. 76 The big, hand-powered *chak* of the kind used in Bangladesh is found generally in the Indian subcontinent. In chapter 8 of the book he coauthored with Haku Shah, *Rural Craftsmen,* Eberhard Fischer provides a model study of a potter from western India; he describes work on the wheel, pp. 138–40, and see figs. 177–271. His collaborator Haku Shah

also describes work on the wheel excellently in his *Votive Terracottas of Gujarat,* pp. 48, 64, 67–68, 100, which is one of the very best books we have on traditional pottery. On the *chak,* its form, and exclusive use by men: Birdwood, *Arts of India,* pp. 310–11; Barnard, *Arts and Crafts of India,* pp. 30, 148, 150–51, 153; Cooper and Gillow, *Arts and Crafts of India,* p. 16; Bussbarger and Robins, *Everyday Art of India,* p. 49; Huyler, "Clay," pp. 206–7, 210; A. Mookerjee, *Folk Art of Bengal,* pp. 28–30; P. Sen, "Potters and Pottery," pp. 43–45, and *Crafts of West Bengal,* pp. 26–29; R. P. Gupta in Dasgupta, *Arts of Bengal,* p. 20; S. K. Ray, "Artisan Castes of West Bengal," p. 315; Shahidullah and Hai, *Traditional Culture in East Pakistan,* pp. 128–29, plate 41; C. S. Rahman, *Life in East Pakistan,* pp. 44–49; Mahmud, *Prospects,* p. 95.

P. 81 S. S. Biswas, *Terracotta Art of Bengal,* pp. 113, 191, plate 58, illustrates two fragmentary tiles from the second or third centuries A.D., showing women carrying *kalshis* of the contemporary type in the way they are carried today.

P. 82 The contrast between *sanat* and *emek* begins my exploration of the Turkish idea of art in *Turkish Traditional Art,* pp. 94–108, 178–86, 332–68, 797–869.

P. 83 As I stress again in this book's conclusion, the Western presupposition that most disrupts understanding of the art of Bangladesh, and of the art of the world's working people in general, is the idea that art must be other than useful. In his important book *The Shape of Time,* pp. 11, 14–16, 31, 38, 80, George Kubler handles the issue subtly but, nonetheless, defines art as the opposite of the tool. His argument might be valid, so long as the view is tightly restricted to the art of the elite in industrial societies, but as soon as the view expands back in time (see Eco, *Art and Beauty in the Middle Ages,* pp. 93–94) or out in space, it fails. Writing in 1880, when industrialization was still recent in England and rare in India, G. C. M. Birdwood understood that the dichotomy of art and industry—the identification of the artful with the useless (art for art's sake being a theme of his time)—was a consequence of industrialization; in *Arts of India,* p. 131, he says, "In India everything is hand wrought,

and everything, down to the cheapest toy or earthen vessel, is therefore more or less a work of art." Inspired by the critical writings of William Morris, the greatest Englishman of Birdwood's day, and devoting himself to the study of the works and ancient texts of India, Ananda Coomaraswamy, the greatest historian of Indian art, argued in a lifetime of writing not only that the contrast of the fine and the applied—the artful and the useful—was inappropriate to the art of the subcontinent, but also that the notion of useless art would seem monstrous and vain to the Indian artist: *Introduction to Indian Art,* pp. vii–viii; see too *Arts and Crafts of India and Ceylon,* pp. 140, 142, and *Dance of Śiva,* p. 18. Then, arguing that what is true of India was also true of medieval Europe, Coomaraswamy criticized the decadence of modern Western art; what is now a luxury for the rich, he said, was once, and should be again, a principle of knowledge by which the physical and spiritual needs of all people are met: *Christian and Oriental Philosophy of Art,* pp. 24–33, 61–85, 111–12, especially 85. Coomaraswamy's study yielded a masterpiece, *The Transformation of Nature in Art,* in which the issue of utility is raised specifically on pp. 9, 16–17, 65, 90. The book is a key text in the study of art, for in it Coomaraswamy bases a general argument on nonwestern sources, as Robert Plant Armstrong would later do in his trilogy, *The Affecting Presence, Wellspring,* and *The Powers of Presence.* Because Coomaraswamy and Armstrong both knew Western art, and yet had studied beyond the West, Coomaraswamy in India, Armstrong in Africa, their writings profoundly challenge those who would, in a neocolonial manner, spread Western assumptions across the globe, separating what is art from what is not and ordering rankings among objects. Coomaraswamy focuses specifically on the subcontinent in "The Part of Art in Indian Life," commenting on the mix of use and beauty and on the artist's desire for service, pp. 73–76, 78–79, and pressing in the essay's fourth section toward a critique, grounded in India, but rising along a Morrisian arc. Other great interpreters of Indian art concur: Kramrisch in Miller, *Exploring India's Sacred Art,* pp. 51–52, says the Western division of art from craft by medium or function does not hold; and Zimmer, *Artistic Form and Yoga in the Sacred Images*

of India, pp. 31–32, stresses the importance of use in art. In Bangladesh, as in India, as in most of the world, through most of its history, use is integral to the idea of art.

P. 84 "To give people pleasure in the things they must perforce *use,* that is one great office of decoration; to give people pleasure in the things they must perforce *make,* that is the other use of it." So spoke William Morris near the beginning of his lecture "The Lesser Arts," delivered in 1877 and printed first among the essays in *Hopes and Fears for Art;* May Morris, *Collected Works,* vol. 22, p. 5. Here I reaffirm my belief that the essays on art by William Morris, gathered in *Hopes and Fears for Art* (1882), *Signs of Change* (1888), and *Architecture, Industry and Wealth* (1902), remain the best and most important writings we have on what he called popular art, what we tend to call folk art today, and which, in an ideal world, would be called art without the need for a qualifier.

P. 84 In *Spirit of Folk Art,* pp. 36–88, working from my experience in the field toward a general idea of art, I argue that, while different cultures do invest certain media with power, with the special responsibility of bodying forth the human complexity, the Western identification of art with painting and sculpture is of little use in the wider world, where ceramics and textiles are more often the key media. Then I argue against the general applicability of the recent Western division of beauty from use, coming to the aesthetic as a necessary but insufficient basis for a definition of art, since feeling and intelligence connect in the individual and the individual exists amid social exchange in a world of needs. Aesthetics can begin but not end the search for art. Meaning, a special case of use, remains.

Pp. 85–86 Tagore, *Glimpses of Bengal,* p. 43; see, too, pp. 109–10.

P. 86 The Japanese tea bowl, one of the world's most refined works of art, is rendered both visual and tactile appreciation, and its beauty and importance grow with use: Mitsuoka, *Ceramic Art of Japan,* pp. 170–72; Sadler, *Cha-no-yu,* pp. 66–79, especially 69; Castile, *Way of Tea,* chapter 8, especially p. 190; Munsterberg, *Ceramic Art of Japan,* chapter 6, especially p. 107.

Pp. 87–89 For examples of the *sakher hari:* A. Mookerjee, *Folk Art of Bengal,* p. 30; Ghuznavi, *Naksha,* pp. 46–47; E. Haque, *Anthology on Crafts in Bangladesh,* pp. 95–96; P. Ahmad, *Crafts from Bangladesh,* pp. 5, 25.

Pp. 87–89 *Alpana:* Dutt, *Folk Arts and Crafts of Bengal,* pp. 95–101; Kramrisch, *Unknown India,* pp. 65–66; Bhattacharyya, *Folklore of Bengal,* pp. 154–55; Ghuznavi, *Naksha,* pp. 56–59, 65; Barnard, *Arts and Crafts of India,* pp. 66–69; and, in general, the fine papers by Huyler and Nagarajan in N. Fischer, *Mud, Mirror and Thread,* pp. 172–203.

Pp. 89–91 The Mirpur Mazar is described briefly in Taifoor, *Glimpses of Old Dhaka,* pp. 58–60, 79.

Pp. 94–96 It surprises me how little has been written on pottery coin banks. I treat the fruit banks of Bangladesh and Mexico in relation to each other in *Spirit of Folk Art,* pp. 110–11. At one point in Banerji's *Pather Panchali,* p. 149, Opu tells of seeing fruit of clay in the market that he thought was real. In Banerji's novel, the sad story of Durga, as powerless as her namesake is powerful, embodies the desire to possess, to hold to little things and to life. The theme to which I refer is developed more fully in the novel than it is in Satyajit Ray's magnificent film version (1955) that emphasizes Durga's theft but not her box of possessions. Nirad Chaudhuri characterizes Bengalis as obsessed with possessions in his *Autobiography,* pp. 187–92.

P. 96 Staffordshire provides the obvious Western instance of a ceramic center in which the production of utilitarian ware and statuary coexisted. Sculpture became common in the Staffordshire potter's repertory after 1740 and was made in vast quantity during the nineteenth century: Shaw, *History of the Staffordshire Potteries,* p. 155; Rhead and Rhead, *Staffordshire Pots and Potters,* pp. 170–72 and chapter 19; Oliver, *Victorian Staffordshire Figures.* The mix is usual in eastern Asia. In China, at Shiwan in Guangdong and Dehua in Fujian, potteries making utilitarian ware developed specializations in sculpture: Scollard and Bartholomew, *Shiwan Ceramics,* pp. 15–22; Donnelly, *Blanc De Chine,* pp. 8–41; Li, *Chinese Ceramics,* pp. 9–10, 139, 272, 311, 331–32; Garnsey and Alley, *China,* pp. 106–32. Other

centers, like the renowned Jingdezhen, while largely producing beautiful vessels, also produced statues. In Japan, many of the famed centers—Arita, Bizen, Echizen, Hagi, Kutani, Mino, Seto, Shigaraki—have produced statues in addition to the dominant useful forms; for examples: Cleveland, *200 Years of Japanese Porcelain,* pp. 55, 96–97; Munsterberg, *Ceramic Art of Japan,* pp. 44, 96, 122, 155, 177, 221; Wood, Tanaka, and Chance, *Echizen,* pp. 70–71; Barriskill, *Visiting the Mino Kilns,* pp. 28, 37, 121; Cort, *Seto and Mino,* pp. 163–64, and *Shigaraki,* pp. 266–67.

Pp. 96–98 Stella Kramrisch classed the little Mother Goddess statues as timeless, and examples from throughout the subcontinent are often depicted, if little discussed: Kramrisch in Miller, *Exploring India's Sacred Art,* pp. 71–73, 78; Saraswati, *Indian Sculpture,* pp. 100–101; Biswas, *Terracotta Art of Bengal,* pp. 40–42; Dutt, *Folk Arts and Crafts of Bengal,* pp. 43, 88–89, plates 31, 50; A. Mookerjee, *Folk Art of Bengal,* pp. 32–34, *Indian Dolls and Toys,* plate 4 (Faridpur, Bangladesh), and *Folk Toys of India,* pp. 15–16, plates 1, 20; Hasan in E. Haque, *Anthology on Crafts in Bangladesh,* p. 100; Ghuznavi, *Naksha,* pp. 49, 51–52; Skelton in Skelton and Francis, *Arts of Bengal,* pp. 57, 59; M. K. Pal, *Catalogue of Folk Art,* nos. 1–19; Meister, *Cooking for the Gods,* p. 90 (the pieces are not located, but no. 65 resembles those from Dhaka district); Huyler, "Terracotta Traditions," p. 63; Bussbarger and Robins, *Everyday Art of India,* pp. 32–34; Haku Shah, *Votive Terracottas of Gujarat,* pp. 107–9, 111, 114, 131.

Pp. 96–98 Pinched earthenware animals of the Chittagong type are illustrated in: Shamsul Hossain, *Art and the Vintage,* nos. 182–207; A. Mookerjee, *Folk Toys of India,* plates 6–8, 27, 30; M. K. Pal, *Catalogue of Folk Art,* nos. 8–9, 14–19, 22–24, 26–30. For earthenware horses of other kinds, see the note to p. 280, below.

P. 107 Statistics on attitudes toward family planning are presented in Siddiqui, Qadir, Alamgir, and Huq, *Social Formation in Dhaka City,* pp. 141, 163, 166, 234, 274. Another fine sociological survey narrows to Muslims, but widens to rural as well as urban opinion on family planning: Banu, *Islam in Bangladesh,* pp. 115–21, 128. See too Hartmann and Boyce, *Quiet Violence,* pp. 115–20.

Pp. 108–14 In tone, structure, and ideology, Amulya Chandra Pal's story of King Karna and the Brahmin fits the *Mahabharata.* Nazimuddin Ahmed, in his book on terracotta art in Bangladesh, *Epic Stories,* p. 97, while describing Karna's character alludes to the story: in his "unbounded liberality" Karna sacrificed his son, Vrishaketu, offering his flesh to Krishna who brought him back to life. I assumed that I would find the source of the story in the *Mahabharata,* and when I did not happen to find it in English translations, I turned to my friend Deeksha Nagar who extended the search in Hindi and Sanskrit, and when she did not find it, she used electronic mail to contact experts who told her the story was fascinating but absent from any version of the *Mahabharata* they knew and that the tale must be specific to Bengali oral tradition. If it is specific to Bengal, where it is known to Nazimuddin Ahmed as well as Amulya Chandra Pal, then its parallel relation to the story from the Bible and the Koran is provocative. Perhaps all the sacred stories derive from an ancient ancestor, and William Hansen has argued intriguingly in his fine paper "Abraham and the Grateful Dead Man" that there is a connection between the Biblical story and one international folktale. Or perhaps, in the cultural exchange between Muslims and Hindus, the Koranic narrative was reworked to fit Hindu cosmology, with generous Karna from the *Mahabharata* cast in the role of Ibrahim. If so, Amulya Chandra Pal's *pala,* his poetic version of the tale, is a key text in the cultural history of Bengal.

Pp. 115–16 I synthesized the brief history of terracotta from these sources: Biswas, *Terracotta Art of Bengal,* pp. 17–19, 37–65; Z. Haque, *Terracotta Decorations,* pp. 15–28; M. Khan, "Potter's Art," pp. 15–22, "Muslim Terracotta Art," "Terracotta Art," and *Terracotta Ornamentation,* pp. 51–225; Michell, *Brick Temples of Bengal,* chapters 1, 6, and *Hindu Temple,* pp. 155–58; Alam, *Mainamati;* N. Ahmed, *Epic Stories,* pp. 114–29; Sirajuddin, *Lyrics in Terracotta;* Kramrisch in Miller, *Exploring India's Sacred Art,* pp. 71–84; Saraswati, *Indian Sculpture,* pp. 97–109, 171; Poster, *From Indian Earth,* pp. 22–28; Blurton, *Hindu Art,* pp. 205–6.

P. 120 Pugh's exhaustive catalogue of *Staffordshire Portrait Figures,* pp. 487–91, shows the common pairs

465

of Shakespeare and Milton. Rabindranath Tagore and Nazrul Islam are linked in the popular consciousness of Bangladesh. In 1971, it was said that Tagore and Islam would be the priests of the new nation: Tewary, *War of Independence*, p. 152. A. Islam, *Victorious Victims*, pp. 73–75, characterizes refined Muslims in a small town as singers of the songs of Tagore and Islam. Ziring, *Bangladesh*, p. 188, remarks the importance of Tagore and Islam for students. In Siddiqui, Qadir, Alamgir, and Huq, *Social Formation in Dhaka City*, p. 215, the working poor are said to like folksongs and the songs of Tagore and Islam.

Pp. 120–23 The excellent new biography, *Rabindranath Tagore*, by Dutta and Robinson, provided me with helpful guidance on pp. 12, 37, 45, 61, 77, 84, 108, 119, 134, 151. To write of Tagore, I used as well: Tagore's own *Reminiscences*, pp. 73–77, 269, and *Glimpses of Bengal*, pp. 43, 80–81; S. Sen, *History of Bengali Literature*, chapter 22 (he says, p. 319, that Tagore is the most complete man the world has known); Bose, *Tagore*, pp. 5 (where he says Tagore is important as the one who brought Romanticism to Bengal and Bengali literature to the world), 23–26, 68–70; Richards, *Modern Hinduism*, chapter 10. Dutta and Robinson discuss Yeats and Tagore in their introduction and on pp. 124, 164–70, 178–79. I take Yeats' opinion from his introduction to *Gitanjali*, pp. vii, xiii–xiv. Dutta and Robinson describe in detail Tagore's attempt to strip himself of knighthood after Jallianwala Bagh, pp. 216–18, 424–25. In his *Autobiography*, pp. 366, 369–70, 377–80, Mahatma Gandhi provides an account of the origin of non-cooperation. The movement did not start with the massacre, but it was the catalyst. On the massacre: Masani, *Tales of the Raj*, p. 112; Farwell, *Armies of the Raj*, chapter 19; de Schweinitz, *Rise and Fall of British India*, pp. 1–3; Wolpert, *India*, pp. 63, 111–12.

Pp. 123–25 Sukumar Sen slights Nazrul Islam in his *History of Bengali Literature*, pp. 355–56, but there is a lively new biography, Talukdar's *Nazrul*, from which I gathered facts and insights: pp. 13–14, 25, 34–40 (poem of the rebel), 47 (his poem to Durga), 50, 53, 59–60, 66–67, 73–74, 90–91, 104–5, 112 (his desire to return as a servant). Novak discusses him in *Bangladesh*, pp. 159–63.

Pp. 124–25 I drew Michael Madhusudan Dutt from

his own letters in K. Gupta, *Writings*, pp. 517–619; from S. Sen, *History of Bengali Literature*, pp. 197–200, 211–24; and Chaudhuri, *Autobiography*, pp. 83, 215–17, 220–24.

Pp. 125–26 Anisuzzaman ends his book *Creativity, Reality and Identity*, pp. 115–16, by quoting Shamsur Rahman's poem "Freedom." Harunur Rashid introduces Shamsur Rahman first among the leading poets of Bangladesh in *Three Poets*. In his *Flaming Flowers*, p. 47, Nurul Huda calls Shamsur Rahman the most celebrated poet of modern Bangladesh. Huda describes the poet's tendency to litany, pp. 129–31, and he analyzes the poem in question, pp. 176–77.

P. 128 I refer to poems 16 and 18, and quote from poem 44, in Abu Rushd's *Songs of Lalon Shah*.

Pp. 128–29 The story of Durga is common knowledge in modern Bangladesh. Thomas Coburn analyzes the classical source in *Devi Māhātmya*; see pp. 9, 60, 211, 221–30, 308. On Durga Puja: Chaudhuri, *Autobiography*, pp. 72–84; Tagore, *Glimpses of Bengal*, pp. 111–12; Day, *Bengal Peasant Life*, p. 104; Banerji, *Pather Panchali*, p. 256; Kumar, *Artisans of Banaras*, pp. 217–21; Moorhouse, *Calcutta*, pp. 197–99.

P. 129 In 1798, Francis Buchanan called Kali the chief deity of Bengal; van Schendel, *Buchanan*, pp. 104–5. In 1840, Taylor reported the importance of Kali in Bengal: *Topography of Dacca*, p. 242. Twentieth-century writers continue to comment on Kali's power in Bengal: Chaudhuri, *Hinduism*, pp. 245–46; A. Mookerjee, *Kali*, pp. 71, 81, 102; Stutley, *Hinduism*, pp. 48, 121–22; Kinsley in Hawley and Wulff, *Devi*, p. 77; McDaniel, *Madness of the Saints*, pp. 273–74, 284.

P. 129 Stella Kramrisch devotes the seventh chapter of *The Presence of Śiva*, her exploration into the god's mythology, to the Linga. Unconventionally, I do not italicize and I do capitalize because of the way I heard people speak of the Linga; it is an abstract image of the god, a form in which Shiva appears as other gods appear in anthropomorphic forms; cf. Kramrisch, pp. 168–70, 173–74, 221, 241–49. Kramrisch treats Shiva, Lord of the Dance, pp. 439–42. That rich image has drawn rich explication: Coomaraswamy,

Dance of Śiva, pp. 56–66; Zimmer, *Myths and Symbols,* pp. 151–75; Blurton, *Hindu Art,* pp. 86–88, 110, 125; Saraswati, *Indian Sculpture,* p. 117; A. Mookerjee, *Ritual Art of India,* p. 164; Eck, *Darśan,* pp. 40–41.

Pp. 135–38 There is nothing original in my description of Hinduism. Larson in *India's Agony,* pp. 20, 82–85, describes Hinduism as a confederation of faiths containing three distinct cults. Stutley writes in *Hinduism,* p. 40, that a speculative monism exists alongside a ritual polytheism, and she describes the three cults in chapters 10–12. The cults of Shiva, Vishnu, and the Goddess are usually labeled with some variant of the names Shaiva, Vaishnava, and Shakta, but I avoided the names to capture the state of affairs in Bangladesh, to prevent this reality from being reduced to some other. Of the books I read on Hinduism, I enjoyed one the most and recommend it highly: Nirad C. Chaudhuri's *Hinduism.* I liked it because Chaudhuri, who finished the book in his eightieth year, was a tough, independent thinker and a gifted writer (his *Autobiography* must be read), and because Chaudhuri came from East Bengal, from Kishoreganj in northern Bangladesh, so his Hinduism resembles the one I met on the ground, and because Chaudhuri did not center his account in ancient texts but in ritual practice—see pp. xi, 70, 186—and I develop my account, not from ancient texts, but from the images in the temples of modern Bangladesh. Chaudhuri describes the easy coexistence of the cults of Shiva, Vishnu, and the Goddess with each other and with the concept of a formless, omnipotent Bhagavan, on pp. 45–50, 59–61, 88–90, 134–51, 172–75, 222, 237, 242–48, 225–61. His spelling—Bhagavan—is usual in the books; mine—Bhagaban—seems right for Bangladesh. Chaudhuri's Hinduism is the one I found in Bangladesh. When Hinduism is provided with a male triumvirate at the top, and the goddesses are reduced to the consorts of male deities, the account, while apt for some areas, drifts from relevance to Bangladesh. David Kinsley, in the introduction to *Hindu Goddesses,* p. 3, says he was struck by the number of goddesses, and his lack of knowledge about them, when he went to Bengal. He does a fine, clear job of arraying the goddesses before us in his book; of particular importance for

Bangladesh are chapters 2 (Lakshmi), 3 (Parvati), 4 (Saraswati), 5 (Sita), 6 (Radha), 7 (Durga), 8 (Kali), 9 (Devi), and pp. 204, 209–11 (Sitala and Manasa). Hawley and Wulff have edited two overlapping volumes on Hindu goddesses. The first is rich in essays on Radha, and it includes a paper by Edward C. Dimock on Sitala. In both books, Kinsley describes Kali, and Coburn introduces the text to which he devoted his book *Devi Māhātmya,* the classic source for Durga. For more on the goddesses, one key to understanding Hinduism in Bengal: Zimmer, *Myths and Symbols,* chapter 5; Blurton, *Hindu Art,* pp. 37, 168–83; Bhattacharyya, *Folklore of Bengal,* pp. 27–52, 83–84.

Pp. 136–37 The importance of Devi, the Goddess, is one key to understanding Hinduism in Bengal. Chaitanya's reformation of Vaishnavism, centered upon Radha and Krishna, is another. The two coexist in devotional space. In *The Chaitanya Movement,* p. 183, Melville Kennedy writes, "the origin of images in many temples is hopelessly confused, and the clarity of sectarian distinctions equally obliterated, to the woe of the foreign observer." He apparently thought of the cults as separate in the way Christian sects are separate, and assumed that clear division among the cults was once the case, but interaction among the cults is normal, images from different strains of Hinduism congregate in the temples (see Eck, *Darśan,* p. 49), and such interaction appears as well in the ancient texts (see Coburn, *Devi Māhātmya,* pp. 42–43). Today statues of Gauranga and Nitai, of Chaitanya and his main disciple Nityananda, which Kennedy describes, p. 194, appear along with Radha and Krishna in temples in which images of Shiva and Devi, the prime deities of the other cults, are also found. For Chaitanya: Chakravarti, *Vaiṣṇavism in Bengal,* chapters 2–4; S. Sen, *History of Bengali Literature,* chapter 7; Chaudhuri, *Hinduism,* pp. 182–84, 282–90; McDaniel, *Madness of the Saints,* pp. 29, 33–40, 168–70, 283; Donna Wulff, "The Play of Emotion," in Sax, *Gods at Play,* pp. 99–114; and Kennedy's *Chaitanya Movement.* The aspects of Kennedy's old book that make it objectionable to the modern relativist—he concludes, p. 257, that the energy in Vaishnavism should be directed to Christ—are so patent that the book remains a valuable source of information. What

is strange is that Kennedy pauses to argue that Buddhist influence on the movement is over-estimated, p. 12, and he spends much time in comparing Vaishnavism with Christianity, to the glory of the latter, but he does not mention Islam, although the correspondences he finds between Vaishnavism and Christianity, pp. 217, 223, 227, could be owed to the Sufi tradition in Islam, and although Vaishnavism, while clearly based upon the ancient Hindu concept of *bhakti,* pp. 56–58, would not have formed precisely as it did were it not for exchanges (perhaps through Muslims welcomed into the movement, p. 119) with Islam. Certainly principles shared with Sufism were central, pp. 92, 99–101, 112, and Chaitanya's movement formed in the period of the independent sultans, when Muslims ruled, Sufis flourished, and Hindu-Muslim inter-action yielded synthetic products, emblematic of a new cultural order; see: Edwardes, *History of India,* pp. 125–30; R. Eaton, *Rise of Islam,* pp. 40–41, 109–12; N. Ahmed, *Epic Stories,* pp. 104–7, 111–12. One product of the period was Chaitanya's recasting of Vaishnavism, and another was the curved ridge and cornice lifted from Bengali domestic buildings and applied to both mosques and temples, giving them a shared local character; see: N. Ahmed, *Discover the Monuments,* pp. 92–94, 133–34; Michell, *Brick Temples of Bengal,* pp. 20–24; S. M. Hasan, *Mosque Architecture,* pp. 151–65; Bari, "Mughal Mosques," pp. 324, 326; S. M. Khan, "Folk Architecture"; Dutt, *Folk Arts and Crafts of Bengal,* pp. 57–61.

P. 138 On ancient trade in peacocks: Wolpert, *New History of India,* p. 56; Hornell, "Indian Boat Designs," p. 192. Chaudhuri describes Kartikeya in his *Autobiography,* p. 74.

P. 141 The popularity of images of Ganesh: Waterstone, *India,* p. 117; Blurton, *Hindu Art,* p. 106; Cooper and Gillow, *Arts and Crafts of India,* p. 35; Maury, *Folk Origins of Indian Art,* pp. 63–64; P. Moo-kerjee, *Pathway Icons,* p. 10; Huyler, "Clay," pp. 218–19; Jain and Aggarwala, *National Handicrafts,* pp. 17, 28–29; Krishna, *Arts and Crafts of Tamilnadu,* pp. 51, 101, 157–58. Courtright's *Gaṇeśa*—in which, pp. 22–24, he treats the traits of the elephant that make it fit for mythological manipulation, good to think—is a fine introduction to the god's mythology.

P. 143 Radha and Krishna in literature: S. Sen, *History of Bengali Literature,* pp. 16–17, 21, 27, 69–77, 103–14, 133–34, 173, 220, 295; Kennedy, *Chaitanya Movement,* pp. 76–77, 141–47; Z. Haque, "Literary Sources," in Michell, *Brick Temples of Bengal,* pp. 171–72; S. Khan, "Bangla Folklore," p. 111; Bhattacharyya, *Folklore of Bengal,* pp. 115, 120, 122–23, 160, 164–65. Dimock and Levertov, *In Praise of Krishna,* offer a selection of translations of poems on Radha and Krishna from Bengal; on p. viii, Dimock relates them to Sufi poetry, a subject considered in more depth by A. Roy in his excellent book *Islamic Syncretistic Tradition in Bengal,* pp. 189–90, 199–206.

P. 144 Examples of the kinds of artifacts available in the best antique shops in Dhaka can be found in the exhibition catalogued in Meister, *Cooking for the Gods.* The images, pp. 48–49, of Krishna and Radha are typical; see too: Skelton and Francis, *Arts of Bengal,* no. 30; Bussbarger and Robins, *Everyday Art of India,* pp. 111–12. I heartily welcome the "ethnographic" purpose articulated in the introduction to Meister's book by Pika Ghosh, p. 12, and commiserate with the difficulty of relating objects from Bangladesh to fieldwork in West Bengal, for it is the goal of ethnography, as it is of art history, to bring texts (objects in this case) and contexts into fruitful interaction. The book's interpretative frame is shaped out of Hinduism, but it is possible that the mats on pp. 76–77 and the engraved tray on p. 71 were made by Muslims.

P. 147 I take the dates for the Taj Mahal from P. Pal, Leoshko, Dye, and Markal, *Romance of the Taj Mahal,* pp. 53–56. To Pal's excellent closing essay on the Taj Mahal as an image, chapter 6, one might add the rickshaws of Bangladesh.

P. 147 Gibbon, *Decline and Fall of the Roman Empire,* vol 1, pp. 46–48. In *Madness of the Saints,* pp. 125–26, McDaniel provides a good account of syncretism in a temple to Kali that displays, along with Hindu images, pictures of Christ of the Sacred Heart.

P. 149 The Gita: "He who offers to me with devotion only a leaf, or a flower, or a fruit, or even a little water, this I accept from that yearning soul, because with a pure heart it was offered with love." Lotus

Sutra: "If there are persons who for the sake of the Buddha fashion and set up images, carving them with many distinguishing characteristics, then all have attained the Buddha way. . . . Or if a person should bow or perform obeisance, or should merely press his palms together, or even should raise a single hand, or give no more than a slight nod of the head, and if this were done in offering to an image, then in time he would come to see countless Buddhas." From Mascaró, *Bhagavad Gita,* p. 82, and Burton Watson, *Lotus Sutra,* pp. 39–40. On art and devotion see *Lotus Sutra,* pp. 32, 38–40, 98–101, 165, 240, and compare Haripada Pal's statement in chapter 6 of this book.

Pp. 153–55 The aesthetic of Gupta, Pala, and Sena times—smooth, coherent, and urged to the ideal by comparison between forms—is described well in: Kramrisch in Miller, *Exploring India's Sacred Art,* pp. 217–22; Williams, *Art of Gupta India,* pp. 61, 69–70; Saraswati, *Indian Sculpture,* pp. 124–26; Alam, *Sculptural Art of Bangladesh,* pp. 66–67. The leading analysts of the sculpture of the Yoruba people of West Africa comment on the quality of fecund youthfulness: R. F. Thompson, *Black Gods and Kings,* chapter 8; R. P. Armstrong, *Wellspring,* pp. 33–35.

P. 158 In his *Topography of Dacca* (1840), p. 91, Taylor mentions Dhakeswari Mandir, saying it is dedicated to Durga and had been rebuilt a century earlier. N. Ahmed describes the temple briefly in *Discover the Monuments,* p. 100.

Pp. 160–63 Chaudhuri, *Hinduism,* pp. 10–14, describes the goal of Hindu worship as securing prosperity through the establishment of a contract between worldly and otherworldly acquisitive communities. Eck in *Darśan,* pp. 6–12, treats Hindu ritual well, emphasizing the importance of sight. For more on the ritual, the temple, and the place of the *murti:* Coomaraswamy, *Arts and Crafts of India and Ceylon,* p. 120; Wolpert, *India,* pp. 88–91; and these general introductions to Hindu art, all three of them excellent: Michell, *Hindu Temple,* pp. 61–67; Blurton, *Hindu Art,* pp. 35, 56–74; Shearer, *Hindu Vision,* pp. 18–21.

Chapter 3: Return to Kagajipara

Pp. 169–70 Fernand Braudel's idea is presented

lucidly in *On History* and exemplified best in *The Mediterranean,* especially pp. 186–87, 460, 734, 798–800, 1073, 1242–45. I schematize the variety of times within which artists work in *Turkish Traditional Art,* pp. 806–36. And see Lévi-Strauss, *Savage Mind,* pp. 232–36.

Pp. 171–72 Babri Mosque: Mehta, *Rajiv Gandhi and Rama's Kingdom,* pp. 169–84; Larson, *India's Agony,* pp. 266–72; McKean in Hawley and Wulff, *Devi,* p. 278; Wolpert, *New History of India,* pp. 437, 439, 444, and *India,* pp. 24, 249.

P. 172 For the production of art in the context engendered by the coup of 1980, see Glassie, *Turkish Traditional Art,* pp. 138–42.

P. 173 My reference is to the regressive-progressive method outlined in the third section of Sartre's *Search for a Method.* Stanley Wolpert is not to blame for my foray into history, but he is the author of one of the best concise histories I have read, *New History of India,* and his clear presentation enabled me to see the big picture while ordering the details from the sources cited below.

Pp. 173–75 English intrusion, consolidation through permanent settlement, and the relations between the Hindu *zamindar* and the Muslim peasant: Wolpert, *New History of India,* pp. 144–67, 178–214; Edwardes, *History of India,* pp. 222–28, 275–77, 307, 328; Braudel, *History of Civilizations,* pp. 163, 236–40; de Schweinitz, *Rise and Fall of British India,* pp. 91–110, 138–40; R. Eaton, *Rise of Islam,* pp. 224, 251–52; Haroun Rashid, *Geography of Bangladesh,* pp. 141–45; Karim, *Dacca,* pp. 19, 30, 69, 71; Taifoor, *Glimpses of Old Dhaka,* pp. 208–25; Banu, *Islam in Bangladesh,* pp. 33–34; N. Ahmed, *Islamic Heritage,* p. 30; Jannuzi and Peach, *Agrarian Structure of Bangladesh,* pp. 1–9; Novak, *Bangladesh,* pp. 77–81; Acharya in S. U. Ahmed, *Dhaka,* p. 222; Hartmann and Boyce, *Quiet Violence,* pp. 14–15; A. Islam, *Victorious Victims,* pp. 11–14.

P. 175 Mutiny: Wolpert, *New History of India,* pp. 236–39 (proclamations against English tyranny); Farwell, *Armies of the Raj,* p. 39; Bruce Watson, *Great Indian Mutiny,* pp. 23–25, 39, 68, 120, 122.

P. 175 The partition of Bengal and India: Wolpert,

New History of India, pp. 263–64, 273–86, 330, 348; Edwardes, *History of India,* p. 325; Larson, *India's Agony,* pp. 182–91; Ziring, *Bangladesh,* pp. 9–11; A. Islam, *Victorious Victims,* pp. 20–22; and the papers by Rashid, W. Ahmed, S. U. Ahmed, Akhtar, and Islam in S. U. Ahmed, *Dhaka,* pp. 141–200. Tagore's prediction is recorded in Dutta and Robinson, *Rabindranath Tagore,* p. 152.

Pp. 175–76 Language Movement: S. M. Islam, *Ekushey,* especially the essay by Rafiqul Islam, pp. 42–56; Musa, "Ekushe"; Anisuzzaman, *Creativity, Reality and Identity,* pp. 97, 100–102; Ziring, *Bangladesh,* pp. 14–15.

Pp. 176–77 Sheikh Mujibur Rahman, the Awami League, the War of Independence, and the creation of Bangladesh: Ziring, *Bangladesh,* pp. 17–18, 37, 46, 49, 59, 67–81, 100–103, 136, 181–87; Novak, *Bangladesh,* chapters 5–6; Wolpert, *New History of India,* pp. 383–401, and *India,* pp. 235–37; Haroun Rashid, *Geography of Bangladesh,* pp. 147–48; Ahsan, *Bangladesh;* Huq, *Bangabandhu,* pp. 15–25, 62–67, 94–118, 131; Kabir, *Radio Bangladesh;* Islam in S. U. Ahmed, *Dhaka,* pp. 202–8; A. Islam, *Victorious Victims,* chapter 3 and pp. 94, 99–102. The opinions of the leaders come from gatherings of documents made at the time of the war. I take Sheikh Mujib's speeches of March 1971 from reports in Tewary, *War of Independence,* pp. 104–29, 149–51, and Indira Gandhi's from her statements in *India and Bangla Desh,* pp. 13, 133, 141, 150. She was clear about American culpability, pp. 89, 146, 158, and used the word genocide for the Pakistani crackdown, as did the declaration of independence: Tewary, pp. 139, 154; Gandhi, pp. 9, 21, 66. The confusion of the time of the crackdown is caught in the fractured novel, *Rifles Bread Women* by Anwar Pasha, a teacher of Bangla at Dhaka University, who was killed in 1971. The photographs in Hasnat and Mamoon, *Dhaka 1971,* showing the aftermath of massacres at Dhaka University and in Rayer Bazar, support the accusation of genocide.

P. 177 I quote from Salahuddin Ahmed, "Bangladesh: Historical Background," in Ahsan, *Bangladesh,* p. 23, on the end of communalism. For the special use of the terms "secularism" to mean religious freedom (as opposed to nonreligious order)

and "communalism" to mean sectarianism (a negative attitude toward the religion of another, rather than a positive attitude to one's own community), which usages are usual in Bangladesh, see: Banu, *Islam in Bangladesh,* pp. 96, 148; Wolpert, *India,* pp. 99–105; Larson, *India's Agony,* pp. 191–98, 286.

Pp. 177–78 Islamization in Bangladesh: Ziring, *Bangladesh,* pp. 127–28, 157–58, 168–72, 176–77, 181, 190, 204, 210, 214; A. Islam, *Victorious Victims,* pp. 80–91, 117–18; and the papers by Khan and Choudhury, together with the critical commentary, published in R. Ahmed, *Bangladesh,* pp. 17–49, 62–80.

Pp. 178–79 A. F. Salahuddin Ahmed in Fishwick, *Bangladesh,* pp. 37–38, argues that there is little cultural difference between Hindus and Muslims. Banu, *Islam in Bangladesh,* pp. 97, 99, 106, reports from her sociological survey that a large percentage of Muslims have Hindu friends, and the majority are tolerant of Hindus. From objective data to subjective reaction: Ziring, *Bangladesh,* pp. 6, 123, describes the Muslims of Bengal as emotional but not fanatic, and he says tolerance is, like melancholy, a part of their character. The similarity of the traditions of *bhakti* within Hinduism and Sufism within Islam is regularly credited for establishing a ground for exchange between Hindus and Muslims: Coomaraswamy, *Arts and Crafts of India and Ceylon,* p. 16; Wolpert, *India,* p. 114; Larson, *India's Agony,* pp. 109, 112–19, 287. Banu, *Islam in Bangladesh,* pp. 12–17, and A. Roy, *Islamic Syncretistic Tradition,* pp. xx, 6–7, 113–16, 120–21, 144–59, 189–90, 199–206, describe the Sufism of Bangladesh, its fundamental compliance with Islam, its focus upon love between God and humankind as the unifying force of the world, and its social construction by *pirs* and their followers. Those traits are described for Sufism in general by Burckhardt, *Introduction to Sufism,* pp. 42–43, 101; Karamustafa, *God's Unruly Friends,* pp. 29, 44, 48, 61, 88–89; and Schimmel in her magnificent book *Mystical Dimensions of Islam,* pp. 15–16, 25, 40, 96, 101–3, 106, 168, 254, 293, 398, 401.

P. 180 Agricultural statistics: Haroun Rashid, *Geography of Bangladesh,* pp. 166, 172–73, 185.

P. 183 Japan's double economy is described by

Dower, *Japan,* pp. 17–19. Within the "nonconcentrated sector of the economy" operate the artists who supply the Japanese need for beautiful ceramic symbols of tradition; for examples: Philip, *Road Through Miyama,* pp. 138–41, 168; Moeran, *Lost Innocence,* p. 224; and see the notes to p. 261 below. Two excellent recent books on Scandinavian folk art are rich in information on revival: Klein and Widbom, *Swedish Folk Art;* Nelson, *Norwegian Folk Art.*

P. 183 In *Portrait of India,* p. 343, Ved Mehta says India is an agricultural land and industrialization threatens unemployment. Braudel, *History of Civilizations,* p. 248, agrees. Haroun Rashid, *Geography of Bangladesh,* p. 183, contends that concern for industrial growth deflects attention from agriculture, the economic endeavor of most people. In a book that is historically interesting, being an assessment from the early days of the republic, *Bangladesh: Test Case for Development,* Faaland and Parkinson argue, pp. 78–79, for an increase in expenditures for agricultural development, and they assert that neglect of simpler needs in favor of more complex technology—copying Western styles of development—benefits the wealthy minority. Criticism of the mentality of progress and the obsession with the magic of alien technology is consistent: K. I. Ahmed, *Up to the Waist in Mud,* pp. vii–viii, 39; Gallagher, *Rickshaws of Bangladesh,* pp. 9–11, 63, 128–29; Jansen, Dolman, Jerve, and Rahman, *Country Boats of Bangladesh,* pp. 1–2, 29, 32–37, 214–15, 224–26.

P. 183 Remembering Dhaka district, the space between the Buriganga and Demra, Claude Lévi-Strauss writes in *Tristes Tropiques,* pp. 145–48, of handcraft taking place within "the ugly outlines of an abstract factory." He saw alienation in the hand weaving of "the muslin veils for which Dacca used to be famous" (see chapter 7 in this book); he saw the "white–tiled mosques" (chapter 1); and, in the manner conventional to the European visitor, he was distressed by crowds and filth.

P. 184 I describe the pattern for Turkey in *Turkish Traditional Art,* pp. 138–42, 194–97, 827–28. With competition from industrial capitalism, the number of shops producing utilitarian objects by hand

decreases, then there is a slight revival with the shift to decorative objects, and production stabilizes at a diminished number. For instances of this pattern in pottery from Japan, Yemen, Morocco, Spain, Hungary, Wales, England, and the United States: Cort, *Shigaraki,* pp. 299–300, 310, 312; Moeran, *Lost Innocence,* pp. 149, 208, 211; Philip, *Road Through Miyama,* pp. 7, 143–44, 158–62; Posey, *Yemeni Pottery,* p. 47; Hedgecoe and Damluji, *Zillij,* pp. 84–90; Artigas and Corredor-Matheos, *Spanish Folk Ceramics,* pp. 9–11; Domanovszky, *Hungarian Pottery,* pp. 69–74; J. M. Lewis, *Ewenny Potteries,* p. 2; Brears, *English Country Pottery,* pp. 78–82; Sweezy, *Raised in Clay,* pp. 23–29; Burrison, *Brothers in Clay,* pp. 203, 276–82; Zug, *Traditional Pottery of North Carolina,* pp. 40–45, and *Turners and Burners,* chapter 13; Lock, *Traditional Potters of Seagrove,* pp. 10–40. The pattern obtains from place to place, but scale is a different matter. At the end of decline, Domanovszky says there are twenty potteries in Hungary, and Brears says there are a dozen in England, fewer than in most of the 680 villages in Bangladesh, where utility remains the goal of most workers. In Japan, the market for useful ceramics, for souvenirs, and for artistic embodiments of tradition keeps thousands usefully employed. Pottery flourishes at the opposite ends of the economic spectrum of modern nations.

P. 185 Saraswati, *Indian Sculpture,* p. 39, says perspective in early Indian art was conceptual, not optical: forms piled up on a single plane instead of retreating into space.

Chapter 4: Dhaka, Kakran, and Shimulia

P. 197 Nazimuddin Ahmed describes the old High Court and Curzon Hall in *Buildings of the Raj,* pp. 24–26, 40–41, 43, and *Discover the Monuments,* pp. 212–14.

P. 200 In *Marbled Paper,* chapters 1–2, Wolfe provides a history of marbling. For pottery with marbled surface decoration: Glassie, *Turkish Traditional Art,* pp. 410–24; Bakurdjiev, *Bulgarian Ceramics,* plates 124, 137.

Pp. 201–3 I treat the storyteller and face jug together in *Spirit of Folk Art,* pp. 44–49. Babcock and

Monthan, *Pueblo Storyteller,* and Bahti, *Pueblo Stories and Storytellers,* tell one of the stories. The history of the face jug is told in Baldwin, *Great and Noble Jar,* pp. 79–90; Vlach, *Afro-American Tradition,* pp. 81–94, and in his essay "International Encounters," in Horne, *Crossroads in Clay,* pp. 17–39; Burrison, *Brothers in Clay,* pp. 76, 229, 235, 269; Zug, *Turners and Burners,* pp. 384–86, and *Burlon Craig,* pp. 6–21. Today's explosion in the production of face jugs is documented in Lock, *Traditional Potters of Seagrove,* pp. 184–90, and Ivey, *North Carolina and Southern Folk Pottery.*

P. 204 Transportation statistics: Gallagher, *Rickshaws of Bangladesh,* pp. 116, 118, 147–49; Jansen, Dolman, Jerve, and Rahman, *Country Boats of Bangladesh,* pp. 18, 25, 29–31, 43, 110.

Pp. 207–10 Throwing pots in Turkey and Japan: Glassie, *Turkish Traditional Art,* pp. 340–45, 403–5, 415–17, 457–58; al-Hassan and Hill, *Islamic Technology,* pp. 162–63 (the unnamed Turkish potter pictured from the back is possibly Mehmet Biçar); Philip, *Road Through Miyama,* pp. 10–15, 123, 154–55; Cort, *Shigaraki,* pp. 231, 235, 255–56, 274–76, 282–83, 288–89, 323, 327, 335. See also Wulff, *Traditional Crafts of Persia,* pp. 154–57.

Pp. 222–23 The devotees portrayed in the worldlier style, flanking the image of Kali, are Ramakrishna (1836–1886), priest of Kali's temple in Calcutta, and his wife, Sarada Devi (1853–1920), for whom see McDaniel, *Madness of the Saints,* pp. 92–103, 151, 202–9, and Richards, *Modern Hinduism,* chapter 5. Examples of the worldlier style of the *murti* are not common in the books, but see A. Mookerjee, *Ritual Art of India,* plate 116 (West Bengal), and *Kali,* p. 67 (of wood from Orissa). The clear parallel is with Japan where sacred images continued to be abstracted to a degree comparable to those of the subcontinent or medieval Europe, while portraits, notably in the Kamakura period, shifted toward realism; see: Noma's superb *Arts of Japan,* vol. 1, pp. 83, 92, 206–8, 214; Mino, *Great Eastern Temple,* pp. 57, 106–11; Nagahiro, Yum, and Kuno, *Great Sculpture,* pp. 82–85; Mason, *Japanese Art,* pp. 149–63.

Chapter 5: Rayer Bazar

P. 225 My reference is to the map of Dhaka and

environs from the copy of James Rennell's *A Bengal Atlas: Containing Maps of the Theatre of War and Commerce on That Side of Hindoostan* (1783), preserved in the library of the Bangla Academy. For the Sat Gumbaz Masjid: Karim, *Dacca,* p. 40; Taifoor, *Glimpses of Old Dhaka,* p. 167; S. M. Hasan, "Muslim Monuments," pp. 303–4; N. Ahmed, *Discover the Monuments,* pp. 174–75; E. Haque, *Glimpses of the Mosques,* pp. 22–23, and *Islamic Art Heritage,* pp. 78–80, 87, 97; Qadir, "Conservation and Restoration," pp. 146–47; R. Eaton, *Rise of Islam,* p. 172.

P. 233 I treat the coppersmiths' market in Istanbul in *Turkish Traditional Art,* chapter 4.

Pp. 240–45 The practice of men throwing pots without bottoms, and women adding the bottoms and paddling them for strength, is widespread in the Indian subcontinent: Fischer and Shah, *Rural Craftsmen,* pp. 139–40; Huyler, "Clay," pp. 206–7, 210; P. Sen, "Potters and Pottery," pp. 43–45, and *Crafts of West Bengal,* pp. 26–29; S. K. Ray, "Artisan Castes of West Bengal," pp. 317–18; A. Mookerjee, *Folk Art of Bengal,* pp. 28–30; C. S. Rahman, *Life in East Pakistan,* pp. 44–49.

Pp. 254–55 K. I. Ahmed, *Up to the Waist in Mud,* pp. 10–15, 39, 56, 115, 118, describes the switch from thatch to tin in Bangladesh and recommends, aptly I think, tiles for roofing, though the heavier frames required would present a problem. Hartmann and Boyce, *Quiet Violence,* pp. 49, 199, mention the tin roof as a sign of status in a village in northwestern Bangladesh. Kumar, *Artisans of Banaras,* pp. 63–65, describes the simultaneous lift in status and shift to permanence in the change from clay to masonry. I describe the Irish pattern and its implications in *Passing the Time,* pp. 416–24. Briggs, *Competence in Performance,* p. 77, found a comparable pattern in New Mexico; the change from the flat, earthen roof to the tin roof is used to contrast one era with the next, and that change has its precise parallel in rural Turkey; see Glassie, *Turkish Traditional Art,* pp. 261, 635.

Pp. 256–58 Earthenware cycle riders made by modern potters are one small thing—decorated cane mats are another (see chapter 7)—that draws Bangladesh with Assam and West Bengal into a larger

cultural region. Riders similar in form to Maran Chand Paul's, though less fine, are made in Bangladesh, Assam, and West Bengal; for examples: Jain and Aggarwala, *National Handicrafts,* pp. 194, 198; P. Ahmad, *Crafts from Bangladesh,* pp. 6, 25–26.

P. 256 Equilibrium: A. Mookerjee, *Ritual Art of India,* pp. 10–11.

P. 260 Acoma: Though it was published in 1929, Ruth Bunzel's *Pueblo Potter* remains the great book. The historical pottery of Acoma is described and pictured in: Batkin, *Pottery of the Pueblos,* pp. 136–47, 154–56; Harlow, *Two Hundred Years,* plates 15–30; Dittert and Plog, *Generations in Clay,* pp. 43–44, 77, 119. On pp. 134–35, Dittert and Plog say that borrowing from the past is not a modern phenomenon only, but a recurrent practice in Pueblo pottery. Trimble, *Talking with the Clay,* pp. 74–80, stresses revival at Acoma. Contemporary Acoma pottery is presented in Peterson, *Lucy Lewis,* and Dillingham, *Fourteen Families,* pp. 82–103. The most complete book on Acoma is Dillingham's *Acoma and Laguna,* in which he describes forms and technology well, and brings history up to the present, providing good information on revival. Dillingham mentions Wanda Aragon's interest in, and return to, earlier forms, pp. 185, 194, 200–201; on p. 182, he shows a jar by her mother, Frances Torivio, and on p. 84 a jar by Wanda. A jar by her sister, Lilly Salvador, can be found in Fairbanks, *Collecting American Decorative Arts,* p. 89, plate 80. Robert Nichols has written a brief introduction to Wanda Aragon, her husband, and her daughter, in "Keeping Tradition Alive." Usually in the company of my dear friend Karen Duffy, I have often visited with Wanda Aragon, her husband, Marvis, who has one of the world's great souls, and her family at Acoma.

Pp. 260–61 Georgia: The Meaders family has been marvelously documented. Allen Eaton described the pottery in 1937. Ralph Rinzler began his research in 1967, when Cheever—the youngest son of John Milton Meaders, who founded the pottery in 1892—was near the end of his life, and his son Lanier was taking over, the other sons having abandoned the trade. Two of them, Reggie and Edwin, in fact, returned to the clay in Lanier's period, which was beautifully documented by John Burrison, who dedicated his major book, published in 1983, to Lanier. Nancy Sweezy also ably described the work of Lanier, Edwin, and Cleater—C. J.—in the same period. In the preface he added to *Brothers in Clay* when it was reprinted in 1995, Burrison comments excellently on the process and importance of revival, and he tells how, though Lanier's work has nearly ended, his nephew David, and David's wife, Anita, have kept the old shop going, and Lanier's cousin C. J. "has emerged as one of the South's finest exponents of the alkaline-glazed stoneware tradition." See: A. Eaton, *Handicrafts of the Southern Highlands,* pp. 212–14; Rinzler and Sayers, *Meaders Family;* Sweezy, *Raised in Clay,* pp. 98–111; Burrison, *Meaders Family,* and especially *Brothers in Clay,* chapters 6 and 16.

P. 261 Mingei: Robert Moes, *Mingei: Brooklyn,* pp. 11–20, *Mingei: Montgomery,* pp. 19–42, and "Morse and Yanagi"; Muraoka and Okamura, *Folk Arts and Crafts of Japan,* chapter 8; Yanagi and Hamada, *Japan Folk Crafts Museum;* and the introductory essays by Pearce and the Yanagis to Sori Yanagi, *Mingei,* pp. 19–32. Noma, *Arts of Japan,* vol. 2, pp. 266–67, 279, is correct, I believe, in seeing antecedents for Mingei in the *wabi* taste of the tea men. The movement's great text is Yanagi's *Unknown Craftsman,* in which the history of Mingei is told in the first papers by Leach and Yanagi, pp. 87–108. Yanagi was influenced by William Morris and by his studies of the art of his own land to conclude, p. 117, that the separation of art from craft is a tragedy of modern times. Yanagi was the prime spokesman. His collaborators, the potters Kawai and Hamada, are represented most articulately in their ceramics, but Kawai's opinions are found in Uchido's *We Do Not Work Alone,* and Hamada's in Bernard Leach's *Hamada,* in which pp. 148–71 and 194–95 are important for Mingei. On p. 168, Hamada argues that too much attention has been paid to Yanagi's principles. Moeran offers a history of Mingei in *Lost Innocence,* pp. 12–27, and then records its impact on one community of potters, pp. 31–32, 121, 130–31, 136, 139, finding it sad, pp. 213, 232, that the potters of Onta have shifted from utilitarian to decorative creations, pp. 149, 208, 211. I assume the potters were never innocent and they adjusted to Mingei as they had adjusted rationally to other conditions in the

past, and what I would find sad is if they had to abandon their trade. Evaluating the impact of Mingei on another pottery village on Kyushu, Philip, *Road Through Miyama,* pp. 161–62, 184–85, says Mingei has chilled creativity, yet it has served to keep the craft alive, the potters at work. Cort describes Yanagi, Hamada, Kawai, and Leach at *Shigaraki,* pp. 294–95, and quotes Kawai on Shigaraki and the communal style of its pottery, pp. 341–42. Munsterberg, *Ceramic Art of Japan,* pp. 234, 242, 245, 247–48, locates Mingei within a general climate of ceramic revival. Ogawa and Sugimura, *Enduring Crafts,* pp. 5–42, and Fontein, *Living National Treasures,* pp. 16–18, 264–66, document the ceramic revivalists among those designated national treasures in Japan. One of those masters of ceramic revival, Arakawa Toyozo, is presented excellently, largely through his own writing, in Barriskill, *Visiting the Mino Kilns,* especially pp. 1–2, 48–50, 59–61.

P. 261 The early history of Kakiemon porcelain, and the reachievement of the milk-white body in 1953, in the time of the twelfth and thirteenth in the Kakiemon line, is recorded in: Nagatake, *Kakiemon,* pp. 6–12, 38–39; Adachi and Hasebe, *Japanese Painted Porcelain,* pp. 16–17, 233–34, plates 38–44, 84–85, 91, 162–64; Noma, *Arts of Japan,* vol. 2, pp. 226, 257, 301; Mikami, *Art of Japanese Ceramics,* pp. 164–65; Lee, *Japanese Decorative Style,* pp. 121–24; Munsterberg, *Ceramic Art of Japan,* p. 141; Fontein, *Living National Treasures,* pp. 265–66. As is the case for the U.S. and Turkey—see my paper on ceramic revival, "Values in Clay"—I am relying here on my own experience. I spent pleasant days with Hirohisa Tatebayashi in Arita in March 1994.

Pp. 261–62 Turkey: Historical ware of the kind made today in Kütahya is presented handsomely in Atasoy and Raby, *Iznik,* though, strangely, the role of Kütahya is obscured, even if, pp. 98, 101–2, 109, 219, they say it should not be; see, too, Denny, "Ceramics," and Carswell, "Ceramics." I present the modern ware of Kütahya in *Turkish Traditional Art,* pp. 425–562, 793–95, 856–61, 897–99, describing the energy of revival, the role of Mehmet Gürsoy, and recording, pp. 532–33, the trip I took with Mehmet and İbrahim Erdeyer, another Kütahya master, to visit Wanda Aragon and Lilly Salvador at Acoma; their technology differs, but their purposes in

creation coincide, and, with me as translator, they enjoyed collegial exchange.

P. 262 In a lecture delivered in support of the Society for the Protection of Ancient Buildings, and published in 1882, William Morris said, "I should say that the making of ugly pottery was one of the most remarkable inventions of our civilization." *Architecture, Industry and Wealth,* p. 46; May Morris, *Collected Works,* vol. 22, p. 242. Le Corbusier's search for pottery is recorded in his *Journey to the East,* pp. 14–19, 163–64, 240.

P. 264 It is customary among Muslims as well as Hindus in Bangladesh for women to return to the homes of their parents to give birth to their first children: Chaudhuri, *Autobiography,* p. 159; Bhattacharyya, *Folklore of Bengal,* p. 66.

P. 272 Dhaka's potters in 1908: G. N. Gupta, *Survey of Industries,* p. 54.

P. 280 Earthenware horses: Kramrisch, *Unknown India,* pp. 56–58, 88–89; Haku Shah, *Votive Terracottas of Gujarat,* especially pp. 77–83; A. Mookerjee, *Indian Dolls and Toys,* plates 14, 15, *Folk Toys of India,* plates 6–8, 24 (Bankura like Maran Chand Paul's), 55, 66, and *Folk Art of Bengal,* pp. 32–34; Barnard, *Arts and Crafts of India,* pp. 162, 164–68; Cooper and Gillow, *Arts and Crafts of India,* pp. 19, 27; Bussbarger and Robins, *Everyday Art of India,* pp. 18–19, 27, 30, 37, 42 (Panchmura, Bankura, like Maran Chand Paul's), 43; Huyler, "Clay," pp. 204, 215–16, 220, "Terracotta Traditions," pp. 60–62, 64–65, and *Village India,* p. 191; Jain and Aggarwala, *National Handicrafts,* pp. 175–76, 181; Inglis in Meister, *Making Things,* p. 160; Krishna, *Arts and Crafts of Tamilnadu,* pp. 87–89, 93–95; Sethi, Devi, and Kurin, *Aditi,* p. 122; Dutt, *Folk Arts and Crafts of Bengal,* plate 29; P. Sen, "Potters and Pottery," pp. 44–46 (Panchmura is the center for the Bankura horse), and *Crafts of West Bengal,* pp. 30, 34 (Bankura votive offering); Craven, *Roy and Bengali Folk Art,* nos. 34, 35; Bhattacharyya, *Folklore of Bengal,* pp. 22, 49; Skelton in Skelton and Francis, *Arts of Bengal,* p. 60 (Bankura); P. Ahmad, *Crafts from Bangladesh,* p. 17 (E-19 shows a horse of the Bankura type probably made by Maran Chand Paul); and see the notes to pp. 96–98 above for Chittagong versions.

P. 283 Agreeing with Michael Baxandall that works of art are the yield of situated intentionality, *Patterns of Intention,* pp. 6–7, 14–15, 41–42, 62, 67, I concur that what is called influence is the consequence of active, rather than passive, conduct by the artist, pp. 58–59. Baxandall also states his strong and correct position on influence in *Limewood Sculptors,* p. 164.

Pp. 283–84 I take the historical importance of horses and elephants from Edwardes, *History of India,* pp. 54, 109–10, 114.

Pp. 287–88 In making sculptures in clay of ancient works in stone and metal, Maran Chand Paul's students were involved in an act of reclamation. They used Casey's *Medieval Sculpture from Eastern India.* (The work I illustrate in this book was based on Casey's plate 21, showing a tenth-century stone sculpture from Dhaka district, depicting Shiva and Parvati, a theme that was common in both stone and metal; see plates 14, 16, 17, and 52.) The works in Casey's book were stolen from the nation of Bangladesh, as Mahmud and Rahman demonstrate in *Museums in Bangladesh,* pp. xiv, 483–87, 517–23.

P. 294 It is tempting to turn history into a rising sequence of internally homogeneous periods, but as I intend this chapter on Rayer Bazar to exhibit, diversity within periods is the normal state of affairs in history. Asian ceramics provide evidence enough to cause rethinking of the trimly segmented and progressive schemes usual in history. Cort, *Seto and Mino,* pp. 10, 71, remarks the complexity and impurity of periods in Japan. In *Shigaraki,* pp. 171, 174–75, 186–87, 190, 298, Cort describes patterns of copying and revival that cycle the past into the present. Mikami, *Art of Japanese Ceramics,* chapter 3, describes Japanese history as more cumulative than sequential. Kerr, *Chinese Ceramics,* pp. 51, 66, 70, 113, 127, speaks of the simultaneity of different styles and of the inappropriateness of Western periodization (in fact, not so appropriate to the West), and of constant revivals. Jenyns, *Ming Pottery,* pp. 10, 67, 189, and Li, *Chinese Ceramics,* pp. 10–11, 134, 215, 266–67, describe the continual process of copying old works, of recursion in China.

P. 305 Kumar, *Artisans of Banaras,* pp. 217–21, comments on the expansion of Durga Puja in the

twentieth century. The *pujas,* she says, are often led by young men, and Saraswati centers *pujas* for the students. In Rabindranath Tagore's novel of love in the time of rebellion, *The Home and the World,* p. 166, Sandip says, "I can swear that Durga is a political goddess and was conceived as the image of the Shakti of patriotism in the days when Bengal was praying to be delivered from Mussulman domination."

Chapter 6: Shankharibazar

P. 307 Karim, *Dacca,* pp. 33–35, 48, 79, calls the waterfront between Babu Bazar Ghat and Sadar Ghat the city's oldest section, says Islampur Road takes its name from Islam Khan, and lists Tanti Bazar, the market of the weavers, and Shankharibazar, the market of the conch-shell artisans, among the city's old neighborhoods for crafts. Taifoor, *Glimpses of Old Dhaka,* pp. 54–56, mentions Tanti Bazar and Shankharibazar, describing the latter as the home of the oldest homogeneous group in Dhaka.

Pp. 308–11 James Hornell left a puzzle for bibliographers by publishing bits of his book on the conch shell in different places. The full text is *Sacred Chank of India,* bulletin 7 of the Madras Fisheries Bureau. He reports research conducted in 1910 and tells us that married Bengali women wear conch-shell bracelets, so the craft is traditional to Bengal, and that Dhaka has been the center of the art since the seventeenth century: pp. 41, 68–69. Hornell describes Shankharibazar, pp. 71–74, 78, and the craft, pp. 91–101, plates 3–17. He comments, p. 100, that the rich are abandoning conch-shell bracelets because of their association with the poor, but the craft continues because of its associations with Vishnu and Shiva, p. 130, with the symbolic power of water, p. 133, with marriage, p. 146, and health, p. 168. There are also scattered brief notices of conch-shell art in Bengal: Birdwood, *Arts of India,* p. 229; S. K. Ray, "Artisan Castes of West Bengal," pp. 340–41, plate 14; P. Sen, *Crafts of West Bengal,* pp. 138–43, 178–79; Gupta in Dasgupta, *Arts of Bengal,* p. 21; A. Mookerjee, *Ritual Art of India,* p. 50; Barnard, *Arts and Crafts of India,* p. 104; Z. Haque, *Gahana,* pp. 73–75; Ghuznavi, *Naksha,* pp. 32, 36; P. Ahmad, *Crafts from Bangladesh,* p. 16; Sirajuddin, *Living Crafts of Bangladesh,* p. 86.

Pp. 311–12 The lotus, its association with water and the conch, and its symbolic power: Zimmer, *Myths and Symbols*, pp. 34–35, 90–102, 109, and *Artistic Form*, p. 157; Kramrisch in Miller, *Exploring India's Sacred Art*, pp. 153–54; Stutley, *Hinduism*, p. 86; Michell, *Hindu Temple*, pp. 38, 68; Chandra, *Indian Art*, pp. 58–59; A. Mookerjee, *Ritual Art of India*, p. 64; Aryan, *Decorative Element*, p. 57; Zaman, *Kantha*, pp. 74–79; Coomaraswamy, *History of Indian and Indonesian Art*, p. 43.

P. 312 Taylor, *Topography of Dacca* (1840), pp. 190, 231, 313, described conch-shell art and said there were about five hundred workers in Dhaka. G. N. Gupta, *Survey of Industries* (1908), p. 57, wrote that five hundred people live on the conch-shell trade in Shankharibazar.

P. 322 In his *Autobiography*, which he says is more ethnology than autobiography, p. 149, Chaudhuri contrasts social classes by knowledge of birthdate, pp. 151–53, saying the wealthy know the date precisely, because of the importance of astrology, but it is almost impossible among poorer people to get an exact birthdate; the best they can do is make a guess in relation to a great event. That is what I found, and it is interesting that the certain dates are those of disasters—the famine of 1350, the storm of 1326—rather than political events, and interesting that the Bengali calendar (and not the Christian calendar that marks the era Western scholars presume to call "common") is used.

P. 326 The books contain pictures and brief descriptions of *murtis* and their making in Bengal, sometimes localized to Calcutta or more precisely to Kumartuli. They show that in technology, style, and dominant images—Durga slaying the buffalo demon, flanked by Lakshmi and Saraswati, Kartikeya and Ganesh; Kali standing upon Shiva—modern work in Dhaka and Calcutta is comparable, the result of artists like Haripada Pal and his teachers traveling between these, the major cities of Bengal. See: P. Sen, "Potters and Pottery," pp. 46–47 (Kumartuli, Calcutta, is the center for image making), and *Crafts of West Bengal*, pp. 162–67; A. Mookerjee, *Ritual Art in India*, pp. 127, 129, plates 82–85, 95 (Kali comparable to Haripada Pal's), 101 (Durga like Dhakeswari Mandir, but, as seems often the case for

Calcutta, a touch more naturalistic); P. Mookerjee, *Pathway Icons*, pp. 49–50, 68; Barnard, *Arts and Crafts of India*, pp. 32–33, 158–62 (good photos of technique from Calcutta); Cooper and Gillow, *Arts and Crafts of India*, p. 18 (*murti* technology in Kumartuli); Bussbarger and Robins, *Everyday Art of India*, pp. 47–48 (Kali and Durga and family, a Calcutta *puja* of 1961); Kumar, *Friends, Brothers, and Informants*, pp. 127–28; McDermott in Hawley and Wulff, *Devi*, pp. 299–301; Sethi, Devi, and Kurin, *Aditi*, p. 162. Describing life in the middle of the nineteenth century, Day, *Peasant Life in Bengal*, p. 104, tells of a country craftsman making a life-like "mud sculpture" of Durga nearly as good as those made in Calcutta. Historical continuities are implied by a clay image of Kali standing on Shiva, made in Bengal about 1894, that was saved in a museum (Blurton, *Hindu Art*, p. 158) and by a mid-nineteenth-century image carved of ivory, showing Durga and her family, much as they are portrayed in clay today (Skelton and Francis, *Arts of Bengal*, no. 232).

Pp. 331–32 Coomaraswamy, *Dance of Śiva*, pp. 21–26, and Shearer, *Hindu Vision*, p. 15, characterize ancient practice in India in a way that comports with Haripada Pal's account: the artist prays for a vision, the mind concentrates on a theme, the image is materialized.

P. 338 Chaudhuri, *Hinduism*, pp. 306–9, describes the freedom of the *sadhu*. A fine portrait of a *sadhu* unfolds through Kirin Narayan's *Storytellers, Saints, and Scoundrels*, and she generalizes effectively about the role in chapter 3.

P. 345 Indian potters believe firing purifies the clay: Kramrisch, *Art of India*, p. 18; Cort, "Role of the Potter," p. 168.

P. 346 In his *Autobiography*, p. 152, Mahatma Gandhi writes, "The physical and mental states of the parents at the moment of conception are reproduced in the baby."

P. 346 In Turkey, the work of art is the object that contains love; it is the result of the artist's total commitment to creation: Glassie, *Turkish Traditional Art*, pp. 119, 504, 806–13, 847–48, 863–64, 869. The quality in the artist that eventuates in art is called passion—love, devotion—by the Turkish artist; it is

the quality that Kandinsky, *Concerning the Spiritual in Art,* p. 75, calls soul, that Leach, *Potter's Book,* p. 17, calls sincerity, that Coomaraswamy, *Transformation of Nature in Art,* p. 90, calls care and honesty. In concentration, Haripada Pal's soul flows into his work; he gives himself to it passionately, sincerely, honestly, completely.

P. 351 Louise Allison Cort, known for her excellent work on Japanese traditional art, reports her research on pottery in Orissa, India, in "Role of the Potter," in which, p. 167, she—correctly, I think—notes a relation between the pot and the *murti:* both are vessels destined for brief lives.

Chapter 7: Art in Bangladesh

Pp. 368–69 Attempts to move cross-culturally toward universally valid theories of art are thwarted by the retention of values developed to fit the industrial West; see the notes to p. 83 above.

Pp. 371–75 Fine mats, occasionally woven with pictures, are made in Bangladesh, West Bengal, and Assam: Taylor, *Topography of Dacca,* p. 234; G. N. Gupta, *Survey of Industries,* p. 59 (1908: mats of the best quality, valued for coolness and smoothness, command a fancy price); A. Mookerjee, *Folk Art of Bengal,* pp. 44–45 (Faridpur and Sylhet are centers for the women's work of mat weaving); Ghuznavi, *Naksha,* pp. 53–55 (the "most exquisite" are from Sylhet; *botnis* are made in Noakhali); Brennan, *Handicrafts in Bangladesh,* pp. 15–19 (in a brief book on handcraft organization, the description of *botnis* from Noakhali is good); Ahmed in E. Haque, *Anthology on Crafts in Bangladesh,* pp. 60, 68, 87; P. Ahmad, *Crafts from Bangladesh,* pp. 12–13, 22, 88; Sirajuddin, *Living Crafts in Bangladesh,* pp. 18–22 (p. 20 shows a used *botni*); T. Ahmad, Hossain, and Sayeedur, "Documentation of Folk Designs," p. 79; Mahmud, *Prospects,* pp. 79–80 (fine mats—*sitalpati*—from Sylhet, *botnis* from Noakhali); Meister, *Cooking for the Gods,* pp. 76–77 (Noakhali-style prayer mats from Faridpur and Comilla); Bussbarger and Robins, *Everyday Art of India,* p. 173; Jain and Aggarwala, *National Handicrafts,* pp. 165, 170; Gupta in Dasgupta, *Arts of Bengal,* p. 23; P. Sen, *Crafts of West Bengal,* p. 42, 46; N. Roy and M. K. Pal, "Basketry and Mat-Weaving in India," p. 2,

plates 19 (Assam, like Bangladesh), 23 (fig. 2, West Bengal, like Bangladesh).

P. 379 I describe varieties of the prayer rug in *Turkish Traditional Art,* especially pp. 576–83. *Prayer Rugs,* by Ettinghausen, Dimand, Mackey, and Ellis, presents the prayer rug as historical Islamic art.

Pp. 382–83 Boatbuilding in the Bangladesh manner: Hornell, "Indian Boat Designs," pp. 187–89, and "Boats of the Ganges," pp. 189, 191, 196; Jansen, Dolman, Jerve, and Rahman, *Country Boats of Bangladesh,* pp. 71–78, 97–103, 220–21; Bølstad and Jansen, *Sailing against the Wind,* pp. 12–17; and Greenhill, who offers the fullest description in his *Boats and Boatmen,* pp. 71–80, 89, 93–97, 99–100, 111–17, 122, 125, 154–56. There are analogs in Scandinavia, and among the parallels in the English-speaking world are the Irish cot, and the bateau and log canoe from North America, for which: Glassie, *Passing the Time,* pp. 568, 783, and "Nature of the New World Artifact"; Chapelle, *American Small Sailing Craft,* pp. 33–35, 291–304; Brewington, *Chesapeake Bay Log Canoes and Bugeyes.*

P. 384 As I did with carpentry and weaving in *Turkish Traditional Art,* pp. 165–78, 575–775, I describe boatbuilding to align material creation with the concept of performance articulated by Dell Hymes in *Foundations in Sociolinguistics,* and focused to storytelling by Richard Bauman in *Story, Performance, and Event.* As I did in my analysis of narrative performance in *Passing the Time,* chapters 3 and 4, I note the importance of hierarchical orders within performative action.

P. 386 In 1798, Buchanan described a tall and elegant tree, of a genus then unnamed, that was used in making canoes, the "Gurgeon"; van Schendel, *Buchanan,* p. 35.

Pp. 391–93 It is natural that thinkers in consumer societies would turn their attention to consumption and the role of the patron, making buyers rather than creators central to their interests. Chandra, *On the Study of Indian Art,* pp. 71, 109, feels the role of the patron has been overstressed, at the expense of the artist, in recent studies. With respect to Islam, Oleg Grabar struggled with the issue of patronage and concluded that artistic excellence was not the

consequence of directions from patrons but of patrons and artists sharing culture; see his essay in Atıl, *Islamic Art and Patronage,* pp. 38–39.

Pp. 393–94 Critics of industrialization decry fragmentation and imagine integration in a preindustrial past. Yet processes were divided long before industrialization, and division in labor seems the norm in complex technical procedures, or so I have found it; see *Turkish Traditional Art,* pp. 70–74, 146–49, 380–86, 400–404, 463–73, 667–77, 703. In his amazing early book, Simeon Shaw, *History of the Staffordshire Potteries* (1829), pp. 104, 166, 236, says division in labor was natural in the days of handwork because not everyone could do everything well, though after 1740 division in labor increased. Coomaraswamy, *Arts and Crafts of India and Ceylon,* p. 34, says division in work is normal. The difference between handwork and industry is that, in workshops based on handcraft, the designer knows the craft. Excellence requires division; what thwarts excellence is not division in work, but ignorance. When the master has risen through the trade and knows the whole procedure, then he is unlikely to task the craft or the artisan with the inappropriate or impossible, and he is unlikely to curtail creativity unnecessarily in obedience to a rationalized, bureaucratic conception. Cardew, *Pioneer Pottery,* p. 213, while acknowledging the problems in division, the separation of the designing mind from the laboring hands, argues that some specialization in the process is a good antidote to extreme individualism. The one-man pottery shop, where a single worker does it all, might seem to represent the ancient ideal of integration, but as Burrison notes in *Brothers in Clay,* p. 9, it is a twentieth-century phenomenon, and a sign of the craft in decline.

P. 394 John James, *Chartres.*

P. 395 I describe the role of *usta* in *Turkish Traditional Art,* pp. 61–74, 146–48, 190, 380–86, 400–409, 448–74, 508–11, 669–71, 813–18.

Pp. 396–97 In the introduction to *Tulips, Arabesques and Turbans,* p. 9, Petsopoulos describes the plain style in Ottoman decorative art; it is exemplified in his book's chapter on metalwork, pp. 27–29. I describe the plain style as one of the three styles that interact

to create vitality today in *Turkish Traditional Art,* pp. 61, 179, 347–50, 360, 367–68, 423–24, 784–99, 827–28, 847–55. In Japan, though Lee, *Japanese Decorative Style,* pp. 47–52, sees it as marginal to the mainstream, and it rose to dominance among the aristocracy for only a brief period, the plain style is essential to the idea of art and to the appreciation for folk art: Cort, *Shigaraki,* pp. 129, 174, 294, 299; Leach, *Potter's Book,* p. 9; Yanagi, *Unknown Craftsman,* pp. 148, 183; Noma, *Arts of Japan,* vol. 1, p. 139. The Shakers have received much attention for their creations within the plain style of Protestant North America: Andrews, *Religion in Wood;* Sprigg, *Shaker Design.* Appreciation extends beyond America. Coomaraswamy wrote an essay on "Shaker Furniture," reprinted in Lipsey, *Coomaraswamy,* pp. 255–59, viewing the Shakers in relation to the *Bhagavad Gita* and medieval Christianity, and Shoji Hamada, the great Japanese potter, said, "The furniture of the American Shakers especially has good features we can learn from," and then he praised the construction, color, and finish of Shaker chairs, their lack of "excessive decoration." Leach, *Hamada,* p. 194; see, too, Peterson, *Shoji Hamada,* pp. 184–88. For examples of metalwork in the plain style from Bangladesh and India: Ghuznavi, *Naksha,* p. 41 (bell metal from Tangail); P. Ahmad, *Crafts from Bangladesh,* pp. 14–15 (the brass *kalshi,* chaste in line, elegant in form, is "attractive"); Meister, *Cooking for the Gods,* p. 70 (bell metal plate and bowl, conceivably from Dhamrai); Longenecker, *India,* pp. 2 (unlocated brass *kalshi*), 40 (brass bowl from Assam).

P. 397 It is conventional for Hindus to use brass, Muslims to use copper: Birdwood, *Arts of India,* p. 154; Bussbarger and Robins, *Everyday Art of India,* p. 64.

P. 397 On the failed prediction of the death of the rickshaw, see Gallagher, *Rickshaws of Bangladesh,* p. 91. Country boats: Jansen, Dolman, Jerve, and Rahman, *Country Boats of Bangladesh,* pp. 143–45, 229–30, 236–37, 245–50, 253, 259–67, 271–72; Bølstad and Jansen, *Sailing against the Wind,* pp. 7, 18–19, 28–32. Pottery: Mohammad Shah Jalal, *Traditional Pottery in Bangladesh,* p. 48.

Pp. 399–402 Firoz Mahmud features Sirajul Islam in chapter 13 of his doctoral dissertation, "Metalwork in Bangladesh." Mahmud quotes Sirajul Islam extensively; I restrict myself to information drawn

from a conversation I had with him in March 1996. Cooper and Gillow, *Arts and Crafts of India,* pp. 58–60, describe Moradabad as a center for work in brass; their book provides good descriptions of metal-working techniques. E. Haque, *Islamic Art Heritage of Bangladesh,* pp. 154–55, 159, 187, illustrates four engraved trays from the nineteenth century, and says the style associated with Moradabad was practiced widely.

Pp. 399–402 The name for the calligrapher's pen might be applied to any slender tool with which a design is created in Turkey and Iran: Glassie, *Turkish Traditional Art,* p. 790; Wulff, *Traditional Crafts of Persia,* pp. 19, 60, 123, 135. The engraver's chisel is also called a *kalam* in India: Jain and Aggarwala, *National Handicrafts,* p. 20.

P. 402 On his first trip to India, V. S. Naipaul found little subtlety in signs of class: the poor are thin and the rich are fat, he writes in *An Area of Darkness,* p. 75. Chaudhuri, *Autobiography,* p. 434, describes the ideal body for both men and women in Calcutta to be sleek, soft, and fleshy. See, too: Lévi-Strauss, *Tristes Tropiques,* pp. 140–41; Blaise and Mukherjee, *Days and Nights in Calcutta,* pp. 24, 52–53, 262.

Pp. 402–3 Siddiqui, Qadir, Alamgir, and Huq, *Social Formation in Dhaka,* p. 211, report from their survey that 48 percent of the city's poor own gold.

Pp. 403–17 In his *Topography of Dacca* (1840), pp. 100, 130–32, 161–75, 363–68, Dr. Taylor described cotton weaving, muslins, the "flowered" *jamdani,* and spoke clearly about the impoverishment of the people as a result of the British destruction of the textile industry. Forty years later, Birdwood, *Arts of India,* pp. 249–50, said *jamdani* weaving had declined since Taylor's day. In 1908, G. N. Gupta, *Survey of Industries,* pp. 11–12, described the "figured muslins of Dacca" as "embroidery done in the process of weaving with needles of bamboo or tamarind wood," and he wrote that, while "demand is limited," *jamdanis* still have "a fair amount of sale." Hossain, *Company Weavers of Bengal,* p. 48, writes that in the nineteenth century the *jamdani* weavers were Muslims, and that they were numerous at Demra and in villages along the Shitalakshya River, just as today. Muhammad Sayeedur Rahman's book on the *jamdani* is the most

complete treatment of the topic, and an English translation is promised. Until it appears, descriptions in English can be found in these works: Coomaraswamy, *Arts and Crafts of India and Ceylon,* pp. 193, 195–96; Lynton, *Sari,* pp. 45–57, 60–61; Stockley and Ghuznavi in Stockley, *Woven Air,* pp. 17–20, 51–55 (Ghuznavi concludes that the future of the *jamdani* is assured); Ghuznavi, *Naksha,* pp. 14–18; P. Ahmad, *Crafts from Bangladesh,* p. 3; E. Haque, *Islamic Art Heritage,* pp. 207, 225–26; Mahmud and Fakhruddin in S. Khan, *Folklore of Bangladesh,* vol. 2, pp. 16–31; A. Mookerjee, *Folk Art of Bengal,* pp. 15–19; P. Sen, *Crafts of West Bengal,* pp. 66–69; Das in Dasgupta, *Arts of Bengal,* p. 49; Jain and Aggarwala, *National Handicrafts,* p. 134; Barnard, *Arts and Crafts of India,* pp. 138–39; Cooper and Gillow, *Arts and Crafts of India,* pp. 90, 95. I am dutiful in describing technology, for it is always interesting to the artists—it is a point at which we connect easily, and it is a topic rich with implications, being the materialization of thought processes—and in the case of the *jamdani* I strove for particular precision because the technical descriptions in the literature cited above are sometimes confused; you are often led to think of *jamdani* as embroidery rather than brocading. I describe the Turkish weavers' objections to cartoons in *Turkish Traditional Art,* pp. 677–83. Barnard, *Arts and Crafts of India,* p. 136, says the pit loom is common in India. Technically the loom is like those described in al-Hassan and Hill, *Islamic Technology,* p. 187, and Wulff, *Traditional Crafts of Persia,* pp. 202–5, and it is like the Japanese *takahata* described by Hecht, *Art of the Loom,* pp. 134–35.

P. 418 In her fine book on the jewelry of Bangladesh, *Gahana,* Zulekha Haque describes the craft in chapter 5, she speaks of the adaptability of the smiths that has saved them from extinction, pp. 58, 60, and she describes modern work of light metal, cut to facets and filigreed, pp. 63–64, 70, 72. See as well her paper in E. Haque, *Anthology on Crafts in Bangladesh,* p. 76, and Ghuznavi, *Naksha,* pp. 33–36. Pierced and faceted, gold and silver play with light. Muhammad Sayeedur Rahman describes a craft of humble materials, paper cutting, that has comparable qualities, in E. Hague, *Anthology on Crafts in Bangladesh,* pp. 24–27.

P. 418 In speaking of light, I follow a Muslim line of interpretation, based in the Sura of Light from the Holy Koran, but light is also symbolically important in Hinduism as Chaudhuri writes in *Hinduism,* pp. 68–70. Eco, *Art and Beauty,* pp. 44–46, speaks of the importance of light in medieval Europe. Light is, for the believer, one sign of the spirit, and so a desirable goal for the creator. When faith fades, subdued colors prevail, and the bright and glittery are dismissed as kitsch.

P. 420 Muhammad Hafizullah Khan, *Terracotta Ornamentation,* pp. 242–43, generalizes that while Muslim art in Bengal is geometric and abstract, there is an urge to depict lush vegetation, and the art rarely reaches the pure geometry that characterizes some Islamic art. Though the art of Islam is centered in geometry, it entails representation. The highest art, calligraphy, is representational, and representation of worldly things is not prohibited. The Holy Koran forbids worship of images, and sacred tradition shuns the statue, anathematizes extreme realism, and favors ornament that connects to utility, leading, say, to the abstract, floral decoration of useful vessels. For the issue of representation in Islamic art, see: Grabar, *Formation of Islamic Art,* pp. 75–103; Arnold, *Painting in Islam,* pp. 4–7; Burckhardt, *Art of Islam,* chapter 3; Glassie, *Turkish Traditional Art,* chapters 5, 23; Al-Qaradawi, *Lawful and Prohibited in Islam,* pp. 100–120. The nature of Islamic Art is not the consequence of prohibition, but of aspirations: the search through abstraction for the spirit, the search through spirit for unity.

P. 424 Kramrisch, "Ajanta," chapter 16 in Miller, *Exploring India's Sacred Art.* See too Rowland, *Art and Architecture of India,* pp. 145–50. In *Art of India,* p. 47, Kramrisch says paintings are modeled for volume, but they are not shadowed. Coomaraswamy's account of the Ajanta caves, *History of Indian and Indonesian Art,* p. 89, parallels rickshaw painting: over a white background, forms are painted, then outlined and shaded for relief. Bussbarger and Robins, *Everyday Art of India,* p. 146, comment that Indian painting seems influenced by the primacy of sculpture.

P. 435 Joanna Kirkpatrick, "Painted Ricksha," pp. 74, 84, reporting fieldwork begun two decades before the year I am describing, 1995, mentions an image of Tagore, and one of Krishna. They were rare, if not unique in her day, and I have seen no poets or deities in mine.

P. 435 The image of the village, so common on baby taxis and terracottas, appeals as well to painters in the international style. S. M. Sultan, the artist treated first in Choudhury's *Nine Modern Artists,* and a man who has exhibited with Picasso and Klee, painted—plate 3—an impressionistic canvas with all the features of the baby taxi's village: a river flowing into the distance, thatched houses on the wooded bank, watercraft, a woman with a *kalshi* on her hip. Sultan's houses are thatched, his picture looks backward, while the baby taxi's picture usually shows the mix of materials—thatch and tin, clay and bamboo—described accurately as normal for the modern village by K. I. Ahmed, *Up to the Waist in Mud,* pp. 25–26, 92.

P. 441 Relying primarily on textiles, I describe these two basic geometric patterns—the overall and the centered—in *Turkish Traditional Art,* especially pp. 798–805.

P. 442 The revival of cast images in Tamil Nadu: Krishna, *Arts and Crafts of Tamilnadu,* pp. 40–51; Barnard, *Arts and Crafts of India,* pp. 35, 92–97. On lost-wax techniques like those of contemporary Bangladesh, see: A. Mookerjee, *Folk Art of Bengal,* p. 36; P. Sen, *Crafts of West Bengal,* pp. 90, 92; Cooper and Gillow, *Arts and Crafts of India,* pp. 62–64.

Pp. 448–49 Jasimuddin's poem *The Field of the Embroidered Quilt* fills a slim volume in its English translation (found in the bibliography under Uddin, for his name, now usually spelled as one word, was formerly spelled in two). Gurusaday Dutt (1882–1941) did excellent research on the *kantha;* his findings in *Folk Arts and Crafts of Bengal,* pp. 104–9, plates 39–41, 55–58, have influenced later writers. Stella Kramrisch brought the *kantha* to the attention of the West in *Unknown India,* pp. 66–69, 116–21, reprinted in Miller, *Exploring India's Sacred Art,* pp. 108–12, and Sethi, Devi, and Kurin, *Aditi,* pp. 254–56. In its first edition (Dhaka: Shilpakala Academy, 1981), Niaz Zaman's *Art of Kantha Embroidery* was an excellent full treatment, and in its new edition

(1993) she has added much of value on the revival that began in 1972 but took off in the 1980s: pp. 1–7, 139, 141–42. She describes recycling, pp. 8, 13, 26, and credits Jasimuddin, pp. 16–17, 20–21. The works by Dutt, Kramrisch, and especially Zaman, provide excellent information on, and interpretation of, the *nakshi kantha,* and in addition see: A. Mookerjee, *Folk Art of Bengal,* chapter 2, plates 30–32; P. Sen, *Crafts of West Bengal,* pp. 54–63 (as in Bangladesh, recently revived); Nag in Dasgupta, *Arts of Bengal,* pp. 62–63; Bussbarger and Robins, *Everyday Art of India,* p. 171; Mode and Chandra, *Indian Folk Art,* pp. 225, 228–31; Cooper and Gillow, *Arts and Crafts of India,* p. 95; Dongerkery, *Romance of Indian Embroidery,* p. 50; Stockley, Sayeedur Rahman, and Hossain in Stockley, *Woven Air,* pp. 16, 23–31, 56–59; M. Sayeedur Rahman, "Nakshi Kantha"; Qureshi, Hafiz, and Sayeedur, in S. Khan, *Folklore of Bangladesh,* vol. 2, pp. 32–63; Qureshi, *Culture and Development,* pp. 49–67; Hossain in S. Khan, *Folklore of Bangladesh,* vol. 1, pp. 461, 466–67; Ghuznavi, *Naksha,* pp. 20, 22–26, 28, 64; P. Ahmad, *Crafts from Bangladesh,* pp. 8–10, 67–68; Sirajuddin, *Living Crafts in Bangladesh,* pp. 44–45, 58–59; E. Haque, *Islamic Art in Bangladesh,* p. 30, and *Islamic Art Heritage,* pp. 189, 193–96, 226, 232; Hafiz in E. Haque, *Anthology on Crafts in Bangladesh,* pp. 29–36, 44–47, 53; Mahmud, *Prospects,* pp. 109–14; Glassie, *Spirit of Folk Art,* pp. 82–85.

Pp. 449–50 The theme of dismembering and reunifying, fit to a cyclical view of time, and symbolized in the image of Ganesh, is common in subcontinental thought: McDaniel, *Madness of the Saints,* p. 268; Courtright, *Gaṇeśa,* pp. 95–96. Myth is one condition for the importance of recycling.

Scarcity is another. A. T. M. Nurul Islam in S. U. Ahmed, *Dhaka,* especially p. 464, stresses recycling within the informal sector of the economy. Huyler in Meister, *Making Things in South Asia,* p. 148, comments perceptively on recycling in creation. In Cerny and Seriff's book on recycling in folk art, *Recyled Re-Seen,* chapter 7, Frank Korom mentions both the *kantha* and the rickshaw in his essay on recycling in India.

P. 450 For the relation of *murid* to *pir,* of intense importance in the Sufi tradition within Islam, see: A. Roy, *Islamic Syncretistic Tradition in Bengal,* pp. 50–51, 159–62; Abecassis, *Identity, Islam, and Human Development,* pp. 28–31, 75–76; Karamustafa, *God's Unruly Friends,* pp. 5–9, 88–89; Schimmel, *Mystical Dimensions of Islam,* pp. 101–3, 168, 254. The parallel with the Hindu relation of guru to student is precise, and Coomaraswamy, "Art in Indian Life," p. 83, says the relation in art of master to worker is like that of guru to disciple. The guru's role is described by Chaudhuri, *Hinduism,* pp. 302–3, 305, and Narayan, *Storytellers, Saints, and Scoundrels,* pp. 44–45, 82–85, 156, 180, 233.

P. 450 Banu, *Islam in Bangladesh,* pp. 111–13, 128, 177, says that while outsiders might characterize Bangladeshis as lazy (they would have to be people who have never spent time in a workshop in Bangladesh), the workers themselves consistently report that they are unhappy unless they have work. The practical reason to argue about art, its definition and value, is to sustain the hope that people might have work worth doing, work that makes them happy enough.

Bibliography

Abecassis, David. *Identity, Islam and Human Development in Rural Bangladesh.* Dhaka: University Press, 1990.

Abrahams, Roger D. *A Singer and Her Songs: Almeda Riddle's Book of Ballads.* Baton Rouge: Louisiana State University Press, 1970.

Acar, Belkıs Balpınar. *Kilim, Cicim, Zili, Sumak: Turkish Flatweaves.* Istanbul: Eren, 1983.

Adachi, Kenji, and Mitsuhiko Hasebe. *Japanese Painted Porcelain: Modern Masterpieces in Overglaze Enamel.* New York: Weatherhill, 1980.

Agee, James, and Walker Evans. *Let Us Now Praise Famous Men.* Boston: Houghton Mifflin, 1960 [1941].

Ahmad, Perveen. *Crafts from Bangladesh.* Dhaka: Bangladesh Small and Cottage Industries Corporation, n.d., c. 1982.

Ahmad, Tofail. *Loka Shilper Bhubane* [In the World of Folk Art]. Dhaka: Bangla Academy, 1994.

Ahmad, Tofail, Hameeda Hossain, and Mohammad Sayeedur. "Documentation of Folk Designs in Bangladesh." In S. Khan, ed., *Folklore of Bangladesh,* vol. 2, pp. 64–117.

Ahmed, Khondkar Iftekhar. *Up to the Waist in Mud: Earth-Based Architecture in Rural Bangladesh.* Dhaka: University Press, 1994.

Ahmed, Nazimuddin. *Islamic Heritage of Bangladesh.* Dhaka: Ministry of Information and Broadcasting, 1980.

———. *Discover the Monuments of Bangladesh.* Ed. John Sanday. Dhaka: University Press, 1984.

———. *Buildings of the British Raj in Bangladesh.* Ed. John Sanday. Dhaka: University Press, 1986.

———. *Epic Stories in Terracotta: Depicted on Kantanagar Temple, Bangladesh.* Dhaka: University Press, 1990.

Ahmed, Rafiuddin, ed. *Bangladesh: Society, Religion and Politics.* Chittagong: South Asia Studies Group, 1985.

Ahmed, Sharif Uddin, ed. *Dhaka: Past, Present, Future.* Dhaka: Asiatic Society of Bangladesh, 1991.

Ahsan, Syed Ali. *Bangladesh: A Souvenir on the First Anniversary of Victory Day, December 16, 1972.* Dhaka: Ministry of Information and Broadcasting, 1972.

Alam, A. K. M. Shamsul. *Mainamati.* Dhaka: Department of Archaeology and Museums, 1982.

———. *Sculptural Art of Bangladesh: Pre-Muslim Period.* Dhaka: Department of Archaeology and Museums, 1985.

al-Hassan, Ahmad Y., and Donald R. Hill. *Islamic Technology: An Illustrated History.* Cambridge: Cambridge University Press, 1986.

Ali, Ahmed, trans. *Al-Qur'an.* Princeton: Princeton University Press, 1988.

Al-Qaradawi, Yusuf. *The Lawful and the Prohibited in Islam.* Indianapolis: American Trust Publications, 1960.

Alver, Bente Gullveig. *Creating the Source Through Folkloristic Fieldwork.* Helsinki: Suomalainen Tiedeakatemia, 1990.

Andrews, Edward Deming and Faith. *Religion in Wood: A Book of Shaker Furniture.* Bloomington: Indiana University Press, 1966.

Anisuzzaman. *Creativity, Reality and Identity.* Dhaka: International Centre for Bengal Studies, 1993.

Appadurai, Arjun, ed. *The Social Life of Things: Commodities in Cultural Perspective.* Cambridge: Cambridge University Press, 1986.

Arberry, A. J. *The Koran Interpreted.* 2 vols. London: George Allen and Unwin, 1955.

Armstrong, Robert Plant. *The Affecting Presence: An Essay in Humanistic Anthropology.* Urbana: University of Illinois Press, 1971.

———. *Wellspring: On the Myth and Source of Culture.* Berkeley: University of California Press, 1975.

———. *The Powers of Presence: Consciousness, Myth, and Affecting Presence.* Philadelphia: University of Pennsylvania Press, 1981.

Arnold, Thomas W. *Painting in Islam: A Study of the Place of the Pictorial in Muslim Culture.* New York: Dover, 1965 [1928].

Artigas, J. Llorens, and J. Corredor-Matheos. *Spanish Folk Ceramics of Today.* Barcelona: Editorial Blume, 1974.

Aryan, K. C. *Basis of Decorative Element in Indian Art.* New Delhi: Rekha Prakashan, 1981.

Atasoy, Nurhan, and Julian Raby. *Iznik: The Pottery of Ottoman Turkey.* London: Alexandria Press, Thames and Hudson, 1989.

Atıl, Esin, ed. *Turkish Art.* Washington and New York: Smithsonian Institution and Abrams, 1980.

———, ed. *Islamic Art and Patronage: Treasures from Kuwait: The Al-Sabah Collection.* New York: Rizzoli, 1990.

Atıl, Esin, W. T. Chase, and Paul Jett. *Islamic Metalwork in the Freer Gallery of Art.* Washington: Smithsonian Insitution, 1985.

Babcock, Barbara A., and Guy and Doris Monthan. *The Pueblo Storyteller: Development of a Figurative Ceramic Tradition.* Tucson: University of Arizona Press, 1986.

Bahti, Mark. *Pueblo Stories and Storytellers.* Tucson: Treasure Chest Publications, 1988.

Bakurdjiev, Georgi. *Bulgarian Ceramics.* Sofia: Bulgarski Hudozhnik, 1955.

Baldwin, Cinda K. *Great and Noble Jar: Traditional Stoneware of South Carolina.* Athens: University of Georgia Press, 1995.

Banerji, Bibhutibhushan. *Pather Panchali: Song of the Road.* Trans. T. W. Clark and Tarapada Mukherji. Bloomington: Indiana University Press, 1968.

Bangladesh Rural Advancement Committee. *The Net: Power Structure in Ten Villages.* Dhaka: BRAC, 1986.

———. *Who Gets What and Why: Resource Allocation in a Bangladesh Village.* Dhaka: BRAC, 1986.

Banu, U. A. B. Razia Akter. *Islam in Bangladesh.* Leiden: E. J. Brill, 1992.

Barber, Edwin Atlee. *Tulip Ware of the Pennsylvania-German Potters: An Historical Sketch of the Art of Slip-Decoration in the United States.* Philadelphia: Pennsylvania Museum and School of Industrial Art, 1926 [1903].

Bari, Md. Abdul. "Mughal Mosques of Dhaka: A Typological Study." In S. U. Ahmed, ed., *Dhaka,* pp. 319–332.

Barnard, Nicholas. *Arts and Crafts of India.* London: Conran Octopus, 1993.

Barriskill, Janet. *Visiting the Mino Kilns, With a Translation of Arakawa Toyozo's "The Traditions and Techniques of Mino Pottery."* University of Sydney East Asian Series 9. Broadway: Wild Peony, 1995.

Bascom, William. *African Art in Cultural Perspective: An Introduction.* New York: W. W. Norton, 1973.

Batkin, Jonathan. *Pottery of the Pueblos of New Mexico.* Colorado Springs: Taylor Museum, 1987.

Bauman, Richard. *Story, Performance, and Event: Contextual Studies of Oral Narrative.* Cambridge: Cambridge University Press, 1986.

Baxandall, Michael. *Giotto and the Orators: Humanist Observers of Painting in Italy and the Discovery of Pictorial Composition.* Oxford: Oxford University Press, 1991 [1971].

———. *Painting and Experience in Fifteenth-Century Italy: A Primer on the Social History of Pictorial Style.* Oxford: Oxford University Press, 1986 [1972].

———. *The Limewood Sculptors of Renaissance Germany.* New Haven: Yale University Press, 1985 [1980].

———. *Patterns of Intention: On the Historical Explanation of Pictures.* New Haven: Yale University Press, 1985.

Becker, Howard S. *Art Worlds.* Berkeley: University of California Press, 1982.

Bhattacharyya, Asutosh. *Folklore of Bengal.* New Delhi: National Book Trust, India, 1978.

Biebuyck, Daniel, ed. *Tradition and Creativity in Tribal Art.* Berkeley: University of California Press, 1969.

Birdwood, George C. M. *The Arts of India.* Calcutta: Rupa, 1988 [1880].

Biswas, S. S. *Terracotta Art of Bengal.* Atlantic Highlands: Humanities Press, 1982.

Blaise, Clark, and Bharati Mukherjee. *Days and Nights in Calcutta.* Saint Paul: Hungry Mind Press, 1995 [1977].

Blanc, Jean-Charles. *Afghan Trucks.* New York: Stonehill, 1976.

Blurton, T. Richard. *Hindu Art.* Cambridge: Harvard University Press, 1993.

Boas, Franz. *Primitive Art.* New York: Dover, 1955 [1927].

———. *Kwakiutl Ethnography.* Ed. Helen Codere. Chicago: University of Chicago Press, 1966.

Bodur, Fulya. *The Art of Turkish Metalworking.* Istanbul: Türk Kültürüne Hizmet Vakfı, 1987.

Bølstad, Trygve, and Erik G. Jansen. *Sailing against the Wind: Boats and Boatmen of Bangladesh.* Dhaka: University Press, 1992.

Bose, Buddhadeva. *Tagore: Portrait of a Poet.* Bombay: University of Bombay, 1962.

Bourdier, Jean-Paul, and Trinh T. Minh-ha. *African Spaces: Designs for Living in Upper Volta.* New York: Africana, 1985.

———. *Drawn from African Dwellings.* Bloomington: Indiana University Press, 1996.

Braudel, Fernand. *The Mediterranean and the Mediterranean World in the Age of Philip II.* Trans. Sián Reynolds. 2 vols. New York: Harper and Row, 1972.

———. *On History.* Trans. Sarah Matthews. Chicago: University of Chicago Press, 1980.

———. *A History of Civilizations.* Trans. Richard Mayne. New York: Penguin, 1993.

Bravmann, René A. *Islam and Tribal Art in West Africa.* Cambridge: Cambridge University Press, 1974.

Brears, Peter C. D. *The English Country Pottery: Its History and Techniques.* Newton Abbot: David and Charles, 1971.

Brend, Barbara. *Islamic Art.* Cambridge: Harvard University Press, 1991.

Brennan, Julia. *Handicrafts in Bangladesh.* Bristol: Evangelism Today, n.d., c. 1976.

Brewington, M. V. *Chesapeake Bay Log Canoes and Bugeyes.* Cambridge: Cornell Maritime Press, 1963.

Briggs, Charles L. *The Wood Carvers of Córdova, New Mexico: Social Dimensions of an Artistic "Revival."* Knoxville: University of Tennessee Press, 1980.

———. *Competence in Performance: The Creativity of Tradition in Mexicano Verbal Art.* Philadelphia: University of Pennsylvania Press, 1988.

Brüggemann, W., and H. Böhmer. *Rugs of the Peasants and Nomads of Anatolia.* Munich: Kunst und Antiquitäten, 1983.

Buck, William. *Mahabharata.* New York: Meridian, 1987 [1973].

———. *Ramayana.* Berkeley: University of California Press, 1981.

Bunzel, Ruth L. *The Pueblo Potter: A Study of Creative Imagination in Primitive Art.* New York: Dover, 1972 [1929].

Burckhardt, Titus. *Sacred Art in East and West: Its Principles and Methods.* London: Perennial Books, 1967.

———. *Art of Islam: Language and Meaning.* Westerham: World of Islam Festival, 1976.

———. *An Introduction to Sufism.* Wellingborough: Crucible, 1990 [1976].

Burke, Kenneth. *A Grammar of Motives.* Berkeley: University of California Press, 1969.

———. *The Philosophy of Literary Form.* Berkeley: University of California Press, 1973.

Burke, Peter. *Popular Culture in Early Modern Europe.* Aldershot: Wildwood House, 1988 [1978].

Burrison, John A. *The Meaders Family of Mossy Creek: Eighty Years of North Georgia Folk Pottery.* Atlanta: Georgia State University Art Gallery, 1976.

———. *Brothers in Clay: The Story of Georgia Folk Pottery.* Athens: University of Georgia Press, 1983.

Bussbarger, Robert F., and Betty Dashew Robins. *The Everyday Art of India.* New York: Dover, 1968.

Cardew, Michael. *Pioneer Pottery.* New York: St. Martin's Press, 1969.

Carswell, John. "Ceramics." In Petsopoulos, ed., *Tulips, Arabesques and Turbans* , pp. 73–119.

———. *Blue and White: Chinese Porcelain and Its Impact on the Western World.* Chicago: David and Alfred Smart Gallery, University of Chicago, 1985.

Casey, Jane Anne. *Medieval Sculpture from Eastern India: Selections from the Nalin Collection.* Livingston: Nalini International Publications, 1985.

Castile, Rand. *The Way of Tea.* New York: Weatherhill, 1971.

Cerny, Charlene, and Suzanne Seriff, eds. *Recycled Re-Seen: Folk Art from the Global Scrap Heap.* New York: Abrams and Museum of International Folk Art, 1996.

Chakravarti, Ramakanta. *Vaiṣṇavism in Bengal: 1486–1900.* Calcutta: Sanskrit Pustak Bhandar, 1985.

Chandra, Pramod. *On the Study of Indian Art.* Cambridge: Harvard University Press for the Asia Society, 1983.

Chang, K. C., ed. *Settlement Archaeology.* Palo Alto: National Press Books, 1968.

Chapelle, Howard I. *American Small Sailing Craft: Their Design, Development, and Construction.* New York: W. W. Norton, 1951.

Chaudhuri, Nirad C. *The Autobiography of an Unknown Indian.* Bombay: Jaico Publishing House, 1994 [1951].

———. *Hinduism: A Religion to Live By.* New York: Oxford University Press, 1979.

Choudhury, Subir, ed. *Nine Modern Artists: Bangladesh.* Dhaka: Bangladesh Shilpakala Academy, 1993.

Chowdhury, Asad. "Rickshaw Paintings." In Fishwick, ed., *Bangladesh,* pp. 72–74.

Cleveland, Richard S. *200 Years of Japanese Porcelain.* St. Louis: City Art Museum, 1970.

Coburn, Thomas B. *Devī Māhātmya: The Crystallization of the Goddess Tradition.* Delhi: Motilal Banarsidass, 1984.

Coe, Ralph T. *Lost and Found Traditions: Native American Art, 1965–1985.* New York: American Federation of Arts, 1986.

Cole, Bruce. *The Renaissance Artist at Work: From Pisano to Titian.* New York: Harper and Row, 1983.

Coomaraswamy, Ananda K. *The Arts and Crafts of India and Ceylon.* New Delhi: Today and Tomorrow's Printers and Publishers, 1984 [1913].

———. *An Introduction to Indian Art.* Madras: Theosophical Publishing House, 1923.

———. *The Dance of Śiva: Essays on Indian Art and Culture.* New York: Dover, 1985 [1924].

———. *History of Indian and Indonesian Art.* New York: Dover, 1965 [1927].

———. *The Transformation of Nature in Art.* Cambridge: Harvard University Press, 1935.

———. "The Part of Art in Indian Life" [1937]. In Lipsey, ed., *Coomaraswamy,* pp. 71–100.

———. *Christian and Oriental Philosophy of Art.* New York: Dover, 1956 [1943].

———. *Essays in Early Indian Architecture.* Ed. Michael W. Meister. Delhi: Indira Gandhi National Centre for the Arts, Oxford University Press, 1992.

Cooper, Ilay, and John Gillow. *Arts and Crafts of India.* London: Thames and Hudson, 1996.

Cooper, Patricia, and Norma Bradley Buferd. *The Quilters: Women and Domestic Art: An Oral History.* Garden City: Anchor Press, Doubleday, 1978.

Cort, Louise Allison. *Shigaraki, Potters' Valley.* Tokyo: Kodansha, 1979.

———. "The Role of the Potter in South Asia." In Meister, ed., *Making Things in South Asia,* pp. 165–174.

———. *Seto and Mino Ceramics: Japanese Collections in the Freer Gallery of Art.* Washington: Smithsonian Institution, 1992.

Cort, Louise Allison, and Nakamura Kenji. *A Basketmaker in Rural Japan.* New York: Weatherhill, 1994.

Courtright, Paul B. *Gaṇeśa: Lord of Obstacles, Lord of Beginnings.* New York: Oxford University Press, 1985.

Craven, Roy C., ed. *Jamini Roy and Bengali Folk Art.* [Gainesville]: University Gallery, University of Florida, 1971.

Csikszentmihalyi, Mihaly, and Eugene Rochberg-Halton. *The Meaning of Things: Domestic Symbols and the Self.* Cambridge: Cambridge University Press, 1985.

Cuisenier, Jean. *French Folk Art.* Tokyo: Kodansha, 1977.

Danto, Arthur C. *The Philosophical Disenfranchisement of Art.* New York: Columbia University Press, 1986.

———. *Embodied Meanings: Critical Essays and Aesthetic Meditations.* New York: Farrar Straus Giroux, 1994.

Dasgupta, Mary Ann, ed. *Arts of Bengal and Eastern India: Crafts of Bengal, Craftsmen at Work, Crafts to Buy.* London: Crafts Council of West Bengal, 1982.

Dastgir, A. S. G. *Motherland in Mind.* Dhaka: Begum Parsa Dastgir, 1994.

Day, Lal Behari. *Bengal Peasant Life.* Calcutta: Editions India, 1969 [1874].

Deetz, James. *Invitation to Archaeology.* Garden City: Natural History Press, 1967.

———. *Flowerdew Hundred: The Archaeology of a Virginia Plantation, 1619–1864.* Charlottesville: University Press of Virginia, 1993.

————. *In Small Things Forgotten: An Archaeology of Early American Life*. New York: Anchor Books, Doubleday, 1996 [1977].

Dégh, Linda. *Narratives in Society: A Performer-Centered Study of Narration*. Helsinki: Suomalainen Tiedeakatemia, 1995.

Denny, Walter B. "Ceramics." In Atıl, ed., *Turkish Art*, pp. 239–97.

de Schweinitz, Karl, Jr. *The Rise and Fall of British India: Imperialism as Inequality*. London: Routledge, 1989.

Dhamija, Jasleen. *Living Tradition of Iran's Crafts*. New Delhi: Vikas, 1979.

Dillingham, Rick. *Fourteen Families in Pueblo Pottery*. Albuquerque: University of New Mexico Press, 1994.

Dillingham, Rick, and Melinda Elliott. *Acoma and Laguna Pottery*. Sante Fe: School of American Research, 1992.

Dimock, Edward C., Jr., and Denise Levertov. *In Praise of Krishna: Songs from the Bengali*. Garden City: Anchor Books, 1967.

Dittert, Alfred E., Jr., and Fred Plog. *Generations in Clay: Pueblo Pottery of the American Southwest*. Flagstaff: Northland Press, 1980.

Domanovszky, György. *Hungarian Pottery*. Budapest: Corvina, 1968.

Dongerkery, Kamala S. *The Romance of Indian Embroidery*. Bombay: Thacker, 1951.

Donnelly, P. J. *Blanc De Chine: The Porcelain of Téhua in Fukien*. London: Faber and Faber, 1969.

Dower, John W. *Japan in War and Peace: Selected Essays*. New York: The New Press, 1993.

Dube, S. C. *Indian Village*. Ithaca: Cornell University Press, 1955.

————. *India's Changing Villages: Human Factors in Community Development*. Bombay: Allied Publishers, 1967 [1958].

Duffy, Karen M. "The Work of Virgil Boruff, Indiana Limestone Craftsman." *Midwestern Folklore* 22:2 (1996): 3–71.

Dundes, Alan. *Interpreting Folklore*. Bloomington: Indiana University Press, 1980.

Dutt, Gurusaday. *Folk Arts and Crafts of Bengal: The Collected Papers*. Calcutta: Seagull, 1990.

Dutta, Krishna, and Andrew Robinson. *Rabindranath Tagore: The Myriad-Minded Man*. New York: St. Martin's Press, 1995.

Eaton, Allen H. *Handicrafts of the Southern Highlands*. New York: Russell Sage Foundation, 1937.

Eaton, Richard M. *The Rise of Islam and the Bengal Frontier, 1204–1760*. Berkeley: University of California Press, 1996.

Eck, Diana L. *Darśan: Seeing the Divine Image in India*. Chambersburg: Anima Books, 1985.

Eco, Umberto. *Art and Beauty in the Middle Ages*. Trans. Hugh Bredin. New Haven: Yale University Press, 1986 [1959].

Edwardes, Michael. *A History of India: From the Earliest Times to the End of Colonialism*. New York: Universal Library, 1970 [1961].

Elwin, Verrier. *The Tribal Art of Middle India: A Personal Record*. Oxford: Oxford University Press, 1951.

Emerson, Ralph Waldo. *Nature*. East Aurora: Roycrofters, 1905 [1836].

Espejel, Carlos. *Mexican Folk Ceramics*. Barcelona: Editorial Blume, 1975.

Espinosa, José E. *Saints in the Valleys: Christian Sacred Images in the History, Life and Folk Art of Spanish New Mexico*. Albuquerque: University of New Mexico Press, 1967.

Ettinghausen, Richard, Maurice S. Dimand, Louise W. Mackey, and Charles Grant Ellis. *Prayer Rugs*. Washington: Textile Museum, 1974.

Evans, E. Estyn. *Irish Folk Ways*. New York: Devin-Adair, 1957.

————. *Mourne Country: Landscape and Life in South Down*. Dundalk: Dundalgan Press, 1967.

————. *Ireland and the Atlantic Heritage*. Dublin: Lilliput Press, 1996.

Faaland, Just, and J. R. Parkinson. *Bangladesh: The Test Case for Development*. Boulder: Westview Press, 1976.

Fairbanks, Jonathan L. *Collecting American Decorative Arts and Sculpture, 1971–1991*. Boston: Museum of Fine Arts, 1991.

Farwell, Byron. *Armies of the Raj: From the Great Indian Mutiny to Independence: 1858–1947*. New York: W. W. Norton, 1989.

Ferguson, Leland, ed. *Historical Archaeology and the Importance of Material Things*. Columbia: Society for Historical Archaeology, 1977.

Ferris, William. *Local Color: A Sense of Place in Folk Art*. New York: McGraw-Hill, 1982.

Fischer, Eberhard, and Haku Shah. *Rural Craftsmen and Their Work.* Ahmedabad: National Institute of Design, 1970.

Fischer, J. L. "Art Styles as Cultural Cognitive Maps." *American Anthropologist* 63(1961): 71–93.

Fischer, Nora, ed. *Mud, Mirror and Thread: Folk Traditions of Rural India.* Ahmedabad: Mapin, 1993.

Fishwick, Marshall W., ed. *Bangladesh: Inter-Cultural Studies.* Dhaka: Ananda, 1983.

———. *Tarnished Gold: Bengal at Bay.* Blacksburg: Fishwick Books, 1983.

Fitch, James Marston. *Historic Preservation: Curatorial Management of the Built World.* New York: McGraw-Hill, 1982.

Flynn, Dorris. *Costumes of India.* Calcutta: Oxford and IBH Publishing Co., 1971.

Fontana, Bernard L., William J. Robinson, Charles W. Cormack, and Ernest E. Leavitt, Jr. *Papago Indian Pottery.* Seattle: University of Washington Press, 1962.

Fontein, Jan, ed. *Living National Treasures of Japan.* Boston: Museum of Fine Arts, 1983.

Forster, E. M. *A Passage to India.* San Diego: Harcourt Brace, 1965 [1924].

Frasché, Dean F. *Southeast Asian Ceramics: Ninth through Seventeenth Centuries.* New York: The Asia Society, 1976.

Fry, Gladys-Marie. *Stitched from the Soul: Slave Quilts from the Ante-Bellum South.* New York: Dutton Studio and Museum of American Folk Art, 1990.

Gallagher, Rob. *The Rickshaws of Bangladesh.* Dhaka: University Press, 1992.

Gandhi, Indira. *India and Bangla Desh: Selected Speeches and Statements, March to December 1971.* New Delhi: Orient Longman, 1972.

Gandhi, M. K. *An Autobiography, Or The Story of My Experiments with Truth.* Ahmedabad: Navajivan Publishing House, 1972 [1927].

Garnsey, Wanda, and Rewi Alley. *China: Ancient Kilns and Modern Ceramics, A Guide to the Potteries.* Canberra: Australian National University Press, 1983.

Georges, Robert A., and Michael Owen Jones. *People Studying People: The Human Element in Fieldwork.* Berkeley: University of California Press, 1980.

Ghuznavi, Sayyada. *Naksha: A Collection of Designs of Bangladesh.* Dhaka: Bangladesh Small and Cottage Industries Corporation, 1981.

Gibbon, Edward. *The History of the Decline and Fall of the Roman Empire.* 12 vols. London: Cadell and Davies, 1807 [1776–1788].

Glassé, Cyril. *The Concise Encyclopedia of Islam.* San Francisco: Harper and Row, 1989.

Glassie, Henry. "William Houck: Maker of Pounded Ash Adirondack Pack-Baskets." *Keystone Folklore Quarterly* 12:1 (1967): 23–54.

———. *Pattern in the Material Folk Culture of the Eastern United States.* Philadelphia: University of Pennsylvania Press, 1968.

———. "Folk Art." In Richard M. Dorson, ed., *Folklore and Folklife: An Introduction.* Chicago: University of Chicago Press, 1972. Pp. 253–80.

———. "The Nature of the New World Artifact: The Instance of the Dugout Canoe." In Walter Escher, Theo Gantner, and Hans Trümpy, eds., *Festschrift für Robert Wildhaber.* Basel: Schweizerische Gesellschaft für Volkskunde, 1973. Pp. 153–70.

———. "Structure and Function, Folklore and the Artifact." *Semiotica* 7:4 (1973): 313–51.

———. *All Silver and No Brass: An Irish Christmas Mumming.* Bloomington: Indiana University Press, 1975.

———. *Folk Housing in Middle Virginia: A Structural Analysis of Historic Artifacts.* Knoxville: University of Tennessee Press, 1976.

———. "Archaeology and Folklore: Common Anxieties, Common Hopes." In Ferguson, ed., *Historical Archaeology and the Importance of Material Things,* pp. 23–35.

———. "Meaningful Things and Appropriate Myths: The Artifact's Place in American Studies." *Prospects* 3 (1977): 1–49.

———. *Passing the Time in Ballymenone: Culture and History of an Ulster Community.* Philadelphia: University of Pennsylvania Press, 1982.

———. "Folkloristic Study of the American Artifact: Objects and Objectives." In Richard M. Dorson, ed., *Handbook of American Folklore.* Bloomington: Indiana University Press, 1983. Pp. 376–83.

———. "Vernacular Architecture and Society." *Material Culture* 16:1 (1984): 4–24.

———. "The Idea of Folk Art." In Vlach and Bronner, eds., *Folk Art and Art Worlds,* pp. 269–74.

487

————."Traditional Crafts: A Lesson from Turkish Ceramics." In Thomas Veunum, ed., *Festival of American Folklife Program Book.* Washington: Smithsonian Institution, 1986. Pp. 68–73.

————. *The Spirit of Folk Art.* New York: Abrams and Museum of International Folk Art, 1989.

————. "A Master of the Art of Carpet Repair: The Life of Hagop Barın." *Oriental Rug Review* 9:6 (1989): 32–38; 10:1 (1989): 16–22; 10:2 (1990): 38–43.

————. "Studying Material Culture Today." In Pocius, ed., *Living in a Material World,* pp. 253–66.

————. *Turkish Traditional Art Today.* Bloomington: Indiana University Press, 1993.

————. "The Practice and Purpose of History." *Journal of American History* 81:3 (1994): 961–68.

————. "The Spirit of Swedish Folk Art." In Klein and Widbom, eds., *Swedish Folk Art,* pp. 247–55.

————. "Values in Clay." *The Studio Potter* 22:2 (1994): 43–47.

————. "Tradition." *Journal of American Folklore* 108:430 (1995): 395–412.

————. "The Word of God and the Song of the Soul: Calligraphic Art in Modern Turkey." *The American Muslim Council Report* 6:2 (1996): 8.

Gluck, Jay, and Sumi Hiramoto Gluck, eds. *A Survey of Persian Handicraft.* Tehran: Survey of Persian Art, 1977.

Goffman, Erving. *The Presentation of Self in Everyday Life.* Garden City: Doubleday, 1959.

————. *Behavior in Public Places: Notes on the Social Organization of Gatherings.* New York: Free Press, 1963.

————. *Forms of Talk.* Philadelphia: University of Pennsylvania Press, 1981.

Goldstein, Kenneth S. "William Robbie: Folk Artist of the Buchan District, Aberdeenshire." In Horace P. Beck, ed., *Folklore in Action: Essays for Discussion in Honor of MacEdward Leach.* Philadelphia: American Folklore Society, 1962. Pp. 101–11.

————. *A Guide for Field Workers in Folklore.* Hatboro: Folklore Associates, 1964.

Grabar, Oleg. *The Formation of Islamic Art.* New Haven: Yale University Press, 1977.

————. *The Mediation of Ornament.* Princeton: Princeton University Press, 1992.

Graburn, Nelson H. H., ed. *Ethnic and Tourist Arts: Cultural Expressions of the Fourth World.* Berkeley: University of California Press, 1979.

Greenhill, Basil. *Boats and Boatmen of Pakistan.* Newton Abbot: David and Charles, 1971.

Griffing, Robert P., Jr. *The Art of the Korean Potter.* New York: The Asia Society, 1968.

Gupta, G. N. *A Survey of the Industries and Resources of Eastern Bengal and Assam for 1907–1908.* Shillong: Eastern Bengal and Assam Secretariat, 1908.

Gupta, K., ed. *The Writings of Michael M. S. Dutt.* Calcutta: Sahitya Samsad, 1974.

Gupta, Sankar Sen. *A Survey of Folklore Study in Bengal: West Bengal and East Pakistan.* Calcutta: Indian Publications, 1967.

Gustafson, W. Eric, ed. *Pakistan and Bangladesh: Bibliographic Essays in Social Science.* Islamabad: University of Islamabad Press, 1976.

Hacker, Katherine F., and Krista Jensen Turnbull. *Courtyard, Bazaar, Temple: Traditions of Textile Expression in India.* Seattle: Costume and Textile Study Center, University of Washington, 1982.

Hall, Michael D. *Stereoscopic Perspective: Reflections on American Fine and Folk Art.* Ann Arbor: UMI Press, 1988.

Hamer, Frank and Janet. *The Potter's Dictionary of Materials and Techniques.* Philadelphia: University of Pennsylvania Press, 1993.

Hansen, H. J., ed. *European Folk Art.* New York: McGraw-Hill, 1967.

Hansen, William. "Abraham and the Grateful Dead Man." In Regina Bendix and Rosemary Levy Zumwalt, eds., *Folklore Interpreted: Essays in Honor of Alan Dundes.* New York: Garland, 1995. Pp. 355–65.

Haque, Enamul. *Islamic Art in Bangladesh: Catalogue of a Special Exhibition in Dacca Museum.* [Dhaka]: Dacca Museum, 1978.

————. *Islamic Art Heritage of Bangladesh.* Dhaka: Bangladesh National Museum, 1983.

————, ed. *An Anthology on Crafts of Bangladesh.* Dhaka: National Crafts Council of Bangladesh, 1987.

————. *Glimpses of the Mosques of Bangladesh.* Dhaka: Ministry of Information, n.d., c. 1988.

Haque, Mahbubul. *Chittagong Guide.* Chittagong: Barnarekha, 1981.

Haque, Zulekha. *Terracotta Decoration of Late Medieval Bengal: Portrayals of a Society.* Dhaka: Asiatic Society of Bangladesh, 1980.

———. *Gahana: Jewellery of Bangladesh.* Dhaka: Bangladesh Small and Cottage Industries Corporation, 1984.

Harlow, Francis H. *Two Hundred Years of Historic Pueblo Pottery: The Gallegos Collection.* Santa Fe: Morning Star Gallery, 1990.

Harper, Douglas. *Working Knowledge: Skill and Community in a Small Shop.* Chicago: University of Chicago Press, 1987.

Hartmann, Betsy, and James K. Boyce. *A Quiet Violence: View from a Bangladesh Village.* Dhaka: University Press, 1990 [1983].

Hasan, Syed Mahmudul. *Mosque Architecture of Pre-Mughal Bengal.* Dhaka: University Press, 1979.

———. "Folk Architecture of Bangladesh." In S. Khan, ed., *Folklore of Bangladesh,* vol. 1, pp. 424–446.

———. "Muslim Monuments of Dhaka." In S. U. Ahmed, ed., *Dhaka,* pp. 290–318.

Hasnat, Abul, and Muntassir Mamoon. *Dhaka 1971: An Album of Liberation War.* Dhaka: Bangla Academy, 1988.

Hawley, John Stratton, and Donna Marie Wulff, eds. *The Divine Consort: Radha and the Goddesses of India.* Boston: Beacon Press, 1982.

———, eds. *Devi: Goddesses of India.* Berkeley: University of California Press, 1996.

Hecht, Ann. *The Art of the Loom: Weaving, Spinning and Dyeing across the World.* New York: Rizzoli, 1989.

Hedgecoe, John, and Salma Samar Damluji. *Zillij: The Art of Moroccan Ceramics.* Reading: Garnet, 1992.

Hilton, Alison. *Russian Folk Art.* Bloomington: Indiana University Press, 1995.

Hofer, Tamás, and Edit Fél. *Hungarian Folk Art.* Oxford: Oxford University Press, 1979.

Holbek, Bengt. *The Interpretation of Fairy Tales: Danish Folklore in a European Perspective.* Helsinki: Suomalainen Tiedeakatemia, 1987.

Holm, Bill. *Northwest Coast Indian Art: An Analysis of Form.* Seattle: University of Washington Press, 1965.

———. *Smoky-Top: The Art and Times of Willie Seaweed.* Seattle: University of Washington Press, 1983.

Horne, Catherine Wilson. *Crossroads of Clay: The Southern Alkaline-Glazed Stoneware Tradition.* Columbia: McKissick Museum, University of South Carolina, 1990.

Hornell, James. *The Sacred Chank of India: A Monograph of the Indian Conch (Turbinella Pyrum).* Madras Fisheries Bureau, Bulletin 7. Madras: Government Press, 1914.

———. "The Origin and Ethnological Significance of Indian Boat Designs." *Memoirs of the Asiatic Society of Bengal* 7 (1923): 139–256.

———. "The Boats of the Ganges." *Memoirs of the Asiatic Society of Bengal* 8:3 (1929): 173–198.

Hoskins, W. G. *The Making of the English Landscape.* London: Hodder and Stoughton, 1955.

Hossain, Hameeda. *The Company Weavers of Bengal: The East India Company and the Organization of Textile Production in Bengal, 1750–1813.* Delhi: Oxford University Press, 1988.

Hossain, Selina. *Plumed Peacock.* Trans. Kabir Chowdhury. Dhaka: Chaturanga, 1983.

Hossain, Shamsul. *Art and the Vintage: A Catalogue of Exhibits in the Chittagong University Museum.* Chittagong: Chittagong University Museum, 1988.

Hubka, Thomas C. *Big House, Little House, Back House, Barn: The Connected Farm Buildings of New England.* Hanover: University Press of New England, 1984.

Huda, Mohammad Nurul. *Flaming Flowers: Poets' Response to the Emergence of Bangladesh.* Dhaka: Bangla Academy, 1986.

Huq, Obaidul. *Bangabandhu Sheikh Mujib: A Leader with a Difference.* Dhaka: Radical Asia Publications, 1996 [1973].

Huyler, Stephen P. *Village India.* New York: Abrams, 1985.

———. "Terracotta Traditions in Nineteenth- and Twentieth-Century India." In Poster, *From Indian Earth,* pp. 57–66.

———. "Clay, Sacred and Sublime: Terracotta in India." In N. Fischer, ed., *Mud, Mirror and Thread,* pp. 204–223.

Hymes, Dell, ed. *Reinventing Anthropology.* New York: Pantheon, 1972.

————. *Foundations in Sociolinguistics: An Ethnographic Approach.* Philadelphia: University of Pennsylvania Press, 1974.

————. *"In Vain I Tried to Tell You": Essays in Native American Ethnopoetics.* Philadelphia: University of Pennsylvania Press, 1981.

Ibrahim, Ezzedin, and Denys Johnson-Davies, trans. *An-Nawawi's Forty Hadith.* Damascus: Holy Koran Publishing House, 1977.

Imamuddin, Abu H., ed. *Architectural Conservation: Bangladesh.* Dhaka: Asiatic Society of Bangladesh, 1993.

Inden, Ronald B., and Ralph W. Nichols. *Kinship in Bengali Culture.* Chicago: University of Chicago Press, 1977.

Ioannou, Noris. *Ceramics in South Australia, 1836–1986: From Folk to Studio Pottery.* Netley: Wakefield Press, 1986.

————, ed. *Craft in Society: An Anthology of Perspectives.* South Fremantle: South Fremantle Arts Centre Press, 1992.

Islam, A. K. M. Aminul. *A Bangladesh Village: Political Conflict and Cohesion.* Prospect Heights: Waveland Press, 1987 [1974].

————. *Victorious Victims: Political Transformation in a Traditional Society.* Cambridge: Schenkman, 1978.

Islam, Syed Manzoorul, ed. *Essays on Ekushey: The Language Movement, 1952.* Dhaka: Bangla Academy, 1994.

Ives, Edward D. *Joe Scott: The Woodsman-Songmaker.* Urbana: University of Illinois Press, 1978.

Ivey, William W. *North Carolina and Southern Folk Pottery: A Pictoral Survey.* Seagrove: Museum of North Carolina Pottery, 1992.

Jain, Jyotindra, and Aarti Aggarwala. *National Handicrafts and Handlooms Museum, New Delhi.* Ahmedabad: Mapin, 1989.

Jalal, Mohammad Shah. *Traditional Pottery in Bangladesh.* Dhaka: International Voluntary Services, 1987.

James, John. *Chartres: The Masons Who Built a Legend.* London: Routledge and Kegan Paul, 1985.

Jannuzi, F. Tomasson, and James T. Peach. *The Agrarian Structure of Bangladesh: An Impediment to Development.* Boulder: Westview Press, 1980.

Jansen, Erik G., Antony J. Dolman, Alf Morten Jerve, and Nazibor Rahman. *The Country Boats of Bangladesh: Social and Economic Development and Decision-making in Inland Water Transport.* Dhaka: University Press, 1994.

Jenkins, J. Geraint. *Traditional Country Craftsmen.* London: Routledge and Kegan Paul, 1965.

Jenyns, Soame. *Ming Pottery and Porcelain.* London: Faber and Faber, 1988 [1953].

Jonaitis, Aldona. *Art of the Northern Tlingit.* Seattle: University of Washington Press, 1986.

————. *From the Land of the Totem Poles: The Northwest Coast Indian Art Collection of the American Museum of Natural History.* New York: American Museum of Natural History, 1988.

Jones, Michael Owen. *Craftsman of the Cumberlands: Tradition and Creativity.* Lexington: University Press of Kentucky, 1989 [1975].

Kabir, Alamgir. *This Was Radio Bangladesh, 1971.* Dhaka: Bangla Academy, 1984.

Kandinsky, Wassily. *Concerning the Spiritual in Art.* New York: George Wittenborn, 1964 [1912].

Kandinsky, Wassily, and Franz Marc, eds. *The Blaue Reiter Almanac.* New York: Viking Press, 1974 [1912].

Karamustafa, Ahmet T. *God's Unruly Friends: Dervish Groups in the Islamic Later Middle Period, 1200–1550.* Salt Lake City: University of Utah Press, 1994.

Karim, Abdul. *Dacca: The Mughal Capital.* Dhaka: Asiatic Society, 1964.

Kaufmann, Gerhard. *North German Folk Pottery of the 17th to the 20th Centuries.* Richmond: International Exhibitions Foundation, 1979.

Kennedy, Melville T. *The Chaitanya Movement: A Study of Vaishnavism in Bengal.* New Delhi: Munshiram Manoharlal, 1993 [1925].

Kerr, Rose. *Chinese Ceramics: Porcelain of the Qing Dynasty, 1644–1911.* London: Victoria and Albert Museum, 1986.

Khan, Muhammad Hafiz Ullah. "Muslim Terracotta Art and Late Medieval Temple Ornamentation in Bengal: A Study in Cultural Influence." In R. Ahmed, ed., *Bangladesh*, pp. 198–213.

————. "Potter's Art in Bengal: An Integrated Study." *The Journal of the Institute of Bangladesh Studies* 8 (1985): 13–28.

———. *Terracotta Ornamentation in Muslim Architecture of Bengal.* Dhaka: Asiatic Society of Bangladesh, 1988.

———. "Terracotta Art of Pre-Muslim Bengal: A Historical Survey." In S. Khan, ed., *Folklore of Bangladesh,* vol 2, pp. 1–15.

Khan, Shamsuzzaman, ed. *Folklore of Bangladesh.* Vol. 1. Dhaka: Bangla Academy, 1987.

———. "Bangla Folklore," *Bangla Academy Journal* 15–18 (1988–1991): 107–20.

———, ed. *Folklore of Bangladesh.* Vol 2. Dhaka: Bangla Academy, 1992.

Khan, Shamsuzzaman, and Moman Chowdhury, eds. *Bibliography on Folklore of Bangladesh.* Dhaka: Bangla Academy, 1987.

Kingery, W. David, and Pamela B. Vandiver. *Ceramic Masterpieces: Art, Structure, and Technology.* New York: Free Press, 1986.

Kinsley, David. *Hindu Goddesses: Visions of the Divine Feminine in the Hindu Religious Tradition.* Berkeley: University of California Press, 1988.

Kirk, John T. *American Chairs: Queen Anne and Chippendale.* New York: Alfred A. Knopf, 1972.

Kirkpatrick, Joanna. "The Painted Ricksha as Culture Theater." *Studies in Visual Communication* 10:3 (1984): 73–85.

Kirkpatrick, Joanna, and Kevin Bubriski. "Transports of Delight: Ricksha Art of Bangladesh." *Aramco World* 45:1 (1994): 32–35.

Klein, Barbro, and Mats Widbom, eds. *Swedish Folk Art: All Tradition is Change.* New York: Abrams, 1994.

Koch, Ebba. *Mughal Architecture: An Outline of Its History and Development (1526–1858).* Munich: Prestel, 1991.

Kramer, Barbara. *Nampeyo and Her Pottery.* Albuquerque: University of New Mexico Press, 1996.

Kramrisch, Stella. *The Hindu Temple.* 2 vols. Delhi: Motilal Banarsidass, 1996 [1946].

———. *The Art of India: Traditions of Indian Sculpture, Painting and Architecture.* London: Phaidon, 1965 [1954].

———. *Unknown India: Ritual Art in Tribe and Village.* Philadelphia: Philadelphia Musuem of Art, 1968.

———. *The Presence of Śiva.* Princeton: Princeton University Press, 1981.

Krishna, Nanditha. *Arts and Crafts of Tamilnadu.* Ahmedabad: Mapin, 1992.

Kubler, George. *The Shape of Time: Remarks on the History of Things.* New Haven: Yale University Press, 1971 [1962].

Kumar, Nita. *The Artisans of Banaras: Popular Culture and Identity, 1880–1986.* Princeton: Princeton University Press, 1988.

———. *Friends, Brothers, and Informants: Fieldwork Memoirs of Banaras.* Berkeley: University of California Press, 1992.

Kuran, Aptullah. *The Mosque in Early Ottoman Architecture.* Chicago: University of Chicago Press, 1968.

Lane, Arthur. *Later Islamic Pottery: Persia, Syria, Egypt, Turkey.* London: Faber and Faber, 1957.

Larson, Gerald James. *India's Agony over Religion.* Albany: State University of New York Press, 1995.

Laub, Lindsey King, and John A. Burrison. *Evolution of a Potter: Conversations with Bill Gordy.* Cartersville: Bartow History Center, 1992.

Leach, Bernard. *A Potter's Book.* Levittown: Transatlantic Arts, 1973.

———. *Hamada: Potter.* Tokyo: Kodansha, 1990 [1975].

Le Corbusier. *Journey to the East.* Trans. and ed. Ivan Zanic. Cambridge: MIT Press, 1989 [1966].

Lee, Sherman E. *Japanese Decorative Style.* Cleveland: Cleveland Museum of Art, 1961.

Levi, Carlo. *Christ Stopped at Eboli: The Story of a Year.* Trans. Frances Frenaye. New York: Farrar, Straus and Giroux, 1989 [1947].

Lévi-Strauss, Claude. *Tristes Tropiques.* Trans. John and Doreen Weightman. New York: Atheneum, 1975 [1955].

———. *The Savage Mind.* Chicago: University of Chicago Press, 1966.

———. *The Way of the Masks.* Trans. Sylvia Modelski. Seattle: University of Washington Press, 1982.

———. *The Story of Lynx.* Trans. Catherine Tihanyi. Chicago: University of Chicago Press, 1995.

Lewis, Bernard, ed. *The World of Islam: Faith, People, Culture.* London: Thames and Hudson, 1992 [1976].

———. *Islam and the West.* New York: Oxford University Press, 1993.

Lewis, J. M. *The Ewenny Potteries.* Cardiff: National Museum of Wales, 1982.

Lewis, Oscar. *Five Families: Mexican Case Studies in the Culture of Poverty.* New York: Basic Books, 1959.

Li, He. *Chinese Ceramics: A New Comprehensive Survey from the Asian Art Museum of San Francisco.* New York: Rizzoli, 1996.

Lipsey, Roger, ed. *Coomaraswamy I: Selected Papers: Traditional Art and Symbolism.* Princeton: Princeton University Press, 1989.

Litto, Gertrude. *South American Folk Pottery.* New York: Watson-Guptill, 1976.

Lock, Robert C. *The Traditional Potters of Seagrove, North Carolina.* Greensboro: Antiques and Collectibles Press, 1994.

Longenecker, Martha. *India: Village, Tribal, Ritual Arts.* San Diego: Mingei International Museum of World Folk Art, 1981.

Lyall, Sir Alfred. *The Rise and Expansion of the British Dominion in India.* New York: Howard Fertig, 1968 [1894].

Lynton, Linda. *The Sari: Styles, Patterns, History, Techniques.* New York: Abrams, 1995.

Mahmud, Firoz. *Prospects of Material Folk Culture Studies and Folklife Museums in Bangladesh.* Dhaka: Bangla Academy, 1993.

———. "Metalwork in Bangladesh: A Study in Material Folk Culture." Ph.D. Dissertation. Bloomington: Indiana University, 1995.

Mahmud, Firoz, and Habibur Rahman. *The Museums in Bangladesh.* Dhaka: Bangla Academy, 1987.

Malinowski, Bronislaw. *Argonauts of the Western Pacific: An Account of Native Enterprise and Adventure in the Archipelagoes of Melanesian New Guinea.* London: George Routledge, 1922.

Marriott, Alice. *Maria: The Potter of San Ildefonso.* Norman: University of Oklahoma Press, 1948.

Marriott, McKim, ed. *Village India: Studies in the Little Community.* Chicago: American Anthropological Association, 1955.

Mani, Zareer. *Indian Tales of the Raj.* Berkeley: University of California Press, 1987.

Mascaró, Juan, trans. *The Bhagavad Gita.* London: Penguin, 1962.

Mason, Penelope. *History of Japanese Art.* New York: Abrams, 1993.

Maury, Curt. *Folk Origins of Indian Art.* New York: Columbia University Press, 1969.

McDaniel, June. *The Madness of the Saints: Ecstatic Religion in Bengal.* Chicago: University of Chicago Press, 1989.

McNaughton, Patrick R. *The Mande Blacksmiths: Knowledge, Power, and Art in West Africa.* Bloomington: Indiana University Press, 1988.

Mehta, Ved. *Portrait of India.* New Haven: Yale University Press, 1993 [1970].

———. *Rajiv Gandhi and Rama's Kingdom.* New Haven: Yale University Press, 1994.

Meister, Michael, W., ed. *Making Things in South Asia: The Role of Artist and Craftsman.* Proceedings of the South Asia Seminar 4. Philadelphia: Department of South Asia Regional Studies, University of Pennsylvania, 1988.

———, ed. *Cooking for the Gods: The Art of Home Ritual in Bengal.* Newark: Newark Museum, 1995.

Michell, George, ed. *Brick Temples of Bengal: From the Archives of David McCutchion.* Princeton: Princeton University Press, 1983.

———. *The Hindu Temple: An Introduction to Its Meaning and Forms.* Chicago: University of Chicago Press, 1988.

Mikami, Tsugio. *The Art of Japanese Ceramics.* New York: Weatherhill, 1972.

Miller, Barbara Stoller, ed. *Exploring India's Sacred Art: Selected Writings of Stella Kramrisch.* Philadelphia: University of Pennsylvania Press, 1983.

Mino, Yutaka, ed. *The Great Eastern Temple: Treasures of Japanese Buddhist Art from Todai-ji.* Bloomington: Art Institute of Chicago and Indiana University Press, 1986.

Mitra, Debendra Bijoy. *The Cotton Weavers of Bengal, 1757–1833.* Calcutta: Firma KLM, 1978.

Mitsuoka, Tadanari. *Ceramic Art of Japan.* Tokyo: Japan Travel Bureau, 1949.

Mode, Heinz, and Subodh Chandra. *Indian Folk Art.* New York: Alpine Fine Arts Collection, 1965.

Moeran, Brian. *Lost Innocence: Folk Craft Potters of Onta, Japan.* Berkeley: University of California Press, 1984.

Moes, Robert. *Mingei: Japanese Folk Art from the Brooklyn Museum Collection.* New York: Universe, 1985.

———. "Edward Morse, Yanagi Soetsu and the Japa-

nese Folk Art Movement." In Weeder, ed., *Japanese Folk Art*, pp. 20–27.

———. *Mingei: Japanese Folk Art from the Montgomery Collection.* Alexandria: Art Services International, 1995.

Mookerjee, Ajit. *Folk Art of Bengal: A Study of an Art for, and of, the People.* Calcutta: University of Calcutta, 1946 [1939].

———. *Folk Toys of India.* Calcutta: Oxford Book and Stationery Co., 1956.

———. *Indian Dolls and Toys.* New Delhi: Crafts Museum, 1968.

———. *Ritual Art of India.* London: Thames and Hudson, 1985.

———. *Kali: The Feminine Force.* Rochester: Destiny Books, 1988.

Mookerjee, Priya. *Pathway Icons: The Wayside Art of India.* London: Thames and Hudson, 1987.

Moorhouse, Geoffrey. *Calcutta.* New York: Holt, Rinehart and Winston, 1985 [1971].

Morab, S. G. *The Killekyatha Nomadic Folk Artists of Northern Mysore.* Calcutta: Anthropological Survey of India, 1977.

Morris, May, ed. *The Collected Works of William Morris.* 24 vols. London: Longmans Green, 1910–1915.

Morris, William. *Hopes and Fears for Art.* London: Ellis and White, 1882.

———. *Signs of Change.* London: Reeves and Turner, 1888.

———. *Architecture, Industry and Wealth: Collected Papers.* London: Longmans Green, 1902.

Moudud, Hasna Jasimuddin, ed. *Selected Poems of Jasim Uddin.* Dhaka: Oxford University Press, 1975.

———. *A Thousand Year Old Bengali Mystic Poetry.* Dhaka: University Press, 1992.

Moynihan, Elizabeth B. *Paradise as a Garden in Persia and Mughal India.* London: Scolar Press, 1982.

Munsterberg, Hugo. *The Folk Arts of Japan.* Rutland: Charles E. Tuttle, 1958.

———. *The Ceramic Art of Japan: A Handbook for Collectors.* Rutland: Charles E. Tuttle, 1964.

Muraoka, Kageo, and Kichiemon Okamura. *Folk Arts and Crafts of Japan.* New York: Weatherhill, 1973.

Murphy, Michael J. *Tyrone Folk Quest.* Belfast: Blackstaff Press, 1981.

Musa, Monsur. "The Ekushe: A Ritual of Language and Liberty." *Language Problems and Language Planning* 9:3 (1985): 200–214.

Nabokov, Peter, and Robert Easton. *Native American Architecture.* New York: Oxford University Press, 1989.

Nagahiro, Toshio, Eun Hyun Yum, and Takeshi Kuno. *Great Sculpture of the Far East.* New York: William Morrow, 1979.

Nagatake, Takeshi. *Kakiemon.* Tokyo: Kodansha, 1981.

Nahar, Sultana. *Poems of Sultana Nahar.* Dhaka: Dhaka Prokashan, 1988.

Nahohai, Milford, and Elisa Phelps. *Dialogues with Zuni Potters.* Zuni: Zuni A:shiwi Publishing, 1995.

Naipaul, V. S. *An Area of Darkness.* London: Penguin, 1968 [1964].

———. *Among the Believers: An Islamic Journey.* New York: Alfred A. Knopf, 1981.

———. *India: A Million Mutinies Now.* New York: Viking, 1991.

Narayan, Kirin. *Storytellers, Saints, and Scoundrels: Folk Narrative in Hindu Religious Teaching.* Philadelphia: University of Pennsylvania Press, 1989.

Nasr, Seyyed Hossein. *Islamic Art and Spirituality.* Albany: State University of New York Press, 1987.

———. *Traditional Islam in the Modern World.* London: Kegan Paul, 1990.

Nelson, Marion, ed. *Norwegian Folk Art: The Migration of a Tradition.* New York: Abbeville, 1995.

Nichols, Robert F. "Keeping Tradition Alive." *Focus/Santa Fe.* Oct.–Dec. 1995, pp. 14–15.

Noma, Seiroku. *The Arts of Japan.* Trans. John Rosenfield. 2 vols. Tokyo: Kodansha, 1978.

Norberg-Schulz, Christian. *Intentions in Architecture.* Cambridge: The MIT Press, 1965.

———. *Genius Loci: Towards a Phenomenology of Architecture.* New York: Rizzoli, 1984.

Novak, James J. *Bangladesh: Reflections on the Water.* Bloomington: Indiana University Press, 1993.

O'Bannon, George. *The Turkoman Carpet.* London: Duckworth, 1974.

Oettinger, Marion, Jr. *The Folk Art of Latin America: Visiones Del Pueblo.* New York: Dutton Studio and Museum of American Folk Art, 1992.

O'Flaherty, Wendy Doniger. *Tales of Sex and Violence: Folklore, Sacrifice, and Danger in the Jaiminiya Brahmana.* Chicago: University of Chicago Press, 1985.

Ogawa, Masataka, and Tsune Sugimura. *The Enduring Crafts of Japan: 33 Living National Treasures.* New York: Walker/Weatherhill, 1968.

Olenik, Yael. *The Armenian Pottery of Jerusalem.* Tel Aviv: Haaretz Museum, 1986.

Oliver, Anthony. *The Victorian Staffordshire Figure: A Guide for Collectors.* London: Heinemann, 1971.

Paccard, André. *Traditional Islamic Craft in Moroccan Architecture.* 2 vols. Saint-Jorioz: Éditions Atelier 74, 1980.

Pal, Mrinal Kanti. *Catalogue of Folk Art in the Asutosh Museum. Part I.* Calcutta: Asutosh Museum of Indian Art, University of Calcutta, 1962.

Pal, Pratapaditya, Janice Leoshko, Joseph M. Dye III, and Stephen Markel. *Romance of the Taj Mahal.* Los Angeles: Los Angeles County Museum of Art, 1989.

Panofsky, Erwin. *Gothic Architecture and Scholasticism.* New York: World, 1957.

Pasha, Anwar. *Rifles Bread Women.* Trans. Kabir Chowdhury. Dhaka: Bangla Academy, 1994 [1976].

Peterson, Susan. *Shoji Hamada: A Potter's Way and Work.* Tokyo: Kodansha, 1974.

———. *Lucy M. Lewis: American Indian Potter.* Tokyo: Kodansha, 1984.

Petsopoulos, Yanni, ed. *Tulips, Arabesques and Turbans: Decorative Arts from the Ottoman Empire.* New York: Abbeville Press, 1982.

Philip, Leila. *The Road Through Miyama.* New York: Vintage Departures, 1991.

Picton, John, ed. *Earthenware in Asia and Africa.* London: School of Oriental and African Studies, 1982.

Pocius, Gerald L. *A Place to Belong: Community Order and Everyday Space in Calvert, Newfoundland.* Athens: University of Georgia Press, 1991.

———, ed. *Living in a Material World: Canadian and American Approaches to Material Culture.* St. John's: Institute of Social and Economic Research, Memorial University of Newfoundland, 1991.

Posey, Sarah. *Yemeni Pottery: The Littlewood Collection.* London: British Museum Press, 1994.

Poster, Amy G. *From Indian Earth: 4,000 Years of Terracotta Art.* Brooklyn: Brooklyn Museum, 1986.

Price, Sally. *Primitive Art in Civilized Places.* Chicago: University of Chicago Press, 1989.

Prown, Jules David. "Style as Evidence." *Winterthur Portfolio* 15:3 (1980): 197–210.

———. "Mind in Matter: An Introduction to Material Culture Theory and Method." *Winterthur Portfolio* 17:1 (1982): 1–19.

Pugh, P. D. Gordon. *Staffordshire Portrait Figures and Allied Subjects of the Victorian Era.* Woodbridge: Antique Collectors' Club, 1987 [1970].

Qadir, Muhammad Abdul. "Conservation and Restoration of Historic Dhaka: Its Future Proposals and Limitations." In Imamuddin, ed., *Architectural Conservation,* pp. 131–163.

Qureshi, Mahmud Shah. *Culture and Development.* Dhaka: National Book Centre, 1982.

Radhakrishnan, S. *The Bhagavadgita.* New Delhi: Indus, 1993 [1948].

Rahman, Choudhury Shamsur. *Life in East Pakistan.* Chittagong: Co-operative Book Society, 1956.

Rahman, Muhammad Sayeedur. "Nakshi Kantha: A Folk Art of Bangladesh." *Bangla Academy Journal* 19:1 (1992): 1–13.

———. *Jamdani* [in Bangla]. Dhaka: Bangla Academy, 1993.

Rahman, Pares Islam Syed Mustafizur. *Islamic Calligraphy in Medieval India.* Dhaka: University Press, 1979.

Rapoport, Amos. *House Form and Culture.* Englewood Cliffs: Prentice-Hall, 1969.

Rashid, Haroun Er. *Geography of Bangladesh.* Dhaka: University Press, 1991 [1971].

Rashid, Mohammad Harunur, ed. *A Choice of Contemporary Verse from Bangladesh.* Dhaka: Bangla Academy, 1986.

———. *Three Poets: Shamsur Rahman, Al Mahmud, Shaheed Quaderi.* Dhaka: Bougainvilea, 1991.

———. *Introducing Bangla Academy.* Dhaka: Bangla Academy, 1993.

Ray, Sudhansu Kumar. "The Artisan Castes of West Bengal and Their Craft." In A. Mitra, ed. *The Tribes and Castes of West Bengal.* Alipore: West Bengal Government Press, 1953. Pp. 293–350.

Razina, Tatyana, Natalia Cherkasova, and Alexander Kantsedikas, eds. *Folk Art in the Soviet Union.* New York: Abrams, 1990.

Redfield, Robert. *The Little Community: Viewpoints for the Study of a Human Whole.* Chicago: University of Chicago Press, 1955.

————. *Peasant Society and Culture: An Anthropological Approach to Civilization.* Chicago: University of Chicago Press, 1956.

Reichard, Gladys A. *Navajo Shepherd and Weaver.* New York: J. J. Augustin, 1936.

Reina, Ruben E., and Robert M. Hill, II. *The Traditional Pottery of Guatemala.* Austin: University of Texas Press, 1978.

Rhead, G. Woolliscroft, and Frederick Alfred Rhead. *Staffordshire Pots and Potters.* New York: Dodd, Mead, 1907.

Richards, Glyn, ed. *A Source Book of Modern Hinduism.* London: Curzon Press, 1985.

Richman, Paula, ed. *Many Rāmāyaṇas: The Diversity of a Narrative Tradition in South Asia.* Delhi: Oxford University Press, 1992.

Rinzler, Ralph, and Robert Sayers. *The Meaders Family: North Georgia Potters.* Washington: Smithsonian Institution, 1980.

Roberts, Warren E. *Viewpoints on Folklife: Looking at the Overlooked.* Ann Arbor: UMI Press, 1988.

Robinson, Andrew. *The Art of Rabindranath Tagore.* London: André Deutsch, 1989.

Rowland, Benjamin. *The Art and Architecture of India: Buddhist/Hindu/Jain.* Baltimore: Penguin, 1968.

Roy, Asim. *The Islamic Syncretistic Tradition in Bengal.* Princeton: Princeton University Press, 1983.

Roy, Nilima, and M. K. Pal. *Basketry and Mat-Weaving in India.* Census of India 1:2. New Delhi: Office of the Registrar General, Ministry of Home Affairs, 1970.

Rushd, Abu. *Songs of Lalon Shah.* Dhaka: Bangla Academy, 1964.

Sadler, A. L. *Cha-no-yu: The Japanese Tea Ceremony.* Rutland: Charles E. Tuttle, 1962 [1933].

Safadi, Yasin Hamid. *Islamic Calligraphy.* London: Thames and Hudson, 1978.

Said, Edward W. *Orientalism.* New York: Vintage Books, 1979.

St. George, Robert Blair, ed. *Material Life in America: 1680–1860.* Boston: Northeastern University Press, 1988.

Salik, Sultan Jahan, ed. *Muslim Modernism in Bengal: Selected Writings of Ahmed Meerza, 1840–1913.* Dhaka: Centre for Social Studies, 1980.

Saraswati, S. K. *A Survey of Indian Sculpture.* Calcutta: K. L. Mukhopadhyay, 1957.

Sartre, Jean-Paul. *Search for a Method.* Trans. Hazel E. Barnes. New York: Alfred A. Knopf, 1963.

————. *Between Existentialism and Marxism.* Trans. John Mathews. New York: William Morrow, 1976.

Sax, William S., ed. *The Gods at Play: Lila in South Asia.* New York: Oxford University Press, 1995.

Sayers, Robert, and Ralph Rinzler. *The Korean Onggi Potter.* Washington: Smithsonian Institution Press, 1987.

Schimmel, Annemarie. *Mystical Dimensions of Islam.* Chapel Hill: University of North Carolina Press, 1975.

————. *Calligraphy and Islamic Culture.* New York: New York University Press, 1984.

Schlee, Ernst. *German Folk Art.* Tokyo: Kodansha, 1980.

Schrempp, Gregory. *Magical Arrows: The Maori, The Greeks, and the Folklore of the Universe.* Madison: University of Wisconsin Press, 1992.

Scollard, Fredrikke S., and Terese Tse Bartholomew. *Shiwan Ceramics: Beauty, Color, and Passion.* San Francisco: Chinese Culture Foundation, 1994.

Sen, K. M. *Hinduism.* Harmondsworth: Penguin, 1984 [1961].

Sen, Prabhas. "Potters and Pottery of West Bengal." In Dasgupta, ed., *Arts of Bengal,* pp. 42–47.

————. *Crafts of West Bengal.* Ahmedabad: Mapin, 1994.

Sen, Sukumar. *History of Bengali Literature.* New Delhi: Sahitya Akademi, 1960.

Sethi, Rajeev, Pria Devi, and Richard Kurin, eds. *Aditi: The Living Arts of India.* Washington: Smithsonian Institution Press, 1985.

495

Shah, Haku. *Votive Terracottas of Gujarat.* New York: Mapin International, 1985.

Shahidullah, Muhammad, and Muhammad Abdul Hai. *Traditional Culture in East Pakistan: A Survey under the Auspices of UNESCO.* Dhaka: Department of Bengali, University of Dacca, 1963.

Shamsuzzaman, Abul Fazal. *Who's Who in Bangladesh Art, Culture, Literature (1901–1991).* Dhaka: Tribhuj Prakashani, 1992.

Shaw, Simeon. *History of the Staffordshire Potteries.* New York: Praeger, 1970 [1829].

Shearer, Alistair. *The Hindu Vision: Forms of the Formless.* London: Thames and Hudson, 1993.

Siddiqui, Ashraf. *Folkloric Bangladesh.* Dhaka: Bangla Academy, 1976.

Siddiqui, Kamal, Sayeda Rowshan Qadir, Sitara Alamgir, and Sayeedul Huq. *Social Formation in Dhaka City: A Study in Third World Urban Sociology.* Dhaka: University Press, 1993.

Sieber, Roy. *African Textiles and Decorative Arts.* New York: Museum of Modern Art, 1972.

———. *African Furniture and Household Objects.* Bloomington: Indiana University Press, 1980.

Siporin, Steve. *American Folk Masters: The National Heritage Fellows.* New York: Abrams and Museum of International Folk Art, 1992.

Sirajuddin, Muhammad. *Living Crafts in Bangladesh.* Dhaka: Markup International, 1992.

———. *Lyrics in Terracotta at Kantajeer Mandir.* Dhaka: Markup International, 1992.

Skelton, Robert. *The Indian Heritage: Court Life and Arts under Mughal Rule.* London: Victoria and Albert, 1982.

Skelton, Robert, and Mark Francis, eds. *Arts of Bengal: The Heritage of Bangladesh and Eastern India.* London: Whitechapel Art Gallery, 1979.

Smith, Cyril Stanley. *A Search for Structure: Selected Essays on Science, Art, and History.* Cambridge: The MIT Press, 1982.

Solon, L. M. *The Art of the Old English Potter.* New York: John Francis, 1906.

Spargo, John. *Early American Pottery and China.* Garden City: Garden City Publishing, 1948 [1926].

Sprigg, June. *Shaker Design.* New York: Whitney Museum of American Art, 1986.

Stockley, Beth, ed. *Woven Air: The Muslin and Kantha Tradition of Bangladesh.* London: Whitechapel, 1988.

Sturt, George. *The Wheelwright's Shop.* Cambridge: Cambridge University Press, 1963 [1923].

Stutley, Margaret. *Hinduism: The Eternal Law.* Wellingborough: Crucible, 1989.

Sweezy, Nancy. *Raised in Clay: The Southern Pottery Tradition.* Washington: Smithsonian Institution Press, 1984.

Synge, John Millington. *The Aran Islands.* Boston: John W. Luce, 1911.

Tadgell, Christopher. *The History of Architecture in India: From the Dawn of Civlization to the End of the Raj.* London: Phaidon, 1994.

Tagore, Rabindranath. *The Crescent Moon: Child-Poems.* New York: Macmillian, 1913.

———. *Gitanjali.* New York: Macmillian, 1914.

———. *The Gardener.* New York: Macmillan, 1914.

———. *Fruit-Gathering.* New York: Macmillan, 1916.

———. *The Hungry Stones and Other Stories.* New York: Macmillan, 1916.

———. *Reminiscences.* Delhi: Macmillan, 1983 [1917].

———. *The Home and the World.* New York: Macmillan, 1919.

———. *Glimpses of Bengal: Selected Letters.* Trans. Krishna Dutta and Andrew Robinson. Calcutta: Rupa, 1992 [1921].

———. *Lipika.* Bombay: Jaico Publishing House, 1994 [1922].

Taifoor, Syed Muhammed. *Glimpses of Old Dhaka: A Short Historical Narration of East Bengal and Assam with Special Treatment of Dhaka.* Dhaka: Banu, 1956.

Talukdar, Rezaul Karim. *Nazrul: The Gift of the Century.* Dhaka: Manan, 1994.

Taylor, James. *A Sketch of the Topography and Statistics of Dacca.* Calcutta: G. H. Huttmann, Military Orphan Press, 1840.

The Teaching of Buddha. Tokyo: Bukkyo Dendo Kyokai, 1991.

Tewary, I. N. *War of Independence in Bangla Desh (A Documentary Study).* Varanasi: Navachetna Prakashan, 1971.

Ther, Ulla. *Floral Messages: From Ottoman Court Embroideries to Anatolian Trousseau Chests.* Bremen: Edition Temmen, 1993.

Thompson, E. P. *Whigs and Hunters: The Origin of the Black Act.* New York: Pantheon, 1975.

———. *Customs in Common: Studies in Traditional Popular Culture.* New York: The New Press, 1991.

———. *Making History: Writings on History and Culture.* New York: The New Press, 1994.

Thompson, Robert Farris. *African Art in Motion: Icon and Act.* Los Angeles: University of California Press, 1974.

———. *Black Gods and Kings: Yoruba Art at UCLA.* Bloomington: Indiana University Press, 1978.

———. *Flash of the Spirit: African and Afro-American Art and Philosophy.* New York: Vintage Books, 1984.

———. *Face of the Gods: Art and Altars of Africa and the African Americas.* New York: Museum for African Art, 1993.

Tillotson, G. H. R. *Mughal India.* London: Penguin, 1991.

Toelken, Barre. *The Dynamics of Folklore.* Logan: Utah State University Press, 1996 [1979].

Trent, Robert F. *Hearts and Crowns: Folk Chairs of the Connecticut Coast, 1720–1840.* New Haven: New Haven Colony Historical Society, 1977.

Trimble, Stephen. *Talking with the Clay: The Art of Pueblo Pottery.* Santa Fe: School of American Research Press, 1987.

Tuan, Yi-fu. *Space and Place: The Perspective of Experience.* Minneapolis: University of Minnesota Press, 1977.

Turan, Mete, ed. *Vernacular Architecture: Paradigms of Environmental Response.* Aldershot: Avebury, 1990.

Turner, Victor W. *The Ritual Process: Structure and Anti-Structure.* Chicago: Aldine, 1969.

Uchido, Yoshiko. *We Do Not Work Alone: The Thoughts of Kanjiro Kawai.* Kyoto: Nissha, 1973 [1953].

Uddin, Jasim. *The Field of the Embroidered Quilt.* Trans. E. M. Milford. Dhaka: Hasna Jasimuddin Moudud, 1986 [1939].

Upton, Dell, and John Michael Vlach, eds. *Common Places: Readings in American Vernacular Architecture.* Athens: University of Georgia Press, 1986.

van Schendel, Willem, ed. *Francis Buchanan in Southeast Bengal (1798): His Journey to Chittagong,* the Chittagong Hill Tracts and Comilla. Dhaka: University Press, 1992.

Vansina, Jan. *Art History in Africa: An Introduction to Method.* London: Longman, 1984.

Verma, Som Prakash. *Art and Material Culture in the Paintings of Akbar's Court.* New Delhi: Vikas, 1978.

Vlach, John Michael. *The Afro-American Tradition in Decorative Arts.* Cleveland: Cleveland Museum of Art, 1978.

———. *Charleston Blacksmith: The Work of Philip Simmons.* Columbia: University of South Carolina Press, 1992 [1981].

———. *Plain Painters: Making Sense of American Folk Art.* Washington: Smithsonian Institution Press, 1988.

Vlach, John Michael, and Simon J. Bronner, eds. *Folk Art and Art Worlds.* Ann Arbor: UMI Research Press, 1986.

Walker, H. Jesse, and Randall A. Detro, eds. *Cultural Diffusion and Landscapes: Selections by Fred B. Kniffen.* Baton Rouge: Geoscience and Man, Louisiana State University, 1990.

Ward, Rachel. *Islamic Metalwork.* London: Thames and Hudson, 1993.

Waterstone, Richard. *India.* Boston: Little, Brown, 1995.

Watson, Bruce. *The Great Indian Mutiny: Colin Campbell and the Campaign at Lucknow.* New York: Praeger, 1991.

Watson, Burton, trans. *The Lotus Sutra.* New York: Columbia University Press, 1993.

Weeder, Erica Hamilton, ed. *Japanese Folk Art: A Triumph of Simplicity.* New York: Japan Society, 1992.

Wheeler, Monroe, ed. *Textiles and Ornaments of India.* New York: Museum of Modern Art, 1956.

Whitaker, Irwin and Emily. *A Potter's Mexico.* Albuquerque: University of New Mexico Press, 1978.

Williams, Joanna Gottfried. *The Art of Gupta India: Empire and Province.* Princeton: Princeton University Press, 1982.

———. "Criticizing and Evaluating the Visual Arts in India: A Preliminary Example." *Journal of Asian Studies* 47:1 (1988): 3–28.

Williams, Raymond. *The Country and the City.* New York: Oxford University Press, 1973.

————. *Marxism and Literature.* Oxford: Oxford University Press, 1977.

Wolfe, Richard J. *Marbled Paper: Its History, Techniques, and Patterns.* Philadelphia: University of Pennsylvania Press, 1990.

Wolpert, Stanley. *A New History of India.* New York: Oxford University Press, 1993 [1977].

————. *India.* Berkeley: University of California Press, 1991.

Wood, Donald A., Teruhisa Tanaka, and Frank Chance. *Echizen: Eight Hundred Years of Japanese Stoneware.* Birmingham: Birmingham Museum of Art, 1994.

Wulff, Hans E. *The Traditional Crafts of Persia: Their Development, Technology, and Influence on Eastern and Western Civilizations.* Cambridge: The MIT Press, 1966.

Yanagi, Soetsu. *The Unknown Craftsman: A Japanese Insight into Beauty.* Ed. Bernard Leach. Tokyo: Kodansha, 1989 [1972].

Yanagi, Soetsu, and Shoji Hamada. *Japan Folk Crafts Museum.* Tokyo: Japan Folk Crafts Museum, 1970.

Yanagi, Sori, ed. *Mingei: Masterpieces of Japanese Folkcraft.* Tokyo: Kodansha, 1991.

Yasin, Mohammad. *A Social History of Islamic India: 1605–1748.* New Delhi: Munshiram Manoharlal Publishers, 1974 [1958].

Yeats, William Butler. *The Celtic Twilight.* Dublin: Maunsel, 1902.

Yoshida, Mitsukuni. *In Search of Persian Pottery.* New York and Kyoto: Weatherhill and Tankosha, 1972.

Zaman, Niaz, *The Art of Kantha Embroidery.* Dhaka: University Press, 1993 [1981].

Zelinsky, Wilbur. *Exploring the Beloved Country: Geographic Forays into American Society and Culture.* Iowa City: University of Iowa Press, 1994.

Zimmer, Heinrich. *Artistic Form and Yoga in the Sacred Images of India.* Trans. Gerald Chapple and James B. Lawson. Princeton: Princeton University Press, 1990 [1926].

————. *Myths and Symbols in Indian Art and Civilization.* Ed. Joseph Campbell. New York: Pantheon Books, 1946.

Ziring, Lawrence. *Bangladesh: From Mujib to Ershad, An Interpretative Study.* Karachi: Oxford University Press, 1992.

Zug, Charles G., III. *The Traditional Pottery of North Carolina.* Chapel Hill: Ackland Art Museum, University of North Carolina, 1981.

————. *Turners and Burners: The Folk Potters of North Carolina.* Chapel Hill: University of North Carolina Press, 1986.

————. *Mark Hewitt: Stuck in the Mud.* Cullowhee: Belk Gallery, Western Carolina Univesity, 1992.

————. *Burlon Craig: An Open Window into the Past.* Raleigh: Foundations Gallery, North Carolina State University, 1994.

Index

R

ART AND LIFE IN BANGLADESH
was designed by Henry Glassie,
prepared for the press by Bruce
Carpenter & John McGuigan,
printed & bound by Thompson-
Shore, Inc., & published by the
Indiana University Press.